THE
CIVIL WAR
RIVALRY

THE
CIVIL WAR
RIVALRY

OREGON vs. OREGON STATE

KERRY EGGERS

THE
History
PRESS

Published by The History Press
Charleston, SC 29403
www.historypress.net

Front cover, bottom right: Terron Ward. *Courtesy of Michael Arellano/Emerald Media Group.*
Back cover, bottom left: Joey Harrington. *Courtesy of the University of Oregon.*

First published 2014

Manufactured in the United States

ISBN 978.1.60949.957.0

Library of Congress CIP data applied for.

To my brothers, Brent and Tom Eggers, who have helped make my life meaningful. There is not more than a pinch of ornery between the two of you. So what happened to me?

CONTENTS

Foreword, by Mark Helfrich 9
Foreword, by Mike Riley 11
Acknowledgements 13

1. The First Game 17
2. Battle of the Unbeaten 24
3. Roses for the Lemon-Yellows 35
4. Civil War Pageantry 50
5. Iron Men Go Down 62
6. The Osseys 68
7. Fisticuffs, Horseplay and More 77
8. Transplanted Rose Bowl Champs 99
9. Van Brocklin and the Cotton Bowl Kids 109
10. Cas and Tommy 124
11. Terry Baker, Heisman Trophy Winner 150
12. Roses for Beavers 174
13. Giant Killers 184
14. The Fouts/Moore/Graham Era at Oregon 200
15. Civil War Giants: Andros and Brooks 229
16. Big Daddy Brooks 254
17. Toilet Bowl 290
18. You Can't Lose 'Em All 301

Contents

19. Ducks Smell Roses for First Time in 37 Years 310
20. Greatest (Civil War) Game Ever Played 322
21. Fiesta for Beavers and Ducks 336
22. Thriller in Corvallis, Overtime Classic in Eugene 360
23. No Roses for Beavers, but for Ducks 378
24. The Letdown Bowl 404
25. What the Rivalry Meant 423
26. Flip Flops and Family Acts 469
27. Tidbits Through the Years 495

Sources 529
About the Author 531

FOREWORD

I was a kid who grew up in Coos Bay with Oregon football and the Civil War. My dad, Mike, played for the freshman team at Oregon. My mom, Linda, also went to school there before transferring to Southern Oregon.

So I was always a Duck fan. My one wavering moment was in high school, when I attended Oregon State's football camp a couple of times with some of my Marshfield teammates. Of course, I also went to the Oregon camps. That's where my heart was.

In Coos Bay, there was a pretty even split between Beaver fans and Duck fans who were always hot and heavy for their teams. When I was growing up in the 1980s, the Ducks were on a 13-year run in which they didn't lose a single Civil War game. Those were good years on our side of the rivalry.

We went to a lot of games at Autzen Stadium, though I don't remember going to that many Civil War games. Maybe we had a harder time getting tickets for those games, I don't know. My most vivid memory is that we were going to go to the Toilet Bowl—the 1983 game that ended 0–0—and didn't end up going. Maybe we were lucky we missed that one.

Being a quarterback, I remember players like Chris Miller and Bill Musgrave. They were the guys I identified with. When I was a freshman at Southern Oregon College (SOC) in 1992, I went to Corvallis for the Civil War game that the Ducks won 7–0. It was wet—really wet.

Rich Brooks offered me the opportunity to walk on at Oregon out of Marshfield. I decided to play at Southern Oregon instead. I don't have any regrets in my life, but that's one thing I've thought about—the "what if?"

But not in a negative way. I had a great college career at SOC. I had a lot of fun, and I made a ton of friends. Things tend to work out as they're supposed to, I guess.

After I coached at Boise State, Arizona State and Colorado, I came to Oregon to serve on Chip Kelly's staff. It was always in the back of my mind that I was in a special place. I've never been one of those guys to write down, "I have to do this and that." But knowing the landscape of college football and how special Oregon is for a lot of reasons, it was always a place I hoped I'd land.

The Civil War is special, too. It's very important. As a coach, you say every game is important, even though every game is virtually the same. But growing up in this state, I know the repercussions of living in a town that is 50–50 split. The game means an awful lot to a lot of people. That's on your mind to a certain extent as you play the game.

There's a sort of visceral feeling that turns the game…more boisterous, I guess, than most. I remember being a grad assistant at Oregon in 1997 when Oregon State came out at Autzen and ran through our stretch lines before the game. Stuff like that adds a little fuel to the fire.

I know the talking that goes back and forth, not just between players but between fans of the two schools. There are bragging rights at stake, but I don't worry too much about that. I worry about winning the game. I've been on both the good side and the bad side of that, and the good side is a lot more fun.

I know some of the history of the game, but not all. This book explores a lot of the great memories that have been created over more than a century of competition between the schools. I'm going to sit down and enjoy reading about all those folks who have helped make it one of the greatest rivalries in the country. I hope you do, too.

—Mark Helfrich
Head Coach, University of Oregon

FOREWORD

I grew up in Corvallis from sixth grade on. My father, Bud, was an assistant coach on Dee Andros's staff at Oregon State. But my earliest memory of a Civil War game was at Hayward Field in 1965, when I was 12 years old. Thurman Bell made a one-handed interception to save a 19–14 Beaver victory. The picture was in the newspapers the next day.

A few years later, I remember being in the stands at Autzen Stadium and watching quarterbacks Steve Endicott and Tom Blanchard—both Grants Pass natives—oppose each other, and their coach, Mel Ingram, sitting there watching both of his kids play. In that game, there was the famous Bobby Moore–Mel Easley standoff. Funny, I don't have any real visual recollection of a Civil War game at Parker Stadium.

But I remember how important it was to win the game. Oh my gosh, it was the biggest game of the season, no doubt about it. Coach Andros always set it up so well. Everybody was so engaged—not just the players but all the people around the state. From a personal standpoint, it was such a big deal to the families involved. It was really fun to be a part of.

I was part of a lot of rivalry games—Alabama-Auburn as a player, Cal-Stanford and Southern Cal–UCLA as a coach—but there is something unique about the Civil War. We're in a relatively small state. It's the No. 1 sporting event in our state every year. The Trail Blazers were always fun and still are, but the Civil War is the No. 1 sports story.

There aren't many fence-riders. You're on one side or the other if you live in Oregon. As a kid, I just remember being so emotionally involved in

wanting the Beavers to win so badly. Maybe that was from my dad. It had to come from somewhere. Whether it was football or watching an Oregon State game and wanting the Beavers to beat Oregon teams led by Jim Barnett or Stan Love or Bill Drosdiak—there was passion there. But it was especially so with football, since Bud was coaching.

As a coach, the Civil War is really special. Sometimes it dawns on me that this is something my dad did, something we grew up watching. You might dream about playing in it one day or maybe even coaching in it. And when the reality is that it's something you get to do in your life, you feel so thankful for it. You're passionate about it. It makes it more meaningful and more fun.

It's absolutely the biggest regular-season game for us. I've talked about this with Don Read, the former Oregon coach whose son, Bruce, is our special-teams coach. At Oregon State, we talk about setting goals before every season—winning home games and conference games, going to a bowl game, getting to the best bowl game we can and beating our rival. If you're not saying winning the Civil War is big, you're not saying the truth. I've wanted to win a rivalry game since I was playing at Corvallis High and I knew we had to beat the Albany Bulldogs. Now it's the Beavers and the Ducks.

There's no doubt that there's an added electricity to Civil War week. You can't help but feel it because of the amplified attention, the extra media around, the number of interviews our coaches and players are doing. People are talking about it on campus. The students are involved. No artificial stage has to be set for that game. It's real.

I'm proud that a lot has been on the line in recent years—going to the Rose Bowl or, for Oregon, playing in the National Championship Game. As I travel more, people talk about the game, that they love the scene as they watch it on TV. It's been fun to see the growth. It's the way it ought to be.

I'm excited that Kerry Eggers has undertaken the project of writing the history of the Civil War. There's no better person than Kerry to write this story, since he has been watching this game for decades. It will be a special book for any sports fan in our state and even across the country, since the Civil War game has grown into a national event.

—Mike Riley
Head Coach, Oregon State University

ACKNOWLEDGEMENTS

After more than four decades of writing about sports professionally, I'm not sure that I've had a more from-the-heart project than *The Civil War Rivalry: Oregon vs. Oregon State.*

The first Civil War football game I can remember was at Parker Stadium in 1962; I was nine years old. In Terry Baker's final regular-season game, the Heisman Trophy winner led Oregon State to a come-from-behind 20–17 victory over Oregon that had as much suspense as a rivalry game can possess.

Over the next half century, I've been witness to about 30 Civil War football clashes, including every game since 2000. Some of them have been mostly about pride and "the right to live in the state," as the Great Pumpkin, Dee Andros, so famously declared. Others, in particular those in recent years, have been meaningful on a national level and for bowl positioning.

All of the games, though, have held drama and passion and intensity, as represented by the many thousands of alums and fans who call the Ducks and Beavers their teams. As I've spoken with the players and coaches from both schools through nine months of interviews for this book, I've come to understand what the game meant and continues to mean to them, too. They have wanted to win for themselves but also for their legions of followers who have always placed a huge importance on the biggest annual sporting event in the state.

I interviewed more than 250 players, coaches, officials and representatives from the two schools, from current members to 97-year-old Andy Landforce Landforce of Corvallis, a member of Oregon State's 1941 team who played

in the "Transplanted Rose Bowl" in 1942 in Durham, North Carolina, at the outbreak of World War II. I spoke with representatives of every era since the 1940s and interviewed all the living head coaches from both schools.

Those interviews provided the greatest pleasure I had while writing this book. What a unique opportunity it was to have so many great gentlemen share stories, provide a window into the Civil War's past and offer anecdotal evidence into what makes it one of the sport's true rivalries.

Most of the greats—from Baker to Dan Fouts to Ahmad Rashad to Bill "Earthquake" Enyart to Pete Pifer to Bob Berry to Ken Simonton to Joey Harrington to Kenjon Barner to Brandin Cooks—were generous with their time and offered compelling reflections for historical perspective.

The coaches, in particular, were terrific sources. Mike Riley and Mark Helfrich were kind enough to pen forewords. Chip Kelly took time from his hugely busy duties as head coach of the Philadelphia Eagles for a 15-minute phone interview, offering his thoughts on the Civil War. Nike's Phil Knight—whose Civil War history dates to his days with the Oregon cross-country and track and field teams of the 1950s—provided important insight, for which I'm grateful.

Some of the interviews hit deeply on a personal level. Cliff "Chief" Snider roomed with my father—John Eggers, the longtime sports information director at Oregon State—for a time when they were attending OSC and told me of introducing him to my mother, whom Snider had previously dated. Chief died at age 87 a couple months after we spoke. Joe Francis, who died of cancer three weeks after we talked, moved both of us to tears as he spoke of his warm feelings for my dad.

Thanks to each and every one of you who provided a treasure-trove of memories. I wish I could have used even more of your thoughts in the book, but space and time prevented it.

Special thanks to archivists at the respective college libraries, Jennifer O'Neal at Oregon and Elizabeth Nielsen at Oregon State. And to Ty Thompson with the Multnomah County Library and Rod Richards of Portland's Title Wave bookstore, who presented the opportunity to pore through newspaper articles to gather information for the book. And to Don Wirth, former director of the OSU Alumni Association, who provided phone numbers and contact information for many of the Beaver players through the years.

Thanks to The History Press for the opportunity write this book, in particular commissioning editor Aubrie Koenig, who offered guidance and showed patience through the tedious process of completion of the project.

Thank you to Erica Jackson Curran, whose thoughtful and good work in the copy-editing process was greatly appreciated.

From those who have represented Oregon and Oregon State on the gridiron, there is antipathy and, in some cases, hatred for the other side. What I found, though, was also much mutual respect from those who have gone into battle wearing green and yellow or orange and black togs.

There is little doubt that the tradition established over 121 years stirs the embers among those who have contributed to it, making it one of college football's most-storied rivalries.

That's why they call it the "Civil War."

THE FIRST GAME

Thirty-five years after Oregon reached statehood and fewer than 30 years after the end of the Great War between the Union and Confederate states, the University of Oregon and Oregon Agricultural College (OAC) met on the gridiron on a sawdust field in front of 500 curious observers.

The "Farmers" beat the "Lemon-Yellows" 16–0 on OAC's College Field that cold, wet November day in 1894, beginning a traditional rivalry that merits comparison with any in college football today. Only three current West Coast rivalries have lasted as long or longer than the Civil War: Utah and Utah State (1892), Cal and Stanford (1892) and Idaho and Washington State (1894).

In some quarters, people were impressed with this new fast-moving, sometimes violent game known as football. Others weren't so convinced.

"The game is little better than the sports of the amphitheater of old or the bullfights of Spain," the *Salem Daily Post* editorialized later that year. "A scientific game like baseball or cricket is all right in connection with universities or colleges, if not carried to excess; but football is on a par with the shinny played with a curved stick."

"Shinny" was a reference to an informal style of ice hockey, or perhaps street hockey, popular in the day. The comparison was not exactly high praise for a sport being introduced in Oregon colleges during that era.

Intercollegiate football began in 1869 with a contest between Rutgers and Princeton in New Brunswick, New Jersey. Two teams of 25 players each attempted to score by kicking a round ball into the opposing team's goal. Throwing or carrying the ball wasn't allowed. Rutgers won 6–4.

By 1880, a more oval, rugby-like ball was in play. There were two 45-minute halves with a running clock, three downs to make five yards for a first down. Scoring was four points for a touchdown, two for a conversion, two for a safety and five for a field goal.

Walter Camp (1859–1925), a player, coach and sportswriter, was the forefather of the more modern game. He standardized an 11-man team, the line of scrimmage, the center snap and advancing the ball by the run or the pass. Camp coached Yale's team from 1876 to 1882 and for three years after that at Stanford.

Football came to the West Coast in the 1880s and was played on a club level in Oregon in the early 1890s. OAC, which established what it called the College Athletic Club in 1892, got a one-year head start in football on the U of O. New OAC president John Bloss—a Civil War veteran who had played a key role in the Battle of Antietam in Maryland—announced in 1892 that the school would begin playing intercollegiate football the next year. Bloss's son, Will, had played football at Indiana, and he became OAC's first coach and quarterback.

On October 15, 1892, the Oregon College Foot Ball Association (OCFBA) was formed. Representatives held their first meeting in Albany, with J.W. McCrum from Pacific (Forest Grove), A.P. Shattuck from State University (Albany), E.E. Washington from Portland, H. Colman from Oregon State Normal (Monmouth) and A.S. Additon from OAC attending. Willamette was unrepresented but played as a charter member of the association.

McCrum was elected president, Additon secretary and Shattuck treasurer at the meeting. Each team in the association was assessed a five-dollar fee to be used in purchasing a pennant to be presented to the team winning the most games during the season. A schedule was drawn up, with games to be played the following winter. Each institution was to select a member to serve on an advisory committee as a court of appeals.

OAC's team color that year was orange—no black yet—and its mascot was a coyote named Jimmie. The school's sports teams weren't called the Coyotes, however. In the early years, newspaper accounts referred to the "Farmers," the "Hayseeds," the "Agrics" and the "Agriculturalists." Later, it was shortened to "Aggies," and sometime in the early twentieth century, "Orangemen" came into vogue.

In Eugene, an Oregon "Athletic Club" was formed in 1893, one year after intercollegiate sports were introduced. The initial color was yellow, and in 1893, students voted to add green and to call themselves the "Webfoots," derived from fishermen who had been heroes during the Revolutionary

War and whose descendants had settled in the Willamette Valley. Despite that, early references to UO sports teams were to the "Lemon-Yellows," the "Dudes" and the "Webfeet."

(In those years, Oregon was unofficially known as the "Webfoot State." Ironically, when the state nickname became the "Beaver State" in 1909, Oregon students changed the name of the yearbook to *The Beaver*. It became *The Webfoot* in 1914.)

By 1893, American college football rules called for two 30-minute halves and three downs to make five yards for a first down. A team scored five points for a kicked field goal, four for a touchdown, two for a conversion and two for a safety. Substitutions were allowed only after injuries or disqualifications; passing was prohibited.

With Bloss as player-coach, OAC won five of six games that first season, beating Albany, Monmouth (twice), Multnomah Athletic Club of Portland and Corvallis Athletic Association and losing to Portland. Meanwhile, Oregon was organizing a football team of its own. Stringent rules were put into place by the faculty: "Each team member must have 42 credits earned, [with] student character above reproach, and he must have been a student of the university for at least one year."

The first game was played on March 24, 1894, against Albany on a Eugene field now on the site of the university's computing center and Gilbert Hall. Oregon won 44–2 at a site that had no bleachers and no seating for spectators—just two long benches for the teams. Spectators lined the field, sat or stood in carriages with the horses still attached or watched from nearby rooftops.

The first UO coach was Cal Young, who had learned to play football in 1886 at Bishop Scott Academy, a military school in Portland. He was 23 and working in the family meat market when Oregon got the go-ahead to form a team. For the first game, Young served as one of the game officials—not an unusual occurrence during the formative years of football in the state.

"Ours was probably the only UO team that didn't know defeat," Young wrote later. "Of course, we played only one game."

While Young goes down as the only undefeated coach in Oregon history, he wasn't the best one. Editorialized the *Eugene City Guard* after the win over Albany: "The University boys had no coaching to speak of before the game, and while individual playing was excellent, the teamwork was open to criticism."

After that game, Young resigned, giving way to former Princeton player G.A. Church. Oregon joined the OCFBA, which now included OAC,

Pacific, Oregon State Normal and Portland. Oregon thus embarked on a three-game fall season in 1894, beginning with the game in Corvallis against the Farmers.

From the *Corvallis Gazette*'s game account:

> *About 500 people saw the OAC football team defeat the State university 11 today by a score of 16–0. The game was marked by brilliant plays throughout. Playing began at 1:30 (p.m.) and for the first few plays, the Eugene players went with a dash that won plaudits from all, and it seemed they would do up the Farmers in short order. Their game consisted principally of straight runs around the end. On center plays, their work was generally ineffectual against the heavy line rush of the home team, and many times cost them considerable loss of yardage. OAC made large gains around Eugene's right end.*
>
> *The best of feeling prevailed during the entire game, and little or no slugging was indulged by either side. The Eugene team made a favorable impression on everyone. With the exception of (Percival) Nash, who suffered a dislocation of a shoulder blade in the first half, none of the players were injured.*
>
> *The playing was spirited throughout, but lost interest after the first half, as it was plainly apparent the varsity (Oregon) team was outclassed. The Eugene players conducted themselves as gentlemen and made a favorable impression with each of the 500 interested spectators. A commendable feature of the game was the general good feeling that prevailed among the players and the absence of slugging on either side.*

The *Gazette* account focused heavily on deportment, a reflection of the feeling of the day. The early years of college were rife with calls to abolish football on college campuses because of the physical nature of the game, which, with no padding to protect the players, resulted in injuries and, in extreme cases, death.

From an editorial in the Eugene-based *Union Republican*: "The next legislature should pass a law prohibiting the playing of the cruel, inhuman and outlandish game of football, at least by the students of the University of Oregon. There is no sense in it. Students are sent there to gain knowledge and refinement, not to cultivate a desire for participating in a cruel game of this kind."

Not everyone agreed, however. A letter to the editor in the *Oregonian* from W.E. Carll of Oregon City reflected the feeling of many during the era and made a case that football was well worth saving. Carll wrote:

The present cry against football, and the action of some of our local university faculties with reference to stopping and possibly prohibiting football, show a woeful amount of ignorance and blind prejudice on the part of those who so quickly jump to criticize and call brutal one of the best, if not the best, of all modern games. The criticism can in no way apply to more than one or possibly two plays in the game, and these can be easily eliminated, and in fact are rapidly being eliminated from the game. So it will be only a question of time when these features will no longer mar the noblest of outdoor sports. Then is it not better to try to clear up these few defects and give true recognition to the benefits which result from a heavy indulgence in football?

Football necessarily teaches a man self-reliance, self-command, perseverance; it cultivates his powers of concentration. A man must have his wits about him, must judge quickly and play quickly—his opponents are pressing, he must hear and instantly obey orders, and further, when fatigue comes on he must force himself to continue constantly watching, being ever ready to see, meet and possibly invent new play to oppose any new play of his adversary. It therefore teaches a man to contend against opposition and therefore teaches perseverance and self-control.

There is no other sport in the world which makes so much demand upon a man's mental and physical qualities. The puny, cigarette-smoking, narrow-chested must avoid it, and must regret that their fathers and mothers had not prepared themselves by physical training to produce offspring better qualified for the battle of life. A few broken bones or a few bruises should not cause us to cry down the game. All manly sports have some drawbacks of this nature. How long will it be before our country may be called upon to try conclusions with some nation, and then, if not before, will the manly training of the gridiron field make heroes well able to carry out the physical power what their mental powers may prompt them to?

It is well to understand why the weak and the timid shrink from the sight of the game. Not having courage to participate, they exclaim in horror that such things should occur. But with one of courage, how different it all is! How he thrills at a quick, alert play, how he actually feels the impetus of a rush! And when some noble fellow makes a creditable run, how he urges him on until possibly a good "tackle" fills him to the brim with applause for the player who had the courage and strength to stop such a cyclone of flesh and blood. All of these things should and will make the game take precedence over all others.

There are points which we must all agree make us ashamed of the participants. There are brute plays by brute natures, more noticeable in a game before spectators on an open field. But no more deplorable than if such cropping out took place in the shop, counting-house or home of the brute. All lovers of good sport should see to it that such players are suppressed.

With all the hue and cry against football the season of '94, just closing, has little serious damage to show, and football men have gained experience, muscle and a priceless stock of health. If college faculties would follow the advice of such men as Walter Camp or Whitney, and make suitable and necessary changes in the rules, the ranks of the railers against the game would be quickly reduced to those who howl and rail at everything except their own existence.

Another newspaper editorial, entitled "The Uses and Abuses of College Athletics, Especially Intercollegiate Football," addressed the need for universities to stress academics and clean play on the field:

he faculties should demand a high grade of classwork from the men on the teams, barring temporarily any man who is neglecting his legitimate occupation, that of study, for the sake of football. It is not at all necessary that training for the games need interfere with the study by any member of the team. As far as I know, the Oregon college [players] represent a high average of intelligence and moral force. In addition to a high ideal of scholarship to be maintained, a still higher ideal of school and personal honor should be insisted upon. The members of the faculties can do much to help make this a clear, concrete, well-defined force in all college athletics. The universal mottos should be, "Much for honors, but everything for honor."

The young men are constantly under the temptation to yield to the lower ideals of some of their enthusiastic admirers outside of college circles…Rumors get afloat as to what the other teams intend to do in the way of "slugging," and anxious would-be friends advise the college men to "do 'em up" if they try any rough play. If these tendencies are not counteracted, there is always danger that the two teams may face each other, each believing it will be obliged to defend itself against the unfair and intentionally disabling play of the other, when, as a matter of fact, neither team means to take the initiative in rough play.

By 1900, 43 colleges throughout the country fielded football teams. The number was increasing each season. Unfortunately, so were the dangers of the sport.

According to the *Chicago Tribune*, there were 18 deaths and 159 serious injuries as a result of playing football in 1904. Newspaper editorials called on high schools and colleges to ban football outright. President Theodore Roosevelt—a proponent of the value of the sport—summoned coaches from 62 schools, including Harvard, Yale and Princeton, to the White House in 1905 to urge them to curb excessive violence and set an example of fair play for the rest of the country. The schools released a statement condemning brutality and pledging to keep the game clean.

But in 1905, the toll was 19 deaths and 137 serious injuries. Following the season, Stanford and Cal switched from football to rugby, and Columbia, Northwestern and Duke were among the schools to drop football. In 1906, radical rule changes included legalizing the forward pass, abolishing dangerous "mass" formations, creating a neutral zone on the line of scrimmage and doubling the first-down distance to ten yards (at that point, still to be gained in three downs).

It led to a gradual decline in the number of deaths and serious injuries. College football was preserved, to be further popularized in the years to come.

BATTLE OF THE UNBEATEN

After the initial loss to the OAC in Corvallis in 1894, Oregon dominated the next 25 years of the intrastate series. From 1895 to 1922, the "Dudes" lost only three times to the "Hayseeds," though six of the 26 meetings over that period ended in ties.

In 1902, the first attempt at forming a regional collegiate athletic league was made. OAC, UO, the University of Washington, Washington Agricultural College (later to be Washington State), Montana and Idaho were among the nine schools in what was called the Northwest Intercollegiate Athletic Association. The NIAA, though, disbanded with little fanfare two years later.

Oregon got a home field in 1903, when Kincaid Field—with grandstands holding 800—was built on land belonging to Eugene pioneer Harrison Kincaid. Kincaid was a newspaper publisher and served two terms as Oregon's secretary of state. OAC would continue playing its games at College Field until 1910, when a stadium was built and renamed Bell Field.

Oregon won 6–5 at Corvallis in 1904 in a game that produced the longest run from scrimmage the series will ever see. OAC went into the contest with a 4-0 record, having allowed only one touchdown (worth five points in 1904) in beating its alumni, the Portland Meds, Washington and Utah State. Oregon was 4-2, having been shut out the previous two weekends by powers California and Stanford. College games that season featured 25-minute halves. Fields were 110 yards long, with no end zones (established for the 1911 season).

On a wet day on a muddy College Field, Oregon led 6–0 at halftime after a Joe Templeton touchdown and the PAT, or what was in those years known as a "goal kick." OAC's star center in those days was Dow Walker, bigger than most of his peers and, if not a great player, certainly opportunistic for history's sake.

Setting the stage for a description of Walker's run, the *Oregonian's* postgame account began this way: "Fancy, if you can, 200 pounds of brawn and muscle racing down a field swimming in water and so muddy that a snipe would have bogged down; fancy, if you can, this giant human form racing across this field of water with a slimy, mud-dripping ball tucked under his arm, with 11 Oregon men howling at his heels like a pack of hungry wolves, and you have a picture of center Walker making his sensational 105-yard run."

On an early second-half possession, the Webfeet methodically worked the ball downfield toward the Agrics' goal. "Templeton, though he was guilty of three serious fumbles, was playing a ripping game," the reporter wrote. "But the fates had it in for him, and in a lively mix-up at OAC's 10-yard line, the greasy ball slipped from his grasp, and it flew backwards as if it had been shot out of a gun."

The writer called Walker "sort of Sandow II," in reference to Eugene Sandow, a pioneering Prussian bodybuilder of the era. Walker, or Sandow II, "was on the fringe of the skirmishers, and saw the ball scooting merrily toward Oregon's goal. Like a panther he sprang forward, grasped the ball and hiding it under his huge shoulder, sped down the field. Templeton howled that he had lost the ball, but the din on the sidelines drowned his cry, and before Oregon realized what had happened, Walker was 30 yards away. It must have seemed countless miles to the goalposts to the big fellow. Once he almost stopped, and the OAC rooters became frenzied in their agony of fear. But he struggled on, planting his colossal feet into the mud and ooze, sending great showers of muddy water right and left. Walker saw the goalposts through bleary eyes, stumbled and staggered on, and was 10 yards in front of the nearest Oregon runner when he stopped."

Nearly 60 years later, Terry Baker's 99-yard run in the Liberty Bowl became etched in most Oregon Staters' minds as the longest in school history. From scrimmage, yes. But it was Walker, the lumbering center with colossal feet, who has the program's longest play ever, covering more real estate than the 100-yard kickoff returns by Ray Taroli (vs. UCLA, 1970), Tim Alexander (vs. Southern Cal, 1998) and Gerard Lawson (vs. Hawaii, 2006).

(Oregon's longest plays: Woodley Lewis, 102-yard kickoff return, vs. Colorado in 1949; Jim Smith, 98-yard fumble recovery return, vs. Oregon State in 1967; Bob Newland, 95-yard pass from Tom Blanchard, vs. Illinois in 1970.)

By 1905, Oregon was figuring out a way to make money from its football team. With 2,000 people looking on at Kincaid Field, Frank Templeton's touchdown run sealed a 6–0 triumph over OAC, and the large crowd provided gate receipts of $760, split between the two schools. It accounted for most of the $400 profit Oregon football would show for the season.

Oregon made a wise investment prior to the 1906 season when Hugo Bezdek was hired as its first full-time coach for $1,500 salary—$1,100 to oversee the "department of physical culture" and $400 to coach. Bezdek was also allowed to hire an assistant coach, a first for the program.

Born in Prague in 1884, Bezdek came to America as a small child when his family settled in Chicago. The 5-7, 175-pound Bezdek played football under the great Amos Alonzo Stagg at the University of Chicago. Bezdek was a four-year starter in the backfield and named to Walter Camp's All-Western team his final season.

"The best player I ever coached," said Stagg, a member of the first All-America team in 1889 whose coaching career spanned six decades and ended in 1946, when he was 84. Bezdek coached a year under Stagg at Chicago before being recommended to Oregon by his mentor, taking over the UO program at age 23.

Before the 1906 season, Bezdek instituted training table, required all 35 players to learn every position and introduced the forward pass, which was being legalized that season.

Oregon had a fine season under Bezdek that fall, going 5-0-1 and allowing opponents only nine points. The one blemish was a scoreless tie against OAC on a muddy sawdust field at Corvallis.

The Agrics were in good hands, too, under first-year coach Fred Norcross, who had been star quarterback and captain at Michigan under the legendary Fielding Yost in 1905. From 1901 to 1905, Yost's Michigan teams went 55-1-1, outscoring opponents by a margin of 2,821 to 42.

Before being hired by OAC, Norcross had spent a short time serving as a surveyor in Montana, pioneering for a railroad. Like Bezdek, the 5-6 Norcross was diminutive in stature and was soon known around campus as "the Napoleon of football" and "The Wise Man of the East" or just

"Norky." His young 1906 team was called "Norky's Green Bunch." The Agrics were 4-0-1, having tied Washington 0–0 at Seattle three weeks before, going into the Oregon game.

The *Oregonian*'s pre-game account focused on Norcross's decision to bar the public from its practice sessions. "The OAC practice throughout the week has been behind closed doors," the newspaper report said. "The exclusion of onlookers from the field has been religiously kept and little is known concerning what finishing touches coach Norcross has given the team...The team is very light compared to the men usually sent out by Oregon Agricultural College. It will hardly weigh an average of 160 pounds to the man."

Oregon, the newspaper said, "expects to win by a small margin after a hard game."

UO star Fred Moullen missed the game with a sore shoulder, which didn't help his team's chances for victory. The visitors, through a post-game account in the *Eugene Gazette*, claimed conspiracy. "The feeling among the Oregon players is that the shifty Corvallis coach turned the hose on the gridiron last night in order to gain the advantage of a sticky field with bottomless mud for his youthful team," the newspaper wrote. "OAC has an 11 composed of hard, gritty players, but the team's hardly in the same class with the veteran Oregon team."

From the *Oregonian*: "It was played on a muddy field, and to this fact the university men attribute their failure to win a victory. The game was very largely a punting duel, with all the honors on the side of Corvallis, both in the long-distance punting by (Carl) Wolff and in the better handling of punts by the Corvallis ends and backs...The collegians early in the game turned their attention solely to punting and often kicked on first down."

Afterward, Bezdek was quoted as saying, "We outplayed OAC 60 percent. We made 15 first downs and got loose several times...but on account of the sticky mud, we could do nothing. Oregon outclassed OAC and would be only too glad to play a postseason game on a good field. I have no fault to find with the OAC people, but I hold them responsible for not having a better field."

Oregon captain W. Chandler said Oregon would have won by 20 points had the game been played "on any field but a muddy wallow like the OAC gridiron."

The man who refereed the game, Bruce Shorts, voiced his agreement. "It was positively the worst exhibition of football I have ever seen," said Shorts, a former tackle at Michigan. "Neither team could do any

playing, as the men were ankle deep in mud. Not of the ordinary kind, but sticky stuff that hindered every movement. There was not a spot on the field that was free of it. After the first few downs, it was impossible to distinguish one player from another. The ball was usually coated with several pounds of mud and punting the ball for any distance was out of the question...On a dry field, Oregon would outclass Corvallis. Oregon is three or four touchdowns stronger than Corvallis, and under anything like favorable conditions would have won easily...Altogether, it was a wretched exhibition."

Shorts, it should be pointed out, had served as Oregon's head coach the previous season.

The *Corvallis Gazette*, in the homer-ish spirit of the era, countered with a story under a headline that read, "Skill, Not Mud, Did It."

"The statement made by the Eugene Guard accusing the OAC players of having flooded the ground the night before to make the field muddy is without just cause," began the *Gazette* article.

Norcross wasn't buying any excuses, either. "On account of the heavy condition of the field, Oregon's superior weight (average 174 to 159) enabled (the visitors) to make the greater yardage," Norcross was quoted as saying. "Our superior punting and handling of punts more than counterbalanced their odds in weight. Oregon played good ball and the contest was gentlemanly and clean.

"I believe the Oregon players to be too sportsmanlike to whine over the fortunes or misfortunes of a football game. It seems too bad our players cannot be given some credit for what they do, and the charge of watering the field is really too silly to discuss. To me the charge sounds like a wail from persons who have wagered and lost. Some people are greater in adversity than in victory; others are not."

The 1906 campaign was the only one in which Bezdek and Norcross met as coaches on the gridiron. After the season, Bezdek returned to Chicago to attend medical school. A year later, he was hired as football coach at Arkansas, continuing a coaching career that would last three decades with many twists and turns.

Former Dartmouth star Gordon Frost—who had coached high school football in Seattle the previous two years—took over the Oregon program for the 1907 season. Frost had graduated from Dartmouth in 1904 and then coached high school ball in Seattle for two years.

There was plenty of anticipation for the '07 matchup in Eugene, which in those years was billed as the "Oregon Intercollegiate Game." Oregon, under Frost, entered the game 3-0 on its way to a 5-1 season. OAC was also 3-0 en route to a 6-0 campaign.

"It is a game both elevens have looked forward to for 12 long months, and the game that the supporters of their respective institutions and all over the state have discussed, wondered about and figured on for a similar period of time," wrote the *OSU Barometer*, the school newspaper. "It is the game all Oregon and all of the Northwest is watching with breathless interest."

Most Eugene businesses were closed for the day so proprietors could be on hand to cheer for Oregon. From Corvallis and Albany, trains bearing nearly the entire OAC student body, among others, carried 1,700 fans to attend the game played on UO's sawdust field. One group of the team's followers, called the OAC Rooters' Club, walked the entire 40 miles from Corvallis.

Gambling, which ran amok in sports much later in the century, was prevalent even in the early 1900s. On the day before the game, William Jaspers Kerr—in the first year of his 25-year tenure as OAC's president—addressed the student body during a special convocation in chapel exercise in the Armory on the ethics of athletic contests.

"He urged students not to wager money on games, insisting the practice tends to bring wholesome sports into disrepute, leads those who wager into evil habits and applies funds that parents provide for education to unworthy and vicious purposes," the *Oregonian* wrote. "No influence can work faster for the demoralization of sports than gambling on games, said the president.

"President Kerr also insisted that gentlemanly deportment, whether player or supporter, is a first essential to clean sports. 'Whether victorious or defeated, accept the result as true sportsmen,' he said, 'and let your demeanor be such that your state and your college will be proud.'"

Players of the era were of small proportions almost inconceivable more than a century later. OAC starters weighed from 147 pounds (Walter Gagnow, the QB) to 206 (Bill Jamison, a tackle), with eight starters weighing under 170. UO starters ranged from 141 (D. Kuykendall, the QB) to 198 (J. Scott, the center), with five starters under 170.

A crowd of 4,000, the largest to watch an intercollegiate game in the state, saw OAC prevail 4–0 for its first win in 10 years in the series.

From a game account printed in both the *Oregonian* and the *Gazette*: "Never before in the history of Northwest football had a game been played that called forth such a magnificent display of strength and skill. It was spectacular from

whistle to whistle, causing the spectators to hold their breath in wonder and then break forth with cheering."

Game stories of that era often commented on the crowds and the pageantry, as they did on this day. "The Oregon rooters did effective work, as did those of the Agricultural College," the *Eugene Guard* wrote. "The latter were attended by the Cadet Regiment Band of 35 pieces, while the Eugene Military Band furnished music for Oregon."

OAC fullback Carl "Tubby" Wolff provided the game's only points with a field goal from the Oregon 30-yard line with 22 minutes to play. From the *Gazette*: "The angle was difficult...A pall of hushed silence fell over the great crowd as he squared away for delivery of the blow with a calm deliberation...He was easily the coolest person on the grounds, and the oval shot from the field and sailed gracefully and unerringly over the center of the bar between the posts, scoring the points that marked the first victory over the University in eight games. Two thousand hearts leaped, two thousand voices howled and two thousand people caroused out of a delirium of delight, while as many or more felt the keen disappointment of impending defeat, though admiring the cool youth whose good foot had saved the day for the Orange."

Oregon missed a number of opportunities to tie the score or win the game. After back Fred Moullen pounded the line on six consecutive plays, carrying the ball for a collective 30 yards to the OAC 20-yard line, he missed the second of two field goals—in the lexicon of the day, "placekicks." Dudley Clark also attempted a dropkick without success.

"(J.R.) Coleman had a golden chance to score after receiving a forward pass but was tackled from behind by the fleet-footed (H. Earl) Rinehart," the *Oregonian* reported. "The game ended with Oregon struggling desperately to cross the Corvallis goal line."

In the school yearbook, the *Orange*, a jingoistic and hyperbolic account read this way: "This mighty aggregation was to lock horns with the U of O for the Northwest Championship. And when they came together in battle, great was the carnage. The two great masses of brawn and muscle came together with a great crash like the grinding of broken metal. And they surged back and forth like two bullocks in deadly combat. There were hundreds of OAC lads and lasses on the sidelines shouting encouragement to their team and praying for victory. When the first half ended with no score, they danced madly around their team in a serpentine and threw up their hats and yelled like an OAC Rooters Club. Then OAC approached U of O's goal line, and the trusty right foot of Tubby the Wolfe made the final

score 4–0. And OAC went raving mad and turned the city of Eugene upside down unto all pandemonium turned loose."

In contrast to the contentious air of the coaches the year before, there was a sportsmanlike tone to the coaches' post-game comments this time. "The teams were evenly matched and both played exceptionally good football," Norcross said. "The Agricultural College team was favored slightly by good luck."

"We were fairly beaten and will take our defeat like sportsmen," Frost said. "Since Corvallis has beaten us, I wish her team all success and I hope to see it win the (coast) championship."

Wrote the *Oregonian*: "Although the rivalry was keen and enthusiasm ran high, a spirit of fairness and good sportsmanship existed throughout the contest. Corvallis has nothing but praise for Oregon's splendid team, and Oregon had the same feeling for the victors. The friendly feeling engendered served to restore the friendship that existed between the two colleges prior to the unpleasant incidents last year. Nobody in Eugene begrudges the Corvallis victory, and there are no sore spots in either side."

OAC's team carried the momentum through the rest of the season, outscoring its opposition 138–0 in six games. The Agrics ended the season by traveling to Los Angeles to face St. Vincent's College—later to become Loyola Marymount—for the Pacific Coast championship. OAC won 10–0.

When the coaches and players returned via train to Corvallis two days later, "great was the rejoicing," wrote the *Orange*. "The people turned out in multitudes to do homage to the champions. The hearts of the fairest maidens fluttered at the glance from the heroes of the hour. The faculty came out with their wives and children to rejoice with the multitude. Bells were rung, cannons boomed and the faculty actually yelled. It was like a cross between the feast of the Gods and a Fourth of July. They were the champions of the Pacific Coast."

The spirited game set the tone for the rivalry to take a quantum leap in intensity for the following year. The 1908 game was scheduled for the first time at a neutral site, at Portland's Multnomah Field.

Oregon was on its seventh coach in seven years. Robert Forbes became the first to man the post for successive seasons, running the program in 1908 and '09. OAC was in its final of three campaigns under Norcross.

The Lemon-Yellows went into the game 3-2, having lost the previous two Saturdays to Whitman and Washington. The Agrics entered with a 4-0-1 mark, having beaten Whitman the previous weekend and having outscored their five opponents 73–0.

"The Farmers are in line for the Pacific Northwest championship and expect to repeat their record of last year," the *Oregonian* wrote. "Members of the university team (Oregon) expressed confidence in their ability to win against their old-time rivals…It is evident that coach Norcross' famous football machine will be put to it to gain the ascendancy."

A throng of 1,500 fans trekked to the game from Eugene, including 60 who decorated a train with the words "University of Oregon," using a letter for every car. Bunting in Oregon colors, flags and pennants was also used "to make the train as attractive as possible." About 2,000 rooters came from Corvallis.

From a dispatch from Corvallis on the Farmers: "Every man is in perfect physical condition and ready to put up the fight of his life."

A capacity crowd of 10,000 watched as Oregon beat OAC 8–0, while an overflow throng "estimated over 5,000 saw the game from the hillside on the south, the roofs of nearby buildings and the Multnomah Club verandas," according to the *Oregonian*.

Fred Moullen was the difference, kicking a pair of four-point field goals to provide all the scoring in a game played in a heavy downpour. From the *Oregonian*: "Before the largest crowd that ever saw a football game in the Pacific Northwest, the University of Oregon 11 demonstrated its superiority over the Oregon Agricultural College team. It was made possible through the accuracy and power of the trusty right foot of captain Fred Moullen. The Oregon captain kicked two goals from placement in the first half of the most magnificent football struggle ever seen in Portland. It brought joy supreme to the wildly cheering and vociferously enthusiastic rooters of the University of Oregon, for the varsity team had been rated as second choice and odds of two and three to one had been offered against the chances of defeating the OAC team."

On its first offensive series, OAC fumbled after a long drive into Oregon territory. The Lemon-Yellows mounted a drive of their own, with Moullen booting a field goal from the OAC 10-yard line for a 4–0 lead. Neither team showed much offense or ingenuity in the hard-fought battle.

"Only once or twice during the 35-minute halves were there individual plays that gave one of the largest and gayest crowds that has ever attended a football game in the city's history a chance to thrill," the *Oregonian* reported. "The new style football was regulated out of the game, and only twice, both by OAC, was the forward pass used, and failed dismally. Only once or twice were fake, or trick, plays tried. It was just straight football, with lots of punting, a game in which Oregon made splendid

use of both brain and brawn and took advantage of every chance and made opportunity for plays that were brilliantly executed. At every stage of the grueling contest, Oregon was ever ready to take advantage of its opponent's fumbles and weaknesses.

"Even those hardworking and loyal OAC rooters that swayed and strained and sang in the grandstand must have realized with a shock that was sickening that they had been fooled into believing Oregon was sending a team of weaklings just to be slaughtered. For down on the rain-soaked field, had they had but half an eye, they could have not helped but known that, man for man, Oregon was outplaying their team. And in the pinches, where brain is pitted against brawn, the better judgment was displayed by the lads from Eugene."

The school annuals, not surprisingly, saw the game's outcome differently. In the *Orange* came the first mention of the nickname "Beavers" for an OAC athletic team. "Time after time, the Beavers tore through the line for good gains," the yearbook wrote. However, "they went into the game with a touch of overconfidence and did not play a consistent game."

The *Oregana* praised Moullen, calling him "the man with the famous stub foot," and said the UO captain "holds the world record for placekicking a game, a boot from the 53-yard line in the Idaho game this year." (Records from the *Oregonian* reported that Moullen kicked four field goals in a 27–21 win over the Vandals, the longest being from 45 yards on a free kick after a fair catch of a punt. No mention of any world records.)

"Moullen, with his two placekicks, was of course the leading figure in the Oregon ranks," the *Oregana* wrote. "But the punting of (Dudley) Clark, the breaking up of plays by (Louis) Pinkham, the fierce tackling of (Robert) Dodson and the running in of punts by (Sap) Latourette all worked together in getting the ball near enough to the goalposts for the kicks to be attempted.

"No wonder the Oregon students took possession of Portland for a brief time after their victory; for their team, composed of four old men and seven freshmen, had practically annihilated the Corvallis team, which contained seven veterans of their last year's Pacific Coast championship team. Some say the cries of 'Oregon, there! Corvallis, not there!' resounded through the Portland streets far into the night."

It was the end of a successful 14-4-3 three-year run for Norcross at OAC. Through his first 18 games, Norky's teams had yielded a total of four points—on a field goal by Willamette in a 4–0 loss to end the 1906 season. His '08 team, though, lost its final three games of the season to Oregon, Washington and the Multnomah Athletic Club.

Norcross never coached again. He left Corvallis and began a long career as a mining engineer and executive.

Latourette's 60-yard touchdown run was the highlight of Oregon's 12–0 win over its rival the following year at Eugene. The Webfeet would win by the same score again in 1910, but hostilities reached an unprecedented pitch that turned the rivals decidedly uncivil toward each other.

CHAPTER 3

ROSES FOR THE LEMON-YELLOWS

Oregon had never had a coach serve for more than two seasons until Hugo Bezdek came back for a second tour of duty in 1913. Bezdek, who had coached the Lemon-Yellows to a successful 5-0-1 season in 1906, returned to Eugene after spending five years as the coach at Arkansas, where his legacy includes the school's current nickname.

Arkansas athletic teams had carried the name of "Cardinals" until the close of the 1909 season. After an unbeaten season, Bezdek referred to his team as "a wild band of Razorbacks" at a post-season rally. The moniker stuck and has been applied to Arkansas teams since that time.

Oregon offered Bezdek a two-year contract at $3,500 annually, with the student body paying $2,000 and the university kicking in $1,500. The school was going to get its money's worth. Bezdek signed on to be the athletic director and head coach of the football, basketball and baseball teams.

OAC, meanwhile, was in the first season of a three-year run with Ed "Doc" Stewart as coach. Stewart was also multifaceted, having coached basketball and baseball for the Aggies the previous season. The son of a Methodist minister, Stewart was working as a newspaper editor and sportswriter in Massillon, Ohio, when he was named as the first coach of the professional Massillon Tigers in 1903. He also played quarterback for the team for four seasons.

Stewart was involved in the first major gambling scandal in pro football. Through his newspaper, the *Massillon Independent*, he charged an attempt was made to bribe some of his players to fix a two-game championship series

with the Canton Bulldogs. No legal charges were ever filed, but it caused Ohio pro football to be in disarray for several years.

Oregon and OAC tied 10–10 at Corvallis in 1913, both teams enjoying only moderate success that season. The next year's fortunes were better for both schools. The Webfeet won their first four games but ended with a 4-2-1 record. The Aggies outscored the opposition 172–15 in running up a 7-0-2 mark, routing Southern Cal 38–6 to end the campaign at Tacoma, Washington.

The Oregon teams met that 1914 season in Corvallis. Bezdek's Lemon-Yellows had fallen 10–0 to perennial Pacific Coast power Washington the previous Saturday at Seattle. Coach Gil Dobie's UW troops never lost a game in eight seasons, going 58-0-3 from 1908 to 1916.

"Coach Bezdek led his squad to Kincaid Field this afternoon and held a practice session behind closed gates," the *Oregonian* wrote. "Even the most ardent fan was barred from the field. Although beaten and scarred by the Dobie champs, there is not an Oregon athlete who is discouraged to an extent that he will predict disaster at the hands of Stewart's huskies next Saturday."

(No, OAC's nickname wasn't the "Huskies" in those days. It's what sportswriters evidently called strapping young athletes. Washington, by the way, was known as the "Sun Dodgers" until its teams became the Huskies in 1922.)

The big news was that Oregon quarterback Anse Cornell had been ruled out of the game by UO trainer Bill Hayward due to injury, though OAC assistant coach Everett May was quoted as saying, "I have bet (Hayward) a new hat that he will play. Cornell saved the game for Oregon last fall with a sensational run around end. If his injuries permit him to enter, it will increase our worries…I look for one of the greatest battles in Northwest gridiron history."

The Southern Pacific and the Oregon Electric ran specials from Portland and Beaverton/Hillsboro and a students' special from Eugene that carried 2,000 fans. The teams played to their second straight tie, this one ending at 3–3, before a Bell Field crowd of 7,000. Cornell did not play. No word on whether May ever settled up on his wager with Hayward.

Wrote the *Oregonian*'s Roscoe Fawcett: "After the rival teams had fought each other to a standstill, (OAC's) Art Lutz booted a placement between the varsity posts in the third quarter, and at that stage the three-point lead looked as big as the Matterhorn alongside Mount Tabor."

Oregon's offense was not having much success "against the husky Orange and Black forwards." Neither team attempted any passes in the first half. But then Oregon, down 3–0, "opened wide the throttle for an

aerial attack." A long pass to Oscar Weist moved the ball to the OAC 30, and then Shy Huntington—"a youngster from The Dalles just breaking into big-league ball"—kicked a 32-yard "placement" to tie the score 3–3 with nine minutes left.

"At the very close of the game it looked as though a placekick would be the Aggies' final resort, as they had the ball on Oregon's 25-yard line," Fawcett wrote. "But Lutz evidently overestimated his time and did not get the kick off."

The Pacific Coast Conference (PCC) opened play for the first time in 1915 as World War I raged in Europe, with UO, OAC, California and Washington as original members. Stanford joined in 1917. For a few years, OAC and UO held dual membership in the PCC and in the Northwest Conference with Washington, Washington State, Idaho and Whitman.

After losing its first two games to Multnomah Athletic Club and Washington State, Oregon ran off seven straight victories, including a 9–0 whitewash of OAC before a sellout homecoming crowd at a Kincaid Field enlarged to seat 8,000.

The Aggies came into the Oregon game with a 5-1 record two weeks after an inspiring 20–0 upset of the Michigan Aggies (now Michigan State) at East Lansing. It was the longest trip ever made by a Pacific Coast team, affording a rare opportunity for the national media to compare the eastern and western games. The Aggies made the trek with nine starters nursing injuries sustained in a 29–0 beating by Washington State the previous Saturday. The Michigan Aggies, meanwhile, had scored a big win over Fielding Yost's powerful Michigan team 24–0 on that day and came in as huge favorites.

After the four-day train ride to East Lansing, Herb Abraham, OAC's 175-pound halfback who was to become the school's first All-American, scored two touchdowns and spearheaded the Aggies' passing attack to a one-sided triumph. Watching the game that day was the legendary Grantland Rice, who wrote a poem in the *New York Tribune* the following day in tribute:

> *How sad to think about the slump, that's soaked the distant West!*
> *To think how far their teams have dropped below the laureled crest;*
> *To think that in that land along the old Pacific's rim,*
> *They haven't any stalwarts left to play the game with vim;*
> *They haven't any team at all, from all their ragged hosts—*
> *Except a team that crushed a team that smashed a team of Yost's.*

Ah yes, it's sad to think about the old Pacific slump,
The way the West has hit the chute and hit it with a bump;
But when you speak of things like this in a manner somewhat free,
Don't mention it at Michigan or up at MAC;
They haven't any stuff at all to call for Autumn's boasts
Except a team that smeared a team that smashed a team of Yost's.

Oregon had the best of it in the showdown with the Aggies, though on a rain-drenched, muddy Kincaid Field. Or perhaps it was a matter of the Aggies getting the best of themselves.

The Lemon-Yellows got their touchdown in the first quarter after OAC's Darius Smythe attempted to punt but fumbled and recovered on the Aggies' two-yard line. Again he tried to punt, but this time the punt was blocked and rebounded into the hands of Lloyd Tegert, who stumbled over the goal line for a touchdown. That made it 7–0, and UO got a safety late in the game when OAC captain Brewer Billie attempted an end run from a punting formation, fumbled and was tackled behind his own goal line.

The yearbook from each school told a different story at the end of the year. From the *Oregana*: "When the present students at the universities are grandmas and granddads, they will still be talking about that game with OAC on November 20, 1915. For that was the game when the old Oregon Spirit was vindicated and our Davids vanquished the Goliaths, who were heralded over the United States in the press as the 'Terrors of the Michigan Aggies.' That was the day when Jupiter Pluvius opened his fountains and deluged field, fans and players. And through the sea of mud and water plowed the wearers of the lemon-yellow, ever on the offensive and leading from kickoff to whistle. They had been told that OAC would plow right through the line; that the best they could hope for was the efficacy of prayer. They didn't need a prayer, a horseshoe or any symbol of luck…It was the greatest exhibition of fight ever put up by an Oregon team."

From the *Beaver*: "The field was a perfect sea of mud and the soft and slippery ground made it quite impossible for the Orange backs to make gains that were so common in previous contests."

After the 1915 season, Doc Stewart left to take the head football coaching job at Nebraska, accepting a salary of $4,000, a $1,400 raise from what he was making in Corvallis to coach football and serve as athletic director. He later coached football and basketball at Clemson and Texas, taking the Longhorns to an 8-0-1 season in 1923. While coaching at what is now Texas–El Paso in 1929, Stewart was shot and killed by a deer-hunting companion.

OAC was a so-so club in 1916, finishing 4-5 under first-year coach Joseph Pipall. He was a learned man, having done post-graduate work at Yale after getting his undergraduate degree from Harvard. Pipall arrived from Occidental in Los Angeles, where he had won five straight conference titles.

Oregon, meanwhile, had a powerhouse brewing, building off momentum from the previous season. The fight song "Mighty Oregon" was played for the first time at Oregon games in 1916, replacing a tune borrowed from "On Wisconsin." Bezdek, no longer coaching basketball or baseball, was keeping his focus strictly on the gridiron.

Oregon entered the game billed in those days as the "annual classic" or "the Oregon classic" with a 4-0-1 record and coming off a 12–3 win over Washington State. It marked the final regular-season appearance of star halfback Johnny Parsons, who nearly cost Oregon a chance at its first Rose Bowl appearance.

The PCC had instituted a rule barring freshmen, leaving players with three years of varsity eligibility. Under the PCC regulations, a player could represent a school in varsity action no more than three years within a five-year period from his first registration in college. Parsons had first enrolled at Oregon in September 1911 but didn't play football because of illness. He played from 1912 to 1914 and then dropped out of school for what he said were financial reasons. He enrolled in school for spring term in 1915 but dropped out again. The next year, at age 26, he was back for what he hoped was his senior season of eligibility.

The PCC rules required an athlete to have completed 12 credit hours during his last semester in school. Parsons, and Oregon, claimed the previous spring term didn't count since he wasn't in school. Problem was, there were charges that Parsons had competed in a track meet under an assumed name for Oregon that spring.

Oregon, claiming Parsons should have one year of eligibility left because the PCC rule was non-retroactive, played him through the first five games of the season. He carried 16 times for 93 yards in a 28–0 win over Multnomah Athletic Club in the team's second game. Parsons scored two touchdowns as Oregon, using the tandem wedge and reverse formations to full effectiveness, stomped California 39–14 the next week.

The next game on the schedule was Washington at Eugene. During the week leading up to the game, Sun Dodgers coach Gil Dobie raised a stink about Parsons, leveling charges of professionalism (playing after his eligibility had expired), playing under an assumed name and leaving school six weeks

before the term ended. He said Parsons shouldn't play against his team and called for Oregon to forfeit its victory over Cal.

Nothing happened immediately. Parsons played in a 0–0 tie with Washington and, ironically, cost the Lemon-Yellows a chance to pin Dobie with his first loss in nine seasons as the Washington coach. Under the rules of the day, certain eligible players from a team could recover an "onside" punt. In the second quarter, Oregon punted and Parsons— "eligible" on the play—got to the ball first at the UW one-yard line. But when he dove for the ball, it slipped into the hands of Oregon center Jake Risley. Risley was ineligible to recover the onside kick, and Washington was given a touchback.

The next Saturday, Oregon beat Washington State 12–3 before a crowd of 6,000 at Portland's Multnomah Field.

"This Oregon team is one of the most powerful physically I have ever seen on the gridiron," said coach William "Lone Star" Dietz, whose WSC team (the school was not called the "Cougars" until 1919) had defeated Brown in the Rose Bowl the previous year. "It should have beaten Washington last week by three touchdowns. Oregon outweighed us by 10 pounds to the man and I'd almost be willing to wager on it."

But Dietz said the Lemon-Yellows should not have played Johnny Parsons. "Oregon knows Parsons is ineligible to play football there this year, and we put in a formal protest against him before the game in Portland," he said. "We have proof that Parsons has not made up work that he flunked last year, and we intend to take it to a meeting of the conference officials. They have made the statement in Eugene that Parsons was not a student at the college last year, but we have found he was allowed to participate in track there just the same. We will have the game against us thrown out, the game against Washington thrown out, and all the other games where Parsons was used."

Oregon's faculty athletic council placed settlement of the ruling in the hands of the PCC court of appeal, a two-man board that was—ironically— composed of a representative from Washington and one from OAC. In a bye week before the contest against the Aggies, the advisory committee declared Parsons ineligible. But Oregon was not ordered to forfeit any games, and Parsons would be back for a grand postseason finale.

There was great anticipation in Corvallis for the annual Oregon Classic. New bleachers had been constructed along the east side of the gridiron and a new board fence built along the south side of the entire athletic field. The

first "homecoming" weekend was to be held, and the double attraction was expected to draw a record-breaking crowd.

"A programme of sports has been arranged in addition and the evening will be given over to dancing," the *Oregonian* wrote. "The business houses of Corvallis will close during the game and the churches are planning on serving meals that day. Hotels are in receipt of many requests for reservations, and the student body is making plans to entertain the large number of alumni that are expected to be drawn to their alma mater by the double attraction of the game and Homecoming weekend. The seating capacity of the field will be more than doubled by the building of new bleachers. The Homecoming exercises will open Friday night, when a monster rally and bonfire will be staged."

Oregon, with a bye week after the WSC game, had bigger fish to fry. UO coaches were hoping they were in line to represent the PCC at the upcoming Rose Bowl game. The candidates were Washington and Oregon, both unbeaten. Word was out from the Football Committee of the Tournament of Roses Association that an invitation would be sent out on November 18 to the team showing the best portfolio for the season, based on comparative scores. Oregon was banking on the decisiveness of its 39–14 win over California. Washington had beaten the Bears 13–3.

The invitation finally arrived on November 21, four days before the OAC game. "Oregon Will Play Penn in Pasadena," the *Oregonian* headline read. "Bezdek's Great Eleven at Eugene Picked as Strongest Team in West."

"Oregon has displayed an offensive punch on a par with that of the old Dobie machines," the story read. "Many of the fans believe that, except for the sloppy, miserable field at Eugene, Washington never would have been able to stop the Bezdek machine. Pennsylvania is not the best of the Eastern elevens, but it is fairly representative of the best the Atlantic seaboard can afford."

On Thursday, November 23, the UO faculty approved Oregon's participation against Penn at Pasadena in the New Year's Day game that wasn't yet called the "Rose Bowl." The faculty authorized pushing back Christmas vacation a week, beginning it on December 2 and starting classes for winter term on January 8 so that school representatives and students could attend the game.

Even without Parsons, Oregon's lineup was loaded with experience. "Practically every one of the Eugene players has had at least one year of service," the *Oregonian* wrote. "Three have played for two years, and one— captain Johnny Beckett—is playing his fourth year. Beckett, an All-Northwest tackle, shifted to halfback to fill Parsons' place."

Players were more than a bit smaller in those days. Only one player on either team weighed as much as 200 pounds. The lineups for the game:

Oregon Aggies: Charles Moist, 5-10, 167, E; John Brooke, 5-11, 205, T; John Wilson, 5-9, 179, G; Ray Selph, 5-11, 198, C; Albert Anderson, 6-1, 175, G; Alex McNeil, 6-1, 185, T; Clyde Hubbard, 5-9, 158, E; Walter Morgan, 5-8, 160, QB; Lee Bissett, 5-11, 165, HB; Charles Low, 5-9, 160, HB; Meier "Darkhorse" Newman, 5-7, 172, FB.

Oregon: Brick Mitchell, 5-11, 177, E; Glenn Dudley, 6-1, 175, T; Bill Snyder, 5-11, 198, G; Jake Risley, 6-0, 174, C; Bart Spellman, 5-11, 180, G; Ken Bartlett, 6-0, 176, T; Lloyd Tegart, 5-10, 170, E; Shy Huntington, 5-10, 178, QB; John Beckett, 6-0, 185, HB; Orville Montieth, 5-10, 168, HB; Hollis Huntington, 5-11, 178, FB.

New OAC coach Pipall, using a nickname that had just begun to come into use on the Corvallis campus, had this to say: "Take it from me that those Beavers are fighting mad, and Oregon will have a real football game on its hands all the way. Whether we win or lose, we will not be outfought."

OAC assistant coach Everett May predicted a barnburner. "If I don't miss my guess, the battle Saturday is going to be a sensational affair, despite the 'dope' against us," he said.

"Two-thirds of football is psychological," Oregon's Beckett was quoted as saying. "In other words, it is the cocky team that loses."

The Lemon-Yellows were evidently all in it together. From a Eugene-crafted piece carried in the *Oregonian*: "Coach Bez has requested the students to forget their cockiness and forget that Oregon has been invited to play Pennsylvania on New Year's Day, but to concentrate on beating the Aggies."

The night before the OAC game, Eugene had what a headline called a "Big, Gay Sendoff."

"A group of 500 students serpentined and hippity-hopped through the main thoroughfares of Eugene, staging a rally send-off for the varsity team," the story read. "Following the rally downtown, the students marched to the gymnasium and heard pep speeches from yell leaders, faculty members, coaches and alumni. Then an all-university hop to the accompaniment of the band closed the programme."

The next day, Oregon pounded OAC 27–0 on a muddy field in Corvallis. The Aggies had a strong group of freshmen who had played most of the season but were barred from participating against PCC rivals Washington and Oregon due to conference rules. George "Tuffy" Conn, in particular, was a burgeoning star. He had run for a 103-yard touchdown in a 17–7 loss to Nebraska.

The *Oregonian*'s Roscoe Fawcett borrowed on the flowery prose of the day to describe the game action. "When in their quest for the strong team of the West to pit against Pennsylvania on New Year's Day, the Pasadena Rose Tournament officials settled upon the University of Oregon football 11, they qualified to wear the crown of Solomon," Fawcett wrote. "Oregon shanghaied, hog-tied, clinched and otherwise bottled up the Coast title by giving the Oregon Aggies a terrific 27–0 walloping, the worst setback for the Orange since 1899. If the Oregon Aggies had been able to use their sensational freshmen—(George) Conn, (Butts) Reardon, (Beverly) Anderson and (George) Busch—the outcome might have been somewhat different...But the Aggies were woefully inadequate to cope with the brawny gridiron machine developed by Hugo Bezdek."

Huntington rushed for three touchdowns and kicked three conversions and Beckett carried 20 times for 100 yards as Oregon had a big advantage in first downs (15–3) and total offense (164–49).

"The gridiron was muddy and as slippery as the ballroom floor in Charlie Chaplin's 'The Count,' but Huntington, the human juggernaut of the varsity, plowed through and around the scrimmage front almost at will," Fawcett wrote. "Huntington performed in a manner that would entitle him to All-American consideration had he been playing with some 11 on the Walter Camp side of the Alleghenies. Time after time, the husky backfield star straight-armed his way through gaping holes on the right side of the Aggie line for gains of from 20 to 30 yards."

Penn went into the New Year's Day classic at Pasadena as the favorite, led by three All-Americans—fullback Lou Little, end Heinie Miller and quarterback Bert Bell. "We were scared to death of them," Oregon tackle Ken Bartlett said later. "They came with quite a reputation."

Imagine the surprise of those in the East when Oregon pulled off the 14–0 upset before a crowd estimated at 27,000, the largest ever to watch a football game on the Pacific Coast.

"Pennsylvania's vaunted football 11 was crushed and humiliated by the University of Oregon football heroes 14–0 in Tournament Park," Roscoe Fawcett wrote. "Penn couldn't even get a placekick or a dropkick past the Oregon line. Three times the Easterners tried this route and on every occasion their kicks were blocked."

Oregon scored twice in the second half to win. Huntington and Lloyd Tegart hooked up for the first touchdown that was set up by a trick play. Parsons—who had regained his eligibility since it was a postseason game—scored the other.

"Oregon won the game late in the third quarter by a pilgrimage from midfield that was as spectacular as it was unexpected," Fawcett wrote. "With the ball on the (UO) 48-yard line, Huntington called for a combination split buck and hidden-ball trick that fooled both the crowd and Penn wing guardians. Before anybody knew what was on, Huntington tore into the open field around right end for a gain of 35 yards. From the 17-yard line, Huntington then shot a nifty forward pass over the goal line into Tegart's waiting paws and the game was won.

"Shifty, nifty little Johnny Parsons proved the hero of Oregon's second touchdown in the fourth quarter. After Huntington intercepted a pass on Penn's 42-yard line, Parsons wriggled around end for 45 yards. (Shortly thereafter he) scored from eight yards out."

Bezdek was to have one more season at the Oregon helm, but he handled his final year in a manner that raised plenty of eyebrows. He left Eugene in early summer to become manager of the National League Pittsburgh Pirates midway through the 1917 season and didn't return until late September, two weeks before the Lemon-Yellow opener. Oregon finished 4-3 in 1917, losing to OAC 14–7 in a Thanksgiving Day game at Portland's Multnomah Field.

From the *Oregonian*'s account of the Oregon-OAC affair: "Five old Oregon men, three of them members of Bezdek's great team of last year, saw the Lemon-Yellow go down to defeat. Shy Huntington, quarterback of the 11 that handed Pennsylvania the short end of a 14–0 score at Pasadena last New Year's Day, held the Oregon end of the yardage chain. Bart Spellman, guard on the same team, held one of the watches."

After the season, Bezdek resigned with a 30-10-4 mark in his six years at UO. He wound up having the distinction of coaching back-to-back Rose Bowl victories. Asked to coach the Mare Island Marines, he took them to a 19–7 victory over Camp Lewis at Pasadena in 1918. Bezdek would manage the Pirates through 1919 and then take over as head football coach at Penn State.

Bezdek coached the Nittany Lions for 12 years, enjoying two unbeaten seasons and taking them to the 1923 Rose Bowl game. In 1937, he was hired as the first head coach of the Cleveland Rams when they joined the NFL. He holds the distinction of being the only person to have been a manager of a major-league baseball club and head coach of an NFL team. Bezdek was elected to the College Football Hall of Fame in 1954.

Shy Huntington succeeded Bezdek as head coach at Oregon in 1918. Huntington, 27, had been the star of Oregon's 1917 Rose Bowl victory over

Penn, running for a touchdown, passing for another and intercepting three passes. He would also coach Oregon's baseball team in 1919 and '20 and the school's basketball squad for the 1919–20 campaign.

At OAC—by this time referred to as "Oregon State Agricultural College"—the new coach was Bill Hargiss, a graduate of Kansas State who had taken a year's post-grad training at Harvard. Hargiss would last only two seasons, going 6-8-2.

Oregon got revenge for its 1917 loss to OAC with a 13–6 win at Corvallis. The Lemon-Yellows finished the season 4-2, with losses to Multnomah Athletic Club and California.

The 1919 season was an important one for Oregon for a couple of reasons. It finally abandoned soggy old Kincaid Field for a new field that would be named for Bill Hayward, the school's gruff but beloved athletic trainer and track and field coach. And Oregon would find itself in its second Rose Bowl game in just four years.

The new 7,500-seat stadium, built at a cost of $11,500, was located five blocks southeast of Kincaid Field. It had room for a quarter-mile running track circling the football field (the track would be installed in 1921), which was sown with grass and provided with a draining system. The grandstand had a shingled roof and contained dressing rooms for two teams and a large press box. The bleachers were placed on foundations at a cost of $1,000. The stadium would be dedicated on November 15 for the annual homecoming game with OAC.

The Aggies didn't intend to serve as fodder for the Hayward Field christening. From a Corvallis release in the *Oregonian*: "Coach Hargiss and assistant coach (Brewer) Billie have been practicing their men every night 'til darkness chases them in. The team has lived together for two weeks at the Phi Delta Theta fraternity house, so the squad may be together for lectures, keeping regular hours and doing everything possible to get the men in trim for the Oregon game."

OAC's prime weapon was fullback Gap Powell, a 6-1, 200-pound sophomore who would go on to All-America recognition as a senior. Alas, "Butts Reardon, OAC's doughty little quarterback, will not be used in Saturday's game due to a leg injury, which has cast a gloom over the Aggie camp," the *Oregonian* wrote. Reardon had been the hero of OAC's 1917 win over Oregon.

From the *Oregonian*: "Betting on the annual clash is slack, with little Aggie money in sight. Some bets have been placed that Oregon will win by seven points, but the prevailed odds are 10-8 on the outcome of the game."

The spread was pretty accurate. Oregon won 9–0 on the day when Hayward Field was dedicated. Governor Ben Olcott and school president Prince Lucien Campbell of UO were among a crowd of 9,000 that filled the new stadium. Also on hand was Hayward, already being referred to as "Oregon's grand old man." Colonel Bill, who had begun working at Oregon in 1904 when he was 36 years old, would coach track and field at the school for another 28 years. He died of a heart ailment months after retiring in 1947 at age 79. Hayward served six times as a trainer and/or coach for U.S. track and field Olympic teams, beginning with London in 1908.

"Hayward sat and watched on the Lemon-Yellow bench the team he had nourished throughout the season fall on the Aggies and trample them in defeat," the *Oregonian* wrote.

Hollis Huntington, Shy's younger brother, scored the game's lone touchdown on a three-yard run eight minutes into the second quarter. Skeeter Manerude had drop-kicked from the 27-yard line for the first three points late in the first quarter.

"The 180-pound Bill Steers, one of the greatest backfield men in the history of the western game, made most of Oregon's yardage until he was knocked crazy as a loon during the latter part of the third quarter," the *Oregonian* wrote. "He was succeeded by the wonderful 128-pound 'Skeeter' Manerude, the smallest player in the conference, who immediately commenced to run the Lemon-Yellow players so fast and heady that the Aggies could not get set."

Oregon's coaches were feeling pretty spry—one might say cocky—in victory. "I guess the Aggies know now that they can't beat Oregon," Shy Huntington said. "We had things our own way through the game. It was the best exhibition of 'Oregon Fight' I've ever seen."

Added assistant coach Bert Spellman, "The Aggies know us now. We are well-started toward another 10 years of victory."

Actually, Oregon would beat OAC only once over the next four years of the Huntington era, playing scoreless ties in 1920 and '21 and losing 6–0 in 1923.

The victory gave Oregon a share of the PCC title with Washington, both teams at 2-1. The Lemon-Yellows, who had beaten the Sun Dodgers 24–13, were chosen to represent the conference in the 1920 Rose Bowl game, facing eastern representative Harvard.

It was to be the third Rose Bowl featuring college teams. Because of World War I, service teams squared off in the game on New Year's Days in 1918 and '19.

"With college football back to normal, we will once more gaze upon the spectacle of two dashing varsity elevens fighting for their alma mater, their state and their section of the country," the *Oregonian* wrote.

The newspaper asked Hayward to size up the matchup. "Hayward said the studious visitors from the Cambridge town are due to handle the Webfoot tourists intimately, if indeed not roughly," the *Oregonian* wrote. "Is Oregon as good as Harvard? Hayward wiggles his head in the negative. But since Bill has been on the job at Oregon for 17 autumns and is rated as one of the smartest shower-bath professors in the business, it is reasonable to suppose he is not telling all he thinks for publication."

Shy Huntington, preparing for the game with assistants Spellman, Johnny Beckett, Brick Mitchell and Elmer Hall (a pretty deep staff for those days), was asked for a prognosis. "Just tell the folks at home we'll be fighting," he said. "We have enormous odds to overcome. Harvard has reserves galore and a might shifty team. They'll know they've been in a battle, but I never predict the result of a game."

Harvard coach Bob Fisher was more direct: "We'll win."

Fisher was right, but barely. The Crimson prevailed 7–6, though the *Oregonian*'s Fawcett considered it a moral victory for the Webfoots.

"Harvard defeated Oregon by the hairline bargain of 7–6, but not before the Pacific Coast champions had demonstrated to a delirious, wildly enthused throng that gridiron geography is not bounded on the west of the Mississippi River or the Rocky Mountains," Fawcett wrote. "Unbluffed by the bulk of the Cambridge Goliaths, Oregon laid into them like a bunch of wild animals, out-scrimmaged them, out-feinted them, but didn't out-pass them, and therein is the answer for Oregon's defeat. Forward passing proved the fly in the Oregon omelet. [The Lemon-Yellows] outplayed their beefy opponents in every department of the game save the aerial style of play. And the Lane County gladiators might have out-foxed them at that had there been more occasions for them to use it more. The ball was in Harvard's territory most of the time."

Hollis Huntington was the individual star in the game watched by a sellout crowd of 30,069, gaining 122 yards on 29 carries. Oregon had its chances, advancing to the Harvard two-yard line with four minutes to play. Skeeter Manerud's dropkick attempt for three points was blocked, only to have Oregon recover (and, in those days, get another chance). This time, Manerud dropped back to the 29-yard line for another try.

"From every angle it appeared as if the kick was true," Fawcett wrote. "The crowd—strictly pro-Oregon—was wild. But the sight of Crimson men

patting one another on the shoulder told the trained eye that the dropkick had failed by inches."

From there, the Crimson marched deep into Oregon territory with a sustained drive that took them within inches of the goal line at the final whistle. "We came 3,000 miles to lick Oregon, and we did it," Fisher said. "We had the better team. But Oregon had a better team than I expected."

"We played as hard and clean a game as we knew how, and I think we made a good showing," said Shy Huntington, who became the first man to both play and coach in a Rose Bowl game. "Harvard has a wonderful team, but we were not outplayed."

Both Huntingtons are enshrined in the Rose Bowl Hall of Fame.

A record crowd of 13,193 packed the stands in Corvallis to watch a scoreless tie in 1920. A sloppy, muddy field was covered with sawdust to try to improve conditions.

Huntington and Hayward "were at Corvallis yesterday looking over the field," wrote L.H. Gregory, a young reporter for the *Oregonian*, prior to the game. "They did a lot of head-shaking as they strode over the reeking sawdust."

A knee injury put OAC's star fullback, Gap Powell, out of commission for the game. Powell had missed the previous two games but had hoped to return for the annual Oregon Classic. On Monday, he reinjured himself in practice.

"Powell turned out for scrimmage and bored through with his old zip on every down," a Corvallis report wrote. "But Old Man Calamity stood on the sidelines as the varsity went through its work. Powell plunged through for heavy yardage, but when he was downed he could not get up. He had to be carried off the field. The injured knee had been thrown again. If he is in the game against Oregon at all, it will be only for one down—just long enough to enable him to get his football letter this year. He cannot walk, let alone play."

Even with Powell playing only two plays and several other injured starters missing, OAC nearly pulled off an upset victory. "Agriculturists Come Within Foot of Victory," the *Oregonian* headline read.

Gregory made it sound like an exercise in mud wrestling. "This well-known and popular commonwealth will have to worry along through the next 12 months without the luxury of a football champion," he wrote. "On a field soggy under its veneer of wet sawdust, slippery, slimy, oozy and swampy, OAC and Oregon battled through four fierce quarters to a scoreless tie."

OAC recovered a fumble at the UO 45 with four minutes to go. Joe Kasberger completed two passes, one for 20 yards to "Wee Hugh" McKenna and another for 15 yards to Pearl Rose, giving the Aggies first-and-goal at the three-yard line.

Three plunges took the ball within a foot of the Oregon goal. "Coach (R.B.) Rutherford called time long enough to take out the light Hugh McKenna," Gregory wrote. "He sent the heavy and eager Harold McKenna into the fray."

Harold McKenna got the call on fourth down. "The Oregon players dug their cleats deep into the sawdust mire as the fresh McKenna catapulted to the assault," Gregory wrote. "When the tangled pile-up had been unscrambled, there rested the ball, still one foot from the goal. The stubborn, fighting, unyielding defense of the battered Oregon line had held for downs and saved them from the bitterness of defeat. It was the same saving defense, under almost identical circumstances, that Oregon made at the close of the great battle with Harvard at Pasadena last New Year's Day."

On third down on Oregon's next series, Bill Steers—playing with a heavy heart as his father lay critically injured from an automobile accident in The Dalles the night before—launched a punt that rolled 88 yards with one minute to play. OAC, suddenly finding offense after a near-game devoid of it, moved upfield quickly, but Andrew Crowell's 35-yard placekick attempt for a field goal was blocked as the final gun sounded.

Shy Huntington was to depart after the 1923 season, and Oregon would find some success under John "Cap" McEwan, the man who coined the term "The Civil War," from 1926 to 1929. The Webfoots moved into a new era under Prink Callison beginning in 1932.

OAC would have six coaches in six years until Paul Schissler took over in 1924 for a successful nine-year run that ended with Lon Stiner's hiring in 1933. The result was a collision of powerhouses in a memorable Civil War game at Multnomah Field.

CIVIL WAR PAGEANTRY

Almost from the start, the student bodies of Oregon and OAC and the communities of Eugene and Corvallis—and even those throughout the state of Oregon—dived wholeheartedly into the schools' football rivalry. In some ways, they have been a part of it as much as the coaches or players.

Through the years, newspaper coverage has reflected intimate involvement among supporters of the two sides in one of the most intense college football competitions this country has known. Games have often been not just athletic contests but spectacles. Pre-game and halftime shows have featured music and other entertainment provided by students. Student bodies and alumni and cheer squads have created traditions that have made everything just a little bit bigger and more fun over the years.

To turn a phrase made popular by Dee "the Great Pumpkin" Andros, the Civil War isn't just a game. It's a way of life in the state. Here's a look at what it was all about through the course of the first part of the rivalry.

Student participation and interest in Oregon–Oregon State football was almost mandatory in the early years. Homecoming bonfires became customary at both schools, but at Oregon, they predated even the idea of a weekend to welcome back the alums.

"On Friday night, November 9, 1905, preceding the game, the greatest rally of the year—the first to be systematically arranged to followed a definite program—was held on Kincaid Field," wrote the *Eugene Guard*. "At 7:30, every male student in the university met on Kincaid Field. They were

lined up and, with lighted torches, marched in lockstep around the goalposts a time or two, forming a complete circle. Then with a yell they closed in and threw their torches on a huge pile of wood saturated with oil. And in a few moments, a huge bonfire was blazing freely, lighting the field lined by spectators."

Thus began a program attended by nearly the entire student body, with high anticipation for the showdown the following afternoon at Kincaid. Everyone, it seemed, was involved with the show. "Regent Friendly addressed the crowd, encouraged the team and urged the rooters to back it up," the *Eugene Guard* article read. "Coach (Bruce) Shorts followed and expressed his appreciation of the way in which the rooters were backing the team by the rally. CW McArthur, dubbed the 'ever-present alumnus,' spoke briefly on duties of both team and the rooters. Captain (Sap) Latourette and a few others also gave brief talks emphasizing loyalty of student body to school and team. The students then marched again and serpentined around the field, three abreast, singing Oregon songs, giving college yells and shouting all the while. The grandstand was filled with admiring spectators who continually applauded the rooters as they sang and danced around the field. After circling the gridiron several times they formed two huge letters—'UO'—to the delight of those in the grandstand, and then with a final 'Oski' dispersed into the night to await the coming day's battle."

In the years before the existence of the NCAA or much regulation in college football, a Corvallis downtown merchant laid out a little extra incentive for the other side. Displayed in his show window was a fancy sofa pillow for the OAC player who scored the winning touchdown. "Each of the Oregon State backs burned with a great urge to win and present it to his best girl," the *Oregonian* wrote.

It was a moot point. Oregon won 6–0.

Cheers were big in those years, too. Prior to the 1906 game, here are a few offerings from the Aggie side:

"Rah, Hoo Zee! Rah Hoo Zee! Orange, Orange, OAC!" Also: "OAC, Rah, Rah, Rah! OAC, Rah, Rah Rah! Ho-ooo Rah, ho-oo Rah, Agrics, Agrics, Rah, Rah, Rah!"

From an ode entitled "Toast to the Team": "Here's to the men we know and love, Agrics tried and true; Here's to the men of the Orange line who are wiping the ground with you! Up with the glass and pledge them, lads, Flashing its amber gleam, While deep in our hearts, the toast shall be, Here's to old OAC!"

Also: "Zip, Boom, Bee, Zip, Boom, Bee, OA, OA, OAC!"

The 1907 UO-OSU matchup at Eugene was the most highly anticipated in the 14 years of the rivalry. The entire western side of the state, at least, focused attention on the upcoming fray. Many were willing to walk great lengths to be on hand for the game.

From the *Oregonian*: "Most Eugene businesses closed for the day so proprietors could be on hand to cheer for Oregon. From Corvallis/Albany, trains bearing nearly the entire OAC student body, among others, carried 1,700 fans to UO's sawdust field. One group of the team's followers, called the OAC Rooters' Club, walked the 40 miles from Corvallis."

"A special train over the West Side, from Independence, Dallas and Monmouth, is to connect in the morning with the special from here to Eugene to carry the excursion to see the game tomorrow afternoon," the *Corvallis Gazette* wrote. "The train to leave Corvallis will be accompanied by the Cadet Regiment Band."

Another big game, another biggest and best pre-game rally, according to the report from Eugene printed in the *Oregonian*. "Tonight was the largest and most enthusiastic football rally in the history of the University," it wrote. "Over 300 rooters marched in the serpentine, led by yell leader Arthur VanDusen, and yelled themselves hoarse when he gave the cue with his mammoth megaphone. The main feature of the big rally took place at Kincaid field, where tomorrow's battle will occur."

The writer turned into a reviewer in his synopsis of the evening's affairs. "The freshman class erected a huge bonfire and in the light of this the ceremonies were held," he wrote. "Yell Leader VanDusen and his lusty corps of rooters did some excellent yelling and introduced some clever new song hits. Many brilliant speeches were made by those interested in Oregon's welfare on the field tomorrow. The speakers were: C.N. McArthur of Portland, the 'Father of Oregon Athletics'; Honorable S.H. Friendly of Eugene, Regent of the University; Walter Winslow, Oregon '06; Ray Goodrich, Oregon '06; Captain Gordon Moores; Coach Gordon Frost; Assistant Coach Chase; Trainer Bill Hayward; Eberle Kuykendall, quarterback on the team; Olen Arnspiger, right tackle, who will be out of the game tomorrow; manager Grover Kestley and Representative Allen Eaton."

Then the writer offered a partisan prediction: "All University supporters are confident Oregon will defeat OAC by one or two touchdowns. There is no OAC money in sight while over $500 of Oregon money is waiting for takers."

Imagine the surprise in Eugene, then, with OAC's 4–0 victory. "Dr. Withycombe, who had been through three days of hard labor, had promised the students when he left Corvallis to serve as one of the judges of the Horse Show, that if OAC team defeated Oregon at football he would toss his hat into the air and give three cheers for OAC," the *Corvallis Gazette* wrote. "The cheers were given and the soft, black hat of the director of the experimental station at Corvallis was tossed high into the air."

During the game, it was written, "the Oregon rooters did effective work, as did those of the Agricultural College. The latter were attended by the Cadet Regiment band of 55 pieces, while the Eugene Military Band furnished music for Oregon."

From the *Orange* annual at year's end, a little gloating in verse: "Strawberry Shortcake, Blueberry pie, V-i-c-t-o-r-y! Are we in it? Well, I guess. OAC champions, yes, yes, yes!"

Football inspired school spirit in both Eugene and Corvallis during those years.

A college yell for the Lemon-Yellows: "Rah, rah, rah, rah, Oregon! Rah, rah, rah, rah, Oregon! Oskey, wow wow! Whiskey wee wee! Oley Muckee-ei! Oley Varsity! Oregonei-i! Wow!"

A song entitled "Oh, Ain't It Great" (sung to the tune of a jangle of the day, "Ain't It a Shame, a Measly Shame"):

"Oh, ain't it great, just simply great, to wipe Corvallis right off the slate;

"Roll up that score, we want some more, to make Corvallis go way back and sit down."

Another song (to the tune of "Tokio"):

"Oregon, Oregon, sons of victory, butt that line, run that end, down with OAC,

"Take the ball, rush 'em all, place it over the line, It's Oregon for mine!"

The 1908 "Oregon Classic," scheduled for a neutral site for the first time at Portland's Multnomah Field, drew widespread interest from around the state. According to a pre-game Corvallis dispatch, "Never in the history of this city has there been such intense excitement over a gridiron contest. Everyone is discussing the coming event, and indications are that over half of the population of the town will follow the team to Portland."

It was a major event for Portlanders, too. On the social page of the *Oregonian* the week before the game was an article headlined "Traditional Grid Game Motif for Many Social Activities." There was a photo of Miss

Madelon Brodie, who was the honored guest at a tea held for those who were to attend the game. "She spent the last four years with her parents in Finland, as her father, EE Brodie, was the U.S. minister there," the story read. There were also a buffet luncheon, several dances and other activities leading up to the game.

Fan support was evident from a post-game Eugene report in the *Oregonian*: "About 1,500 rooters came from Eugene, including 60 students who decorated the train with the words 'University of Oregon,' using a letter for each car. Bunting in Oregon colors, flags and pennants will also be used to make the train as attractive as possible."

Cheers were a huge part of the spectating at football games of that era. One of them became part of the lead of a game story following Oregon's 8–0 victory in the *Oregonian*, written by Will G. MacRae: "Sting, stang, stung, Corvallis! Sting Corvallis, Stang Corvallis, Stung."

Wrote MacRae: "And the Farmers from OAC were stung in a game that was brilliantly played throughout, from the time of the first kickoff to the shrill blast of the whistle that ended the game. Two goals from placement, both driven between the post by that trenchant foot of Old Iron-Toes Moullen, as he is lovingly called by the students of Oregon, both in the first half, tells the story of Oregon's victory and OAC's defeat on Multnomah's football field yesterday afternoon."

Also from MacRae, focusing more on the fans than the competitors themselves: "It was a brilliant and happy crowd that watched the struggling athletes that were fighting like warriors of old down in the water-soaked field. If anything, the Corvallis rooters were in the majority and the section of the grandstand in which were seated the cadets, students and friends, was a pretty picture. It was not the fault of the OAC rooters that they did not win, for with band and college yells, a weird, screeching bomb effect, that began low and then ended with a shriek and hiss, they frequently drowned out the Oregon rooters. While the students were battling for dear life on the field, quite a different scene was being enacted in the grandstand. There it was a battle of lungs and band music. Taunts and gibes were hurled back and forth, all to be drowned with the fierce, exulting cry of victory hurled from where the Oregon rooters were quartered."

The article said that "10,000 were crowded into the Multnomah amphitheater, and it is estimated over 5,000 more saw the game from the hillside on the south, the roofs of nearby buildings and the Multnomah Club verandas."

The *Oregonian* social editor, Leone Cass Baer, even weighed in with an article entitled "Football Game as Viewed by a Novice." She seemed to enjoy the spectacle, if she didn't quite understand what was taking place on the field in her first look at this strange game of football. "In the first place, I was late," Baer wrote. "Women always are, except when they're going to be married or are going to grab some bargain sale."

Through the years, relations between representatives of the schools have ebbed and flowed. A mêlée after the 1910 game in Corvallis caused severance of athletic relations between the sides for nearly two years. By 1914, conditions had mellowed. At least that was the take of a writer with the *Oregonian*, who described the lively scene of a 3–3 tie at Bell Field a century ago.

"It was the biggest day this little city of Corvallis had enjoyed in many years," he began. "From early morn, this town was jammed to overflowing with Oregon and Aggie partisans. At dawn, the automobiles began streaming into this city from all points of the compass and the crowds coming by special train helped the restaurants and barber shops to do a thriving business. And such a day—bright, sunny, crisp. It seemed that all the horticulturists in the valley had shipped their chrysanthemums into Corvallis. There were thousands of orange mums for the Aggies and just as many yellow mums for the varsity.

"Second Street, alive with a surging throng, and Jefferson Street, en route to the new Corvallis stadium, was a hurly burly of gossiping visitors. Out in the stadium, you would never imagine that the two big Oregon institutions entertained any bitter thoughts about each other. The crowds of students, banking the sides, were plainly jealous of each other's rooting stunts but there was no unsportsmanlike act recorded. In fact, the cheer sections set a precedent that is hoped will be emulated by other Northwest colleges. Upon the request of the officials, no cheering was signaled by the leaders when the rival team had the ball. Once, after Oregon's long pass, the Aggie enthusiasts forgot themselves and began booming forth that time-honored 'Hold 'em, Aggies, Stonewall,' but only for a moment. Instantly, upon signal from referee Varnell, the noise subsided."

(So the referee controlled the crowd noise. Imagine that happening today!)

Now, a description of the plethora of halftime activities:

Between halves, stunts were clever and kept the crowd happy. Oregon
students, as the guests of the day, were given the field first. Carrying

lemon-yellow bunting over their heads, the rooters formed a "U" and then an "O" and released a number of green balloons, which sailed away in the breeze, as the rooters circled the field, cheering and singing... The Aggies started things by forming an "OAC" in orange in the bleachers as the team took the field. Between halves, the Aggie rooters, 1,000 strong, serpentined while a miniature fort, labeled "Oregon," appeared on the field. Two college comedians, picketing from the fort, sighted in the distance a 42-centimeter gun, made from a pair of wagon wheels and a section of sewer pipe. Advancing on the fort, the battery was unloosed with a loud report and the fort turned over, revealing a much abused and startled goat, wearing Oregon's colors. The quadruped thereupon was captured by the waiting Aggie rooters. The stunt was well-staged and amusing.

It was all good fun, the writer emphasized. "The best of feeling was evidenced between the players and the rooting sections," he wrote. "The game was fierce but clean; there was no crabbing...Campus games between the two leading colleges of the state appear firmly re-established."

Crabbing? Did the writer mean nobody complaining or exchanging barbs with the other side? Whatever, there was none of it on the glorious November day in Corvallis in 1914.

Flyovers have become somewhat of a staple prior to kickoff of contemporary college football. In 1915, early aeronautical entities were beginning a legacy. "A Curtiss airplane owned and operated by the Oregon, Washington and Idaho Airplane Company will make a flight to Eugene today in time for the big game between Oregon and OAC," the *Eugene Guard* wrote. "It is planned to drop a football over the field before the start of the game. Between halves, while the serpentine is in action, the pilot will take the plane up in the air again and drop confetti, the colors of both institutions being showered from the clouds."

A year later, Oregon's Rose Bowl–bound team had the students fired up. On the night before the UO-OAC game in Corvallis, "500 students serpentined and hippity-hopped through the main thoroughfare of Eugene, staging a rally send-off for the varsity team," the *Oregonian* wrote. "Following the downtown rally, students marched to the gymnasium and heard pep speeches from yell leaders, faculty members, coaches and alumni. An all-university hop to the accompaniment of a band closed the program."

The 1917 game was staged at Portland's Multnomah Field for the second time. There was plenty of pomp and circumstance involved in travels up the Willamette Valley.

Wrote the *Oregonian*'s James Richardson: "The Aggie 11, accompanied by a band and 700 or more rooters, is scheduled to arrive this morning. The Eugene team, accompanied by about 300 rooters and led by coach Bezdek, coach Walker and physical instructor Hayward, arrived in Portland yesterday."

Admission costs for the game: $2 box seats, $1.50 grandstand, reserved; $1 general admission.

"Irrespective of which team wins, the rooters of both schools will parade the business district from Multnomah Field immediately after the game," Richardson wrote. "Between halves, the rival yell leaders will hold forth with their rooters and something new in the serpentine and yelling is promised by both leaders."

A review after OAC's 14–7 victory: "It has been a long time since any football game at the Multnomah Field brought forth such a display of color as was shown in the rival rooting sections in the bleachers, along the east side of the field. While the yell leaders and their crews kept the 4,000 persons in the stands entertained during the few moments when the ball was not in play, it was between halves and after the final whistle that they staged their big play.

"When the teams trotted off at the close of the second period, the Aggies, bedecked in orange and black hats and gay sweaters and coats, took the field in serpentine, led by Ted Craemer, president of the student body. To the strains of marches and popular airs by the cadet band, they marched in circle formation, completely surrounding the field. Here they gave their yells and ended with the song of their alma mater, 'Hail to old OAC.'

"The teams were entering the field for the second half when the orange and black rooters filed back into their section and the Oregon yell artists had to satisfy themselves with a demonstration from the bleachers. Following the game, though, the lemon-yellow supporters had their inning, and not even defeat dampened the ardor of their procession, led by the student band, around the field and out through the Chapman Street gate. 'Once in 10 Years' was the refrain to which they marched." (The reference, evidently, was to OAC's last victory in the series having come in 1907. Since that time, Oregon had gone 6-0-2 against the Aggies.)

The 1919 game was a centerpiece for the dedication of the new stadium, Hayward Field, named for respected athletic trainer and track and field

coach Colonel Bill Hayward. It made for a festive atmosphere the night before the game.

"Led by a 40-piece band, the Oregon students put the 'old Oregon fight' in their team with a monster pajama and costume parade that serpentined through the principal business streets of the city, and then wound its way through curbstones lined with thousands of out-of-town visitors back to the campus baseball field, where under the influence of 'Jazz King' Crandall, the greatest rally Eugene ever witnessed was assembled," the *Oregonian*'s run-on sentence read.

"About the great bonfire built for the occasion by the university freshmen, the huge throng of students, ex-students and graduates cheered themselves hoarse in answer to the pep talks of (Shy) Huntington and Hayward and the related tales of past victories over the orange and black as told by the old-timers.

"Present indications are that the capacity of the bleachers and grandstands at the new field will be reached by the attendance at the game. Aside from the hundreds of visitors who have already arrived, telegrams and telephone messages for seat reservations are pouring in and special trains arriving during the night and tomorrow will bring between 2,000 and 4,000 more visitors. Hotel accommodations are already filled to overflowing and visitors are being housed in hundreds of private homes. The fraternity houses and dormitories at the university are full."

Hayward, often quoted during those years, was a veteran of 15 years of what would someday be called "The Civil War."

"There is such a feeling of rivalry between the two colleges that the teams will fight harder against each other than against any outside schools," Hayward said. The Aggies, he noted, "are not going to outfight us. They never have and they never will."

Oregon won 9–0.

The next year, wrote the *Oregonian*, "the spirit of the OAC campus makes it evident that Oregon will have to send a number of rooters with the team if they are to make any showing at all in the stands. The students at Corvallis have all been wearing 'smear Oregon' buttons all week, and Friday night they are planning a big rally and bonfire at which the coaches will speak, telling of the things they are going to do to Oregon."

The game ended in a scoreless tie.

In 1921, a large steel grandstand was built in connection with the varsity field in Corvallis that was now named "Bell Field" in honor of former regent John Robert Newton "Doc" Bell, a Presbyterian minister who lived

just across Madison Street. Because of his steadfast attendance at practices and games, Bell became the official school mascot. He created one of the school's earliest football traditions—throwing his top hat into the waters of the Marys River after each Civil War victory from 1894 to the 1920s.

(Bell's downfall began in 1921 when "Beavo the Beaver" was introduced as a live alternative. Beavo died in a couple of years, though, and it wasn't until 1952 that the mascot "Benny Beaver" made his first appearance in a Civil War game at Portland.)

In 1922, an expanded Bell Field was able to hold a crowd of 18,000, which witnessed Oregon's 10–0 win. This was the scene described in the *Oregonian*: "The university students effected a mighty invasion of the Beaver camp today when the entire student body boarded the special train or traveled by automobile to Corvallis. The Lemon-Yellow colors reached the Aggie stronghold at 12:45 p.m. and were immediately organized more than 1,600 strong into parade formation for the march to the field. The Oregonians were met by the OAC band, which followed the Oregon band, both of them leading the line of green- and yellow-capped fans. The arrival of the Oregon rooters at Bell Field was greeted by the shrieking Aggie siren. The OAC spectators were already seated in their covered bleachers, the boys adorned in orange fezzes and the coeds carrying pale orange balloons. The Lemon-Yellows swarmed the field, lost for the moment as to where to take their places. Then they bolted for the north bleachers like a bunch of wild colts and stormed the temporary structure. There were about a thousand varsity spectators in those orange seats. The Oregon women were given seats in the north end of the Beaver bleachers, and decorated with their yellow chrysanthemums played a pretty contrast to the orange and black at their left."

By the late '20s, highway reports were a staple of pre-game news. "Eight state traffic officers patrolled the roads leading into Corvallis today... Although thousands of automobiles were pressed into service by the football fans, there was no serious accident during the day," read a newspaper report after Oregon's 12–0 triumph in Eugene.

Students were always looking for stunts to pull on the other side. Wrote the *Oregonian* before the 1928 game at Oregon: "Exuberant Oregon Aggies plentifully bedaubed the Oregon 'O' on Skinner's Butte in Eugene. Soon after, a copious amount of yellow and green paint appeared on the Oregon Aggie 'Iron Woman.' So the peace treaty, signed earlier in the week, apparently helped but little."

From a 1929 post-game story written in Eugene by the *Oregonian*'s Palmer Hoyt, a UO grad who later became editor and publisher of both the *Oregonian* and the *Denver Post*:

In the dusk of a perfect day, this college town started making whoopee in the several and diverse ways a college town has of celebrating pigskin conquests. Even a staid and bent university janitor predicted Oregon's 16–0 victory over the collegians from Corvallis would probably make for "a hot time in the old town tonight."

More than 17,000 rabid football fans packed into Oregon's synthetic stadium for the occasion. During the morning hours, Jack Benefield, the university's genial graduate manager, was heard moaning loudly, "My kingdom for 20,000 more seats." Choice grandstand seats were said to be going for 10 bucks a throw.

A parade, headed by the Oregon band and composed of a number of the "Order of the O" of all ages and sizes, was the first preliminary. The band was especially dolled up for the occasion by virtue of the leaders' white grenadier's cap set off by a huge yellow cockade, which by the way, he almost ruined by repeated if inadvertent thumps of his baton.

Eugene knows now what the phrase "saturation point" means as applied to traffic. This town is so full of automobiles that pedestrians are actually safe. The automobiles can't get around fast enough to hit anyone crossing the streets on foot.

Hoyt should have seen it 85 years later.

Advance newspaper copy prior to the 1933 game at Portland's Multnomah Field focused on traffic, pageantry and a little sartorial splendor:

A special traffic committee has been formed by state, city and county forces to keep Portland from being jammed like the Chicago loop district on Armistice Day..."Don't cross Washington or 19th streets" is the slogan of the committee...The big idea for motorists is to drive direct toward the stadium and not try to circle around it to look for parking spaces, thus causing jams by crossing other major lanes of traffic. Portlanders are requested to leave their cars at home if possible in order to show courtesy to the upstate visitors, who must drive their cars in to see the game and will need parking space in the stadium area Saturday...Referee Wade Williams (the Lincoln High coach) will use a half-dollar for the coin toss

instead of the usual 10-cent piece…Colonel Bill Hayward will wear a violet jacket and tan golf knickers.

During the national anthem before kickoff of the 1947 game at Eugene, a low-flying plane showered Hayward Field with orange "Beat Oregon" pamphlets. It came on the occasion of the Ducks' dedicating the game to Hayward, who was near death. Oregon won 14–6. A month later, he died at the age of 79.

In 1959, Warren Spady—as an undergrad art student at Oregon—was commissioned to make a Platypus trophy, a two-foot-tall maple carving. He bought two blocks of wood and began to carve, using a stuffed platypus for inspiration. With four mallets and six chisels, he carved a figure with a beak that resembled a duck and a tail that looked like that of a beaver.

In 1962, the trophy went missing and was largely forgotten. In 1986, while on sabbatical at Oregon, Spady saw the platypus in a water polo trophy case on the UO campus. It had been commandeered by water polo players, who had affixed their own metal plate and used it in their Civil War rivalry from 1964 to 1968.

In 2005, Dan Williams, who had been student body president at the time at Oregon and was now the school's vice-president of administration, found the trophy in a storage closet. It rests now in the student alumni association office.

IRON MEN GO DOWN

Plenty of changes were in store at both schools in the 1920s. By the end of the decade, Oregon was coached by John "Cap" McEwan, a three-time All-American and squad captain at Army who had also served as head coach at West Point. McEwan started with two losing seasons but was very successful the next two years, going 9-2 in 1928 and 7-3 despite losing his last two games in 1929.

McEwan will go into the history books for a different reason. He was the one who first labeled the Oregon–Oregon State football game as "the great Civil War" in the lead-up to the 1929 game in Eugene.

L.H. Gregory picked up on McEwan's sobriquet in his pre-game story for the *Oregonian*. "This game today has been much referred to as 'Civil War,' and it doesn't fall far short of exactly that," Gregory wrote. "'Big Game' is too tame a description. Feeling between the old rivals for some reason is flaming at the hottest point in years. It's in the air. Official peace pronouncements by each side are as little reflective of the underlying sentiment as are most official statements."

Gregory predicted Portland's Multnomah Field, with a capacity of 35,000, would soon be the Civil War venue. Bell Field could accommodate 22,000. Hayward Field's capacity was far shy of that. "At Hayward Field, 30,000 persons would like to attend this game, but the Oregon fences are not elastic—only 17,000 can cram in," Gregory wrote. "Another year or so, you'll see this game in Portland—either that, or prices will be raised to $4 or $5, as they charge for the California-Stanford game, to hold down the customers. No other alternatives."

The Civil War game wound up being staged at Multnomah in 1933, '34 and '38. By that time, important changes had been made at both schools. In 1927, the UO student body voted "Ducks" as the school's official nickname. Many sportswriters, however, continued to call the school's athletic teams the "Webfoots" into the 1960s.

In 1927, OAC became known as Oregon State Agricultural College, which was shortened to Oregon State College (OSC) in 1937. By this time, the nickname "Beavers" was becoming established, though the media continued to refer to them as the "Orangemen" into the '60s. (Gregory, the longtime sports editor at the *Oregonian* who wrote for the newspaper from 1914 to 1973, resisted calling them the "Beavers" to avoid confusion with the Pacific Coast League baseball Portland Beavers. He often referred to the Ducks as "the Oregons.")

Oregon State hired its first long-standing coach in Paul Schissler, who was known on the Corvallis campus as the "Little Fire Eater." Schissler arrived after two seasons at tiny Lombard College in Illinois, where his 1923 team had outscored foes 441–14. He was hired in 1924 and stayed through 1932, suffering losing seasons in only his first and last campaigns.

In 1929, Schissler faced the player he considered "the greatest halfback on the Pacific Coast" in Oregon's 6-foot, 165-pound Johnny Kitzmiller. "The one man who compares at all is Irv Mohler of Southern California," Schissler said. "Kitzmiller is a star at everything. He shines on defense as much as offense. I admire more than anything the way he takes chances."

"The Flying Dutchman" did do everything—ran, passed, kicked, punted and returned punts. Against OSC, Kitzmiller kicked a field goal and set up a score with a long punt return in Oregon's 16–0 win. Bob Robinson scored both of the Webfoots' touchdowns, one on a 15-yard punt return (yes, 15 yards) and the other on a 16-yard pass reception. But Kitzmiller was carried off the field after a punt return on the final play of the first half.

"It was a grim touch of real war as he was placed on a stretcher and carried to the hospital," Gregory wrote. "Kitzmiller may never play football again, physicians said after examining X-ray photographs. The fracture is such that it will take several weeks to mend and the injury may be permanent, physicians declared."

McEwan left after the 1929 season to accept the head coaching position at Holy Cross. He would eventually serve two seasons as head coach of the Brooklyn Dodgers of the NFL. Ironically, he was succeeded by Schissler, who left OSC after the 1932 season to begin a four-year run as head coach

in the NFL—the first two years with the Chicago Cardinals, the next two with Brooklyn.

C.W. "Doc" Spears took over at UO for two seasons. Kitzmiller, as a senior in 1930, had returned to action with a flourish, rushing for 162 yards with several long punt returns in a 7–0 win over UCLA the week before the Oregon State game. But Kitzmiller had pulled a tendon in an ankle when he caught his foot in a drain hole against the Bruins and was limited to two plays in the Aggies' 15–0 victory—a game featuring a Pacific Coast record 51 punts.

Storms had pelted the area, and in the week prior to the game, OSC had brought in a pair of "Joe Bedcovers Jr." tarps used on Portland's Vaughn Street baseball park infield.

"Even that didn't hold off the rain," Gregory wrote. "The ground was dry for awhile but it took some mighty manpower to pull the twins off the gummy field."

In an era when punting on second or third down wasn't unusual, Oregon punted 25 times for an average of 29 yards, Oregon State 26 times for an average of 35. Oregon State's "Wild Bill" McKalip blocked a pair of Steve Fletcher punts in the first quarter, Hal Moe scoring on a 17-yard pass from Ralph Buerke after the first one, a safety resulting in the second.

In 1931, the teams played to a 0–0 tie at a wet Hayward Field. It must have been a spectators' delight. Oregon State finished with 61 yards total offense, Oregon with 104. The Webfoots had the best scoring chance, moving to the OSC five-yard line in the first quarter after recovering a fumble, but didn't score. Oregon State played a "safe game," often punting on first or second down. OSC's Keith Davis averaged 38 yards on 19 punts. That's a punt nearly every three minutes.

In 1932, Spears was replaced at Oregon by Prink Callison, 34, who had been an All-Coast center at Oregon in 1921 and '22 and then coached football and basketball at Medford High, taking the Black Tornado to state basketball championships in 1924 and '29. Callison guided the Ducks to a 6-3-1 record his first year, including a 12–6 win over OSC.

Mark Temple's spectacular fourth-quarter 65-yard punt return for a touchdown won the game for Oregon, spoiling Oregon State's homecoming. Temple's fumble at the UO two had set up Moe's TD run in the first quarter. Oregon's Mike Mikulak scored on a one-yard run to tie the game at 6–6 in the third quarter.

Both schools fielded powerful squads in 1933. Schissler's replacement was Alonzo "Lon" Stiner, an assistant coach at OSC the previous five seasons

who had been an All-America tackle for Schissler at Lombard College in Galesburg, Illinois.

Stiner's first team became one of the most famous in Oregon State history for a couple of reasons. The Aggies were 4-0-1 when they invaded Portland's Multnomah Stadium for a matchup with the nation's best team, Southern Cal, which was riding a 25-game win streak. Stiner went the entire way with his 11 starters, who became known as the "Ironmen" or "Iron Immortals." The result was a shocking 0–0 tie. Football tradition of the time was that in the event of a tie, the game ball went to the visiting team. But after the game, captain Ford Palmer of the Trojans handed the game ball to OSC captain Vic Curtin, remarking, "Here, Vic, you've earned it."

Oregon State also used the innovative "Pyramid Play" in an effort to block kicks. Stiner came up with the idea of having his tackles, Ade "Tar" Schwammel and Harry Field, hoist 6-6, 200-pound teammate Clyde Devine onto their shoulders. The first time it was used was the game before the Aggies faced Oregon, in a 2–0 win over Washington State. No kicks were blocked. After a bye week, OSC used it against the Webfoots, and Devine successfully blocked an extra-point attempt.

The ploy was used in the team's final two games, against Fordham and Nebraska, though it resulted in no blocks. At the end of the season, it was outlawed by the national rules committee.

"It helped spoil a great many placekicks," Stiner said later. "Even such a good man as Ed Danowski of Fordham flubbed a kick when he saw the big guy rising up in front of him."

The Civil War matchup was a battle of the unbeaten. Oregon State's senior-laden team, 5-0-2, was loaded with talent, including All-Americans Schwammel and halfback Norm "Red" Franklin. Schwammel, Field and halfback Pierre Bowman all played in the post-season East-West Shrine Game. There was a proposal before the Civil War game that Oregon State play in a December 9 game at Chicago's Soldier Field by something called "The National Championship Committee."

Oregon was led by 200-pound fullback Mike Mikulak, considered a "giant" in the day. Callison's Webfoots entered the Civil War contest 7-0, having yielded only 14 points all season.

During the bye week, Stiner had taken his Iron Men to Eugene to watch the Webfoots beat Utah 26–7. "Upon arriving back in Corvallis, they were taken to the gym, where each man was required to answer a set of questions which the head coach prepared," a Corvallis dispatch read.

Stiner, an ascendant from the school of Chip Kelly, said this in the days leading up to the Civil War: "My players, as well as myself, consider Saturday's game at Portland just as we have every other game on our schedule this year—the next game on our list."

Both teams practiced behind closed gates during the week. From the Friday *Oregonian*: "The Webfoots were to arrive at Portland late in the afternoon, retiring immediately to the Waverly Country Club. A few of the backfield men and ends will make a short inspection of the Multnomah Stadium field later in the day."

Even with the advantage of what amounted to a collective scouting report, Oregon State was no match for Oregon, losing 13–3.

"Over a desperately resisting Oregon State team on Multnomah Stadium rolled an unstoppable football juggernaut in University of Oregon green for two mighty touchdown thrusts, one of 71 yards in the second quarter and the other for 76 yards in the fourth," wrote L.H. Gregory in the *Oregonian*. "Lights were twinkling through the early dusk of a gray afternoon as 32,183 persons, a capacity throng, rose spontaneously at the final gunbark to acclaim a brilliant 13–3 victory for the Webfoots, and with it a prospective championship of the Pacific Coast Conference and perhaps of the nation."

Schwammel kicked an 18-yard field goal three minutes into the game for a 3–0 lead, but as the OSC annual, the *Beaver*, noted at year's end, "the great power attack of Mikulak and clever deceptive runs of (Leighton) Gee and (Mark) Temple finally proved too much for the Orange defense."

Wrote Gregory: "It was Mike Mikulak, a crashing, powerful fullback, who played with such inspired fire…by hammering for a total of 89 yards. Big Mike was a super-football player, a gridiron titan, as his smashes split the same Orange line that only a few weeks ago turned back Southern California's fiercest attacks for a 0–0 tie."

Oregon, benefitting from strong line play by future NFL All-Stars Bernie Hughes and Bill Morgan, rushed for 244 yards on 61 carries, with Iron Mike (22 for 89 and a touchdown) leading the way and Gee (13 for 77) and Temple (22 for 64 and a TD) also doing damage. The Webfoots eschewed the pass, going 0 for 2. Franklin gained 73 yards on 19 carries for Oregon State, which passed for 173 yards while completing nine of 17 attempts.

OSC broke a pair of long pass plays, both going to the Oregon 16—Johnny Biancone for 64 yards in the first half, Hal Pangle for 57 yards in the second half. The Aggies scored neither time. They used the Pyramid Play to block one of J. Milligan's two conversion kicks, but it was of little solace to the losers.

The win placed Oregon 8-0, in position for a Rose Bowl berth. Next in line was a date with Southern Cal, smarting from a 13–7 defeat the previous week to Stanford that ended the USC's 27-game unbeaten streak. Alas, Howard Jones's Trojans, with Cotton Warburton running and passing leading the way, thumped the Webfoots 26–0 at the Los Angeles Coliseum.

Oregon ended the season 9-1 after a win over St. Mary's. The Webfoots hadn't played Stanford, though. The teams had each gone 4-1 in Pacific Coast Conference games. The Rose Bowl Committee selected Stanford, which wound up losing to Columbia 7–0 in the New Year's Day game.

Mikulak, who became Oregon's third All-American, went on to play three seasons with NFL's Chicago Cardinals and later was backfield coach at his alma mater from 1937 to 1940 under Callison and Tex Oliver.

THE OSSEYS

Bud Ossey was five years old in 1924 when his mother, Nadia, took him for a ride aboard an Oregon Electric train from Portland to Corvallis to visit his father, Abraham, who was working toward an engineering degree at Oregon Agricultural College. Ossey and his parents were in the stands at Bell Field to watch the University of Oregon beat OAC 7–3—five years before the term "Civil War" was first used to describe the in-state rivalry.

The coaches were Paul Schissler of OAC and Joe Maddock of Oregon. Calvin Coolidge had just been elected U.S. president for a second term. A loaf of bread cost nine cents, a gallon of gas 22 cents. The average new automobile retailed for $265. That was 90 years ago.

Ossey, who turns 95 in November 2014, hasn't seen every Civil War game since, but he hasn't missed many of those played in Corvallis. "I missed a few in the 1930s when I was working and when I was in the army during World War II," he said. He has attended every Civil War contest in Corvallis since 1946, "and I've seen lots of them in Eugene, too."

All the while, cheering for his beloved Beavers. "Civil War football has been lots of excitement," said Ossey, a 1943 Oregon State graduate who is retired and living in Tualatin. "At times, hate. At times, revenge. At times, cheering for the Ducks as well as ourselves if things were good for both teams."

Ossey and his late wife, Maxine—she died in January 2013 after 70 years of marriage—had three sons. To Ossey's consternation, only one became a Beaver. Worse yet, two of them became Ducks.

Oldest son Dick, 69, graduated from OSU in 1966, works in real estate development and lives in Lake Oswego. Middle boy Bob, 65, graduated from Oregon in 1970, is retired and lives in Perth, Australia. The baby, Don, 57, is a 1980 UO graduate who sells commercial real estate and lives in Portland.

Going to Oregon, older brother Dick said, "was pretty consistent with a lot of the bad decisions they have made in their lives."

It has made for some good-natured ribbing in the divided family for more than four decades. "It became a very serious family feud," Ossey said in deadpan. "I wrote Bob and Don out of my will long ago."

"It is serious," Bob said. "There are certain things we don't speak about. How Donnie and I can locate Corvallis without a road map is something the Beavers have never really understood. All Ducks can smell, rather, find their way to Corvallis."

Over the years, Bob and Don have had a running bet—a bottle of Scotch—with their father and Dick on the outcome of the annual Civil War game. "I think I'm 20 or so bottles up on Dad and somehow have to figure out how to collect," Don said. "Dick's in on the same bet. There must be a class at Oregon State that teaches how to weasel out of paying."

"It's a 400-level course," offered Bob, "and it's mandatory."

"I know I keep a half-gallon of Chivas and Johnnie Walker Black Label and single malts for those guys," Dick said. "They've been whittling away at the debt I owe them."

It's all in good fun, of course. For Bud Ossey, who has owned season tickets to OSU football and basketball games since 1946, Beaver athletics has been more than a passion. "It's been my whole life," he said, "except for my family and my profession."

One game always stands above the rest. "Civil War football always was a time of excitement in our family," Ossey said. "It still is."

Bud Ossey was born Bernard Osipovich in Odessa, Russia, in 1919. (He changed his surname to Ossey during his college years.) An only child, Bud fled the next year to Portland with his mother after the Russian revolution. His father followed two years later. Beginning in 1924, mother and son stayed at their South Portland home while Abraham worked toward his degree in Corvallis, which he got in 1927.

In the meantime, there were sporting events to watch on the OAC campus. Thus began the Ossey odyssey that makes Bud among the oldest active Beaver believers.

In those years, football games were played at Bell Field. "I remember sitting up there in the wooden stands with my parents," Ossey said.

Ossey and his mother would take the train to spend time with his father and attend football games at least once a year. The family would also go to OAC games in Portland. Ossey has programs from 1927 games against Stanford and Carnegie Tech played in Corvallis.

During the Depression years, Ossey earned nickels selling programs at ballgames. As a 14-year-old in 1933, he worked the fabled "Ironmen" game at Portland's Multnomah Field in which OSC coach Lon Stiner used only 11 players in a 0–0 tie against two-time defending national champion Southern Cal.

Ossey graduated from Portland's Benson Tech in 1937, having played basketball and baseball against Boston Red Sox legend Johnny Pesky. Ossey enrolled at Oregon State in 1937 and played freshman basketball under coach "Wild Bill" McKalip.

That year, Ossey was part of one of the wildest post-game incidents in Civil War history. It lasted for parts of three days. Oregon had won four in a row against Oregon State until the Beavers broke through to win in Corvallis in 1936. After a 14–0 victory at Eugene gave their first back-to-back triumphs in years, OSC students attending the game rushed the field with the intent to tear down the goalposts.

"Being a brash young freshman, I was up there in the lead," Ossey recalled. "I had a brand-new overcoat on that my folks had bought me for college. We got to the goalposts and the Duck students came after us, and we got in fistfights. I had my coat ripped off and lost it, got bloodied up, but it was a fun deal. We had a great time. I got soused celebrating that night. When I got back to my boardinghouse in Corvallis, my landlady caught me stumbling up the stairs and threatened to report me to the administration for being drunk."

During the post-game mêlée, Oregon State students temporarily made off with Oregon's mascot duck—a real, live duck. Webfoot students retrieved the fowl after a few harrowing moments. Sometime over the weekend, OSC students surreptitiously painted Oregon's yellow "O" at Skinner's Butte orange.

Even at that, the fun wasn't over. On Monday, a large group of OSC students skipped school and caravanned to Eugene to do a little more celebrating. "I hopped into the lead car," Ossey said. "We had about 15 or 20 cars, which was about all the cars students had on campus that year. First thing we knew, we were on Highway 99 heading south to

Eugene. Pretty soon, we had a police escort because the word got out we were coming."

The Oregon Staters arrived in Eugene at about 11:00 a.m. to a hostile crowd of UO students. With state police looking on to make sure things didn't get too far out of hand, the Beavers were pelted with rotten apples and tomatoes and drenched with fire hoses.

"I remember being bombarded with hoses and water balloons as we drove through Eugene," Ossey said. "They were furious about the 'O' at Skinner's Butte. They grabbed ahold of a bunch of Beavers, took them up on the hill, stripped them to their underwear and got big buckets of yellow paint. They physically took the guys, dunked them ass-end first and slid them down the 'O' to paint it back to yellow. It was quite a scene."

Ossey had unwisely chosen to wear a belt with a big Oregon State buckle. As he was walking down the street with a pair of OSC students, a group of UO students saw them and yelled, "Let's get those Beavers!"

"We were able to cover up our Oregon State gear and started walking with them and yelling, 'Get those Beavers!'" Ossey said. "It worked. They would have taken us and thrown us into the Millrace with all the others."

Reports were that as many as 250 OSC students were "ducked" against their will with a cold bath in the Eugene Millrace. For a spell, about 50 OSC male students were held hostage at Seymour's Cafe before police arrived and dispelled the mob.

After the wet, shivering students returned to Corvallis later that day, they did a serpentine dance through the school's Commerce building.

After a year attending school in Corvallis, Ossey returned to Portland and spent three years doing engineering work for the Bonneville Power Administration. He spent time with the U.S. Army Corps of Engineers during World War II and was stationed in Corvallis, where he completed his education as part of the school's ROTC program. He graduated in 1943, the year after he and Maxine were married.

At OSC, Ossey lived a part of college football history. On January 1, 1942, the Beavers participated in the only Rose Bowl game ever held away from Pasadena. Concerns about a Japanese attack on the West Coast moved the game to Durham, North Carolina, where OSC defeated Duke 20–16 in what came to be known as the "transplanted Rose Bowl."

The shift of venue was a blow to Ossey, who had tickets and was planning to drive from Corvallis to Pasadena for the game. "I felt so bad, I threw them away," he said. "Would I give anything to have those now."

In 1939, Ossey joined an OSC booster club called "The Buck of the Month Club," which became "The Beaver Club" in 1946. Only two original members remain today—Ossey and Dwight Quisenberry of Salem.

Ossey retired from the corps of engineers in 1974 and went into the insurance business for seven years. Retired since 1981, he spent the next three decades continuing his tradition of traveling to Oregon State football games throughout the country.

The OSU connection doesn't stop there. Ossey did a long stint keeping statistics for broadcaster Bob Blackburn at football and basketball games in the 1950s and '60s. "I'd take turns having the kids sit with me in the press box," Ossey said. "Invariably, one or two would come with me."

In 1971, Ossey started a fundraising golf tournament for the OSU golf team and remains as an emeritus chairman. He was on the original board of directors for the Beaver Club and Beaver Athletic Student Fund and is still an active member. He is a member of the Oregon State Engineering Hall of Fame and the BASF Hall of Fame and was a recipient of the Martin Chaves Lifetime Achievement Award for Athletics at OSU.

In May 2013, Ossey received a call from OSU athletic director Bob De Carolis, asking if he had any objections to naming the Beavers' new golf practice facility in honor of Bud and his late wife. "I broke down and cried, because they included Maxine's name," Ossey said. "It was a shock to me. I felt very honored."

To call Ossey an institution at his alma mater is an understatement.

All of the Ossey boys were raised Beavers. "I didn't know there was a school in Eugene," Bob said. "We weren't allowed to discuss that at the dinner table.

"As a kid, a great weekend for me was to go down to Corvallis with my parents and watch sports at Parker Stadium or Gill Coliseum. I was there when the Beavers beat USC 3–0. It goes clear back to the '50s until 1968. I was a Beaver through and through."

Bud Ossey was close friends with former OSU football coach Dee Andros. "I was a ball boy for OSU football games," Don said. "After every home game, we were at the Andros house. We were in the circle of friends of Dee. I was on the team bus, on the field. When they played in Portland, we'd go over and meet them at breakfast at the hotel and ride with them to the stadium. I was a diehard Beaver. We did not follow the Ducks. They just didn't exist."

"As far as we knew, Oregon State was the only school on the whole West Coast," Dick said. "During Civil War week, we wouldn't even step into the same room as a Duck."

There was little question whether Dick Ossey was going to be a Beaver. "I was interested in engineering," said Dick, who wound up majoring in business with a minor in engineering. "Oregon State had one of the better schools in the country, and Oregon wasn't on the map for that. Having the legacy there with Dad and my grandfather and being quite familiar with the school, it was a pretty easy decision."

The wrong one, his youngest sibling is quick to offer. "He went to Oregon State primarily to stay in the good graces of our parents," Don said. "He's the biggest kiss-ass in the family. Bob and I were far more rebellious and open-minded."

Countered Bud: "Dick is brilliant, much more so than the other two boys. He's the smart one who went for an education to Oregon State. The others took the social route to Oregon."

Dick Ossey worked a few years for AT&T and then got a master's degree in business from the University of Washington, setting up a long career in real estate development in the Portland area.

"Dad has written those two years when I was at the U of W off his calendar," said Dick, who has two stepdaughters and lives with his wife, Kathleen, in Lake Oswego. "Somehow Washington accepted me—God knows how that happened."

Bob Ossey was an All-City outfielder who broke a leg during his final game as a senior at Portland's Cleveland High, temporarily ending his goal of playing baseball at the college level. "The prognosis was I'd never run or play competitive sports again," Bob said. "A year and a half later, I couldn't run at all. Never in my wildest dreams at that point did I think I'd be able to play competitive baseball again."

He enrolled at Occidental College in Los Angeles and spent a year there, "but I didn't love Occidental," he said. "I missed what was going on back in Oregon."

Several of Bob's good friends were attending Oregon. "So I transferred to Oregon, occasionally went to a class and enjoyed the lifestyle and being closer to home," he said.

Bob had never been in Eugene until his first day as a student at Oregon. "I'm not sure if Dad had ever been in Eugene before I went there," Bob said. "But when he went there, he found he liked the town."

"Not really," his father was quick to add.

Bob's leg came around well enough that, as a junior, he walked onto the Oregon baseball team as a southpaw-hitting first baseman. "Played a couple

of years without great distinction," he said. "Had a very modest career, and that's probably exaggerating it."

After college, Bob played a couple of years with the semi-pro Portland Lobos, and as his leg gained strength, an enjoyment of the sport was renewed. In 1972, when an opportunity to travel and play baseball for two years in Australia was offered by a wealthy Aussie businessman, Bob thought, "Why not?"

"Dad made sure he had a one-way ticket," Dick joked.

"My father banished me to the South Pacific," Bob said. "Australia was originally set up as a penal colony for the British; my father expanded it as a penal colony for those from our family who went to the U of O."

Bob played baseball in Australia for 13 years. "I think I made several million pennies," Bob said. "It wasn't a lot of money. It was an adventure."

More than 40 years later, Bob remains in Australia after running a consulting business for service companies there. He and his wife, Judi, have two sons. "I am very lucky to have lived in two fantastic locations—Oregon and western Australia," Bob said. "I love them both."

His brother had opened the door to Eugene, and Don Ossey walked through it. A PIL golf champion at Cleveland High, he decided on the Ducks, playing one season on their golf team while studying architecture. He was a Kappa Sigma fraternity brother of UO golf luminaries Peter and David Jacobsen and Jeff Sanders.

While a senior at Oregon in 1980, Don remembers venturing to Corvallis to watch the Ducks beat the Beavers 40–21. Afterward, Bud invited Don and some friends to stop by a post-game party at Nendel's Motel—one being attended by OSU's first-year head coach, Joe Avezzano.

"I was wearing a UO letterman's jacket," Don recalls. "Joe almost physically tried to throw me out of the party before Dad came to the rescue on my behalf. [Avezzano] calmed down, but that was a taste of the intensity of the rivalry."

During his high school years—still very much a Beaver—Don enjoyed a period in which Andros-coached teams won nine of 11 Civil Wars. From the time he started at Oregon in 1976, the Rich Brooks–led Ducks were on their way to going 12-0-1 against their rivals in a 13-year period.

"I was on the winning side every year," Don laughs. "I was just like Rich Brooks."

Upon graduation, Don worked one year for the Skidmore, Owings and Merrill LLP architecture firm, "but my talents were exposed," he said.

"I realized it probably wasn't a great career move." He wound up selling commercial real estate in the Portland area. With his wife, Katherine, he has a son and a daughter. Don remains a one-handicap golfer who still competes in amateur events and is a member of Tournament Golf Foundation, which runs the LPGA Safeway Classic.

Family was the premise by which Bud and Maxine Ossey lived their 70 years together. "After I moved to Australia, my parents made a commitment that my family would never lose touch with the rest of the family," Bob said. "Bud and Maxine flew down at least once a year and would stay for several weeks.

"They made 26 trips to Perth in 30 years. In the early years, you had to go from Portland to L.A. to Honolulu to Fiji to Auckland to Sydney to Perth. It was a two-day journey just to get there."

Bob's family made the trip to the States on several occasions, and the families of Dick and Don flew to Perth for visits, too. "Even though our children and Bob's children live thousands of miles apart, they're like siblings," Don said.

Don Ossey followed his father's lead through many years of service to his college's athletic program. He is past president of the Oregon Club of Portland, was named "Duck of the Year" and received the Harold Taylor Lifetime Achievement Award.

"My parents were always community-oriented, whether in coaching sports or the Cubs Scouts or our schools' PTA," Don said. "They instilled that spirit in all of us—to be active and service-oriented, especially when it comes to our alma maters. The compassion for others and loyalty for school and spirit of volunteerism is something they taught us."

"The work Dad did in high-profile activities like football and basketball was very visible," Bob said. "What he did behind the scenes was even more extraordinary.

"The amount of effort he put in over decades and decades to help needy people get an education or a chance to play Little League baseball or to raise money selflessly and tirelessly for other pursuits—he has always been there, for no personal return other than to help people. That's what the three brothers are most proud of about our father."

Still in the deep grieving process of a man who just lost his life partner of seven decades, Bud Ossey sent credit her way. "Maxine was the one who held us all together, the stabilizer of our family," he said. "Thank God we had a solid family thanks to my wife. That was the important thing in our

lives—our sons and their families. We had a wonderful life together, and the beauty of our lives has been our family.

"We have supported them all the way. They made their choice what they wanted to do. No matter which course the kids took in life, it was our aim to make sure they did it the right way. And they did."

Truth be told, Bud Ossey probably holds more antipathy toward the "other school" in the Civil War rivalry than do his sons. He has had a few more years to live it. The boys say they pull for the other school except at Civil War time.

"I'm not one of those Beaver-hating Ducks," Don said with a laugh.

"I never had that feeling [about the Ducks], either," Dick said. "It's kids playing ball. You have to add some kind of reality to this. A lot of Beavers tend to overplay the rivalry and the 'hate the Ducks' thing. I don't go there.

"I think Dad is similar to me. During Civil War week, there is some good kidding that goes back and forth. Afterward, whoever wins, wins, and we congratulate each other. If we lose, it's, 'see you next year.'"

FISTICUFFS, HORSEPLAY AND MORE

Through a Civil War rivalry that has spanned 120 years and 117 games, proceedings have, at times, grown acrimonious.

To say the least.

It didn't take long to get that way. In 1896, two years after the University of Oregon and Oregon Agricultural College met on the gridiron for the first time, the schools played home-and-home games. Oregon won the opener in a 2–0 thriller at Eugene, which at the time was considered a "practice game" but in the record books is now treated as a counting contest. Controversy roiled during and after the rematch.

Today, Oregon is officially credited with winning the second game at Corvallis. At the time, Oregon claimed a 10–4 victory. OAC argued it should have been a tie verdict. More than a century later, the schools still can't agree on the final score. In the current media guides, Oregon State lists the score as 12–8; Oregon has it at 8–4.

The score disparity paled in comparison with what happened on the field that day and the debate that ensued between the schools—and the hometown periodicals—afterward. From an article in the *Eugene Guard*: "The college boys (from OAC) claim…that an erroneous decision by referee Otto Burchhardt of the Multnomah Club gave the university (UO) men points they were not entitled to. Eugene got the ball on a fumble within a few feet of the college goal, and carried it over the line, but lost it without making a down. (Players from) both teams fell on it, and apparently (Charles) Osborne of the OAC secured it. The referee decided it was the

Farmers' ball, but when the teams lined up, he changed his ruling and allowed Eugene a touchdown."

At one point in the fray, the *Guard* reported, "J.F. Frick, Eugene's coach, went on the field during a dispute and offered some advice. He was ordered off and, refusing to go, was carried off forcibly." By whom, the account doesn't say.

Later, when Burchhardt awarded Oregon the protested touchdown, "(Pat) Kelsay of the Farmers' team accused him of unfairness. Burchhardt told Kelsay he lied, and the latter knocked the referee down. Kelsay was then ruled off."

Each team accused the other of unscrupulous tactics during the game. According to a report from Oregon officials, Kelsay—son of the Corvallis mayor—and brothers Brady and Bruce Burnett "initiated slugging tactics and played dirty football, while the language they…used toward their opponents was such as, to put it mildly, should have been foreign to college young men meeting on the field of sport."

The referees evidently agreed. The other official, F.J. Raley, said the OAC trio "played the dirtiest football I have ever seen."

Coach Frick was quoted as saying that one player "was simply registered at OAC because of his ability as a bruiser," adding that "prizefighters and other dirty players on the OAC team were decidedly angry with the officials because they would not permit a steal of the game nor an exhibition of dirty football."

In a book written later by Edward Warren entitled *The Development of Football in the University of Oregon*, the author described the rowdy scene on that game day in 1896: "After a 2–0 loss in a practice game in Eugene, the Corvallis boys were much elated by the close score and returned home declaring vigorously that they would surely win the championship game to be played on their own field in the next two weeks…So much rain was there that the lines were washed out as fast as they could be laid; as a substitute, small ditches were dug, and served admirably as five-yard lines and touch lines, but failed to keep out the spectators. So the crowd accompanied the players in their progress up and down the field, milling about in a most confusing manner imaginable as 'friends' of the opposing teams attempted to get in the foreground, with the result that they tended to move bodily toward the center of the field, hampering the free playing of the teams, but making fine interference for some bucky, mud-besmattered figure dashing forward with the ball. The outcome of

the game was for some time in doubt till the U of O players braced up and secured a touchdown and goal.

"When the tide turned in favor of the visitors, the Corvallis rooters, at no time very friendly to the U of O representatives, started in earnest to make things more than merely interesting. They rapidly pushed to the front along the sidelines, forcing the Oregon backers behind them by superior numbers, and lost no time in supplying the needed interference for their team, to the discomfort and occasional rough handling of angry Oregon players. Howls of rage and disappointment, yells of derision, shouts of joy and frantic screams of unknown source and cause…urged the players on as they struggled desperately for the slightest advantage. Amid that excitement of the second half, both teams scored a touchdown but failed to kick [a] goal; the score stood at 10–4 until time was finally called. The Eugene boys got out of Corvallis as soon as possible as feelings still ran high, and vowed they would never go back."

The *Corvallis Gazette* had a decidedly different outlook on the affair, of course, quoting OAC team manager Ralph Terrell. "We wanted other [game] officials but Eugene wanted the two who worked, so we accepted them, although we were warned that the fact that Multnomah and Eugene were scheduled to play Thanksgiving Day would have made the clubmen desirous of having Eugene win," Terrell told the newspaper. "Burchhardt knows nothing about the game and should not have consented to act as referee. The fact that his errors were perhaps unintentional does not compensate us for the loss of the game.

"The charge against Bruce Burnett is peculiarly insulting, for he was slugged out of the game in the first five minutes, although he appealed to Raley against the big Eugene fellows. The man who took [Burnett's] place was not used to the position, and but for his fumbles, the college team would have won easily. Citizens who attended say the only foul playing they witnessed was when Bruce Burnett was deliberately hit in the face and hurt so that he had to leave the game."

Raley, Terrell contended, "paid no attention to any of our protests, and we perhaps did not talk to him in ladylike terms when we called his attention to the constant gross off-plays of the Eugene men. In playing football, we have not time to say 'Please' and 'sir.'"

As for Raley's charge that the OAC players said before the game that they intended to rough up the opposition, "I would never tell the umpire any such stuff," Kelsay said. "If I did, it was his business to prevent me from playing; and if I slugged, it was his duty to order me off the field."

Kelsay admitted he was out of line in slugging Burchhardt, for which OAC officials apologized. From the *Gazette*: "The boys are sorry for the difficulty between Burchhardt and Kelsay. It was not Kelsay's place to say anything, but he could not be blamed for resenting Burchhardt's insulting reply."

A game scheduled between OAC and the Multnomah Club the following week was canceled. "And it is unlikely that Eugene will consent to play Corvallis again," the *Guard* wrote. "The conduct of three members of the Agricultural College team and the behavior of some of the spectators at the Eugene-Corvallis game at Corvallis is said to be the cause of this taboo."

The teams did meet in Eugene in 1897, OAC gaining revenge and then some. The final score at the time was listed as 26–0, which is as reported in the current UO media guide. (Oregon State's guide has it at 26–8.)

From *The Development of Football in the University of Oregon*: "The growing feeling of rather unchivalrous rivalry between the two Oregon state institutions approached a climax in the game. The OAC, smarting from the two defeats of the previous year, was out to win by any manner or means.

"The pace set by the teams was at times terrific. Both sides often resorted to brutal trickery, as if the injuries received in the execution of the heavy mass formations were not enough. More than one unfortunate player was stretched out temporarily motionless on the sod, and many another was so crippled as to be assisted from the field whence he did not soon retire attired in a football suit. One does not wonder that the boasted 'sportsmanlike qualities' of the game were so seriously questioned after a time by all true sportsmen."

Things got heated again in 1910, when post-game shenanigans caused suspension of the series for a year. Oregon beat the Aggies 12–0 during the first season of play at OAC's new stadium at Bell Field. By this time, the game was a major event on the social calendar in the state. Thousands traveled by train from the region to take in the game, witnessed by a crowd of 5,000 in what the *Oregonian* described as "the most bitterly fought football game in the history of the two institutions."

Newspaper reports varied in description of the happenings, depending on the source of the information, of course. The headline of an account printed two days later in the *Oregonian*: "Clashes Follow Football Match; Eugene and Corvallis mix: One Hurt. Both sides make charges. Harold Bean of Oregon felled unconscious by blow. Oregon president hissed.

Aggies say trouble started in fun and varsity shares blame equally. College caps taken as souvenirs."

After the game, the account said, nearly 1,000 "strong-lunged" Oregon students stormed the field in celebration. "Yelling like mad, the crowd bore the victorious team members in triumph on their shoulders," a Eugene account said.

OAC students, evidently taking offense, stole hats from several of the UO students that were never returned. "Immediately after the game, as students from both schools took to the field, there was a general grabbing of hats from each other's schools," a Corvallis account said. "The entire proceeding was in the spirit of college fun."

It precipitated an on-field dust-up between OAC's star right tackle, freshman Tom May, and former UO standout Fred Moullen. May played in the game to the chagrin of Oregon officials, who claimed he should have been ineligible since he had played at Willamette in 1908 and for the Multnomah Club in 1909.

During the post-game celebration, an automobile bearing Moullen and UO star quarterback "Sap" Latourette—who was injured and unable to participate in the game—was driven on the field. At some point, the car was intercepted by a crowd of OAC students, which included May. The two players squared off.

The Eugene account of what happened next: "Oregon's banners were torn from the machine and the lights and horn apparatus were badly damaged. The only defense for this performance by Corvallis students was that [UO students] were 'flaunting their colors in our faces.'"

The Corvallis account had this explanation: "Fred Moullen was in the car and waved a piece of green bunting in May's face with the remark, 'How do you like that?' Now, an Orangeman could never abide green, and when May saw that green Eugene emblem waved before his eyes, he naturally resented it. He jumped from the shoulders of his fellows and grabbed the bunting and tore it from Moullen's grasp. It happened that the bunting was affixed to the horn and the headlight of the automobile, so in pulling it away, May damaged its engine to some extent. Thereupon Moullen got down from the machine, attacked May and a general mix between the two men resulted."

The Eugene side charged that UO students were later attacked on the streets and at the train depot as they headed home to Eugene. "One boy was felled unconscious to the sidewalk and lies in the hospital in Eugene," the Eugene account said. "Another's head was shaved, and even other

depredations are charged…Many of the Oregon supporters of both sexes returned minus personal belongings, which had been stolen. An automobile from Eugene was damaged to the extent of $40."

Another account, written by Chester A. Moores from the University of Oregon, put it this way: "One student came home in a semi-conscious condition, another with his head sheared, and many of the Oregon supporters of both sexes were minus personal belongings, which had been stolen."

Moores wrote that the injured student was Howard Bean, the son of federal judge R.S. Bean of Portland. "In the riot, he was struck over the left eye and felled to the railroad track in an unconscious state," Moores wrote. "He is tonight in the Eugene Hospital in a serious condition."

Upon regaining consciousness, Moores reported, Bean claimed he was struck by Charles King, the right guard and captain of the OAC freshman squad. "Young Bean, who is a popular and well-behaved student at the university, has submitted to two different operations on the part of the forehead where he was struck, and the blow revived the old wound where a nerve had been removed," Moores wrote. "Suffering agonies, the plucky young man was removed to Eugene in a baggage car and now lies in Eugene Hospital. The hospital management reports tonight he is resting easier."

According to the initial account emanating from Eugene, "A horde of Corvallis students or town boys gathered downtown and commenced raid on all the visitors wearing Oregon colors. An attempt was made to steal every rooter's hat in sight, and in some instances, the colored armbands were torn from the clothes of the varsity coeds."

At the train depot, according to the Eugene account, "a general tussle ensued for an hour and a half, and by this time, both sides were active." The UO school president (Prince Lucien Campbell), waiting to board the train, appeared before the mob and "attempted to pacify the excited partisans, told them their demonstrations were a disgrace and pleaded for them to disperse. During his talk, he was hissed and booed by the Corvallis contingent."

"It is hinted from Eugene," the account concluded, "that athletic relations between the two institutions may be severed if an apology is not forthcoming."

An apology was not forthcoming.

The Corvallis account, not surprisingly, saw things a different way. At the depot, the account read, "everything went joyously until Oregon began singing a jeering song, and a general rush followed. Then it was that Harold Bean was hurt, entirely by accident and not due more to the Corvallis boys than the Eugene boys."

The UO student whose head was shaved, the Corvallis account said, was Herman Sigglin, a former OAC student who had transferred to Oregon. At a pre-game rally in Eugene, "he made uncomplimentary remarks against OAC students, the college, the faculty and the spirit. This was resented and the attack on him followed."

After investigation, Corvallis chief of police Wells—a witness to the fray—was quoted as saying Bean "admitted to me he was not struck by another student. The injury occurred by being in the crush of students and against the cement walls of the depot, where UO students are equally to blame in the premises." He characterized the entire event as "good-natured."

The Corvallis account reported that Dr. Long of Harrisburg, who attended to Bean, "said emphatically that not a sign of injury or any mark of a blow could be found on the boy's head and that it was his belief that he had simply given way to the excitement of the occasion and, already weakened by previous operations, had fainted."

In the fracas at the team depot, the Corvallis account said, "several local co-eds and Corvallis ladies lost their collars to Eugene rooters. The evidence seems to point to guilt of members of both student bodies."

The Corvallis investigation "completely exonerated" King of hitting Bean. "He did not strike a blow, but was the object of an attempted attack by several Eugene rooters," the account said. "When he appeared at the depot, some university student is reported as saying, 'There is the big rookie tackle; soak him!' A rush was made at him, but he succeeded in avoiding the men who came for him."

During the week that followed, an OAC faculty subcommittee concluded that "the entire report was conjured by a small body of Eugene firebrands, while taking the fainting spell of a weakly Eugene student as an excuse, seized upon the rush as an occasion for stirring up enmity and ill feeling between the institutions."

If it was a ploy, it worked.

Following a special meeting of the OAC administrative council, the school voted for an indefinite suspension of athletic competition between the schools.

Nearly two years later, the schools agreed to meet at a neutral site—on a hastily built field in a park in Albany—with Oregon prevailing 3–0 before a throng of 6,000. That November, after a Saturday in which Oregon was beaten 30–14 by Washington and OAC had defeated Whitman 20–3,

came a truce. Today, games are scheduled years in advance. Then, it could happen at the spur of a moment.

Wrote the *Oregonian*'s Roscoe Fawcett, the newspaper's chief sports scribe of the day: "There appeared slight hope for a meeting this fall until the scores of last Saturday's games were hung out on the line. Then the Aggies decided this was the psychological time to masticate their hated foe, even though concessions had to be made, while Oregon made up its mind to take the drowning man's chance to make up for its rather disappointing showing in one gulp."

After special sessions of student body councils, the schools agreed to bury the athletic hatchet. On a Tuesday, the schools signed to play that Saturday at a neutral site. Billy Eagles, owner of a cigar manufacturing company in Albany and related by marriage to OAC coach Sam Dolan, approached both schools with an offer to facilitate the game.

A trainload of 30 carpenters constructed a temporary stadium (later known as Hudson Field) in an Albany park at a cost of $500. The City of Albany donated the grounds free of charge and raised $200 to help defray expenses of both teams.

A crowd of 6,000 watched Oregon win on a 28-yard second-quarter field goal by Carl Fenton. Wrote Fawcett: "Perfect order was maintained on and off the field."

An on-field fistfight resulted in expulsion of players from both teams—Oregon's towering Alex Eagle and the Aggies' Jack Brandis—during the second quarter of the Webfoots' 9–6 victory at Eugene in 1934.

"Just what started it, nobody seemed to know, not even the players," wrote William Lair Hill "L.H." Gregory, who became sports editor of the *Oregonian* in 1921 and wrote for the newspaper for 59 years. "There had just been a timeout for the Webfoots, who had the ball on their own 33 after an eight-yard dash by Maury Van Vliet. (Frank) Michek on a cruncher plowed three yards to a first down. As referee Nibs Price galloped forward to down the ball, he was noticed to hesitate an instant, apparently to caution two linemen who were still struggling after the whistle had blown. One was Eagle, the other Brandis.

"Eagle got to his feet and said something to Brandis. Whatever the remark, it drew a retort from a discourteous Tommy Swanson, who at this point came to support his teammate Brandis. In full view of the stands and officials, Eagle suddenly lashed out his right fist and smacked Swanson in the nose. Back went the Oregon State tackle for a clean knockdown. Before

the officials could break in, Swanson had jumped on Eagle's back. Players for both teams converged in a swirling mass about the combatants as the officials tried to pry their way through. Coach (Prink) Callison ran on the field from the Oregon bench, in front of which it all happened. Callison caught Eagle by the neck.

"The other players of both sides seemed to be trying to stop hostilities and separate the fighters, rather than to swing more fists, but a wild blow or two went home in the mix-up and it wouldn't have taken much to set them all at each other. But Price got there before much damage was done and soon had control. Nibs banished Eagle and Brandis and sent Swanson out with Brandis. Brandis was averred to have opened hostilities by taking the first swing, though it missed Eagle. Price gave both teams a vigorous dressing down before blowing his whistle for play to resume. His efforts were aided by coaches Callison and (Lon) Stiner, who called their athletes together and cooled them off."

Oregon State's 14–0 victory in 1937 before a Hayward Field record crowd of 18,000 triggered perhaps the wildest post-game theatrics in Civil War history (covered through OSU legend Bud Ossey's eyewitness account in chapter six).

Two days later, hundreds of celebratory Oregon State students caravanned to Eugene for a little rub-it-in time, which boomeranged into an all-time donnybrook. *Time* magazine labeled it "the largest riot in the history of intercollegiate football."

Oregon students, taking offense at the visitors' hubris, "ducked" (not dunked, apparently) many of them in the Eugene Millrace and even took a group of them to Skinner's Butte for a little color recalibration of the giant yellow "O," which had mysteriously turned orange.

An unidentified Oregon State student later recounted the genesis of the uprising:

> *We came out of the men's gym on Monday morning and a string of cars was coming toward us, with a loudspeaker shouting, "No school today!" They announced they were going to Benton Lane Park and there was a band there and we could spend the day there. My roommates got into the Model T topless tour car and filled that up. The next car was full of girls and I got on the right front fender and used the headlamp to hang on. When we got to Benton Lane Park, no one was around. The lead car had a loudspeaker and announced we will go to Eugene, and circle around*

Hayward Field, honking our horns and sing Oregon State's fight song, and then head back home.

When we got near Santa Clara, the state police stopped us and asked what we were going to do. The leaders replied, "Just going to Eugene and go around Hayward Field and then come back." The police asked, "Are you going to get into a fight?" The answer was no!

They let us go. No state police were with us when we got to Eugene. As we were going past the movie theater on West 11th, a Eugene sand and gravel truck came into the lead car and stopped it. We all then stopped. University of Oregon students were there and grabbed all the boys in the Model T Ford and took them to the Millrace and threw the Beavers into the water. I got out off the car and stood by the theater to see what was going on. When I saw my roommates thrown into the Mill Race, I decided I had seen enough.

A short time later a Model A Ford came up the street singing the Oregon State fight song. I was with two OSC boys, and we held up our hands for help. The car slowed down and when they took their arms down it was a University of Oregon group. They grabbed one of the fellows with me and I ran toward them and took a swing at one of their chins and missed. Two of them came at me and I ran a good quarter of a mile. I had only one still after me and I was getting winded. I found a six-foot 2-by-4 with a spike in the end. I let the runner keep coming. When he was almost up to me I jumped out with the club. He turned around and ran back the way he came from.

We walked about two miles out of Eugene toward Junction City and a car stopped and asked if we'd like a ride. It was two OSC grads who had a dairy in Junction City and they came to see what had happened.

The student escaped Eugene for Corvallis with no further harm. Some of his peers were not so lucky. A large group of Oregon State students congregated at Seymour's Cafe on 10th and Willamette that day. From an *Oregonian* account:

The siege at Seymour's threatened for a time to become more than just clean fun, when state, city and county officers were called in response to a mob yell: "Take the Beavers Out!" The Staters made a tentative peace proposal just before they came out, but the offer was rejected. A melee such as Eugene has never seen before ensued....No one was seriously injured, although many a beefsteak will be bought for other than eating purposes.

With officers stationed at both doors, the mob settled down to watchful, exciting waiting, but gave not an inch. The officers formed a corridor of uniforms and escorted some 50 Oregon State girls out of the restaurant amid the mob's derisive shouts. Then, when the male Beavers stayed in the restaurant, there came a series of chants: "Seymour's Got a Beaver. Seymour's Got a Beaver. Unfair to Oregon. Unfair to Oregon."

Finally the Beavers came out, and most of them were ducked (in the Millrace).

The newspaper reported that "traffic up and down the length of Eugene's main streets was almost at a standstill. One wild-eyed partisan attempted to move a policeman out of the way and swung as the latter resisted. He was tapped lightly enough with a night stick, but it was enough to quiet him."

On Tuesday, said the Oregon State student who detailed the story, "the whistle at OSC called for an assembly. Dr. (George) Peavy told all of us who had gone to Eugene we had disgraced OSC and had given it a really bad name. He really sounded sincere. Then he said, 'I'll bet you all enjoyed it.'"

During Oregon State's 39–2 rout of Oregon at Bell Field in 1942, two Webfoots were "put out" of the game—Floyd Rhea in the first quarter and Tommy Roblin in the fourth. It didn't end there.

Wrote the *Oregonian's* L.H. Gregory: "After the game, some of the red-hot lads of the two camps, forgetting all about warfare raging in foreign lands, created a brief incident with several fistic clashes on the field of play. This was after the teams had gone to the clubhouse, however, and it didn't last long."

The 1950s were a rather wild time for Civil War shenanigans.

In the week leading up to Oregon State's 7–0 victory at Eugene in 1953, a group of Oregon students was caught burning a giant "O" on a campus lawn in Corvallis. According to a news report, OSU students apprehended the youths, stripped them to the waist and painted their bodies orange and black. They also flattened their tires and painted their car orange and black.

The next year, before Oregon's 33–14 win at Parker Stadium, 50 to 60 Oregon students infiltrated Corvallis and lit the traditional OSU homecoming bonfire early. OSU students were able to capture 25 of the UO students and hold them prisoner. The Webfoots had their heads shaved and, true to what was becoming tradition, were painted orange and black. Some were forced to do menial labor at OSU fraternities. One captured UO

student was marched through the OSU campus with a sign that read, "I'm a dumb duck."

In retribution, the UO raiding party kidnapped a single OSU student and paraded him around the UO campus.

Oregon creamed Oregon State 28–0 at Eugene in 1955, during which a few UO rooters tried to toss a couple of luckless Beaver fans into one of the many rain puddles bordering Hayward Field.

"That was the signal for a general rush on both sides and soon the brawl was in full swing," the *Oregonian* reported the next day. "Order was restored, however, before too many eyes were blackened or noses bloodied."

Oregon State quarterback Ron Siegrist played in pain that day, having been wounded by birdshot from an accidental blast to his leg by a discharged gun on a—irony of ironies—duck-hunting expedition with teammates the week prior to the game.

"The guy who shot me was Larry Stevens, our center," Siegrist explained. "We were going to go hunting ducks, jump shooting in a gravel pit south of Corvallis. His gun was laying in the floor of the backseat of the car, with shells in it and no safeties on. Before we got out, the gun went off. [The birdshot] went through the door and was dispersed before it hit me, which kept it from blowing my leg off. It knocked me down, but I got back up. Luckily, I had boots on. When we went to the hospital, I pulled the pants off, and my leg was all bloody."

Newspaper accounts said Siegrist started the game but left after a few plays. Siegrist said that wasn't the case. "I played the whole game," he said. "I always had a high pain threshold. Normally, I was a good pursuer. I couldn't move very well that day."

Oregon State halfback Earnel Durden and Oregon guard Spike Hillstrom were booted from the 1956 game, which ended in a 14–14 tie, after the second-half kickoff for what the referee said was trading punches. Durden had set up the first OSC touchdown with a long run of a short pass from Joe Francis to the UO five. After the game, Durden told reporters he swung at Hillstrom after Spike had jolted him in the ribs with an elbow. "I know I shouldn't have done it. I learned a lesson I'll never forget."

Hillstrom's response afterward: "I simply blocked Durden and then went back to the huddle. The next thing I knew, someone said I was out [of the game]. And out I went."

Today, Durden remembers it this way: "We had kicked off. I remember [Hillstrom] coming up the field. I saw him coming up, and before I got to him, Ted Bates made the tackle. As I turned around to go to the huddle, I

bumped into [Hillstrom], and as I stepped back to go around, he stepped in front of me. I looked up at him, and I pushed him out of my way. I don't think I hit him. When I pushed him, he pushed back. The ref saw us both and kicked us out. I got a lot of letters from different people afterward saying it was a put-up deal, that he was sent into the game to get me out. I don't know if that was true. I do know I heard a big yell come up from the Oregon sidelines when we were tossed. It was a lesson I would not forget. I wanted to win the game. That wasn't how I did things."

Norm Chapman, a junior on that Oregon team and a close friend of Hillstrom, offers this postscript: "Some years later, when he was head coach at Air Force, Spike was speaking somewhere. I was there. Someone mentioned the incident between him and Durden in that '56 game. Spike said, 'You know, I didn't contribute to my team that year as much as Earnel. He was a star, a breakaway threat. That was a hell of a tradeoff for us.' I'm not sure it was a confession, but…"

In the week leading up to the 1957 game—Oregon State beat Rose Bowl–bound Oregon 10–7 at Hayward Field—about 50 carloads of OSC students arrived in Eugene bent on wrecking UO homecoming festivities. Eugene police, warned of the intended attack, set up roadblocks and turned back most of the cars. A few got through and were nabbed by UO students as they started to dismantle the artistic signs in front of the frat and sorority houses. About 15 OSC students were taken to a fraternity house where their heads were shaved. They were then taken to Skinner's Butte, where university students had assembled materials to rebuild the huge "O" overlooking the campus. The OSC youths were put to work in finishing the creation.

OSC students pulled another stunt during the week, renting a plane equipped with a loudspeaker that blared out the OSC fight song as it flew over the Eugene campus. Also that year, four UO students kidnapped OSU's homecoming court and took the young women to Salem. It was a different world back then.

In an account years later in the *Corvallis Gazette-Times*, the students were identified as members of the Theta Chi Fraternity. All were athletes—track and field performers Jim Grelle and Steve Anderson, golfer Bob Prahl and baseball player Ron Dodge.

The Monday before the game, pranksters from Corvallis had not only stolen the "O' from Skinner's Butte but had cut it into little sections, the remnants laying scattered in several basements.

"We all agreed some kind of response was in order," Anderson said. "That's when the idea of kidnapping was discussed, but it had to be done

in the name of fun. We phoned our president's office and were told the prank was OK, provided we didn't break any laws and if nothing physical happened. We all thought if we could just con them out to the cars, the prank would be a success. It was all we could do to keep a straight face."

Masquerading as reporters from the *Seattle Post-Intelligencer* newspaper, the students arrived in Corvallis supposedly sent to interview queen Pearl Friel and her court. After sitting for an interview, the coeds were asked if they would accompany the *PI* team to nearby Avery Park for a few photos. The queen and two other members of the five-woman court obliged. Friel and princess LuAnn Mullen got into one car while princess Verle Pilling got into the other.

"I remember driving away from the Kappa Kappa Gamma house with these young men who said they were reporters from Seattle," said Pilling, later Verle Weitzman. "But we headed north, out of town, and it didn't take long for me to realize something wasn't right."

But she said she quickly realized it was a Civil War prank and she wasn't scared. "They were all very nice young men, acted like gentlemen the entire afternoon and treated us with great respect," Weitzman said. "And we all thought they were very good-looking."

Verle and Grelle—a 1960 Olympian—eventually dated. They drove to Prahl's parents' home in Salem, where his mother awaited with homemade cookies. "If someone had panicked, that would have been the end of it," Grelle said. "We would have certainly turned them loose."

Once they got to Prahl's house, they called OSC dean of men Dan Poling, who was assured they were fine and would be returned to Corvallis in time for the homecoming rally and parade that night. By that time, word was that members of the team were out looking for the women, including team captain Ted Searle, who was dating Friel.

"We heard they were out looking for us and were going to beat the crap out of us," Grelle said. "Later, we heard they were going to drive to Eugene, hold us down and cut our hair off. I spent the next three weeks looking over my shoulder. I even took buddies with me to class as bodyguards."

"That's the first time I've heard about the kidnapping," Searle, 79 and living in Hawaii, says today. "Pearl and I went out a couple of times, just to the movies. We were both from Hawaii. We had a Hawaiian club, where we would all get together and go to a movie or something."

Sometimes, lessons aren't easily learned. In 1960, OSC homecoming queen Ardin Henry of Seaside was kidnapped at a Friday homecoming celebration. Two young men lured her by ruse from her house and then forced her into

a car, blindfolded her and held her in a motel at the edge of town. They did not identify themselves, but she later told the media she got the impression they were UO students.

Henry said she was assured she would be freed as soon as the OSC student body president, Richard Seideman, got started on the way to Eugene. Shortly after the abduction, Seideman told state police he got a note telling him to get on a motor scooter and ride to Eugene, where the queen would be turned over to him.

Early that evening, Henry's captors called a taxi and sent Henry to her house in time to join the evening's festivities. District attorney John Fenner—also the OSC Alumni Association president—said civil authorities would take no note of the affair.

The 1965 Civil War game at Eugene ended on a riotous note when two rival combatants engaged in a brief fist-swinging scrap and were quickly joined by players from both sides along with some spectators.

Defensive back Thurman Bell intercepted a pass at the Oregon five-yard line on the game's final play to seal the Beavers' 19–14 win. "My momentum carried me to the sideline, and [an Oregon player] in his frustration hit me out of bounds," Bell recalled. "All of a sudden, people are going at it everywhere. I was a spectator. I'm not a fighter. A bunch of guys came to my rescue. I was just excited to have the football. I didn't want to give it up, but I didn't want to fight anybody."

The Oregon marching band began playing the national anthem as a free-for-all ensued to try to restore order. Oregon State's Al Frei wound up battling with a couple of Oregon players and later matched up against spectators. He was wrestled to his knees, and a fan whacked him on the fanny with an umbrella. "I saw some cat hit [OSU's Joel] Heacock, so I jumped in," Frei said after the game.

OSU's star fullback, Pete Pifer, remembered "a fight-your-way-into-the-locker-room type of thing. It was emotional. Everybody was into it in that rivalry. At any time, something could set things off. Everybody was so invested in a Civil War game in those years, emotionally and physically. It was not something anyone walked away from easily if they lost. That was a good example. I remember starting to get into it with somebody, and [assistant coach] Sam Boghosian grabbed me and took me out of there."

Oregon fullback Dick Winn didn't need such prodding. "I immediately headed for the locker room," he said, adding with a laugh, "I figured they could kick our ass in a street fight, too."

It was Oregon State coach Dee Andros's first taste of the Civil War rivalry. "Those are all good kids out there who wanted to win…Tempers will flare," Andros said afterward. "I just got out of the way of one awfully wild swing. I've been around a lot of rivalries—Cal-Stanford, Oklahoma-Texas—and this is the equal of any."

"This is my 15th Civil War and we've never had a fighting finish," said Oregon's veteran coach, Len Casanova. "I don't know what the heck started it, but I was smart enough not to get in the middle of it. I did grab (Pat) Matson away from somebody, but anyone taking on that 250-pounder isn't too smart."

All hell broke loose early in the 1969 game in Eugene. Oregon State won a defensive struggle by a 10–7 count, and you'd have a hard time convincing the Beavers that Mel Easley didn't play a huge part in the victory with an intimidating tackle on Bobby Moore (later known as Ahmad Rashad) early in the game.

Moore was a sophomore wide receiver with boundless talent. Easley was a pounding senior defensive back with enough grit to melt pavement.

"Mel had the best build on a guy who never lifted a weight in his life," said Mike Nehl, who kicked the game-winning field goal that day. "He was cut like a Greek god. He had like a 26-inch waist."

In the week leading up to the game, a reporter had asked Moore about the Beavers' hard-hitting 6-1, 195-pound back. "Who's Mel Easley?" Moore responded.

The OSU school newspaper, the *Barometer*, picked up the quote, running it with photos of both players in the lead-up to the game. "The coaches used that article as fodder and put it on our walls," Nehl said. "Mel never said much about it. He wasn't a big talker. He was a doer."

All the Beavers, including Easley, noticed. Was he bothered by Moore's comment? "Wouldn't you be?" Easley says today. "Of course I was, and so was the Great Pumpkin [Dee Andros]. Don't forget, it was the Civil War game. We had to beat these guys, period, no matter what."

"We took it that Moore was mouthing off, intimating our defense wasn't that good," offensive tackle Chris Veit said.

"The Ducks were bragging about him," said Easley, now 67 and retired after 28 years in law enforcement in the Chicago area, including six years as police chief of University Park. "I was a hitter, but they were saying, 'He thinks he's going to stop Bobby Moore?'"

"Mel didn't like that at all," OSU halfback Bryce Huddleston said. "He said, 'We'll take care of that.'"

In the first quarter, Moore caught a short pass near the sideline. Easley made the tackle and didn't stop there, swinging the 6-3, 205-pound receiver out of bounds and beyond. "I hit him and drove him into a retaining wall," Easley said. "Cleaned his clock. That was one of my best hits. Wish I had a film clip of it. It was just to let him know I was around after the big stink. Kind of got me hyped up."

His teammates, too. "I remember the reaction of the crowd," OSU tackle Mark Dippel said. "It certainly laid the foundation that we weren't going to be taken lightly. We were underdogs. We didn't feel like underdogs. We were letting them know."

Dippel made clear he didn't think Easley's hit was a cheap shot. "Mel was a clean player but a tough player, and a great guy," Dippel said. "He gave everything he had. He was a real team guy—encouraged everybody. His leadership came with the way he played the game. Even in practice, he'd give every ounce he had."

The Ducks didn't take kindly to Easley's tackle, which resulted in no penalty. "A bunch of the Oregon players came over, and there was some shoving," Easley recalled. "I didn't say anything, but it pretty much took him out of the game. I was thinking, 'Now you know who Mel Easley is.' Don't get me wrong. Ahmad Rashad was a hell of a player. But my ability to hit was what it was all about. That was one of my best hits. It made my day."

"All hell broke loose there for awhile, but I don't think Mel knew he was throwing Moore into the wall that hard," receiver Jeff Kolberg said. "That was just Mel's personality. He was a tough, no-holds-barred guy. He was stronger than any defensive back around. Moore didn't do jack the rest of the game."

Moore left the game briefly. When he returned, he was largely ineffective, finishing with four catches for 24 yards. "It seemed to us that Bobby Moore didn't want any part of Mel Easley," OSU defensive tackle Craig Hanneman said. "He heard footsteps. For such a great player, it was my impression that Mel had his number and Bobby knew it."

"He was walking around pretty gingerly after that," OSU center Erin Haynes said. "He was doing a lot of looking around."

After the season, the retaining wall—too close to the sidelines to begin with—was removed. "I always called that the Mel Easley Memorial Wall," Nehl said. "He changed Autzen Stadium."

Even today, Rashad seems befuddled by the incident. "That guy threw me into the wall," the NFL Hall of Famer said. "I caught a ball and the guy kept on swinging me around and threw me right into the retaining wall. How

about that? That shocked me. I said Mel Easley couldn't cover me, but to throw me into a wall? OK, Mel. That was about as far as that went."

Rashad said he wasn't himself the rest of the game. "I think that might have been my very first concussion," he said. "I don't remember much after that play."

Huddleston said Rashad wasn't feeling that much pain that evening. "He came to Corvallis that night," he said. "Bobby used to come down to our place and party a lot. There were more black kids in Corvallis than Eugene at the time. He used to ride around in a white 1967 Riviera with psychedelic lights right underneath the dashboard. He was always such a sharp dresser. He wore a white camelskin overcoat."

Two years later, in the 1971 game at Autzen, the Oregon Duck mascot took a blow with which Rashad could empathize. The deliveryman was Oregon State defensive end Steve Bielenberg, a senior playing his final game as a Beaver. Oregon was on a seven-game losing streak in the series but was the favorite, with such stars as Rashad, Dan Fouts and Tom Graham. Oregon State went into the game with a 4-6 record, destined for its first losing season since 1959.

"The Ducks were loaded," recalled Bielenberg, 64, a retired fishing guide who lives in Montana. "They had a hell of a team. But Coach Andros had us lathered. He went all-out with his pre-game pep talk. We were ready to kill anything that moved. Guys like Jim Sherbert were mashing their head against the lockers. We were ready to roll."

"Dee had a way of reaching down in his country style in a way that was very compelling," said Sherbert, a star defensive end. "Tears were running down my cheeks."

"Dee's speech was classic," Haynes said. "He finished with, 'I just want to tell you one thing'…and he had a hard time getting the word 'love' out… He told us he loved us. Every player had a heart for Dee and loved him, too. There were a lot of tears. That was in the day before men told other men they loved them. Everybody rushed to the center of the room. I remember looking over my shoulder and there was [linebacker] Steve Brown, punching a cement wall. The emotions were so heavy."

"Dee's speeches were the best, but the speech that day at Autzen is the one I'll remember forever," Kolberg said. "Everybody was crammed into that little locker room. Dee was giving his speech, the tobacco was coming out of his mouth, his cheeks were red and tears were flowing down his eyes. Half the guys on the team were in tears themselves. It was wild. We gathered and

said, 'Let's go,' and damned if the door wasn't locked shut. I can't remember if we busted it down or what."

Before the Beavers departed the locker room, Andros had reminded them to show poise that day. "The Oklahoma word for 'poise' is 'pause,'" Haynes said. "He told us to keep our pause."

There are plenty of versions of what happened next. What is agreed upon is that the Beavers were waiting as the Oregon marching band departed the field. When the band cleared, Andros—as was tradition—would run out and lead his troops onto the field.

"Bielenberg and I were standing next to each other," Sherbert said. "As the band members walked off, the Duck mascot, with his papier-mâché head, was dancing and flaunting and throwing foil-wrapped candy kisses at our players. They hit some of us. Bielenberg picked him up and crashed him on his papier-mâché head. The head part wound up dislodging. Steve literally put the guy on his head, and the guy's head broke."

"Bielenberg was right in front of me," tackle Chris Veit said. "The Duck mascot comes marching by. He was real excited and came close to us. He's high-stepping it, unnecessary to begin with. Steve kicked him right between the legs. The mascot falls to the floor, and his head falls off."

"I'm right at the front, and over my shoulder is Bielenberg," Haynes said. "The mascot slips in between the band and us and starts to come toward where Dee was, and he puts his hands up and is yelling, 'F you, F you' to Dee. And then Steve jumps over my shoulder and starts pummeling the guy. They're down, [Bielenberg] is throwing punches. It turned into a mêlée, with Dee yelling, 'Keep your pause!' He thought we'd get a penalty. I remember this one guy from the band who was trying to stab us with his trombone. Dee tried to grab that thing and do a bend on it. Finally some of security were able to separate us from the band and got them over to where they needed to be and us toward the sidelines."

Allow Bielenberg to tell his version of the story: "We're standing there, grouped up, ready to run behind Dee, minding our own business. The Oregon band is clearing the field, and we're waiting to get on. Here comes this mascot. Thank God it was a guy, not a girl. He comes over, big papier-mâché head, comes right up to this group of guys, and we had just come out of this locker room ready to storm Iwo Jima. He starts taunting us, throwing candy kisses at us. At this point, you're not even thinking. What is this guy doing? He's yelling, 'F the Beavers!' Then he flips off Coach Andros.

"This isn't a conscious decision on my part. This is what happens when you want to kill somebody. I dart out from the group and just kind of put the

forearm shiver and hit this guy and lift him off the ground, and he goes one way and his papier-mâché head goes the other way. I jump on him and am putting it to him. And Dee jumps on top of me, all 300 pounds, and said, 'Steve, you're going to get us all killed.' He yanks me up, pulls me off and pushes me back into the group."

Veit stole a look at Andros as order was being restored. "He said all the right things," Veit said, "and kept saying, 'Bielenberg, keep your poise.' But he had a half-grin and a twinkle in his eyes, as if to say, 'Hell of a job, Bielenberg.'"

A few fans who had arrived early in the stands saw it and booed, but the game proceeded. No penalties were issued as the Beavers went on to a stirring 30–29 victory.

"We didn't think much about it afterward," Sherbert said. "It was almost like, 'That's what the ass deserved.' The guy crossed the line. Steve took care of it. It was no big deal."

More than 40 years later, Bielenberg doesn't express much regret. "You do something like that guy did, there are going to be consequences," he said. "He deserved it. In today's world, it would have been on TV and I'd have gone to jail. Back then, it just happened. Some spectators saw it. A few people came up to me and say what a poor sport I was. Thank God it wasn't on some Jumbotron. As the years went on, that became Dee's signature story. *Sports Illustrated* used a tiny clip about Coach Andros and relived that story."

Later that day, Kolberg revisited an old rivalry with a high school adversary and got him kicked out of the game. Kolberg and Oregon safety Bill Drake had gone against each other in the Portland Interscholastic League—Kolberg at Lincoln High, Drake at Jefferson.

"We had a history of going back and forth," Kolberg said, "and I had a tendency to talk a little."

Kolberg and Drake had exchanged quotes in the newspapers through the week leading up to the game. When the pair had gone against each other in previous Civil War contests, "every time I'd get a shot in a game to throw a block on him, I'd do it, whether he was involved in the coverage or not. I tried to make life as miserable as possible for him, knowing we were going to run the ball and I wasn't going to catch a bunch of passes. Might as well make myself useful."

In the second quarter, Oregon State—trailing 14–3—drove deep into Oregon territory. The call was a 53 power to fullback Dave Schilling.

"My job was to come from the left side and seal off Drake from coming in, so if Schilling broke loose, Drake couldn't make the tackle," Kolberg said. "I

released downfield and cut inside of Drake, and we were both standing there as Schilling crossed the goal line. I grabbed one of the Ducks and pulled him off of Schilling and helped him up. Then I turned around real quick, and Drake was standing right in front of me.

"I put my hands up and didn't mean to push him, but I did, and he fell over one of his teammates on the ground. The minute he fell over, I knew he was going to come up and retaliate. I turned my back and walked away. He came off the ground and pushed me in the back. They threw the flag and kicked him out of the game."

Asked about it after the game, Drake's version was like this: "Kolberg came up and put his knee in my back. He pushed me and was holding my jersey; there was no reason for it. The play was over. I turned real quick and the referee saw me turn and swing my arm."

Did he connect? "Yes, I did."

"I didn't mean to push him, and that's the truth," Kolberg said. "To this day, I'm sorry it happened. Bill was a great athlete, but he didn't have any influence on that game. We only threw 15 passes the whole damn game."

Kolberg offered this postscript: "A few years later, Bill and I dated the same girl. A very pretty girl. I don't know how she met Drake, but she met me. One of my buddies said, 'She goes out with Bill Drake.' That made it even more interesting."

The next year, Oregon ended an eight-year hex by thrashing Oregon State 30–3 at Parker Stadium. Oregon students, jubilant and ready to celebrate the end of the long losing streak, rushed the field—some with the intent to bring down the goalposts.

They couldn't wait until the final gun, either.

"We had the ball, and I'd just given a handoff to Mike Ritchie," OSU quarterback Scott Spiegelberg said. "There was a minute or two left on the clock. Then I notice this disturbance. I look over, and the Oregon students have already gotten one of the goalposts down. And they're carrying it onto the field, charging like a Spartan battering ram. They got it to the 20- or 30-yard line."

Fullback Dick Maurer, who was in uniform but did not play in the game due to injury, was watching from the sidelines when the UO students paraded the goalpost in front of the OSU bench. "One of our tackles, Fred Jaross, said, 'Fellas, strap your chin straps,'" Maurer said. "And he took out the first four or five guys carrying the goalpost. I remember how bitter that scene was. I've never had a liking for the Ducks since."

"Once they started at our bench, those people got hit a couple of times," OSU safety Jim Lilly said.

At the other end of the field, UO students were working to tear down the other goalpost.

"I couldn't believe what was happening," said OSU center Greg Krpalek, who was in the game at the time. "All those students had rushed the field. There was no security. It was a nightmare. It got completely out of hand. They'd gotten the goalpost down on our side, and they were shaking the other one, trying to get it down."

It was too much for some OSU players to bear. One of them was Lilly. "When they started taking the other goalpost down, that's when I headed down there," he said. "I think [linebacker] Steve Brown was with me. There were several of us in full uniform who waded into the crowd. We decided enough was enough, especially since it was the frigging Ducks. You just don't trample on the other team's turf. But I know, fans are fans. It's not something I'm proud of."

Just after the gun sounded, "one of the Ducks fans grabbed my jersey," Krpalek said. "[Offensive guard] Mike Kobielsky came up and popped him. I told him, 'Mike, I can handle myself.'"

It was a surreal scene, with what security that was on hand trying to break things up along with coaches and officials of both teams.

"I was thinking, 'Somebody's going to get killed,'" Spiegelberg said. "Our guys had helmets on going against some hapless, drunk Oregon students."

Among those who joined the mêlée was none other than Kolberg, whose eligibility had expired the previous year. "I'd been sitting in the student section as a spectator," Kolberg said. "They'd torn down one and were going for the other. That's when I got involved. I thought it was BS. I decked a guy. That's our field. You have to do something. You can't let them take down your goalposts. I remember [assistant coach] Mike Dolby saying to me, 'Jeff, you shouldn't have gotten out there.' I said, 'Mike, wouldn't you have?' And he said, 'Yeah.' I wish it wouldn't have happened, but it happened."

From the other side, the scene didn't look any prettier. "It was a little scary," Oregon offensive tackle Tim Stokes said. "I can remember leaving the field as the students came down and tore down the goalpost. It turned out to be a brawl, but we were already off the field. It kind of shocked me.

"But the importance of the Oregon–Oregon State game was all out of whack, at least during that period of time. Part of it was that Oregon State had beaten us eight years in a row. That irked a lot of us. There were so many close games that could have gone either way."

TRANSPLANTED ROSE BOWL CHAMPS

L on Stiner was only 38 but already into his ninth season as Oregon State's head coach in 1941. The Beavers enjoyed an outstanding season in 1939, going 9-1-1, losing only to seventh-ranked Southern Cal 19–7 in Portland and drilling an outmanned Hawaii team 39–6 in the Pineapple Bowl.

Oregon State had gone 5-3-1 in 1940 but lost its last two games, 28–14 to Stanford and taking a 20–0 thumping from Oregon at Bell Field. Oregon, meanwhile, had turned its program over to Tex Oliver in 1938. He would serve as head coach for all but one season through 1946, with a host of .500 or sub-.500 records.

The Beavers entered the 1941 season having finished third in the Pacific Coast Conference standings three years running, but they had lost a number of stalwarts, including Jim Kisselburgh, Ken Dow, Vic Sears, Len Younce and John Leovich. Many of the pundits were predicting a cellar finish, though Stiner proffered better.

From the Oregon State annual, the *Beaver*, at year's end: "Laughed at by preseason dopesters when he claimed his team would finish in the upper division of the Coast Conference, Stiner let experts have their say, kept his faith in his boys and handed the sporting world a winner."

Oregon State opened the season with a heartbreaking 13–7 loss to Southern Cal in Los Angeles, the Trojans completing a six-yard pass for the game-winning touchdown with 17 seconds to go. The Beavers had twice driven deep into USC territory in the fourth quarter, once to the three-yard line.

After a 7–0 loss at Washington State, OSC was 2-2 after the first month of play, and any margin for error was gone. Then the Orangemen, using a stifling defense to full advantage, won four straight games via shutout. After knocking off Idaho, UCLA, California and Montana in succession, they went into the Oregon game with a 6-2 record and a shot at the Rose Bowl.

Oregon provided a stiff challenge. After the Webfoots' 19–16 victory over Washington the week before, Huskies coach Jimmy Phelan declared, "Oregon has the finest material of any squad we've faced this season. I don't see how they have lost a single game."

Maybe Phelan's comment was a shot at Oliver, because Oregon was 5-3 to that point, having lost to Stanford, UCLA and Washington State. Oregon State had beaten Washington 9–6 earlier in the year.

Oregon State was riding the greatest one-two punch in school history in the "D&D Boys," senior halfbacks Don Durdan and Bob Dethman. OSC had a number of other stars, including quarterback George Peters, fullback Choc Shelton and center Quentin Greenough. The Orangemen faced a tough test to get a Rose Bowl nod. They needed to win on their archrival's home turf.

Oregon State and Stanford entered the final Saturday tied atop the PCC standings at 4-2, but OSC had beaten Stanford 10–0. The Indians ended the season against California.

Oregon, led by star halfback Tommy Roblin, went into the game with a number of walking wounded. Oliver told a Eugene dispatcher that the school should have moved its infirmary to McArthur Court's football locker room.

Due to all the injuries, Oregon drafted Colonel Bill Hayward for extra help in the rehab department. Read the report: "The venerable Oregon track coach who served as trainer until three years ago when he dropped all but his track coaching duties, offered his services to coach Tex Oliver and trainer Bob Officer. Hayward has long been famous for his ingenious braces made from old bits of light metal, canvas and covered with sponge rubber. He spent all Tuesday afternoon in his tiny McArthur court workshop, fashioning gadgets for the many Duck cripples." (In the lexicon of the day, injured players were often referred to as "cripples.")

Joe Gordon, the reigning Most Valuable Player from the World Series for the New York Yankees and a Webfoot alum, "was hovering around to help the colonel a bit," the report said.

Even with all the injuries, the report said, "general opinion in Eugene is that Oregon will win. Oregon's scoring power is the reason."

"We did feel we were going to win the game, even though we had some injuries," said Bob Koch, a freshman fullback-linebacker on that Oregon team.

In Corvallis, a dispatch was headlined "Corvallis Campus Agog as Grid Gigantic Nears."

Began the report: "This campus and town are burning with football fever, and temperatures are soaring higher by the hour. But those responsible for all the fuss are calm and collected."

Practice at both schools was held behind tightly locked gates. "There was not a single word from coaches, players or managers as to what transpired," the *Oregonian* wrote.

In the spirit of the day, Stiner went for the usual contact at practice. He sent his troops through "a modified" scrimmage session on Tuesday and a full scrimmage on Wednesday. "We have to scrimmage regardless of possible injuries to get our offense in shape for Oregon," the coach explained.

Stiner wanted no part of any Rose Bowl talk. "We play Oregon Saturday," was his squelcher. "The cards are on the table. Let the best man win."

By Thursday, all 20,000 tickets for the Civil War game were sold out. Hotel rooms were just as scarce as the tickets. The largest special train in the history of the Civil War—18 cars—brought more than 800 people from Portland to Eugene aboard the Southern Pacific Saturday morning.

The *Oregonian*'s Billy Stepp picked it Oregon State 14, Oregon 6. He must have known something.

Oregon State prevailed 12–7. Sometime during the game at Eugene, word leaked that Cal had knocked off Stanford. That meant the Beavers could clinch the Rose Bowl berth and sole possession of the PCC championship with a victory.

"Oregon State's battling Beavers clinched themselves a bid in the Rose Bowl, driving to a 12–7 victory over Oregon in a thrilling gridiron gigantic witnessed by an overflow crowd of 20,500 wild-eyed fans," wrote the *Oregonian*.

Oregon made it anything but easy. The Webfoots, with Roblin injured and exiting after the game's third play, led 7–6 in the fourth quarter. But the Orangemen marched down field for the game-winning drive, Joe Day scoring on a 28-yard run for the clincher.

"Old Man Atlas didn't do so much," L.H. Gregory wrote in reference to Day, the hero of the day. "He only carried the world on his shoulders."

More Gregory: "When Joe Day, from about 28 yards out and with approximately 11 minutes left in the fourth quarter, suddenly broke through

the opposing Oregon line and into the open here Saturday afternoon, not only the world but the 20,500 spectators, a 7–6 score against his side and the Rose Bowl itself, all were riding on the husky young man's back."

After a scoreless first half, OSC's Shelton—a sophomore from tiny Union in eastern Oregon—scored on a three-yard plunge to provide a 6–0 lead. But Oregon's Curt "Curly" Mecham raced 52 yards for a touchdown, and the extra point gave Oregon a 7–6 lead on the first play of the fourth quarter.

Three minutes and five seconds later, Oregon State had regained the lead.

Oregon forced Oregon State to punt to the UO 23. Koch gained three yards on first down, and offsides gave Oregon second-and-two on its 31, but the Orange defense then held. After a punt, Oregon State took over on its 40. Durdan went to the air, hitting George Zellick for nine yards, then Peters for 13 to the Oregon 37. Dethman ran for nine yards to the UO 28.

Then it was Day racing through a big hole over right tackle. He broke into the secondary and headed for pay dirt. Oregon safety Jimmy Newquist—who had thrown what appeared to be a sure touchdown pass in the third quarter, only to have Mecham drop it—hit Day at the five-yard line, but Day shrugged it off and crossed the goal line. The PAT attempt was blocked, but Oregon's offense was through for the day.

"Day was the star of that game for them," said Koch, who was a linebacker on the winning scoring play. "He broke loose. I can't remember if I had a shot at him, but Newquist did. Didn't get him, unfortunately."

When it was over, the visitors were in the driver's seat headed, they thought, for Pasadena. Wrote Gregory: "Don Durdan, the hinge-hipped halfback whose All-American play stood out in the bruising battle, dropped tiredly onto a bench, sighed gratefully as an alert manager peeled off his jersey, then flashed a jubilant grin and said, 'Boy, am I glad that one is over.'"

Did Oregon hit hard?

"Say, fellow, you'd think a steamroller was a creampuff after getting smacked by those big Webfoots," Durdan said. "They hit as hard as any club we faced, but they were awfully clean."

"I just knew we'd take them, even when [the Webfoots] were ahead 7–6," Dethman was quoted as saying. "I could tell by the way [the OSC players] acted in the huddle. Their eyes were all but popping out of their heads and they gritted their teeth as though inspired by some atavistic [did he really use that word?] urge. You just can't beat down

a spirit like that. Sure enough, good old Joe Day came through with the winning run."

Stiner looked pale as he met with reporters afterward. "We won, we won," he said. "The boys played a great game, every one of them. And don't think Oregon wasn't tough."

Oregon State had dominated the statistical sheet, winning the battle in first downs (12–3), total offense (351–163) and rushing yardage (252–126).

Oliver, in an act of sportsmanship, walked across the field after the game ended, grabbed Stiner's hand and said, "Nice going, kid!"

Later, the Oregon coach added, "They have fine balance, weight and speed and will be a pushover for no one…There is only one team other than Oregon State I would rather see in the bowl."

That was the sentiment of most of the UO players, too. "They were a good team that year," Koch says today. "If it wasn't us that got in the Rose Bowl, I'm glad they got it. They were an Oregon team. They were good guys. I got to know Durdan a little bit. After the game, we congratulated them. We tried to keep them out [of the Rose Bowl], but we were halfway happy they were going, compared to some other schools."

Such as?

"Oh, USC," Koch said. "In those years, [the Trojans] beat Oregon quite often [though the Webfoots beat them 20–6 that season]. We lost to UCLA that year [14–7], and Jackie Robinson played for the Bruins. He was a great guy. You'd tackle him and he'd say, 'Nice play.'"

Two weeks later came news that, due to Japanese attacks at Pearl Harbor, U.S. military officials were worried about a possible invasion on the West Coast. They announced the Rose Bowl was to be "closed" and the game would not be played in Pasadena.

Oregon State athletic director Percy Locey immediately began looking for a site to relocate. Duke agreed to host the Rose Bowl at its stadium in Durham, North Carolina. Thus resulted the "transplanted" Rose Bowl—the only time the "Granddaddy of Them All" was staged away from Pasadena.

Before a crowd of 56,000, Oregon State won 20–16 over a heavily favored Duke team that entered the game undefeated and ranked No. 2 nationally. Durdan was the star, scoring the game's first touchdown on a 15-yard run, catching a 42-yard pass and averaging 47.8 yards per punt through the afternoon. But it was reserve "flankback" Gene Gray who took the hero's role, racing 69 yards on a pass from Dethman for the winning touchdown in the fourth quarter.

The author was able to interview three people who were on hand for the 1941 Civil War game.

One of them was Koch, a fullback and linebacker who lettered in 1941, '46 and '47 at Oregon. His quotes are sprinkled throughout the book.

A close friend of the great Norm Van Brocklin, Koch, now 92, retired and living in Lake Oswego, spent four years in the navy from 1942 to 1945. He played one year for St. Mary's Preflight in California and then served three years in the South Pacific before returning to finish his college career at Oregon.

Andy Landforce, now 97 and living in Corvallis, was a senior reserve halfback on the Oregon State team. This delightfully spry gent shared many of his thoughts during a 20-minute interview in April 2013.

Landforce had come to Oregon State in 1938 from Snoqualmie, Washington. Recruited out of high school by Babe Hollinsberry of Washington State, the 5-8, 165-pound back instead enrolled at Oregon State but didn't play football until his senior year, when he was president of the student body.

"I looked at it as a way of bringing the student body closer to the team," Landforce said. "I was third-string, one of the guys who backed up Dethman at right halfback. Even though I was little, I enjoyed a collision, and I was pretty quick. I could leave some of the real good guys in their tracks in practice. But I only got in games when we got way ahead."

Landforce held great respect for Stiner. "Lon had the coaching ability, and he had a personality like Mike Riley," Landforce said. "He was a motivator. You were willing to play for him even if it killed you. He had a quiet voice and concentrated on the positive. He was very good for my ego. I needed a lot of nourishment, anyway. When I did things that were good, he'd compliment them. He wasn't just for the star players. I remember one time in practice, Dethman took the ball and went into the middle and scored. Lon went up to the guard and tackle [who made the blocks] and complimented both of them for making the touchdown."

Landforce didn't play in the Civil War game, but he was there in uniform. "We knew we had to win in order to get to the Rose Bowl," Landforce said. "We had to play Oregon on their field. That wasn't easy. The game was tight at halftime. It was tense. When we went into the dressing room, it was quiet. The players got there first. Then the door opened up and Stiner walked in. He said, 'Well, we can win this one.'"

Stiner went to the chalkboard at the front of the room and designed a play. "He said, 'Here's a play that will work for us,'" Landforce said. "He said, 'We'll get the ball to Joe Day. If [the blockers] move your men this way,

Joe can move through there time after time.' He called out Norm Peters by name. 'If you block your man in, Joe can go around the outside. Keep on playing the way you're playing. Don't be afraid to make a mistake. Use your athletic skills. Play 110 percent and you can win this game.'"

It was just the right speech for the players. "Everybody's feeling was, 'We're going to go out there and run right through the wall for Lon,'" Landforce said. "He had a great ability to inspire the team."

There was jubilation in the locker room after the victory. "You can't imagine the feeling of achievement in winning that game and knowing we were headed for the Rose Bowl," Landforce said.

In the days after the Pearl Harbor attack and the announcement of cancellation of the Rose Bowl, the letdown on the team was palpable. "If you've ever felt depression, you know how we felt after they told us they would cancel the game," Landforce said. "You're born naked and hungry, and then it gets worse."

The chance to play at Durham made up for all the previous disappointment. The Oregon State traveling party departed on its five-day, 7,384-mile round trip via train—the "Portland Rose," with Pullman lounge and club-car service—taking a northern route through Pocatello, Cheyenne, Omaha, Chicago, Pittsburgh and Washington, D.C. The Beavers set up quarters in Chapel Hill on the University of North Carolina campus.

"I have wonderful memories of that," Landforce said. "They treated us very graciously and with good taste. Before the game, there was a special program with both teams and dignitaries in a big banquet hall. Bill Stern, who did the radio play-by-play of the game, was the master of ceremonies. He was very eloquent, very dignified. When it was time to introduce Lon, he said, 'Coach Stiner, you are playing the Blue Devils, the champions of the Southern Conference. They are undefeated, and you have lost two games. What do you think your chances are of playing this mighty Blue Devil team?' Lon turned to Bill and said evenly, 'We'll give you the answer on the field.'"

Landforce didn't see action in the Rose Bowl game. He lived it with his teammates, though, and loved being a part of the scene.

"The determination of our team was so profound before the game," he said. "It was quiet and subdued [in the locker room]. When we were dressing down, Don Durdan busted his shoelaces tying his shoes. I said, 'We can tie those up,' but a manager was there and got him a new pair of shoestrings. Then we went out and won the game. I've not had too many better feelings, I have to tell you."

Landforce, who served in the army in the European theater of World War II, has always objected to the popularized nickname of the Oregon–Oregon State athletic competition. "I am totally against calling it the 'Civil War,' because the term 'war' has no place in an athletic contest as far as I'm concerned," he said.

Landforce has lived a full life, seeing much of the globe during his army stint. He began in field artillery and ended up as company commander for an all-black unit at Fort Benning, Georgia. "I was the only Caucasian amid a company of a couple of hundred African American soldiers," Landforce said. "That was a truly interesting experience." He was in Munich when the war was declared over in 1945. He spent much of his professional career working with the OSU extension service, served as a wildlife conservation educator and guided for steelhead fishermen on Oregon rivers for 15 years. "I quit guiding when my wife said she was tired of me getting on the phone and saying, 'Yeah, I can do that,'" he said.

As for what others call the "Civil War," Landforce at least identifies with the civil part of it. "I remember the rivalry as one of a couple of good teams playing each other," he said. "You're going to play as hard as you can and win like a man or lose like a gentleman. You play with pride for your school against another good school. I don't remember any animosity toward the University of Oregon. My senior year, some Duck students came to Corvallis and painted green on the MU quad. As president of the student body, we stopped a group that wanted to retaliate of a prank nature. No, that doesn't show much class."

Victor Atiyeh was a football player long before he served as governor of the state of Oregon. He was on the sidelines during the 1941 Civil War game as a member of the Oregon Frosh, watching as Oregon State wrapped up a Rose Bowl berth with a victory over the Duck varsity.

"We had played the Oregon State Rooks twice the previous year, in Portland and in Eugene," Atiyeh, now 91, retired and living in Portland, recalled. "There were some players who tried to get me fired up to play against them, the 'bad guys' that they were. Yeah, they tried to get us to hate the Beavers. But there was respect there on both sides."

In the '41 Civil War game, "we knew we were going nowhere, and Oregon State was headed to the Rose Bowl if they beat us," Atiyeh said. "We were not going to give it to Oregon State. We wanted to beat Oregon State, but it was mostly just to win the game, not to knock them out of it. It was a matter of honor to beat our rival.

"That was one tough game. I went into the locker room after the game. Our players were totally exhausted. They had given their all. There was pride even in defeat. One thing that was said around, [the Beavers] were a good team. I want to tell you, our guys played their hearts out."

Atiyeh had lettered as a left guard at Portland's Washington High. He had started out as a sophomore playing fullback. But Koch, who was in Atiyeh's graduating class, was first-string at that position. "Bob wound up being an all-city player," Atiyeh said. "He was good, and for most of the season, I was sitting on the bench. I had never thought about playing the line. Finally the coach asked me, 'Do you want to play some guard?' I said, 'I want to play football.' He moved me there, and I got to play from then on."

The 5-10½ , 205-pound Atiyeh started for the UO Frosh.

"In those days, you played both ways," he said. "I was good on defense. I could take on anybody. On offense, I was just adequate. I played the guard who pulls and gets the linebacker. I worked like hell on that. I would practice after practice. But I couldn't get much better than adequate."

John Warren, the freshman football coach who later served five seasons as Oregon's varsity basketball coach, took over for Tex Oliver as varsity football coach for the 1942 season. Many of the players had gone on to serve in World War II, but Atiyeh still wasn't good enough to earn a letter.

"I did a lot of bench-sitting," he said. "John picked five guards for the travel team. I didn't make it, but I was on the team for home games."

It was a rough season for the Webfoots. They had a 2-5 record entering the final game of the season against Oregon State. Atiyeh hadn't played all season and appeared headed for a redshirt year. "We were pretty well geared up for the game," Atiyeh recalled. "On our first series, the Beavers intercepted a pass, and it was like a pin burst our balloon."

With Oregon trailing 20–0 at halftime, defeat was all but assured for the Webfoots. "I remember walking back to the lockers with John Warren," Atiyeh said. "He asked me, 'Do you want to play?' I said, 'I sure do.' I knew I would lose a year of eligibility, but of course I wanted to play.

"In the fourth quarter, he yelled my name. I thought, 'Oh my God.' I grabbed a helmet. I wasn't sure it was going to fit. And then a couple of my teammates, Ed Moshofsky and [Floyd] 'Scrap Iron' Rhea, came over. They told the coach, 'No, you're not going to burn Vic's year.'"

Warren thought better of it and kept Atiyeh out of the game. "I went to tears," he said. "But there was not one single moment I was mad at those guys. I knew they were looking out for me."

Atiyeh was never to play varsity football at Oregon. He left school in 1943, intending to enlist in the army along with his older twin brothers, Edward and Richard, who were also at UO. Victor had an ankle problem, though, that had required a bone graft. "Took a physical three times and never passed it," he said. "Really pissed me off. I said, 'Draft me.'"

With his brothers off at war, Atiyeh helped run his family's rug and carpet business in Portland. He soon began a distinguished political career that carried him to the state's governorship from 1979 to 1987. "I was always disappointed I never played varsity football in college," he said. "That's something I always looked forward to as a kid."

Atiyeh did have one more brush with football fame. In 1944, he received letters from four NFL teams—New York, Chicago, Cleveland and Green Bay—asking about his services.

"The Packers sent me a contract, the others didn't," he said. "Unfortunately, my father had passed away that year. I really wanted to go [play in the NFL], but my brothers were in the service and there was nobody to run the shop. I turned it down. I still have the contract as a souvenir."

Why would NFL teams be interested in someone who hadn't even made his college team?

"Mainly, during the war, it was hard to get young bodies to play football," he said. "I was pretty good-sized, and I have to admit, I was good on defense. I wasn't all that bad."

VAN BROCKLIN AND THE
COTTON BOWL KIDS

S ince the early years of Tex Oliver in the early 1930s, Oregon had gone through many seasons of mediocrity when Jim Aiken took over as head coach of the Ducks in 1947. Aiken had played for Washington & Jefferson's 1922 Rose Bowl team and had been head coach at Akron and Nevada before arriving in Eugene. He brought a T-formation offense to replace the single wing employed during the Oliver era.

When Aiken arrived, he inherited a player named Norm Van Brocklin. A good but not great two-sport athlete at Acalanes High in Lafayette, California, he came to Oregon on the advice of prep teammates Robert Oas and George Bell. Van Brocklin would tell the Oregon student newspaper, the *Emerald*, that he came along because Bell "was happier than a dead pig in the sun up here."

Van Brocklin had not been recruited by any California college. "I guess they figured I was a better baseball bet as a pitcher than a football prospect," he mused.

After a stint in the navy in World War II, Van Brocklin came to Oregon as a freshman in the fall of 1946. A passer but not much of a runner, Van Brocklin didn't fit well in Oliver's single wing. He played 11 minutes as third-string tailback and didn't earn a letter.

One of his appearances that season was in the Civil War game in Corvallis, won by the Beavers 13–0. Oliver had resigned as coach earlier, effective at the end of the season. It was a nasty day on a sloppy Bell Field, as described in a game account by the *Oregonian*'s L.H. Gregory: "You wouldn't have turned a

cow out to grass or a dog out to die on the kind of day this was, or the muddy morass of a football field on which Oregon State and Oregon played their 50th annual football game. For exactly halfway it was that kind of a contest, too, with neither side able to get anywhere in a squishing bee of a first half. But Oregon State then got her power working and plowed through the slime for two touchdowns and a 13–0 victory over her ancient Webfoot foe. After one slide in the gooey gumbo, the players' numbers were smeared out, their uniforms became a mass of sticky mud and they resembled giant-jumbo bullfrogs leaping in a bog. Under the circumstances, it was surprising how well they played.

"The mud was ankle deep and more, and when some Oregon rooters went onto the field between halves with their famous duck mascot, Puddles, the poor bird squatted in the mud and actually tried to swim. It was a day for mud horses, jumbo bullfrogs and ducks, but not for the Ducks as a team."

Oregon was facing an excellent Oregon State that would finish 7-1-1, led by star backs Ken Carpenter and Don Samuel. After a scoreless tie at halftime, Samuel threw five yards to Dave Anderson for the first touchdown while Carpenter scored from the two, set up when Bill Gray blocked Bob Koch's punt and recovered it at the UO 39. Oregon managed 10 yards total offense for the afternoon.

"It really was a horrible field that day, a sea of mud," recalled Ralph Davis, a reserve end on the Oregon State team. "You couldn't tell one person from the other. Fortunately, we were able to get some power plays in there and do some damage in the second half."

Late in the game, Van Brocklin got the call from Oliver to go in. On the sidelines that day was Harry Glickman, later to become president of the NBA Portland Trail Blazers. Glickman was then a student at Oregon and campus correspondent for the *Oregonian*. He was keeping play-by-play for Don McLeod, who was covering the game along with Gregory for the newspaper.

"I went to a lot of practices that year," said Glickman, now 90, retired and living in Portland. "Norm started the season as a fifth-string tailback in Oliver's single wing, but I'd seen him throw the ball down the field. You didn't have to be a genius to figure out this guy could pass.

"The game is a mudbath, and I see this guy go into the game with an all-white jersey. It's Norm. I tell McLeod, 'Watch this guy. He can really throw the ball.' Norm throws a really bad pass, misses his receiver by a mile. Don says, 'Yeah, great passer.'"

Things changed for Van Brocklin after Aiken got on board. The new coach saw his talent right away. "Here was a kid who could hit an end in the ear, cutting crosswise, from 50 yards," Aiken said. "He threw the ball high and hard—very tough to intercept."

Glickman became friendly with Van Brocklin. Many on the Oregon campus came to refer to Norm as "Dutch" or "the Dutchman." Glickman and other close friends called him "Stub."

"Aiken lived in a house right next to my fraternity," Glickman said. "He had Stub over there all the time. Aiken would have me come around when the team had dinner. I was around Norm a lot. We got to be pretty good friends."

By his junior year, Van Brocklin had married Gloria Schiewe, a lab assistant and his tutor in a biology class. They soon had three children and would adopt three more.

The Webfoots were good immediately in Aiken's first season, going 7-3 while winning their final six games, including a season-ending 14–6 victory over Oregon State. Van Brocklin threw for 939 yards and nine touchdowns and ran only twice all season, both on scrambles. He established himself as a team leader, sometimes to a fault.

"Norm would read out a teammate in the huddle, give him all kinds of hell, then forget about it," Glickman said. "But the guy he gave hell to did not forget about it. There was so much respect for him, it worked out OK. He was damn good, I'll tell you that. Great player, great competitor, but sometimes tough to deal with as a teammate."

One of his teammates, fullback-linebacker Bob Sanders, considered Van Brocklin a good leader. "Everybody liked that," Sanders said. "Norm had a reputation as being hard to deal with, but no way. He wasn't that way at all."

"If you made a mistake, he'd call you on it," said Bob Koch, a senior fullback-linebacker on the 1947 team. "A couple of guys resented it. But Norm wouldn't hold a grudge."

Koch was one of Van Brocklin's closest friends. When Norm was playing in the NFL, they maintained their friendship. "We did a lot of things together in the off-season," Koch said. "I was with him the night before he died of a heart attack [at age 57, in 1983]. For a few years, he spent the off-season in Portland when he was with the [Los Angeles] Rams. I was an architect, and he had a sales job in the same building I worked in. He liked a lot of the same things I did. He liked to fish. We'd go trout fishing on the Deschutes River. We got along. I thought he was a great guy. And he was a great player, a great passer who knew the game awfully well. He could throw the ball a

mile. He wouldn't knock you down with it on purpose, but he threw that ball hard."

In the 1947 Civil War game, the Beavers struck first on a third-quarter 59-yard pass play from Dick Gray to track man Bob Laidlaw.

"Laidlaw was a long jumper, fast and a smooth player," Oregon State's Ralph Davis said. "And Gray was a darn good passer. For those times, we threw the ball an awful lot. We'd shoot the short ones and launch the long ones."

Davis is one of the few men who can say he played for both Oregon and Oregon State. A member of the graduating class of 1939 from Portland's Jefferson High, Davis went with four prep teammates to Oregon, recruited by then–freshman coach John Warren. Davis served as captain of the UO freshman team under Warren in 1939. The varsity coach at the time was Tex Oliver.

"I didn't like Oliver," said Davis, 94 and a Portland resident. "I never had any contact with him to speak of. I liked John Warren very much. A good coach, and real personable."

Davis injured a shoulder during training camp before his sophomore year at Oregon, left school, worked in the shipyards in Portland for a while and enlisted in the coast guard from 1943 to 1946. He said he wound up at Oregon State by happenstance with a visit to Bashor's Sporting Goods in downtown Portland. Oregon State coach Lon Stiner was on the phone with the owner, Frank Bashor, when Davis arrived.

"Frank said to Lon, 'Do you want to talk to Ralph Davis?'" Davis recalled. "I had a wife and a six-month-old son. Lon and I talked. He asked if I had a car. I said no. He said, 'Get on a bus. I'll have [assistant coach] Jim Dixon meet you at the Corvallis Bus Depot and we'll have a place for you to live.' They could do those things in those days."

Davis had mixed emotions about Stiner as a coach. "He was very knowledgeable and on top of everything, but it was toward the end of his time at Oregon State," Davis said. "He didn't have the fire a head coach should have. He was kind of aloof. The guy who got us fired up was the trainer, Bill Robertson, whom we called 'Ropes.' He'd read us poems (his most famous one was 'Casey at the Bat') and get us fired up."

Davis, who was a reserve in 1946 and then a starter in '47, felt more at home at Oregon State. "Corvallis was the type of college town I liked," he said. "Eugene was a little bigger and more of a city. I enjoyed my fraternity at Oregon, Phi Delta Theta, very much. Otherwise, I didn't care for Eugene.

"Oregon was one of the key games of the year for us. You always wanted to beat the Ducks. I knew a lot of their players. Some of them were fraternity brothers. It didn't register with me there was much ill feeling between the teams, but I loved going in there and making tackles on 'em. Van Brocklin was a guy I enjoyed tackling. I got to him a couple of times in the '47 game. He was an excellent quarterback and had good protection, a very good passer. He was the best quarterback we played against that season."

One of the highlights during Davis's time at Oregon State was getting to play with Carpenter and Samuel. "Oh my God, Ken Carpenter was fantastic," Davis said. "He could go laterally as fast as he would go forward. Such an athlete. Uncanny. He pitched and played another position for the baseball team. Samuel was a very good player, too, a very confident player. He was the guy who called the plays. He had everything under control. He was a good passer, too. When he threw, I'd keep in mind which way the ball was going to be spinning. It always turned the opposite way. He was a power, boom-boom runner, quite agile but not with the exceptional speed like Carpenter. Kenny was the epitome of a ballplayer."

Davis, with a wife and two sons to support, left school after his junior year in 1947 to work in the construction business. He was a staff member at Portland State from 1954 to 1983, serving as head football coach for two years and head track and cross-country coach for 17 years. He is most well known as the father of the marathon in Oregon, having directed the first Trail's End Marathon in Seaside in 1970.

After Oregon State had scored to go ahead 6–0 in the 1947 game, Oregon's Bob Koch fumbled the ensuing kickoff, and it was recovered by Bud Gibbs at the UO 42. Gibbs, later a member of Tommy Prothro's coaching staff at OSC, was an end who had a been a star in the Beavers' 13–12 Civil War win as a freshman in 1945, catching a five-yard touchdown pass from Dick Gray.

"The thing I remember most about that play, as I was releasing on my route, Dick led me by quite a bit," said Gibbs, 86 and living in Corvallis. "I took a dive, caught it with one hand and was able to drag my foot in the end zone to make it a legitimate catch."

Gibbs, a Hood River native, had chosen Oregon State over Oregon and Washington because of the history of Hood River athletes who had become Beavers, including Samuel, Bob Dethman and Hal Puddy. "Those were guys I knew and admired a lot, and they'd had success," Gibbs said.

Stiner, Gibbs said, "was a very good coach. Very good with fundamentals. His teams were very sound offensively and defensively. And he was a very good man."

Like many players at Oregon State, Gibbs had started college because he wasn't old enough to be in the draft. After his freshman year, he went into the army and played with the great Doak Walker on a Fort Sam Houston team in San Antonio that won the national service championship in 1946. He re-enrolled at OSC in 1947 and played there through 1949.

Gibbs had great respect for Van Brocklin, whom he played against for two years and later became friends with. "Norm was one of the best," Gibbs said. "What a blessing it was for him when Aiken came in. Norm couldn't run a step. He would never have played at all if they hadn't changed to the T formation. It was perfect for him. He was one of the great quarterbacks in the country, no doubt. He had a terrific arm, was very accurate and was tougher than nails—a great competitor.

"In those days, we had a big rivalry, but we were always friendly with the Oregon guys. I got to know him and liked him a lot. I had some great visits with him when he was playing in the NFL and, later, when he became a coach."

Oregon State stalled after Gibbs's fumble recovery and was forced to punt. On Oregon's next possession, though, Dick Twenge intercepted Van Brocklin at the UO 36-yard line. The Beavers moved to the 17, but Bell intercepted a Samuel pass at the Oregon three and returned it to the 22. On the next play, Bell motored 78 yards for a touchdown that turned the game the Webfoots' way. It was vindication for Bell, who had fumbled at the OSC one-yard line in the first half.

The Beavers didn't cross midfield again. Van Brocklin hit Darrell Robinson for a 24-yard pass for a touchdown in the fourth quarter to ice Oregon's first victory in the rivalry since 1940. The sophomore quarterback completed eight of 16 passes for 86 yards and punted six times for a 37.5-yard average. But it was Bell, with 167 yards rushing on 15 carries, who was the star as Oregon won the ground battle 265–62.

"It was a hard-fought game," Gibbs remembered. "The teams were pretty evenly matched. But Oregon deserved to win. We didn't play all that well that day."

It was another Civil War played in inclement weather, this time at Hayward Field.

"The field was solid mud," Bob Sanders said. "Fall down one time, and your number was obliterated. The only guy whose number you could

read was Norm's. Toward the end of the game, he fumbled the snap from center, had to fall on the football, and all of a sudden, his number was unreadable, too."

Sanders had come in as a freshman with Van Brocklin in 1946. Sanders, 86 and still operating six sawmills in southwestern Washington, grew up in tiny Charleston, 10 miles from North Bend in southern Oregon. He had intended on playing at Oregon State.

"The Beavers were my team growing up," Sanders said. "I loved that school. I followed them closely during the 1942 Rose Bowl year. I still have a letter from Lon Stiner saying that my room was ready in Corvallis."

But Robinson, a good friend of Sanders, was going to Oregon. The day before Sanders was to report to OSC, Robinson talked him into meeting with Tex Oliver.

"Oliver sold me," Sander said, "and didn't do a thing he promised to do."

Sanders played his freshman year for Oliver before Jim Aiken took over. "I was totally disappointed in [Oliver]," Sanders said. "I thought he was a terrible coach. I was proven right, too. He didn't demand any discipline from his team and had a poor system. When we got Aiken in there, it was a bright day for us. He ran a full-house T, had a great new system, and that was a step forward from those single-wing days. I considered him an excellent coach, and that was John McKay's opinion, also. We talked about it a number of times. Jim was tough, a disciplinarian."

McKay, a halfback who was best man in Sanders's wedding (he and wife Jane celebrated their 64th wedding anniversary in 2014), went on to fame as head coach at Southern Cal and in the NFL. Sanders also became good friends with Van Brocklin.

"I was 18 years old as a freshman, and most of the guys were war veterans and three or four years older than me," Sanders said. "Almost all the starters were married. Van was such a good guy. He remained a friend long after our college days. He never changed. He had the same style of clothes when he went out as when he came in. He was a genuine guy. All the notoriety didn't go to his head, that's for sure.

"He was an excellent quarterback, the best passer in the country. He wasn't very fast, had no foot movement, but he could really throw the ball. Funny thing was, we didn't throw the ball that much. He called the plays and controlled the offense. He always did what was best for the ball club."

Van Brocklin had more weapons than ever around him for his junior season in 1948, with halfbacks Bell, Woodley Lewis (a transfer from L.A. City

College) and McKay and fullback Sanders the backfield stalwarts. Ends Dick Wilkins, recruited from the basketball team, and Dan Garza and linemen Brad Ecklund, Chet Daniels and Jim Berwick provided more talent around the Dutchman.

It was a bit of a charmed season for the Webfoots, who won six games by 10 points or fewer. But they just kept winning. "The clutch kids of the Coast," reporters were calling them. Their one regular-season defeat came in the third game of the season, a 14–0 loss at Ann Arbor to a Michigan powerhouse that went 9-0, was declared the national champion and outscored the opposition 252–44 that season. (Michigan did not play in the Rose Bowl because, under Big Nine Conference rules of the day, a school could not represent the league at Pasadena more than once every three years.)

"Ducks Keep Bowl Bubble Bouncing" was the headline after Oregon's 13–7 win over Washington on November 6. Van Brocklin completed only five of 18 passes but for 130 yards, including a pair of scores.

"Norm Van Brocklin, the wizard of Walnut Creek who has parlayed a right arm and a right foot into All-American rating for himself, employed those two vital physical assets in brilliant fashion, leading Oregon's wonderful Webfoots to a rousing victory over Washington," wrote the *Oregonian*'s Don McLeod. "The dark-haired boy from California threw two touchdown passes and did some place-punting that has seldom been equaled, even in the Big Nine, where infants are taught to kick a football instead of the slats of their cradles. Norm used the sidelines for an ally so proficiently that the eager Husky safety had only one chance all day to return a punt. And that came on the next-to-last play of the game, when Van Brocklin deliberately thumped down the middle in order to run out the clock. The rest of the time most of his kicks were out of bounds, once on the Washington 3, on another occasion on the 2."

Wilkins caught a 27-yard pass from Van Brocklin for Oregon's first score. Wrote McLeod: "Wilkins, who in every game gets more passes than a babe walking a Navy yard, made so many circus catches that the young collegian charged with the duty of listing the competing lineups had him down as a centerfielder."

On the TD pass, McLeod wrote, "Van Brocklin, with as much protection as the secret service gives President Truman, sailed a pass high into the end zone, high over the heads of the Washington sentinels. And there waiting for delivery, with his arms outstretched like an imploring cheerleader, was old, reliable Dick Wilkins."

By that time, it was no secret that Van Brocklin might be playing his final season at Oregon. Normally, an athlete was ineligible to play in the

NFL or competing All-America Conference until his class graduated. But Van Brocklin, due to his time in the navy, was eligible contingent on him completing his classwork the summer after his junior year.

In an interview with a Seattle writer before the Washington game, the Dutchman was quoted this way: "I may turn professional in 1949 if I receive the right financial offer. I'm a junior in health and education, and I can still complete my course work if I do play money football next year."

The next day, ostensibly after a chat with Aiken, Van Brocklin claimed he had been misquoted. "Naturally, I am interested in playing professional football if I can get the right financial offer after I complete my college eligibility," he backtracked.

The Rose Bowl also had a rule against PCC teams playing in any bowl but the Rose (though Oregon State wound up facing Hawaii in the Pineapple Bowl on New Year's Day because it was construed as "not a competing game" but an exhibition). It appeared Oregon and California were on a collision course to become the PCC representative to Pasadena. Problem was, they weren't on each other's schedule that season.

After St. Mary's had fallen 14–13 at Eugene on October 30, Gaels coach Joe Verducci said he felt California was the better team. Cal had beaten St. Mary's 20–0 four weeks earlier—an ominous note. The murmur along the coast was a suggestion that faculty members of the PCC authorize a Cal-Oregon "playoff" game, provided both go through the conference regular season unbeaten.

Before Oregon beat UCLA on November 12, Aiken told reporters that Oregon was willing to face Cal for the right to go to the Rose Bowl any time and at any place. He said a number of California sportswriters and authorities had told him Oregon was the best team to play in the Los Angeles area, better than Cal.

A couple of the writers backed Aiken's claim. Wrote Bob Hunter of the *L.A. Examiner* after Oregon had defeated UCLA: "The victory was much more convincing than Cal posted over UCLA last week, though whether this will influence the Rose Bowl balloting is problematical. Aiken's club appeared to have a better line than California, with Brad Ecklund, Jim Berwick and Chet Daniels all playing top ball."

Added Al Wolfe of the *L.A. Times*: "Most of the 42,700 who went to the Coliseum probably would cast their votes for the Webfoots after watching them decimate UCLA. Van Brocklin was terrific."

Funny, because the Dutchman's numbers that day were pedestrian—6 for 12 passing for 89 yards. But the Webfoots piled up 291 yards on the ground.

And the 6-2 Van Brocklin, who started at 195 pounds but had dropped to 173 by season's end, was all about winning.

"Our running attack was working," he offered afterward. "Why throw the ball?"

On the Monday prior to the November 20 Civil War game, a proposal was made to have California and Oregon face each other for the right to represent the PCC in the Rose Bowl. The proposal, offered by the Southern California Football Writers Association, suggested a Cal-Oregon showdown at the Rose Bowl on November 27, contingent upon Oregon beating OSC and Cal defeating Stanford that weekend.

PCC commissioner Victor Schmidt, attending the luncheon, said there was no conference rule against a playoff but that a poll via telephone of conference faculty representatives would happen immediately after Saturday's game and be announced on Monday. L.A. writers, in an informal poll, favored the Ducks over the Bears 21–6. The Northern California Football Writers Association voted in favor of an Oregon-Cal playoff game 17–3.

As for Cal coach Lynn "Pappy" Waldorf, his response to the playoff proposal was a terse "no comment."

Wrote Seattle *P-I* sports editor Royal Brougham: "I'd like to see Oregon in there without a playoff. I don't blame California for not accepting a playoff. [The Bears] probably figure they have the Rose Bowl clinched, so why take a chance? That Van Brocklin can pass. California doesn't want him firing at the Bears."

Michigan athletic director Fritz Crisler, who had abdicated coaching duties to Bennie Oosterbaan before the season, called Oregon the best team the Wolverines had faced, "and I mean every word."

Superlatives flowed from Corvallis, too. OSC line coach Jim Dixon, who had played for OAC from 1924 to 1926, called Lewis "one of the better ball carriers on the coast" and said of the Ducks: "Oregon has a great team, probably the best I've seen come out of Eugene in the 26 years I've been connected with OSC athletics. If selected, Oregon should make a fine representative for the West Coast in the Rose Bowl Game."

Oregon State entered the Civil War with a symmetrical 3-3-3 record. The Beavers had thrashed UCLA 28–0 but were drilled by top-20 teams Cal (42–0) and Michigan State (46–21). They were coming off successive ties with Washington State and Utah.

Van Brocklin was already tired of any kind of postseason talk. "This is it," he said. "We have to beat Oregon State before we can start thinking about

California or the Rose Bowl. And don't let anyone tell you the Beavers aren't going to be tough."

On the Tuesday before the Civil War game, Cal rejected an offer from Oregon for a postseason game to determine the Rose Bowl rep and conference champion. UO athletic director Leo Harris had made a firm offer the previous week to play either November 27 or December 4—at Cal's home field.

"Oregon has done everything possible to arrange the game without success," Harris said.

Cal's reason, said athletic director Brutus Hamilton, was scholastically based. "I'm opposed to such games for purely academic reasons," Hamilton said. "We have a 10-game schedule. Our academic pace is very fast and our boys need time to devote to their studies. Of course, I realize I'm taking an unpopular stand. The kids would like to meet Oregon, but it's purely a matter of getting the proper amount of studying done. Football is a pretty intense game. The boys work pretty hard at it and some may have fallen behind in their laboratory work or term papers during the season. We are quite willing to use the established procedure after Saturday's game of letting the conference choose the Rose Bowl rep and stand by that decision."

Plus, Cal had an agreement with its archrival that there would be no games after the annual "Big Game" with Stanford, unless it was the Rose Bowl.

An editorial writer in the *Oregonian* acerbically summed it up this way: "It may be assumed that the California players have not been doing well with their studies and risk ineligibility if they don't hit the books. That's too bad. But the Oregon team is willing to help them out. If the Californians could stave off flunking marks for another week, the Webfoots are prepared to send them back to the classrooms freed of their gridiron worries. Would that be better, the Oregons are asking, for those scholastically harassed athletes of Berkeley to play one more game and then retire to the books, than to have to keep worrying and practicing right up to New Year's Day?"

Oregon beat Oregon State 10–0 in Corvallis, the Ducks keeping OSC's halfback twins Ken Carpenter and Don Samuel off the scoreboard. Cal beat Stanford, too, leaving the Bears at 7-0 in conference games to the Ducks' 8-0.

Johnny McKay scored the game's only touchdown on a 15-yard pitch play from Van Brocklin late in the first half. Chet Daniels' 27-yard field goal provided the game's other points.

Wrote the *Oregonian*'s Don McLeod: "They were muddy and they were sweaty. But those rockin', sockin' Ducks of Oregon were thinking only of

Roses when they filed into their dressing room after blanking Oregon State in the traditional state grid classic. 'How can they keep us out of Pasadena now?' the Webfoot warriors warbled as they headed for the shows to erase the mud-pack stains of a bruising battle.

"As might be expected, the dressing room was bedlam after the boys left [Bell Field], proudly carting coach Jim Aiken on their padded shoulders. Even Aiken, usually the epitome of reserve when off the sideline, joined in the noisy fun. He whacked his proud protégés on the back, ran his fingers through trainer Tom Hughes' tousled hair and in his best gravel-tone, rumbled: 'Gee, I hope we make it.' Perhaps the happiest guy in the cheering mob was Chet Daniels, the Negro guard who, in addition to playing a bang-up game on defense, contributed four precious points to the Webfoot total—a conversion and a 27-yard field-goal boot. 'It really sent me,' Daniels said, a wide grin splitting his face. 'It was the first time I ever tried a field goal in a game. Yessiree, I had never kicked one before, even in my high school days in Los Angeles.'"

Bell carried 17 times for 115 yards on a muddy field to lead Oregon. Van Brocklin was only 5 for 10 passing for 32 yards.

"The interesting thing was, the Ducks were all wearing white uniforms on a muddy field," OSC's Bud Gibbs said. "Norm never got his uniform dirty that day."

And the Ducks stuffed the OSC offense.

"They were better," Samuel said after the game "Their defense was an awful tough nut to crack, and that Van Brocklin can run my team any day in the week."

Stiner, whose 17-year run as OSC's head coach would be over at the end of the season, doled out the plaudits to the victors afterward. "We stopped the passing attack," he said. "So when Oregon went on to beat us on a running attack, it showed the Webfoots to be a very well-balanced team, and I take my hat off to them. I can pay them no higher compliment than in saying there was no part of our plan I would have changed. Our boys did everything they had been coached to do, to the best of their ability, but Oregon was just too good."

Stiner noted that Van Brocklin, calling Oregon's plays, went with what was working. "I must compliment Van highly for not trying to glorify himself by throwing more passes when we had his passes controlled, but turning to the running game," the OSC coach said. "That was a fine example of playing for his team instead of himself. He used splendid quarterbacking judgment."

On the losing side that day was OSC's Cliff "Chief" Snider, a sophomore quarterback who would be moved to end and linebacker his final two seasons. Snider, out of Milwaukie High, was to play six positions in the season-ending 47–27 win over Hawaii in the Pineapple Bowl.

In those years, there were freshman teams in addition to varsity squads, and first-year players were allowed to swing between the freshman and varsity units. Snider had played for the OSC Rooks in a win over the UO Frosh, with Van Brocklin at tailback, in 1946.

"He was just another quarterback to me," said Snider, who died in December 2013 at age 87. Of course, that was before Aiken arrived with the T formation. "Later on, we became friends. One year I helped him move from one house to another in Eugene. He became a darn good quarterback, I'll tell you."

Snider, three-fifths Chinook Indian, was an honorary chief of the Chinook tribe in Oregon. He taught and coached 26 years at Tigard, Molalla and Clackamas high schools. The Clackamas field is named in his honor.

After high school, Snider was an army sergeant who served at Hiroshima. He was discharged in August 1946 in time to enroll at Oregon State. After playing as a freshman, Snider "blackshirted" in 1947, playing quarterback for the scout team. He played some as a sophomore and then was a regular his final two seasons under Stiner's successor, Kip Taylor.

"I liked Lon Stiner," Snider said. "He was the best, a great coach. He and his staff, especially Jim Dixon, were fabulous. They prepared us very well for the games. We had a better team than our record indicated that '48 season. We lost some close games."

The Civil War "was always the biggest game," Snider said. "The Ducks were our biggest rival. We had so many friends between the teams. We knew a lot of their players from high school. They were always the No. 1 team we had to beat."

The best player during Snider's years at OSC was Carpenter. "Just an outstanding halfback," Snider said. "Kenny was so fast. I remember playing defense against him in practice. I'd have him cornered, and he'd beat me to the outside. His hips were so strong, you'd grab one of them, he'd tear away from you. The best back I ever tried to tackle."

Snider's final two seasons at OSC were under Taylor, who had been an assistant coach under Biggie Munn at Michigan State. Taylor lined up an excellent staff, including ex-OSC standout Len Younce and former Michigan greats Bump and Pete Elliott. Also on the '49 team was Gibbs, by then a senior.

"Kip was a very smart guy, and the Elliott brothers were golden boys from Michigan," Gibbs recalled. "Pete was my position coach. I got to be very close to him and had a lot of great experiences with him after he left here."

Taylor had little success during his six years at Oregon State, except in the Civil War. He would win his first five against the Ducks before losing in 1954.

"The rivalry was very big, but there was no animosity at all," Gibbs said. "Players from the two schools had respect for each other. It was a lot of fun. There couldn't have been more intensity to it, but you still liked and respected the guys on the other side. When the game was over, you'd get together and have a nice visit."

Snider offered a postscript to the 1949 season. During the prior winter, Snider had attended a basketball game with teammate Stan McGuire. It had snowed that day, and during the game, someone said, "We're going to go sledding after the game." But Snider was showing a basketball recruit around the campus that weekend, so he didn't go. That night, McGuire was killed in a sledding accident.

"I might have escaped being killed on that sled because I was working for [basketball coach] Slats Gill," Snider said.

On the following Monday after the 1948 Civil War, news came over the teletype that the PCC's 10 faculty reps had voted for California to represent the conference against Northwestern in the Rose Bowl. The Bears would go on to lose 20–14 on New Year's Day.

In the event of a 5–5 vote, the team that had been to the Rose Bowl last was eliminated. Cal had played in the 1938 game; Oregon hadn't been since 1920. The results of the vote were not announced, but it was widely believed that the vote was 6–4 for Cal, with Oregon State, Washington State and Idaho joining Oregon to vote for the Ducks.

"The word was that Washington and Montana voted with the southern schools," Glickman said. "A lot of us old-timers have never forgiven the Huskies for that."

Added Sanders: "Washington bailed out on us and voted for California. If the Northwest had stuck together, we'd have been in the Rose Bowl."

Speaking at an Oregon Club luncheon that day, Aiken cracked, "I'm from West Virginia, and down there we never forget a favor, or a slight."

Van Brocklin, attending the luncheon, broke down and cried. "I think our team has been slighted," he said.

That day in Berkeley, thousands of students paraded the streets, bringing out all available police and firemen. Bonfires flared on street corners, and

jubilant students crowded the streets, cheering and shouting. At a campus rally in Eugene, more than 4,000 students paid tribute to the Ducks after learning they didn't get the Rose Bowl bid.

The PCC, breaking tradition, authorized Oregon to line up an arrangement with another bowl. One promoter was trying to arrange a December 18 Oregon-Oklahoma game at the L.A. Coliseum. Eventually, Harris accepted a bid to play Southwest Conference champion Southern Methodist, led by Heisman Trophy winner Doak Walker and Kyle Rote, in the Cotton Bowl. It was the first time a PCC team had played in a major bowl game except the Rose Bowl.

SMU won a competitive game by a 21–13 score. Van Brocklin threw for 145 yards, including a 24-yard touchdown to Wilkins, and Sanders scored on a one-yard run in the fourth quarter. Oregon's defense kept Walker (66 yards on 14 carries) in check, but Rote gained 104 yards on 16 attempts. The Mustangs' biggest weapon that day was quick kicks. Walker booted one that traveled 82 yards. Rote one-upped his teammate, booming one 84 yards.

It was the end of the Van Brocklin era at Oregon. He completed his academic requirements that summer, was the fourth pick in the draft by Los Angeles and went on to a Hall of Fame career. In a game in 1951, Van Brocklin threw for 554 yards, a record that stands more than 60 years later.

"We were disappointed when he left, but he made the right move at the time," Sanders said. "He started out with about a $17,000 contract with the Rams. That was big money in those days."

Guard Darrell Aschbacher, who played for Oregon in 1957 and '58, later played two seasons with Van Brocklin in Philadelphia. "After I got there, he said, 'Darrell, I know how to put weight on you—steak and beer,'" Aschbacher said. "I thought, 'Excellent.' He was a great guy, and I think he's the best quarterback who ever played."

At Oregon's postseason banquet, Aiken spoke bravely. "Well, we'd love to have Van back—but everyone can be replaced—the quarterback, the coach, even the school president."

Within a year, president Harry Newburn was replaced. Aiken didn't last much longer. Found to have violated the PCC's academic code and rules for financial aid and athletic subsidies, he was forced to resign after the 1950 season. Len Casanova was hired to replace him, and an important new era in Oregon football had begun.

CHAPTER 10

CAS AND TOMMY

Oregon hired Len Casanova after one year as head coach at the
University of Pittsburgh. Casanova, then 46, didn't have a lot of
success in his year at Pitt. With the team's roster depleted by defections to
the Korean War, the Panthers went 1-8 in 1950.

Casanova inherited just as sorry a scene in Eugene. The Ducks had gone
1-9 in Jim Aiken's final season, beating only Montana. By the time he retired
after the 1966 season at age 61, Casanova was the winningest coach in
school history with an 82-73-8 record, including 47-31-4 over his final eight
seasons. His Civil War record, though he never lost a game by more than
eight points, was only 4-10-2.

It didn't help Casanova that Tommy Prothro had come onto the scene in
1955. Prothro was 5-3-2 in his 10 years of the rivalry.

But Cas had trouble, too, against Prothro's predecessor, Kip Taylor, who
won their first three meetings before losing 33–14 in 1954, his final year at
the OSC helm.

Casanova, the son of Swiss immigrants John and Marie Casanov, had
grown up in Ferndale, California, played at Santa Clara and then coached
for many years at his alma mater, from 1936 to 1942 as an assistant and,
after a break for World War II, from 1946 to 1949 as head coach. It was his
work there that impressed Oregon officials. His 1948 team beat Stanford
and Oklahoma and tied Michigan State. The Broncos went 8-2-1 the next
year, beating Bear Bryant's Kentucky team 21–13 in the Orange Bowl.

In the weeks following the victory, Santa Clara officials announced they
were dropping major college football as a cost-cutting measure. Casanova

departed for Pittsburgh, but he was a West Coast guy at heart. When Oregon beckoned, he was only too eager to take the job.

Casanova's record gradually improved through his first four years at Oregon, from 2-8 to 2-7-1 to 4-5-1 to 6-4. By that time, two-sport All-American George Shaw (he also played baseball) was a senior, quarterbacking the Ducks to Cas's first Civil War victory, a 33–14 triumph at Corvallis. Shaw, who rivals Mel Renfro as the most complete player in Oregon history, threw three touchdown passes, ran a kickoff back 67 yards and returned an interception 42 yards in his final career game.

Prothro arrived on the scene at Corvallis in 1955 after Taylor's firing following a 1-8 season. The son of former major-league player and manager Doc Prothro, Tommy was a familiar name to Oregon State fans. He had been the quarterback for Duke in the 1942 "Transplanted Rose Bowl," won by OSC 20–16. Prothro had been backfield coach at UCLA for six years under Red Sanders, helping the Bruins to an unbeaten season and the national championship in 1954. Using Sanders's single-wing, they had rushed for 498 yards in beating Taylor's Beavers 61–0 in Corvallis that year. That remains the second-most one-sided loss in school history, behind only a 63–0 thumping by Southern Cal in 1985. During Prothro's final three seasons as an assistant in Westwood, UCLA outscored Oregon State by an aggregate 159–0.

Prothro was a southern gentleman and a man of great intelligence, an avid bridge and chess player who chain-smoked cigarettes and chain-drank Coca-Colas.

"I used to watch him smoke a cigarette and drink a Coke," said Don Kasso, who played at Oregon State from 1959 to 1961. "He'd take that cigarette up to his mouth and cover his entire mouth with the smoke from that cigarette, and you'd watch it slowly disappear. You'd find yourself riveted on the guy, whose physical stature was so big. When he entered a room, he commanded attention. The room would get very quiet. He was bigger than life itself. When he spoke, you hung on every word. His philosophy was beyond football, but about life. He had a big ego, one he guarded well, but it was there, and I sensed he enjoyed the limelight.

"Once he called me into his office. On his blackboard he had this very involved math problem. I asked him, 'Are you teaching a class?' He said, 'No, I do intricate math problems to stimulate my mind.' It took up the entire board. I don't know if it was calculus or what, but I think he was being sincere. He was an impressive, super-intelligent man."

"Had he been in college administration, Tommy would have been a college president," the late Bobb McKittrick once said; he played and coached for

Prothro at Oregon State and later gained fame coaching the offensive line for five Super Bowl champions with the San Francisco 49ers. "Had he been in business administration, he'd have been the president of General Motors. He was a step ahead of most people. He never had to coach for a living. He did it because he liked it."

"We'd heard that Tommy got hired for $10,000 and donated the salary to get good assistants," said Frank Negri, who played from 1955 to 1957. "He didn't need the money."

"Tommy lived two houses away from us, so he'd be at our house three or four nights a week," said Bud Gibbs, who coached for Prothro at OSC from 1958 to 1960. "I got to know him very well. Very smart, very high class. His father, Doc, had made a lot of money in coaching and later real estate. Both Doc and his wife came from families with a lot of money. They were very well-to-do people."

Casanova drew first blood in his coaching rivalry with Prothro, Oregon blitzing Oregon State 28–0 in 1955 at Eugene. The Beavers, with tailback Joe Francis limited to a few plays because of an arm injury, managed five first downs and 77 yards in total offense on a sloppy Hayward Field.

The surprising part of that was Prothro was having a successful first season. In his second game, the Beavers went into their game at Stanford a 30-point underdog and won 10–0. OSC had won four in a row, including wins over Washington State, Washington and California, and was 6-2 and ranked 19th nationally entering the Civil War. Before the game, many were suggesting Prothro as Pacific Coast Conference Coach of the Year. Some—Red Sanders and OSC athletic director Spec Keene among them—said he ought to be national Coach of the Year. Even with the loss to Oregon, OSC finished second in the PCC that season behind UCLA at 5-2.

The Ducks, meanwhile, had started 1-3 and then reeled off four straight wins. But a 44–7 home loss to Stanford the week prior to the Civil War left some of the partisans unhappy with the head coach. On the following Monday, Casanova was hanged in effigy with a makeshift dummy from a tree outside Johnson Hall, the school administration building. It was taken down quickly, but it had its emotional impact. Quickly, the Oregon rally squad and a group of students staged a rally. A banner was erected that read, "We're behind you, Cas."

The players were, too.

"We loved Cas," said Norm Chapman, a sophomore starter that season as a center and linebacker. "What you're doing by that is kicking sand

in the face of the players, too. That irritated people. Maybe that was inspirational to us."

Ironically, the following day Casanova was sent to Sacred Heart Hospital with an acute appendicitis attack. His assistants, Jack Roche, Johnny McKay and Jerry Frei among them, took over practice for the rest of the week. Cas was released Wednesday afternoon and went straight to practice as an "observer."

There was another indignity the Ducks were to endure. One of the earliest snowfalls in the Willamette Valley in memory had dumped eight inches in Eugene early that week. There was no indoor facility to use. Hayward Field was off limits.

"They bussed us out to the cattle sheds at the Lane County Fairgrounds," Chapman recalled. "We practiced two or three times there that week. It smelled like you know what—just awful. I think our last practice was in Mac Court, just going over plays and running pass patterns."

On Thursday, the ground maintenance crew used a tractor to rid Hayward Field of snow. "In the process, it tore up a lot of turf," Chapman said. "Then a warm spell came through, thawed all the snow and ice and left Hayward a quagmire of mud. It was unbelievable."

"It started raining that morning," remembered sophomore QB Jack Crabtree, a native of Norwalk, California. "I'm in a foot of mud on the sidelines, wondering, 'Why did I ever come to Oregon?' In Southern California, they'd call off the game."

"The field was a disaster," said Francis, a sophomore tailback at Oregon State that year. "It was a sea of muck, a mud hole. The only way you could tell who not to knock down was the color of the helmet. The uniforms were so dirty, you couldn't read numbers."

"Mud was up to the ankles," said Frank Negri, who played at OSC from 1955 to 1957. "We couldn't block or pull. But I remember Prothro didn't put much emphasis on that game. That first year, he didn't realize the importance of the Civil War. He hardly prepared us for that game."

The field's condition didn't bother Oregon's "Speed Boys." Sophomore Jim Shanley carried 27 times for 160 yards and two touchdowns, and senior Dick James—who was to learn of an East-West Shrine Game bid that day—added 114 yards on 22 totes as the Ducks gained 327 yards on the ground.

UO fullback Jack Morris, an ex-GI who kicked four extra points to set a school scoring record with 68 points, gave the line the credit. "Never have I seen such holes open up," Morris said. "Those guys up front made it an easy job for the backs."

A standout on the defensive side that day was end Phil McHugh, who would be a two-time All-PCC selection and later serve as an assistant coach at his alma mater from 1958 to 1968.

"He did the greatest job of end play I've ever seen," assistant coach Jack Roche said. "All week long, he studied movies of the UCLA-OSC game, using the films as a means of learning everything he could about the single wing. And the hours he spent certainly paid us big dividends."

"The '55 Civil War will always be the biggest win for our class, after the loss at Stanford and Cas was hung in effigy," McHugh would later say. "We totally stuffed [the Beavers]. That's the one I will remember forever."

After the game, all the UO assistant coaches were whisked away by the players and dunked in the showers.

"They can cut me open now without using any anesthetic," a still recuperating Casanova said. "Weren't those kids swell? Every one of them really put out."

Prothro was gracious afterward. "We were beaten by a team that was much better than us on this afternoon," he said. "They outplayed us and outscored us. What else is there to say?"

Prothro was already denying rumors he was headed "for different pastures."

"I'm not considering a coaching job at any other school," he said. "When I accepted the Oregon State job, I told them I would stay, and I'm not going to go back on my word."

Kip Taylor had used the T formation during his time at Oregon State. Prothro went to the single-wing attack of the Stiner era and moved Hawaiian Joe Francis from second-string quarterback for the Rooks to first-team tailback. Francis would become a first-team All-Pacific Coast Conference selection as a senior in 1957.

"Joe had more physical talent than you can imagine," teammate Frank Negri said. "He could run. He wasn't fast but shifty. He threw a great touch pass, a tight spiral, a catchable ball, not hard or heavy. And the SOB could really punt."

"He was big and strong and could throw the ball," said Bob Milum, a fullback from 1957 to 1959. "They had an all-school boxing championship. He won his weight division. He was a tough guy."

"Joe was really good," said Dave Jesmer, a tackle from 1955 to 1957. "He called the plays. We had a very simple but effective offense. We used to drive opposing linemen crazy. You could double-team up and down the line of

scrimmage with our single wing. Bobb McKittrick [a lineman in 1956 and '57] and I would talk to [opponents]. We'd say, 'We're going to get you on this play.'"

It worked the other way in a 38–0 loss to seventh-ranked UCLA in 1955. The Bruins, coming off a national championship the previous year, were loaded.

"They had three All-Americans on their line," Jesmer said. "On one play, two guys told me, 'We're going to put you in the cheap seats, and Tommy's not going to like it when he sees it on film.' And that's what they did. They put me up in the stands. It was embarrassing."

Francis knew nothing about Oregon State when he arrived in Corvallis from Honolulu in 1954. Taylor, in his final year as OSC coach, didn't offer a scholarship. "My first thought was to join the navy out of high school," Francis said in March 2013, three weeks before he died of cancer at age 76. "My mother wouldn't sign the papers. I wanted to get off the island, get a new start. I had a basketball scholarship offer from Utah. I looked at the map, and Utah was another 1,000 miles away. Two or three other guys I knew were going to Oregon State. I decided to give it a try. Soon after I got to Corvallis, I wanted to go home. But I figured, what the hell, let's stick it out and see what happens."

Prothro was no walk on the beach. "A lot of the guys who had played for Kip were pushed off the team that first year," Francis recalled. "Tommy made it real tough on everybody. You either played your way on to the team, or you didn't play at all. My first impression was, he seemed like he just hated all the guys.

"But it turned out OK. He was an intelligent guy. If he felt you weren't up to his intelligence, he could be rude. But he was one of the finest football coaches I've ever seen. He knew his football. He was fantastic for Oregon State. I found by my junior year, I liked him. I learned that, 'Hey, he knows what he was doing.' I didn't know what the hell I was doing. He took a lot of players who really weren't players and turned them into players."

The 1956 season turned golden for Oregon State. In the backfield were such stalwarts as Joe Francis, Paul Lowe, Earnel Durden, Tom Berry and Nub Beamer. Up front to block were Dave Jesmer, Ted Bates and John Witte, the latter two who would both earn All-America recognition. (For two summers, the 6-2, 230-pound Witte had worked as an apprentice mortician in a Corvallis funeral home. "That kid hits as if he's looking for clients," one reporter wrote.)

Lowe "was a tremendously gifted athlete," said Durden, 77 and living in San Diego. "He might have been the best athlete I ever played with. He had so much talent, it was pathetic."

"Paul didn't start that year, and I don't know why," Francis said. "He was fantastic. I remember Tommy once asking me what I thought about Paul. 'Can he go on to play in the pros?' I said, 'Hell, yes.' The kid had speed and plenty of talent. Look what happened."

Lowe would go on to a stellar career in the AFL with the Los Angeles/San Diego Chargers, winning the league's Most Valuable Player award in 1965 and earning a spot on the all-time AFL team.

Prothro wound up making perhaps the greatest recruiting haul out of Los Angeles in Oregon State history his first year, nabbing Lowe, Durden, Ted Bates and Joe Wade in one swoop. They drove up together for their recruiting visit with a Prothro crony from his years in L.A., Howard Johnson.

"I hadn't planned on going to college until I talked to Prothro," said Lowe, 76 and living in San Diego. "I couldn't get into UCLA because I didn't have a foreign language in high school. For awhile I wanted to go to Grambling. But my people said, 'Go to Oregon State. It's a mixed college and you will learn about all different people.' It was a great experience. I really enjoyed it. We went to the Rose Bowl. I was thrilled I made that decision."

Wade would letter only one season, in 1957, as a reserve. The other three became stars, Lowe and Bates going on to play in the NFL.

"It was a wonderful time for all of us," Lowe said. "Getting a scholarship was a godsend to me. Being poor and my parents didn't have any money, I might not have gone to college. It was a great thrill and a relief to my family for me to go to Oregon State."

Looking back, Bates feels the same way. "It was all great, my time at Oregon State," he said. "I went from a place where it was mostly cement to greenery. I learned to fish and about the outdoors, and I learned about people, too. I developed some very close friends while I was up there."

Prothro had an aura about him. Always dressed at games in a dark suit and tie, top hat and black-framed glasses, he carried a briefcase with him to the sidelines. "I always wondered what was in it," said Booker Washington, a fullback who played on Prothro's final Oregon State teams. "Must have been something important. But I never saw him open it."

"He'd carry the game's dope sheet in it," revealed Ron Siegrist, a senior quarterback during Prothro's first year at OSC and later an assistant coach under him.

All who played for Prothro at Oregon State had a large measure of respect for the coach.

"He was great as a coach and a person," said the 6-2½, 215-pound Bates, 77 and living in Los Angeles after a long career with the Pasadena Parks Department. "I appreciated Prothro for what he stood for, his consistency and interest in the players. He made sure we went to class. He held us to a high standard. Once I was caught smoking while I was studying. I remember doing a bunch of laps, running around a big hill while everybody was practicing."

"Tommy was so committed," Lowe said. "He'd learned a lot under Red Sanders at UCLA. He was so qualified. He taught us things we wouldn't have gotten from any other coach. He was a smart man who knew about football. It was great to get that experience of having him as my coach. I learned a lot from him."

"Prothro was the greatest," said Durden, who would go on to coach with him at UCLA and in the NFL with the Los Angeles Rams and San Diego Chargers. "He was my idol in terms of coaching. He was a no-nonsense coach who didn't laugh and joke and talk and do those kinds of things. But he knew the game. He knew how to finesse, how to get his guys ready. And we had to have the best coaching staff there was in college football at the time."

One of those coaches was Bud Gibbs, who often charted substitutions for Prothro in the early years of two-platoon football. "Tommy was one of the greatest coaches of all time, I'm convinced," he said. "To this day, as I see what coaches do, I realize how smart he was and how far ahead of his time he was."

Also on the staff was Bob "Tiger" Zelinka, who had played guard at UCLA and served as backfield coach during Prothro's entire time at Oregon State. "Tommy was the most intelligent man I've ever met," said Zelinka, 84 and living in Portland. "He had an incredible memory. That's what made him an outstanding coach. He had an analytical mind that was incredible. In our meetings, we'd be talking about defenses that would stop an opponent. He'd step up and solve a problem without any hesitation. He had coached defensive backs at UCLA, so he was the pseudo-defensive coordinator. He had a broad knowledge of the game and was able to break down opponents' offenses. We would scout opponents thoroughly through film to look for tendencies, which was ahead of those times. We would diagram on the chalkboard what they did from the left hash mark, middle and right hash mark. That helped us win games without material maybe not as good as others."

"The man was a genius," Siegrist said. "He was an unbelievable game coach. When college football was changing its substitution rules [in the late '50s], he had Bud Gibbs on the sideline, almost like a Bible, telling him who he could put in, when he could put them in. Strategically, we felt like we were ahead of our opponent with Tommy at the controls."

Prothro had anything but the warm-and-fuzzy demeanor of his successor, Dee Andros. "He was a big man, 6-4 and 230," said Frank Negri, who played quarterback and end. "He spoke in that drawl. When he spoke to you, we stood still, rigid, trembled in our pants. He would never yell at you. But he'd raise his voice a little."

"He never said an awful lot, to be truthful," said Beamer, a fullback from 1956 to 1958. "But he got the message across. I enjoyed playing for him, but he said no more than 50 words to me in four years."

Not every player felt that way. "I really liked him personally," said Ted "Pump" Searle, a quarterback from 1956 to 1958 who came over with Francis from Honolulu. Searle had inherited his nickname from his father, who had pumped his arms as he played fullback on a Honolulu town team.

"The summer after my junior year [at OSC], Tommy flew over to recruit some kids from Hawaii," Searle said. "I was there and got to spend time with him, answering questions about who I thought would be good to fit into our system. We got to be pretty good friends."

"He was a very professional individual," said Denny Brundage, a guard/linebacker from 1957 to 1959. "He never talked down to you or criticized you. He let his assistant coaches do that. He commanded respect and knew the game quite well. Off the field, he was very personable. He was great to my parents. He and his wife, Shirley, became good friends of my parents."

"I certainly didn't like all the hard work he made us do," said Jesmer, a tackle from 1955 to 1957. "I considered him a great motivator, because what he said, you listened to. You hated to get singled out after a game for a bad block or a missed tackle. One time he turned to me and said, 'Jesmer, you look like you're looking for an outhouse in the fog.' I wanted to crawl under my desk. But he was a coach who made it simple. We drilled on the fundamentals every day. We didn't have great players, but we had a great team."

"I don't remember Tommy ever giving a fire-'em-up speech," said Pete Pifer, the great Beaver fullback of the mid-'60s. "He relied on Tiger Zelinka and some of his assistants for that. They were fire-'em-up kind of coaches. You play to your strengths."

"Tommy was a real introvert," Zelinka said. "But part of it was his eyes were bad. A lot of times he would walk by people he should have said hello

to because he didn't recognize them. We'd be walking down the hall and he'd say, 'Tiger, who's coming?'"

"He'd walk down the hallway and wouldn't say hello to you, maybe because he was deep in thought," suggested Dick DeBisschop, a center-linebacker at Oregon State during the Prothro era.

"Tommy was very aloof," Siegrist said. "You didn't know what he was thinking a lot of the time. You wondered whether he was pissed off. He was very demanding. When I coached, some of my linemen thought he was mean, but he was demanding. That is the best word."

"That's the way Tommy wanted it," Gibbs said. "He wanted the players to respect him, but he didn't necessarily care if they liked him. He wasn't unkind or nasty, but he didn't get close to players. And they always respected him."

"I loved the guy," Zelinka said. "We were extremely close. If you were close to him, you felt his love and warmth. He was a strict disciplinarian. The kids respected him, and if they ever got in trouble, he was right there for them. He never turned his back on a kid."

Prothro dressed the Beavers in black uniforms for games. They were to become known as the "Black Bandits of Benton County."

"We were little in size and lighter than anybody we played, and I wanted to emphasize that," he once explained. "I think darker colors make you look smaller. Black was one of Oregon State's colors, and orange wasn't much to me."

Oregon State started the 1956 season 1-2, losing back-to-back games against top-20 opponents Southern Cal (21–13) and Iowa (14–13). Then the Beavers ran off five straight victories, all against PCC competition, to take the lead in the race for the Rose Bowl, with powerful UCLA ineligible due to the no-repeat rule.

The Beavers went into their November 17 game at Idaho needing a win to clinch the Rose Bowl berth. The Vandals were anything but a pushover before OSC escaped with a come-from-behind 14–10 triumph on a muddy field on a blustery, wet day in Moscow.

"The worst weather conditions I played a game in, at least at Oregon State," Paul Lowe said. "It was cold, man. Snow, ice on the field."

"The weather was miserable—snow, ice and cold rain and sleet in the hours before the game," Ted Bates said. "I remember at halftime I went into the locker room to try to find a pair of gloves. My cleats froze toward the end of the game. I was cutting my fingers on the ice when I'd get down in my stance."

"Tommy never let us wear anything underneath our jerseys—no T-shirts, no nothing," Joe Francis said. "We were freezing."

Oregon State was without three injured starters on its line, ends Bob DeGrant and Norm Thiel and guard Vern Ellison. Perhaps in part due to that, Idaho controlled the game, winning easily in the statistical categories of first downs (15–4), rushing yardage (154–75) and total offense (209–140). The Vandals were led by linemen Jerry Kramer and Wayne Walker, who would go on to long careers in the NFL.

"They had a lot of good players," Earnel Durden said.

"It was a battle," Bob Milum said. "All of us third-stringers thought we'd get to play a lot, but we never got in."

Francis felt it was one of the few times in his OSC career that the Beavers went into a game ill-prepared. "The week before the game, we never even looked at Idaho," he said. "We didn't know Idaho's plays or nothing. We didn't work against their formations. Tommy must have felt Idaho was no threat."

"I don't know if we overlooked them as much as Idaho played a good game," Bates said. "The Vandals might not have had as much talent as we did, but they made some plays and we didn't."

Kramer's 36-yard field goal gave Idaho a 10–7 lead early in the fourth quarter. Things looked bleak moments later when Francis, punting into a 35-mile-per-hour wind from deep in Oregon State territory, had it go one yard, giving Idaho the ball at the OSC eight-yard line. But the Vandals backed up and failed on a fourth-down pass play, and the Beavers took over on their own 15 with four minutes left. A few plays later, a 61-yard pass from Lowe to Durden put the ball on the Idaho three.

"In those years, the tailback called most of the plays," Durden said. "I remember going into the huddle and Coach Prothro sent the play in—wingback out and down. I ran my out pattern to the sideline. When I turned to go upfield, the defensive back was lost. Paul threw the ball out there, and I was wide open. I could barely feel the ball hit my hands. I had dropped a pass earlier in the game because it was so cold. I watched it go into my arms and wasn't at full blast until I tucked it in, which might have given the safety a chance to get an angle on me. I raced down the sideline, and he came across the field and tackled me at the three."

It took Lowe three cracks to get into the end zone. On third-and-goal from the three, he hit pay dirt with 2:10 remaining for the game-winning touchdown.

"We called a sweep with Paul going left," Frank Negri recalled. The Vandals "had it diagnosed. I was the tight end that play. There were three

guys outside me. I thought, 'This play is not going to go.' But that sumbitch turned on the burners and just beat them to the corner and stepped into the end zone."

"I remember thinking I had to get in there," Lowe said. "I had that in my mind. And I did. Everybody was so pumped. I was 10 feet off the ground at the time."

Mostly, the Beavers felt relieved. "We were just glad to get out of there with a win," Durden remembered. "The Vandals beat the heck out of us."

With the Rose Bowl berth clinched, the Beavers turned to the Civil War game at Corvallis. Oregon, coming off a 7–0 win over Southern Cal, was 4-3-2.

"I think we'll be a little more aware of Oregon than we were Idaho," remarked Prothro before the game, perhaps lending credence to Francis's theory about the coach's lack of preparation for the Vandals.

Oregon wanted to win the game but not to make a statement about the Beavers. "We didn't dwell on the fact they were going to the Rose Bowl," UO back Jim Shanley said. "We knew they'd had a good season. We just wanted to win."

Oregon State didn't need to win to get to the Rose Bowl. To most of the Beavers, that didn't matter. "I didn't like losing to Oregon in anything," Dave Jesmer said. "That's a school I considered out of high school, except they didn't have forestry. My high school coach had played service ball with Len Casanova. I went to Eugene for a visit and found him to be a great guy. I would have loved to have played for him. And I knew some of the players down there. They were good guys. But I didn't like losing to them."

The game was telecast by NBC to viewers west of the Mississippi, the first Oregon–Oregon State game held on Thanksgiving since 1920. Extra bleachers were erected in the end zone in Parker Stadium to accommodate 24,000. Reserved seats sold for four dollars, general admission for two dollars and kids for one dollar.

Perhaps because of the rare TV opportunity, only 17,300 showed up to watch a 14–14 tie. Oregon scored on a 17-yard pass from Tom Crabtree to Jack Morris with 1:51 remaining. Crabtree had come in to replace the Ducks' other Crabtree, Jack, who had been knocked out of the game in the third quarter.

"They carried me off the field," Jack Crabtree remembered. "I got hurt making a tackle on defense. The next thing I knew, I woke up in the locker room."

On Oregon's final drive, Shanley—who finished with 63 yards on 13 carries—got loose on a third-down play to make first down. "I had Shanley

dead on for a six-yard loss," said Negri, 78 and living in Roseville, California, after coaching for 55 years. "Came up to tackle him, grabbed him around his thighs and knees. But that little SOB had strong legs, and he just stepped out of it and got the first down. I've kicked my ass over that over the years. I should have hit him high."

Oregon State had scored first, early in the second quarter on a Tom Berry two-yard run. The Ducks took advantage of an OSC fumble at its 36, evening the score on a five-yard Shanley TD run with 10:17 left in the third quarter. The Beavers went back ahead when Sterling Hammack scored the go-ahead TD on a 14-yard reverse early in the fourth quarter with 12:05 left after an 89-yard TD drive.

Hammack had four carries for 51 yards but also fumbled twice on punt returns (Earnel Durden was the usual guy), including the one that set up the Ducks' first score. He had been pressed into action when Durden was ejected on the opening kickoff of the third quarter. Durden and Oregon's Spike Hillstrom had gotten into it after the play, and both were tossed.

"Sterling was a real good friend of mine," Durden said. "He probably hadn't been back there to return punts all year. I truly believe if we'd been at full strength, it would have been a different result. There was some thinking that the game didn't mean that much to us. Even though we knew we were going to the Rose Bowl, we always wanted to beat Oregon. That game was a blemish we wish we'd been able to correct. It stuck in my craw for years. I didn't forget that one."

Oregon State went on to the Rose Bowl, but the game wasn't a happy affair. Iowa beat the Beavers 35–19. Just being there, though, was the thrill of a lifetime for most of the players. "It was something I could never have envisioned as a kid growing up in Hawaii," Joe Francis said. "I remember being on the plane to Los Angeles. I looked down from the sky and said, 'Son of a gun, I can't believe how big L.A. is.' And somebody said, 'That's not L.A., that's San Francisco. When you get to L.A., you'll know.' It was such an experience, playing in the Rose Bowl. I just wish we could have won."

The power of the PCC was in the state of Oregon in 1957. Oregon State, ineligible for the Rose Bowl via the no-repeat rule, had nearly all of its 1956 squad back. Oregon, with Jim Shanley leading the way, was loaded with veteran talent, too.

Casanova would finally begin to be appreciated by Oregon fans. His players already appreciated him. "We all loved Cas," said Shanley, a first-

team All-PCC selection as a senior who would become Oregon's leading career ground-gainer that season. "He was a father figure for all of us— even when he growled at us. I can remember watching game films, and Cas would always be the guy to run the projector and make the comments. Invariably he'd say, 'Come on, Shanley. A good back would run through that arm tackle.' He was demanding, which I think coaches have to be. He held us accountable on and off the field. He saw that we attended practice and went to school."

The 5-8, 170-pound Shanley, who played one year with Green Bay in the NFL, had considered both Oregon State and Washington coming out of North Bend High. Kip Taylor was still the coach at OSC during Shanley's senior prep season.

"It was before Prothro, but he seemed too stiff and too removed, anyway," said Shanley, 78 and living in Walla Walla, Washington. "I went up to [Corvallis] and visited a couple of times. It was a fun thing to do, but I never had a desire to be a Beaver. I was always enamored of Oregon. I grew up close [to Eugene]. I'd listen to their games on the radio. I can still remember the announcer saying, 'Here come the Webfeet!' I was intrigued."

Shanley grew to love the Oregon backfield coach, Johnny McKay. "I thought the world of him," Shanley said. "We'd go to a chalk talk, and he'd make the most complicated things seem so simple. I'd think, 'What's so hard about learning that?'"

McKay had recruited quarterback Jack Crabtree out of San Bernardino, California. "He knew exactly what he was talking about," said Crabtree, 78 and living in Eugene. "I was in his brain, he was in mine. Whenever I called a play on the field, I knew that's the one he wanted me to call."

"Cas was a great mentor," center-linebacker Norm Chapman said. "There was everything about Cas you would like your father to be. He could be very stern, but his door was always open. He was never aloof, but he was a tough coach. Not necessarily outwardly, but you either performed or you heard from him."

"He was tough but he was compassionate," said guard Darrell Aschbacher, who played in 1957 and '58. "He wanted you to go 100 percent every game. If you did that, you were on Cas's good list. That's the way I played football, anyway. He knew not just all the players' names but all their wives' names, too. And a lot of them were married in those days."

"Anytime Cas looked at your hair, he never said a word," Crabtree said. "You knew you had to get a haircut, and you did. In those days, some of the players were the barbers."

On the Oregon team that season was a reserve end named John Robinson. "I played about 11 minutes of college football," Robinson likes to say. "My high school coach, Jess Freitas, played at Santa Clara for Cas. That connection got me a scholarship at Oregon. It was extremely intense recruiting. They said, 'OK, we'll take you.' I said, 'Where do I sign?'"

"Playing for Cas was unique," said Robinson, who would go on to fame as head coach at Southern Cal and with the Los Angeles Rams. "It was like playing for the pope, your father and a hard-driving guy all at once."

Robinson lettered only his senior year. His love for Casanova runs deep. Robinson's father had died during his freshman year. "I went into that next training camp with two broken ribs, and I was down," he said. "I came into Cas's office one day to quit. After we talked for awhile, he said, 'Come with me.' We got into his car and, without conversation, drove to his house. He introduced me to his wife and took me to his backyard. She fixed me lunch. He said, 'John, enjoy this lunch. I'll be back in a few hours.'"

The Ducks practiced without Robinson that afternoon. "There I was, at his house," Robinson said. "I'd had a great sandwich and looked at his swimming pool. He gave me time to think about things. I was so embarrassed, I never mentioned it again. He didn't do what he did because I was going to influence the future of the Oregon football team. It was him using his skills to keep a young person going. What would have happened if when I told him I was going to quit, he'd have said, 'OK'? He could have gotten a scholarship back. I might never have gotten into coaching or had the career I was lucky enough to have. It was one of those pivotal moves in a young man's life. He didn't let me jump off the cliff. I owe Cas an awful lot."

As with the Beavers the previous year, the Ducks entered the 1957 Civil War contest knowing they had the Rose Bowl clinched after beating Southern Cal 16–7 the previous Saturday. Oregon went into the game 7-2 and ranked 15th in the country. Oregon State was also 7-2. The Beavers had risen as high as seventh nationally after starting 4-0, but back-to-back road losses to UCLA and Washington dropped them out of the polls.

After the Ducks knocked off the Trojans at the Los Angeles Coliseum, an estimated 1,000 students greeted them as their chartered United Airlines plane landed in Eugene. A parade of cars escorted the team through the Eugene streets.

"I know the thing uppermost on your minds, and it should be," Casanova told the crowd at the airport. "But the game we want most is the one that

will give us the undisputed Pacific Coast Conference championship. So help us beat those Beavers next week."

"It's been my dream ever since I can remember to play in the Rose Bowl," said Jack Morris, the fullback/linebacker/placekicker. "But next Saturday means a whole lot. We'll really be playing reckless football to win that game."

Oregon State still had plenty on the line. The Beavers could become the first Northwest school to win or share back-to-back PCC championships. The Ducks were going for their first undisputed PCC title since 1919. It was the first time the state schools had ever played with the PCC crown on the line.

It figured to be a defensive battle. Oregon had given up only 77 points all season, best in the league.

Both coaches closed practice during the week. "This is the one we want to win," Casanova said. "Right from the start, we said we didn't want to back into any title or bowl invitation. We won the bowl date, and now we want to win the title."

"I believe our boys will be high enough, but whether they'll be able to match the Ducks' quickness is another matter," Prothro said. "Boy, they can really move."

It was a kinder, gentler period. Prothro and Casanova each spoke to his school's student section prior to the game, asking that the students conduct themselves in a proper manner. Homecoming queen Pearl Friel presented Casanova with a floral football in yellow with a red rose on top as a gesture of goodwill from the OSC student body.

Before a capacity crowd of 23,150 on a dry Hayward Field, Oregon State won 10–7 in a game televised regionally by NBC. Ted Searle's third-quarter 27-yard field goal provided the winning margin for the Beavers, who went without injured star Earnel Durden.

Each team scored on its first possession. Joe Francis—who carried 17 times for 76 yards—scored on a three-yard run to give Oregon State a 7–0 lead. Oregon came back with a 10-play drive, finishing it with a one-yard TD pass from Jack Crabtree—who was 13-for-17 passing for 104 yards—to Jim Shanley.

Searle came through with a left-footed three-pointer early in the third quarter, atoning for an earlier gaffe. After Oregon State's opening score, Searle had whiffed the ensuing kickoff. "We'd practiced all week that if we scored the first touchdown, we were going to onside kick," said Searle. "As I approached the ball, I looked up too quick and totally missed it. It was still sitting on the tee. That was embarrassing."

Joe Francis's memory of the play was slightly different. "Tommy had told us, 'If we score a touchdown, we're going to do an onside kick. We're going to recover the onside kick and score again. You guys believe me?'" Francis said. "Yeah, we believed him. Then Pump tried it and the ball went two, three inches. So [the Ducks] got the ball and went down and scored. We had thought we were going to run them out of Parker Stadium. Lo and behold, we won the game, but it was a tough one."

"When I made the field goal, it took the pressure off of me," said Searle, who suffered an ankle injury a few plays later and was out the rest of the game. "You're damn right, that felt good."

The Ducks came as close as a losing team can come to winning. Late in the game, the Beavers fumbled and Oregon's Ron Stover recovered at the OSC 19. The Ducks moved close to pay dirt. On third-and-goal from the two, Shanley got the call, skirting around left end. But as he was crossing the goal line, OSC linebacker Nub Beamer knocked the ball out of Shanley's hands and recovered the fumble at the Beavers' two.

"I was being partially blocked by one of their offensive linemen and just happened to get off the block," said Beamer, 78 and living in Winfield, British Columbia. "Shanley was within a yard of the goal line, and I happened to hit the ball out of his arms at just the right time. It was fluky more than anything. I just happened to hit his hands fairly hard, and the ball came right out."

Beamer, who gained 81 yards on 18 carries that day, then laughed, adding a postscript: "We go back a long way, Shanley and I. I went to Roseburg. We were in the same league as North Bend in high school, so we were rivals."

"Nothing against Nub, who was a hell of a player, but that was a terrible-looking tackle," Oregon's Norm Chapman said. "He had his head down, he stuck out his arm and happened to hit the ball and it came loose."

A rumor surfaced that night—and was printed in the *Oregonian* two days later—that a despondent Shanley had jumped off the 30th Street bridge in Eugene. "Fortunately, the rumor was unfounded," the newspaper account said.

But 57 years later, Shanley hasn't forgotten the play. "I still have bad memories of that game," he said. "As I was crossing the goal line, Nub was on the ground. He reached up and got ahold of my arm and pulled it down, and the ball came loose. He made a heck of an effort, I'll have to say that. But I've said for years, whenever that play would come up in conversation, it should have been a touchdown. I crossed the plane. But you have to remember, in those days there were only four officials. They couldn't see all the things that were happening."

Turns out it's a moot point. There was no "break-the-plane" rule in college football in those years. You had to get the ball into the end zone, either by stepping across the goal line or having the ball touch down in the end zone.

"Jim was one of my best friends," John Robinson said. "He was one of the greatest backs ever at Oregon. Had he been 6 feet and 200 pounds, he'd have been a 10-year, All-NFL type of player. He did fumble when we were driving to win that game, but…the dirty bastard Oregon State guy screwed us," he added with a laugh.

"What a fluke," Chapman said. "Jim was the toughest-minded player I ever saw. He was never a fumbler. He was going in for the touchdown to win the game."

"It was Jim's only fumble all year," Crabtree said. "Today, that would have been a touchdown. It's too bad. We thought we were the better team. I still think we were the better team. But they won."

"To have that happen was devastating, no question about it," Shanley said. "No matter what happened and how we feel about it now, the call was made and it stood up. I have never gone back and watched film of that game. Never had a desire."

Beating the team that was going to the Rose Bowl "was an added incentive for us," Beamer said. "We had a really good team—maybe better than the year before. It's unfortunate we couldn't go to a Rose Bowl again. To knock [the Ducks] off, regardless of how good a year you had, it was great. There was a lot of competitiveness between the two schools. The towns aren't that far apart. But there was never bad blood. I can't remember it ever being like that."

"We felt great about beating them," Searle said. "I knew a lot of their players well. It felt good to say, 'Hey, we beat those guys. We should have gone.'"

"At that moment, we really didn't care whether we went to the Rose Bowl," OSC's Denny Brundage said. "We'd just beaten Oregon. It was a good feeling."

Prothro wanted the recruiting edge a Civil War victory could provide. "We had to knock them out to help recruit kids to come to Oregon State," said Francis, who played four years with Green Bay in the NFL and then coached two years with Prothro at OSU in the early '60s. "It was pretty difficult to get guys to come to Corvallis. To be honest, during my years, we didn't have a lot of football players. We had a lot of guys who were pretty average. I put myself in that category, too. We played a different offense, and that made it tough for people to play us. Tommy was one of the best

strategists, and we had a lot of good kids with great attitudes. From where we started, the only direction we had to go was up. That made it easy."

After the game, Prothro got a ride off the field from his players. "Men, we're still Coast champions," he told them in the locker room. "That was one of the most bitterly fought games I've ever seen."

Casanova called it "my toughest loss. We are terrifically disappointed."

"It hurt," Chapman said. "Not only the fact you had your bubble burst, but it was the Beavers who did it. But we got over it quick. We were headed to Pasadena."

With plenty of negative press about backing into the Rose Bowl bid providing extra motivation, Oregon took Ohio State to the limit before losing 10–7. Crabtree was named Player of the Game, and Stover caught a Rose Bowl record 10 passes in the Ducks' first visit to Pasadena since 1920.

The Ducks dominated the Beavers in Corvallis in 1958, winning 20–0. The result was shocking on the surface. Oregon State entered the game 6-3, Oregon 3-5. But the Beavers had lost a lot of talent, including Francis. Durden missed the entire season with a knee injury. The Ducks would end the season with a 2–0 loss at Miami to finish 4-6, with four shutout losses— including a 6–0 road defeat to top-ranked Oklahoma, coached by Bud Wilkinson—and having yielded only 93 points all season.

"The most frustrating season I ever had," Casanova would say later. "Every time we would get into scoring position, we would fumble or get a penalty or an interception. We'd find some way to foul it up."

Some of the Beavers were puzzled at Prothro's approach to that game. "A lot of the seniors didn't play much," Beamer said. "I think I carried the ball four times. We weren't going to a bowl game, so maybe he was preparing some of the younger players in that game for the following year. There were a few of us who were really disappointed. We never said anything. Now it doesn't really matter, does it?"

The PCC broke up after the 1958 season, with the four California schools and Washington joining to form the Athletic Association of Western Universities (AAWU) and Oregon State, Oregon and Washington State going independent. John McKay left for USC, but Casanova had Jack Roche, Jerry Frei, Phil McHugh, Max Coley and John Robinson with him on his staff for his last seven seasons.

The 1959 Civil War produced one of the biggest upsets in the history of the series. Oregon entered the game 8-1, with its only loss 13–12 to Washington. "The most amazing Oregon team in memory," wrote

George Pasero, sports editor of the *Oregon Journal*. Going into the Civil War, the 15th-ranked Ducks were still mathematically alive for the Rose Bowl, needing to beat the Beavers and for Washington State to upset Washington. The Beavers, with a difficult schedule calling on them to make visits to Texas Tech, Nebraska and Michigan on successive Saturdays, were 2-7.

"This is the most unusual bunch I've ever coached," Casanova said before the Civil War. "They're all deadpans and you never know for sure just how they'll react. Most of the kids have nicknames, but if I were asked to give them some, I'd throw up my hands and call them all 'silent Sams.'"

Oregon entered the game as a 14-point favorite. Prothro had already locked up the first losing season of his long career as a player and coach. There was surprise all around when Oregon State won 15–7 despite not completing a pass. Sophomore tailback Don Kasso scored one touchdown on a 16-yard run and set up the other with a 27-yard scamper.

"I had one of my best games," Kasso said. "Prothro played me even after I fumbled twice, one allowing them to make their only score. I also threw an interception, yet Prothro kept me in there. I kept looking over my shoulder to see if he was going to bench me."

The game started with a 77-yard kickoff return by Oregon State's Ron Miller, but he fumbled at the end of the play and UO's Ted Wilcox recovered at the Oregon 22. The Ducks soon went ahead 7–0 on a five-yard pass from Cleveland Jones to Willie West. That was set up when Kasso fumbled on the Beavers' first play from scrimmage, recovered by Dave Grosz at the OSC 21.

Oregon never scored again. Kasso, breaking five tackles along the way, evened the score at 7–7 on a TD run from 16 yards out. "I just did a crazy move I didn't think they would expect," Kasso said. "Rather than breaking away from the group of tacklers, I broke into the group and rolled. I think they were taken aback a little bit, and weren't in position to make a clean tackle. I broke free and scored."

The Beavers failed on a two-point conversion attempt, but Amos Marsh kicked a 30-yard field goal to push them ahead 9–7 before halftime. Marsh, a standout fullback who played seven years in the NFL, had never attempted a field goal in a game and wasn't considered a kicker until the Wednesday before the game.

"Shows how lucky you can get," Prothro said. "I saw him kick one in practice, so I went over and had him kick another. He tried one just before the game and I decided to use him."

Oregon crossed midfield on its first possession of the third quarter and then then got only to the OSC 44—and never again in the game. In the fourth quarter, Marsh intercepted a Grosz pass for Dave Grayson and returned it 11 yards to the UO 33. On second down, Kasso went off tackle 27 yards to the UO four. "I cut against the grain and broke free, but Grayson—he could really move—caught me at the four and drove me out of bounds," Kasso said.

Three plays later, Jim Stinnette scored from the one to make it 15–7. Prothro had sent in a play, a keeper for Kasso. Instead, he called for a run by Stinnette. "Prothro chewed my ass when I got to the sidelines," Kasso said. "What it boiled down to, I didn't have the confidence, and I was fearful I might fumble. Jim got it over, thank goodness."

Washington had beaten Washington State, anyway, to clinch a Rose Bowl bid as the West Coast representative.

"The kids had a great season, far better than we anticipated," Casanova said. "They don't have great ability, but they have an 8-2 record."

Unlike his successor, Dee Andros, Prothro didn't think a Civil War victory could save a season. "I'm a season man," Prothro said. "I don't believe one game proves that much. It's awfully tasty, but it doesn't give us a better season."

Prothro took his 1962 team, led by Heisman Trophy winner Terry Baker, to the Liberty Bowl. His final team, in 1964, made it back to the Rose Bowl. Those who played for him in his latter years at Oregon State held a variety of feelings about their coach.

"Tommy was a brilliant coach and person," said Rich Brooks, who played for Prothro from 1960 to 1962 and later coached with him at UCLA. "He was the best fundamental football coach, the best-prepared coach, and he could come up with some of the greatest game plans that would give his team a chance to win against, a lot of times, superior talent."

"He was a genius," fullback Booker Washington said. "The first time I met him in his office, within five minutes we were out running pass routes. How pragmatic he was about taking the opportunity to work with you and do something that was productive. Tommy was like a second father to me. I trusted him. I never remember having a problem playing for him or following his direction. I could go to him if I had a problem and he was there for me. I admired what he did in terms of the way he ran his program. That's what drove me to want to be a coach."

Dick DeBisschop had met Prothro when he was a youngster serving as bellboy for the East-West Shrine Game in San Francisco. Prothro was coaching one of the teams. "I did it for several years," the center-linebacker

said. "I'd go into the locker room and listen to what the coaches would say at halftime. Tommy is the only one who ever kicked me out. He kicked out everybody who wasn't part of the team. He wanted to be in control of every situation—when you practiced, what you ate, when you ate, when you showed up. He had a bullhorn and he would blow it. Everything was on the numbers."

Prothro had a tower erected overlooking the practice field that would one day bear his name. "He stood up in that tower for almost the entire practice and watched it from up there," defensive end Thurman Bell recalled. "He used his voice, and you could hear him very clearly. I can still picture the tower. The offense would set up right in front of it. He was right on top of everybody.

"I remember one time, having my name posted on the board to report to his office at 8:30 the following morning. I didn't sleep the entire night. 'What'd I do wrong?' I was scared to death. I got in there, and they were going to have me change positions. That's the way it was. He struck a little fear. I can remember him saying at practice, 'Bell, do it again.' You didn't get close with him. But he knew the game and got the most out of his talent."

"Coach Prothro scared the hell out of me," safety/wingback Danny Espalin said. "He was a very stern, very disciplined individual. In the four years I was there, I don't think I ever saw him laugh. He was a student of the game. He knew what was going on at every position at every play, it seemed. Very intelligent, but I can't say he instilled a whole lot of confidence in guys like me. He scared me too damn much, and he wasn't much about patting them on the back. If you didn't screw up, you were doing your job, that's all."

Espalin got in trouble the spring after his junior season. "A few fisticuffs situations," he said. "I had a little chip on my shoulder." He also was two hours short of eligibility requirements to play the next season.

Prothro called him into his office to inform him he was no longer a member of the team. Said Espalin: "He said, 'Espalin, you're getting in a whole lot of trouble these days, and I'm tired of it. I've been awfully easy on you, and I take the blame, because I like you. But it has to stop.' He said if I wanted to play for him, I'd have to change my ways. I'd have to come back in the fall and win my scholarship and position back. He told me point-blank, I'd have to do it on my own."

Espalin took summer school at Harbor JC in Wilmington, California, arrived at August training camp, won back his scholarship and starting job and had a successful senior season.

Quarterback Paul Brothers, who started as a sophomore on the '64 Rose Bowl team, is another who said he was "scared to death" of Prothro. "But I had a huge amount of respect for the guy," Brothers said. "I admired his genius as far as offensive football and the way he handled his quarterbacks. He wasn't the easiest guy in the world to play for, but he knew exactly what he was talking about. I never questioned his authority or his direction. I was really upset when he left. I went to Oregon State to play for him. We had such a great year. I felt like we were going to have more the next two years. I understood why he left. He wanted to get back to his L.A. roots, but it was a blow to a young guy."

Fullback Pete Pifer, who played his sophomore season for Prothro in 1964 before finishing out his career under Andros, recalls the personal touch he received from Prothro. "Tommy would take me off on the side and try real hard to teach me how to block," Pifer said. "It was my weakest skill, and the essence of his offense was to do that. So he'd hold the blocking dummy and get me to try to improve my blocking skills. He was willing to work with anybody he thought should be worked with and do it one-on-one. He was the kind of coach you appreciate more after you had the experience. A great thinker and strategist, but it took a while to understand that. And he was not an Andros type of motivator. I remember him saying, 'Men, you only play 10 games a year. If you can't get yourself up for 10 games, nothing I can say will do it.'"

Kasso found Prothro to come across as "distant, cold, not overly friendly. We had no rapport, really. It was all business, nothing on a personal level. The only player he had rapport with was Terry Baker. They communicated and worked together very well."

"Tommy was aloof, certainly not close to most of his players," agreed Rich Brooks, who backed up Baker at quarterback after Prothro converted to the T formation in 1961. "He and Terry had a special relationship that none of the other players shared with him."

Baker was cognizant of that, even worried that his teammates might resent his unique relationship with their coach. He grew to know Prothro well. "Tommy and I had some similarities," Baker said. "I'm a little more private and not as gregarious or outgoing as a lot of other people. I'm comfortable with a small number of close friends, and Tommy was much the same way. He was an extremely intelligent guy, a great storyteller. He dealt with people at different levels—military people, businessmen. He played bridge at a near professional level. He'd talk about economics and public policy. He was very conservative politically and opinionated about it.

"As a coach, he was a stern father figure, but he cared about players. One year, a fraternity brother had invited me to go to his home in Kansas City and spend Christmas break with him and his family. I thought it would be fun and said yes. Tommy got word about it. He called me into his office, sat me down and said, 'I hear you are going to Kansas City for Christmas with a friend.' I said, 'Yeah.' He said, 'Well, you know the only person your mother has around anymore is you.' It kind of hit me. After we talked for a minute, I said, 'I get your point.' I told him I'd go home and spend Christmas with my mom, and I did."

Near the end of Prothro's life, when he was dying of cancer, Baker flew to Memphis for a roast. "A lot of his former players and coaches were there," Baker recalled. "I saw another side of the guy. He was very emotional that night. He was in tears. He might not have shown his emotions easily, but the relationships he had built were there."

Prothro left after the 1964 season to become head coach at UCLA. He stayed there six years, taking the Bruins to the Rose Bowl his first season and coaching another Heisman Trophy winner, quarterback Gary Beban. Prothro then went to the NFL, coaching the Los Angeles Rams for two seasons and the San Diego Chargers for five seasons. He spent three years as director of player personnel for the Cleveland Browns before retiring. Named to the College Football Hall of Fame, he died of cancer in 1995 at age 74.

Casanova would enjoy an upturn after the 1961 season, taking Oregon to a 6-3-1 record in 1962 and an 8-3 mark behind Bob Berry in 1963, beating Southern Methodist in the Sun Bowl. Perhaps Cas's best coaching job came in 1964. The Ducks, who had lost three-fourths of their "Firehouse Four" backfield of Bob Berry, Mel Renfro, Lu Bain and Larry Hill from the previous season, went 7-2-1. The losses were to Stanford (10–8) and to Oregon State (7–6).

"Smoke and mirrors, honest to God," Berry said. "We didn't have the same kind of personnel as the previous year, but we were ranked in the top 10. Guys like Ray Palm, Dennis Keller and Corkey Sullivan stepped up. Renfro could run faster backward than those guys, but they did a heck of a job."

The men who played for Casanova during his latter seasons at Oregon held the same affection as those who had played earlier in the coach's time there. "It was an incredible deal to play for Cas," said George Dames, a noseguard and linebacker from 1966 to 1968 who is writing a book on

Casanova's time at Oregon. "He was interested not only in the athlete but in seeing you go to college and staying there and finding some spiritual answer to life, be it Catholicism or Christianity. He was very concerned about those things in your life."

"He really cared about his players," Berry said. "They were his family. He was a coach but also a mentor and a father figure to most of the guys. He was a great man. I believe he could have run for governor."

"One thing I appreciated, Cas had great respect for all his players and treated us well," Renfro said. "You'd do your job and work hard, and during the off-season he'd come and check on you from time to time and see how you were doing. Cas and all of his coaches demanded a lot out of us but treated us with respect. I was never the type of player who liked coaches to scream at players, and these guys never did. I look back on all those experiences with fond memories. Cas was tough. He had great coaches and he let them do a lot of the coaching, but he was the guy in charge. Off the field, though, you could always talk to him about your issues and how you were doing."

"If he thought you were doing something wrong or your grades weren't real good, he'd call you in and give you a little lecture," end Ray Palm said.

"There was tremendous respect for Cas, almost to the point of being scary," said Doug Post, who played in the early '60s. "You didn't want to have to face Cas with some kind of issue—grades or off-the-field stuff. I was a little bit afraid of him. I didn't want to screw up in any way, shape or form, or I'd head back down the I-5 to Oroville."

"We were all scared of Cas, but in a good way," said Dick Winn, a fullback in 1964 and '65. "You didn't want Cas pissed at you. But he was what I'd call a players' coach. And he continued to care about his players after they left school. He got me my first job. It was truly a wonderful experience to play for Cas."

"Cas started the term 'the Oregon family,'" said Denny Schuler, who played under Casanova in 1966 and later coached at Oregon. "The people at Oregon still want to use that phrase, but it doesn't have the same meaning it did in those days. Cas looked after you and made sure you were going in the right direction. My father passed away the summer before I went to Oregon, from a heart attack at 55. Shortly after, I got the nicest letter from Cas. He had lost his first wife to cancer, and I remember the letter saying he had been there himself."

"When I was a freshman I was in the athletic department office," said Claxton Welch, a freshman during Casanova's last season. "Cas was

walking out and stopped to talk to me. He said, 'Claxton, you have a great smile. Have you ever thought about becoming a dentist?' I'll never forget that. That was Cas. He always had great expectations of the kids he recruited."

Casanova's last two years were losing seasons. Two months after the 1966 campaign, Casanova resigned and moved over to the athletic director job, which he held until retirement in 1970. He was voted into the National Football Foundation Hall of Fame in 1977 and died in 2002 at age 97.

TERRY BAKER, HEISMAN TROPHY WINNER

In December 2012, Terry Baker and his wife, Barbara, flew from Portland to New York City, where he was honored by the Downtown Athletic Club on the 50th anniversary of Baker winning the Heisman Trophy Award as the nation's top collegiate football player of 1962.

The Bakers spent five days in New York and attended the 78th Heisman Award presentation on a Saturday night at the Best Buy Theater in Times Square. During the week, they had time for some sightseeing—"museums, going out to eat, visiting the Ground Zero Memorial, which is a must-see," Baker said.

Monday night was the highlight for Baker—a black-tie, $600-a-plate banquet with past award winners sitting on the dais together. This was the event in which he was being honored. Baker delivered a speech, as did the 25th-anniversary winner, Tim Brown of Notre Dame, and the current recipient, Texas A&M quarterback John Manziel.

"I got to see some of the guys I hadn't seen for some time—Paul Hornung, for one—and was introduced to some of the guys I'd never met before," Baker said. "There were guys who came up and put their arms around me and thanked me for coming. I spent a lot of time with [former UCLA quarterback] Gary Beban—we had the connection of being coached by Tommy Prothro.

"I was lucky enough to be seated next to Tony Dorsett on one side and Earl Campbell on the other. Talk about nice, down-to-earth guys. That was a real pleasure."

The evening brought back memories of Baker's heroics for Oregon State on the football field a half century earlier.

"Time has gone by quickly," said Baker, 73, retired and living in Portland after a 40-year career practicing business law. "I was 21 when I received the Heisman. If you had told me I'd be back there to be honored 50 years later, I'd have bet you every dime I had that I wouldn't. Just to live to be this old is something."

Baker, the first Heisman winner from the West Coast, remains in select company. He is the only recipient from the Northwest. Only four other Pac-12 schools had a winner—Southern Cal (six) and Colorado, UCLA and Stanford (one apiece).

There's not much argument that Baker, a graduate of Portland's Jefferson High, is the greatest college football player ever from his part of the country. But he was just one of a bevy of players who met on the gridiron in the early 1960s who helped make the Civil War series of that era special.

Mel Renfro. Vern Burke. Bob Berry. Rich Brooks.

It was a time that deserves to be revisited.

All-America quarterback. Recipient of the Heisman Trophy and Maxwell Award, both given to the nation's top player. *Sports Illustrated*'s "Sportsman of the Year" Award winner. Ran 99 yards for the only score in a 6–0 Liberty Bowl victory over Villanova. Carried off the field by teammates after Oregon State's come-from-behind 20–17 victory over Oregon in the Civil War. No. 1 pick in the NFL draft by the Los Angeles Rams.

Could life get any better for Terry Baker during his senior year at Oregon State?

Well, yes.

Four days after flying back to Oregon from Philadelphia and the Liberty Bowl, Baker was on a plane headed for Lexington, Kentucky, with the OSU basketball team. Three days later, after playing his first two games of the season, he was named to the Kentucky Invitational all-tournament team. Three months hence, the 6-3, 195-pound Baker earned All-Coast honors after helping the Beavers to the NCAA Final Four.

Soon thereafter, Baker—just short of Phi Beta Kappa standards—was named as one of eight student-athletes nationwide to receive a post-graduate scholarship by the National Football Foundation and Hall of Fame. All of this was a continuation of a veritable Horatio Alger story for Baker, the product of a lower-income, single-family household in northeast Portland.

His mother, Laura Baker, raised three boys—Terry was the youngest—by herself. Laura, who never owned a car, took the bus to work, usually a checking job at grocery stores. She never saw her son play a game until he

was in college, primarily because she was always working late and had no transportation to and from the games.

Baker always took his studies seriously, but sports were his sanctuary. Football, basketball, baseball. Whatever was in season, that was his game. At Jefferson High, he earned nine letters—four in baseball, three in basketball and two in football. As a senior, Baker was first-team all-state in all three sports and led the Democrats to state titles in football and baseball.

An amazing sidelight: Baker, who considers himself a natural southpaw, threw the football with his left hand but was a right-handed pitcher in baseball. To him, the reason is simple. As a youngster, the family could afford only one baseball glove. Older brother Gary was right-handed. Baker got the hand-me-down glove when it was time for Gary to get a new one.

"I learned to throw the baseball right-handed by necessity," Baker said. "I'm not ambidextrous. I'm left-handed. I can only throw a baseball with my right hand. I can only throw a football with my left hand."

Still, Baker writes and eats left-handed. He bowls right-handed and kicks a football right-footed. He plays golf right-handed but swung from the left side in baseball.

Sounds ambidextrous, doesn't it?

Baker landed at Oregon State primarily to play basketball for Slats Gill. Tommy Prothro employed the run-oriented single-wing offense and at first questioned whether Baker was tough enough to play the tailback position in college. Then, after watching him play in a prep all-star game in 1959, Prothro changed his mind. But after choosing Oregon State, Baker's plan was to play basketball in the winter and baseball in the spring. He skipped freshman football in 1959 to focus on academics (he majored in engineering) and preparation for basketball.

"One of my childhood dreams was to play basketball in the Pacific Coast Conference," Baker said. "Whether it was at a California school or an Oregon school didn't matter."

During the fall, Prothro used Baker as a bellboy during home varsity games. "I worked the home side, and I'd be throwing footballs to the other side, and fans were yelling from the stands, 'Why aren't you playing football?'" Baker said.

Prothro was wondering that, too, after seeing the freshman Baker launching 50-yard passes from sideline to sideline as a bellboy. That spring, when rain had scrubbed a baseball practice, he lured Baker to a football meeting. Soon, he was a member of the team.

Baker divided time with senior Don Kasso at tailback during his sophomore season in 1960. Before long, many were calling them the greatest one-two punch in school history. Going into the season-ending Civil War game, they had combined for nearly 2,000 yards in total offense in nine games, though Kasso had missed three games due to injury. With Kasso out, Baker had accumulated 302 yards total offense in a 30–29 loss to Washington.

Kasso, a Berkeley, California native, was the star on a high school team that won the northern California championship his senior year. He had picked Oregon State from what he says were nearly 200 scholarship offers because of Prothro and his single-wing offense. "I ran, passed and punted and thought it would be the best place for me," Kasso said.

He was also familiar with Oregon, having spent time in the summers on his aunt's farm in Yamhill-Carton, working the combine or picking beans and strawberries. He even spent one term of school there when he was 12 or 13.

"My father was an alcoholic," he said. "My mom worked as a maid in homes. It just wasn't working out at home for me."

Kasso played Rook ball at OSU in 1958 and then became the starting tailback as a sophomore in 1959, leading the Beavers to a 15–7 upset of 15th-ranked Oregon in Eugene at season's end. By that time, he had learned of the growing legend of Terry Baker at Jefferson High. The summer before Kasso's sophomore year, Prothro asked him to talk to Baker about coming to Oregon State.

Baker participated in spring practice in 1960, leading up to Kasso's junior year. Kasso opened the season as the starting tailback that fall, and the two joined forces to help the Beavers, an 18-point underdog, score a 14–0 win over eighth-ranked Southern Cal at the L.A. Coliseum. Kasso scored the game's first touchdown on a 16-yard run, rushed for 87 yards and even intercepted a pass. Baker ran for 47 yards and threw for 59.

"I like Tommy's two tailbacks—Kasso and Baker," USC coach Johnny McKay said afterward. "They both have a fine future."

Baker and Kasso got along well from the get-go. "We would banter back and forth," said Kasso, who roomed with Baker on some road trips during their two seasons playing together. "We had a pretty good rapport. I called him 'Turkey,' because he had a turkey neck and a big Adam's apple. I'd dig him with that. I didn't have any animosity or concern about him taking over my job. I wanted to win. However we could do that, it didn't matter. Sure, I wanted to play, but you couldn't help but be impressed with Terry's play. He was a better ballplayer than me. I never

felt badly that he played more than I did. I respected Terry so much as an individual—not just for his athletic ability but as a nice guy, super humble, smart, cool."

Kasso was injured in the season's fourth game, at Indiana, and didn't play again until the seventh game, against Cal. By that time, "Terry was coming into his own," Kasso said. "He was a superior all-around player to me, with tremendous poise under pressure, something I didn't have. He was an outstanding runner and passer—by far a better passer than me. He could maneuver out of the pocket. He could feel the pressure and had good depth perception in determining where [opposing defenders] were. If he saw somebody was covered, he could go to the second receiver. As a passer, he didn't have the power you see in today's game. The quarterbacks burn them in there. Terry threw a soft ball, but he was accurate. He could put it right there."

Baker didn't disagree with Kasso's assessment of his passing prowess. Speaking primarily about his brief NFL career, Baker said, "I think I came 50 years too early. The game has evolved. The West Coast style used by so many teams today is more my style. I could throw the five-yard pass— probably still could—but I wasn't as good a drop-back passer as was required in those days."

He probably would have thrived in Chip Kelly's spread offense at Oregon, too. Baker could run every bit as well as he threw. "He was a hell of a runner," Kasso said, "and he was deceptive. He took really long strides, and if you misjudged him, he'd be hard to tackle. He had a sort of sense about where he needed to run. He was able to get away from people and find that open field. That was a really good skill."

In the open field, Baker often ran away from defenders, too. "I always thought I could run with Terry," said Dick DeBisschop, a center-linebacker who was in the same class at OSU as Baker. "But if somebody was chasing him, he'd be twice as fast."

"When he got with some space to run, he became faster than he was," agreed Bud Gibbs, an assistant coach on Prothro's staff from 1958 to 1960. "If you'd line him up to run the 100-yard dash, he wasn't fast. But give him an opening, he was fast. And he was a heck of an athlete."

Baker was also very much the student-athlete. His engineering schedule was rigorous, and he couldn't afford to miss any class time. "Terry had lab courses that made it impossible to get to practice every day," Gibbs said, "and we'd go ahead without him."

Oregon and Oregon State entered the 1960 Civil War game evenly matched. The 17th-ranked Ducks, who would go on to lose 41–12 to Penn State in the Liberty Bowl, went in 7-2, the Beavers 6-3. Both were ranked in the nation's top 10 in total offense—OSU fifth (345.9 yards per game) and Oregon eighth (341.4).

"This is the best team Oregon State has produced since Tommy Prothro came here," Oregon assistant coach Phil McHugh told the media before the game.

"We'll be going up against a club with as much speed as any we've faced all year," Oregon State assistant coach Bob Zelinka said of the Ducks. "Perhaps Iowa has just as much, and maybe Washington has, but I don't know that either is any more dangerous than Oregon."

Despite splitting time with Kasso, Baker entered the Civil War ranked second nationally in total offense behind Washington State's Mel Malin, 1,487 to 1,460—608 of it coming on the ground. Baker had already broken Joe Francis's school single-season mark of 1,082 in 1957 and Gene Morrow's single-season passing yardage record of 615 in 1949.

In his "Pasero Says" column for the *Oregon Journal*, George Pasero predicted a 14–13 Oregon win but added, "Ha, maybe it'll be a tie!"

Pasero was prescient. The game, played at Parker Stadium in Corvallis, ended in a 14–14 tie. It was anything but an offensive showcase. Oregon managed 238 yards total offense, OSC (it would become OSU the next year) 193 before a crowd of 27,009 in a day when reserved tickets cost $5, general admission $2.50.

Baker was a non-factor in his first Civil War appearance, gaining two net yards on four carries, completing one of six passes for 11 yards with two interceptions. Though he was zero for four passing, Kasso was more successful, rushing 20 times for 63 yards while scoring all of his team's points on two touchdowns and a two-point conversion.

"Prothro played me more than Terry that game. Why, I don't know," Kasso reflected modestly. "Perhaps the outcome would have been more favorable had he gone 100 percent with Terry."

Oregon quarterback Dave Grosz was seven for 18 passing for 89 yards and was intercepted three times. He ended up with minus-four yards rushing. UO's star halfback, Dave Grayson, gained only 43 yards on 14 carries.

The Ducks lost four fumbles in the first quarter, the latter setting up Kasso's one-yard TD dive. Kasso ran for the two-point conversion and an 8–0 lead. Joe Cieseri's 23-yard interception return of a Baker pass gave Oregon the ball at the OSC 20, setting up Grosz's one-yard TD run.

TheDucks failed on a two-point pass attempt, and after three quarters, the Beavers still led 8–6.

In the fourth quarter, baseball-player-turned-safety Grimm Mason intercepted a Grosz pass and returned it 16 yards to the UO 24. That set up Kasso's seven-yard TD for a 14–6 lead. But Amos Marsh missed the PAT attempt, effectively costing the Beavers a victory.

Oregon fought back. The Ducks were aided by personal foul penalties by Beavers Dick DeBisschop and Chuck Marshall as they moved from their own 29-yard line to pay dirt. Cleveland Jones—referred to in the newspapers as "the Midget Marvel"—threw a nine-yard TD pass to Paul Bauge with 5:48 remaining. It was Bauge's only reception of the season. Jones then scored on a double-reverse for the two-point conversion to tie the score at 14–14.

Oregon State responded, moving to the Oregon seven-yard line in the final minutes. But Tim Ankerson missed a 24-yard field goal attempt with 19 seconds left. Beaver coaches protested Oregon was offsides on the attempt, but to no avail, and the game ended in a tie.

Prothro said afterward he used Ankerson—who hadn't practiced much through the season due to a knee injury—because he was a better close-in kicker than Marsh. Neither was very good on that day.

Prothro made a wise decision in the off-season between the 1960 and '61 seasons. He chose to switch from a single-wing offense to the T formation or, as Prothro called it, the wing-T. There's no question part of the reason was to better take advantage of Baker's enormous talents. But there was another factor involved. The Pacific Coast Conference had broken up after the 1959 campaign, leaving Oregon, Oregon State, Washington State and Idaho as independents.

"The main reason I switched was the schedule," Prothro explained then. "When we were in the PCC, we had seven games automatically and had to get three. When the conference broke up, we had three games automatically—Oregon, Washington State and Idaho—and had to get seven. [Athletic director] Spec Keene would call up [athletic directors] and they'd say, 'We'd like to play you, but we don't want to play a single-wing team in the middle of the season.' Everybody else was playing the T formation and it would be a real disadvantage when they played us, and a real disadvantage the week after they played us."

Gibbs, considered Prothro's ace recruiter at the time, said he was the one who persuaded the head coach to make the change because the single wing had grown outdated.

"Tommy was going to have me in charge of the offense in 1961," Gibbs recalled. "I told him, 'You have to realize the star players, the kids coming up, they don't want to play in the single-wing offense. No pro team is going to use it again. If you're going to get a star quarterback, you're not going to get him to play single wing.' It got down to where no other schools were using it.

"I kept telling him, and he finally agreed. He had so much success with the unbalanced-line single wing, not only as a player but as a coach. It was a hard thing for him to do, but he made the transition. Tommy recognized Terry would be a good fit [for the T formation], but that was not the reason he changed. He knew to have a single-wing offense wasn't the thing for the future of the program."

Since assistant coaches made low salaries in those days and Gibbs and his wife, Anita, had three young children, Bud left the coaching staff after that season and moved into administration, eventually becoming the school's registrar. Gibbs wound up looking from the outside in, wondering how successful Baker would be in the new offense.

"You knew he was going to be a very good one," Gibbs said. "I can't say I knew he was going to be a Heisman Trophy winner."

Prothro, along with new coach Bob Gambold, who had replaced Gibbs, studied the T formation and installed it during the winter.

"Tommy had me stay in Corvallis over spring break to meet with the coaches and attend all the meetings," Baker recalled. "Some of the coaches resented it."

The Beavers had another new addition to the program for the 1961 season, though he wasn't in uniform. Vern Burke, a transfer from Bakersfield, California Junior College, had to sit out the year. But he played on the scout team, a star end in the waiting.

"What a terrific year that was," Burke said. "I had that entire season to watch Terry play and see what he was doing. The success Terry and I enjoyed later came from working together my redshirt year."

Baker had no receivers the likes of the 6-4, 205-pound Burke. "I was just waiting for Vern to get into the lineup," Baker said. "I had seen his ability to get open and his great hands. He didn't have blinding speed, but he was smart and knew how to get open."

The T formation wasn't an instant success at Oregon State. The Beavers started 1-4, including close losses at Wisconsin (23–20) and Arizona State (24–23). Prothro had moved Kasso, first to halfback and then to end, and Baker was getting all the snaps at quarterback.

Prothro called all the plays, either from the press box—where he coached some of the games—or the sidelines.

"The previous year, when we were using the single wing, Ankerson—the blocking back—would call the plays," DeBisschop said. "When we went to the T formation, Tommy called all the plays."

Baker didn't always use them, though. "I learned that year that Terry was always cool in the huddle," Kasso said. "He was poised, calm. I remember plays coming in from Prothro that Terry didn't think would work. He'd say, 'Screw that, we're going to run this.'"

"In the huddle, Terry was in charge," DeBisschop said. "Outside the huddle, he wasn't even the team captain. Coach Prothro never had quarterbacks be captains. He always wanted to have a lineman be the captain. [Guard] George Gnoss was the captain our senior year. All through the years, Coach Prothro would have no backs or receivers as captain. 'They get enough glory. I want a lineman,' he would say. That was one of his philosophies."

Fullback Booker Washington grew to appreciate Baker in much the same vein as did Kasso. "It wasn't so much that Terry had a leadership role," Washington said. "But he exhibited cool under pressure, which always seemed to bring out the best of his talents. When everybody else was shaky or not sure of themselves, he was like a rock. You knew all you had to worry about was what you had to do. He never seemed to get rattled, to rush himself. He was consistent with what he did. And he gave 100 percent on every play."

In one of Washington's classes, he was asked to do an extemporaneous speech. "I tried to describe why Terry was such a great player," he said. "He wasn't fast, or at least didn't have great speed, but he was one of the greatest broken-field runners I've ever seen. He was brilliant. He thought on his feet and was the embodiment of Prothro's offensive plan. He could run right or left. We were trained to block a certain way and run certain plays to favor his strengths. I couldn't have been more impressed with him, for both his athletic talents and the way he was as a person."

"Terry was phenomenal," said Thurman Bell, a freshman during Baker's senior season. "From the hips down, he had the best body for an athlete I've ever seen. The guy was strong and could move. He was never in the weight room. He never muscled up like they do now. He was pretty lean, but he could run, he could glide. He was a lot faster in the open field."

DeBisschop, 6-1 and 210, always considered himself more a linebacker than center. Kasso, who had played with DeBisschop in a high school all-star game in Los Angeles after their senior seasons, felt that way, too. "If

Dick tackled you in practice, there was a good chance the pain would stay with you awhile," Kasso said. "He could hit like a truck, and he wasn't that big. He reminded me of a cat, moving ever so quickly and smoothly. Both he and [defensive back] Rich Brooks, their timing in making tackles was outstanding. They did not miss many."

Kasso had helped influence DeBisschop to choose Oregon State over Oregon and San Jose State. DeBisschop was a three-year starter for the Beavers, going both ways until his senior year, when single-platoon football was installed in the college game. He wound up being the player who snapped the ball to Baker in the two seasons the Beavers used the T formation.

"I'm left-handed and Terry is left-handed," DeBisschop said. "He enjoyed my snap better than anybody else."

Baker and DeBisschop were fellow members of Phi Delta Theta fraternity. They became good friends. "Terry wasn't real vocal," DeBisschop said. "Nobody on our team was that way. Terry was straight-laced. You knew you weren't going to have him get caught with beer or cause any problems. He was strictly business. Because he was an engineering student, he had to spend time on the books. He was so brilliant. One time he came into the house reading this book. I said, 'What are you reading?' He said, "I'm taking a literature class.' He read it in an hour, took the test and got an A. He's the kind of guy, you told him something one time, he'd remember it."

Understandably, Baker became a personal favorite of Prothro, who gave him special treatment. "Coach Prothro would never put Terry in a position where he'd have to say, 'Terry, you did this wrong,'" DeBisschop said. "Terry rarely did anything wrong, but Coach Prothro wouldn't put him in a position where he'd have to call him on something. Terry never had a film session with the rest of us. He did it with Coach Prothro alone."

Baker became a de facto coach his final two football seasons. "Coach Prothro would have me over to his house frequently for meetings, to talk about a game plan and what we were trying to do," Baker said. "On road trips, he would sit with me on the plane all the way back on the return flight and talk to me. He would run me down all over campus. I remember one time I was visiting at a friend's apartment. There's a knock on the door, and it's Tommy. He says, 'I'm looking for Terry Baker. Is he here?' There were times he took my mother and me out to dinner in Portland. After my NFL career, when I became a lawyer and he was with the [San Diego] Chargers, he had me do some legal work for him. And when I got into the GTE Hall of Fame, he flew out for the induction. We had a unique relationship."

Baker had a good relationship, too, with his understudy, Rich Brooks, who would go on to serve seven years as an assistant coach at his alma mater before an 18-year tenure as head coach at Oregon. Rich's wife, Karen, cut Baker's hair during their college years. "It didn't take much," Brooks said with a chuckle.

Once he saw Baker's talents, Brooks was glad he was skilled enough to start at defensive back. "I wasn't going to start at quarterback," Brooks said. "Terry was so talented, just a guy who could make things happen. His greatest strength was he never panicked. He was able to slow down the game in his mind and execute and use his athletic ability to make plays. He made play after play after play."

When the Civil War game came around in 1961, Baker would meet up with an old friend. Oregon's standout sophomore halfback was Mel Renfro, who had joined forces with Baker to lead Jefferson High to undefeated seasons and state championships in 1957 and '58, Renfro a year behind Baker in school.

"Mel was a tremendous teammate and just a fantastic overall player," Baker recalled of their years with the Democrats. "What a backfield we had with Mel, his brother Raye and Mickey Hergert. I probably never would have had to pass the ball. A totally unselfish bunch of guys. All they cared about was having fun and winning."

Baker called the plays on his high school team. "I tried to be democratic," he said. "We divided it up. I couldn't just give the ball to Mel every play. Raye and Mickey got it some of the time. Everything we did worked. As a team, we averaged eight yards a carry. Why not spread it around?"

Renfro, though, was Baker's chief running mate. "Mel could do anything," Baker remembered. "He played varsity football as a sophomore, which was very unusual at Jeff in those days. He played quarterback as a senior after I left. I saw him play baseball a couple of times. He hit the ball like he would have been a major-league talent. He was the best track-and-field athlete in the state. The only thing he didn't really work at or excel at was basketball.

"Mel was a gentle, classy guy to be around. He never raised his voice. He was the type of guy who would do anything you asked him to do at practice. If I wanted him to run five deep pass patterns while I was trying to get the timing, he wouldn't bat an eye, he'd do it. That's the way he was."

Baker and Renfro met even before their high school years. "We used to play ball at Peninsula Park when I was in seventh or eighth grade," Renfro said. "Terry was either at Jeff or going to be at Jeff, and I had

three older brothers already at Jeff. We'd throw the football around or play basketball. We didn't buddy-buddy around, but we had a great relationship right from the start.

"Terry was a phenomenal athlete, the best I ever saw at the high school level. He was so versatile. He could do anything. He played all sports. We played ball and had so much fun. My three years playing varsity football at Jeff, I only lost one game. That was the last one I played in—the 1959 state championship game, when we lost to Medford 7–6."

Baker and Renfro very nearly played together in college. Renfro had fully intended to become a Beaver. "I was headed to Oregon State," Renfro said. "I was recruited by Amos Marsh and the Beavers, and I really liked their program."

Oregon football coach Len Casanova and track coach Bill Bowerman had made an impression on Renfro's parents, though. "I'm not sure exactly what happened," Renfro said. "I do know I saw Cas at my front door that summer, and Bowerman had made a pitch to my folks. Two weeks before I was getting ready to report to Corvallis, my dad sat me down and said, 'Melvin, you're going to Oregon.' I said, 'Oh?' He said, 'You're going to Oregon.' And that was that. I liked Oregon and the coaches there, but I felt a strong pull because Terry was down at Oregon State and I wanted to follow him. But I was the type of kid who was going to do what my parents wanted me to do. I would have loved to have played with Terry. I was headed to Oregon State. My parents changed that part of history. But I have no regrets."

Oregon State coaches always felt the Ducks had paid off Renfro's parents for his services. "If they did, it was very well hidden," Renfro said. "I do know that about that time, my dad bought himself a new car. At the time, not one iota did I think anything like that. I have to admit, I wonder now. I didn't think about that until after my pro days. My dad never said anything about it. If they fooled me on that, I have to give it to them."

Today, Baker chuckles at the lost opportunity. "It's too bad we didn't get him at Oregon State," he said.

Renfro was an immediate star at Oregon in his first year on the varsity as a sophomore in 1961, entering the Civil War game that season averaging 7.2 yards per carry. Asked about Renfro's specialty, Prothro said, "His specialty is just about everything. He can run outside, run inside, catch passes and throw passes. You can't get much better than that."

"Mel was the best athlete I ever played with, by far," said Doug Post, the starting quarterback during Renfro's sophomore campaign. "He could do

anything. He could play offense, defense, return punts and kicks, throw the ball on the halfback pass. We should have had the ball in his hands about three of every four plays."

"Renfro was unbelievable," said DeBisschop, who spent much of two Civil War afternoons chasing him. "He was so fast and could do things nobody else could do. I remember tackling Renfro by his toes in one game. He was hell on cleats."

Neither team was overly successful that season. Oregon State went into the game with a 4-4 record, destined to finish 5-5 after a season-ending loss at Houston the following Saturday. Oregon was 4-5 but fielded a strong defense that ranked fourth nationally in pass defense, allowing only 62.8 yards per game.

Four inches of snow fell in Eugene on Friday. It was cold and wet the next day as a capacity Hayward Field crowd of 21,300 turned out to watch Oregon State win 6–2. The Beavers had the edge in total offense 275–206, but nobody had a big day. Renfro gained 67 yards on 24 carries. Baker ran seven times for 21 yards and completed four of seven passes for 107 yards, including a pair of 39-yard strikes to Leroy Whittle and Bill Monk.

The only touchdown came in the second quarter after OSU's Roger Johnson recovered a fumble on a pitch play to Renfro at the Oregon 16. "We called a 19 sweep," Post recalled. "The snap was a little late. I turned to pitch and was thinking I had to lead Mel. I pitched it to where I thought he was going to be, having left early. He wasn't there. The pitch hit the ground, and [the Beavers] recovered."

Baker hit Johnson for a 14-yard pass to set up Tom Gates's two-yard touchdown run, but Ankerson missed the PAT. Ankerson—his Civil War memories can't be fond—also missed a 25-yard second-quarter field goal. Baker hit Herb Washburn for a 26-yard TD that was negated when officials ruled the junior quarterback had crossed the line of scrimmage before throwing.

In the third quarter, with OSU in punt formation at its 14-yard line, John Farrell's snap sailed over Kasso's head and out of the end zone for a safety. After a free kick, Oregon drove deep into Beaver territory. The Ducks had first-and-goal at the OSU five with a chance to take the lead.

Three times, Post pitched the ball to Renfro on a sweep right, picking up a collective four yards. "The thinking was, we'll take our best back against their best defensive linemen," Post said.

That led to Renfro being stopped on fourth-and-goal at the one, a play that will live in Renfro's memory forever. "Everybody and their mother knew who was going to get the ball on that play," Renfro said. "They jammed up

that hole. I went up in the air and couldn't get there. Unfortunate, but it happened."

Oregon State had been well prepared for the situation. "We had eight game films of the Ducks and spent a lot of time looking at them throughout the season," OSU assistant coach Ron Siegrist said. "We knew exactly what they were going to do and at what time. In short-yardage situations, Renfro would always get the ball from the quarterback and dive over right tackle. Any time they got in that position, we'd have our linebacker get to that spot and dive at him. Every time they ran it on that series, we were ready for him."

Oregon's last gasp took the Ducks to the OSU 37 before Monk's interception at the 30 ended the threat. "We had Steve Barnett and Ron Snidow on a good offensive line," Post said. "The Beavers had a great defensive team, though, with guys like Neil Plumley. They just beat us at the line of scrimmage that day, and we couldn't score."

Afterward, Prothro jokingly complained how many towels were ruined keeping Baker's hands dry on a wet day. "We cut 'em up into thirds and sent one piece in before each offensive play," the OSU coach said. "Baker would use the rag to wipe his hands so he'd be able to handle the ball. I began to worry late in the game because our supply was running low."

Casanova lamented not being able to score on the drive that took the Ducks near the goal line in the third quarter. "Any time you can't score from the five with four downs to go, there has to be a mistake somewhere," he said. "This finishes the most frustrating season I've ever endured. Whenever a team has to rely on a lot of sophomores like we have, you are bound to make mistakes. When you make them against a foe as strong as Oregon State, then you are dead."

Things had changed dramatically at both schools as the 1962 season unfolded. In Corvallis, the "B&B Boys" were unveiled. Burke was eligible to participate and quickly became Baker's favorite target and the nation's top receiver. In his debut in a 39–35 win over Iowa State, Burke caught 12 passes and scored three touchdowns. He ended the 10-game season with 69 receptions for 1,007 yards, both NCAA single-season records.

Baker more than did his part, throwing for 1,738 yards, running for another 538 and shattering the NCAA single-season total offense record by more than 300 yards on his way to being named the top college player in the land.

In Eugene, a new sheriff had arrived in town. Casanova had won a recruiting battle with the likes of Southern Cal, California, Washington and

Washington State for the services of quarterback Bob Berry out of San Jose. Berry's father, also named Bob Berry, was a high school coach who knew Cas from his days coaching at nearby Santa Clara.

"My dad really respected him," Berry said. "During the recruiting process, he told me, 'Do me one favor. Go look at Oregon and check out Len Casanova.' The best advice he ever gave me."

After quarterbacking the Frosh team in 1960, Berry was not in school for the 1961–62 academic year. "Took the year off and went surfing in Hawaii," he said, perhaps figuratively. "Got in a little trouble and they asked me to leave. Went to a JC for a semester and worked a little bit."

When Berry returned, "you can't automatically get your job back," he said. "You have to win it back."

But Post tore up a knee during training camp and redshirted, leaving Berry as the guy. Post and Berry became best friends. "Bob was a great player and a good leader," Post said. "He wasn't very big or terribly athletic, but he was hard-nosed, a competitor and a tough guy."

Smart, too. Casanova and backfield coach Max Coley let Berry make decisions on his own during his three years running the Oregon offense. "My whole career there, I was lucky enough to call my own plays," Berry said. "Cas and Max gave me free rein. We had meetings all the time and were on the same page. Once I got in the game, they backed me up."

Dave Wilcox, like Renfro destined for a spot in the NFL Hall of Fame, took immediately to Berry. "You talk about a leader and a guy who knew exactly what to do," said Wilcox, who joined the Ducks from Boise Junior College in 1962. "He was probably 5-10 and maybe 175 pounds. But he could throw the ball, knew where to throw it and knew what was going on out there. In the huddle, he knew what everybody was supposed to do. People listened to him and trusted him."

Berry developed an immediate appreciation for Renfro. "When John Robinson and Phil McHugh were recruiting me, they said, 'Come to Oregon. We have the best running back you've ever seen,'" Berry said. "I said, 'Come on.' But you know what? They were right. Mel is the best athlete I've seen in my life. He could do it all. He was one of my big passing targets. I used to ask him when we'd watch film of an opponent, 'Do you see something in the defense? What can you do against that halfback?' He'd tell me, 'Anything you want,' and it was pretty much true. He was our best receiver, best running back, best defensive back, best return guy. He probably would have been our best quarterback. He was fantastic."

Renfro's junior season was his most successful at Oregon, primarily because he stayed relatively healthy. In 10 games, he rushed for a then-school-record 753 yards, completed five of 12 passes for 114 yards and two touchdowns, caught 16 passes for 298 yards, intercepted two passes for 67 yards, returned six punts for 42 yards and returned 10 kickoffs for 244 yards. His 13 total TDs set another school mark.

Renfro had perhaps his best game that season in a 31–12 win over Rice at Houston, the city in which he was born before moving to Portland. In those years, African Americans weren't normally allowed to play at Rice's stadium or even to watch the Owls' games.

"They made an exception because of me," said Renfro, who rushed 13 times for 141 yards, caught two passes for 27 yards and returned an interception 65 yards. "They cordoned off an area around the 30-yard line where they let 20 of my relatives attend the game. They were the only black spectators in the place."

One of Renfro's new teammates was Wilcox, a swashbuckling farm boy from Vale in eastern Oregon who had spent his first two college years at Boise. Wilcox was one of eight children—seven boys and a girl—of parents who had moved west from Oklahoma and homesteaded a place in Willow Creek, 10 minutes outside of Vale.

"When I was little," Wilcox said, "all I wanted to do was play football for Vale High and beat the crap out of people." Wilcox led Vale to the state 1A title in 1959, the same year Renfro's Jefferson Democrats were losing to Medford for the 3A state crown.

Two of the Wilcox boys, Jerry and William, attended Oregon State but didn't play football. Dave and his older brother, John, played at Oregon, and both wound up in the NFL, with John spending four seasons in Philadelphia.

There were 11 kids in the neighboring Schaffeld household in Vale. One of them, Joe, played with John at Oregon and coached for the Ducks from 1974 to 1997, spanning the eras of Don Read, Rich Brooks and Mike Bellotti.

Dave Wilcox had several big-time scholarship opportunities out of Boise JC, including USC and Washington, but wanted to stay close to home. Oregon State's Prothro and Oregon's Casanova both paid visits to the Wilcox household in Vale. "My parents liked Tommy, but Tommy smoked cigarettes in our house," Wilcox recalled. "Cas smoked, too, but he went outside and smoked. Oregon State's program was better than the Ducks' at the time, but my brother having gone to Oregon and Cas was the difference. My coach at Boise, Lyle Smith, had been in the navy with Cas, too."

The 6-3, 225-pound Wilcox's forte was defensive end, but he also played end on offense as a junior at Oregon and then guard as a senior. "But defense is what I really liked," he said.

Wilcox was a tight end at Boise, but when asked to switch to offensive guard, "the guy never said a word," Berry recalled. "He had to learn a whole new position. He was one of the best guards in the country, but he made his reputation on defense.

"Dave was an easy-going cowboy, but he had that mean streak in him. I played against him for 10 years in the NFL. I have a picture of him strangling me in Candlestick Park when I was with Atlanta. He hogtied me around the neck. I'm glad I lived to talk about it."

Oregon entered the 1962 Civil War 6-2-1, Oregon State 7-2 with a postseason spot on the line. Casanova later called the '62 Ducks "probably the best team I had" during his 16 years at the school. The Ducks were offered a Bluebonnet Bowl bid if they could beat the Beavers, who were being looked at by officials representing the Sun, Gator and Liberty Bowls.

"The Ducks are the best team we'll have faced all year," OSU assistant coach Bob Zelinka said prior to the game. It was a duel between Oregon State's pass offense and Oregon's pass defense, which had allowed opponents to complete just 69 of 181 attempts, with 18 interceptions.

"That week, Coach Prothro congratulated me on setting my records," Burke recalled. "Then he said, 'Vern, we're not going to throw you the ball this game.' His strategy was, Oregon's defense was going to be structured to stop the pass, so we were going to use me as a decoy. That's what we did. I was disappointed, of course, but Tommy was a great strategist. I played hard in that game, just like I always did. I just didn't catch the ball."

Burke actually caught three passes for 20 yards, including one for a three-yard touchdown. And the junior end drew an important pass-interference call on Renfro in 18th-ranked Oregon State's come-from-behind 20–17 victory. The game was played on a day when winds on the Oregon coast hit 95 miles per hour, just two weeks after the Columbus Day storm had ravaged the Northwest. It was windy and rained mostly in the first half as a Parker Stadium record crowd of 28,447 looked on.

Neither offense had a big day. Baker carried 17 times for a net-27 yards and completed eight of 17 passes for a season-low 90 yards, though two of the completions went for scores.

"They ran the option a lot, and I'd play against the option at Boise," Wilcox said. "I made a couple of tackles on Terry and made him pitch. They didn't gain many yards there that day."

Oregon finished with only seven first downs and 225 yards total offense and had three turnovers. Renfro gained 75 yards on 17 rushing attempts and caught a 50-yard touchdown pass from Berry, who threw only eight times, completing four for 131 yards. Berry ran for the other Oregon TD, and Buck Corey kicked a 38-yard field goal to send the Ducks into halftime with a 17-6 advantage.

Casanova hadn't told his players before the game about needing to win to gain a Bluebonnet Bowl bid "because I wasn't sure how they would react. They were emotional enough about playing the Beavers."

Wanting to make sure there was no letdown, the veteran coach told the players about it at halftime. "There was no reaction," Casanova said later. "They were a funny team that way."

Oregon got past midfield in the second half only once, and that was to the OSU 48. Oregon State, meanwhile, scored on its first possession of the third quarter, a 36-yard pass-interference penalty against Renfro on Burke setting up the Beavers at the UO 25. Several plays later, Bruce Williams slammed over from the one-yard line to draw OSU within 17-12.

On their next offensive series, the Beavers moved to the UO four-yard line. The Ducks held, though, Bill Swain swatting away a Baker pass in the end zone on fourth-and-goal from the four. After an Oregon punt, Baker ran 17 yards to the UO 18 as the third quarter ended. On the next three plays, Baker was tackled for losses totaling 16 yards. On fourth-and-26 from the UO 34, Brooks went back to punt.

"Terry was the long-field punter, I was the short-field punter," said Brooks, Baker's backup at quarterback and a starting defensive back that season.

Brooks's squib kick was muffed by Renfro and recovered by Oregon State's Dick Ruhl at the UO 13. "I was indecisive on the play, and it cost me," Renfro recalled. "I first planned to catch and run, but the wind was pretty strong and the ball seemed to wobble. I let it go, and it took a weird bounce and hit my leg. Before I could make another move, [Ruhl] fell on it."

Wilcox, who says he blocked eight or nine punts during his two seasons with Boise JC, recalls nearly blocking Brooks's attempt, getting his fingers on it and tipping the ball as it left Brooks's foot. Perhaps that's why it took the odd bounce that ultimately cost the Ducks the game.

The day was about to get worse for Renfro. Wilcox twice tackled Baker for no gain. On third down, the southpaw signal-caller threw an incomplete pass for Burke.

Then Danny Espalin made one of the biggest plays in Civil War history. The 5-7, 165-pound sophomore from Los Angeles wound up at Oregon State as a fluke. He wasn't even sure he would attend college until he played in the California state all-star game that summer. OSU assistant coach Ron Siegrist was at the game, recruiting a couple of Espalin's teammates.

"I happened to be sitting in the locker room after the game when he was talking to them," Espalin said. "We struck up a conversation, and he asked if he could meet my parents. As soon as my dad found out I had a chance to go to college, he said, 'You're going to Oregon State.'"

Espalin wound up playing outfield for the OSU baseball team and started three years at safety and was a punt return specialist in football. But it was on the other side of the ball that he made his mark during the '62 Civil War game.

With the Beavers facing fourth-and-goal from the 13, Espalin sought out Baker in the huddle. "On the previous drive, Terry was throwing just about every play to Burke," Espalin said. "My responsibility as left halfback was to block and seal the end. Every time he called a play to Burke, I'd go to seal the end, but the linebacker and end were dropping off to cover the deep hook zone. That was the favorite play of Terry and Vern. I told Terry, 'Every time you call that hook, there's nobody covering in the flat. Give me a look.'"

Baker listened but wasn't sure it was a good idea. "Of all the plays I called that season, no other player had ever suggested a play," Baker said. "Espalin says, 'Let's try this.' We had used the play successfully against Oregon the year before with Leroy Whittle, but it wasn't even in our playbook [in 1962]."

Baker called the play. He was to roll right and look right at Burke, who was running the deep hook pattern, setting up Espalin for what amounted to a screen pass left. "The idea was the defense would rotate with me to that side and Danny would flood into the left flat," Baker said.

The safety in coverage—Renfro—bit on the guise. As Baker rolled right, "Mel moved in that direction," he said. "Danny slipped out the left side, and I threw it against the grain. Bam! It connected, it's a touchdown. Once I flicked it to Danny, I'm watching Mel. He drops his hands like, 'I've been had.'"

Said Renfro: "I got fooled on the play. I had studied films on them and thought I knew what was coming, but I got caught in the wrong position."

"In our system we didn't even have a screen pass," Baker said. "It was always long-yardage passing. We were lucky to be able to swing it."

Baker hit Williams for a two-point conversion and a 20–17 lead with 11:24 remaining. With two minutes left, Berry was hit while trying to pass, and

Ross Cariaga recovered at the UO 17. The game ended with the Beavers on the Ducks' nine.

"The blame for that loss was squarely on my shoulders," Renfro said. "That was very disappointing. It stayed with me for a long time."

"We felt like we were the better team," Berry said. "But that day, [the Beavers] were the better team. I played in three Super Bowl games and lost every one. You gotta play good that day."

Baker, said Berry, "was the guy who won that game. He was a great athlete. I really respected him. Oregon State was tough and had a great coach in Tommy Prothro."

After the game, several players hoisted Prothro to their shoulders and gave him a ride off the field. Other players lifted Baker and carried him off the field, too.

"In all my years of football," Prothro was later quoted as saying, "I've never seen the players do that to one of their teammates."

"It was such a surprise," Baker said. "Hell, I'm no different than those guys. It was touching to know they felt that way. I figured a lot of my teammates thought I was a prima donna because I got such favorite treatment from the coaches."

Baker was beloved by his teammates, who figured he deserved special treatment. And soon, he was to become the West Coast's first Heisman Trophy winner, with the help of an innovative campaign by sports information director John Eggers.

Players in the West had historically been handicapped by the three-hour time zone difference from the East, where the majority of the Heisman voters resided. Results of West Coast games sometimes didn't make the Sunday papers in the East, so deserving candidates had often been overlooked. Long before the days of the Internet, Eggers decided to be proactive in getting Baker's weekly game heroics some notice throughout the country.

"John did it two ways," said the late Bob Swan, a close friend of Eggers who later became deputy sports editor of the *Oregonian* and enjoyed a long career as a journalist. "He knew who the voters were and sent them postcards on Mondays with Baker's stats along with quotes from the opposing coaches and players. And on Sunday mornings, he hustled out before sun-up to Western Union at the old Corvallis Hotel to send out telegraph updates on Baker's games the day before. We called them 'Terrygrams.' Prothro was a clever guy. He had some contacts back East that helped Terry, too."

Oregon State advanced to the Liberty Bowl, where Baker made his college finale an unforgettable one. On a frigid, icy day in Philadelphia, Baker got

loose for the most famous run in school history, going 99-plus yards for the game's only score in a 6–0 victory over Villanova.

With Baker gone to the NFL, Oregon got revenge in the 1963 Civil War game, winning 31–14 at Eugene. And the Ducks did it without the services of Renfro.

The game was postponed a week because of President Kennedy's assassination. Visiting with friends the night before the rescheduled game, Renfro severely injured a hand. "I was really frustrated and upset about a few things…the assassination and over a problem in my marriage," he said. "We sat around drinking more beer than we should have. I did something stupid. I got angry and smashed my fist into the bathroom mirror. I cut a nerve, and it bled pretty bad. I almost died that night. I'm sitting there bleeding to death."

Renfro had the injury stabilized and the hand sewn up at a hospital emergency room. He was unable to play in the game the next day, though. "Not only was it very disappointing not to play my last game at Oregon, it was a Civil War game," Renfro said. "I wasn't able to play in any of the postseason all-star games afterward, either. That was frustrating. I'd have played in all of them. I played in the college all-star game the next summer but missed the Hula Bowl and the East-West Shrine game."

Renfro wasn't missed. Berry passed for a school-record 274 yards and two TDs for the Ducks, who led 31–0 at one point and breezed to their first win in five years in the series. "We just rallied around," Berry said. "It was, 'Let's win this game not for Mel, but for us.' That was a good Oregon State team, but Oregon hadn't beaten them for awhile. We had their number that day."

"Berry cut the Beavers to ribbons," Wilcox said. "They had a special defense for us; Bob would audible a lot. It was a pretty good day for Oregon."

Afterward, OSU quarterback Gordon Queen—who had the unenviable task of succeeding a Heisman Trophy winner—was asked what he was going to do. "Commit hari kari, I guess," Queen quipped.

"They beat our butts that year," said Burke, who caught six passes for 79 yards. "It was really disappointing to end my college career on that game. It wasn't much of a contest. They dominated."

Berry, said former teammate Ray Palm, "was one of the toughest guys I've been around. He wasn't the greatest passer in the world, but he got the ball to you somehow. He was fun to play with."

Mike Brundage was a sophomore understudy during Berry's senior season. "We were good friends," Brundage said. "He was an excellent leader, the kind of guy who just somehow made everything happen. He didn't throw a pretty pass, but it always got there. He was a good runner and he was tough. I learned a lot from him. The coaches wanted me to do some things he did, but it wasn't natural. He had a quick release. I had a windup and tried to change, but it just didn't come naturally."

Palm led Oregon receivers that day with six catches for 50 yards. He wishes Renfro would have had an opportunity to finish out his career with the Ducks that day. "I was just a little sophomore; he was an All-American," Palm said. "Mel was a very quiet guy, not a guy you really got to know. But he was one of the greatest players ever—probably the best athlete I've seen in my life. What a graceful runner, and with all that speed."

Oregon State finished at 5-5 despite Queen leading the nation in passing yardage and Burke earning first-team All-America honors. The Ducks went on to beat a Southern Methodist team that finished with a 4-7 record by a 21–14 count in the Sun Bowl, their first bowl victory since the 1917 Rose Bowl.

For the central figures, the Civil War rivalry was intense in the early '60s but nothing bitter.

"There were a bunch of guys on the Oregon team I had played high school against," said Baker, now retired and living in Portland. "I'm not the most emotional guy when it comes to those things. I pretty much took them one game at a time. Back then, the Civil War was the big game and the culmination of the season, but it was more of a local thing— more bragging rights in the state. Today, it almost always has bowl and national significance. It's a bigger thing today than it was then, except to the people involved. Oregon was a big game, but the biggest? I don't know about that. Washington was always a big game. Tommy did a good job of controlling the [players'] emotions on things like that."

"Berry and Renfro, those guys were outstanding," said Burke, 73 and living in Ladera Ranch, California. "I really enjoyed playing against the Ducks, especially Wilcox. Dave and I played together in the Hula Bowl, and he was the game's outstanding player. He and I were roommates with the 49ers for a couple of years. He turned out to be one of the best linebackers in NFL history.

"Since I was from Bakersfield, California, the USC game was always the biggest game for me. The Ducks were second. Respect was all I had for them.

I think it was the fans who stoked the rivalry. The players were receptive to all the excitement, though, and we were motivated by the competition. It was just a tremendous competitive environment."

Though he was a Civil War hero, Espalin—who with Len Frketich and Rich Koeper were the only key fixtures on both the '62 Liberty Bowl and '65 Rose Bowl teams—had no special feeling for the intra-state matchup.

"I was not one of those guys who got all jacked up for the Ducks," said Espalin, 71 and living in Gresham. "The coaches and the training staff tried to jack it up all week, but I was pretty much a low-key guy. I didn't get too excited about things. I never got overly worked up for the Oregon game. I looked at it as another game. I always wished [the Ducks] well, except in the games we played them. I was the opposite of what 'Mad Dog' O'Billovich was. I was pretty cool. I tried to stay that way. I internalized everything, focused on what I needed to do and what was happening. The most nervous I ever got was for the games at California schools, because some of the people who knew me from high school would be around."

Kasso had much the same feeling as Espalin, being a Berkeley native. "When we played at Stanford and Cal, you're playing in front of your folks and in your hometown area," said Kasso, 73, a retired division manager for Pacific Gas and Electric living in Twain Harte, California. "All the Oregon games were special, too. I'll never forget the hype and excitement. You get sucked into it. You're playing at a higher level of intensity. You're floating, you're excited, the hitting is more severe. Is there hatred? I never felt that. It was just always exciting to be able to play in a game like that. I never lost to them, but I don't like that tie. We should have won."

DeBisschop went 2-0-1 against Oregon State. His son, Bobby DeBisschop, was 4-0 playing for Oregon against the Beavers in the mid-1980s. "He never lost to the Beavers," said Dick, 74 and living in Ontario. "It would have been better to be 3-0, but at least we never lost to the Ducks."

DeBisschop's first taste of the Civil War was as a freshman. From 1950 to 1971, first-year players were ineligible for varsity college football and played on freshman teams. The OSU Rooks and UO Frosh would meet up twice a season, once on each of their home fields.

"We drove a bus down Highway 99 to Eugene and arrived at this ugly green-and-yellow place called Hayward Field," DeBisschop said. "And then we got out there and it really was a war. We won, but it was a close, hard-fought game. That was an awakening. That set the tone for how you felt about winning and losing against the Ducks. Coming from California, it was nothing ingrained. I've never had that really bad feeling about them, except

I didn't want to lose to them. I rooted for the Ducks during Bobby's time there. I root for the Ducks now, except when we're playing them."

"The Civil War was pretty big, but I looked at Washington as more of a rivalry," Doug Post said. "I had a bigger dislike for the Huskies than the Beavers. There's just something about the Huskies I didn't like in the Jim Owens era, and it carried over. I don't have any love for the Huskies even today, though at my age, I'm a little less intense about it than I used to be."

"The whole state is either Ducks or Beavers, but we never had the animosity with the Beavers like we did with the Huskies," seconded Berry, 72, who lives in Santa Cruz, California. "I knew a lot of the Oregon State guys. It was a big game, we wanted to win, but there was never the hatred there like there was for the Huskies. I kind of approached it, I wanted to win every game. I looked at every game as a battle. And every week, I'd get pounded."

For 27 years, Berry, Post, Wilcox—at 71, a Junction City resident since 1978—and several other ex-Ducks from the era get together annually for a winter retreat in the sun in Phoenix. Occasionally, Civil War memories are rekindled.

Fifty-plus years is too long ago for Baker, whose Civil War ledger read 2-0-1. "I don't think about those games anymore," he said, adding with a laugh, "Only if I'm talking to someone from Oregon who is telling me how much better the Ducks are than the Beavers. They weren't when I was playing, at least."

ROSES FOR BEAVERS

After four years playing as independents, Oregon State, Oregon and Washington State joined up with members of the Athletic Association of Western Universities to form the Pacific Athletic Conference (PAC) in 1964. For a couple of years, the new alliance was called the AAWU or PAC before it became known as the Pac-8. That became the Pac-10 when Arizona State and Arizona were added in 1978.

Schedules had already been set several years in advance, so it meant that some teams would play as few as four conference games in 1964, some as many as seven. Going into Civil War weekend, there were six AAWU teams in contention for a Rose Bowl berth—Oregon State, USC and UCLA at 2-1, Washington at 4-2 and Oregon and Washington State at 1-1-1. If UCLA were to beat USC that Saturday, the Rose Bowl representative would have been chosen by a vote of conference faculty representatives the following Monday. If the Trojans beat the Bruins, faculty reps would wait another week, until after SC's game against Notre Dame.

Oregon State had a defense-oriented squad led by linebackers Dick Ruhl and Jack "Mad Dog" O'Billovich and safety Danny Espalin, yielding no more than 16 points to an opponent through the entire regular season. The offense, spearheaded by sophomore quarterback Paul Brothers, featured backs Cliff Watkins, Oliver Moreland and Bob Grim and big tackles Rich Koeper and Ken Brusven. It was not a team expected to contend for a conference championship. Before the season, members of the Skywriters' media tour picked the Beavers to finish sixth in the PAC.

After an opening 7–3 loss at Northwestern, OSU navigated the schedule smoothly, winning seven games in a row until stumbling 16–7 at Stanford. Oregon, meanwhile, had cranked out six straight wins to start the season before losing 10–8 as Stanford converted a field goal with 13 seconds to go. It was the first time the Indians had beaten both Oregon schools since 1953. (Ironically, it proved to be a mediocre Stanford team that went 5-5 overall and 3-4 in league play.)

The Ducks had gone into their penultimate game of the season at Indiana, in which they rallied from a 21–7 halftime deficit to win 29–21, knowing the Beavers had to lose to Stanford to keep the Ducks' Rose Bowl hopes alive. "We just about crashed over Sioux Falls [South Dakota] on our flight home when we learned the outcome," UO sports information director Hal Childs cracked.

Oregon was led by senior Robert Chadwick "Bob" Berry, who would earn first-team All-America recognition. "The best quarterback in America," coach Len Casanova would declare.

"Berry is fantastic," Oregon State assistant coach Tiger Zelinka was quoted as saying before the game. "He does things a coach can only dream about. He throws extremely well, runs extremely well and when he's healthy, no one can stop him."

With three-fourths of the famed "Firehouse Four" backfield—Mel Renfro, Lu Bain and Larry Hill—departed, Casanova relied more on the passing game. Entering the Civil War, Berry had thrown for 1,358 yards and 15 touchdowns despite missing the Washington State game with shoulder and leg injuries. The 5-11, 185-pound senior had already set the school single-season total-offense mark. Ray Palm (37 catches, 522 yards and four touchdowns) had set a school single-season yardage record. Corkey Sullivan (30, 477 and four) and Steve Bunker (27, 364 and five) were also chief targets.

Interest in the Civil War was at an all-time high. A sellout crowd was expected at Parker Stadium, and closed-circuit broadcasts were scheduled for Portland's Memorial Coliseum and Eugene's McArthur Court. Cost was two dollars for adults and one dollar for children.

Oregon State's defense won out over Oregon's electric offense in a 7–6 win before a Parker Stadium record crowd of 30,154, the Beavers coming from behind in the final minute to win and secure their first Rose Bowl appearance since 1957. It was a blocked extra point that made the difference.

When the Ducks, ranked 10th nationally going into the game, jogged into Parker for pre-game warm-ups that day, they got a chuckle. Two weeks

earlier, Oregon students had burned in oil a big "UO" on the turf near the 50-yard line. It was still very much in evidence.

Before the game, the *Oregonian* reported, Jim Barratt—then Oregon State's athletic business manager, later to serve as athletic director—got the first hit of the day. Barratt tore open his pants when he made a running tackle on a student trying to climb the fence for free admission. "Barratt ruined a suit," the story read, "but he nailed his prey."

It was a cold, blustery afternoon in Corvallis. "The conditions were extreme—20 degrees and the field was partially frozen," said Dick Winn, a junior fullback at Oregon that year. "When you hit somebody, it was bone-crushing, it hurt so bad. It was a tough day to play football. We were hands-down a better team than Oregon State. I say that because I'm an Oregon guy. We had Bob Berry, the best player I ever played with. My claim to fame was I got to block for Bob. The Beavers were more ball control. We were a higher-scoring team than 7-6. The conditions on the field held us back and played perfectly into their type of football."

It was a physical, hard-hitting game, and emotions occasionally got the best of players on both sides. "O'Billovich chewed my ass after I got a penalty when I hit a guy out of bounds before the Ducks scored their touchdown," Espalin said. "He came over and hit me harder than I hit the ball carrier. He said I was playing out of control. I couldn't understand Jack telling anybody he was out of control."

Nerves were in evidence early, especially with the Beavers, who fumbled on their first two possessions. The second time, Oregon State had recovered Winn's fumble at the Oregon 34. It was the lone dark spot on a great individual day for Winn, who got the call 16 times and picked up 85 yards.

"Second-best day of my career," Winn said. "It wasn't because of me, trust me. Our coaching staff figured out the situation was perfect for a little play that featured me running the ball."

Winn, an Anaheim, California native out of Fullerton, California JC, had chosen Oregon over Southern Cal, Washington, UCLA and Utah because his coach at Fullerton, Hal Sherbeck, loved Casanova. "My dad thought Sherbeck was a savior, thought he walked on water, because I was such a bad kid when I went to Fullerton," said Winn, 70, retired after 35 years as a lumber broker in Portland and dividing time between living in Montana and Arizona. "Hal didn't like [USC's] John McKay or [Washington's] Jim Owens. Hal told my old man I ought to go to Oregon because of Cas. My dad still thought he could tell me what to do, and he told me to go to Oregon. So I went to Oregon. Looking back,

Hal Sherbeck and Len Casanova saved my life. Those two men got me turned around and on the road to success."

Many members of Oregon's 1964 team had nicknames. Winn was known as "Red Pelt" because he had long red hair. "Bob was my idol, and he told me to grow it out," said Winn, who played at 5-10½ and 210. "Berry was 'Flaps' because he had big ears. Doug Post was 'Jaw' because he had a big jaw. Ancer Haggerty was 'Smags.' Jack Clark was 'Plug' because he was built like a fireplug. He was 5-9 and 220, wider than he was tall."

After Winn's fumble, the Beavers drove to first-and-goal at the Oregon three-yard line. But Booker Washington gave it back to the Ducks, his fumble being recovered by Oregon's Les Palm at the UO five. Like Winn, the fumble was an anomaly for Washington, who would experience the greatest day of his career on the final day of his career.

Booker M. Washington came to Oregon State from Carson, California, the son of Booker T. Washington. "My father got that name because his parents wanted to name him after Booker T. Washington," Booker M. Washington said, referencing the great African American educator, author and orator of the late 1800s and early 1900s. "They wrote him a letter and said, 'We'd like to name our son after you.' He was flattered, wrote them back and said it would be a great privilege. He also enclosed an autographed copy of his autobiography, which my father kept. When I was born, my mother told my father, 'I'll let you call him 'Booker,' but I'm not walking out of here with a junior.' My dad's best friend was named Michael. To my knowledge, there's only one Booker Michael Washington."

Washington was student-body president his senior year in high school. He was also a star on the football team and an all-around gymnast. He wanted to go to UCLA but didn't have the second language credit necessary. He signed a letter of intent to attend Southern Cal, but Coach John McKay decided he wanted Washington to go to junior college for a year. Oregon State got into the picture, with assistant coach Bob Watson as Washington's recruiter. He chose OSU along with teammate Olvin Moreland. "We drove up to Corvallis together to start our careers in 1961," said Washington. Now 70 years old, he is retired in Los Angeles after a long career as an educator and coach in Watts and in publishing sales.

The 5-10½ Washington—who entered Oregon State at 180 pounds and departed at 205—backed up starting fullback Bruce Williams as a sophomore and junior and had no quarrel with it.

"Bruce was a great example for me," Washington said. "He was a warrior. He'd just grab the ball and go as far as he could. He'd find some way to get into that end zone. And he was a great blocker. As far as what a fullback was supposed to do in our offense, he was the right man."

Washington was the starter his senior season in 1964. The backup was sophomore Pete Pifer, who would go on to win the Voit and Pop Warner awards as the top player on the Pacific Coast in 1966. "I would get in for a few token plays here and there," Pifer said. "Booker was a great guy. I roomed with him all year. He did special exercises. He would always go up to the wall and stand on his head for about five minutes as part of his pre-game ritual. ["Helped the blood circulate," Washington explained.] I never got into that.

"I never expected to play in front of Booker. Why mess with the chemistry? I know Tommy wanted me to play. I sensed that. But Booker was a much better blocker than I was. And it was critical to Tommy's offense that the fullback be an excellent blocker."

After Washington's fumble, Oregon drove 95 yards for a touchdown. From the UO 46-yard line, Berry found Corkey Sullivan all alone at the OSU 35. He took it to the Beavers' two before being forced out, a 52-yard gain. Dennis Keller ran it over from there for the touchdown that gave Oregon a 6–0 lead. But Oregon State's Al East blocked Herm Meister's extra-point attempt.

There have been some important blocked kicks in Oregon State's 120-year grid history—Ben Siegert's blocked PAT and field goal in a 2006 Civil War win come to mind—but none bigger than that of East. It got the Beavers into the Rose Bowl.

East, a 5-10, 185-pound junior defensive end out of Central Catholic High, was a walk-on but a regular on special teams. He flew in from the right side untouched to block Meister's PAT try.

"I've come close before, but never blocked a kick," East told reporters afterward. "I came through clean that time. Nobody touched me."

Nearly 40 years later, he finds it is what he is remembered most for in his athletic career. "Whoever was supposed to block missed me on that play," he recalled. "I leaped for it, and the ball got me right in the chest. It hit me so quick. What a feeling. I want to say it wasn't a big deal, but it was a big deal. Turned out to be the difference in the game, the difference between making the Rose Bowl or not. Afterward, I felt rewarded, to be honest. I always wanted to be a first-string player. That was a high point."

Meister finds that the missed conversion attempt is what he is most known for, too, all these years later. As a junior in 1963, Meister had kicked a first-quarter field goal and gone four-for-four in extra points in a 31–14 victory over Oregon State. The next year, he broke his arm in August training camp and didn't join the team until midseason. He was three-for-three on extra points the previous week against Indiana but hadn't kicked a field goal his entire senior season leading into the Civil War. "Field goals weren't much of a weapon at that time, especially for Len Casanova teams," Meister said.

Bob Berry was the holder on the fateful miss. "It was a little bit of a high snap, and I saw Bob reach up a little bit," Meister said. "I stutter-stepped and kicked. Out of the corner of my eye, I see East come off the edge and block it."

Meister, who lives in Sunriver, said friends often tease him about the miss. "I show them an article I keep in my wallet, proving that it was blocked," Meister said. "They say, 'Well, you got it off too slow.' You can't win. When we had a team reunion in 1995, one of our ends came up to me and said, 'I have something to tell you. I was supposed to block Al East that day. I blocked down instead, and he had a free run at you.'"

Meister thought he was going to get a field-goal opportunity. Oregon had the ball at the Oregon State seven-yard line late in the third quarter. On fourth-and-one, Casanova opted to go for it, but a holding call moved the Ducks back farther. "I always thought if we kicked that field goal—had I missed it, I'd have had another monkey on my back—we'd have been up 9–0 and would have probably won that game," Meister said. "That haunts me to this day."

The second half turned into a punting duel between Oregon State's Len Frketich and Oregon's Doug Post. Early in the fourth quarter, Danny Espalin returned a punt 48 yards to the UO 37. From the Ducks' 27, Paul Brothers's pass was intercepted by Ron Martin at the UO three.

Brothers, a sophomore from Roseburg, had chosen Oregon State after sifting through about 40 scholarship offers. "I really liked Eddie Crowder, but it was his first year coaching at Colorado," Brothers said. "I wasn't sure how the program would be. I ended up choosing Oregon State because Tommy had done such a great job coaching Terry Baker."

After playing freshman ball in 1963, Brothers went into spring practice as the third-string quarterback. A couple of quarterbacks got hurt, though, "and I ended up playing the entire spring game on both sides of the ball.

That gave me some confidence going into the summer. But I had no idea the coaches had me pegged to be the starter."

Junior Marv Crowston started the opener at Northwestern, ran two plays and gave way to Brothers. His baptism under fire was difficult in a 7–3 loss to the Wildcats. On his first three plays, Brothers was sacked for losses of eight, 10 and seven yards. Brothers played most of the rest of the way, getting loose for a 23-yard run in the second half. But Brothers and Crowston were sacked nine times for 95 yards in losses as the Beavers managed only 10 first downs and 112 yards total offense.

Brothers wound up being a catalyst to an Oregon State offense that was just good enough, aligned with an outstanding defense, to get the Beavers to Pasadena. He entered the Civil War game ranked among the top 10 in the PAC in passing (fifth) and rushing (seventh).

"Paul was a super quarterback, steady, solid," fullback Pete Pifer said. "He would do anything that needed to be done. There were times when I'd get my bell rung and he'd tell me what to do on the next play. You didn't come out in those days for little things like concussions. Paul would have shined even more if he'd finished his career under Tommy. When Dee Andros came in our junior year, it was all about the running game. Paul could run, but he was more a passer than a runner. That changed the whole thing."

Time was running short, and the Ducks were not going down easily. After the Brothers interception, OSU's defense forced another Post punt, and the Beavers took over at the UO 42 with less than four minutes remaining. Brothers, who had been playing with torn rib cartilage since getting injured on October 31 at Washington State and had hardly been able to practice since then, gathered his teammates in the huddle.

"We looked at each other and said, 'We either do it this time or we don't go to the Rose Bowl,'" recalled Brothers, now 68 and living in Eugene. "And Prothro did just an awesome job of calling plays on that last drive."

Booker Washington had been hurt, too, injuring his shoulder the week before in the loss at Stanford. "My mother was at the game, and I was excited about that," Washington said. "I went out to block, and as I hit a guy, my shoulder pad flipped up and I suffered a navicular separation. I didn't know if I'd be able to play again."

Trainer Bill Robertson molded a protective device, and Washington toughed it out through the week of practice, proving to Coach Tommy Prothro he was healthy enough to play in the Civil War. Washington took a cortisone shot to the shoulder before the game.

With the ball at the Oregon 42 and the Rose Bowl on the line, Oregon State moved to the UO 16. On second-and-six, Prothro sent in a play from the sidelines. "I thought I would come out of the game," Washington said. "Usually when we got close to the goal line, one of the bigger, heavier fullbacks would come in. I thought they would put Pete Pifer in."

Not only did Washington—normally a blocking back in the coach's offense—stay in, Prothro called for a draw play to him. "I'm thinking, 'This Coach Prothro is smart,'" Washington recalled. "He was thinking of all the things that could be in our favor. [The Ducks] weren't expecting that play. They knew I was injured. I figured I'd be limited if I could play at all. At that crucial time of the game, he knew I ran the draw play well."

Brothers dropped back to pass and stuffed it into Washington's arms. Brothers looked around and saw "a giant hole opening up. I can still see how wide open it was. And there was Book, with a monster dash. I'd never seen him run that fast in my life. A genius call."

"We hadn't used the draw much, and I figured Oregon would expect us to pass," Prothro said later. "It was a good call, but only because [OSU players] blocked and ran well."

Washington made it 15 yards before being tackled at the Oregon one-yard line. "I'd been hollering to the defense all afternoon to look out for that draw play," Casanova would say later. "That was one of the few times I didn't yell a warning."

About a minute and a half remained. Prothro called Washington's number again, a dive play. The Beavers' senior co-captain gulped. Through Washington's career, he had never scored a touchdown. "I never seemed to do well near the end zone," Washington said. "But they left me in."

On first down, Washington slipped and fell short of the goal line. "I thought, 'That's good, they gave me a shot, I'll let it go.'"

After a timeout, in came the play. Another dive play to Washington. "I thought, 'If I fail, I'll never be able to look my teammates in the eye,'" Washington said. "The guys said, 'We'll make a hole for you,' and they made a hole for me. I can remember that play like it's now. I remember every step I took. I got the hand-off and got hit just as I crossed the goal line. I hit the ground, and the ball came out. I was worried they'd call it a fumble. I thought, 'I better make sure I have that ball in my hands when I get up.' There was an Oregon player right there, too, but as the pile fell on me, I tucked it in. When everybody got up from the pile, I had it in my hands."

It was the zenith of Washington's career. "It kept alive our hopes for the Rose Bowl," Washington said. "And it turned out we were able to go. I was

born on one minute after 12 on New Year's Eve. My only touchdown and I'm going home to Los Angeles for my birthday. It all fit in. It was just magical."

Steve Clark's conversion kick gave Oregon State the lead with 57 seconds left. The Ducks, with Berry going to the air, moved to the Oregon State 36-yard line in the closing seconds. Before the final play, Casanova beckoned punter Post for a 53-yard field goal attempt. Nobody was more surprised than Post.

"Right near the end, Cas called me over and said, 'Hey, you want to try a field goal?'" Post recalled. "I'd never tried one in my career. He knew I had a very strong leg as a punter, and I always practiced kicking off. I said, 'I'll give it a shot.' Cas felt I had a stronger leg than Herm. I didn't have a square-toed shoe that kickers of that time used. Everybody thought it was going to be a fake, but I kicked it. It was true to the uprights but about 10 yards short. The one and only field-goal attempt of my career."

Asked about it afterward, Casanova explained, "Post has the best foot of anybody on the squad. As for the Meister kick, I just don't know. A high pass from center didn't help."

Prothro was given a ride off the field by his players. Southern Cal had trounced UCLA 34–13. He was asked if he thought Oregon State would get the Rose Bowl nod. Oregon State and USC were tied for the best record in the PAC at 3-1, but the Beavers had the better overall record, 8-2 to the Trojans' 6-3 going into the Notre Dame game. Oregon finished 7-2-1 but 1-2-1 in league play.

"I have no idea," Prothro said. "I do know we are tied for the conference championship and have the best overall record."

OSU assistant Bobb McKittrick had an opinion: "We'll either be in the Rose Bowl or get cheated."

Berry completed 14 of 28 passes for 195 yards. "We knew Berry could burn us, so we went with a guessing game, sometimes rushing and sometimes dropping back," Prothro said. "We didn't have poise today with all the mistakes and fumbles, so I'd say we won it on emotion."

Brothers had a terrible passing day, completing only six of 19 attempts for 66 yards. But he rushed 16 times for 60 yards, and fullback Charlie Shaw (16 for 64) provided some help on the ground. "We were thrilled to think of going to the Rose Bowl," Pifer said. "That's like a dream come true. Not only had we won a great Civil War, it looked like we were headed to the granddaddy of the bowl games."

On the other side, the Ducks were crestfallen. "It's been a long damn day," UO assistant coach Jerry Frei said afterward. "We had this game won, too. That's what really hurts."

"It was devastating," Dick Winn said. "In those days, you didn't go to other bowl games. It was the Rose Bowl or nothing. After the year we had, it hurt to the deepest part of my toenails. We were a better team. Under normal weather conditions, we'd have beaten them 27–7."

"We were deflated," Ray Palm said. "We'd run up and down the field but couldn't score. I thought we were better than them. We just couldn't get it in the end zone."

The stats were nearly dead even, though, with Oregon holding a slight edge in first downs (16–14) and total offense (254–252). Oregon State had four turnovers to one for Oregon, was penalized 65 yards to Oregon's 29 and still won.

Those closed-circuit broadcasts? They worked out fine at McArthur Court in Eugene—everything but the final result for Duck fans. At Portland's Memorial Coliseum, 7,000 paid customers never got to see the game. Just before the opening kickoff, the screen went dark due to a projector failure caused by defective tubes. "If that's what they call a closed circuit, I know how they got that name," one unhappy fan said as he left the arena. "Right after the coin toss, the circuit closed real fast." Refunds were given.

A week later, after USC had knocked off No. 1–ranked Notre Dame 20–17, many figured the Trojans would get the Rose Bowl nod. The vote of PAC faculty representatives was tied at 4–4, though, giving the Beavers the berth via the whoever-hasn't-been-there-the-longest rule.

"I was this little farm boy from Roseburg, talking about going to L.A. and playing in the biggest bowl game of that time," Brothers said. "It was surreal."

The members of the Los Angeles media who complained long and hard when Oregon State got the Rose Bowl bid over USC felt vindicated after Michigan drubbed the Beavers 34–7 at Pasadena. "It was still the experience of a lifetime," Washington said.

Brothers, who also won Civil War games in 1965 and '66, considers that one of the highlights of his career. "I always had lousy passing stats, partly because the Ducks always played good defense," Brothers said. "All those games were close. I remember every single one of them. I didn't care about the stats. I just wanted to beat them all three times. That's all I cared about. I can tell you, I had a lot of respect for Oregon. I ended up having a lot of really good friends who were Ducks, and to this day, they remain close friends. And if I have to, I'll remind them I was 3-0 against them."

GIANT KILLERS

The apex of Dee Andros's 11 years at Oregon State came in his third and fourth seasons, 1967 and '68. Some of the players were remnants of the Tommy Prothro era. More were Andros recruits who were big, strong, farm-boy types who fit perfectly into his "Power-T" offense and physical 6-2-3 defensive scheme.

Many of the stars on those two great Beaver teams were from small towns in the state of Oregon. Defensive tackles Jess Lewis and Craig Hanneman played together at Cascade High north of Salem.

"I came from a three-room, eight-grade Cloverdale Grade School near Turner," Hanneman said. "Jess came from the big town of Aumsville. I'll bet they had four rooms in their eight grades."

Other key players included Jon Sandstrom from Sandy, Don Whitney from Pendleton, Larry Rich and Bill Plumeau from McMinnville and Bill Enyart and Mark Dippel from Medford. There was also Scott Freeburn from Salem, Donny Summers from Grants Pass, Charlie Olds and Bob Jeremiah from Cottage Grove, Clyde Smith and Mike Nehl from Bend and the Barton boys, Duane and Gary, from Baker. If you spread out a map of Oregon and pinpointed every rural section of the state, you'd be well represented on the Oregon State football squads of those years.

Andros recruited fullbacks and moved them to tackle or linebacker. Lewis and Hanneman were both fullbacks in high school. So was Sandstrom. In 1967, the starting interior defensive four were Lewis, Sandstrom, Ron Boley—who had been a quarterback at Parkrose—and 6-7½, 260-pound

Bill Nelson from Berkeley, California, who went on to play five seasons with the Los Angeles Rams.

The "Great Pumpkin" utilized an offense featuring a full-house backfield—a quarterback, two halfbacks and a fullback. Through his first seven seasons, the fullback was the focal point, with Pete Pifer, Bill Enyart, Roger Smith and Dave Schilling all taking on workhorse loads and having plenty of success. The Beavers ran the option, and quarterbacks Paul Brothers, Steve Preece and Steve Endicott were all excellent runners—Preece the best of them— and savvy in orchestrating Andros's patented option play.

"Dee's offense was no-frills," Enyart said. "It was a very basic system, but it was an effective system. We weren't unexciting. We were a very exciting team. We had a great option quarterback, guys like Billy Main who could pick up big chunks and break it long, and we sprinkled in a few passes. I wish we'd have passed more. But it was basic and it was emotional. Dee was a fiery guy. With emotions, it goes two ways. Some games you win that you probably shouldn't have. You probably lose some games you shouldn't have because you didn't prepare at a strategic level."

Andros was always good with his motivational talks. He cranked it up a notch for the Civil War. "His speeches were better for the Ducks," Enyart said. "He always said the game is for the right to live in the state for one year. It's metaphorical, but in a sense, it's true. If you live in the state, you're either a Beaver or a Duck. After the game, you're either gloating or you have your tail between your legs. He conveyed that to us. Nobody understood that more than me. When we played the Civil War game, it was more than just another football game. It was the most important thing in the world."

Preece—his teammates called him "Fox"—was a fleet quarterback from Boise with limited passing skills but a perfect fit for Andros's offense. Recruited by every Pac-8 team except California and UCLA, he took advantage of the recruiting process. "In those years, you could sign a letter of intent with one school in each league," Preece said. "I signed with Oregon State, Brigham Young, Utah, Colorado and Columbia. I visited Washington. On his visit to my home, [Coach] Jim Owens took us out to dinner and ordered a glass of wine. My mom said, 'You're not going there.' I thought seriously about Stanford. They'd just been in the Rose Bowl and had a good team. At one point, I was convinced I was going to Colorado. Then Dee got the Oregon State job. I'd been recruited by Tommy Prothro. It came down to Oregon State and USC. I became sold on Oregon State because I loved Dee and his offense. The weekend I visited Corvallis, I wasn't on campus for more than 20

minutes. [Recruits] Bill Enyart, Jerry Belcher and I drove to Portland to watch the [basketball] Final Four. It was a blast. I came home and said, 'I'm signing with Oregon State.'"

Enyart considered Stanford and Oregon before deciding on OSU. He admired Oregon coach Len Casanova. "Cas was a class act, for sure, and I liked his assistants Jerry Frei and Max Coley," Enyart said. "It was between Oregon and Oregon State. Prothro had recruited me, and I'd made several trips to Corvallis for games during high school. Dee was the deal-maker for me."

Andros was an Oklahoma native. Enyart lived in Oklahoma before moving to Medford at age 11. The Enyarts loved Oklahoma coach Bud Wilkinson, who had coached Andros with the Sooners. Enyart's father knew Dee and his brother from the Oklahoma days. There was a strong connection there.

The 6-3½, 235-pound Enyart played fullback and linebacker on the Rook squad in 1965. As a sophomore, he played weakside linebacker, moving into the starting lineup as a sophomore when starter Jim Godfrey was injured in the opener at Michigan. Enyart had a great season on the defensive side and had a big game in a 20–15 victory over Oregon. "My kids and I have watched film of that game quite a few times," Enyart said. "I told them, 'Guys, the older I get, the better I used to be.' But I did have a pretty good game. I caused a fumble and made quite a few tackles."

That spring, with Pifer having graduated, Enyart moved to offense permanently. "Dee had been a little resistant to me being a fullback," Enyart said. "Dee and Ed Knecht, my freshman coach, wanted me to stay at linebacker. Dee and I had a meeting. I told him, 'Coach, I want a shot at fullback. I love playing linebacker, but I came here to be a fullback.' He gave me a shot, and I think it worked out pretty well."

Enyart's public nickname was "Earthquake," the result of sports information director John Eggers liking the alliterative sound in promoting the Beaver fullback for All-America consideration. But Enyart's teammates called him "Buffalo Bill," which was shortened to "Buff." He proved to be the right guy to play fullback in Andros's offense. In the Power-T, an effective fullback was vital.

"We needed a blue-collar, durable fullback you could count on," Enyart said. "Dee would roll over in his grave if he knew you were going to throw the ball on third-and-two. We made no secrets we were going to run the ball, and you're not going to stop us. Our offensive line was fantastic, incredibly disciplined under Coach [Sam] Boghosian. We had a great quarterback in Preece, too, and a lot of very good halfbacks."

The halfbacks on the '67 and '68 teams—Billy Main, Donny Summers and Jerry Belcher—were excellent blockers. "We all had to block in our offense," Main said. "Our split end, Roger Cantlon, was a great blocker. Our offensive line was terrific—guys like Lee Jamison, Dave Marlette, Rocky Rasley, John Didion, Clyde Smith and Roger Stalick. Those teams had a tremendous rapport between the backs and the linemen. We loved those guys, and they loved us. As a team, we coalesced better than you could ever imagine. I've never been in an environment where there was more love or camaraderie.

"Enyart was the go-to guy, but Donny Summers and I were blocking the linebackers for him. We'd run 53 power, 57 power, back and forth. We had traps and passes I caught, but my career at Oregon State was mostly blocking middle linebackers. It was down-in-the-trenches football. That was Dee's style. The theory was we'd hit the linebacker helmet to helmet, and Enyart would at least get his three or four yards. But Buff always gave the credit to the line and to Donny and me, unequivocally. He was so humble. And in that huddle, those linemen would look up to him."

The best of the linemen was Didion, the 6-4, 255-pound center from Woodland, California, who initially committed to Brigham Young. "Their coach was Lavell Edwards, a great guy and a very successful coach," said Didion, who died of a heart attack in December 2013. "Then [OSU assistant coach] Rich Brooks came to an all-star game I played in Sacramento and offered me a trip to Corvallis. I said, 'Why not?' And I fell in love with the school. It's what a college campus is supposed to look like—ivy-covered brick buildings. Woodland is small. I didn't want to go to an urban area. I got to talk to Coach Andros, and what a great communicator he was. I felt like I wanted to be part of what they were building."

As a sophomore in 1966, Didion played behind 6-6, 270-pound Rockne Freitas, who went on to an 11-year NFL career. "Rocky was instrumental in my beginning weight training," Didion said. "I weighed 190 as a freshman and about 205 as a sophomore. Having to go one-on-one against him was like throwing a BB against a wall. That was one of the bigger keys to whatever success I had, getting bigger and stronger."

Among the defensive stars was junior tackle Lewis, who had chosen Oregon State over Washington and Oregon. Lewis became one of the great two-sport athletes in Oregon State history, earning All-America recognition in football and winning a pair of NCAA heavyweight wrestling championships in 1968 and '69. He finished sixth in the 1968 Olympic Games at Mexico City, earning a draw in his match with the gold medalist, Aleksandr Medved of Russia.

"Casanova had come down to our farm in Aumsville to recruit me," Lewis said. "I got a kick out of that. I wasn't a Duck type of guy, though. I visited Oklahoma for the wrestling part of it. The real reason I went to Oregon State was [wrestling coach] Dale Thomas. He didn't give me a choice. He said, 'If you want to wrestle at the highest level, you have to come and be involved in my program.' He was so determined. I was wet behind the ears. He convinced me. And of course I loved Dee Andros and his assistants, like Ed Knecht and Rich Brooks, who recruited me. It was a combination of all those people coming into my life at the same time. I knew I wanted to wrestle, and football was paying for everything. Dale liked that idea."

The 1967 Oregon State team began the season with impressive wins over Stanford, Arizona State and Iowa. The Beavers stumbled in Seattle, losing five fumbles in a 13–6 loss at Washington in which the Huskies scored the winning touchdown with two minutes to play. Hangover from that loss played a part in an ineffective performance the next week at home in a 31–13 loss to Brigham Young.

The next week, Oregon State paid a visit to Purdue, the nation's No. 2–ranked team led by All-America halfback Leroy Keyes. The Beavers pulled off a stunning 22–14 upset. Two weeks later, OSU was facing another No. 2–ranked team on the road, UCLA. The result was a 16–16 tie that could have been another victory had not one of Mike Haggard's extra-point attempts bounced off an upright.

After that game, talk turned to the Beavers' next opponent—top-ranked Southern Cal and All-American O.J. Simpson. "We're tired of playing No. 2," Andros famously told reporters. "Bring on No. 1."

Haggard's second-quarter field goal held up in the Beavers' 3–0 upset at Parker Stadium in what still remains on a short list of great performances in school history. Hence the term "Giant Killers" was born. Because of OSU's loss to Washington and the tie with UCLA, the Trojans were headed to the Rose Bowl that season to face—ironically—Purdue. In those years, Pac-8 teams were prohibited from playing in any bowl games other than the Rose Bowl. So the Beavers, 6-2-1 and ranked eighth nationally, had only the Civil War game left to play.

In Eugene, the Jerry Frei era had begun. Len Casanova had retired and been replaced by his longtime assistant. Frei had played at Wisconsin and then moved to Oregon in 1949 to become an assistant coach at Portland's Grant High. He served as head coach at Portland's Lincoln High, was an assistant coach at Willamette and then joined Casanova's Oregon staff in 1955.

"Jerry was one of those type of people who was inspirational, and he had visions of Oregon becoming more than what we had been," said Claxton Welch, a halfback from Portland's David Douglas High. "He was the one who came up with the nickname 'Fighting Ducks.' He saw there was opportunity to become something special. We would come out of the locker room, jog over to our warm-up position in single file, break into four or five lines and then you would start your exercises. It was something he picked up when he visited Notre Dame during spring practice. He wanted us to emulate the Fighting Irish."

Welch had been an Oregon fan since junior high school. "I had always been a Mel Renfro fan," he said. "I followed his career. I liked the campus in Eugene. It seemed like a great place to get an education. It just felt right, and it was."

Welch wound up playing five years with the Dallas Cowboys, three years alongside Renfro. "One of the highlights of my career was playing with Mel, arguably the greatest Duck ever and one of the greatest defensive backs to play football," Welch said. "His knowledge of the game and the way he played were almost unparalleled. Only a handful of players played at that level for that long. Mel deserves his Hall of Fame credentials."

Denny Schuler was a split end out of Snohomish, Washington, who grew up a Washington fan but, at 5-10 and 155 out of high school, wasn't recruited by the Huskies. He had offers from Washington State and Oregon. Ironically, the assistant coach recruiting Schuler for WSU was Jim Shanley, who had been a star running back for Oregon a decade earlier.

"I was really torn between the schools," Schuler said. "One of the convincing factors was I loved Oregon's uniforms so much. I just loved the green and yellow. They looked so much like the Green Bay Packers' uniforms. And I decided I wanted to play for Len Casanova. Oregon was known for having a wide-open offense. Cas was every bit the Chip Kelly of that era, and I wanted to be a part of that offense."

Schuler soon became a Frei fan. "As much as everyone loved Cas, everyone loved Jerry even more," Schuler said. "He was a players' coach. He was a wonderful human being. He taught us a lot more than just football. Unfortunately, when he took over he had too many players like me and Ken Woody and Dave Walker and not enough of the players he got later. After he took over, they started recruiting some players like Bobby Moore, who was a freshman my senior year. Thank God freshmen couldn't play in those years, or Bobby would have played and I'd have sat the bench."

Andy Maurer was another player Frei inherited from the Casanova era. A product of eight-man football in tiny Prospect in southern Oregon, Maurer was a sophomore fullback in 1967, Frei's first season as head coach. "After Jerry took over, the players had a meeting to decide whether we should stay at Oregon and play for this assistant coach," said Maurer, who would go on to an eight-year career in the NFL as an offensive lineman, playing in a pair of Super Bowls. "I wasn't a very sophisticated player. I was naive. Some of the California kids said, 'We came to Oregon for Cas,' and they left. I stayed. Jerry turned out to be a very high-quality coach. He was a great human being, and so many members of his staff—John Robinson, George Seifert, Jack Roche, Bruce Snyder—were great human beings. And Jerry was a very good coach. We had talent during my years at Oregon, but maybe we never had enough."

Another player out of southern Oregon for the Ducks was George Dames, a walk-on out of Medford. "I was last-string my freshman year, last-string my redshirt year," said Dames, who wound up being a three-year starter at noseguard and linebacker. "Nobody wanted me out of high school. My brother had gone to Oregon. In fourth grade, Cas had spoken at the Medford High football banquet. I had a dream of playing for him someday. I wound up playing my last two years under Jerry, who had been a phenomenal line coach and was a good head coach, too. He delegated authority to his assistant coaches and totally let them do their jobs."

Oregon went into the 1967 Civil War game with a 2-8 record. The Ducks had played better in their last two games, a 17–13 win over Washington State and a 17–14 loss to Stanford, but the Beavers were nationally ranked and heavily favored when they invaded brand-new Autzen Stadium. Autzen opened that season with a capacity of 41,698, more than double that of old Hayward Field, which had become a hindrance to the program's progress. In 1965, the Ducks had played three of their five home games at Portland's Multnomah Stadium. Former athletic director Leo Harris—then employed as a part-time consultant by the athletic department—considered the new facility a first step toward joining the big time in college athletics.

"From a cold, analytical standpoint, football is the only successful method to finance the entire athletic program, and our objective is to build a first-class program," Harris told the Duck Club the week before the Civil War. "Our facilities at Oregon—I think they are the best in the PAC—will make a tremendous contribution to our athletic program. But we must build with football as the foundation. We must field a representative team every year,

not every other year or every three years. Money has never been the problem in the football program. We've always had plenty of money. Until this year, the Oregon athletic department has never used all its aid money. We've never had enough football players to warrant using it all. The difficulty has been in the area of recruiting...Football hasn't seemed important...There has been a general apathy toward football. Until you solve this, it won't make any difference whether or not you have the money to get players. Football is important at Oregon, just as all school-related activities are important. I hope you as alumni demand this. You have been too complacent in the past, but you have the ability, and I'm sure the desire, to change this."

After watching film of Oregon State's win over USC, Frei remarked, "That's the greatest game I've ever seen Oregon State play, and I'm concerned to learn if [the Beavers] can do it again Saturday. Our staff didn't realize how strong Oregon State was until that victory. But I assure you we're not ready to lie down. We'll be going after them, we'll hit with them and we'll keep after them. This is the third team in the top 10 we've met this season, so we're used to it."

"When Oregon and Oregon State get together, you never know what will happen," said Oregon's standout safety, senior Jim "Yazoo" Smith. "It's 'Katie Bar the Door' with both teams going for broke."

Jon Sandstrom, a defensive guard who would go on to be an All-American in 1968, was another Beaver who said emotion was never a problem playing the Ducks. "My dad went to Oregon, and I wanted to go there, but [the Ducks] didn't offer me a scholarship," he says today. "I went to every Oregon football and basketball game as a kid. I thought I was going to go there. They invited me down there but didn't give me an offer. It made me want to play harder every time I played them. It ticked me off, to tell you the truth.

"When we played them as freshmen, I got kicked out of a game. I'd get so competitive, I'd get to the point of not playing fair. I pulled a cheap-shot play, tried to egg somebody into a fight. Rich Brooks came by and said, 'You'll never do that again.' He had me running wind sprints for some time after that."

Enyart had played at Medford with a pair of Ducks, center Tom Wooton and quarterback Mike Barnes. "I was a pitcher on the baseball team, and Mike was the catcher," Enyart said. "A couple of times, Wooton and I hunted pheasant near Medford. We rode home together after [Civil War] games. That was the ultimate game for us. They were our rival. That was our bowl game. That game was the most important game by far of the year for us."

A Civil War record crowd of 40,100—paying six dollars for reserved seats, three dollars for general admission and one dollar for students—watched the two-touchdown-underdog Ducks nearly pull off an upset. Oregon led 10–0 going into the fourth quarter before Oregon State pulled out a 14–10 victory. Earlier in the day, USC had beaten UCLA, clinching a Rose Bowl berth.

Perhaps there was some hangover on the Beavers' part from the emotional victory over Southern Cal the week before. Perhaps there was disappointment that there would be no bowl game. Perhaps they overlooked the Ducks.

"We found out during warm-ups we were out of the Rose Bowl picture," Steve Preece said. "I really feel we'd have been capable of beating the Ducks by 30 if the Rose Bowl had been on the line, but we played pretty miserably."

John Didion wasn't buying it. "There's no way to my way of thinking anybody went into a Civil War but with the highest, most competitive feelings," said Didion, who became a consensus All-American as a senior and would go on to play seven years in the NFL. "You couldn't take baggage. You had to leave it and walk away."

Junior Bill Enyart, whose fourth-quarter work was the key to Oregon State's comeback that day, felt it was his coming of age as a Beaver fullback. "We were coming off the SC win and had a little bit of an emotional letdown, and the Trojans can physically take a lot out of you, too," said Enyart, who carried 35 times for 167 yards. "But I was feeling good. That day was when I came into my own as a fullback. They'd never given me the ball that much. I had about 800 yards that season [851], but early in the year they didn't use me that much. I'd been more a decoy while we were running the option. That day, a light bulb went off with Dee and Preece that I wasn't a speedster but a pretty good mid-range fullback. I had a lot of quickness, used my height to advantage, had a forward lean when I got hit.

"Bud Wilkinson always said if you make 3.4 yards a carry, you'll never get stopped. I averaged about five yards a carry. With that in mind, if they gave the ball to me, we were theoretically never going to get stopped. That was Dee's philosophy. I knew I wasn't going to break long runs, so I was content to get a lot of good short runs and make the [defenders] pay a price to tackle me and set up the option for the bigger runs. When they started giving me the ball, we started moving it down the field that day. Believe me, I didn't want to lose that game, and I wasn't the only one."

Andros was known for his pre-game speeches. On this day, Frei had his own means of inspiration. "Before the game, as he was addressing the team, Jerry jumps up on the taping table and says, 'Hey, gang, we're going to do this and that,'" George Dames recalled. "He could feel where everybody was

not connecting. It wasn't the right thing to be saying. Then all of a sudden, he started crying. He said, 'You know how much I love you guys. Just go out and beat them. I know you can do it.' It was the most emotional pre-game scene I was ever involved in."

Oregon State dominated the statistics in total offense (380–195) and rushing (286–104) but lost four fumbles. UO's Cam Molter blocked two Gary Houser punts, and Duck linebacker Kent Grote recovered three fumbles.

Oregon took an early lead on a 27-yard field goal by Marc Scholl. In the third quarter, the Beavers moved to the UO 43 when Main fumbled and Grote recovered. The Ducks marched 57 yards to pay dirt, Claxton Welch carrying over for the touchdown from one yard out for a 10–0 lead with five minutes left in the third quarter.

The margin could have been greater. Welch had a TD plunge nullified by an offside penalty, and Scholl missed a 47-yard field goal. The Beavers had missed some chances, too, having twice driven inside the UO five in the first half. Once, Jerry Belcher fumbled on the two-yard line. On the other, Preece coughed up the ball just as he was crossing the goal line.

Time was running out on the Beavers.

"Everybody was busting their hump, but it just wasn't fluid," Billy Main said. "It felt like the BYU game. We couldn't get it together. It was palpable."

"We were about to ruin our season," Preece said. "On the sidelines we said, 'No way we're going to lose this game. We cannot lose this. We're going to go score twice.' Everybody was of that ilk. We had really good people up front, and the guys in the back all wanted the ball. The only thing we had to keep people together on was eliminating mistakes. If we didn't make a mistake, we were pretty unstoppable."

"We're looking up at the scoreboard and it was 10–0 Ducks," Enyart said. "Donny Summers was a miniature hulk, one of the most muscled guys I've ever seen. He comes up to me and said, 'Dee is getting that sick-to-the-stomach look.' Then Donny went to Dee in the fourth quarter and said, 'Don't worry, coach, we're going to get 'em.' Dee looked at him and said, 'Well, I sure as hell wish we'd get started.'"

Early in the fourth quarter, Preece hit Summers for 35 yards on a third-and-eight from the OSU 22. "That gave us the spark," Andros said after the game. The Beavers marched 80 yards in 15 plays. On second-and-goal from the eight-yard line, Preece found Roger Cantlon on a diving reception to the one. Enyart scored on the next play, and it was 10–7 with 8:54 remaining.

After an Oregon punt, Oregon State took over on the 45-yard line with six minutes to go.

"When we got on the field, Preece said, 'OK, we've screwed around long enough. We have to have it,'" Main said. "Preece had tremendous command in the huddle. He had a way of connecting with the O-line like nobody I ever saw. They believed in him because he was as tough as any of them, and they respected and loved him for it. Fox was the leader on the field, and the chemistry behind him was incredible. At that moment, he looked at every guy and said, 'We gotta have this. No mistakes. We're going to drive this effer right down their throats.' It was a come-to-Jesus kind of moment. We took that ball right down the field."

The Beavers drove 55 yards in nine plays, Enyart scoring from the four with 2:30 to play.

"There's a picture of me blocking George Dames on that play," Main said. "I can see it in my mind today. That drive was the one that had the most drama and pressure of any one in my career."

Dames was crestfallen. "We made a phenomenal game of it," he said. "We should have led more than 10–0. We had our chances. That loss was very hard to take."

The Beavers experienced a mixture of jubilation and relief. "It was great to christen Autzen Stadium with a win," Preece said.

"We never lost our poise," Andros said afterward. "Everybody pulled together, the offense yelling for the defense and vice-versa."

"You certainly have to give Oregon State credit for a lot of poise," Frei agreed. The Beavers "showed it in putting together those two drives."

"We almost got our tails beat by the Ducks," Sandstrom says today. "It would have taken away everything we'd done that season, but we didn't give up."

"We weren't going to quit," said Jess Lewis, recently retired after 21 years as supervisor of athletic ground maintenance at OSU. "Coach Andros and Coach [Rich] Brooks wouldn't let us quit. Everybody disliked the Ducks so much—it's the same way today—that we couldn't quit. We felt like we could still get them. That's the part I remember."

"We earned every yard with Billy Main or Enyart up the middle," said John Didion, who spent a 35-year career in law enforcement, including three terms as sheriff, in Naselle, Washington. "After the game, Coach [Sam] Boghosian said, 'Take a couple of weeks off and start hitting the weights again.' We all did. There was such a love on that team. It was always there from our freshman year. I've never experienced anything like that again—in pro football, in law enforcement—guys who just got along and worked so perfectly together. It was a special time."

The 1968 season was a "could-have-been" campaign for Oregon State. The Beavers were ranked No. 2 nationally in *Playboy* magazine's preseason spread. They wound up losing three games by a total of six points in a 7-3 season. They dropped two of their first four contests by a point apiece—21–20 at Iowa in the opener and then 35–34 in the fourth game at Kentucky. The only other loss came in the penultimate game, a 17–13 defeat at Southern Cal.

Oregon State and USC both went into the game 4-0 in PAC play, so in essence, the Rose Bowl was on the line. The Trojans, led by Heisman Trophy winner O.J. Simpson, were 8-0 overall and again ranked No. 1 nationally. With Simpson carrying 47 times for 238 yards, the Trojans scored 17 fourth-quarter points to win.

The lack of a placekicker had been OSU's Achilles' heel all season. Highly regarded sophomore Pat Arnold had been in a preseason automobile accident and wasn't able to perform. Larry Rich was called on to kick extra points, and tackle Kent Scott handled field goals. Rich had missed extra points in the losses at Iowa and Kentucky, the latter after OSU's final touchdown and the Beavers behind 35–34. Against USC, Scott missed field-goal attempts of 21, 30 and 32 yards in the first half.

"Had Mike Haggard been back, we'd have been national champions that year," Bill Enyart said. "I felt sorry for Scotty. He had kicked a 50-yard field goal in high school and was an incredibly gifted athlete. They'd been experimenting with kickers all year, and then they throw him to the wolves in that pressure cooker in the L.A. Coliseum. We were physically better than USC that year. We were physically inferior the year before when we beat them."

Every Wednesday during those years, the Beavers would scrimmage, first-team offense against first-team defense. "As hard as we could go," Preece said. "It was a different world back then. Didion and Sandstrom—I'm not sure Jon wasn't our best player—would go against each other. They'd be slugging it out, beating the crap out of each other. I remember one day, all of a sudden, Didion yells out, 'What is going on here, Jon? You're my best friend.'"

Preece offered another observation about the Oregon State teams of 1967 and '68. "Dee convinced us all that we'd only win if we were a group playing as one," he said. "Everybody believed it. There wasn't a selfish guy on those teams down to the last guy on the team. Enyart and Didion and Sandstrom, they treated the last guy on the team the same way they treated me, and vice versa."

Oregon had made strides in Frei's second season. The Ducks went into the Civil War 4-5 with a chance to finish the year at .500. Before the game, Frei called Oregon State, ranked 16th nationally, "the finest college offensive football team I've ever seen." But, said Frei, "I'll tell Dee or anyone else we won't play this Saturday as we did against Cal [a 36–8 loss], and we're not going to Corvallis to concede."

The Beavers, though, were ready. "That game was the crown for the Giant Killers group," Enyart said. "We had struggled against the Ducks the year before. They'd put up a great effort against us. The seniors knew this was the last time we were putting on an Oregon State uniform. It was an emotionally charged time. We always stayed together at an Albany motel the night before a home game. We'd have cookies and cocoa together about 10 o'clock. Donny Summers read a poem to everybody that he had put together that day. I didn't know Donny had it in him. I swear we had tears in our eyes listening to him."

The Ducks were no match for the Beavers in a 41–19 loss at Parker Stadium. "We were pissed because of what had happened the week before at USC," Main said. "It was such a heartbreaker. We'd remembered what had happened the year before when we had our heads up our ass and almost lost. Everybody was ready before the game. You could feel it."

"We made up plays all the way through that game," Preece recalled. "We'd done that against Purdue our junior year, too. The position that Dee and Sam had on that was, 'Do anything it takes to win, as long as you don't fail.' Everything was so set in our system, but we ran one dropback or bootleg off one of our options we'd never shown before. I remember Didion coming back to the huddle and saying, 'What's going on?' Guys were having fun and loving beating the Ducks. They had some good players—George Dames, Scott Cress—but we were real good."

Oregon was poised to take out Preece on Oregon State's patented option play. Preece had broken a shoulder the previous season, and opponents that year often took shots at it. Early in the game, UO defensive end Dennis Gassner cold-cocked him. Main saw it.

"Billy told me, 'Run that play again,'" Preece recalled. "I ran it again, and Main goes flying by me and hits [Gassner] so hard I thought he was going to kill him. He's standing over him, screaming, 'Don't touch my quarterback again.'"

"We had a slight altercation," Main acknowledged. "There was quite a bit of trash talking by their D-ends, because they had to deal with the option and it really pissed them off. The defenses we faced were taught

to handle the option by busting the quarterback no matter whether Fox pitched or not. I was uncharacteristically agitated—I was more a lover than a fighter—and Gassner was pushing because Fox had the marginal shoulder. It came close to shoving, with lots of mouth. I was ready for a dust-up. But we were seriously restricted by the Pumpkin's code of behavior— no fighting, just do your job. Success is the best reward. Summers was the guy who elevated the rhetoric in those situations. He was the resident junkyard dog in the backfield. Buff never said much, nor did I, but Donny was usually mouthing off a bit."

Enyart rushed 37 times for 168 yards and three touchdowns.

"Bill was awesome," Didion said. "It was like self-preservation. When you were blocking, you had to get out of his way or he'd take you with him. People don't realize how quick he was for a big man. He'd hit the hole hard. He was a smart runner who knew the offense well and where the blocks were coming from."

Main had his own reverence for Didion. "He was the rock of Gibraltar," Main said. "Never said much but was the greatest team player I ever saw in football. It was an honor to play with him."

From watching game film over the years, Boghosian had noticed a tendency with George Dames, Oregon's best D-lineman. "George wasn't big, but he was really quick and tough, a very good player," said Didion, charged with blocking him. "George would pick a side and try to do a swim move and get by you. When he was going to his right, he'd have his left hand on his left knee. When he was going to his left, he'd have it open. It wouldn't be on the knee. For two years, I knew which way he was going every play. It helped immeasurably. After the game our senior year, I walked up to George and we shook hands. I said, 'Hey, you might want to look at your hand. You're tipping your stance.' I thought he was going to punch me. It fired him up."

When Didion's story was relayed to Dames, he grew quiet for a moment. "I don't remember him saying that," Dames said. "Maybe I was so wiped out I didn't hear him."

Main returned a kickoff 94 yards for a TD to break a 7–7 tie. "We did a little huddle before the kickoff, and somebody said, 'See you in the end zone,'" he said. "There was absolutely no brilliance on my part. Everything fell into place beautifully. Bryce Huddleston threw a great block. Nobody even touched me. I came right up the chute, there were a couple of key blocks and it was over. If you draw up a kickoff on a board, this was the one. Everybody did their job."

The 5-8, 170-pound Huddleston, who backed up Main at wingback that season, took pride in doing whatever he could for the cause. "I threw a lot of good blocks," he said. "That was what I got to be known for. Back home, I'd bucked a lot of hay and did a lot of roller-skating and ran a 47-second quarter mile. That's what helped to block, to use your torso to get into blocking position. I got in the way of a lot of guys. The person I was trying to please more than anybody was Boghosian. He was sharp as a tack—one great football coach."

Enyart got a block on Main's kickoff return, too, on Oregon kicker Ken Woody. "Earthquake is the guy who starts their wedge," Woody recalled. "I kick off and [Main] catches it, and Enyart's head swivels, he sees the wedge-breaker—me—and here he comes. I'm just overrun like a wave. He was on my chest. I was brave but not very effective on that one."

Mike Groff intercepted a pass and returned it 44 yards for a score to put it away after the Ducks had gotten within 27–13 in the third quarter.

"We totally outclassed them that day," said OSU's Scott Freeburn, a sophomore offensive guard. "We were a much better team. I wasn't surprised in the outcome. That was a team led by a great group of seniors, part of the Giant Killers bunch, and they'd had enough of the Ducks."

"We were a really good team—arguably better than the Giant Killers of the year before," said defensive tackle Craig Hanneman, a sophomore that season.

"When we were clicking," Main said, "we were the No. 1 team in the nation in both '67 and '68."

"We handled the Ducks that day," Enyart said. "We were hitting on all cylinders. We had just had the right mix of execution and emotion. And when it was over...you're 21 years old, your last game is over, you've given so much...in a sense, it's the end of your youth. You're never going to play this game again at the college level. The finality to it is incredible. We knew that was it. It was bittersweet."

It was a difficult day, Denny Schuler said, to be on the losing side. "I dropped a touchdown pass in that game," the Oregon split end said. "Hit me right in the hands in the end zone, and I dropped it. I still have nightmares about that one. But we weren't going to win that game. You just knew. In those years, [the Beavers] literally had bigger, stronger, faster players than we did."

"That was a hell of an Oregon State team," Oregon tight end Andy Maurer said. "They should have beaten us a million to nothing."

Claxton Welch, who ended his career 0-3 in the Civil War, also paid homage to his adversaries. "The Beavers were outstanding, one of the

best teams in the country those years," Welch said. "Dee Andros had put together a superb roster of players. A lot of my friends played there. I'd played high school basketball against Bill Enyart, and he was one of the great ones. Steve Preece was a great quarterback, and they had a number of outstanding linemen.

"I got to play with some great ones at Oregon, too. Jim Smith was one of the greatest teammates I ever had. George Dames was a heck of a competitor. I always found that you play as hard as you can on the field and off the field and hope that it results in victory. It never did against Oregon State. In those days, our defense played well against them, but we were never able to score enough points."

THE FOUTS/MOORE/GRAHAM ERA AT OREGON

A pretty good quarterback on a very good team at St. Ignacius High in San Francisco, Dan Fouts didn't exactly get the bum's rush by college recruiters. "My junior year, we won the city championship," said Fouts, who would go on from Oregon to a Hall of Fame career with the San Diego Chargers. "We had 11 guys get scholarships to Division-I schools. We were good."

That year, Oregon coaches were recruiting St. Ignacius center Jim Figoni, a year ahead of Fouts in school. Head coach Jerry Frei and assistants John Robinson and George Seifert watched St. Ignacius beat Bellarmine in Santa Clara, "and I had a good game," Fouts said. "They remembered that."

Figoni wound up at Oregon. Seifert, in charge of recruiting the Bay Area, kept after Fouts, who took trips his senior year to California and Southern Cal "because they were interested in a couple of my teammates and thought we were a package deal."

"When letters of intent came out," Fouts said, "my mailbox was empty, except for one letter."

Oregon appealed to Fouts because of Frei's wide-open offense. "Oregon was throwing the ball in those days, one of the few college teams that featured it," Fouts said. "My dad, an acquaintance of [former UO coach] Len Casanova during his years coaching at Santa Clara, met him when the Ducks played Cal at Berkeley my senior year and watched the game. I was the fourth of five children. My dad told me he'd put the first three through college but didn't have enough money to put me through, too. I'd have to get a scholarship."

Fouts's father, Bob Fouts, was a sportscaster who worked many years as the radio play-by-play voice of the San Francisco 49ers. The younger Fouts developed a love for sports being around his dad and relished the opportunity to meet his boyhood Bay Area sports heroes.

"It was tremendous," he said. "How many kids get to meet Wilt Chamberlain and Willie Mays and John Brodie and Y.A. Tittle and Nate Thurmond and Hugh McElhenny? I was around great athletes all the time. I'd spend training camps with the 49ers as a kid. I got to be a ballboy for home games. It was a rare chance to see these guys as human beings and not supermen."

Fouts arrived in Eugene in 1969, Frei's third season as head coach. Oregon was only so-so, but the talent base had been improved. Members of the sophomore class included middle linebacker Tom Graham and wide receiver Bobby Moore, the latter who would go on, like Fouts, to become an NFL Hall of Famer.

During Fouts's three years as starting quarterback at Oregon, the Ducks' record fell each season, from 6-4-1 in 1970 to 5-6 in 1971 to 4-7 in 1972, his final season and the first under Coach Dick Enright.

"Our starters were very capable," Fouts said. "The problem in those days was the lack of scholarship limits. We had no depth. If we had an injury to a key player, that's when we'd have problems. With the limitations imposed by the NCAA now, USC can't grab every Tom, Dick and Harry. It was different then. Three of my high school teammates went to SC, and they never saw the field. If they'd come to Oregon, they'd have played. And we beat the Trojans two out of three. So there."

Senior Tom Blanchard was the incumbent quarterback when Fouts began his sophomore season in 1970. Oregon opened against California at Portland's Civic Stadium, a multipurpose facility used by the Pacific Coast League Portland Beavers.

"They had cut out parts of the infield where the base paths were," Fouts said. "Tom, who'd had knee problems throughout his career, tripped on the seam and hurt his knee in the first half."

Offensive coordinator John Robinson had promised Fouts that, in the event of an injury to Blanchard, he'd insert him and let him throw a bomb on the first play. During a roast at Eugene in April 2013, Robinson told the story: "I had just been BS'ing Fouts. Then Blanchard gets hurt. Tom's on the ground, Dan puts his helmet on and comes over and says, 'OK, coach, you have balls enough to make that call?' That pissed me off a little bit, but

we made that call. Dan takes a five-step drop and throws a beautiful, long pass, and wide open, five yards behind the secondary, is Bob Newland. Stand up, Bob."

Newland, who would go on to a four-year NFL career, was among those in attendance. He stood, offering, "Remember, it was a baseball field."

"We were playing football," Fouts, who was emceeing the event, shouted to a chorus of laughs.

"And Bob looked good dropping that damn ball," Robinson said, finishing the story. "Dan has always been a pain in the ass. He comes over and says, 'Who in the hell is that guy playing end? I'll never throw to him, ever again.'"

In reality, Robinson hadn't been BS'ing Fouts. "Robby had said, 'We're going to put one in on these bastards,'" remembered Greg Specht, who played tight end that season. "Dan hits Newland sprinting in toward the MAC club, and Bob drops it. But we knew what Dan could do. It was, 'Oh, this kid can play.'"

Blanchard re-entered the game, but the knee didn't hold up. Fouts returned and led Oregon to a 31–24 upset victory. Blanchard came back the next week at Illinois but reinjured the knee. Fouts finished that game, a 20–16 loss, and made his first career start the following week in a 33–10 defeat by Stanford. Two weeks later against UCLA, Blanchard returned but separated a shoulder and was done quarterbacking for the season. Fouts threw the game-winning TD pass to Specht in the fabled 41–40 win in which the Ducks rallied from a 40–21 fourth-quarter deficit.

"Dan had greatness in him mentally," Robinson said. "He was a fabulous quarterback. Then our staff got fired [after Fouts's junior season], and he ran the option as a senior."

Robinson was part of the Frei staff that was fired after the 1971 season. Dick Enright took over, and yes, Fouts did run the ball some his senior season.

"We'd run a guy in motion out of the slot and use a triple-option wishbone set like Oklahoma and Texas, but we'd also pass out of it," said Donny Reynolds, a sophomore tailback during Fouts's senior campaign. "The idea was to try to utilize Dan's passing skills and also maintain a running game. The offense was set up to run and throw equally. His main thing was to hand off and pitch. If he did run, he wasn't looking to break and take a big hit. He'd get a few yards and go down. It wasn't a true option. His body wasn't designed to do that. He wasn't that quick-footed."

But man, could Fouts pass. He was the guy who seemed destined to lead the Ducks to their first bowl game since 1963. "Dan came in as our savior," linebacker Fred Manuel said. "He was the guy who was going to save us by

throwing the football, and he could throw. We had the receivers, too, guys like Bobby Moore, Bob Newland, Greg Specht and Leland Glass."

Fouts's teammates appreciated him as a teammate, a leader and a friend. "You talk about field generals and guys possessing leadership qualities—that was Fouts," Reynolds said. "The first time I got in the huddle, I noticed how he got everybody's attention. He was decisive in calling a play. He'd call guys out. He epitomized no-nonsense leadership. The confidence he exuded was amazing.

"He could throw the football with great touch. I didn't get the concept of what a bomb was until watching an Oregon practice when I was a freshman. He'd launch it up into the stratosphere with a lot of arc on it. I dropped one of Fouts's bombs against San Jose State. He still hasn't let me forget about it. He says, 'I'd have had one more touchdown pass if you'd have caught that ball.'"

Graham considered Fouts, who had star status, "just one of the guys."

"In the off-season, they'd go to play pickup games with him at Mac Court," said Graham, who played seven years in the NFL. "And he'd be right there in the middle of it, shoving people as they're throwing the ball up in people's chests. I never did play basketball, so I'd be there just watching the games going on. I'd say, 'Dan, you gotta cool down, because if one of these jokers goes after you, I'll be in the fight. I'll have to jump in there to save you.' I played with Dan in San Diego. He is just a good guy. Being a great quarterback, he was not aloof from the rest of the players, which went a long way with all of us."

"Dan is a character and a competitor," said offensive lineman Tim Stokes, who had a 10-year career in the NFL. "I don't care if it's basketball, ping-pong, whatever, Dan had the passion to win. He's one of the most competitive people I've ever met. There was no question he had that ability. He could be a real physical presence, even though he wasn't all that big and strong. He worked hard and had a real knack for the game. There was no fooling around in the huddle. There was only one person in charge."

Moore, who played as Ahmad Rashad in the NFL, said the two greatest quarterbacks he played with both made the Hall of Fame—Fouts and Fran Tarkenton. "They both had the toughness and the leadership qualities," Rashad said. "Dan had a much stronger arm. Dan was never going to be stopped. He was one of those guys who was a leader from day one. He was a year younger than me, but he ran that huddle like he was two years older. You'd go to the wall for him. I was a running back, but any time he'd pass, I'd block for him to try to make sure he didn't get hurt. We bonded as friends

in college. I think of him as one of my dearest friends today. I was never surprised with all the success he had in the NFL. Never surprised me for a minute. I feel fortunate for the time I spent with him as a teammate."

Specht played freshman ball in 1968 and then redshirted in '69. "That was the best thing that happened to me," Specht said, "because a skinny kid from St. Ignacius High named Dan Fouts enrolled."

Specht played tight end as a sophomore and then starred at receiver his final two seasons. He and Fouts played together in the East-West Shrine Game. "My roommate there was Washington State's Bill Moos," said Specht in reference to the man who would later become athletic director at Oregon.

"Dan always threw a good ball," Specht said. Fouts's successor, Norval Turner, "was a great guy, but he couldn't throw a spiral to save his soul. We called them 'Norval balls.' Both ends would be fluttering."

"Fouts was a good college friend and a very good leader. We just had a lot of fun. He was a good guy to drink beer with, to play catch with, to go on dates with our girlfriends."

Oregon's offensive coordinator was John Robinson, who would later go on to fame as head coach of the Southern Cal Trojans and the Los Angeles Rams. "Robbie was a creative play-caller," Specht said. "He taught me how to run patterns against D-backs. That was the year I learned more about running routes and how to catch balls than in any other year."

Robinson was a young coach at 28 during Denny Schuler's recruiting trip to Eugene in 1964. "All I remember about that experience is I laughed the whole evening," said Schuler, who played for Oregon from 1966 to 1968 and coached there from 1986 to 1992. "His style of coaching was positive. He'd say, 'This is how we're going to beat Washington.' And he could make football fun. He always had that ability."

When he was with the Rams, Robinson hired Schuler as a low-income quality control coach. "He gave me his white Eldorado Cadillac," Schuler said. "The neighborhood I was living in wasn't the same as his. When I drove that around in my neighborhood, everyone thought I was a pimp."

Robinson started his 12-year coaching stint at Oregon on the defensive side and then switched to offense. Fouts kiddingly said that Robinson—who dealt with a stuttering problem, especially in his earlier years—would introduce himself as "John R-r-r-obinson, with one R."

Former player Jim Franklin has a Civil War stutter story. "Robby was getting us ready for the Oregon State game [in 1967]," he said. The Beavers

"had just beaten USC 3–0. He's talking to the team and he says, 'Jimmy Franklin. You know what Jimmy's going to do? Jimmy is going to hit B-b-b-ill Enyart right in the middle of the ch-ch-chest. And you know what's gonna happen? He's going to leave a little green spot.'"

"He'd get excited, and we used to give him unmerciful stuff," Specht said. "Eventually he cured that speech impediment, but we didn't really care. What a guy, and what a coach."

Rashad is one of the few who doesn't look back fondly at Robinson's time at Oregon. "I played my heart out for John Robinson," Rashad said. "He was a great offensive coordinator. But when he left for USC, he kind of looked down his nose on us. It bothered me. We had little teeny guys slugging it out with the big guys, and he made it look like he was just an SC coach at heart. There's a brotherhood of sorts. Once a Duck, always a Duck. I don't feel like John Robinson had that same sort of feeling."

Robinson did what he could to get the ball in the hands of the 6-2, 205-pound Rashad (then Moore), who played receiver as a sophomore and then switched to tailback his final two seasons at Oregon. "Oh God, I loved him," Robinson said. "He was one of the all-time players. All-conference wide receiver, then we moved him to tailback and he was all-conference there. He was as good as any tailback I ever coached at USC. I just loved watching him play. He played during the black-protest era and is identified in that context, and a lot of people in public didn't like him as much as everybody who knew him liked him. But he was a hero to everybody around him."

Moore, a Tacoma, Washington native, narrowed his college choices down to Notre Dame and Oregon before choosing the Ducks. "The Huskies never recruited me," Moore/Rashad said. "That was weird. Oregon State really recruited me. My high school coach was a big fan of Dee Andros. As a junior, I was at Parker Stadium when they beat USC [in 1967]. There were always a lot of Oregon State boosters in Tacoma, but it wasn't my kind of school. They had one of those run-it-up-the-middle offenses and didn't throw many passes.

"Oregon was the frontrunner all the way. I had always been an Oregon fan. As a kid, I loved the Ducks, loved the uniforms. I was a big fan of Bob Berry. I don't know what it was, but that was my team."

Rashad's teammates held him in awe. "You knew he was a thoroughbred," fullback/tight end Andy Maurer said. "He ran different, caught the ball different, moved different. He was awesome."

"Ahmad was the best athlete I'd ever seen in my life," Tom Graham said. "He raised my awareness as to how good a player could be or how good you had to be to reach that 'greatness' plateau."

"He was the most gifted athlete I ever played with," Bob Newland said. "I would put him into the same category as Mel Renfro and Akili Smith in that regard. He would have been a starter on the basketball team. He would have been a fine decathlete. He probably could have played just about any position on the field."

"He was one of the earliest true stars of Oregon football, the kind of player who attracts the eyes of a crowd," Greg Specht said. "He was a genuine, honest guy who was great for the U of O, helped elevate the program. I remember my freshman year, seeing him come across the middle and catch a ball behind him, thinking, 'Hmm. That guy's pretty good.' I signed as a free agent with St. Louis after my senior year in 1972, and he'd made the NFL's All-Rookie team that year. When I got there, he couldn't have been nicer. He welcomed me and was a very friendly, outgoing guy."

"Bobby and I roomed together when I first got there the summer of '68," Fred Manuel said. "He was a very quiet young man, very personable. Everybody seemed to love him. He was all they said he was. I was glad to be a teammate. I came out of high school as a running back and thought I was hot stuff. The first day, with his size and talent, he stepped over me. That's when I transferred to defense. I'm no fool. You'd throw Bobby a short pass, he'd stop on a dime, switch directions and give you nine cents change."

"During my time in the NFL, he's one of those handful of guys I would say had exceptional athletic ability and did miraculous things," offensive lineman Tim Stokes said. "His hand-to-eye coordination was extraordinary. You don't see many Bobby Moores come down the pike, and he was a really nice, soft-spoken guy."

"Ahmad was like a pro player playing with high school kids when he was at Oregon," Fouts said. "That was the difference with his talents and abilities and toughness as compared to the rest of us. He was a phenomenal college player. For him to make the sacrifice of playing tailback after being so great as a wide receiver his sophomore year, that shows you the type of team player he was."

It was at Frei's suggestion that Rashad made the switch. "I didn't mind," Rashad said. "I enjoyed playing tailback. Jerry stuck with me pretty good. I carried 20 times a game for two years. Everybody said, 'Keep him back at receiver,' but he said, 'I'm not going to do that. He's a better running back.' From that time on, I started piling up yards."

As a freshman in 1969, Fouts had watched from the stands as Oregon lost to Oregon State 10–7 at Eugene. That was the game in which sophomore Tom Graham was credited with 37 tackles—20 of them unassisted—and blocked a field-goal attempt.

It may have been the strangest ending of a game in Civil War history. With the score tied at 7–7, 19 seconds remaining and Oregon State deep in Oregon territory, Mike Nehl's 26-yard field goal attempt was blocked by Jim Franklin. But the ball caromed off a referee, bounced off Graham's foot and was recovered by OSU's Bill Plumeau at the UO four. Given a reprieve, Nehl made a 21-yarder with nine seconds left to cinch the Beavers' sixth straight win in the series.

"Mike knuckle-balled it through, which was a microcosm of the game," OSU defensive tackle Scott Freeburn said. "It was a comedy of errors that day. The game wasn't pretty, but there was plenty of hard hitting."

Freeburn found that out on the second play from scrimmage. "The guard playing across from me punched me right in the eye," he said. "Split my cheek open. It was like, 'OK, that's how this game is going to be.'"

Oregon State had gone without a reliable field-goal kicker for two seasons. The Beavers had lost two games that season on missed extra points. After the 1968 campaign, Nehl, recruited as a defensive back and a punter, sought out assistant coach Rich Brooks, who worked with the special teams. "I'd kicked extra points at Bend High," Nehl said. "I told Rich, 'I can miss them as good as anybody else.'"

Nehl got the job but made only two field goals all season going into Civil War weekend. "Because I was a punter rather than a kicker," Nehl said, "they didn't trust me that much. During the week before the Civil War, I worked mostly on my punting. I didn't spend as much time on field goals."

An unlikely hero, Nehl was on edge as he lined up—again—for a game-winning attempt. "I thought of the Flying Burrito Brothers," Nehl said. "It was, 'If I miss this, I am not going back to our bench. I'm heading for the nearest foreign border.' When the ball went through [the uprights], the weight of the world was off my shoulders. Oh my God, what a day. It was a great feeling. The thrill of victory and the agony of defeat."

Nehl missed three field-goal attempts in the game, two of them blocked, including the one that led to the game-winning three-pointer. One of the blocks was by Graham, who provided one of the most unforgettable moments in Civil War history on one of Nehl's misses that he didn't block.

Anticipating the snap, Graham leaped over the Oregon State line into the OSU backfield without making contact. "He didn't touch anybody," Nehl recalled. "He quickly realized what he had done, went to the left, ran around our right end [back to the Oregon side] and we just continued. It was a freaky, weird play. Today, he would have been called for encroachment. It was like a blooper. I thought, 'What, am I really seeing this?' He was so feared and such a great linebacker, it sent the fear of God into me. I didn't know if I'd die right then."

Today, Graham doesn't recall the play. Nor another similar play against Air Force, in which he stepped on center Oltheria Mitchell's back to get over the line of scrimmage. "Maybe I did it twice," Graham said. "I'm told that's the case."

Like Fouts, Graham wasn't highly recruited out of high school in Los Angeles. He had offers from two major-college schools, Oregon and Colorado. "I grew up a Trojan fan," said Graham, 64, living in Denver and working as a minister. "I watched Mike Garrett and was fascinated by him as a player. I guess I wasn't good enough for USC or UCLA. It wasn't that big of a deal. I fell in love with Oregon and all the trees and rivers and the nice outdoors."

For three seasons, the 6-3, 240-pound Graham patrolled the middle of the Oregon defense. He was renowned for both his ability and leadership qualities and is the school career leader with 433 tackles—206 his sophomore season.

"Tom was larger than life," Bob Newland said.

"He'd fill up a room with his personality," Greg Specht said. "Big, loud, boisterous, in your face. I learned that in a good way. He loved playing football, and he loved everybody. He'd yell across campus, 'Hey, Specht! How ya doin?'"

"Tom was one of the greatest defensive players I played with at any level," Ahmad Rashad said. "He was one of the most dominating players I've ever seen. He made tackles from sideline to sideline. He was our guy, a wonderful guy, a real superstar."

Fred Manuel started at linebacker with Graham his last two years at Oregon. "He was very intense, went about his business," Manuel said. "I was a no-nonsense person, and he was the same way. We kept each other grounded. He had great size and could run fast. He was a stud."

"Tom was a Christian with strong moral ethics," offensive tackle Tim Stokes said. "Back then, you didn't see guys like him play linebacker. He was built, with a really physical presence. He was big and rangy and ran through blocks. Tom was quite a football player."

"He was like the Ahmad on the other side of the ball for us," Dan Fouts said. "He was a teammate of mine for a couple of years in the NFL. His speed and explosion on tackles was just amazing. The prototypical middle linebacker."

Oregon State didn't run away from Graham during his years playing in the Civil War. "Seemed like they came at me just about every play, especially my sophomore year," Graham said. "That's why I was able to make so many tackles, I guess."

Dave Schilling, OSU's 6-3, 225-pound sophomore, carried 31 times for 115 yards in the '69 game. "He was a big fullback, along the lines of Bill 'Earthquake' Enyart," Graham said. "They ran the triple option, but you knew he was going to get the ball. He wasn't going to try to outrun you and get to the corner. He was going to get his three to five yards in the trenches. I just thought, 'Hey, I'm heading for you.' Evidently, I didn't make enough tackles on their side of the line."

On those plays—52, 53, 56 or 57 power—the halfbacks would lead block. In 1969, that was often Billy Main. "I was blocking guys like Adrian Young of USC and Don Widmer of UCLA and Don Parish of Stanford," said Main, who caught a 13-yard pass from Steve Endicott for OSU's only touchdown in the '69 Civil War game. "I knew them intimately. I have memories of Tom Graham. He was the toughest guy I went against—mean as hell. He was fast and a smart player, elusive. With his speed and athleticism, you could never get a clean shot at him."

Oregon's offense struggled that day, managing only 10 first downs and 225 yards total offense with six turnovers. Bobby Moore did not have a big day—one rushing attempt for 14 yards, four receptions for 32 yards. The trend was to follow through his three years as a varsity player at Oregon. He never had a big game, and the Ducks never won.

There was a major disparity in viewpoints in the schools in those years. Oregon State, under Dee Andros, was the more conservative, blue-collar group. Oregon, with Jerry Frei at the controls, was the more liberal, socially conscious program.

"It was the '60s and early '70s, and Eugene was an island of liberalism," Dan Fouts said. "Jerry was such a pleasure to play for, because he treated us like men, even though we weren't really men yet."

"We were the flamboyant, hippie, long-haired guys, very liberal," Ahmad Rashad said. The Beavers "were like the crew-cut farm boys going to show us what's what. Dee Andros and Jerry Frei—two different philosophies, two

different offenses, two different schools, two different people. When you live in Oregon, you realize a major difference between Oregon State and Oregon—100 percent difference.

"Attending Oregon was one of the most important decisions I made. At a lot of the schools, they had separate dorms for the athletes. In that kind of environment, I would never have had a chance to do things normal students do. Those were turbulent times, with anti-war protests going on in campus. If guys were socially inclined to be involved with that, Jerry would let them do it. If I was at some sort of protest, it was fine, as long as I fulfilled my responsibilities to the team and the school. He was really interested in turning out responsible young men. I had a wonderful college experience at Oregon. That's why I'd do it again. You're supposed to have that kind of experience."

"Jerry demanded we perfect our skills on the field, but he allowed us to be men off the field," Tom Graham said. "He didn't tell us we couldn't wear big Afros or have facial hair. He was a coach who would listen to us. With my class, we went from maybe three African Americans on the team to 20 or so. There might have been some culture shock about that in Eugene, but Jerry was wise enough to realize it was probably not just culture shock for them, but for us, as well."

Frei advocates always mention the great coaching staff at Oregon, with men such as Robinson, Bruce Snyder, George Seifert and John Marshall, who all went on to either successful careers in the NFL or as head coaches in the Pac-8.

"Jerry took over at Oregon in the most difficult of circumstances," said Robinson, who coached the last five of his 13 years at Oregon under Frei. "On the social issues, we were in the forefront. If you were a radical and couldn't quite make it at Cal, they sent you to Oregon. Oregon was the Triple-A club for the radicals. Social things were just out of control, but he kept our program going. Under different circumstances, he could have been a memorable coach in terms of record. But he suffered through and kept everybody together in a magnificent way. No one will ever understand that in a historical resume, but God, he was super that way."

Tim Stokes, for one, disapproved of what the Beavers were about in those years. "Hated 'em with a passion," he said. "They were polar opposites of us in just about everything, from uniforms to type of football to culture. Oregon was a liberal arts school that was more counter-culture. It wasn't Berkeley, but it wasn't Oregon State. Oregon State was an agricultural/industrial school, and their teams reflected that. We were a wide-open offense

and threw the heck out of the ball, and they used the Power-T, grind-it-out approach. They had Dee Andros, the Pumpkin from Oklahoma, a country type of guy. We had Jerry Frei, who was one of the great gentlemen of all time and a fantastic coach. He treated us like young men. I can't say enough good things about Jerry."

"This was at a time when adults and young people were at war, literally," UO placekicker Ken Woody said. "Dee kicked a guy off his team for having a mustache, that's how bad it was. We had guys politically active in anti-war demonstrations, guys with long hair, and Jerry said, 'I will never treat young men as kids. I will respect the fact they are adults.' We had only one rule: Don't do anything to embarrass the program. There were people who criticized him as being too soft, but we appreciated him for the faith he had in us. You had to think about what you were going to do."

"It really was a battle of philosophies," Graham agreed. "On one side, you had Jerry Frei, the coach who allowed you to be a man and become a man. On the other side, you had Dee Andros. Everybody who played for him had to have the butch haircuts. Black players were not allowed to have facial hair and big Afros. It was, 'Which side is right?' It was a cultural war as well when Oregon and Oregon State played."

Specht tells a story about his redshirt year in 1969, when he had hitchhiked to the beach by himself. "I'm on my way home the next day, and I look like a hobo," Specht recalled. "I'm outside Eugene, and Jerry picks me up hitchhiking. It's raining like crazy. And during our 10- to 15-minute ride to my fraternity, we talked about how I was doing as a player, and in school, and the culture and the climate, and family. No judging. No put-down. That's the kind of guy he was. Everybody really liked Jerry."

"Jerry was one of the most important people in my entire life," Rashad said. "A wonderful coach, a guy who cared about every single player on the team. He never played favorites. His thing was to turn out responsible young men and not pro players. If you were fortunate enough to play in the pros, that was another thing, but he was more interested in helping you deal with the college experience, whether you come out of there a responsible person. He was a great motivator—really more than a coach to me."

Oregon State's players felt just as strongly about Andros and his staff in those years, as is explored in depth in the next chapter. And the Beavers usually had the last laugh in the Civil War those years, winning nine of 11 times during the Andros regime, including eight in a row from 1964 to 1971.

"We were real fortunate to have the quality of coaches in Sam Boghosian, Bud Riley, Rich Brooks, Red Smith," split end Jeff Kolberg said. "Dee

put it all together, and he was neat about one thing. He made you believe in yourself and in the program. If you did what it takes to compete and focus, you had a chance to win. We didn't have a lot of talent compared to Oregon—guys like Fouts, Rashad, Specht, Graham, Chuck Bradley, Tom Drougas, Bill Drake. They had all those guys, and they couldn't beat us."

Andros made the Civil War more than a game. Frei, said at least one player, did not. "Jerry's mentality was pretty much to treat that game like any other game," said Greg Marshall, who played fullback and tight end at Oregon from 1968 to 1970. "It was just as much importance but no hugely great significance, which is maybe why we never beat the Beavers even though we felt we had more talent. Andros thought about that game totally differently than Frei and his staff. It's not that we took it lightly, just not being the thing that could make or break your season.

"Jerry's problem—maybe it wasn't a problem, just a fact of life—he expected all the young student-athletes to be mature men. Unfortunately, we had some immature young men. They didn't do what they were supposed to do. It wasn't a problem for me, but it was for some guys. The coaching staff in general was struggling to help us bridge the gap between being somewhat competitive and winning. They didn't know how to win, and we didn't know, either, because we never had won before. A winning mentality wasn't prevalent. That compounded itself in terms of creating a team that wasn't bad, but we weren't as good as we could or should have been."

With Andros, the Civil War was the ultimate. "You never thought you were going to lose. It was a matter of how well you would execute and how badly you would dominate the Ducks," said defensive tackle Mark Dippel, who was 3-0 against Oregon from 1968 to 1970. "We didn't always dominate them, but we always beat them. It was not part of our vocabulary that they would play well enough to beat us. You just knew with Dee that you'd be ready.

"He started on Sunday, worked through it until Friday and then it was, 'Let's beat the snot out of the damn Ducks.' When I first came in, I was shocked at how intense a feeling I could get toward a goal to physically give every ounce I had to make sure it happened. It went to a whole different dimension. There was an attitude that you gave every fiber to accomplish what you were trying to do that Saturday afternoon."

Oregon, on the way to its first winning season since 1964, had the better record going into the 1970 Civil War, 6-3-1 to Oregon State's 5-5. The Beavers needed to win to enjoy their fifth straight winning season under Andros, and they got it done, upsetting the favored Ducks 24–9.

Without injured quarterback Steve Endicott, Oregon State was even more run-oriented than usual, with Dave Schilling (35 carries, 173 yards) keying a ground game that amassed 336 of the Beavers' 372 yards total offense. Both teams were without star middle linebackers—Oregon's Tom Graham and Oregon State's Steve Brown—due to injuries.

Oregon went into the game leading the nation in passing yardage, with the sophomore Fouts throwing to such receivers as Moore, Specht, Newland and Glass. Even with Brown missing, Oregon State's defense—ranked No. 1 in the Pac-8—shut down Fouts, who was only 13 for 32 for 145 yards passing with three interceptions.

"We had a good rush and good coverage," OSU secondary coach Bud Riley said after the game. "That helped the kid throw poorly."

"I was horrible," Fouts says now. "I was not good that day."

Third-string quarterback Jim Kilmartin, playing in the place of Endicott and injured No. 2 Ralph Keck, rushed 20 times for 54 yards, and Mike Davenport carried only four times but for 40 yards and a pair of TDs as Andros went to 6-0 in the Civil War. Turnovers were a huge part of the story. Oregon had six, Oregon State none.

Moore would have his best individual numbers in a Civil War game, carrying 18 times for 81 yards from the tailback position and catching four passes for 32 yards. It wasn't enough to carry Oregon to victory.

"I was the poster guy of who they wanted to get when we played them," Rashad says more than 40 years later. "Those guys always played over their heads against us. I couldn't do anything right, it seemed like. We tried to prove a point. We never wanted to lose to Oregon State no matter what. It always came down to a real battle."

OSU's Scott Freeburn, a senior defensive tackle playing in his final game, hurt his knee in the first quarter when blocked by Oregon's Greg Specht—a teammate at South Salem High. "I had been very emotional before that game," Freeburn said. "I had a few things to say to the guys, something about how the last thing I wanted to have happen to me was to lose going out. That would have meant a losing season and losing to the Ducks in my last game. I'm not sure if the Oregon game was more important than the other games combined, but there was no close second in terms of emotions, my senior year especially.

"Then I get hurt, but we're a team. Those guys took over. I limped off."

With Oregon State leading 17–9 and owning the ball with fourth-and-one on its own 30 with 5:30 left, Andros made an appeal on the sidelines to his defense. "Dee turned around and screamed at us, 'Should

we go for it? If we don't make it, can you hold them?'" defensive tackle Craig Hanneman recalled. "It was crazy. But he knew the answer to that question without asking. We were going to make it. We had Dave Schilling. The key was in Dee trusting the defense and telling the offense to stay on the field."

Schilling burst through a huge hole for 63 yards to the Oregon seven-yard line, setting up the Beavers' final touchdown.

After the game, Dippel said he was talking to his wife on the field when a father of one of the Oregon players—the player who had been across from him all day on the line of scrimmage—confronted him. The player's father "grabbed me and started yelling at me," Dippel said. "I was taken aback. I had kicked the crap out of his kid, and he thought he had to come down and stick up for him, I guess. [OSU assistant] Sam Boghosian broke it up, and we headed to the locker room."

Moore, who had fumbled in the second quarter, setting up a short OSU field goal, said bravely after the game, "There's no way we'll lose three straight to Oregon State."

When that comment got back to the Oregon State locker room, OSU guard Dave Nirenberg shot back: "You're always keyed for Oregon, but comments like that fire you up even more."

More than 40 years later, members of that Oregon senior class haven't forgotten the hurt. "My last college game," Ken Woody said. "Football was everything to me. It capped three years of frustration against the Beavs. They converted a couple of fourth-down plays, and we couldn't hold them. I'd hate to think we went into the game thinking, 'What's gonna happen when we lose again this year?' but it was heavy on your minds."

The 1971 Civil War game was one of the most exciting of all time, Oregon State coming from behind to win 30–29. The Beavers—a one-point favorite, making the odds-makers prescient—drove 61 yards for the game-winning touchdown, Billy Carlquist scoring on a six-yard pitch play from Steve Endicott with 1:40 left for their eighth straight win in the series.

"That has to be the greatest spectator game I've ever seen," Dee Andros said afterward. "Jerry [Frei] had a great plan. In my seven games against them, I've never faced an Oregon team with that kind of determination."

Frei, tired of losing to the Beavers, thought Andros was out of line in some of his pre-game comments. "Our bulletin boards and walls are full," Frei told reporters the week before the game. "Dee has said more than enough to make us mad."

Cracked Andros: "We have a lot of material on our bulletin board, too, whether anyone said it or not."

Maybe Andros wasn't kidding.

"We're going to win," OSU center Jack Turnbull promised beforehand. "We have a better team and it will make our season. The way Oregon is talking, they think they are the only ones who want to win."

Oregon went without Bobby Moore, who went into the game leading the Pac-8 in rushing with 1,211 yards but watched from the sidelines due to a thigh contusion. OSU players "have said a lot of bad things about me," Moore said that week. "Last year, it was that I wasn't a good football player. When I was a sophomore, they said I was a sissy. It's aggravating."

Years later, Ahmad Rashad recalls it this way: "I got a thigh bruise a week earlier. I spent the whole week at the infirmary trying to get my thigh to loosen up, but I couldn't run. To not be able to play in that game was one of the biggest disappointments in my life. It still bugs me that I was never able to beat Oregon State. That was one of the toughest things for me. But man, those guys, I've never been more keyed on any more in my life, I'm telling you. They used to just beat me up something terrible. Whatever our differences were, Oregon and Oregon State, they took it out on me.

"I was in tears the week before that game. I remember sitting down with Jerry, and me asking if I could go, and he said, 'I don't think you should try. That thing's swollen up. You have a great career ahead of you.' One of the toughest things I faced as an athlete was not being able to play that game. And we lost. That's not the way I wanted to go out."

Andros had used a little different variation of an old pre-game speech. "He thanked us for playing as hard as we'd played that season," offensive tackle Chris Veit recalled. "And he apologized from the coaching staff for us not winning more games. But then he got going and emphasized we had a chance to go out on top by beating the Ducks. He had us all in tears. We go out for the pre-game toss, all the seniors as honorary captains, and we're wiping tears from our facemasks, and the Ducks were looking at us like, 'What's with these guys?'"

Endicott still marvels that Oregon State was able to win that game. "They had Fouts, Graham, Bill Drake—geesh," Endicott said. "I don't know how we beat them. But we were a lot more physical than the Ducks. It was just a matter of styles."

Drake had intercepted an Endicott pass in the fourth quarter after audibling from a play offensive line coach Sam Boghosian had sent in from

the sideline. "A huge mistake," Endicott said. "Sam grabbed me by the facemask and said, 'What the hell are you doing?'"

Carlquist scored the winning touchdown on fourth-and-two from the Oregon six. "It was an option right," Endicott said. "I hated running the option. I was kind of a wussie. I just wanted to throw the ball. I faked it to Schilling and decided I would try to score. Then Tom Graham—what a stud he was—comes scraping off a block into the hole and was about to hit me in the mouth. I went 'Eek' and tossed the ball to Billy, and he walked into the end zone."

Veit asks for an assist on the game-winning score. "I had a penchant for trying to call plays," Veit said. "Every once in awhile, Endicott would tell me to shut up. But I told him the Ducks were keying on Schilling over right tackle because we'd run it so often. They were pinching in and trying to stop it. I told Endicott, 'You might try a 38,' which was a pitch play to Carlquist.

"Steve calls timeout and goes to the sideline to talk to Andros and Boghosian. He comes to the huddle and says, 'We're going to run 38.' We fake the 56 power, we sell the blocks hard, Schilling dives over without the ball and the pitch to Billy is wide open."

"That may be the best college game I was involved with," OSU defensive end Jim Sherbert said. "It went back and forth, and we won in a shootout. Oregon had as much, if not more, talent than we had. We just played a better game than they did. Dee and his staff just outcoached Jerry Frei and his staff."

"We won on Beaver guts," Veit said. "We just ran it down their throat, and they couldn't stop us. It was just power-T football."

Junior Dan Fouts had a solid game for Oregon, completing 17 of 28 passes for 251 yards and two touchdowns. But Schilling had another dominating performance, carrying 24 times for 119 yards and three TDs as Oregon State rushed for 304 yards.

Frei wasn't unhappy with his team's performance afterward. He called it "our best game of the season. We got 29 points and our defense did a good job. We should have won."

"I felt in my heart we had better talent than the Beavers did," Oregon's Fred Manuel says now. "We had All-Americans, stars, and we just couldn't get it done. It was heartbreaking to lose to them knowing we had better talent. They probably had a more solid game plan."

The Ducks "had a lot of great players," Veit agreed. "They were better than us on paper. They just couldn't beat us on the field."

Looking back, Fouts has regrets only about the results. "Offensively, we did have a good plan," he said. "We did play better. The memory of that

game that will stick with me forever, though, is when we were ahead [29–24] in the fourth quarter. We had a fourth-and-short, I turned the wrong way on a handoff and got tackled and that basically was the game. If I turn the ball the right way and hand it off, we get the first down and maybe we go on to win the game.

"The writing was on the wall for Jerry. I went up to him with tears in my eyes and said, 'Gosh, I'm so sorry, coach.' And he said, 'You didn't lose this game. Don't worry about it.' But for me, it was devastating."

The loss "bothered the hell out of me," Greg Specht said. "We lost at home. We thought that would be the year we'd finally beat them."

Tim Stokes felt it, too. "Probably the most disappointing game of my college career," the Oregon O-lineman said. "A heartbreaking game in so many ways. We had a bunch of guys who stepped up and played great, because we almost got it done. And it basically cost Jerry his job."

It was to be Frei's final game as coach. He was 0-5 in the Civil War. He sought perspective in his remarks to the media afterward. "The game is blown into strange shapes and proportions, but it's still for the young people," he said. "I wanted our people to have the experience of winning this game. It's not to settle a bet, or what the coach wants, or what the alumni want. It's for the younger people."

After the season, Robinson left to go to USC. Defensive coordinator Norm Chapman resigned to go into private business. Athletic director Norv Ritchey, under pressure from alums, suggested Frei fire several of his remaining assistants. Frei refused, announcing his resignation under fire on January 19. Offensive line coach Dick Enright took over. Frei left to become an assistant with the Denver Broncos. Frei, who spent 11 years coaching in the NFL, died in 2001.

"My dad felt the ultimatum by the powers-that-be at Oregon was to sacrifice assistant coaches, just to be able to show some scalps to boosters, who could thump their chests about having some control and influence in the program," said Terry Frei, Jerry's son and a longtime sportswriter for the *Denver Post*. "It was a way to get him, because they knew he wouldn't do it. His resignation letter was genuine. Things had gotten out of control. It wasn't an atmosphere in which he wanted to operate.

"Dad was very disappointed with the Civil War results. He understood the importance of it and the unique nature of the rivalry within the state. He didn't think that necessarily was how you should be defined as a coach. He was disappointed by that. I have always been very resentful of his identification as a coach being 0-5 to the Beavers. That's so shortsighted and

unfair. If you talk to his players and look at the overall situation, there was so much more to the man and his program. To this day it bothers me."

It still bothers Frei's players, too. "Shows what kind of a man he was," Rashad says now. "They wanted him to get rid of his staff, and he wouldn't do it. Such an impressive man. I took to him right away. If I had to do it all over again, I would. Oregon fit me like a glove."

"Jerry said, 'I'll make those decisions,'" Denny Schuler said. "He was a man of stature. It was tremendous he would stand up for his staff that way. Coaches often want to save their own neck, but that wasn't the type of person Jerry was."

What resulted in Frei's dismissal "was brutal, absolutely brutal," Fouts said. "Jerry was one of the finest, classiest men I've ever met, running a program in which we had great pride. He built a great staff. It was such a family feeling. I know it's a cliché, but everybody liked each other. We got along with each other. As a coach, he gave us a feeling that if we did the right things, we would win. Ultimately we did a lot of the time, though we were often underdogs.

"The people in position to make these decisions aren't always right. Time usually proves a number of them wrong. I know it was hard for the alums and fans that we couldn't beat the Beavers, but it wasn't because of the men in charge. We had great coaches."

"I still give crap to some alums in Portland about it," Ken Woody said. "I say, 'You guys put the Ducks in the Ice Age.' Oregon had good players who were dynamic, and when Jerry left, all that went away for a long time. It was like the *Titanic* going down."

The Ducks put to rest their eight-game losing streak, and how, with a 30–3 pounding of the Beavers in the 1972 Civil War game before a Parker Stadium record crowd of 41,544.

"Nightmare Ends for Ducks" read the headline after Dan Fouts ended his college career by finally beating his archrivals.

"The odds were in our favor," Fouts cracks today. "We were going to win eventually."

It had not been a banner season for either school. Oregon State came into the game 2-8. Oregon, in its first season under Dick Enright, was 3-7. The Ducks had lost 68–3 to Oklahoma and 65–20 to UCLA back-to-back in the first month of the season.

"If we were 10-0 and had the Rose Bowl bid wrapped up, losing to Oregon would make our season unsuccessful," Andros said in the week before the game.

"If there is such a thing as law of averages, we have to have a lot going for us," Enright said, echoing what Fouts would say more than 40 years later. "Dee is like the guy playing Russian roulette. He knows there has to be a bullet in the chamber somewhere."

Before Oregon State's final two games, Andros had guaranteed victories. His team had come through with a 26–23 win over California the week before.

"I'm half-right on my guarantee," he quipped. "I know that might fire up Oregon, but I'm not worried about that. I just want to make sure the Beavers are fired up…I'm so fired up, I had to take a tranquilizer this morning."

Andros's guarantee rubbed some of the Ducks the wrong way. "I read where Dee Andros guaranteed Oregon State will win the last two games," Oregon defensive end Greg Brosterhous said. "Just tell him that we want very much to shove those words down his throat."

"This is the most important game of my life," Fouts said. "We are not going to lose to that team…No, it's not a guarantee. It's just the way I feel. That guarantee thing can do nothing but help us."

Oregon State's defensive linemen took issue with Fouts's comments. "Fouts and a lot of the Ducks have talked that way before," Mike Shannon said. "If you'll remember, Bobby Moore made that comment, 'There's no way they'll lose three straight to the Beavers.' Well, they did. They continue to say those things, but until they do something about it, I can't take their talking seriously."

"Fouts is shooting his mouth," guard Lee Nielsen said. "He feels he has to act confident, but I don't think he really is…We know we can knock them off, and if he thinks that, too, they're dead."

"He's lost to us twice," tackle Billy Joe Winchester said. "He's a desperate man. It's his last chance. I respect him for the great athlete he is, but it's the Civil War now. You have to live with yourself if you lose…The key is to get to Fouts, and if we get to him, I think we'll win."

Oregon sports information director Hal Cowan, who would later switch sides to work at Oregon State, channeled his inner Joe Namath with a pregame guarantee: "No one has ever emphasized how close some of those eight straight were, but you can be sure of this: Oregon State won't win any ninth straight."

The Beavers, using their fourth starting quarterback of the season in true freshman Steve Gervais, managed only 179 yards total offense. They fumbled a remarkable seven times in the first quarter, a school-record 11 times in all, losing three of them on a rainy, windy day. The Ducks also had two pass interceptions and blocked a punt for a touchdown.

Said UO freshman linebacker Reggie Lewis, who hounded Gervais and was the game's outstanding defensive player: "What got me going was Andros guaranteeing they were going to win the last two. I wouldn't do that for any team, even USC. You can't tell the outcome of a game until you play it."

The game's big story, though, was the performance of UO sophomore tailback Donny Reynolds, a Corvallis native. Reynolds, a prep teammate and close friend of Mike Riley, Bud's son and the current Oregon State coach, wound up at Oregon primarily to play baseball. Had it just been about football, he said it would have been different.

"The Beavers recruited me as hard as anybody," said Reynolds, 61, who lives in Portland and works as a scout for the Arizona Diamondbacks. "Dee picked me up at school several times my senior year. I rode in that orange and black Oldsmobile 88 [known as the "Pumpkinmobile"] that he drove. Bud Riley was my contact, and you know how I felt about the Riley family. But Gene Tanselli was Oregon State's baseball coach, and he never said a word to me. Not a word. I'd come up and he'd instantly stop talking, turn around and walk away. I think he was a racist. If he'd have even said, 'I'll give you a chance to make our team,' I'd have gone to Oregon State. I would have been a Beaver.

"I liked Dee a lot. Their offense was the same offense we ran in high school. It would have been hard to walk away from that whole group there. I felt very welcomed being around those guys in the football program. All the people were great at Oregon State, with one exception."

Reynolds signed a letter of intent to play baseball for Mel Krause and thought he was done with football. But after the Oregon Shrine All-Star football game that August, Jerry Frei came into the North locker room and told Reynolds, "I'd consider it an honor if you'd play for our freshman team."

"That shocked me," Reynolds said. "Then Mel told me, 'If you don't play this year, you'll be making a mistake.' He talked me into going out for football."

Reynolds played both ways, returned kicks and "pretty much played every down" for the UO Frosh, earning the Len Casanova Award as the team's top player during Frei's last season at Oregon. He later started at tailback for most of three seasons for the UO varsity, the first two under Dick Enright.

Unlike many of the Ducks of that era, Reynolds preferred Enright over Frei. "I liked Dick," Reynolds said. "He did a good job in a bad situation. He was trying to bring together a disjointed group of guys. We had a star

system there when I was a freshman. It didn't seem like there was a lot of camaraderie to me. Dick tried to create more unity, a team approach. He thought it was important that we begin to unify the two sides of the ball. Jerry had talked a lot about moral victories. I don't know if you ever have a moral victory. I remember guys joking about that.

"Enright was trying to change the culture. He was young and exuberant. He had just become a Christian and was high with that feeling, trying to help us all find the good news. I don't know if all the guys bought into it, but Dick was a real positive guy. His heart was in the right place."

Fred Manuel agreed that Enright "was a good person."

"He wasn't as hands-on as Jerry had been," the linebacker said. "He brought a lot of kids in from Southern California. He catered to them. Since I wasn't from Southern California, I didn't get much of his attention, but I didn't want it. I was cocky and arrogant enough to think I didn't need him to validate me. I just went about my business."

Tim Stokes had worked often with Enright when he was offensive line coach. "He was really good with the O-line," Stokes said. "He was ahead of his time there. He took over as head coach in a tough time and a tough situation. He was over his head in some ways. But I know he really helped me as a player, and I always thought he had a real, genuine interest in his players."

Receiver Greg Specht, who played for Enright as a senior at Oregon, had been on the selection committee that chose him as Frei's successor. Specht agreed with many of his teammates who spoke badly of Enright but didn't want to go on the record. "We had quite a list of capable assistants on Jerry's staff who went on to bigger and better things, and we ended up with Dick Enright," Specht said. "I remember thinking, No. 1, why in the world do they have students on the selection committee? And No. 2, this isn't the guy we want. He was just a big blowhard. I never wanted anything to do with him."

Frei, Specht said, "was the best. Great coach, better person. He'd get mad. He'd grimace, his eyes would tilt sideways and he'd look at your upper left forehead. But he never ranted and raved like Enright would."

Dick Enright would cringe at Specht's assessment. He believes during his time at Oregon—from 1970 to 1972 as Jerry Frei's offensive line coach and then as head coach in 1973 and '74—he had an excellent relationship with his players. "I was an X's and O's guy," Enright said in an interview for this book in December 2013 from his home in Fallbrook, California. "It was a gift. And the kids liked me."

Enright had come to Eugene after a successful high school coaching career in Southern California. A starting offensive lineman at Southern Cal in the mid-1950s, he had gone into private business for a spell and then become an assistant coach at his alma mater at Gardena (California) High. He soon became co–head coach, winning a city title in 1964, and after taking over the program, "we shut out the whole league" in 1969, going unbeaten and outscoring the opposition 177–0.

"I didn't know Jerry at all," Enright said. "What a great guy. The reason I got the job was John McKay. Jerry and John were good friends. Jerry wanted someone who could recruit Southern California and coach the [offensive] line."

Enright said on the first day of spring practice during his first year at Oregon, it started raining hard. "I asked one of the other coaches, 'We're going to go in, right?'" Enright said. "He said, 'We're never going to go in because of a little rain.' That was my first shock."

Enright said one day shortly after the end of the 1972 season, he got a call from Frei asking to come by his house. "I'm going to resign, but I'm not going to tell the other coaches until tomorrow. You have to keep it a secret,'" Enright said Frei told him. "I loved this guy. I begged him not to resign. He said he was exhausted and couldn't take it anymore. His father had died. And there was alumni pressure he was dealing with."

It was the Vietnam era. There was plenty of student unrest on what was considered a very liberal campus. "There were so many interesting things about Oregon when I got there," Enright said. "Things there were so strange. I'd never seen anything like it, other than the government we have now."

Why did Frei confide in Enright with his decision to resign? "He said, 'I think you should apply for the job,'" Enright said. "He said, 'The other coaches are tied into me. You're new. And the alumni really like you, speak highly of you.'"

Enright said he had made big changes during his time as an assistant, in his coaching of the offensive line and use of his personnel. He said he handled things differently than his cohorts on the road. "We'd go on a trip, and a lot of coaches would be in the bars," Enright said. "I'd be out by the pool with my linemen, and we'd go over assignments. We made no mental mistakes. I changed the line that first year. The guys who had been first string were now second team. Our line was really good. The alums saw that."

Enright applied for the job and got it. "Two years removed from high school," he said, and only 38 years old. In retrospect, Enright says he wasn't ready, "but you're not going to turn down the job if they offer it to you."

He didn't respect the man who hired him, athletic director Norv Ritchey. "Nice guy but maybe the weakest person I've ever been around," Enright said. "I still have dreams about McArthur Court. Norv had an office and hid out in there. [Basketball coach] Dick Harter drove him crazy, wanting stuff. Norv was afraid of him."

Enright said he made $14,000 his first year as head coach, $16,000 his second year. The entire annual recruiting budget, he said, was $22,000. "Oregon spends that much in an hour today," Enright said.

Those years, he said, "Harter got $55,000 [for recruiting] for basketball."

"The first year, we spent only $20,000 because I got hired so late," he said. "[Assistant coach] John Marshall and I were the only ones recruiting. We still got a great recruiting class. We wound up starting eight or 10 as freshmen that first year. Most of them were players the power schools didn't want. We knew we couldn't recruit against USC in those days. Now [the Ducks] can, with all the money that has poured in there."

Enright said he wanted to hire Iowa State defensive coordinator Jackie Sherrill, later to be head coach at Washington State, Pittsburgh, Texas A&M and Mississippi State. "My idea was, I'd take his salary, he'd take mine and he'd run the program," he said.

"But I had no money to pay coaches," Enright said. "I didn't ask for much, and I didn't get anything. In our little tiny coaches' office, there were broken tiles on the floor, no drapes. My high school had better facilities. Our situation was terrible. It was Mickey Mouse. There was a graveyard across the street. To bring recruits in there and try to sell them on coming was…

"I gave all my season tickets away for a guy to put carpet and drapes in. Harter got everything he wanted from Richey. I was there one day and heard Harter tell Norv, 'Listen, you SOB, there better be carpet in our dressing room or I'm going to expose what a chicken you are.' Guess what? [Harter] got everything he wanted."

Enright said Richey didn't expect Oregon to contend for a Pac-8 championship—in football. "I was surprised when Norv said, 'You don't have to go to the Rose Bowl. Just win some games. In basketball and track, we can maybe do some really big things,'" Enright said.

It didn't take Enright long to learn about the Civil War. His first year at Oregon in 1970, he was in for an awakening as the Civil War loomed. "I'd never seen anything like it," Enright said. "[Defensive coordinator] Norm Chapman was a tough, fiery, great guy. You cut him, he bleeds yellow and green. He gets up in front of the team and goes, 'It's Beaver Week.' It's like a

big storm coming, and all of a sudden, he goes crazy. 'Those effing Beavers, we're going to kill them.'

"At USC, we pretended like we had a rivalry with UCLA, but we all went to parties together. In Oregon, people go crazy. You could feel it the whole week. There was tension everywhere. And hatred."

Enright saw it in his neighborhood. "The guy right across the street was a Beaver fan," he said. "His house was painted orange and black. I'm sure he got as much as he gave."

After he became head coach, Enright became more acquainted with OSU coach Dee Andros. "I liked Dee, I really did," Enright said. "He was funny. I didn't hate him. How could you hate Dee Andros? We'd go on the stage [at a pre–Civil War luncheon], and people would think we were a comic act. I was the straight man. But all the time, I was thinking it's just a game. I told Dee, 'It's not life or death.' He said, 'It is for our families, for our kids.' I guess he was right."

But when he was head coach, "I made up my mind I wasn't going to approach it that way," Enright said. "You put too much pressure on yourself and the kids. You're tying yourself up in knots. Hey, it's just another game."

Donny Reynolds began his sophomore season as fourth-string tailback but worked his way up quickly. After busting a 32-yard touchdown run at slotback in loss to Washington State at midseason, he became the starter at tailback.

The bus ride from Eugene to Corvallis was surreal for Reynolds, who grew up across the street from Parker Stadium, where Reynolds had played his home games at Corvallis High and starred with Riley on the Spartans' 1970 state championship team.

"It was the strangest feeling driving into Parker but now not as the home field," he said. "It was sad. That had been my home field for a lot of years. Now I'm the enemy. That week practicing for Oregon State was hard. I knew some of those guys, like linebackers Steve Brown and Butch Wicks. Butch scared the life out of me. I was more terrified of him than anybody. Brown was a great linebacker, but he'd just tackle you; Butch would knock your head off."

It was a tradition at Oregon State that Coach Dee Andros would lead his players onto the field before every game. Enright decided to follow suit. "Dee was slow," Enright said. "He was really heavy. I had run the hurdles in high school. I was really fast for a lineman. I told the guys, 'I'm going to show how you really should be led out.' Out the door we go, it's cold, and

I'm out in front of them. And then I pull a groin muscle. It's like somebody shot me. I didn't go down, but I'd ripped something in there. It took me a full five years to get over it, because I was trying to show Dee up. That's what you get for showing off."

It was a nasty weather day. "I'd never seen rain like that," Enright said. "There had to be an inch of water on the field. There was so much water, [the Astroturf] wasn't green, it was like Boise State's blue field."

That didn't affect the hometown kid. On the first play from scrimmage, Reynolds went up the middle on a counter play for 60 yards, a touchdown and a 7–0 lead before the blink of an eye. "I trapped the inside linebacker, Steve Brown," tackle Tim Stokes said. "Couldn't believe how open Donny was. You don't see that very often."

"We were just going to hand off and establish the running game," Reynolds said. "My goal was to get to the hole as quick as I could before [defenders] could move. I hit it hard, something popped and I was in the clear. I was as shocked as anybody."

Such were his feelings for the Beavers that he now admits to having mixed emotions then. "I'm happy to score for Oregon, but I'm looking into the stands at people I know," he said. "I wasn't euphoric like you might think. This is my home field, and I have people rooting against me, yelling at me as I walk on and off the field before and after the game and at halftime. That's not the way it should be."

Reynolds's run started a banner day for the Ducks. Fouts, playing the final game of his college career, completed only seven of 20 passes for 120 yards, but one was a 65-yard bomb to Greg Lindsey for a second-quarter touchdown. Hugh Woodward kicked three field goals, and Tim Guy blocked a punt and recovered it in the end zone on the final play of the first half to give Oregon a 27–3 lead.

"We didn't approach this game any differently than the rest of our schedule," Enright said afterward. "Basically, we talked about hanging onto the football. We thought they would drop it and they did. We didn't. We beat them on their field under their kind of conditions. We beat them at their game. I wish Jerry Frei were here. This one was for Jerry. My heart was with him. He has been on my mind all week. He got most of these guys here and he's still part of the team."

Reynolds, who finished with 79 yards on nine carries, said he was happiest for Fouts. "It made him go out a winner as a college player," Reynolds said. "For me, it was different. I was just going out there with a chance to play in front of people I knew in my home stadium, a lot of guys wearing orange

and black I had a huge respect for. It was a great honor to play against the Beavers and all those coaches—Dee Andros and Rich Brooks and Sam Boghosian and Bud Riley and Ed Knecht—who I had worshipped as a kid. When we won, it was great."

Oregon rushed for 206 yards and negotiated the wet, sloppy field much better than Oregon State. Enright gives Oregon track and field coach Bill Bowerman—"a giant of a man"—an assist. Bowerman and Phil Knight had just created Blue-Ribbon Sports, soon to be Nike. Bowerman provided the Ducks with some waffle-sole shoes to deal with the weather.

"Some of the linemen tried to wear them, but they'd rip them out," Enright said. "But the backs loved them, they were so light. On artificial turf when it was wet, they would hold. Oregon State's guys were falling down. Our guys were like walking on water. Those shoes really helped."

With the Ducks employing an eight-man front and blitzing often, Gervais was sacked for 78 yards in losses, and the Beavers finished with 46 net yards rushing.

"It was raining like crazy," Fouts recalls, "and one of the yard markers was washed away. I was forced to run and got to the sideline. I was clearly out of bounds, got clipped and knocked off my feet and slid. I caught my neck on the bench on the Beaver sideline. I was shaken up a little bit. The first guy to come over to see if I was OK was Dee. He had about 12 towels around his neck. I grabbed one to dry my hands and face. I was soaked. He's asking me if I'm OK, and I'm saying, 'Thanks, coach.'"

Brown had been flagged for an unsportsmanlike conduct penalty for a late hit on the play. "Fouts is a class guy," Brown said after the game. "They called me for a cheap shot when I hit him out of bounds—hell, you couldn't see the sidelines—but Dan knew. Oregon earned the win, but it's going to take a while to live again."

"The fact we scored the first play of the game set the tone," Fouts says today. "In really bad weather like that, it helps a passing game more than you'd think. It's hard to generate much of a pass rush, and if you can find a dry spot on the ball, you can throw it. I was able to hit Greg for the one bomb."

Near the end of the game, Oregon was deep in OSU territory when Fouts broke a foot. "Some big, fat Beaver fell on the back of my feet," he said. "It was disappointing. It cost me a couple of all-star games, and who knows how it affected my status in the draft.

"The win was a year late for a lot of us because of what happened with Jerry. Losing Jerry set the program back for a number of years. But I

was glad we got off the schneid. Eight in a row was pretty embarrassing. Having lost two of them and contributing mightily to one of the two, it was absolutely sweet."

After the game, Fred Manuel followed cigar-chomping teammate Chuck Bradley into the locker room and shouted, "Where's the champagne? I wanna hear the cork popping."

"I remember it felt like winning the Rose Bowl," Manuel, who had an interception in the game, says today. "It was long overdue."

"It was this burden being lifted after having lost to them for eight straight years," Specht said. "It was a very satisfying end to a very ugly season. We had much higher expectations than 4-7."

Even so, Enright was on top of the world, if only for awhile. "I could have run for office after that game," he said now. "I could have been governor after we'd won. The next year, I couldn't have."

Fouts, 63, lives in Sisters, Oregon, and continues to serve as a TV analyst for NFL and college football. "The Civil War is such a great rivalry," Fouts said. "I've been lucky enough to broadcast it a few times. It's unique. Such a small state. You're a Duck or a Beaver, one or the other. And I can tell you, I'm proud to be a Duck."

Dick Enright was to last one more season at Oregon. The Ducks lost 17–14 to Oregon State in Corvallis to finish 2-9 in 1973. "We had no depth, and we didn't have Fouts anymore," Enright said. "Some of the kids we recruited were from losing programs. You can find diamonds in the rough, but they had gotten used to losing. Even though I was a great high school coach, I had no [college] playbook. Another mistake I made: I listened to my assistants. In high school, I called all the shots."

Enright said he was undercut by a couple of his assistant coaches, including the man who succeeded him as head coach—offensive coordinator Don Read. "There are guys who are burning to be head coaches," Enright said. "I had been one of them. I had people laying track on my job. I was torpedoed. I was stabbed in the back. It was Read and [Jesse] Branch [a defensive coach]. They weren't loyal. Don wanted the job, and he laid track. He was mad at me because Jesse and the defensive people wanted to move him to the offense and move Don to the defense. He got wind of it and begged me, 'Don't do this to me; this will embarrass me.'"

Read served as coach of quarterbacks and receivers both seasons. Branch moved from coaching the defensive backs in '72 to offensive coordinator and running backs in '73.

Besides Enright, all those at Oregon at the time who were interviewed for this book deny he was undercut by any of his assistants. Read, now retired and living in Corvallis, said he didn't want to get into a verbal sparring match with Enright over his comments. After some prodding, he said this: "I feel bad he feels that way. My experience with Coach Enright was positive. He was a good coach. He was a terrific assistant coach. He was not ready to be a head coach. He was let go. They asked me. I took the job. But as far as me campaigning or back-stabbing him, that's ridiculous."

The thing that Enright remembers most about his time in Eugene was his conversion to Christianity. "I was an atheist who hated Christians," he said. "My wife was the first to find Christianity, and then me. I was not as good a coach after I became a Christian. Before that, football was my god and I was my wife's god. She found another one, a better one. Then I found him. She had everyone in Eugene praying for me to become a Christian."

After leaving Oregon, Enright coached a year in the World Football League and then a year as offensive line coach for the San Francisco 49ers before returning to the prep ranks, where he coached 18 years at Capistrano High in Mission Viejo, California, retiring in 1997. One of his players there was quarterback Todd Marinovich.

Enright thinks the passion people have in Oregon for the Civil War is overdone. "I think it's too much," he said. "What's really bad—and they almost ought to be ashamed of themselves—is they split families over that game. What I saw was not normal. I don't know if it's still that way. I guess when you go eight years losing [in the Civil War], things are going to build. It's building at Oregon State right now. It would be better if the teams split every year."

Enright has not set foot in the state of Oregon since leaving four decades ago. "I can't go to Oregon because of what happened," he said. "I have bad feelings. I was treated wrong. I'm not for Oregon when [the Ducks] play. I don't have any feeling for Oregon. I do like Phil Knight. I like what he did for the university. They ought to rename that school Nike University. I like him best of all the things in Oregon."

Enright, married to his high school sweetheart, Jean, for 58 years, turned 80 in May 2014. "I feel like I'm 40, except for my knees," he said. "I have a great life. Always remember: Happy wife, happy life."

Norm Van Brocklin, one of the greatest quarterbacks in Oregon history, was also an outstanding punter. Van Brocklin, known as "Dutch" or "Stub" to his teammates, was 2-0 in Civil War games and led the Ducks to the 1948 Cotton Bowl. *Photo courtesy of University of Oregon.*

Following pages: Oregon State coach Lon Stiner (center front) is surrounded by players on the train ride back from Durham, North Carolina, where the Beavers beat Duke 20–16 in the famed transplanted Rose Bowl game in 1942. *Photo courtesy of Bud Ossey.*

When Len Casanova retired as Oregon's head football coach in 1966, he was the winningest coach in school history. "Cas," revered by those who coached with and played for him, was only 4-10-2 in Civil War games, though. *Photo courtesy of University of Oregon.*

Bud Ossey watched his first Civil War game in Corvallis as a five-year-old in 1924. Ossey, ninety-four, hasn't missed many in Corvallis since. Ossey, a 1943 OSU graduate, is widely considered the Beavers' number-one fan. He comes from a divided household. His eldest son, Dick, is an OSU graduate; sons Bob and Don are Oregon grads. *Photo courtesy of Bud Ossey.*

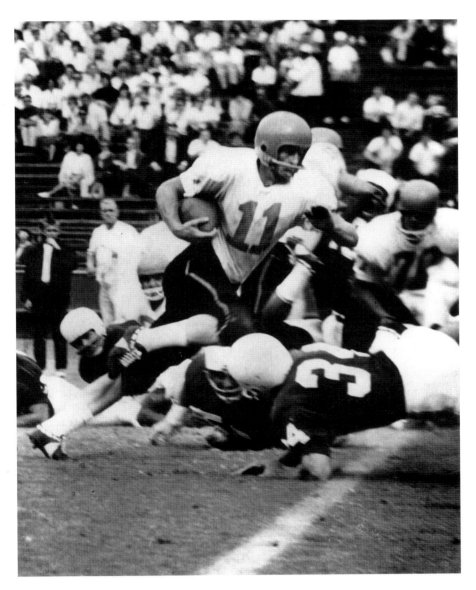

Terry Baker motors for real estate on a bootleg during his senior season at Oregon State. Baker, who was 2-0-1 in his Civil War contests, won the 1962 Heisman Trophy and was the No. 1 pick in the 1963 NFL draft.

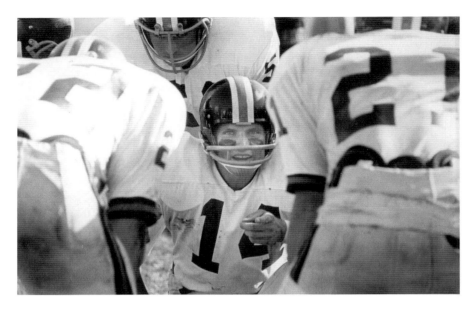

Quarterback Steve Preece calls a play as Oregon State's 1967 "Giant Killers" squad huddles up. Preece's teams went 3-0 in Civil War games of the late '60s. *Photo courtesy of Billy Main.*

Dee Andros charges out ahead of the Beavers onto the field prior to the 1970 Civil War game at Parker Stadium. The "Great Pumpkin," who traditionally led his players onto the field before games, was 9-2 in Civil War contests from 1965–75. *Photo courtesy of Craig Hanneman.*

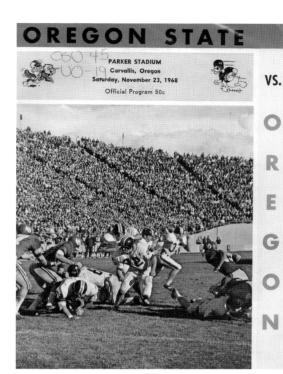

OREGON STATE

PARKER STADIUM
Corvallis, Oregon
Saturday, November 23, 1968

Official Program 50c

VS.

O
R
E
G
O
N

Left: The cover of the game program for the 1968 Civil War game at Parker Stadium. *Courtesy of Billy Main.*

Below: Legendary Oregon quarterback Dan Fouts passes over Oregon State's Jim Sherbert (90) during the 1970 meeting of the rivalry. Fouts, who went on to a Hall of Fame career with the San Diego Chargers, lost his first two Civil War games but won in 1972 in the final game of his college career. *Photo courtesy of Craig Hanneman.*

Left: Ahmad Rashad, known as Bobby Moore during his playing days at Oregon, was among the most talented players to ever wear the Ducks' green and yellow. Rashad was 0-3 in the Civil War from 1969 to 1971, though, saying, "It still bugs me that I was never able to beat Oregon State." *Photo courtesy of University of Oregon.*

Below: Oregon State's Craig Hanneman (left) accepts congratulations from Oregon coach Jerry Frei after the Beavers' 24–9 Civil War triumph at Autzen Stadium in 1970. *Photo courtesy of Craig Hanneman.*

Above: Rich Brooks gets a ride off the field at Parker Stadium after Oregon's Civil War victory in 1994 as the Ducks made it to the Rose Bowl for the first time since 1958. "Big Daddy" owned the Civil War. His overall record in the rivalry was 22-3-2—2-0-1 as a player and 6-0 as an assistant coach at Oregon State and 14-3-1 as head coach at Oregon. *Photo courtesy of University of Oregon.*

Left: Joey Harrington, shown throwing a pass with Oregon State's Kyle Rosselle (97) in pursuit, was 2-1 as a starter in Civil War games. Harrington, who would finish fourth in Heisman Trophy balloting and become the third pick in the 2002 NFL draft, said the Civil War "is passionate, and it's real." *Photo courtesy of University of Oregon.*

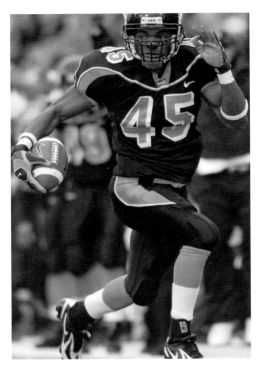

Oregon State linebacker Derrick Doggett returns an interception 34 yards for a touchdown in the Beavers' 30–28 win in the 2006 Civil War contest at Reser Stadium. Doggett had a pick-six in OSU's 38–31 double-overtime victory in the 2007 game at Autzen Stadium. *Photo courtesy of Oregon State University.*

Oregon's Josh Huff celebrates after scoring the winning touchdown in the Ducks' 2013 Civil War victory at Autzen Stadium. Huff caught nine passes for 186 yards and three touchdowns in the final game of his college career in Oregon's 36–35 victory. *Photo courtesy of Ryan Kang/Emerald Media Group.*

CIVIL WAR GIANTS: ANDROS AND BROOKS

When you get what you want, in your struggle for self, and the work makes you
king for a day.
Just walk to the mirror and look at yourself, and see what that man has to say.
For it isn't your father, or mother, or wife whose judgment upon you must pass,
The fellow whose verdict counts most in your life, is the one staring back from
the glass.
You may be an A student, or an all-state plum, and say "I'm a wonderful guy,"
But the guy in the glass says "You're only a bum if you can't look him in the eye."
He's the fellow to please, never mind all the rest, for he's with you right through to
the end.
And you've passed your most dangerous, difficult test if The Man in the Glass is
your friend.
You may fool the world down the pathway of years, and get pats on the back as
you pass,
But your final reward will be heartaches and tears if you cheated The Man in the
Glass.
—Peter Dale Wimbrow Sr., "Man in the Glass," 1934

In the beginning, there was "The Great Pumpkin." Along the way, he begat "Big Daddy."

The impact that Dee Andros and Rich Brooks had on the Oregon–Oregon State football rivalry reaches almost biblical proportions.

Andros, who coached at Oregon State from 1965 to 1975, was 9-2 in Civil War games and coined the phrase "for the right to live in the state of Oregon." Brooks played at Oregon State, coached under Andros at his alma mater and then was head coach from 1977 to 1994 at Oregon. His overall record in the rivalry was 22-3-2—2-0-1 as a player, 6-0 as an assistant coach at OSU, 14-3-1 as head coach at Oregon.

Neither coach enjoyed overall success in terms of win-loss percentage. Andros was 51-64-1 as a head coach at Oregon State. Brooks was 91-109-4 as a head coach at Oregon.

They knew how to win the Civil War, though. Coupled with their success in that game, the love and respect they commanded from those who played for them is unparalleled.

"There will be great coaches in the years ahead at both Oregon State and Oregon," said Craig Hanneman, a defensive tackle who had Andros as head coach and Brooks as position coach during his time at Oregon State. "But there will never be anyone like those two."

Demosthenes Konstandies Andrecopolous was a Greek-blooded, Oklahoma City–bred marine who enjoyed slices of life by the belly full. A marine corps sergeant in World War II, he won the Bronze Star for valor in the Battle of Iwo Jima in 1945.

"For heroic achievement in connection with operation against the enemy while serving with the Marine Corps Infantry Battalion on Iwo Jima volcanic island," the citation read. "Field Cook Andros volunteered for two combat patrols against enemy resistance. As a member of these patrols, he acquitted himself with distinction in the face of accurate machine gun and rifle fire."

Andros had volunteered for the marines out of high school. "He did his basic training in San Diego, then was shipped to Hawaii for some advance training," said his longtime Corvallis friend Paul Marriott. "His first combat action was at Iwo Jima, the worst spot you could have been in the whole damn war. The normal turnaround for a guy there was three to five days. Dee was there 31 or 32 days."

Andros's regiment, the storied 28th of the fifth Marine Division, had landed with the third wave in the assault on the powerful Japanese military power. In more than 6,500 strategically placed bunkers, rifle pits and mortar and artillery emplacements, 22,000 Japanese troops sat in waiting, ready to force the invading Americans, through slaughter, back into the Pacific.

Though Andros, then 18, was a field cook, he would cook nothing over the five weeks it took to secure the tiny island. The 30 members of the 28th

Regiment had been told to expect the worst, that every man would be needed in combat once they were ashore. What food they ate came from tin cans.

"Our regiment's assignment was to take Mt. Sarabachi," Andros told the *Corvallis Gazette-Times* shortly before his death in 2003. That's the spot where the famous photo of four soldiers raising the American flag was taken.

"They gave me a box of hand grenades and told me my job was to get the box ashore," Andros said.

The grenades never made it. As the regiment approached their destination, fire from the enemy exploded everywhere. All around, marines were screaming and dying. "When we touched the beach, I ran like hell for cover," Andros said. "I realized either me or the grenades weren't going to make it. So I threw them away."

An explosion behind Andros caused him to turn around and look for an instant. The landing craft that had carried the U.S. soldiers to the beach had received a direct hit from an artillery shell. It was gone, along with the coxswain.

"As soon as we hit shore, I knew the Japanese were playing for keeps," Andros said. "There was no safe place anywhere."

Less than a day after the 28th and three other regiments had landed, more than 2,300 had been killed or wounded. At one point, Andros's commanding officer told him and two other soldiers to go to the beach for water. As they proceeded, two of them took direct hits from an artillery shell.

"They were not two feet away from me," Andros said. "I didn't know what had happened. I yelled, 'Let's go, Lump,' but he was dead."

Andros made it back and said he followed all orders, never questioning anything he was told during the entire campaign. He volunteered for any job that had to be done, serving as stretcher-bearer, infantryman, runner and lookout. As stretcher-bearer, he had to pick up the wounded and the dead. "We would pick up a head here, an arm there," Andros said. "And the chaplain would say a few prayers as comfort, mostly for us, I guess."

After the flag-raising on Sarabachi, Andros's regiment and the rest of the Fifth Marine Division was assigned to assault the network of caves and bunkers that sat farther up the island.

"Dee didn't like to talk about it," Marriott said. "It was pretty severe stuff. He once told me the thing that really turned the battle for them were tanks that were converted flame-throwers. They could waltz in and hit the nucleus of Japanese."

Of the 200 men in his company who initially stormed the Iwo Jima beach, 40 survived. Andros always considered himself "lucky as hell" to have made it alive.

Andros was a starting guard at Oklahoma, first under Jim Tatum, who later won a national championship at Maryland, and then the legendary Bud Wilkinson, who won three national championships and coached Oklahoma teams to a 47-game win streak. Among Andros's Sooner teammates were Darrell Royal and Jim Owens, whose later success as head coaches at Texas and Washington, respectively, was considerable.

As a senior, Andros was named to the "Greek All-America team."

"There were 12 Greeks playing college football that year," the self-deprecating Andros loved to say. "I beat out one of them."

After serving assistant coaching stints at Oklahoma, Kansas, Texas Tech, Nebraska, California and Illinois, Andros's first head coaching job was at Idaho. In 1964, the last of his three seasons there, the Vandals gave Rose Bowl–bound Oregon State a scare before succumbing 10–7 at Corvallis. That caught the eye of OSU athletic department officials. When Tommy Prothro left after the Rose Bowl to take a job at UCLA, Andros was hired by athletic director Slats Gill.

Andros, a roly-poly figure if there ever was one, usually wore an orange windbreaker during games. The Great Pumpkin was a character in the popular cartoon series of the day *Peanuts*. After a game against Washington State during his first year at Oregon State, Spokane, Washington sportswriter Harry Missildine referred to Andros as "The Great Pumpkin." The nickname stuck.

Andros could poke fun at his girth. As he took to the Civil War rivalry, he liked to say, "The Ducks make my stomach hurt. And when the Punkin's stomach hurts, I'll guaran-damn-teeya, he's sick all over."

It became traditional for Andros to lead his players onto the field with a great charge before each game. Even at the beginning of his time at OSU, Andros's 40-yard dash was timed with a sundial. As the years went on, he slowed down even more. It became all the players could do to be slow enough not to trample him on the way to the bench.

After a 5-5 first season in 1965, Andros's Oregon State teams enjoyed five straight winning campaigns. From 1966 to 1968, the Beavers were 21-8-1 and ranked among the nation's top 20 each year. Andros's early teams featured a "Power-T" offense with a full-house backfield and powerful fullbacks such as Pete Pifer, Bill "Earthquake" Enyart and Dave Schilling. The defenses used a six-man front and were tough and physical.

The 1967 "Giant Killers" started arguably the most memorable month in Oregon State football history with a 22–14 upset at No. 2–ranked Purdue.

Two weeks later, the Beavers tied then No. 2–ranked UCLA 16–16 at Pasadena, with a conversion attempt bouncing off the upright. The next week, with Andros proclaiming, "We're tired of No. 2, bring on No. 1," the Beavers upset top-ranked Southern Cal 3–0 at Parker Stadium in Corvallis.

Andros's fortunes at OSU gradually diminished, the result of inadequate facilities, the loss of several key assistants and a black walkout at the school during the tumultuous times of the late 1960s that left it difficult for him to recruit quality African American players. The walkout was inspired by a 1968 incident involving Andros and a linebacker, Fred Milton, who chose to wear a Van Dyke goatee during the off-season. Andros's rules included no facial hair year-round by any of his players.

"The Fred Milton incident set Oregon State football back 20 years," said Bill Enyart, Andros's great fullback in 1967 and '68. "It was an unfortunate thing. Dee wasn't racist. He was a disciplinarian. We all had short hair and no facial hair. But the changes were coming in society. Young people were challenging authority. The country was lightening up in terms of physical appearance. Dee didn't see the train coming on that one. He was an anachronism. He missed out that the times were changing. And the Beavers found themselves unable to recruit black athletes for awhile."

Mel Easley was a defensive back from 1967 to 1969 who epitomized the toughness Andros implored. During the school's black walkout, when most of the African American students left school, Easley remained.

"Bryce Huddleston and I were the only brothers who stayed," Easley said. "The walkout, it bothered me. We were a team. I disagreed with that. There could have been some compromise. Coach Andros put his foot down, and that's the way it was. But I loved Dee."

Somehow, Andros was still able to get victories over archrival Oregon. He won his first seven Civil War games, lost in 1972 and then won two more before losing his final one in 1975. Other than in his first season, Oregon State always played ranked opponents and teams of national prominence. No matter what, Oregon was Andros's No. 1 priority.

"It was the ultimate game every season, regardless of who they were playing," recalled Jeanna Andros Baker, the only child of Dee and Lu Andros. "He always said it was the game for the right to live in the state of Oregon. It was the last game of the season, and he wanted his team to go out winners. He felt very strongly about it.

"At his funeral, Steve Preece said, 'He hated the Ducks.' I called the athletic department the next day and said, 'No, he didn't hate the Ducks. He had a lot of great friends who were Ducks. He just hated the Ducks one day a year.'

"And I don't know if hate's even the right word. My father wasn't a hateful person. It was for pride, it was for bragging rights, and he always wanted very badly for his boys to win that game."

Andros enjoyed a very good relationship with most of the Oregon coaches he went up against, including Len Casanova, Jerry Frei and Don Read. "My dad and Dee were genuinely friends," said Terry Frei, Jerry's son who is a sportswriter for the *Denver Post*. "Nobody understood that. It was no act. Part of it was, they both had been in the South Pacific during World War II. They had a lot in common."

"After I was hired at Oregon, we'd often talk on the phone, and we had a friendship through the years," said Read, as assistant at Oregon under Dick Enright in 1972 and '73 and the head coach from 1974 to 1976. "Of all the guys I met in the coaching business, he was one of the five or six guys I'd put at the top.

"When I was at Portland State, I'd go to clinics in Corvallis and just spend time talking with him. It wasn't that you got so much football out of him, but you got a lot of ideas about management skills and motivational stuff and camaraderie—the kind of things that are so important in football. He was a master at that. It was genuine."

Early in his career at Oregon State, Andros explained his emphasis on the Civil War this way: "When I was hired by Slats Gill, he told me, 'Dee, be sure and do one thing—beat the Ducks.' I took him to his word."

During the week leading up to his final Civil War game in 1975, Andros embellished his thoughts. "I coached in the Cal-Stanford game and was involved with Michigan-Illinois and Kansas-Missouri, and I played and coached in Texas-Oklahoma," he said. "Hell, those were games. This is war. The whole dang state is involved. Any place you go there's a Duck living next door to a Beaver and the guy who wins is going to be a nasty neighbor all year. I've won nine out of 10 and I'll guarantee you the worst year I spent was the one after we lost to the Ducks.

"What makes this game different is the way the state chooses up sides. Technically, we go into it like any other game and usually it's decided by the breaks. There have been damned few times when either of us had an edge in personnel. I can only remember once thinking we were clearly better. That was 1967, and we were down 10–0 at half."

Steve Preece was the option quarterback for Andros's best teams from 1966 to 1968. The Civil War "was the only game, really," Preece said. "We were prepared for all of our games, but nothing like we were for the Ducks. We

were the farm kids from places like Grants Pass and Turner and Aumsville. They were the spoiled city kids from San Francisco. You got so you hated the Ducks big-time. The guys from my era still feel that way about Oregon. The Ducks have the upper hand now, and the guys will grind their teeth and say, 'How can we lose to the Ducks?' We considered beating Oregon more important than SC and UCLA and Purdue."

"The part that stuck in my head was there was no losing that game," said fullback Pete Pifer, who played on Andros's first two OSU teams. "I don't care what, you were not going to lose that game. You just felt that. It was that important to everybody. It was communicated in lots of ways. But it sure as heck was communicated by Dee."

Andros's homespun demeanor was no act. He had the rare quality of connecting with all types of folk, which nearly all those who played for him and worked with him will attest to.

Hal Cowan was the first man Len Casanova hired when he became athletic director at Oregon and the first employee Andros brought on when he became AD at Oregon State. Cowan served seven years as sports information director at Oregon, 28 years in the same department at Oregon State. "There were four guys in the coaching profession I was around whom I would put in the very top class as human beings—Cas and Don Kirsch at Oregon, Dee and Mike Riley at Oregon State," Cowan said. "If you didn't like those guys, something was wrong with you."

"I loved Dee to death," said Paul Brothers, a quarterback who started his career playing for Tommy Prothro but played his final two seasons under Andros. "He was a funny man. It was always great to listen to him talk. He truly loved his players. He was way more open than Tommy was."

The shift from Prothro's balanced offense to Andros's option-oriented Power-T attack wasn't suited for Brothers's skills. "It was not the style of football I liked," Brothers admitted. "I wish he would have been more of a passing coach. Didn't work out that way. I had to become more of a runner. I'd done a lot of running under Tommy, but Dee had me run the option. In defending that, some teams target the quarterback and rip your head off. That was a learning experience for me. I'd get hit just about every play. I had to learn how to duck better. But we had success, and it didn't affect the way I felt about him. He was a beloved Beaver to the end."

Defensive tackle Craig Hanneman had scholarship offers from Oregon and Washington State, but during the recruiting process, "when I met Dee,

it was all over. You couldn't find a more genuine, authentic human being. He was the real deal, a pretty uncomplicated guy. He was just himself.

"We were a little different than the teams we played. He was old-school offense, old-school defense. The game is about blocking and tackling, and he kept it simple. We had coaches like Bud Riley, Rich Brooks, Sam Boghosian—you don't find better assistants at the college level. Those guys were really good at taking small-school athletes and making them decent players. There was nothing fancy about it. It was about doing the same thing over until you got it right. We played with a lot of enthusiasm and esprit de corps."

"It was an honor to play for Dee because of the integrity and discipline he portrayed," said Butch Wicks, a linebacker who played from 1972 to 1974. "The expectations were on a level that you knew if you performed well, you'd be treated well. It was intense. And [defensive coordinator] Bud Riley was way ahead of his time as far as what we did defensively against team, schemes and so forth. But Dee was exceptional. I've never come across anybody who was more inspirational, as well as direct in expectations."

Andros let his assistants do most of the on-field coaching. "His No. 1 assistants during my years were Boghosian and Riley," said Erin Haynes, a reserve center who played from 1969 to 1971. "They were quiet individuals. They weren't going to make speeches. They both communicated precisely and calmly. When they got excited, that was purposeful. When Sam would yell, it would be like a knife to your heart.

"The toughest guy I ever played with was [offensive guard] Rocky Rasley. Sam was 5-9 and Rocky 6-3, but Sam would get in his grill if he screwed up. 'How you gonna get that play back?' One time Sam went up to the blackboard and drew a line and told all of us, 'This side is for when you're off the field. If you act like a gentleman, I'll treat you like one. On the other side, I'll do everything short of killing you to make you the best player you can be.' That was the longest speech I remember from Sam. There were toughness and expectations."

Mel Easley also revered Bud Riley, the late father of Mike Riley and Easley's defensive backs coach. "Coach Riley made a difference in my life," Easley said. "He made me tough. I remember at practice one time I made a mistake and he told me to get my butt off the field. He was that type of guy. Do it right or get off the field. He made me work for everything."

Jim Lilly, a defensive back and punt return specialist who played from 1970 to 1972, felt the same way. "Riley was the guy who got in my face every day," Lilly said. "I wouldn't have been the player I was without Bud."

During the Andros era, the Beavers played with a blue-collar work ethic.

"Anybody who played against Oregon State in those days knew it wasn't going to be easy," Bill Enyart said. "There was no such thing as easy when you played against an Andros-coached team. You were going to get hit. You were going to have to stop a pounding running game, be prepared for an option and a few deep passes. The biggest thing was you could not take an Andros team for granted."

Billy Main was a running back out of Walnut Creek, California, who narrowed his college choices to Oregon State, California, Washington State and Utah. Main's father and uncle both played for Pappy Waldorf at Cal. "I grew up bleeding blue and gold," Main said. "For me, it was a done deal. I was going to Cal."

Main wound up not having the grades to get into Cal, which wanted him to attend junior college. But Main's basketball coach, Doug Pederson, was a close friend of Oregon State basketball coach Paul Valenti. That contact got the Beavers in the door. Boghosian showed Main around Corvallis on his recruiting visit. Then it was time for Andros to close the deal.

"I sat down with the Great Pumpkin, and it was one of those moments," recalled Main, who played from 1967 to 1969. "We chatted about my pop, who was on a destroyer in the Pacific during World War II. Dee said, 'Billy, we want you to come here to Oregon State.' I committed on the spot. The Pumpkin had a special gift. He inspired us in ways that it's difficult to define. It was magic.

"It turned out to be a very good move for me. I loved my time at Oregon State. Now, 40-plus years later, my daughter Kimberley is part of the Oregon State family." (She was a freshman during the 2013–14 academic year.)

"Playing for Dee was a remarkable experience," said Scott Freeburn, a lineman from 1968 to 1970. "What a character he was and a remarkable man. How different he is than what you see in most football coaches today. There was never any doubt he was a players' coach, always in your corner, though he expected you to be a responsible young man. He was perceptive. When it was time to inspire, cajole, push, get us in the right place when things weren't going well…he was at his best having the sideline talk that would get us turned around. It didn't always work, but he was good at that."

"Dee had such a great spirit about him," said Jay Locey, a safety who played from 1973 to 1976 and later coached at OSU under Mike Riley. "There was a connection there. He had a genuine interest in you as a human being. He was the kind of coach you wanted to win for, to play your best game for."

"He was a wonderful guy, the kind who would give you the shirt off his back," said Ken Maurer, an offensive tackle from 1973 to 1975. "Even when we had graduated and been gone awhile, he remembered everybody's name. A great storyteller, loyal to his staff and players and to Oregon State and very sincere."

Andros remembered names, but he often had trouble pronouncing them. Dave Schilling was always "Schillings." Steve Preece became "Priest." Dee butchered Sam Cirrincione's name so often, he took to calling him "Sal from Chicago."

Jim Lilly flunked out of OSU after his freshman year. "I'm down at the Pendleton Elk's Club and the manager hands me the phone and it's Coach Andros, who had found out that I flunked out," Lilly said. "That's the first time he ever really spoke to me one-on-one. He was pumping me up, telling me I could get my grades back up. I went to summer school and got back in. From that point, Dee was always in my corner. You wanted to play for him. You saw how much it meant for him, and you wanted to make sure you walked off the field having given all that you have. Nobody wanted to let him down. He was there behind me, patting me on the butt and telling me I was going to do a good job."

Lilly followed star defensive back Don Whitney, another Pendleton native, to Oregon State to play for Andros. "Dee gave me No. 39, which was what Whitney had worn," Lilly said. "For six straight years, a Buckaroo wore No. 39 for the Beavers."

Chris Veit, an offensive tackle who played from 1969 to 1971, enjoyed Andros's personal touch, too. "Dee had a talent for getting the players to believe he was really interested in them personally," Veit said. "During practice, he'd occasionally come over to each [personnel] group. Like, he'd come over to the offensive lineman and say, 'OK, Chris, I'm watching you on this play.' I liked that. It motivated me to be more sharp, to make my blocks. As a team coach, he was an easygoing guy who made us feel he was part of us as a team instead of just a coach on the outside."

When he needed to be tough, Andros was well equipped to do it. But the soft spot in his heart often showed up. "Dee and I had a few 'Kolberg, you're in trouble' conversations," said Jeff Kolberg, a split end from 1969 to 1971. "One time, I'd gotten a speeding ticket by the campus cops and busted my ass to get to practice but was late. I told the whole story to Dee. He reaches into the back pocket, gives me $20 and says, 'That's the best effort to make practice I've seen in my lifetime.'"

Kyle Grossart was a quarterback on Andros's last Oregon State team. "I remember one of my great compliments from Dee at practice one day," said Grossart, who played from 1975 to 1977. "He came over with that Oklahoma drawl and said, 'Kyle, I knew you was a good football player, but I didn't know you was tough as a mule. Good job out there today.' That meant a lot to me. I came back the next day ready to give it my all at practice again. I thought a lot of Dee. He was an icon, a guy we all looked up to. Craig Fertig, not so much."

After Andros was hired, he was replaced by Fertig, a former quarterback and offensive coordinator at USC, beating out the other finalists, Terry Donahue and Rich Brooks. In his first two seasons at OSU, Fertig's teams were 2-10 and 2-9.

"There were some things he brought about to change the program," said Grossart, who played for Fertig those two seasons. "It wasn't all about negligee-orange uniforms and the June Taylor Dancers. There were some good changes, too, but overall, he tried to play off that USC mystique, and it didn't work. There were at least five NFL guys on that [1976] team, including Jarvis Redwine. We should have been above .500. We had some players there, but they didn't coordinate it well. Brooks would have been a lot better as far as identifying with the players. There were a lot of us hoping he would get the job."

Redwine, Oregon State fans will remember, was a freshman tailback who pussyfooted more than ran hard during his single year as a Beaver. He transferred to Nebraska, where he thrived in the Cornhuskers' veer attack under Tom Osborne, becoming a legitimate Heisman Trophy candidate before an injury midway through his senior season in 1980. He played three years with Minnesota in the NFL.

Dennis Boyd, who wound up playing five years with the Seattle Seahawks, was another Oregon State player who played for both Andros and Fertig. "The difference there is that Dee bled orange," said Boyd, a defensive end from 1973 to 1976, playing his final season under Fertig. "He loved Oregon State. He lived Oregon State. I didn't get that feeling from Fertig. He was like a USC transfer. It seemed like Oregon State was a steppingstone for him to try to go on to another level.

"I remember working out in the summer in Corvallis that first year. Craig's staff had a summer camp for high school kids. Craig's roaming around in his golf cart, handing out Gatorades and probably collecting tens of thousands of dollars for that camp. The kids weren't getting a lot out of it. It seemed like it was just a money thing. It sent the wrong message. You didn't get the feeling he was there to build the program at Oregon State."

Some players got to know Andros beyond the football field. Jim Sherbert was a defensive end for Andros from 1969 to 1971 and then coached on his staff from 1973 to 1975. "I got married out of high school," Sherbert said. "Dee and Lu Andros took in my wife, Tina, and me like we were their kids. They had an adopted daughter, but we felt like we were their adopted kids, too. They included us in whatever was going on. It was a special personal relationship. You'll hear that a lot from guys who played for Dee. The camaraderie he was able to build with our team is something I've carried my entire life. I can't overemphasize how unusual that is. In my professional career, I've run seven different companies, and I've reached back to that kind of relationship. He made everybody feel like they were special.

"During his early years at Oregon State, he was a good coach for what was going on in the world. As times changed, I'm not sure he kept pace. He went to more of a passing game those last few seasons. I don't think he was ever comfortable with that. As a result, he may have not fully embraced it, and it just didn't work. But as a human being, I've never met a more genuine man in my life. How lucky I was to have that when I needed it in my life."

Steve Endicott, Andros's quarterback from 1969 to 1971, would have preferred an earlier move to the passing game. "I don't think we were progressive enough," Endicott said. "But I loved Dee as a father figure."

Andros called on his relationships at times. In 1985, when he was athletic director and Dave Kragthorpe was in his first year as head coach, he asked Thurman Bell to play in an alumni game. Bell, whose final season as a defensive back with the Beavers was 1965, was 42. "Dee talked me into it," Bell said. "He made me the honorary captain. He told me, 'You won't have to play much.' I lined up against Reggie Bynum, who was an All-Pac-10 receiver. I played the entire game. Couldn't walk for two weeks."

Talk about Andros by those who played for him always comes back to his motivational skills.

"He was always good with the pregame speech," Scott Freeburn said. "He had a way of getting you jacked up with the theme of the week. He was a natural as an inspirational leader."

"He made you feel like you would go back-to-back with him anywhere, in an alley fight, wherever," said Steve Bielenberg, a defensive end from 1969 to 1971. "He just had that way."

"His halftime talks were legendary," Veit said. "I remember a game in Corvallis. We were behind Cal 10–0 at halftime. Our offense was terrible;

our defense was keeping us in the game. We go into halftime and we're sitting in the locker room, eating orange slices and sipping on Pepsi. The coaches disappeared. We thought, 'This is different. They're not yelling and screaming.'

"They come back just before we're supposed to get out of the door for the second half. Coach Andros said, 'Men, we've been stinking this place up. We have minus-four yards total offense. We're going to run two plays over and over and shove it down their throat. Now get out there and do it.' That's what we did. We had two long touchdown drives, controlled the ball and won 16–10. That was all Coach Andros there."

"I can remember him in the locker room," said Bell, who played his final season under Andros after playing his first two under Tommy Prothro. "He could give pre-game talks that were mind-boggling. He always had that chew of tobacco in his mouth. It would start running down his face when he got going. That's why I've never chewed."

"When he was doing his pre-game talk, you didn't want to get on his downside," Lilly said. "If you did, you usually got chew spit in your face because he was yelling so hard."

Andros saved his best pre-game talks for the Oregon game. "He'd get us fired up for every game, but Civil War time was extra special," said Greg Krpalek, a center from 1972 to 1974. "He said it was the right to live in the state of Oregon. We believed him."

On Civil War game day, in the locker room before the game, Andros would invariably recite his favorite poem, "The Man in the Glass," from memory.

"'The Man in the Glass' was always saved for the Oregon game," said Jerry Hackenbruck, a defensive end from 1972 to 1974 who coached high school football in Oregon for more than 30 years. "I think it stuck with all of us. I've read it to teams on occasions over the year. You want to save it for the most special moments."

"I coached a little bit of high school ball, too, and I used 'Man in the Glass,'" said Dick Maurer, a fullback who played the same years as Hackenbruck. "Dee would get all amped up. He'd say he was hurting all over his body, he wanted to beat the Ducks so badly. He'd almost frighten you, being in that locker room. 'This is going to be it, fellas.'"

"I have a copy of 'Man in the Glass' right here in my kitchen," said Steve Endicott, a quarterback from 1969 to 1971. "I can't recite, but I can come close."

"Before the Oregon game, Dee would get so doggone fired up, you couldn't hardly understand a word he said," Hackenbruck said. "But you'd

run out of there in tears, ready to beat the world. We were two different kinds of programs. Oregon was a more liberal style of play and a different style of players. There was such a big pride thing with Dee in winning the Civil War. He saved his best for last and got us kids fired up. We'd have run through a brick wall for him—especially against the Ducks."

"When we played Oregon, by the time he got done [with his pre-game speech], we were ready to tear the wall down," said Dan Sanders, a safety from 1972 to 1974. "He was pretty motivational and a very open-door kind of coach."

Andros would have other inspirational words to say, depending on the moment. The moments were always biggest in Civil War games. "It would start right on Sunday morning, before our next-to-last game," said Ken Maurer, an offensive tackle from 1973 to 1975. "By the time the week was over, he had us at a fevered pitch."

"The speech before our senior Civil War game at Parker is the one I remember," Preece said. "After Dee is done, he says, 'You think about it for five minutes, and we'll all go out.' We're ready to go out and kill the Ducks. After about 10 seconds, Roger Stalick busts down the door and sprints out onto the field. That door is ruined."

Enmity for the opponent reached a zenith when it came to the Civil War. "Deep down, Coach Andros couldn't have really believed it, but I can't be absolutely certain," Hanneman said. "He'd tell us during the off-season or at training camp, 'I'd rather lose every game and beat the Ducks than the other way around.' The week of the Civil War game, he'd remind us he said that. That was something he would preach. Then the day of the game…unless you saw him delivering his speeches, you have no idea just how different a man he became and how the atmosphere was unlike any other week of the year. He was possessed. That put the players in a frame of mind unlike any other week they played."

"Dee was a unique individual," Dennis Boyd said. "He had the ability to communicate with just about everybody regardless of your background. He found ways to motivate you. For the Oregon game, in particular, he'd get fired up. Both Oregon teams could be having lousy years—which we both did at the time I played—but if you could win the state you could hold your head up. That was a big deal. It always surprised me, especially as a freshman coming in, how huge the game was. You could be 0-10 and it was still like the Super Bowl. Your whole season depended upon winning or losing that game."

"The man had a knack for motivation," said Jess Lewis, an All-America defensive tackle in the late '60s. "It came natural to him. His enthusiasm was

contagious. Before you knew it, you were out there playing your heart out for him. I just loved that. I've used that all my life.

"My image of Dee is sitting around after practice and during banquets. He liked a good cigar and peppermint ice cream. The Civil War was No. 1 on his list. He always said if you lost to the goddamn Ducks, you had to move out of state. You couldn't live here. There wasn't anything artificial about it. Dee really felt that way. He wasn't putting on a show."

Or, if he was, he was incredibly adept at it. "I've been in business all my life and have heard a lot of good speakers, but Dee was one of the best motivators I've heard in my life," Pete Pifer said. "Even when you knew it was coming, it still got you. He just had that unbelievable ability of getting you into the moment, getting you to a peak emotionally to go out and be fired up. I still wonder how the heck he did that game after game, year after year. That was one of his great strengths."

"The great coaches have to win their rivalry games," Enyart said. "Dee understood that more than anybody. In sports, there is a manufactured hate. It's not a true hate. The guy on the other side puts on the same uniform as you. Is he really your enemy? No, he's your rival. Every player knows that deep down, but you still have to go through a rationalization that they are somehow different from you. Dee was a Greek Okie, an emotional type of guy in the great oratory tradition. Give him a microphone, you were going to hear a speech. He'd get you so fired up. He was from the win-one-for-the-Gipper school. He'd use something like, 'Gentlemen, there's going to be blood on the moon.'"

Before the 1970 Civil War game, Jim Lilly said, "Dee kept saying, 'There was going to be blood on the moon, and it's not going to be our blood.'"

"For Civil War, the build-up was different," Erin Haynes said. "He had a great lead-up from Sunday to game day. He'd use his 'It's a war' speech. 'It's no goddamn game, it's a war!' He knew war, having been a World War II hero at Iwo Jima. We were thinking, 'Yeah, he knows about this.' It made a hell of an impact on 19- and 20-year-old kids. It would resonate. The guys who had been there for three years, we'd heard it all before, but it always had an impact. He was a master at that."

Soon after he arrived at Oregon State, Matt Hammock said he had been told by Preece, "wait 'til you hear Dee's pre-game talks for the Civil War."

"I remember looking around the locker room," said Hammock, a receiver from 1973 to 1976. "I was amazed how many people were crying. He had everybody so jacked up. He'd talk about the time he fought at 'Eewer Jeemer.' For years, I wondered where that was."

When Dennis Erickson was coach at Oregon State from 1998 to 2002 and Andros was long retired, Erickson would still bring "The Great Pumpkin" in for a talk to his players during Civil War week. "Are you kidding?" Erickson said. "Dee was the best guy in the world to talk to the team. He'd get going and have those kids so ready to go. I loved it. It's what Oregon State is all about. I don't know that there will ever be another Dee Andros."

In 2001, Erickson wore a gaudy fluorescent orange windbreaker to a Tuesday news conference in a sartorial salute to Andros, who had undergone open-heart surgery the previous day. "When it gets to Civil War week and you're a Beaver, you've got to think about Dee and all the things he's done over the years," Erickson told reporters.

Andros's first taste of the Civil War came with a 19–14 victory at Eugene in 1965. His coaching adversary was Len Casanova, who would end his 16-year stint as Oregon's head man the following year. "I thought when I got off of Iwo Jima I had seen my last war," Andros quipped before the game. "Now I'm faced with a Civil War. Butterflies? Yes, I've got them."

Casanova admitted to nerves, too. "You should see how many cigarettes I've been smoking," he said. "I've been through this game so many times. You just never get over the nervousness."

Oregon State won the game 19–14. "I said I would be happy with a one-point win, and since we won by five, I'm five times as happy," Andros said afterward.

It was a matchup of contrasting styles. Oregon State finished with 216 yards rushing, Oregon minus-24. Pifer led the way, carrying 34 times for 136 yards and a touchdown to set the school single-season record with 1,095 rushing yards. Oregon had 258 yards passing, with Mike Brundage throwing a pair of second-half TDs. OSU's Brothers was one for seven for 11 yards passing.

Oregon State jumped to a 19–0 lead and held on. Oregon had one first down and eight yards total offense through intermission. "We never played better team defense than we did in the first half," Andros said.

OSU benefited from six Oregon turnovers—four interceptions, including a game-saver by Bell at the UO five-yard line on the final play—and two fumbles. But the Beavers also lost five fumbles—two by Pifer—after having lost six in the first nine games.

"It wasn't that spectacular," Bell said of the last of his two picks in the game. "Just happened to be in the right place at the right time."

The Beavers scored their third touchdown after Al Frei recovered a Hugh Oldham fumble of a punt at the UO 20. Six plays later, Brothers sneaked in from the one-yard line. "We had a miserable first half and could have folded pretty darn easily," Casanova said. "I told the seniors they should be proud of their comeback. Those fumbles and interceptions ate us up."

Bell scored a TD in the second quarter on a 10-yard interception return. The Ducks were backed up deep on their four-yard line. "That interception killed us," said Brundage, who finished 13-for-32 passing for 212 yards and two TDs with three interceptions. "From the four-yard line, I probably shouldn't be passing, but I thought I fired it hard enough so if [Steve] Bunker couldn't get it, neither could the defender. [Bell] just stepped in front of Bunker and went for the touchdown."

"It was an out pattern to my side," Bell said now. "I just happened to rotate right into it and was able to cut in front of the guy and pick it clean and get in untouched. What, it was only 10 yards? Seemed liked 80 yards...You know how those things grow over the years."

Bell had played as a 6-foot, 190-pound defensive end as a junior on Prothro's Rose Bowl team in 1964. He hadn't intended to come back for his senior season. "All I needed was one semester to get my degree," he said. "Dee talked me into coming back as a defensive back and gave me a scholarship for the whole year. I was limited speed-wise but figured, 'OK.' I was learning the halfback position, and in the first or second game, Lew Scott got hurt. They put me in, and I ended up starting there the rest of the year and winning the Most Improved Player award for the season."

Bunker, who had five catches for 127 yards and a 58-yard TD, set the UO record with 103 career receptions in the game.

It was the final game for UO receiver Ray Palm. Consider him one of the Ducks less than enamored of Andros. "It wasn't a fun way to go out, losing to the Beavers and Andros," Palm says today. "I wasn't crazy about the guy. I thought he was a little phony. He was a rah-rah guy. He was always saying stuff about it being for the right to live in Oregon. That was kind of over the top."

Oregon State finished that season 5-5, Oregon 4-5-1. OSU was 1-3 in league play, UO 0-5.

"We didn't have as good a team that year as we'd had the previous two," said Dick Winn, a fullback on that Duck team. "We'd lost Bob Berry, who carried us on his back the whole '64 season. The Beavers were a pound-it-out, grind-it-out team. In that game, they beat us fair and square."

Pifer ran rampant on the Ducks again in his final appearance for the Beavers, rushing for 130 yards and a 14-yard touchdown on 31 carries in a 20–15 victory over Oregon in the 1966 game at Parker Stadium. The 5-10½, 210-pound Pifer finished with 1,088 yards and became the first player in Pacific Coast Conference/Pac-8 history to post back-to-back 1,000-yard rushing seasons. He set the school single-season mark with 12 rushing TDs, led the league in scoring with a school-record 72 points and won the Pop Warner and Voit awards as the top player on the West Coast.

Pifer had been recruited by Tommy Prothro out of Ridgecrest, California, in the Mojave Desert. Oregon coach Len Casanova had also recruited Pifer. "I really liked both schools and coaching staffs," said Pifer, now 69 and living in Eugene. "When Tommy came down to recruit me, it was 120 degrees. He said, 'Pete, I only want to make one trip down here.' Tommy was the winningest coach on the West Coast at the time. Tommy was not exactly a fullback coach, but you want to play for a winner. For me, it was more about getting an education and a degree. Sports was my way to pay for college. On my visit, I interviewed with the dean of the business schools, and that was a great experience. I wound up at Oregon State. A great piece of luck, to pick the right school."

Pifer played sparingly as a sophomore during the 1964 season on the '65 Rose Bowl team. Andros's hiring was a strike of good fortune. "I could not have played for a more perfect coach for what I was as a player," Pifer said. "You couldn't have two more different philosophies than Tommy and Dee. Dee ran his fullback. And he had some fantastic offensive linemen, guys like Rockne Freitas and Rocky Rasley and Jim Wilkin and Roger Stalick. But both coaches did well with the same personnel. Tommy ran the ball, but his was a pass-oriented offense. Dee was a ground game guy. But he and his assistants—he had a great staff—did an excellent job and changed the style completely on the fly and still won right away. We were 5-5 my junior year but 7-3 my senior year and lost only to USC in a league game. We were one game away from going back to the Rose Bowl."

The Civil War game "was like a bowl game for us," Pifer said. "Half the team was from Oregon, but even with us out-of-state guys, it was the biggest game of the year. It was an all-year-long thing. If you lost that game, you had to put up with hearing it from the Ducks. The good news is, I never had to put up with it. During that week, you would work on special plays. The coaches always made special scouting efforts. It was a well-publicized, well-hyped game, and everyone got into that. I thought it was easy to get into that psychology.

"There was no love for the Ducks, I'll guarantee you that. I got to know a few of their players my senior year. Andy Maurer and I would team up to talk to youth groups. They had some good guys down there. You were always surprised if you found a decent human being who was a Duck.

"It was always a dogfight. Even when you're ahead, a score could turn it around in a minute. You fought to the end because you didn't trust a lead. There was no let-up even if you got ahead. They had good players and a good coaching staff, but we always felt we were the more deserving."

Pifer, who owned several McDonald's restaurants for many years, is semi-retired and helping with a small start-up business while living in Eugene. "I wish we were still winning the Civil War games," he said. "It would make it a lot easier to live around here. But being able to say the Ducks never beat you, it doesn't get any better than that."

In the 1966 Civil War contest, Pifer did most of his damage after having three teeth knocked out in the first quarter. He didn't miss a series. "It was that kind of a game," he said. "A wet day, a lot of grit and mud. We didn't have Astroturf yet. It was three yards and mudballs."

Oregon State entered the contest 6-3, having won five in a row. "We're the best team on the coast right now," Andros said.

It was to be Casanova's final game. The Ducks went in 3-6 but with painfully close losses to Utah (17–14), Washington (10–7), Washington State (14–13) and Arizona State (14–10). "It's obvious there's not much comparison between the teams," Cas told the media. "We look forward to Saturday's game whether people think we have a chance or not. In this game, you find the qualities you seek in players. That's what makes football a great game. I hope those qualities come out for Oregon on Saturday."

Casanova called Pifer "the best fullback in the country." At a sportswriter and sportscaster luncheon, Dee looked at Cas and said, "By the way, Len, we have a new offensive set where we spread Pifer way out wide as a flanker."

Casanova's retort: "Is that a promise?"

Oregon State won the total offense battle 305–102, gaining a 276–29 advantage on the ground. But the Beavers lost five fumbles and had a pass interception. Oregon had four turnovers, too.

Brothers had another poor passing day, completing two of seven for 23 yards with an interception. He augmented Pifer's big day with 10 carries for 74 yards, though, and wingback Bobby Grim added 71 yards on 10 attempts.

Oregon quarterback Mike Brundage had a rough day through the air, too, connecting on five of 12 attempts for 66 yards with two picks.

Mike Haggard kicked field goals of 29 and 34 yards and Brothers had an 18-yard run for TD in the second quarter to fire Oregon State to a 13–0 lead. Les Palm intercepted a Brothers pass at the OSU 31 in the third quarter, setting up the Ducks' first score on a 25-yard pass from Brundage to Scott Cress over a leaping Mark Waletich in the end zone on the first play of the fourth quarter.

Then a miscommunication on Oregon's part benefited Oregon State. The Ducks tried an onside kick. It traveled only seven yards. The Beavers recovered at the UO 47 and, after an exchange of punts, needed only 42 yards to score a TD to go ahead 20–7.

Oregon linebacker/kicker Gunther Cunningham said one of the Oregon linemen was yelling, "Watch your offside, watch your offside," which another lineman interpreted as "on side," and he told Cunningham to execute the onside kick.

After the game, Andros said about the onside attempt, "I probably would have done the same thing in their situation. I've done it before. The Ducks were playing to win. A gamble is either great or it backfires. This one backfired."

"[Cunningham] said he heard somebody call for it," Casanova said afterward. "Nobody called it. I may be stupid, but I'm not that stupid. But that didn't decide the game. We couldn't move the ball consistently. Oregon State beat us up front all day."

The final score wasn't indicative of the decisiveness of Oregon State's victory. A 98-yard fumble recovery return, most of the yardage covered by Oregon defensive back Jim Smith, provided the shocking conclusion on the game's final play.

"The final score was close only because of me," said Preece, then a sophomore backup to Brothers at quarterback. "We were at their three-yard line and ready to score again. Dee had emptied the bench, and our third-string center, Louis Armstrong III, came in. Louis got excited and took a step as he snapped it. The ball didn't get to my hands—I'll take the blame there—and bounced to an Oregon linebacker [Harry Cartales]."

Cartales picked up the ball at the two-yard line and then lateraled to Smith, who went the remaining 95 yards as the partisan OSU crowd sat in stunned silence. The Ducks tacked on a two-point conversion to make the final score 20–15.

"I remember running off the field so mad, I could spit," Preece said. "But at least we sent off some great seniors—guys like Brothers, Pete Pifer, Bob Grim—with a win."

Oregon State won again in 1967, coming from behind to overhaul Oregon 14–10, and convincingly in 1968 by a 41–19 count. Andros continued his mastery of Oregon until 1972, when the Ducks broke through with a vengeance, winning 30–3 at Autzen in Dan Fouts's final game. The Beavers won again in '73 and '74, going ahead in the series 37-32-9.

The Beavers won the '73 game 17–14 at Eugene, striking first when the Ducks fumbled on the first play from scrimmage and OSU recovered at the UO 26. On first down, Ray Taroli threw a halfback pass to Grant Boustead for a TD and a 7–0 lead 33 seconds into the game. Oregon took control, though, with Rick Kane (18 carries, 133 yards) and Donny Reynolds (24 carries, 106 yards) leading the way to a potent ground attack. The Beavers won it by going to the ground themselves, Dick Maurer scoring the game-winning fourth-quarter touchdown from two yards out.

Maurer should not have been playing at all. The week before, the junior fullback from Prospect in southern Oregon had dislocated a shoulder against UCLA. "But being an Oregonian, I had to play in the Oregon game," he said. "On Monday, I asked Dee, 'What do I have to do?' He said by Wednesday before the game, I had to be able to do 10 pushups."

After 48 hours of ice and heat treatments, Maurer flagged down offensive coordinator Sam Boghosian in the hallway outside his Gill Coliseum office. "I said, 'Watch this,' and did my 10 pushups," Maurer said. "I got on my bike and howled in pain all the way home."

On Maurer's scoring play, OSU coaches had called for a pass on the sidelines. "We'd been having trouble passing all day," recalled Dick's brother Ken, an offensive tackle. "The pass call came in, and [center] Greg Krpalek said, 'Nope, we're not going to do that. We're going to push it in with a run. Give it to Dick.' We did, and we won the game. Dee used to say, 'Three things happen on the pass, and two (an incompletion and an interception) are bad.' We had a hard time throwing to the right team that year."

One of Oregon's big weapons that season was tight end Russ Francis, later an All-Pro with the New England Patriots. Oregon State's defense focused on slowing him down. He didn't catch a pass in the game. "We doubled up on him, corralled him pretty good," safety Dan Sanders said.

"Francis was a big, amazing athlete but not a super physical guy," said Sanders's brother Rob, a linebacker. "Our strategy was to bang him on the line and stay with him, and it neutralized him. They ran for a lot of yards but were one-dimensional."

Oregon still nearly pulled off the win, but Bob Palm missed a pair of second-half field goals. The Ducks had a late chance, but Dan Sanders intercepted a Herb Singleton pass deep in OSU territory to preserve the victory. "Singleton had a strong arm," Sanders said. "The ball was thrown hard over the middle and deflected off Palm's hand. I happened to be there and caught it. It was just a lucky break."

After the interception, "you could hear a pin drop at Autzen," Krpalek said. "What a beautiful sound."

Reynolds, who went over 1,000 yards for the season in the game, left with a sprained ankle in the third quarter. Oregon State defensive end Jerry Hackenbruck, who had played with Reynolds at Corvallis High, recalled Reynolds's 49-yard touchdown reception on the final play in a 20–19 win over Medford their junior season.

"I can remember being scared to death they'd put Donny back in and he'd win it like the Medford game," Hackenbruck said. "I can remember yelling near the end, 'Watch the screen pass!' The fun thing about that game was playing against him, to be honest. He's one of your best friends, and you're on defense and he's their best running back, and you're tackling him once in awhile.

"I had probably the best game of my career to that point. It was almost like I knew what they were doing. I was reading their pulling guards, and I made a lot of tackles. It was fun for that reason, for being able to get back at them for beating us the year before. And it's one thing to win the Civil War, but to win it at their stadium was even more special."

Oregon State dominated the 1974 game in Corvallis, winning 35–16 after spotting Oregon a 10–0 lead. On a sloshy day at Parker, the Ducks fumbled 10 times, losing five. After the Ducks burst to the early advantage, the Beavers' running attack took over, leading the way to three first-half touchdowns. Dick Maurer ended his career with 116 yards and a TD rushing.

"About the middle of the third quarter, a pass play came in, and there was Krpalek again," Maurer said. "He said, 'Screw that stuff; give it to Maurer. We're going to drive it right down.' We had a bunch of Oregon guys on our line—my brother Ken, Jeff Hart, Jim Walker, Krpalek—and they dominated the line of scrimmage."

"We took the game over," Krpalek said. "Of all the football I played, that was the greatest win I can remember. It was a team effort. We weren't going to lose to those Ducks. Being the last game of my career and the last game for a lot of us, we still talk about it. It was one of the great moments of our life."

With pressure mounting as Andros was going through his fifth straight losing season, he announced his retirement prior to the 1975 Civil War game. At the sportswriters' and sportscasters' luncheon prior to the game, he was asked about motivating his players for the game. "The older kids don't need my help," he said. "I'll try to help the younger ones understand."

Oregon coach Don Read said he agreed with Andros that the Civil War was above and beyond other games, in particular with what it meant to supporters of both schools. "It's a whole new game up in the stands," Read said. "The alums really rise to the challenge...The world turns a little faster in Civil War week. We have rallies on campus and my phone is ringing constantly."

Read was asked if he meant the game was more important to the fans in the stands than the players. "It's very important our players take this game in context," he said. "We will be emotional, but more than that, I want to think we will be consistent, which we haven't always been, and we will avoid mistakes, which we haven't always done.

"As far as intensity, attitude, desire—you pick the word—I doubt the Oregon State game will be different than the others. At Oregon, we are looking for the kind of young man who will play 11 games, the first as hard as the last."

Read paid tribute to Andros. "This should be Dee's day," he said. "He has done so much for so many. I've talked to a whole bunch of his ex-athletes and I've never run into one who didn't have a good thing to say about him."

Oregon State's players wanted to send Andros out a winner. "We, as a team, want to dedicate this game to Coach Andros," guard Mike Kobielsky said.

"We want to remember this game as a win, for ourselves and for the coach," linebacker Bob Horn said.

Governor Tom McCall, on hand for the luncheon, quipped about Andros, "I've never known a better friend, or a worse golfer."

Andros, perhaps giving away a little truth while cracking a joke, said, "The worst thing I did was to put air in the football three years ago. I haven't won since."

He wasn't to win that day at Autzen Stadium, either. Oregon, which went into the game 2-8 and as a one-point favorite, prevailed 14–7 for its first home win in the series in a dozen years. The Beavers fumbled six times, losing four, and were intercepted twice. The Ducks had four turnovers themselves, two fumbles and two interceptions. UO quarterback Jack Henderson was four for 18 passing for 36 yards with two picks.

Oregon State's only score came via its defense. Jay Locey gave OSU a 7–0 lead late in the first quarter with a school-record 94-yard interception return. "They were right at our goal line, and we were pressuring Henderson," Locey said. "I manned on a halfback coming out in the flat. It was a rub play, with a wide receiver as a tight split, and he was supposed to create a screen with his route. I was able to slip underneath. For a minute, the guy looked wide open, but I was able to step in front of it. It was like a dream. I was running right in front of the Oregon bench. I remember glancing at their coaches. Seemed like it took forever to get to the end zone."

It still stands as the longest interception return in Oregon State history. "They called it 94 yards," Locey said now, adding with a laugh, "I think it was 96."

The Beavers' euphoria evaporated quickly. The Ducks answered when Chuck Wills intercepted a Kyle Grossart pass and went 15 yards for a TD in the second quarter. "I still have nightmares about that game," Grossart said. "That interception haunts me to this day. I wake up sometimes thinking about it.

"We're ahead 7–0. It's third-and-five, and the call is a rollout, where I either hit the tight end on the corner or throw the ball to the flat. [Tight end] Phil Wroblicky went to the corner. It was exactly what I wanted to see, and I let it go, but Wills had given me a false read and rotated over there real fast. I threw it on a line trying to stick it in between the corner and safety, but he got a jump on the ball and picked it off and returned it for a touchdown. Those things you don't forget. I was sick to my stomach for about a month after that game."

OSU's Rich Dodge fumbled the second-half kickoff, and four plays later, the Ducks scored on a four-yard run by George Bennett, the game's offensive star with 129 yards on 32 carries. The Beavers had a last chance when Grossart's Hail Mary slipped through the fingers of Ron Cuie in the UO end zone.

"Had the Pumpkin been in better humor," the *Oregonian*'s Leo Davis wrote, "he might have pointed out it was Oregon State's seventh turnover of the afternoon."

Davis was right about one thing. The loss didn't help Andros's mindset as he completed his final season as a coach 1-10. "This has been the worst year ever, and this was the worst loss," he said. "I'm going to remember it for a long, long time."

After the game, OSU president Robert MacVicar turned to the media and said, "Gentlemen, American football is losing one of its great figures."

Had the 5-10, 300-pound Pumpkin been in better humor, he'd have had fun with that comment.

On the Oregon side, spirits were high. "It was a win," Read said. "Not pretty, but there are none bigger for us."

Bragging rights were now with the Ducks. "It gets old losing to these guys," said Wills, who had two interceptions, including a fourth-quarter pick at the Oregon seven-yard line. "I've taken two years of bleep from Oregon State. No more."

"We've made ourselves winners," sophomore safety Bruce Jensen said. "This is a good start back. This is the end of the Andros era and the start of the Read era."

"Now that [school president William] Boyd is giving us extra money," sophomore defensive end Mel Cook said, "this has to give us a big edge in recruiting. We'll go out as winners, not losers."

"The program should turn around now," senior offensive tackle Ron Hunt said. "We can start getting the guys Southern Cal gets. That's how you build a winner."

Not all of the proclamations would come true. The Read era would last only one more year. Oregon did not start recruiting talent the Trojans were after, at least not until a man named Chip Kelly arrived far into the future.

The 1975 Civil War game did signal a shift in the series, however. Oregon State would not win again until 1988. The biggest reason was Rich Brooks, who would change his allegiances from orange and black to green and yellow and one day have the field at Autzen Stadium named in his honor.

Ironically, Brooks wanted very much to succeed Andros as head coach of the Beavers. It was the Great Pumpkin who got in the way.

CHAPTER 16

BIG DADDY BROOKS

When Rich Brooks arrived at Oregon State from small-town northern California in 1959, he was a perfect fit for the Beavers' blue-collar existence.

Brooks's parents divorced when he was 12. His father worked in the gold mines of Allegheny, Forest City and Nevada City. His mother was a nurse in Grass Valley. It was a small-town environment where Rich and older brother Wayne played all sports.

"I lived alternately with each of my parents, sometimes living with my father at Allegheny in gold-mining country, sometimes with my mom," Brooks recalled. "Finally, he told me I had to live with my mother in high school, which was smart. There was a better opportunity to play sports there."

Brooks knew by the time he completed high school he wanted to become a coach. "I just liked my high school coaches, and I liked football," he said. "It was something I wanted to do."

Brooks came to Oregon State to play for Tommy Prothro, who was running a single-wing offense. Brooks was starting tailback—the position that received the snap in the single wing—for the Rooks in 1959. That year, Brooks got his first taste of the Civil War in Oregon State's 15–7 upset victory. "I watched from the stands at Hayward Field," Brooks said. "After the game, some of the Oregon State students were told to steal the hats of the Oregon band as it marched off the field. Just a nice, fun prank, although some fights broke out later."

The following spring, Brooks's role on the team seemed murky. Don Kasso, who had started at tailback as a sophomore, was returning. And a youngster named Terry Baker, who had not played as a freshman, decided to turn out for the team.

"I went into a meeting before spring practice and they had a depth chart posted," Brooks recalled. "I looked for my name at tailback, and I was at wingback. Tommy told the team, 'Anybody who disagrees with your position, you can come into my office and talk.' I was dumb enough to do that. I told him, 'Tailback is what I came here to play.' He switched me back to tailback. It lasted about three days."

With Kasso and Baker—a member of Brooks's pledge class at Phi Delta Theta fraternity who would become a close friend—getting most of the turns at tailback, Brooks moved to wingback. "I went through the drills getting double-teamed by tackles and tight ends," Brooks said. "I proved I could survive and didn't quit. By the end of spring practice, they elevated me to third string instead of fifth."

Brooks was a reserve wingback and defensive halfback as a sophomore. As a junior, the Beavers brought in assistant coach Bob Watson to install a T-formation offensive attack. It was during college football's transformation to two-platoon football, and with Kasso moved to halfback and split end, Brooks found himself backing up Baker at quarterback and starting in the defensive secondary.

"You could substitute two guys every time the ball changed hands," Brooks said. "When we'd go to defense, Paul Seale and I would substitute for Terry and Vern Burke."

Brooks wound up playing plenty of defense but very little offense his final two seasons at OSU. "I really got to play only one game at quarterback," Brooks said. "I was three for three against Idaho. I tell everybody I led the nation in passing that year."

Baker enjoyed his relationship with Brooks and admired his teammate, whom he called "an overachiever."

"Rich was an extremely hard worker and a dedicated guy," the 1962 Heisman Trophy winner said. "Whatever he lacked, he made up for with smarts and toughness. He was a great friend and fraternity brother."

Danny Espalin played safety alongside Brooks in the defensive backfield. "Rich was great to play with," Espalin said. "He was very cerebral, with an instinct for what was happening on the field. There was good communication between us. You knew he'd be taking care of his responsibility. All I had to do was keep my own responsibility. I liked playing with guys who knew what they were doing.

"He was a good hitter. I'm sure he has the arthritic neck and shoulders to pay for it the rest of his life. He was a hard-nosed player. You knew if he got into coaching, he'd expect a whole lot from his players."

Kasso remembers Brooks delivering a hit "you could hear all over the stadium" in Oregon State's 1961 season victory over Syracuse at Portland.

"Rich was tough and showed no fear," Kasso said. "He had a really good sense of timing. He wasn't big or overly fast, but he could hit like a mule. And he was an intelligent player. He could read what was going on in the offense and was just an outstanding defensive player."

Center/linebacker Dick DeBisschop, who remains a close friend of Brooks, calls him "one of the toughest guys pound per pound we had on the team. He won his weight division in the intramural boxing tournament. I know how tough he was, because I sparred with him and I outweighed him by 30 pounds.

"You talk about an intelligent player. Without great speed, he was unbelievable. He was solid in everything he did. Coach Prothro was really close to him. There was a special bond between the two, probably because he knew Rich was one day going to be a coach."

"Rich was not one of the best players we had, but he was a good, solid defensive back," said Bob Zelinka, an assistant coach during the Prothro era. "He had a tough, aggressive attitude, and his kids showed that when he coached at Oregon. I'm not surprised he turned out to be a great coach. He always had a great football mind."

As a senior, Brooks was part of a come-from-behind 20–17 victory over Oregon that landed the Beavers in the Liberty Bowl. "I've never forgotten the thrill of that win," Brooks said. "And during my time at Oregon, I always wanted my seniors to have that kind of experience."

Brooks began a 45-year coaching career as a grad assistant helping with the Rooks in 1963 along with DeBisschop. "He worked hard," DeBisschop said. "He must have taken a light course load, because he did all sorts of extra stuff. Our grad assistants coached the freshman team then. He worked film and did lots of varsity stuff, helped Coach Prothro with opponents' tendencies and stuff like that. It was that work ethic that made him into what kind of a coach he was going to be."

Pete Pifer was the fullback on that OSU freshman team and a member of the same fraternity. "I always thought Rich was a super guy and could tell he was going to be a good coach," Pifer said. "He was an advisor at the Phi Delt House my freshman year and was in charge of the Phi Delt smoker

boxing matches. He was out there making sure everybody got paired up and fought, and I'm pretty sure he fought, too. He had a reputation as being a hard-ass and tough."

When Brooks was a full-time OSU assistant in the late 1960s, he would referee the Phi Delt smoker. "At the end of the night, Rich would take on all comers, anybody who had the guts to go one-on-one with him," quarterback Steve Preece said. "Rich was a tough son-of-a-bitch."

After a year coaching high school in northern California in 1964, Brooks returned to Corvallis to serve five years under Dee Andros at his alma mater. It was during those years he grew to appreciate the importance of the Civil War rivalry, beginning a legacy continued through his 18 years coaching at Oregon that has no match in the long history of the series.

"I played for a great coach in Tommy Prothro who coached against a great coach at Oregon in Len Casanova," Brooks said. "But I learned the emotional part of the Civil War, the intensity of the rivalry, how much it meant to the people in the state, when I was an assistant under Dee. Even as a player, I didn't appreciate it that much. With Andros, you knew how important it was. Dee was an emotional guy who could bring tears to your eyes as an assistant coach with pre-game and halftime speeches. You were always anxious to get out on the field and get after their ass, as he would say. He really took it to another level.

"I carried that with me to Eugene. I used Dee's phrase, 'You're playing for the right to live in the state,' during my years at Oregon. It always was the biggest game. I tried to convey what I didn't know as a player—how important the game was—to the players I coached as an assistant and then as a head coach. It's a very special thing to be able to stand up and say you never lost to your archrival or that you beat them three of the four times.

"I didn't fully appreciate that as a player myself. I wanted to have my players understand it, particularly the seniors leading the way, that they can have bragging rights over their rival for the rest of their lives. You wanted the seniors to win their last game. When I was at Oregon State, we wanted them to be able to say they never lost to Oregon. When I got to Oregon, I decided I wanted that same thing for my players."

During his pre-game talks before Civil War games while coaching at Oregon, Brooks often used the "Man in the Glass" poem Andros had employed before facing the Ducks.

"Rich picked up on Dee's motivational ability," said Pifer, Oregon State's star fullback in 1965 and '66. "Rich played for Tommy but bought into Dee's fire-'em-up style."

Several factors go into what Brooks has come to call "one of the best rivalries in college football."

"It's unique because the schools are 40 miles apart," he said. "Even if people don't go to Oregon or Oregon State, they choose sides. Whether it's because of the ag science and a more conservative approach in Corvallis versus the liberal arts school in Eugene, I don't know. But people choose sides and line up and root for one of the teams."

Brooks never lost a Civil War through nine games as a player or assistant at Oregon State. He was unbeaten through his first 11 years as head coach at Oregon, finally losing one in 1988. In 27 years, Brooks lost only three times.

"Rich screwed the whole series up," Pifer said with a laugh. Oregon State "had dominated for a long time, but when he got to Oregon, he turned the thing around and won damn near every time against us."

Often, a win over the Beavers was the biggest thing that kept Brooks from being fired. "When I started at Oregon, we had some bad teams, and Oregon State had some bad teams, too," he said. "I'm not sure I'd have survived had I not won that game on a regular basis. I don't think the Duck people trusted me until after about my third Civil War win."

Brooks left Oregon State in 1970 to join Prothro's staff at UCLA and then moved to the NFL for two years when Prothro took the head job with the Los Angeles Rams. Brooks returned to OSU as defensive coordinator under Andros in 1973 and then left again after the season to coach for two years under Dick Nolan with the San Francisco 49ers.

When Andros resigned in 1975, Brooks applied for the job. He was one of the finalists, but Oregon State hired Craig Fertig, the offensive coordinator at Southern Cal. Fertig beat out Brooks, then coaching at UCLA, and fellow Bruin assistant Terry Donahue, who went on to become a successful head coach for the Bruins.

Bud Gibbs is a former Oregon State player and assistant coach who went on to become registrar at the school. He served on the 13-member athletic board that made head coaching hires in those days. "The board voted 12–1 for Rich," said Gibbs. "We knew he had a great background, that he was very smart and he had everything we thought would turn things around. I think he would have turned the program around almost immediately. The situation he took over at Oregon was a lot worse, no question about it.

"Our second choice was Donahue, who desperately wanted the job. [San Francisco 49ers assistant] Bobb McKittrick was third. Fertig was fourth and [OSU assistant] Tony Kopay fifth."

Andros, who had moved into the athletic director role, overruled the board. "Dee met with President [Robert] MacVicar, and for some reason, he let Dee have his way," Gibbs said. "We didn't understand why. I was on the board for 22 years, and that was the one and only time the president didn't take the request of the athletic board. We had an outstanding board, and the members were just appalled."

Fertig lasted four years, coaching the Beavers to a record of 8-36-1. "After things went bad with Craig, Dee always made it look like it wasn't his choice," Gibbs said. "But it was absolutely Dee, without question. He never said why. But when the decision to hire Craig was made, he made it very clear that it was his choice, and if Craig didn't work out, he was responsible for it. Craig had never been anywhere but USC except for a brief time with the [World Football League] Portland Storm. He had no idea what it takes to win at a school like Oregon State, and he never did."

As for a reason Andros decided against Brooks, Gibbs offered this: "Dee used to say that Rich has been disloyal by leaving Oregon State twice. That's not a good enough reason for putting the school in a bad way."

Forty years later, Brooks has grown weary of the subject. "I've heard different versions of that same story that Bud tells," he said. "I don't know whether the president or Dee did it. Twice, I left Dee's staff to go to other places. I'm sure he wasn't thrilled about me leaving, particularly the second time."

After the 1976 season, Don Read was fired at Oregon. Shortly after being turned down by his alma mater, Brooks lost his job with the 49ers when Nolan's staff was fired in San Francisco. He briefly contemplated going into private business but instead joined Donahue, who had just been hired by UCLA, for a season. Then he applied at the school he had been bred to hate for so many years.

The Ducks chose Brooks. Reports were that first Bill Walsh and then Jim Mora turned down the job. "I know I wasn't their first choice," Brooks said, "but I don't really care about that."

Brooks was concerned that his orange and black roots would be held against him. "I had real doubts about how I would be received in Eugene," he says today. "After I got hired, I went straight from the airport to the Valley River Inn for a meeting with boosters and alumni. As people were sizing me up, the first thing somebody said was, 'So you're that damn Aggie.'"

It took Brooks three years to have a winning season, and he enjoyed only seven of those in 18 seasons at the UO helm. There were grumblings about

him from alumni and fans on and off throughout his tenure there. After the Ducks went 5-6 in 1993, including a 15–12 loss to Oregon State, a large group of UO supporters wanted Brooks's scalp. Following the season, he gave up his athletic director duties to focus on football.

"This will be a critical year for the head football coach," he said cryptically as he met with the media during August training camp prior to the 1994 season. At the time, did Brooks really think his job was in peril?

"I knew it was," he said. "We had beaten Portland State in the opener but then lost an ugly game at Hawaii [36–16]. They were selling 'Ditch Rich' T-shirts in the parking lot before the next game, against Utah, and we lost 34–16. We were 1-2 with a pretty young team before we made our run."

Through the Brooks era, the Ducks struggled for consistency. But they almost always found a way to beat the Beavers.

Though his experience as a player was in the backfield, Brooks coached linebackers at Oregon State in 1965 and then worked with the defensive line the next four seasons as an assistant at Oregon State. During that time, he coached All-Americans Jess Lewis, Jon Sandstrom and Craig Hanneman.

"Rich was more than an assistant coach for me," said Hanneman, who played at OSU from 1968 to 1970 and went on to a four-year NFL career. "I had a special relationship with him then, and I do now. I was lucky. What a great guy. Too bad he became a Duck.

"He was just beginning his coaching career. Andros hired him on Prothro's recommendation. He was in his mid-20s, with zero experience at the position, but he immediately demonstrated a real capacity to teach and develop small-school or out-of-position players. Jess, Jon and I had been fullbacks in high school. Ron Boley had been a quarterback, Dale Branch a linebacker, Scott Freeburn an offensive lineman, Bob Jossis a split end. He took guys with raw talent who couldn't find a home at another position and did amazing things with them. That established what great capacity he had to teach and develop."

"Rich was a really good teacher," said Freeburn, who played the same years as Hanneman. "I don't know that D-line was his strong suit, but he did a good job and was a motivational coach. He was sort of a Mr. Football Guy. Coaching was his passion. He was pretty much no-nonsense, all about football and improving you as a player.

"He was only a few years older than us, but we respected him a great deal. He had a natural talent for leading and coaching, and his dedication to football was obvious. We all loved him, just like we did Dee."

The 6-2, 235-pound Lewis was the stud of the group, an All-America defensive tackle, a two-time heavyweight champion who represented the United States at the 1968 Olympic Games in Mexico City. He fit in perfectly with Brooks. "Rich was such a competitor," Lewis said. "He knew how to win. Love the man. He knew quite a bit about football. He always worked on quickness, making sure his linemen got off the ball and were in the right spot. And he was a stickler on conditioning. We called him the 'D-I'—drill instructor."

Brooks devised an obstacle course for his D-linemen, who labeled themselves the "Dirty Dozen."

"I was a young coach who had played quarterback and defensive back, and here I was coaching the defensive line," Brooks says today. "I figured if I couldn't coach them as well as I should in technique, they were going to be the best-conditioned D-line in the country. I made this obstacle course, and they hated it.

"The maintenance guy built me horizontal bars. They ran circles around posts and through a crawl space, like they do in the army. I'd add one or two things every year to make it longer and more difficult. They used to get so mad. They'd be all sweaty and they'd get sawdust under their pads."

"Rich told us we were simulating the action in the line when you had to get rid of a blocker," Lewis recalled. "He put stakes out there to spin around, six-by-sixes to crawl under, hurdles to dive over, holes to crawl through. It was something you had to do at the end of practice or if you missed an assignment. Everybody had to do it some. The more you screwed up, the more often you had to do it. It made you concentrate on not screwing up, that's for sure. It was a killer."

The down linemen—the defensive guards and tackles in Andros's 6-2-3 defense—were the regular participants. Occasionally the ends would join in the fun, or other players "if they got in trouble," Freeburn said. "But very rarely."

"It was a horrible obstacle course," Preece recalled. "He'd make them do it in full uniform during two-a-day workouts in [August training] camp, no water on sawdust shavings. Rich would always do it, too. He'd say, 'We're going to do this; I'm going to do this. Anybody who can't keep within distance of me, you're going to do it again.'"

The rigors of the obstacle course didn't stop his players from loving him, though. "You talk to any of the defensive linemen," Preece said. "They'd do anything for Rich."

When Brooks was inducted into the Oregon Sports Hall of Fame in 2011, eight of his defensive linemen from Oregon State bought a table in salute to

their old coach. "I gave him a hard time," Sandstrom said. "I was smiling at him, and he looked at me like, 'What's wrong?' I told him, 'Rich, the way I look at it, you spent 18 years at Oregon. You spent three-quarters of your life as a Beaver. So I'm OK with you.'"

Athletes who played other positions during those years for the Beavers respected Brooks, too. "I admired him a lot," defensive back Mel Easley said. "Coach Brooks was loose in those days. He got strict in later years. He was hilarious at times. He seemed to get along with us better than most of the other coaches. Coach [Bud] Riley was all about business."

Steve Endicott, who succeeded Preece as quarterback and later served as a grad assistant during Brooks's second tour of duty as an Andros assistant, often played pickup basketball during the noon hour. "We always guarded each other," Endicott said. "He fouled the crap out of me. I just loved him. He was my kind of guy, a tough guy. When we didn't hire him as head coach, I didn't get it."

Mike Nehl was a defensive back who mostly punted for the Beavers from 1968 to 1970. He forged a close bond with Brooks, who worked some with the special teams and took him under his wing.

"I didn't have a male mentor in my life after my dad died when I was 12," Nehl said. "It left a real void. My mom was an alcoholic. Later she got clean and sober, and that was great. But at the time, it was tough.

"During a time at Oregon State I was having some up-and-down things, and one day Rich took me aside and asked, 'What's wrong, Nehl? You're not focused.' We had a long talk. He shared some similar stories with his life growing up. He said, 'Deal with what you're dealt with.' If you had the guts to open up to him, he could be a tremendous influence on you."

Later, in the 1990s, Nehl said he was going through "some physical problems that became emotional problems." Brooks was head coach of the St. Louis Rams at the time. "I'll be damned if I didn't start getting calls from Rich and Craig Hanneman," said Nehl, now 64 and living in Bend. "Rich told me to hang in there, that it would get better. There it was, 25 years after our time at Oregon State, and he still cares about an old punter of his. I thanked him profusely for taking the time to call a schmuck like me in Oregon. He said, 'I just wanted you to know I'm thinking about you. I'm in your corner.' I respect the hell out of Rich Brooks."

After the 1969 season, Brooks left to join Prothro's staff at UCLA. Before he reached a decision, Brooks called Hanneman, a junior during that season, into his office. "He said, 'Craig, I'll stay here for your senior year if that's what you want me to do,'" Hanneman recalled. "I thought, 'That's not fair

to put me in this position.' I told him he should do what was best for him, but I was devastated when he left.

"He was not just a great coach; he looked after me. Today, almost every career decision I've made, I've called him for counsel. Rich and his family have been extraordinarily special to me in my life."

Brooks returned to OSU for a single season in 1973, coaching the secondary and serving as defensive coordinator.

"I loved and respected him," safety Dan Sanders said. "He demanded a lot out of you, but he worked so hard as a coach, you gave it back. We were so prepared with scouting reports. Every Sunday before the next game, you'd get an in-depth scouting report on the opposing offense. After he left, that level of preparation pretty much went away."

Many of his former teammates and players he coached at Oregon State maintained a friendship with Brooks after he left for Oregon and in the years beyond. Terry Baker and Brooks have gotten together many times over the years, often over a golf game.

"I'm really proud of him and what he did with his coaching career," Baker said. "To have a friend of yours to go on and do what he did, it's fantastic. The side of him that developed that I would have never seen in the early stages is how outgoing he is and how well he relates with people. He had swarms of supporters wherever he coached, and he enjoyed being around people."

Pifer, a Eugene resident, would occasionally join Brooks for lunch during his coaching years at Oregon. "I've always had a very high opinion of Rich," Piper said. "He has a heart as big as gold. The Ducks were lucky he came in when he did. He put that program on solid footing."

For most of the Brooks era, Pifer held Oregon season tickets. "Rich is the only guy who could make me buy tickets to a Duck game," he said. "If they weren't playing the Beavers in those years, I rooted for them, because Rich was doing a hell of a job. He commanded loyalty. He was that kind of a guy. A lot of the players who played with him at Oregon State, their kids played for him at Oregon.

"But nowadays, I don't even like to talk to a Duck. When Rich left, I quit following them altogether."

Pride was pretty much all that was on the line as Brooks went into his first Civil War game on the other side of the rivalry in 1977. The teams entered the game with a combined 3-17, including 0-12 in Pac-8 play. Oregon had allowed opponents to score 361 points, second-worst in the country. Still,

there was plenty of juice flowing from players on both sides during the week before the game as Oregon went for its third straight win in the series.

Oregon senior quarterback Jack Henderson, slowed by a knee injury, was bound and determined to play the final game of his career. He was 41 yards short of becoming No. 2 on the Oregon career passing yardage list behind Dan Fouts. "I'd much rather forgo that and beat the Beavers," Henderson said. "This game means more to me than any game since I've been at Oregon. It's hard for me to think about ending my college career losing to Oregon State. If I were not a senior and if it were not with the Beavers, I'd probably sit it out. The intensity of this game makes it totally different from any other game on our schedule. You can feel it when you walk into the stadium. The fans make it all that more intense.

"Recruiting is one of the main things at stake. Every high school player in the state will know about the game and the outcome. And if we can beat them, it's going to make a big difference in how hard Coach Brooks has to work to turn this program around."

Oregon State center Jim Walker, out of Myrtle Point, said he took the Civil War games personally. "The Oregon staff told me in high school I was too slow to play Pac-8 ball," Walker told the media. "For 60 minutes Saturday, there is going to be a lot of hatred in my mind. I don't think a win can rescue our season, but the program is headed in the right direction, and it would help that much more."

"If we lose to Oregon, five years from now I won't admit I played football at Oregon State," said offensive guard Larry Winkler out of Grants Pass. "I don't want to remember my college football career by a loss to Oregon."

At a combined Duck Club/Beaver Club luncheon on the Thursday before the game at Portland's Memorial Coliseum, the Duck Club presented Oregon State's second-year coach, Craig Fertig, with a T-shirt with a Duck holding a Beaver by the collar and an inscription, "Ducks eat Beavers." Fertig presented Brooks with an old OSU coaching jacket with the name "Brooks," courtesy of OSU equipment manager Don Shelley.

"I'd like to thank Coach Brooks for pointing me in the right direction," said OSU's senior defensive tackle, Greg Marshall, who would be forced to miss the game with a knee injury. "He recruited me for Oregon State."

"I know people are calling this the Bottom Bowl, but we consider it a damned important game," Brooks told the crowd.

"I'm sick and tired of hearing people say Oregon schools can't play football," Fertig said. "Some day soon this game will determine who goes to the Rose Bowl."

If "soon" meant 30-plus years down the road, Fertig was prescient.

Brooks had plenty in his bag of tricks in a 28–16 victory, including:

- A 65-yard halfback pass from freshman Gary Beck to Ken Page to set up a one-yard touchdown dive by Kim Nutting just 2:45 into the game. (Afterward, Fertig quipped, "I guess I did my job pretty well. I had Beck in a John McKay football camp three years ago and I was in charge of the throwing drills.")
- A fake field goal and five-yard gain by holder Tom Cafferty on fourth down at the OSU six, leading to Nutting's second TD and a 14–0 first-quarter lead. The Beavers had fumbled at their 20-yard line to set up the score.
- A 27-yard touchdown run on a fake punt—one of two the Ducks tried in the game—by Beck, who gained 131 yards on 19 carries in his second career start at running back.

"We weren't blitzing after they started using all those wild, out-of-this-world plays," Oregon State middle linebacker Kent Peyton said. "We practiced for that stuff this week. But it seemed like we'd do our job, get off the field and they'd make those trick plays work."

The 6-foot, 205-pound Beck was an unlikely hero, a true freshman thrust into an offensive role after spending most of the season at safety.

"Gary came out of nowhere," Oregon linebacker Willie Blasher recalled. "He was the difference in that game, the blond-haired kid. He came in and tore it up."

"I was thinking, 'Why wasn't this guy playing offense the whole year?'" Oregon noseguard Vince Goldsmith said.

"Rich was going to pull out all stops to win that game," said Steve Greatwood, an offensive tackle who later coached the Oregon O-linemen for many years. "We were running the trap option, some sweeps with Gary and were able to get him out on the edge. He was a change-up Oregon State hadn't seen. He had a fantastic game for us."

Late in the season, Brooks had switched Beck to running back, giving him his first start in a 48–16 loss to California the week before the Civil War. He had five carries for 50 yards for the season going into the Oregon State game.

"Gary asked me during the game if he could play defense, too," said Brooks, who got a ride off the field from his players after his first Civil War win. "He's the kind of player who is willing to do anything to help the team."

Gary Beck grew up in La Crescenta, California, 10 minutes from the Rose Bowl. He was a USC fan as a kid, but Brooks had recruited him for UCLA during his senior season in high school. Beck chose Oregon over the Bruins and Colorado largely because of his relationship with Brooks.

"I remember watching UCLA playing in the Astro Bluebonnet Bowl on TV," Beck said. "At the end of the game they said Coach Brooks had just been named the coach at Oregon. I told my buddy, 'I'll be getting a call tomorrow.' I did. The next week, I went on a recruiting trip to Eugene, liked what I saw and committed to Oregon."

Beck graduated from high school early in January and was in Eugene for Brooks's first spring practice. He made enough of an impression to play some on special teams and as a backup safety before the switch to running back late in the fall. Then came the game of his career in the Civil War.

"It was a very cold morning," Beck said. "We woke up with snow on the ground. I remember meeting a recruit, Dwight Robertson. We talked a little bit. During the pre-game, Coach Brooks used the 'Man in the Glass' poem on us. That got us fired up, and we took care of business. The holes were big and the line made my job easy.

"It's funny. It paralleled what I had done in high school. I was injured my sophomore year and came back the last two games and my last game ran for 170 yards and two TDs."

Beck was the feature player as the Ducks gained 466 yards total offense, highest by an Oregon team in two seasons. Nutting rushed for 94 yards as the Ducks picked up 298 yards on the ground, 198 in the first half. They led 28–10 at halftime and held off the Beavers in the second half, twice keeping them off the scoreboard on forays inside the Oregon 20.

After the game, Brooks said about Beck's future, "I don't know where Gary is going to end up playing—but I know wherever it is, he'll start."

It didn't quite work out that way. Beck didn't like the Oregon weather. "The rain drove me crazy," he said. "I was an immature freshman. I was really homesick. I was a Southern California kid, used to running around in shorts and flip-flops. I was unhappy. I thought the grass was greener somewhere else."

Beck left school the week after the Civil War game and went home to La Crescenta. On January 1, Brooks called and convinced him to return to school. Beck stayed for winter term but departed again before spring ball started. He transferred to San Diego State, where he was ticketed to play fullback in a passing offense. A week into spring practice in 1978, he left there, returned to La Crescenta and got a job. That summer, he received a

call from Oregon assistant coach John Becker, asking if he was interested in returning.

"I talked to my dad, and an hour later, I was headed back to Eugene," Beck said.

Before he was welcomed back to the UO program, Brooks told Beck to make a speech to the players. "I'd left twice," Beck said. "The guys were probably skeptical about me coming back. We needed to clear the air. I told them I was there for good, and I apologized for leaving. I knew I needed to buckle down and make good of that opportunity and work hard to try to get back in the good graces of my teammates. There were some people who weren't happy I was back."

Beck lost his sophomore season of eligibility, spending the year on the scout team. He played mostly free safety his final two years, starting much of his junior campaign and splitting time with Mike Nolan as a senior. The Ducks went 3-0 in the Civil War during his three seasons.

"We went into those games expecting to win, and we did," Beck said. "We felt we were moving in a different direction than [the Beavers] were. I never had a hatred for them. They're an Oregon team, and if they were playing somebody else, I wasn't hoping they'd lose. It wasn't like the rivalry we had with the Huskies. That was the nasty rivalry."

Beck went 1-2 against Washington, losing 54–0 in 1977, winning 34–20 in 1980 and losing 17–3 in 1981.

"When you played the Huskies, you'd better have your head on a swivel, because if you didn't, you're going to get knocked down," said Beck, now 55 and living in Scottsdale, Arizona, where he runs a digital video game exchange operation. "There was a very intense feeling out of what Oregon felt was a lack of respect by them. They acted like we were secondary citizens, not quite in their league."

The Civil War rivalry in those years was, well, civil—at least according to some of the Ducks.

"It was intense," said Blasher, a transfer from Contra Costa College in San Pablo, California. "It caught me by surprise. I was a California kid who didn't know much about anything up here. Coach Brooks came in with a clear message wanting to establish a different mindset in the program. He was more intense than ever the week of the Civil War. You felt it. Bragging rights, pride—those are two words that come to mind."

Blasher won four games in his two years at Oregon. Two of them came against Oregon State. "For me, it was a big game, but it wasn't personal," said Blasher, now 55, living in Portland and working as supervising chief for

the federal probation office for the state of Oregon. "One of the things a lot of fans miss, I believe athletes have a certain respect for each other. That doesn't mean you don't play hard during the game. But when the game is over, you shake hands and go on with your life. Fans have this pent-up stuff they don't ever get to let out. It wasn't like I wanted to hurt someone. But I bought into it more and more as time went on because of the implications in the state.

"Mostly though, it was banter. We had a respect for each other as players. It was a very fun time. You know what I learned most? Adversity. I hadn't experienced losing before I came to Oregon. To go to school on Mondays after losing a game was really hard. You find out about yourself when the score doesn't end up in your favor. It's about how you go on and get your degree and make something of your life."

Oregon went 2-9 in 1978, beating Oregon State 24–3 to end a dismal campaign. Fortunes turned when Brooks was able to recruit quarterback Reggie Ogburn out of College of the Canyons in Santa Clarita, California. Oregon had winning records only twice in Brooks's first seven years—6-5 in 1979 and 6-3-2 in 1980, both years with Ogburn at the controls.

The 5-10, 190-pound Ogburn, a Miami native, considered Arizona, Arizona State and Oregon State before choosing Oregon. He took a recruiting trip to Oregon State, where Fertig was about to begin his fourth and final season at the OSU helm.

"Those wacky Beavers," Ogburn said. "I went to Corvallis and found that, even though I liked wildlife, I didn't like the wilderness. It was a pretty bleak town, a little bit slow for me at the time. I made a visit to Eugene and found it a very wholesome place, not overly small or big. Not Miami, of course, but in Corvallis there was *nothing* to do. I didn't want to go there. And it seemed like Oregon's program was much more advanced than the Beavers were at that time."

Ogburn passed for 905 yards and rushed for 644 more in leading Oregon to a 6-5 record in 1979. He was even better as a senior, throwing for 1,257 yards and rushing for 527 as the Ducks went 6-3-2, their best record since 1964.

"The offense became dynamic behind Reggie," teammate Gary Beck said. "He had great vision, speed and very quick feet."

Brooks built his offense around the multiple skills of Ogburn. "He was just a tremendous athlete and an even more intense competitor," Brooks said. "If the game was on the line, he wanted the ball in his hands, running or throwing or making a play. The guy was phenomenal."

"Reggie was great to play with," defensive tackle Vince Goldsmith said. "Before he got to Oregon, the defense was on the field too much because our offense would go three-and-out or turn the ball over. Reggie was a playmaker. The offense would have long drives and he'd break a long run. He'd get the team motivated by doing something when we needed it. He inspired people to play harder, to fight against adversity. You knew you had a guy who just needed one crease or a tiny hole, and he could go to the house."

"Reggie was a great leader," said Greg Moser, a receiver from 1979 to 1982. "He commanded the huddle. Whatever he said—and he would look you in the eye—you knew it was going to happen. He might say, 'split right, option right. Charlie Bisharat, I'm going to keep the ball. You get that lead guy. I'm going to clear the corner.' And that's what would happen. He had unbelievable talent and was an incredibly clutch performer.

"It's too bad Reggie was 5-8. He might have been 5-9 with his cleats. He could run, had incredible change of direction and was a much better passer than anybody gave him credit for. If a defense stacked the box, he could get it downfield and on time."

In those years, quarterbacks didn't wear red shirts. Players didn't get in trouble for tackling them. "I went through drills and had to hit," Ogburn said. "I was expected to be physical. I wasn't a pansy. We practiced every play like it was going to be a touchdown. During a game, Rich allowed me to participate in play-calling and audible every once in awhile. It was all about execution. We didn't have the best athletes but a bunch of hungry guys with physical attributes and the perseverance to badly want to win. Every game, we expected to win. A lot of teams were scared to play us. We had that pride in ourselves, knowing we could win."

The star of the Oregon defense those two years was Goldsmith, like Ogburn vertically challenged at 5-11 and 230 pounds. He was All-Pac-8 first team both seasons, a potent mixture of toughness and quickness in the middle.

"Vince was dynamite," Ogburn said. "We mirrored each other from defense to offense. He was like the quarterback of the defense. A great athlete. I'd put him up against the best. He was like 5-9 and 250 and bench-pressed the world."

("I'm 5-11," Goldsmith says today, with a laugh. "Some people would say that's debatable.")

"Vince didn't have those blue-chip numbers when it came to size, but people didn't know what they were missing," Ogburn said. "He was a rock in our defense. When we played USC our senior year [a 7-7 tie], he made

Marcus Allen look like a schoolboy. He had him in the backfield that entire game, put him flat on his back."

Goldsmith had chosen Oregon over the three Northwest Pac-8 schools for two main reasons. His best friend, tailback Vince Williams, was going there. And Oregon's track and field program played a big part. Goldsmith was a standout shot putter, throwing 63-10¼, and finished second in the Pac-8 as a senior in 1981.

Goldsmith, a member of Brooks's first recruiting class, had made a visit to Oregon State. "I spoke with Coach [Craig] Fertig," Goldsmith said. "I'll just say I wasn't impressed with him. We had a meeting in his office. He had a lot of USC paraphernalia around and talked about his days there and some of the great players at USC who were there when he was there. It didn't seem to me as if he was selling Oregon State. If the head guy is not really into the school, I'm not sure that's the place for me to go."

Ogburn and Goldsmith seized on the importance of winning the Civil War. Neither lost to the Beavers. "It was cut-and-dried that we would not lose this game," Ogburn said. "We had quite a few guys from the state of Oregon on our team. They lived it and breathed it. You can imagine what it was like for somebody from the outside not knowing the rivalry. But when you're in Rome, you feel like the Romans do. When I first got to Eugene, everybody said, 'You have to beat the Beavers if you don't beat anybody else.'

"I call it a hatred for the Beavers. I developed that. I'm Eugene from the heart. Some of [the Oregon State players] would come and visit our campus. They knew a couple of guys and had relationships with guys on our team. It was for bragging rights, that's the best way to describe it. No matter where you were from, once you became a Beaver or Duck, that's who you were. And you had to win."

"I had never heard of the Civil War until my freshman year," said Goldsmith, 54 and a health-care administrator in Tacoma. "I figured it out quick. We were not very good those first two years, and it was like the rest of the season didn't exist. That week, everything changed. There was more excitement, more of a build-up. I never wanted to lose to them. That was a big deal. It was one of the things we could hang our hats on, that we'd never lost to them. Nowadays, I've been converted. I'm a staunch Duck fan now. Whenever we play Oregon State, it's a big deal."

Oregon won handily, 24–3, during Ogburn's junior year. Freshman Moser saw action in the fourth quarter and caught the second and third passes of his career. "Coach Brooks always gives me a bad time because I was such a

horrible blocker," Moser recalled. "But my freshman year, there were guys [who were] apparently worse blockers. That's what they usually brought me in to do, to crack back on a linebacker or something."

Ogburn was at his best in his final game, leading Oregon to a 40–21 win at Corvallis before a record crowd of 41,600 in 1980. It was the first season for Oregon State under coach Joe Avezzano, and the Beavers would go on to an ignominious 0-11 record. They were competitive against the Ducks, though, with Ed Singler completing 22 of 39 passes for 260 yards and Victor Simmons catching eight passes for 118 yards and a touchdown. The Beavers had the ball at the Oregon 48-yard line after recovering an onside kick with the Ducks ahead 33–21 and eight minutes left.

"I've been around a lot of teams as a player and coach," Avezzano said afterward, "but I'll be damned if I can remember a team that played with so much emotion for such a long time as this team did today."

The difference was Ogburn, who carried 14 times for 173 yards, including a 59-yard TD for Oregon's first score. "We just couldn't stop him," Avezzano said.

"Coach Brooks and Coach [Erik] Widmark kept calling my number," said Ogburn, 54, living in Miami and working in the freight business. "We'd call spread right or spread left. I kept thinking, 'More yards; I know I can do it.' They ran the tongue out of my mouth that day. It was so much fun, I didn't realize how tired I was. I had a great offensive line, too. When we stepped up and were excited about winning, there was nothing stopping us.

"It added up to another win over the Beavers. Have they beaten us since?"

It was Oregon's sixth straight win in the series. "That's something that's never happened before at Oregon," Brooks noted afterward.

"This is a game for bragging rights, and we lost," Bobby Roper, Oregon State's defensive coordinator, said afterward. "Now we have to listen to Duck BS for a full year. We'll listen to it, and we'll come back after them next year. This is what the Civil War is supposed to be about. We played like hell out there all day, but we lost. Nobody should ever feel good about losing to the Ducks."

Goldsmith, who went on to a 10-year career in the Canadian Football League, offered a little "Duck BS" afterward: "We own this school."

Oregon continued its win streak with a 47–17 pounding of the Beavers in 1981 but suffered through a 2-9 season. The next year, things were no better. Going into the Civil War, each team had achieved its first win of the season the previous Saturday—Oregon upsetting Arizona

13–7 while Oregon State was handling Montana 30–10. Even after the wins, Oregon ranked No. 9 and Oregon State No. 10 on Steve Harvey's lampoonish Bottom Ten list. The Beavers went into the game having lost eight straight Civil Wars.

Oregon had tried four quarterbacks through the season and lost 41 fumbles. "Why would anybody say my offense is conservative?" Brooks quipped. "When you lay the ball on the ground as much as we have, that's not conservative, that's exciting—for the other team."

Countered Avezzano: "We haven't earned the right to talk a whole lot."

"It's a must-win," Oregon safety Doug Judge said. "Even the alumni, the students, the people on the streets tell me, if we could only win one game, please, let it be the Oregon State game."

"What you're going to have Saturday," Moser said, "is two frustrated teams bent on destroying each other to salvage their season. It's going to be a banger."

Singler, in the final game of his Oregon State career, offered, "We've never beaten them. I want to look back and say, 'Yeah, we finally did it.' You know your time will come."

It never did. Oregon won the 1982 game 7–6 on a wet, nasty afternoon in Corvallis.

Brooks's Civil War unbeaten streak was put to a test. The Beavers hurt themselves with four fumbles, two deep in Oregon territory, and OSU's Larry Clemons dropped a sure touchdown pass along the sidelines. Terrance Jones rushed 20 times for 139 yards, the first time in 22 games an Oregon player had a 100-yard day. But he couldn't crack the end zone. Neither could the Beavers, though they managed a pair of field goals.

The Ducks trailed 6–0 and were out of timeouts when they took the ball at their own 41-yard line with 3:33 remaining. After two incompletions, quarterback Mike Jorgensen threw low to receiver Rourke Lowe. But Lowe dropped to his stomach and made the sure grab for a 21-yard completion to the Oregon State 38.

"Being remembered for one catch is better than nobody remembered you played at all," said Lowe, a senior that year. "We'd been struggling all day. Osborn Thomas and I ran a crossing route. I was going north to south and for whatever reason, Jorgy threw it my way. It was a really awful pass. I slid underneath it and caught the ball."

After a Ladaria Johnson 12-yard run, the Ducks ran a crossing pattern with Lowe and Thomas again. Jorgensen hit Thomas for 26 yards and the game-winning score with 2:32 left.

"The only spiral I threw in my entire career," Jorgensen joked. "I can shut my eyes today and see that ball leaving my hands. I saw Thomas in the back corner of the end zone. He caught it."

Oregon State cornerback Forrest Pellum was defending on the play. "When Rourke and I crossed, Pellum sat, thinking the ball would be short," Thomas said afterward. "I just ran behind him. He turned and tripped. I really wasn't open. If he hadn't tripped, I would have had to make a great catch."

Pellum was a senior, the older brother of Oregon linebacker Don Pellum. Forrest Pellum was pumped for his final game. "I was playing with a green towel in my pocket," he said. "I was having a hell of a game. Any time I'd make a play, I'd wave that towel toward their sideline. We had them on the ropes. I take the blame for that loss.

"We were running what we called 'Bluff Sinbad,' with a lot of guys at the line of scrimmage and the cornerbacks pressing. Coach [Ray] Braun ran a lot of different schemes to keep the other team off-balance. When Osborn went out on his pattern, I went back to cover but I slipped. I tried to make it up and get back, but he got behind me. It was a heartbreaker. That was a very hard one for me. I still haven't forgotten that. Osborn and I were in training camp together with the Seattle Seahawks the next year. He never let me forget it."

Singler, who completed 13 of 30 passes for 181 yards, never forgot it, either. He'd been benched but had won the starting job back late in the season. "I remember that game more than any of the other Civil War games," Singler said. "Avezzano had decided to shake things up, to go back to the 'Black Bandits of Benton County' during the Tommy Prothro era. We wore new black jerseys. Instead of coming down the ramp before the game, we came through the student section. We were all hyped up. I remember thinking, 'Just don't trip, Ed. Don't trip.'

"We outplayed Oregon in that game. Our defense was great that day. We moved the ball between the 20s, but we couldn't score a touchdown. Then Jorgensen, who hadn't done much all day, threw the touchdown pass. That one stuck with me. Over time, as I see Jorgy over the years, it's painful. We're all competitors. To not have beaten them has stayed with me throughout my life. We all have fun talking about games, but it's always been a tough one for me to say, during our tenure, we never beat the Ducks."

It was a sweet memory for Jorgensen. "After the touchdown pass, I remember looking up and seeing my mom and dad 25 rows up in the stands, standing and cheering," he said. "I can remember them crying after the

game. With all the bad football we played, it was a bright spot that made it worth it. It's one of those plays that sticks with you for a long time."

Moser had broken his foot earlier in the season and was relegated to holding for placekicks. "I always kid Jorgy, who said he completed two passes in that game, and one of them was a spiral," Moser said. "I quickly correct him. The only spiral thrown on the field that day was between the legs of Steve Johnson when we kicked the extra point. None of his passes were spirals."

Oregon offensive guard Gary Zimmerman, a junior on that team who went on to a Hall of Fame career in the NFL, doesn't recall much about the 1982 game. "I just remember," Zimmerman said, "that it was a hell of a lot better than the following year."

Zimmerman's reference was to the 1983 "Toilet Bowl" affair, one that will live in infamy. It is covered later in this book.

Brooks continued his unbeaten streak in the series until 1988.

"Rich took great pride in winning all those years," said Denny Schuler, who coached for Brooks at Oregon from 1986 to 1992. "I'm not sure how he did it, but players win games. We had better teams than Oregon State did for most of those years."

In 1988, Oregon, behind sophomore quarterback Bill Musgrave, had started the season 6-1. Then Musgrave broke a collarbone in the next game, a 21–20 loss to Arizona State, and was out for the season. The Ducks had lost four in a row heading into the Civil War.

Oregon State, meanwhile, was better in its fourth season under Dave Kragthorpe. The Beavers were 3-6-1, had been competitive in every game and were looking for their first four-win season since 1971. They had offensive weapons, led by a trio of seniors—quarterback Erik Wilhelm, who entered the game needing 14 yards to break the Pac-10 career record; receiver Robb Thomas; and running back Pat Chaffey. All would go on to have NFL careers.

Oregon had blown out Oregon State 44–0 the year before, knocking Wilhelm from the game with an injury in the second quarter. It had been the most decisive win in the long history of the series.

"That's forgotten," Wilhelm told the media. "It's totally out of our minds. We know we have a legitimate chance to win."

"This is the battle for the state's bragging rights," Oregon running back Derek Loville declared before the game. "We've had those for 13 years, and we plan on keeping them."

They didn't. Oregon State won 21–10 in front of a Parker Stadium crowd of 40,597 on a wet, windy day. Pete Nelson started at quarterback for Oregon but departed with an ulnar nerve injury in the second quarter, giving way to freshman Bob Brothers—son of ex-OSU great Paul Brothers. The Ducks crossed midfield only three times in the second half and never passed the Oregon State 36-yard line.

Still, Oregon led 10–7 midway through the fourth quarter until the Beavers rallied. Wilhelm found Bryant Hill for 34 yards to set up Chaffey's two-yard touchdown run for a 14–10 lead. Later, Billy Hughely's interception gave the Beavers the ball on the Oregon 32. Chaffey's 17-yard TD run clinched it with 1:30 left.

Parker Stadium's goalposts came down in no time as Beaver fans celebrated their first win in the series in 14 years.

Wrote the *Oregonian*'s Terry Frei: "If you couldn't feel a twinge of happiness for Oregon State faithful Saturday, your blood is either green—in which case take two aspirin and see your doctor Monday morning—or you love hanging around Santa Claus in shopping malls and spilling the beans to the children in line."

"We honestly believed we were the better team," said Chaffey, who gained 109 yards on 24 rushing attempts. "We were a little inconsistent, but when we had to get it done, we got it done."

Loville rushed for 117 yards on 31 carries to finish the season with 1,068 yards, second on the school's single-season list. Brothers completed only five of 22 passes for 59 yards. Wilhelm had a rough day, too, connecting on six of 15 passes for 59 yards and losing 50 yards in sacks.

"I had people in my face all the time, and they covered well, making it hard to adjust," Wilhelm said afterward. "But I don't care about that or the records. My No. 1 goal was to beat the Ducks. That was accomplished."

OSU senior cornerback Teddy Johnson said he felt good for his team's long-suffering fans. "I can relate to them. They may not have played, but this is still a win deep down in their hearts. They're part of this. Now they can go out and wear their Oregon State shirts in Eugene, instead of taking them off when they go down I-5 South. Now they'll be proud to wear them."

Asked if the Ducks had lorded their dominance over the Beavers, Kragthorpe replied, "To a certain extent. When you're the guy on the underside, there's not much you can say. Even if you're a smart aleck, or the rear end of a horse, there's not much you can say. So I had to swallow a lot. I just hope this marks the beginning of an era that's going to be competitive."

The Beavers felt the win signaled a turnaround in the series. "It feels so great to be a part of the team that broke the string, the team that started a tradition of its own," Chaffey said.

Added a cocky Hughely, "The streak is over. They might never beat us again."

Some 26 years later, the principals look back at the 1988 game this way:

Loville: "We just turned the ball over too much. We moved the ball well. The Beavers played well. They were up for the game. It might have been one of those games where we thought we would walk over them. They showed up to play, and we didn't."

Oregon State linebacker Todd Sahlfeld: "We had a pretty good team. We lost a lot of games we probably should have won. I was really happy for the seniors. A lot of those guys had never beat the Ducks and were able to end on a successful note. There was a video that came out that season with the theme, 'We own the state.' Well, at least we owned the bragging rights for a full year. As the celebration went on and you could see it in the eyes of the players and coaches, we started talking about it. It started to sink in we'd done something we hadn't done in a long time."

Oregon defensive end Matt Brock: "I really felt the crap part of losing that game. To this day, it still doesn't feel good. That's how much it meant when we lost that game. It was my senior year. I got hurt and ended that game standing on the sidelines with a neck brace on me. I remember seeing the goalposts going flying past me. Bitter last images."

OSU receiver Robb Thomas: "It was really important. Our level of frustration had grown. I wanted that game more than any game in my life. To win was beyond fulfilling, especially at home. I was double-teamed and don't think I caught a pass in that game. I didn't care. Winning was everything."

Brooks fell to 18-1-2 as a player, assistant coach and head coach in the Civil War. He didn't take his first loss well. "Rich was suicidal that whole winter, literally suicidal," Schuler said. "It affected him a great deal. We had to goad him into getting involved in recruiting because it lingered so long. He took that loss so hard."

Brooks, who had interviewed for jobs at Arizona State, Stanford and Missouri during the previous two years, finally came around. The result was an 8-4 season in 1989 and a trip to the Independence Bowl, Oregon's first bowl appearance in 26 years.

There was more anticipation for that year's Civil War than in some time. Oregon, 6-4 going into the game, was a 17-point favorite. But the Beavers

went in 4-5-1 and, with a game at Hawaii scheduled to end the season, still had a chance for their first winning season since 1970.

"It shows how things have progressed," Brooks said before the game. "That's the way it ought to be."

"I really learned what this is all about last year when we finally won," Kragthorpe said. "When you lose, you slink off and get after recruiting. You find other things to do and try to stay out of the limelight so you don't have to talk about it. It isn't until you win a Civil War game that you see all the excitement that's out there."

"It's been a bad year," Brooks said. Oregon State's win the previous year "has come up more often than I'd like. I saw how the other half lives last year and I didn't like it. I don't want to go through it again."

Neither did his players. "Those pukes up the road rubbed it in last year," fullback Latin Berry said. "I guarantee you, there will be some parties going on Saturday night, and we'll be 7-4."

Oregon won 30–21 before an Autzen Stadium record crowd of 46,087. Oregon State lost three offensive starters to first-quarter injuries, including quarterback Matt Booher. Billy Hughely fumbled the opening kickoff, leading to an Oregon field goal, and the Ducks led 16–0 at halftime.

But Hughely's 57-yard interception return set up a 25-yard Maurice Wilson touchdown reception from Nick Schichtle, and a two-point conversion drew Oregon State to within 16–8 late in the third quarter. The Beavers were within 23–21 after scoring another TD with 7:51 remaining, but the Ducks finished them off when Loville—who rushed for 111 yards and two TDs on 27 carries—scored from two yards out.

"I could never live here if Oregon State had beaten us two years in a row," Berry said afterward. "I would have remembered that the rest of my life. It would have killed me...Also, I hate to say this, but I have a lot of respect for [the Beavers] right now. They never got down, never gave up, never stopped hitting."

Musgrave completed 19 of 38 passes for 267 yards and a touchdown with one interception. The Beavers nearly had another.

"They were deep in their territory in the second half," Sahlfeld recalled. "Musgrave threw a delayed screen to their tight end. I stepped in front of it, bobbled it down to their five-yard line and dropped it. It would have been a touchdown. Then they drove all the way down to score. That play has haunted me. What would have happened had I made that play?"

After the season, Oregon president Myles Brand authorized a guarantee that the school would buy several thousand tickets for the Ducks' participation

in the Independence Bowl at Shreveport, Louisiana. Oregon beat Tulsa 27–24 in the school's first bowl appearance since 1963.

"One of the best decisions ever for Oregon football," Brooks said. "It showed people we would travel some fans, and we were able to win that game. That turned the tide of Oregon football."

Oregon and Oregon State traded Civil War victories the next four years, the visiting team breaking through each time. In 1994, more than ever was on the line for the Ducks—a spot in the Rose Bowl. They got the job done in Corvallis and visited Pasadena in the postseason for the first time since 1958.

After the 1994 season, Brooks left Oregon to take the head coaching job with the St. Louis Rams. Fired after two seasons, he spent four years as defensive coordinator of the Atlanta Falcons, reaching the 1999 Super Bowl. He served as head coach at Kentucky from 2003 to 2009, taking a program saddled with NCAA sanctions imposed for recruiting violations. In 2006, the Wildcats beat Clemson in the Music City Bowl, their first bowl victory since 1984. Playing in the tough Southeastern Conference, Kentucky enjoyed winning seasons during Brooks's final four years before he retired after the '09 campaign.

During his time at Oregon, Brooks earned the respect of those around him for his intensity, competitiveness and toughness.

"The most competitive person I've seen in my life, by far," said Todd Welch, a linebacker from 1982 to 1984, "whether it's a game of gin rummy, a 40-yard dash or a football game—and especially a Civil War. He doesn't like to lose in any respect in any way, shape or form in anything."

"When it got time for business," said Patrick Johnson, a receiver who played for Brooks as a freshman in 1994, "he was as ready to go as anyone who put a uniform on."

Offensive lineman Steve Greatwood began his career at Oregon under Don Read and then played his final three seasons under Brooks. Greatwood coached many years with Brooks at Oregon and for two years with him in the NFL at St. Louis. "Don was a great gentleman, a very knowledgeable coach," Greatwood said. "I really enjoyed Don. Rich was quite a contrast, I have to say. Don's demeanor was soft-spoken and quiet. Rich was just so demanding and competitive. His character really sunk through. It permeated everything we did—his wanting to win so badly."

"Rich was very serious," said Bill Musgrave, a four-year starting quarterback for Brooks who is now offensive coordinator for the Minnesota Vikings. "He brought an element of toughness to the team.

We were a reflection of his intensity and toughness. He was a very good coach. He was supportive of us, always in our corner. I don't know that we had a lot of talent in my years, but we were definitely a smart team because of him."

"The most intense coach I've been around," said Mike Jorgensen, the ex-quarterback who has served as the Ducks' radio analyst for the past 26 years. "Yet he cared for his players so much—for life beyond college. Even when he went to St. Louis and on to Kentucky, you still felt like when he came back, he never left. You felt that with him. He demanded respect because of how intense he was. He was also the type of guy you can jab every once in awhile as a player and he'd have fun with it, but you knew where the line in the sand was. The two coaches I learned a ton of life lessons from were Rich and Ken Krahn, my coach at Ontario High."

"The best coach I ever played for," said cornerback Alex Molden, who went on to play eight seasons in the NFL. "He was stern, but he was a players' coach, too. He gave it to you in black-and-white. There was no gray area. He didn't play any favorites. If you worked hard, he gave you your props. If you didn't, he'd get right in your face and tell you he needed more."

"The most unique coach I ever had," said noseguard/defensive tackle Vince Goldsmith, who played for a decade in the Canadian Football League. "Rich was all about Oregon. A real intense person, focused, hardworking. I didn't have a problem with all of that. He was a disciplinarian from the word go. You could never be late for anything. Even if you showed up just on time, you got a funny look. He wanted you to be early. He'd put everything on the table. If you're going to play, this is why. If not, this is why. He said everyone had equal chance. I believed him, and it proved out to be that way."

Ed Hagerty, a native of suburban Chicago, chose Oregon over Mississippi in part because of a recruiting visit by Brooks and assistant coach Nick Aliotti. "Rich and Nick got so drunk with my dad drinking Irish whiskey, they both fell asleep on my couch," said Hagerty, a linebacker from 1978 to 1981. "I always loved them for that. Today, Rich is one of my dearest friends. We play golf together. He is a mentor in my life.

"I tell people if Rich ate bananas for dinner, he'd crap nails for breakfast the next morning. He is so mentally tough and imposing. The trait I liked, he was a 'buck-stops-here' guy. He did not blame coaches or players or referees. I admired that. When times got tough, he'd say, 'The responsibility is mine. I didn't prepare the staff correctly. I need to work harder.'"

"He'd take responsibility when things went wrong, and players respected that," said Gary Beck, the running back from Brooks's first Oregon team.

"The players loved him. We still call him 'Big Daddy.' He was like a dad to 100 guys on the team. He was a players' coach, never threw anybody under the bus."

Others saw him as a father figure, too. "Hard-nosed, old school—reminded me of my dad," said Damon Griffin, a receiver during Brooks's final year at Oregon. "An in-your-face type of coach, but respectful. It was tough love."

"I've had three fathers—my paternal dad, my position coach at Oregon, Bill Tarrow, and Rich Brooks," said Tom Talbot, a linebacker from 1984 to 1987. "Coach Brooks loved you when you'd do well, but he was not afraid to get in your face and coach you up and tell you when you've done something wrong. I reacted favorably to that."

"He was a hard-nosed guy," said Dan Wilken, a safety in the early '80s. "'Big Daddy' was the person who was in control. He wasn't your friend; he was a father figure. I liked Rich as a person, but he told you how he felt, and it wasn't always good. There was no sugarcoating anything. Still, he was supportive. He was constantly trying to get us better. He was a coach who cared about you."

"Coach Brooks was an old-school, hard-ass coach," said Eric Winn, a freshman during Brooks's final season at Oregon. "You always knew where you stood with him. He was very straight up. Sometimes that was good; sometimes that was bad."

Kenny Wheaton picked Oregon over Arizona, Oklahoma State and Oregon State for that very reason. "Coach Brooks was very straightforward in the recruiting process," said Wheaton, a safety who played three years in the NFL. "That's what I liked and my parents appreciated. He and Coach [Denny] Schuler didn't come in trying to sell me the world. They let me know that if I competed and played hard, I'd get a chance to play. Their approach was different than anyone else."

Not all of Brooks's players appreciated his stern, non-coddling manner. "Rich was demanding," said Bob Brothers, who played quarterback in 1988 and 1990–91. "In some instances, he was unorthodox in his approach to motivating players. We did not have a great relationship."

Both Rich Ruhl and Rourke Lowe say they get along better with Brooks now than they did as players. "His leadership style was an intimidation type of thing," said Ruhl, who played from 1992 to 1995. "He and my dad played together at Oregon State, and I thought I might have a better relationship with him during those years because of that, but that wasn't the case. He had this thing about him where he was stone cold to his players. I like Rich a lot better now than when I was playing."

"He was an intense coach all of the time," Lowe said. "His availability to the players was limited. I never felt comfortable with that. I struggled through college with it. But some of the things that happened between us [were because] I needed to grow up. Rich did a good job of managing most of the things that went on. He was a fair guy. The last two or three times I've seen him in recent years, I've found a nice place in my heart for him."

Even those who enjoyed playing for Brooks were sometimes intimidated by his presence. "He was no joke. He could be a meanie. Don't get on his bad side," said defensive back Anthony Newman, who played 12 years in the NFL and has worked on the Ducks' broadcasting crew for the past decade. "I loved playing for Rich, but I was scared to death of that man. He put the fear into you. You didn't see it during recruiting, but he was an intimidating force."

The players often tried to steer clear of Brooks. "You didn't get to talk to him much," Ruhl said. "You kept your distance. He was a pretty intimidating coach."

"Rich seemed unapproachable at times," Greatwood said. "It took me a couple of years as a player before I could walk in his office to talk. He had a certain persona that I didn't know if wanted to go in there. He kept you at arm's length."

"Rich coached from the bleachers at practice during my time at Oregon," said Ryan Zinke, a center from 1980 to 1983. "You spent time looking at the bird's nest, hoping he wasn't going to come over to you. When he would come down, you knew it wasn't good. Even today when I see Rich, my palms sweat."

Zinke went on to join the Navy SEALs. "To have a coach with that intensity helped me become a SEAL," Zinke said. "He was a very good coach. He wasn't intimate with the players as far as warmth goes, but I think his coaching style changed over the years. I liked Rich. There are very few guys who had more passion. I'm grateful for what he did for the Oregon program."

"As Rich would walk the [practice] field, guys would know where he was," Hagerty said. "If he walked by your individual area, the intensity would drastically increase. He was so competitive. I've probably played golf with him a couple of hundred times, and he still occasionally makes me nervous."

"He was very intimidating. An old-school coach, a guy you didn't like to look in the eye," said J.J. Birden, a receiver from 1984 to 1987 who went on to play nine years in the NFL. "If he was walking toward you, you'd walk the other way. When we were both in the NFL, he was different. He was so

cool. It took me awhile to be comfortable around him, to be, 'OK, you can talk to Rich.'"

"We all feared and respected him," said Chris Miller, a quarterback from 1983 to 1986. "If you had to go see Big Daddy, you might have done something sideways. It's probably much like Nick Saban at Alabama. Rich had that air about him."

Miller reunited with Brooks a decade later with the St. Louis Rams. He saw the same difference as Birden. "It was neat to see his maturation as a coach, to see him mellow, if you will," Miller said. "He still had the same fiery persona, but he had evolved."

Even the broadcasters got a glimpse of Brooks's sometimes threatening persona. "I really enjoyed being around Rich," longtime radio play-by-play man Jerry Allen said. "Scared me sometimes, but I had great respect for him. He was the one who introduced me to how important and how much of a lifestyle coaching really was, how much of their lives they put into it. He was tough but fair."

Brooks's intensity reached its greatest level on game day. His custom of vomiting before games was legendary.

"Rich has had a real history," said old friend Terry Baker, "of being the most nervous coach in the world."

"Before every game, he'd be pacing around," Greg Moser recalled. "The trainers had garbage cans strategically located in the locker room. He'd be in the fire-and-brimstone mode of his pre-game talk, pause, maybe in midstream—you never knew—and hurl into a garbage can. Then he'd wipe off his mouth and continue."

"It started when I was a player and lasted through my first dozen years or so at Oregon," Brooks said.

Or maybe longer, if his latter-year players remember correctly. "You'd be walking down the tunnel toward the field," Patrick Johnson said. "He'd step aside and puke."

"You get nervous and fired up," Brooks explained. "After I started coaching, if I didn't get that way, my players wouldn't think I was ready."

"We'd always know Rich was ready after he'd thrown up in the bathroom," Lowe said. "You'd hear him do it, and then he'd come in and we'd start the pre-game."

Brooks would normally retreat to the toilet adjacent the locker room to do his business. "I remember from the first year I was there, he'd be throwing up in the stall before the game," Beck said.

"A couple of times, I was in there, and I'd hear it and, 'Aww. He's doing it again,'" Alex Molden said.

"It got to the point where he'd wrap a towel around his neck, and he'd be puking in a garbage can somewhere so he could wipe off his mouth," Miller said.

"Rich always had a towel around his shoulders," Schuler said. "He'd always throw up before a game because he'd get so emotional. He was also apt to throw up right in the middle of a game on the sidelines. I never saw him do it, but I know that's why he had that towel."

Said Hagerty: "Our team doctor, Ken Singer, would always ask, 'Do I have to give him a B-12 shot? He's throwing up again.'"

"Before we played at Georgia, the first game of my career, Rich was in the end zone, throwing up," Goldsmith recalled. "I thought, 'Man, he must be sick.' He wasn't sick. It was nerves."

"It's my junior year and we're playing Oregon State in Corvallis," Greatwood said. "Rich lets the team out of the visiting locker room at Gill Coliseum, and I'm walking behind him down the asphalt ramp to Parker Stadium. And suddenly, I swear to God, I'm dodging his little piles of vomit. He vomits every third step. He would get so worked up he couldn't control himself. You just tried not to step in his stuff. It was nuts."

Many consider Brooks a great teacher.

"I loved him as a head coach," said Danny O'Neil, a quarterback during Brooks's final four years at Oregon. "He knew what he was doing. He'd been coaching for a long time. As an 18-year-old coming in, I needed that direction and coaching."

"Rich was an incredibly sound coach with fundamentals and a real good defensive coach," said Neil Elshire, a defensive end in 1978 and '79. "I learned a lot. He was a taskmaster, and I fit well in that kind of a discipline-oriented system."

"He reminded me of Marty Schottenheimer in that he could coach every position on the field," said Birden, who played for Schottenheimer in Kansas City.

"I don't know that I've ever been around a coach who knew more about every aspect of the game," Schuler said, who coached with Brooks in St. Louis, too. "When Rich was with the Rams, he was called the 'fundamental' coach. He taught Merlin Olsen how to take on a block. At Oregon, Rich was our kicking-game coordinator. He was a defensive coach for years. He got involved in the offense to a certain degree. He was a thorough, hands-

on coach. He was tough, and he instilled that in his players. It was not uncommon for him to get two linemen down and going one-on-one in the locker room before a game.

"Recruiting was a necessary evil. It wasn't his favorite part of the business, and that's the lifeblood of the college game. [Mike] Bellotti and [Chip] Kelly moved on to a better level in terms of talent, but Rich started that turnaround at Oregon."

If there were mixed emotions about Brooks's coaching demeanor, he eventually won over most of his players. "Playing for Brooks was an incredible experience," said Cristin McLemore, a receiver from 1992 to 1995. "He's a good guy and an excellent coach. He taught me a lot about being a man outside of football. I didn't appreciate him as much when I was there as I have as the years go on. He was an old-school, no-nonsense kind of guy. I was more of a players' coach type of player. When Bellotti took over, he was more my speed. But I still loved Coach Brooks."

"It was an honor to play for Rich," Newman said. "He knew the game. He understood how to motivate his players. He was demanding, yet he gave you a lot of love. My sophomore year, I had a bad game against Colorado. He brought me in and said, 'If you don't tackle people and take care of business, you won't play here.' He was straightforward, which I liked."

Griffin considered Brooks a master at pre-game speeches. "It was impossible not to lose your mind and have the craziest energy after them," he said. "He has to be one of the best ever at that."

E.J. Duffy, a linebacker from 1983 to 1986, thought it was quite the opposite. "He was not a great motivator," Duffy said. "He would prepare you during practice through the week, then it was up to you. His thing was, 'If you can't get excited about a game, I'm not going to be the guy to help you.' Rah-rah pre-game speeches were not his thing. But I really enjoyed playing for Rich. He was honest, with no BS. You knew exactly where you stood with him."

Others saw it the way Griffin did. "Believe me, Rich could get a team fired up for a game," said Bruce Jensen, a senior during Brooks's first year at Oregon. "As mild-mannered as Don Read was, Rich was the opposite."

"Rich was one of the greatest motivators ever," said Greg Moser, who went on to play four years in the USFL. "I got to play for a lot of guys, including Mouse Davis, Pepper Rodgers and Jack Pardee. For me, there was nobody close to Coach Brooks. He was honest. You always knew where you stood with him. If I were picking a coach to play for, whoever's in second place would be quite a ways back."

"He knew how to push my buttons," said Matt Brock, who played seven years in the NFL. "He would get me fired up, boy. A compliment from Rich Brooks was him hitting me in the stomach and telling me I'm getting fat. I never knew what he thought of me until years later, when I played against him while he was coaching for the Rams. Talking to him after the game, I realized he thought highly of me and my work ethic. He was a tough nut to crack."

"He'd be hard on you, get in your grill when it was deserved," Tom Talbot said. "But when he gave praise—he was always trying to give you crap first—it was more rewarding than anything. I'm a huge Rich Brooks fan. He made a big impact in my life in a favorable way."

Brooks was at his best in preparation for the Civil War game.

"Rich was always a competitive son of a gun," said Nick Aliotti, who coached seven years with Brooks at Oregon and three in St. Louis. "There was no doubt when we got ready to play Oregon State."

"I don't think anyone has, or ever will have, the intensity Rich brought to those games," Greatwood said. "I was proud that I never lost to the Beavers as a player and proud that three of those were with him. I don't know if it's ever burned any hotter in anybody. He basically willed his teams to win. Back then, I think Oregon State had better talent than we did, but he found a way to get it out of us."

"Rich wanted that week to be really special," said Schuler, who played for both Len Casanova and Jerry Frei at Oregon. "Cas and Jerry treated it no different than any other week, but Rich really did."

"For all of us guys from the state of Oregon, the Civil War game carried a little more meaning," Eric Winn said. "For Rich, it was even more meaningful, having gone to Oregon State."

"He had been spurned by his alma mater for a job, and he had an intense dislike for Oregon State after that," Greatwood said.

"Being turned down by Oregon State was a big part of it," Schuler said. "I worked in the OSU alumni office in 1997, and I was told [former OSU basketball coach] Jimmy Anderson never forgave Rich for being a Duck. They were best friends before. I grasped how much venom Rich had for Oregon State after they didn't hire him."

"He never came out and said it, but we all knew the history," Greatwood said. "Oregon State had hired a USC guy while Rich was at UCLA. There was something Rich felt he needed to prove to the guys up the road. We all got the message loud and clear. We understood."

For awhile, that was probably true. And through his time at Oregon, most of Brooks's players knew he had played at Oregon State. But especially in his latter years at Oregon, many of them were unaware he had been passed over for Craig Fertig when OSU replaced Dee Andros in 1976.

"I didn't find out about that until later," Molden said. "But oh my goodness, yeah, he wasn't the same Rich Brooks the week of that game. We had to beat Oregon State to have a successful season. It was always clear he hated the Beavers."

"I remember thinking because he went to Oregon State, he wasn't going to be easy on them," Jensen said. "It bore out. He was more inspired by the fact that he was playing the Beavers than for any other game."

And as Brooks himself noted, Civil War victories helped him keep a job through the lean years.

"I don't recall Rich ever mentioning he played there or got passed over" for the coaching job, O'Neil said. "But we all understood if a coach lost the Civil War too many times, he wasn't going to have a job."

"He couldn't face the alums if he lost," Ogburn said.

But more than that, it was wanting to beat his old school that had turned its back on him. "Coach Brooks had been a Beaver," said Dino Philyaw, a fullback in 1993 and '94. "It would give me more motivation if it was my alma mater and they didn't think I was good enough."

Actually, preparation for the Beavers started well before Civil War week. "That game meant a lot to Rich," said Mike Walter, who played for Brooks from 1979 to 1982. "He talked about that all the time. We'd do an Oregon State period in the middle of the season."

"Particularly in the early years," Brooks acknowledged. "In [August training] camp and sometimes through the season, I would take 10- to 12-minute periods to work on things I wanted to do specifically against Oregon State. A lot of times I'd put in a different formation or play that we didn't use all year but saved it for that game."

Losing the Civil War was not an option for Brooks. "It was a battle between state schools that couldn't stand each other," Newman said. "One program was at the bottom of the Pac-10 and the other in the middle. Rich took the game seriously. My freshman season was the year after the Toilet Bowl. We were told, 'This is not going to be a tie this year.' Every year, it was, 'We can't lose to the Beavers.' We were going to take care of business. The things that came out of him before that game, I never saw throughout the season. It was a very intense week of practice. It was a necessity to have that game—to not just win but to dominate."

"The coaches treated the Civil War game differently than any other," Goldsmith said. "I think that was all Rich."

"The week of the Oregon State game was always 100 percent different," Duffy said. "We'd normally review film of the previous game on Sunday. A couple of years, we didn't do that at all. We just started looking at Oregon State. Everything was different about that week. During practice, we'd be in lines and he'd make a comment about the Beaver somebody was going up against. Like, 'Dan Ralph, you're not as good as we thought. This guy's going to eat your lunch.' Or, 'E.J. Duffy, boy it'd be a shame if you lost this game.'"

"He'd swear, he had names for the Beavers—he'd get pretty vocal," Schuler said. "And that rubbed off on the rest of us."

Picking up on a tradition started by Andros at Oregon State, Brooks brought in coaches and former Oregon players to speak to the team during Civil War week. "They talked about what that game meant to them and what it should mean to us," Gary Zimmerman said. "I think once, the Great Pumpkin came in."

Zimmerman's memory is faulty there. But no one would have put it past Brooks to go to that extent to get his team ready to play. Each night after practice during Civil War week through the Brooks era at Oregon State, players joined together to sing the OSU fight song. The Oregon version, that is.

"That was a tradition that was passed on through generations," said Josh Wilcox, a linebacker who played during Brooks's final season at Oregon.

Many ex-Ducks, including Jorgensen and Hagerty, can still recite the trumped-up version word for word. "Well, it's only been 35 years," Hagerty said with a laugh.

"That was a lot of fun," Brock said. "I still know two verses of it."

"I don't know if I ever knew the words to the Oregon fight song," Lowe said, "but I knew the Oregon State song with all the embellishments."

When Schuler later coached at Oregon State under Jerry Pettibone, "I only knew the Duck version of the fight song," he said. "It started, 'O-S-U our pants are off to you…'"

"It was led by the seniors or by Rich himself," Bob Brothers recalled. "He didn't discourage that in any way. He was very clear about his dislike for that program."

"I didn't even have to learn the X-rated version because my dad and uncle [who had played at Oregon] had taught it to me," Winn said. "The older guys were surprised a freshman knew the words verbatim."

Many of the players weren't even aware it was based on the Oregon State fight song. "I just knew it was a song we sang that had colorful language," O'Neil said.

"It was crude and lewd," Hagerty said. "But you have a bunch of 18- to 22-year-old kids. You don't think we enjoyed that?"

Brooks laughs when asked about it all today. "I used to tell my players, 'I'm the only guy who knows the dirty words to both schools' fight songs,'" he said. "But I didn't start that tradition. When I got to Oregon, the seniors started it up during Civil War week. When I called the team up, they broke practice by singing it. I don't know how long they'd been doing it, but I believe it started under Don Read."

Memories are hazy on that. Read, now retired and living in Corvallis, doesn't remember. Several players during the Read era can't recall it, either. The tradition continued through the Bellotti years. It began to peter out after Kelly took over, though there remains a flicker to the flame.

"There is still a fight song with the words rearranged to express our thoughts about our rival," said current Oregon defensive coordinator Don Pellum, who played for the Ducks under Brooks in the early '80s. "It has carried on. It's still around a little bit. It still rears its head."

Today, Brooks is 73, retired and dividing his time between homes in Eugene and La Quinta, California. He takes pride in what he helped build at Oregon. "It's been so much fun seeing the facilities continue to get better and the program play in BCS bowls every year," Brooks said.

Brooks has met Coach Mark Helfrich and is eager to see how the Ducks fare moving forward. "Mark's a nice guy and has had success throughout his career," Brooks said. "All indications are he'll do a good job."

If there was bitterness toward his alma mater, it seems gone. He is close with Oregon State coach Mike Riley, whose father, Bud, coached with Brooks on Andros's OSU staff. Mike had Brooks speak to his team during training camp in 2012.

"I'm really happy to see Mike have the success he's had at Oregon State and to see the development in the program," Brooks said. "Oregon forced things on Oregon State from a physical plant standpoint. Because [the Beavers] responded, they moved ahead of Washington and Washington State in terms of programs in the Northwest. The Oregon State facilities are among the best in the league. It's been a wonderful thing to see that the Civil War has decided a Rose Bowl berth and BCS bowl games. It speaks volumes for where both programs have gone."

So what is it now? Is Brooks a Duck or a Beaver? "I met my wife [Karen] at Oregon State," he said. "We had great years coaching there. It's my alma mater. I spent 18 years of my life at Oregon, and my kids pretty much grew up in that environment. I consider myself both a Beaver and a Duck."

TOILET BOWL

There have been six scoreless ties in the 120-year history of the Civil War, but the last one is the one that will forever live in infamy. At the time, some called the 1983 0–0 tie the "Donut Bowl." Since then, it has been entrenched in memory as the "Toilet Bowl."

"Even now, that's what most people remember me about at Oregon," NFL Hall-of-Famer Gary Zimmerman said more than 30 years later. "I played in the Toilet Bowl."

Eleven fumbles. Five interceptions. Four missed field goals.

"An incredible, strange game," Oregon coach Rich Brooks said afterward. "It was almost like neither team wanted to win, and found ways to mess up."

Oregon State blew five forays into the Oregon red zone in the first half. Oregon repaid the favor, driving six times into OSU territory in the second half with no points to show. The game film, wrote the *Oregonian*'s Steve Brandon, could "singlehandedly bring back *Fractured Flickers* to television."

It was the first scoreless Civil War game since 1931 and became the last Division I game to end without points when overtime was introduced to college football in 1996.

"When I was in the NFL, I was certainly happy I was gone from Oregon by the time they played the Toilet Bowl," said linebacker Mike Walter, who played for the Ducks from 1979 to 1982.

The game was played in a torrential downpour on an Autzen Stadium field that didn't drain all that well. "It was a weather disaster and a bad game between two not-very-good teams," Brooks says today.

Overall, it was probably the worst game during the modern era of the 120-year rivalry. "A cold, dark day that nobody wants to remember," UO linebacker Todd Welch said.

Both teams entered the 1983 Civil War game with losing records. Oregon State was 2-8. That represented a step up for fourth-year coach Joe Avezzano, who had gone 0-11, 1-10 and 1-9-1 in his first three seasons. Avezzano—who came to OSU in 1979 after serving 11 years under Johnny Majors at Iowa State, Pittsburgh and Tennessee, the last seven as offensive coordinator—carried a 1-28-1 mark in Pac-10 games into that Civil War contest.

During the Avezzano era, the coach brought in former Oregon State coach Dee Andros for pre-game talks prior to the Oregon game. "The Great Pumpkin was the guy who made the game feel really important to us, especially the younger guys," said OSU safety Kenny Taylor, who played from 1981 to 1984. "His speeches were legendary. He'd come in on Monday or Tuesday and help get you fired up through the week. That week, we didn't call it 'Oregon Week.' We called it 'Civil War Week.'"

It was the seventh year of the Rich Brooks era at Oregon. The Ducks, after an upturn during Reggie Ogburn's two seasons in 1979 and '80, had fallen off to 2-9 in 1981 and 2-8-1 in '82 and were 4-6 going into the '83 Civil War.

Oregon State had thrashed Division II opponent Portland State and upset Stanford, but each of its eight losses had been by two touchdowns or more, including a 38–3 whipping at Arizona State the week before. There was much dissatisfaction with Avezzano among OSU supporters, and word that week was that his post–Civil War firing "awaits formality."

Avezzano, 36 when he took over at Oregon State, was a hard guy and wanted his players that way, too. Rudy Guice was a linebacker who had started his career at Oregon State under Avezzano's predecessor, Craig Fertig. "I really liked Coach Fertig," Guice said. "I liked his whole staff. But as far as preparation and off-season conditioning, Coach Avezzano was night and day from Fertig. The winter Joe and his staff took over, they had us running and conditioning in the snow and ice. They wanted to see what we'd endure. At the time, it rubbed me the wrong way. I'm tough. It seems a little disrespectful. Through the years, I've understood it more."

"That first spring under Avezzano, the coaches were trying to establish toughness," said Jim Wilson, an offensive guard in 1980 and '81. "It was like, 'Who are they trying to run off?' They were pushing us to the limit of what

a body can do. Joe said, 'On the whistle, it's not a block, it's a fight.' There were some very intense and tough times."

"Joe started off trying to break us, to make people quit," offensive tackle Eric Pettigrew said. "I'd never worked so hard, pushed myself mentally so hard, never worked on technique so hard as under him. He gave you half T-shirts, tiny socks and shorts, and we'd be out there running in icy conditions in the winter. He'd be running the crap out of us. He was trying to eliminate the folks who didn't want to be there. I had nowhere else to go.

"Joe was a tough dude himself. During practice, he'd come over to position drills, and you'd see him burying his head in the middle of somebody's pads and really knocking them back without any equipment on."

Pettigrew had also begun his OSU career under Fertig. "We had a lot of issues off the field that came up with players when Fertig was coach," Pettigrew said. "Guys missed team meetings or got busted doing something. I can remember one time we had a detective come in and talk to the coaches, who told us, 'If you're involved in any of this, you need to stop.' They had inside information about something. I really liked Coach Fertig as a person. He was very good to me, even after he was fired. He was very hurt about getting fired by Oregon State.

"But Avezzano was the best coach for me, although we didn't talk or weren't as close as I was with Fertig. Joe and Coach [John] Gough, my position coach—if I'd had them for four years, I'd have been a much better player. Joe had high expectations of you on the football field, in meetings, at meal time, in school. You just knew you did not want to mess with him. You studied harder, you lifted harder, you made sure you went to class. Joe and [academic coordinator] Don Whitney were the guys most responsible for me graduating."

Wilson—a slugging first baseman who wound up playing for Cleveland and Seattle in the Major Leagues—remembers the final game of his football career, a 47–17 loss in the 1981 Civil War game. "We're behind, third-and-long, a couple of minutes to go," said Wilson, who gave up his senior year of football to sign a pro baseball contract. "Eddie Singler throws a deep ball up for grabs, and it gets intercepted. I see the Ducks are forming a return wall to the left. I don't want them to score, so here we go. I crash into the wall, break up the wall and they don't score on the play. It's near our sideline. I start to walk off, and Avezzano sees me and starts yelling, 'Run off the field!'

"Joe was an intimidating guy. He had me scared. He liked me as a player, but he had a problem with me playing baseball, which was keeping me from being as good in football as I could have been. I'd have been bigger

and stronger and a better football player if I'd focused on that, and it just showed. I was a guy he liked to yell at. But Joe worked hard as a coach. The problems he had both on and off the field are well documented, but there was some good there."

Nick Aliotti, who coached running backs at Oregon State from 1980 to 1983, wished only that Avezzano had an "off" button to his personality. "Joe was highly competitive," said Aliotti, who retired as defensive coordinator at Oregon after the 2013 season. "He was a driver. Battled his butt off. Did all the things you wanted a coach to do. I liked him. But everything was a big deal. Everything shouldn't carry the same weight. There should have been a different weight to preparing for the Civil War game than having the proper hors d'oeuvres for a staff party."

Ron Heller chose Oregon State over Tennessee because Avezzano promised him a chance to compete for a starting job as a freshman. "They'd just gone 0-11, and Joe said, 'We're building. Nobody's safe,'" said Heller, a tight end and linebacker who wound up playing seven years in the NFL. "I wanted to play, not watch from the bench for a top-10 team. Avezzano was a great coach, a lot of fun to play for. He had a really young staff. He worked us to death, but he treated the players well. He treated us like men and had big expectations for us.

"A big problem was facilities. The weight room, a tiny dungeon in a corner of Gill Coliseum, was a joke. We had to practice on that bad turf field. The other downfall was Corvallis was a tough place to recruit to. He was competing with USC, UCLA, Washington—schools in much bigger cities, much more of a draw for guys who wanted that kind of lifestyle. Me being from Clark Fork, Idaho, population 400, getting to duck hunt on the equipment manager's farm south of Corvallis every week was a big lure."

"I was very appreciative of Coach Avezzano giving this young kid a chance to get a full-time job at 24 in the Pac-10," Aliotti said. "But we were awful—as bad a football team as you can imagine, and it wasn't because of coaching. It was the whole nine yards."

Talent, or lack of it, was a major issue.

"When Avezzano came in, a lot of the Fertig guys had transferred," Wilson said. "We had maybe 15, 20 scholarship guys left. We were so devoid of talent, it made it hard to compete."

There was more to it than that, Pettigrew argues. "It was a mental thing," he said. "We had gotten used to being bad. We had talent. I look at some of the game highlights from back then, and man, there were some good players. But mentally, we weren't there. And it became harder and harder to recruit."

"Joe had good knowledge of football," quarterback Ladd McKittrick said. "I'm sure he was a very good position coach. But he did not have the management skills to be a head coach, nor did he have the discipline personally or professionally to run a good program.

"Joe came from the South. Everything was SEC football where he grew up, the good ol' boy network. He had the haves and the have-nots among the players. There was always somebody getting a little better treatment. He had different sets of rules for different players. That does not bode well long-term in any program."

McKittrick had transferred to Oregon State from Cornell. His father, Bobb, was offensive line coach of the San Francisco 49ers and had played and coached at Oregon State. Ladd was born in Corvallis and spent one of his grade-school years there. He came to OSU as a walk-on and began the season battling with Jay Kirschenman for third-string quarterback. The starter was fleet JC transfer Ricky Greene, a sprint-out quarterback who was to signal a new, more mobile offensive era under Avezzano. Greene looked good until he blew out a knee in the season-opening 51–14 win over Portland State and was lost for the year.

Backup Jeff Seay took over but proved ineffective. By midseason, McKittrick was the starter, with Kirschenman No. 2.

Like Avezzano, Rich Brooks had his detractors among the UO faithful, too, but owned a 5-0 Civil War record to fall back upon. Oregon had some talent, notably Zimmerman, who would go on to help the Denver Broncos win the 1997 Super Bowl on his way to the Hall of Fame.

"Gary was our best player," safety Dan Wilken said. "He was soft-spoken, hardworking, quiet, modest. A typical offensive lineman. I remember in one spring game, I'd come back from knee surgery. I go around a corner waiting for a kickout block, and Zimmerman just rolls me. I'm on my back, and Gary says, 'Welcome back, Dan.' I didn't know how good he was going to be, but he was such an athlete, such a great pulling lineman."

Like the Beavers, the Ducks had quarterback issues. Starter Mike Jorgensen had broken his leg against UCLA and was done for the year. True freshman Chris Miller was brought out of a redshirt year to play.

"I get blamed for the Toilet Bowl—and I love it, by the way," Jorgensen says now. "People have so much fun with it. If I'm going to be remembered for something until the day I die, it will be a Toilet Bowl game that I never played in. I get associated with the worst game of them all. Miller was the

starting quarterback for that game. He probably doesn't remember because of all the concussions he's had."

Miller remembers, though he'd just as soon forget. "The backup, Mike Owens, didn't play well, so they took me out of a redshirt year," said Miller, who would go on to a 10-year NFL career. "They threw me in the second half against UCLA, and I started against Stanford and in the Civil War. It was just an ugly game. I missed Ladaria Johnson on a 10-yard flat route that would have gone for an easy touchdown. The Beavers played bad, but we did, too. Disappointing, because going into the game we had beaten them, what, 14 years in a row? [Editor's note: actually, eight.] What I like to remember are the butt-whippings we put on them my last three years."

In the week leading up to the 1983 Civil War, Oregon State's players were talking bravely about their team and their coach.

"We all know what Joe is going through," fullback Bryce Oglesby said. "We haven't won a lot of games. I don't think you can put the burden on one man, but [detractors] do. People don't know what's going on the inside. They're going to have a good club next year. All the key players will be seniors."

"You can just take a look around and see how far this program has come," tailback Randy Holmes said.

At a pre-game luncheon, Avezzano did some posturing. "This is as fine a rivalry as there is in the country," he proclaimed. "It's all about people taking sides, getting after each other on and off the field. Teddy Roosevelt said, 'Walk softly and carry a big stick.' Right now, we're kind of hollering and looking for a Sequoia."

Former coach Dee Andros, now the school's athletic director, was tired of Brooks—his former assistant coach—beating his old school. "I can't stand up here and say I want him to win again," the Great Pumpkin said. "It gnaws at my gut."

Oregon State, a 14-point underdog, dominated the first half, holding Oregon to one first down and 45 yards total offense through intermission. The Beavers, meanwhile, blew five scoring chances. Fumbles at the Oregon 20 (by Oglesby) and the UO 11 (by James Terrell) killed drives. On a day marked by driving rain and stinging wind, Marty Breen missed field-goal attempts of 26 and 36 yards. And Dan Wilken intercepted a McKittrick pass at the UO 17.

"I'd broken my thumb against Stanford the week before and was playing with a rubberized cast over my hand," Wilken remembers. "It was

barely above freezing, ice cold and the ball was slipping all over the place. Defensively, I felt like we could handle them. I never felt worried they would beat us. But every time we'd get the ball back, we'd turn it over to them. It was a futile feeling, like *The Twilight Zone*."

How cold was it? "I don't remember what the temperature was," OSU's Kenny Taylor said, "but it was bone-chilling. Once your body got frozen, you couldn't warm up. Neither team was very good, especially on that day. Who could throw a pass or hang into the ball in that kind of weather?"

McKittrick had a hopeful feeling at halftime. "You're thinking, 'We have a chance,'" he said. "We weren't playing Arizona State or USC. We can do some things and get a win. But it was two teams that weren't very good, playing in crazy weather conditions. I'm guessing it was 38 degrees, raining sideways, the turf a slippery mess.

"Everything goes wrong no matter what. You try to make plays. You're back there ready to throw the ball, and all of a sudden the ball slips out of your hand. It was a comedy of errors. You think your field goal kicker hits the ball pretty well. You get a good hold down and it misses. You throw passes and guys drop them. You throw bad passes and they get intercepted. Good running backs fumble the ball. It looked like an NFL bloopers film."

Oregon turned the tables in the second half but failed to convert on six scoring opportunities. Paul Schwabe missed field goals tries of 20 and 50 yards.

"Todd Lee had been our kicker all year," said Oregon linebacker E.J. Duffy, who had an interception and two fumble recoveries in the game. "Rich used Schwabe. We all were sitting there confused, saying, 'Why is Todd not being used?'"

There were fumbles by Todd Bland at the Oregon State six and Ladaria Johnson at the OSU 45. Miller, who threw interceptions at the OSU 30 (by DeMonty Price) and 25 (by Kenny Taylor), left the game with a concussion when hit by Heller while throwing the second pick.

"Chris ended up being my roommate with the [Atlanta] Falcons," Heller said. "I knocked him out of the game. He would never own up to it. He scrambled, I pushed him out of bounds and he went headfirst into an equipment truck."

Taylor, who played a season with the Chicago Bears, still has the ball he intercepted. "It has the Oregon logo on it, which was kind of cool," he said. "But I didn't make a great play or anything. The pass was a total duck—no pun intended—thrown right to me. You couldn't get velocity on the ball that day."

Rain turned into a torrential downpour as the day went on. "Water was pouring down the stairs of the stadium like a waterfall," Brooks recalls. "The drainage system couldn't keep up with it. Rain was running from the crown of the field to the sidelines. We were standing in about two inches of water the last quarter of the game."

Oregon State had a late scare. Oglesby—who rushed for 96 yards on 21 carries—appeared to fumble at the OSU 37, and UO cornerback Wendell Cason scooped it up and was on his way to the end zone when officials ruled it no fumble. The Beavers then moved into Oregon territory, but McKittrick's pass was picked off by Danny McCalister at the UO 23 with 2:21 left.

After regaining the ball in the final minute, Avezzano chose to punt on fourth down from the OSU 40 with 14 seconds left. "I didn't want to put our team in position to lose the game," he said afterward. "No way did we deserve to lose."

McKittrick was among those who didn't understand the move. "Why not do everything to try to win? That was my thought," he said. "Try not to lose? What are you doing at that point of the season? You have to try to win. What do you gain by punting? It's not very likely the Ducks were going to make a play from midfield at that point—especially the way the game was going."

"It was chicken of him," Oregon's Duffy said. "Who punts to tie in a game? He's happy to get a tie. Well, we weren't happy to get a tie."

Brooks certainly wasn't. "Some of those turnovers were not taken, they were given," he said afterward. "People just dropped the ball. I feel badly for our seniors, that they couldn't find a way to win. I'm not very happy. I'm sure neither team is very happy."

The Beavers seemed less unhappy. "After that game, they were really excited," Oregon linebacker Don Pellum said. "It was almost as if they'd beaten us, because they'd been fighting so hard to level the rivalry. We took it as a loss. Our locker room was down, but the Beavers walked off the field with a lot of spirit."

"We were ecstatic," Heller said. "We didn't have a loss. You always want to go for the win. But we hadn't won a Civil War game for awhile. Getting a tie was better than nothing."

McKittrick agrees only to a point. "My thought was, 'Did this really happen?'" he said. "Ties are like kissing your sister, but it's not even that. It's more a numbness. You're just shaking your head. You're always glad when your opponent doesn't win, especially in the Civil War. But a tie is not a victory."

Taylor wasn't sure how to take the tie. "It was kind of a numb feeling, physically and emotionally," he said. "It was like, 'Did that game just end

like that?' I guess it was better than what happened through most of my career at Oregon State. There were a lot of games where it was over in the second quarter. Your job is to do your job, do what you can and develop and try to get better. There were some games we went in knowing we weren't going to win.

"I knew quite a few of the Ducks on that team, including Don Pellum. I had no personal vendetta against them, but it was good that at least they didn't walk off the field winners."

"I felt like crap," Oregon's Bobby DeBisschop said. "I remember after the game seeing a friend of mine at Oregon State, Ernie Brown. We'd played high school ball together. He looked a lot happier than I did. I was upset."

"Seeing the seniors go out like that, that was amongst the sadness of a season where we could have done better," said Oregon's Todd Welch, a junior that year.

"We'd played some good football," DeBisschop said. "I felt like we were a much better team than Oregon State that year. I don't even like to think about that game. I played special teams and a little defense, and we pitched a shutout. We played really good football. You can joke about it, but there's some pretty good scheming defensively when you don't allow a point."

"There was a lot of good defense out there," Dan Wilken offered. "It wasn't as much a terrible game as it was terrible weather that made it really hard to play football."

The following day, the *Los Angeles Herald-Examiner* reported the game under the headline "Is There a Score Yet from Eugene?"

"That might have been the greatest sports headline I've ever seen," said Darrell Aune, Oregon State's radio play-by-play announcer from 1971 to 1998. "We laughed about that for days."

After the game, Avezzano sounded buoyant on his future with the Oregon State program. "Only one thing could have made me prouder—if we'd been able to make one of those field goals and won 3–0," Avezzano said after the game. "Anybody has to give a young team credit for being improved and having a lot of character. And we have a lot of ability coming back, too."

"An interesting statement," Aliotti said. "Every coach sees it differently. We were the underdog. A tie for Oregon State was probably good. I know Rich [Brooks] was fuming. I didn't take it as a victory, but I was happy we didn't lose. We were both in the bottom 10. The tie didn't put a feather in either of our caps. It only gave more fuel to the fire, more cannon fodder to that sort of thing. It was like one of the team's defenses could have left

the field, and the other team could have taken 20 plays to score. That's how it was."

Most fans assumed Avezzano wouldn't be back, but they were wrong. The OSU athletic board voted 11–5 for his firing, but Andros recommended he be retained, and president Robert MacVicar gave him another year, a decision he admitted "some of the staunch supporters of this program are very disappointed with."

"We are disappointed with coach Avezzano's record, but...other things than wins and losses must be considered in terms of football's impact on the essential character of [the university]," Avezzano said the next week. "The integrity of Oregon State University is involved here, and to terminate a member of the faculty without adequate cause would be undermining to the principles of administration that I have followed in my career. In addition, Mr. Avezzano's commitment to academic improvement and the support system that he provided, not only to athletes in football but to the entire program, has been a positive and significant influence...I believe the coach and his associates deserve the opportunity to play out the string through the Oregon game in November 1984."

That's all Avezzano got—one more year. After a 2-9 season and another Civil War loss, he was jettisoned, replaced by Dave Kragthorpe.

What remains is memory of the unforgettable.

"It was an exercise in futility," Aliotti said. "I remember walking off the field—I'm not trying to be funny—coming down from the press box and thinking, 'Wow, if this doesn't put the Oregon and Oregon State football programs in proper perspective.'"

"It was a pitiful game," Oregon's Gary Zimmerman said. "A few years later, a little kid came up to me and said, 'Hey, are you Gary Zimmerman? You played in the Toilet Bowl.' So the Toilet Bowl has tagged people from our class. It was the most memorable game from back then. I laugh about it now. It's pretty funny."

"It took me quite a few years to realize what a big deal the Toilet Bowl is," Dan Wilken said. "It's one of those games people remember."

"It was a terrible game," said OSU's Eric Bosworth, who missed his senior year due to injury and sat in the Autzen stands. "And an amazing spectacle to watch."

"I have a cloud over me," E.J. Duffy said. "The minute somebody hears I played in the Toilet Bowl, they perk up. I could have won in [the Civil War] 17 times, but it's, 'Really, you played in that?' Yeah, I started and had a heck of a game."

"It was a circus of a game, almost humorous because of how sloppy the conditions were," Mike Jorgensen said. "It was two teams that were not very good. Neither team could even punch a field goal all day. You could have played with rubber balls and it wouldn't have made a difference. It was ugliness at its best. Nobody will ever forget that game, but for all the wrong reasons."

YOU CAN'T LOSE 'EM ALL

Perfect records, good and bad, are almost impossible to come by in college football. Simply by fortune, a team won't win or lose every game over the course of a season.

Since intercollegiate football began in the state in 1893, Oregon has never endured a winless season. Oregon State has had two—in 1895, when Paul Downing's team went 0-2-1, and in 1980, when Joe Avezzano's first Beaver team was 0-11.

Jerry Pettibone came close during his first season at the OSU helm in 1991. The Beavers entered the Civil War that year 0-10 and coming off a 58–6 pounding by Washington at Parker Stadium. Oregon State's losing streak stood at 15 games over two seasons, longest in the nation.

Pettibone had come to Oregon State after six years as head coach at Northern Illinois, where he took the Huskies to a 9-2 record his final season. His run-oriented, triple-option-based wishbone offense was triggered from his years as an assistant coach at Oklahoma, Nebraska and Texas A&M. The offense was the polar opposite of that of his predecessor, Dave Kragthorpe, whose "Air Kragthorpe" offense was based on the short passing game and had featured eventual NFL players Erik Wilhelm, Robb Thomas and Pat Chaffey in the late '80s.

Pettibone's hiring was, in many ways, an act of desperation by athletic director Dutch Baughman and OSU officials, who had grown weary of nearly two decades of losing football. All other Pac-10 schools at the time were running a variation of the pass-oriented West Coast offense

first made popular by the Bill Walsh teams at Stanford and with the San Francisco 49ers. The idea was this: defenses wouldn't be used to facing the antiquated wishbone.

"We felt like that was going to be part of the success we could create at Oregon State, by running the offense we ran at Northern Illinois," said Pettibone, now 74 and retired in Colorado Springs, Colorado. "I wanted to be able to recruit smart players who could learn the offense and give us a chance to be competitive in the Pac-10."

Problem was, there were no option-style quarterbacks left from the Kragthorpe regime. Senior Ed Browning began the season as the starter, and freshman Mark Olford—really more of a halfback type—got his turns through the season. In a 45–21 loss at Arizona on November 2, freshman Ian Shields got his first start at quarterback. He was to become part of Beaver football lore three weeks later.

Shields had come to Oregon State on a baseball scholarship. A three-sport standout at Oregon City High, the 5-11, 180-pound Shields had been an option quarterback and shortstop for the Pioneers.

"I was recruited by the OSU football staff [headed by Kragthorpe] and was offered a ride," said Shields, 43, now head coach at Lenoir-Rhyne University, a Division II school in Hickory, N.C. "I had a very good relationship with the baseball coaches, Jack Riley and Kurt Kemp, and loved the school, loved the campus. I thought that was where I needed to be. I thought about playing football, but I figured my best opportunity to play was in baseball. It didn't work out that way."

Shields pitched and played second base as an OSU freshman in 1990 and would return to the diamond to pitch in 1992. But he missed playing football. After Pettibone was hired, a holdover from Kragthorpe's staff, Jake Cabell, told the new coach, "Your quarterback is over there playing second base for the baseball team." Shields played spring ball and made the football team, beginning as the third-team quarterback.

Athletic and football smart, Shields was a good field general and ran the option well. "I wasn't very good, but I could get the ball in the right place and hand it to [halfbacks] Chad Paulson and J.J. Young," he said.

But Shields broke a big toe during a 27–14 loss to California on November 9 and sat out the next week against Washington. "I dressed down and told [offensive coordinator] Mike Summers, 'I think I can give this a go,'" Shields recalled. "He said, 'Let's sit this one out and save you for the Civil War.'"

The toe was painful, but Shields fully intended to play. "I grew up in the state of Oregon," Shields said. "That game meant the world to me."

On Monday, Shields practiced but with a limp.

"I asked Ian, 'How is the toe?'" Pettibone recalled. "He said, 'It's OK.' I said, 'Doesn't look OK to me.' The next day, he was still limping but executing the offense. I asked him, 'How's the toe?' He looked at me and said, very respectfully, 'Coach Pettibone, this is the Civil War game. My foot is fine.' I knew there was nothing that was going to keep that kid from playing. We didn't have a very complicated game plan, anyway. We were going to run a few plays and run them well and not make mistakes and play for field position."

"I was hobbled pretty good," Shields said. "The middle joint in the big toe was broken. You don't know how much you need that to run until it happens. My foot was so swollen, it wouldn't fit into the shoe. So we cut out part of the shoe to hold the toe. To be creative, we taped over the shoe. I was spatted ahead of my time. Through the miracles of pharmaceuticals and the trainers' handiwork on the shoe, I was able to play."

In Rich Brooks's 15th season at the helm, Oregon entered the Civil War with a 3-7 record. What had begun as a promising season with freshman quarterback Danny O'Neil had gone sour after he suffered a dislocated thumb in an October 5 victory over New Mexico State. The Ducks went into the Civil War on a five-game losing streak. Over that stretch of games, they had started five different QBs.

Going into the Civil War, Oregon State ranked dead last nationally with 206.9 yards per game in total offense as they struggled to master the triple option. In the 58–6 loss to Washington the previous Saturday, the Beavers were 0 for 4 passing. In seven Pac-10 games, they were a combined seven for 32 through the air. Even with its own problems, Oregon entered the Civil War a 19-point favorite. The Ducks fully expected to beat the Beavers.

"We don't like them, and they don't like us," Oregon linebacker Joe Farwell said before the game. "Right now, all we're playing for is bragging rights in the state. We just want to win. And besides, we usually beat them, anyway."

Pettibone had other ideas. Over the second half of the season, the Beavers had set aside two five-minute periods during each practice to prepare for Oregon. "We called them 'Duck periods,'" Pettibone said. "I told the players that even though it was 10 minutes a day, it was going to add up and give us an edge in the Civil War game."

"Sometimes, the coaches would have [scout-team players] wearing green jerseys, just to get us thinking about Oregon," said Todd Sahlfeld, a senior linebacker that season. "You're never looking ahead, but in the back of your mind, you kept thinking about the Civil War game. It was something we looked forward to."

Pettibone reflected confidence going into the Civil War. "We went in with a good game plan," he said. "Even though we were losing games, we were getting better. I could see the improvement of the team. I really felt like all the ingredients were there for us to spring an upset."

The players felt it, too. "Coach Pettibone and his staff were able to keep our spirits up," Sahlfeld said. "They did a good job of keeping us together. We were 0-10, and that could have been a pretty ugly scene. Through team-building and different things, we didn't have our heads down. We saw it as something we could do to end on a positive note."

"All of our guys knew we were getting better, improving in that system," Shields said. "I remember saying to a reporter that week, 'I don't know if we'll win or not, but I guarantee you we'll cover.'"

During the week prior to the game, Pettibone made it clear to reporters how he felt about the Civil War. "Within about 24 hours of being named the coach at Oregon State, I was made to realize how important this game is," he said. "Dee Andros grabbed me by the back of my neck and said, 'The Civil War game is not just for the right to brag. It's for the right to live in the state of Oregon.' Dee made sure I understood that. I get the same feeling as I did when I was an assistant at Oklahoma and we were getting ready to play Texas."

On the Friday before the game, Pettibone did two important things. One, he bused the players to Eugene for a final walkthrough at Autzen Stadium. "Previous coaches had practiced in Corvallis and come in on game day," Pettibone said. "I felt it was important for us to go to Eugene and practice at Autzen. I wanted the players to do it on the field where it was going to happen the next day."

After the closed practice session, Pettibone gathered his players in the end zone. "I had read a book by Lou Holtz," Pettibone said. "One year when he was at Arkansas, he talked to his players about visualizing what was going to happen in the final game. He felt like it was important for them to act it out before they did it. So he assigned two underclassmen to each senior, and they practiced carrying the seniors off the field after winning the game.

"At the end of the workout, I called the team together. The last thing I told the players was, 'Men, we're going to win this game. It's going to be a hard-

fought game, but we're going to make the plays we need to make. When we win, we're going to honor our seniors and carry them off the field.'"

Pettibone had prepared a list and assigned two underclassmen to each of Oregon State's 14 seniors.

"Tomorrow, when we win, you get your senior and carry him off the field," he told the players. "We're going to practice it right now."

Said Pettibone: "The kids picked up their seniors and gave them a ride off the field. They were so fired up…It was magic."

It may seem hokey, but it didn't at the time to the OSU players. "I was like, 'Are you serious?'" Sahfeld said. "It was great. As we practiced it, I thought, 'Yeah.' It gave you a vision. We're doing this tomorrow."

"It might be rubbing salt in the wound and look like poor form, but we hadn't won a game yet," Shields said. "I thought it was a great mental exercise. It helped us see that victory. Like, 'This is gonna happen. We're practicing winning.'"

"We thought it was corny, but we were getting into it," said Cory Huot, a redshirt freshman who backed up Sahlfeld at linebacker. "It was our last game. The Ducks weren't that good. We knew we had a good chance. We were starting to jell a little bit. The tone was much different than under Coach Kragthorpe."

Oregon State won 14–3 before a Civil War–record crowd of 42,141. OSU rushed for 278 yards, with Chad Paulson gaining 149 yards on the ground and throwing a halfback pass to Maurice Wilson in the fourth quarter to seal victory.

Oregon quarterback Brett Salisbury was 5 for 20 passing in the first half and then was lifted for senior Bob Brothers, who was six for 16 in the second half.

"At the end of my junior year, I met with Coach Brooks in his office," Brothers said. "He said, 'We have these four young guys coming in at quarterback. You haven't had a ton of success. We want to give them the reins. I think you can play safety or receiver for us.' I said, 'I'll play receiver. Just don't come back to me and ask me to play quarterback.'

"Then Danny O'Neil, Doug Musgrave, Kyle Crowston and Brett Salisbury all went down. They pulled me back [to quarterback] against Stanford. I got a thigh contusion at Arizona State and was out the next week against UCLA. Then I ended up in the Civil War game. I didn't have a good career. I wish I would have played better. Oregon State was the game I most wanted to do well in, but I didn't."

The Ducks scored first on an early field goal, but the Beavers went ahead for good on Ian Shields's six-yard run on a broken play 1:50 before halftime.

"It's better to be lucky than good," Shields says today. "We were going to run a counter to Paulson that had been successful, but the crowd noise was so loud, the center snapped it late. By the time I turned around to hand Chad the ball, I'd missed the handoff. I'm sitting there, and I instinctively took off running. I had an OSR—an oh-shit reaction—took off for the corner and got in the end zone."

The second touchdown caught the Oregon defense off guard. "That was set up by the option play," Pettibone said. "We'd run it a lot. [Offensive coordinator] Mike Summers had put that play in off the option. We'd noticed Oregon supported out of the secondary, brought the free safety to the pitch man real hard. When we started the option action, we felt we could run a post corner and sneak a receiver behind the free safety for the big play. We ran it and executed it to perfection."

"I was kind of surprised we called that play," Wilson said. "The ball didn't go into the air too much with that team. I remember making eye contact with Chad in the huddle, giving him that look like, 'Just get it there.' He got it there, and I caught it. What a great feeling."

When the game was over, the Oregon State players hoisted the seniors onto their shoulders and carried them from the field, just as they'd practiced a day earlier.

"Maybe the world looked on it as an upset," wrote the *Oregonian*'s Ken Wheeler, "but the Beavers saw it coming."

"I'm glad we practiced it the day before," Pettibone says today. "No way I could have orchestrated that at the end of the game."

"All of us [underclassmen] remember trying to go find our senior after that game," Shields said. "Those seniors' last experience as a college player was beating the Ducks and getting carried off this field. I have a picture of myself and a teammate carrying Todd Sahlfeld. What a memory."

"They deserved to win," Oregon coach Rich Brooks said afterward. "They outplayed us. They took it to us up front on both sides of the ball. We couldn't run it. We couldn't throw it. We couldn't hold onto the ball. We were inept. They appeared to want it more than we did. Bottom line, they kicked our fannies."

It was the end of a lost season for the Ducks. "At the beginning of the season, we were probably one of the best teams in the Pac-10," running back Sean Burwell said. "Now we're probably one of the worst."

"We actually thought we were going to the Rose Bowl this year," linebacker Andy Conner said. "Sometimes things just don't work out."

Pettibone, who had played in the Orange Bowl and coached on two national championships at Oklahoma, took a Gatorade bath from athletic

director Dutch Baughman after the game. Pettibone told his players, "This is the proudest I've ever been of a football team."

"I have all the respect in the world for Rich Brooks," Pettibone says today. "I ran up to Rich, he grabbed ahold of me and said, 'Jerry, your kids played a great game. Congratulations.' I said, 'Rich, this means the world to me because of this rivalry and everything it means to win the Civil War.'"

The win meant the players got to sing the school fight song afterward.

"We'd practiced it so we knew the words when we won a game," Cory Huot said. "That was the first time we got to sing it. The bus ride home was crazy, almost surreal. A huge morale boost and a great way to send our seniors out."

Sahlfeld was one of those seniors. "Sometimes winning is contagious and losing is contagious," he said. "It had been a long time since we'd tasted victory. Sometimes you forget how to win. We'd worked hard every week. We'd put in a lot of time and effort. To always lose, it affected us more than other people. To finally get a victory in my last college game, I can't tell you how much that meant."

Two years later, Pettibone became the only Oregon State coach since Dee Andros to win back-to-back games at Autzen Stadium, beating the Ducks 15–12. In between, there was a 7–0 Oregon victory over Oregon State at Parker Stadium.

(The Ducks, by the way, did not carry their seniors off the field that day. "We don't waste practice time like that," linebacker Joe Farwell said. "We get down to business.")

During Pettibone's first five years as OSU's coach, the Civil War was always a knock-down, drag-out battle to the finish. The Ducks clinched a Rose Bowl berth with a come-from-behind 17–13 win at Parker in 1994 and then used four field goals by walk-on freshman Joshua Smith to win 12–10 in 1995. Only Pettibone's final game as the Beavers' mentor in 1996 was a blowout, a 49–13 Oregon triumph.

Oregon State never won under Pettibone, topping out at 4-7 in 1993 and '94. He had an impressive coaching staff, many of whom went on to big things, including current head coaches Brady Hoke (Michigan), Rocky Long (San Diego State) and Bronco Mendenhall (Brigham Young). Under Long, the Beavers had some of the best defenses in the Pac-10. The offense, though, was outdated and made it hard to recruit top-flight athletes.

"I had a good time playing for Coach Pettibone," said Don Shanklin, a quarterback from 1994 to 1996. "But he didn't want to change things

we were doing with our offense. It wouldn't have taken many changes for Oregon State to become really successful. We had some success in the early years running the option, but we didn't ever change blocking assignments or schemes. Defenses adjusted and made it much tougher on us the last couple of years."

"Jerry was a little too conservative, a little out of touch," said Reggie Tongue, a safety who would go on to a 10-year NFL career. "He was the opposite of progressive. He knew the wishbone, and he was going to live and die with it, and we were going to be the sacrificial lambs.

"I don't say that disrespectfully. He was a man of integrity. But in the Pac-10, there are linebackers just as fast as your running backs. The idea of the wishbone was to stretch the defense, cut somebody, stretch it, cut somebody. When you have a defense that can beat you in a race to the sideline, there's not much you can do."

There was mixed reaction to Pettibone's conservative approach. "No facial hair, no earrings, wear ties, no horseplay," linebacker Cory Huot said. "That kind of hurt the team, held us back a little bit. College is about finding yourself. Put those restrictions on a 20-year-old kid, some rebelled and resented that. I know I did. When I graduated, I grew a beard out of spite."

"I don't have nothing good to say about [Pettibone]," receiver Dwayne Owens said. "He'd been around great coaches, but he didn't know how to coach, how to interact with the players. I figured he would be there for no more than three years. I call him a politician. He'd tell you what you wanted to hear, just to make sure everything was running smooth. But it wasn't."

Others offered a more positive appraisal. "I love Coach Pettibone," Ian Shields said. "I don't think there could have been a better man to play for. He had the right intentions. He tried to develop us on and off the field."

"I had great respect for Coach Pettibone," said Buster Elahee, a four-year starter at safety who played all but his senior season for the man. "He had his players' best interests at heart. He wanted us to succeed in academics, in life."

Pettibone was fired after a 2-9 campaign in '96. But the man left his imprint. The Valley Football Center was built the year before he arrived, with the players' locker room and equipment room on the first floor, the weight room on the second floor and a donor area on the third floor. Pettibone spearheaded a fundraising drive to renovate Valley and move the coaches' offices there in 1996, his final season.

During the 2012 season, Pettibone's teams held a reunion in Corvallis when Oregon State played Brigham Young. The day before the game, head

coach Mike Riley gave Pettibone a tour of the Valley Center and the school's revamped athletic facilities and had him speak to the OSU team.

"Men, this is Jerry Pettibone, who coached here and did a lot of things to get this program started and started the improvement of facilities," Riley told the players. "He's all about toughness and attitude. We owe a lot to him for where we are right now."

"I really appreciated Coach Riley for saying that and letting me speak to the team," Pettibone said. "I have warm memories of my time at Oregon State. I just wish we could have won more. I take pride in what they've done with the program since then."

DUCKS SMELL ROSES FOR FIRST TIME IN 37 YEARS

If you picked Oregon to win the Pac-10 championship in 1994 and play in the 1995 Rose Bowl and for Rich Brooks to claim the Bear Bryant Trophy as the nation's outstanding coach, you may have accompanied Doc and Marty in the DeLorean headed back to the future.

The Ducks were coming off a 5-6 record in 1993, a season in which they lost their final three games, including a 15–12 Civil War setback to Oregon State, the second straight loss to their archrival at Autzen Stadium.

"That was a bad way to end that season, but really, that spawned our Rose Bowl run the next year," said Jeff Sherman, a senior safety on Oregon's 1994 team. "We had a lot of good players [in 1993], but the character of the team wasn't as good that year. We had an awesome group of juniors who were the senior class in '94. There was a real determination to never let that happen again."

Even so, there was no bonafide reason to think Oregon was going to beat out Southern Cal, Arizona and Washington State, which would all field top-25 teams in 1994. Or even Washington, which had beaten the Ducks five years in a row and was to finish 7–4. John Robinson's Trojans were powerful. Arizona, with its Desert Swarm defense, was coming off a 10-win season and a 29–0 whitewash of Miami in the 1994 Fiesta Bowl.

Rich Brooks, beginning his 18th year at the UO helm, was concerned about his job security, and for good reason. An element of Oregon followers felt it was time for a change at the top. Sean Burwell, who led the team with 457 rushing yards in 1993, was gone. Leading receiver Derrick Deadwiler (59 catches for 823 yards) had departed.

But the Ducks had assets. Returning were senior quarterback Danny O'Neil, running backs Ricky Whittle and Dino Philyaw and receiver Cristin McLemore, who had caught 50 passes for 791 yards and 10 TDs as a sophomore in 1993. O'Neil would throw for 2,212 yards and 22 touchdowns while Philyaw (716) and Whittle (606) would share the rushing load. McLemore (42 catches for 564 yards and nine touchdowns) and sophomore Dameron Ricketts (42 for 534) would lead the receivers along with freshman Patrick Johnson and sophomore tight end Josh Wilcox. The defense was led by a veteran secondary composed of Sherman, Herman O'Berry, Alex Molden and Chad Cota, along with redshirt freshman Kenny Wheaton. All but Sherman would go on to play in the NFL.

"We were destined to play good defense," Sherman said. "We had unbelievable corners in Molden and O'Berry, with Wheaton emerging. You ask anybody on that team, he'd say Herman was the best of the lot. He broke his ankle the first game of '93 and missed the year. He came back ready to ball."

Oregon started inauspiciously, losing two of its first three games—36–16 to Hawaii and 34–16 to Utah—and was 3-3 at the midway point of the regular season. Then the Ducks gathered steam, winning five in a row as they headed into the Civil War game. In a 55–21 rout of Stanford the week before, O'Neil had set a school record with six touchdown passes, moving the surprising Ducks up to ninth in the USA Today/CNN poll and twelfth in the Associated Press rankings.

The Ducks were in position to wrap up the school's first Rose Bowl berth since 1958 by beating Oregon State.

"This is what I've wanted ever since I've been at Oregon," Brooks said at the time. "It's down to one game now, and it's great there will be national attention on the Civil War."

Oregon State, though, was no pushover. The Beavers were 4-6 and entered the Oregon game coming off victories over Pacific and Washington State. They had won two of the last three Civil War games under coach Jerry Pettibone, both at Autzen Stadium. And this one would be in their home confines of Parker Stadium, with a partisan throng on hand.

"We were playing a very good Oregon State team," Oregon assistant coach Don Pellum recalled. "Those guys were good. They were doing some great things on defense. They were running the option. They were scary."

The Ducks, of course, were on a mission. "The last three weeks of the season, we had been in control of our destiny," O'Neil recalled. "If we won out, we were going to the Rose Bowl. That game was even more than

a normal Civil War game. You know how close you are to realizing your dream. So much is on the line. We're so close to achieving something great in the history of Oregon football. All you have to do is beat your rival in the last game. There is a lot of anxiety and anticipation. Yet it can all go away if we don't finish it off."

Danny O'Neil had chosen Oregon over Southern California and Alabama coming out of Mater Dei High in Santa Ana, California. "I didn't even trip to the other two places," O'Neil said. "I loved Oregon and Eugene. With [quarterback] Bill Musgrave leaving, I thought it was the perfect opportunity for me."

O'Neil started all four years but experienced his ups and downs, including the Civil War. He was injured and didn't play when a winless Oregon State team scored a 14–3 upset at Autzen in 1991. In howling winds and torrential rain, he threw a pass to tight end Willy Tate for the only touchdown in a 7–0 win the next year. In the "Fog Bowl" of 1993, he suffered through a 15-for-34 passing day as the Beavers won again at Autzen 15–12.

"There was almost zero visibility that day," O'Neil said. "In the first half, I threw a deep ball to Kory Murphy. He was five yards behind the deepest defender. It looked perfect in the air. I was sure it was a touchdown. Then the ball lands a few yards in front of him. He never saw the ball. All he had to do was see the ball and he'd have run right under it."

During the 1994 campaign, promise met performance with O'Neil, who led Oregon to come-from-behind wins in back-to-back games against Washington and Arizona.

"Early in his career, Danny had taken criticism," offensive line coach Steve Greatwood said. "He persevered. I don't think there were many critics during his senior team. Danny, [offensive linemen] Steve Hardin and Mark Gregg, so many of our players on the defensive side…We had some really tough, competitive kids."

The Ducks went into practice that week with a determined, yet light, approach. "That was one of the most fun times in my life," said Damon Griffin, a true freshman receiver that season. "So much anticipation, so much angst to get to that game. That was the one time you wanted the week to fly by. Let's not worry about game plans and speeches and everything else. Let's just win the game and go to the Rose Bowl. You knew how important the game was, not just because of Rose Bowl but because Oregon State would do everything possible to win. That was [the Beavers'] Rose Bowl. We knew the passion our rival would come in with."

"That week of practice was different from other Civil War weeks," cornerback Alex Molden said. "We were relaxed and crisp during practice. It all came from Coach Brooks. A lot of times if he was wound up, everybody was kind of tight. He was relaxed and gave people a chance to relax. Danny O'Neil was always relaxed. He was a huge leader for us. We looked at Coach Brooks, and the next person in line was Danny."

Southern Cal was still in the Rose Bowl mix. A win that Saturday against UCLA coupled with an Oregon State upset of Oregon would give the Trojans the bid to Pasadena.

"We didn't care about USC and UCLA," tight end Josh Wilcox said. "We weren't going to settle for sneaking in [to the Rose Bowl]. We wanted to win it on our own."

The week of practice, tailback Dino Philyaw offered, "was kind of lax, believe it or not. We knew what we had to do. We didn't want to leave our fate in SC's hands. When it's so close you can taste it, it turns out a different beast within you. Everybody was so focused and so determined that we weren't going to be denied, no matter what happened."

The 98th Civil War game proved a classic. Oregon State led much of the way on a wet, nasty weather day, had a grand opportunity to extend a 13–10 lead in the fourth quarter and then gave way to a final Oregon touchdown drive that led to the Ducks' 17–13 victory.

Even before the game, things weren't easy for the Ducks. "It was pretty intense," Cristin McLemore said. "We're getting ready to head onto the field. Chad Cota and Jeremy Asher are getting excited and are bashing heads. I look up, and Chad is spitting out front teeth. I just about fell off on the turf laughing. We were cracking up. It was funny as hell. But it was time to go play."

O'Neil and the 5-11, 175-pound Philyaw—a senior who had transferred from Taft (California) JC for his final two seasons—connected on a 12-yard touchdown pass to give Oregon a 7–0 first-quarter lead. Oregon State answered early in the second period on a blocked punt by Larry Bumpus that was recovered in the end zone by backup receiver Chris Cross, but Randy Lund's conversion attempt hit the upright. Matt Belden's 34-yard field goal gave the Ducks a 10–6 lead at intermission.

After O'Neil fumbled at the OSU 35, the Beavers marched 65 yards for the go-ahead TD, sophomore quarterback Don Shanklin carrying over from the one for a 13–10 lead with 6:01 left in the third quarter.

The Beavers, going for their first five-win season since 1971, still led 13–10 and were driving in the red zone for what might have been a game-

clinching score midway through the fourth quarter. "You could feel the momentum had changed," Jeff Sherman said. "They were on top of us and were starting to get a better push against us at the line of scrimmage. We were starting to bite on the dive fakes in that triple option. You can't break down on assignments against that offense."

Then fate smiled on the Ducks. On fourth-and-two at the Oregon 14-yard line, OSU coach Jerry Pettibone disdained what would have been a 31-yard field goal attempt to go for it. "I wanted to make it 20–10," Pettibone said after the game. "We felt good that [the Oregon defenders] were going to slant inside, feeling we would run some sort of inside play. We had double-option called outside. We had it all sealed off."

Shanklin took off to the sidelines, following his fullback's block. He faked the pitch, started to cut and saw open field. "It was a touchdown," Shanklin said then. "The [defender] I was optioning went for the pitchback. There was a running lane right there in between."

But pulling guard Darin Borter was pushed back, and Shanklin stepped on his foot, lost his balance and fell for a three-yard loss. "That was the play of the game," Pettibone said. "If Don doesn't trip on the guard, we're probably going to score."

Shanklin, whose uncle Ronnie Shanklin played six years in the NFL and was a receiver on Pittsburgh's 1975 Super Bowl championship team, was Pettibone's first big quarterback recruit. The 5-11, 195-pound Amarillo, Texas native had chosen Oregon State over Oklahoma, Baylor, Tennessee and UCLA.

"Oklahoma and Baylor had recruited me as a quarterback," Shanklin said. "UCLA and Tennessee saw me as a wide receiver. I wanted to play quarterback, and I wanted to play as a freshman. I had so many people tell me I could not play quarterback at the collegiate level, I set out to prove them wrong."

But Shanklin was ineligible academically and sat out his first year in 1991. After passing his ACT, he played some as a freshman in 1992 but got hurt and missed the Civil War. It was a foreboding note, as injuries slowed him throughout his career.

Shanklin was healthy for the 1994 Civil War, though, and went into the game feeling confident. "We matched up pretty good with the Ducks," he said. "They were a good but not dominating team. As long as we executed, we liked our chances. And we executed pretty well, right up until the last two drives."

Shanklin will never forget the fourth-and-two play at the 14. "The play call was 'Rocket,'" he says today. "I was supposed to turn and run straight

to the sidelines. I'm looking at my read, the [defensive] end, and I didn't notice [Borter] had lined up wrong—maybe a half yard back from where he was supposed to be. I cut up, and suddenly there was a hole you could have driven a truck through all the way to the end zone. All I saw was space in front of me. There was nobody to stop me—and I tripped over his foot and before you knew it, I was falling. I fell flat on my face."

When Shanklin cut up field, "your heart stops," Oregon assistant coach Don Pellum said. "It was like, 'Oh no.' Then he falls, and it starts beating—boom, boom, boom. Relief."

The Ducks had dodged a bullet but couldn't move the ball. After an exchange of punts, they got the ball back at their own 30-yard line with 4:42 to play.

It had been a dismal day for O'Neil up to that point. He had completed only seven of 20 passes and was hit by blitzing Oregon State defenders on nearly every release. "We were talking on the sideline, and some guys were getting to him," OSU linebacker Kane Rogers said afterward. "We said, 'Keep it going. Hopefully he's going to buckle here pretty soon.' I've got to hand it to him. He stood in there and took it like a man."

With nine minutes left, O'Neil had been knocked woozy when OSU linebacker Cory Huot sent him head over heels on a third-down pass play. "I'd broken my hand against Washington State the previous week," Huot recalled. "I'm playing with a busted-up knee and this huge cast on my hand. But we were doing some damage."

When Oregon regained the ball for its final drive, Brooks was considering replacing O'Neil with backup Tony Graziani. O'Neil, maligned through much of his career with the Ducks, wouldn't hear of it.

About that time, the public-address announcer reported UCLA had upset Southern Cal. Win or lose, the Ducks were in the Rose Bowl.

"It didn't matter," UO assistant coach Steve Greatwood said. "I remember my players coming up and saying, 'F that, coach, we're not backing into this thing.' It served as a huge motivation. Our fans were chanting 'Rose Bowl,' and we were behind at the time. It ticked our players off that our fans would be content with that. I knew right then and there we were going to win the game because of the mindset of the kids."

O'Neil felt a calm as he gathered his teammates in the huddle. "The thing about that team, we had all read the same press and had gone through the same challenges together," O'Neil said now. "Everybody in the huddle knew the criticism I'd taken as quarterback and we took together as an offensive unit. Not going to a bowl game in 1993 was the culmination of all that.

"We were all on the same page. We knew it had come down to that point. That team was unique. On some teams, when it gets to crunch time, everybody's timid or afraid to do something great, or, 'Gosh, we want to win, but how are we going to do it?' With that team, it was the complete reversal. It was, 'Let's make a play.' That's what you saw on that last drive. Everybody wanted to make a play and do something spectacular."

"Danny said, 'Hey guys, we're going to score,'" Dino Philyaw said. "We were listening. He was in charge."

"Danny was hurt a little bit, but we knew it was probably our last chance the way [the Beavers] were keeping the ball," Steve Hardin said. "I told the guys, 'This is it. This is for all the hard work we put in all year. We've come too far. We don't want to back in. This is for the championship.'"

Back in the huddle was Cristin McLemore, who had been carted out of Parker Stadium after being injured early in the third quarter, his hand puffed to twice normal size. The 5-11, 175-pound junior, who had caught only one pass to that point, was having a rough week. He had been banged up with bruised ribs and a tender ankle in previous games.

"My left ankle was the biggest problem," McLemore recalled. "I had torn ligaments and wasn't supposed to be playing football at that point. I was getting shot up every game. It was starting to not work quite as well by the Beaver game. I got shot up twice that day, once at halftime. It was really bothering me."

Early in the third quarter, McLemore was out ahead of Ricky Whittle on a running play. "I was blocking one of the D-backs, and Ricky collided with us," McLemore said. "He brought his helmet down on the guy's shoulder pad where my hand was, and it busted up my hand. It bubbled up. I thought it was broken. I was pretty sure the game was over for me."

McLemore was carted through campus to the OSU infirmary to take X-rays, which were negative. "People were throwing stuff at me and talking bad stuff about my mother," he said. "Just a bunch of snide remarks. That was one of the few times where I was upset about things. I was trying to understand it was just part of the deal. I never had a realization of what the Civil War was about—the hate and animosity—because I just like to play ball and have fun. Then I got a little upset. I don't play with anger, but when I was on that cart, I got angry."

By the time McLemore returned to the sidelines, Oregon was getting the ball back one last time. When offensive coordinator Mike Bellotti asked if he could go back in, McLemore didn't hesitate. "This was my chance,"

he said. "I didn't want to have it taken from me. This is what you dream of, what you work so hard for, what the practices are about. I said, 'Let's play some football.'"

On the last drive, McLemore said, "I wasn't worried. I never worried. I always felt like there were three or four routes where nobody in the world could cover me if my teammates did their job. Funny, though, I never had big statistical games against the Beavers. It never worked out that way. We had to grunt and grind for our points against those bad boys."

O'Neil, meanwhile, was surprised to see McLemore return. "I looked up in the huddle, and there he was," O'Neil said. "We know we had to score on that drive or we lose. The way the Beavers ran their offense, if they got the ball back, they'd plug away three or four yards at a time, chew up time, and if they got a couple of first downs, it would be over. We felt strongly that was the last time we were going to touch the ball. We had to score."

"Those guys had done it over and over," Sherman said. "By that point in the season, you believed. You had so much confidence in what they were about to do."

It took the Ducks less than a minute to cover 70 yards. Part of that is because O'Neil struck quickly twice to McLemore, for 31 and 21 yards, on pass plays. O'Neil was 4 for 5 passing on the drive.

"There was no sense of panic," tight end Josh Wilcox said. "We'd done it against Washington and Arizona. There was a quiet confidence in the huddle. Danny and Cris had a really good chemistry. He would throw it to where Cris was going to be, and Cris would get there."

Oregon had moved to the OSU 14-yard line when Wilcox, who had the flu and got progressively weaker through the game, keeled over backward before the snap, drawing an illegal-procedure penalty.

"When Wilcox fell on his bottom, I was thinking, 'What in the world is he doing? What kind of play is that?'" Damon Griffin said. "Josh and I were roommates at that time. We have never let him live that down."

"I didn't feel too good the night before, and on our first kickoff return, I got poked in the eye," Wilcox said. "I couldn't see. Felt like dog crap. I was throwing up on the sidelines. Some of it was nerves.

"The play call was 449, a pass to Cris Mac. I had to look outside, check to see if anybody's coming on a blitz. I started leaning backward, checking to see if I have to pick up somebody. I started rocking back, and I lost my balance. I was frozen in the moment. I fell over. Embarrassing."

On first-and-15 from the 19, Bellotti sent another play in from the sidelines, much to McLemore's dismay. The original play "was going to me,"

he said. "Every time we ran that play, it was a touchdown. It was going to be six points, and Mr. Wilcox cost me that glory."

The new call was "Tom motion, H-wide, screen left." Philyaw went into motion out of the I-set, set up as a receiver and, after the snap, hit the flat and took a short flip from O'Neil.

"I cut-blocked a safety, and that opened up the lane for Dino," Wilcox said.

"I accelerated, hit the seam and it was a wrap," said Philyaw, who was to be runner-up at 100 meters at the Pac-10 Track & Field Championships the next spring. "It seemed like I was wide open, but I looked at it on film and there wasn't as much daylight as I thought at the time."

Enough to get Philyaw into the end zone for a touchdown and a 17–13 lead with 3:43 to play.

"It was beautiful," Jordan said. "Absolutely wide open. Dino's still running right now. The only thing that stopped him was that building [Valley Center] past the end zone. [The OSU] donors were sitting right there. It was fitting."

Cory Huot was blitzing on the play. "I hit O'Neil as hard as I could," he said. "Hit him right on the chin. He got the ball off, and then I heard the Duck fans start to cheer."

"That play still is like slow motion in my mind," OSU linebacker Kane Rogers said. "I just couldn't get there. I don't remember who had coverage responsibility. It might have been me. I distinctly remember thinking, 'I can make this play,' and I couldn't."

OSU cornerback Buster Elahee thought he could make the play, too. "I was there for a minute, but then I saw two big linemen in front of me," he said. "They parted the sea, and that was it. Touchdown."

As the Ducks celebrated in the end zone, the only player not completely happy was McLemore. "I'll be honest, I was a little bit disappointed," he said. "I knew I was about to make six. I was so excited. I was amped. But when Dino scored, I was happy. He was one of my best friends on the team."

There was still plenty of time. Too much for the Ducks to feel secure with a four-point lead.

"I remember feeling the nerves when we went back on defense," Jeff Sherman said. The Beavers "got a few first downs. I gave up a completion. There was still some time."

"There was a little bit of panic," UO punter Josh Bidwell recalled. "Holy cow, why can't we put these guys away? They have nothing on the line. It wasn't until that final whistle blew that we could all exhale."

"We felt confident we were going to score and win the game," Don Shanklin said. "We moved deep into their territory. Things were working for us. But we didn't finish the job."

Oregon State drove to the Oregon 25 with a minute remaining. On third-and-six from the UO 21, Shanklin's pass missed by inches of connecting with Cameron Reynolds inside the UO five. On fourth-and-six, Shanklin underthrew Joe Douglass near the goal line.

"Inches," Pettibone said afterward. "That's how close it was. If we hit that one and have first-and-goal inside the five, we have about 40 seconds to line up and score. That was plenty of time."

After the final second ticked off, Oregon fans stormed the field, many of them carrying roses. "It was absolutely nuts," Griffin said. "Coach Brooks got carried off the field. They asked me to put a rose in my mouth to take a picture. I'd always wanted to do that. They ran it the next day in the paper. There were grown men hugging and kissing each other like I'd never seen. Our fans had been waiting so long.

"You can't write a better story, to beat your cross-state rival and go to the Rose Bowl. They were in the perfect role to play spoilers. We didn't play our best game, but we found a way at the end to win it."

"I remember total strangers tapping me on the shoulder and giving me hugs," Josh Bidwell said. "Danny and a lot of the guys carrying roses around."

"It was surreal," said Damon Griffin, a Monrovia, California native. "Me being a true freshman, you understood from the other players a lot of times the feeling of being at that height would not happen. I thought, 'I made the best decision to go to this school, and now I'm going to play in the Rose Bowl in my backyard, two exits from my house.'"

"It was pandemonium," Alex Molden said. "I remember jumping up and down, being so excited. Somebody handed me a rose. I was yelling in Herman O'Berry's ear, 'We're going to the Rose Bowl!' It was one of the top moments in all my playing days, doing something a lot of people did not believe we had the capability of doing. It was magical, the belief we had in each other. I was never part of another team that was that close and that selfless."

"I have three kids, but it was right there with that as the best moments of my life," Jeff Sherman said. "I remember losing my composure, dancing around with a rose and getting leveled from behind by one of my best friends, Grady O'Connor. He dropped me on my face. There was a dog pile."

Sherman sought out O'Neil. "I used to give Danny a really hard time," Sherman said. "Until he was a senior, he never led us from behind to win

a game. I said, 'When are you going to nut up?' That senior year, he did it three times."

"I was just so excited about what we accomplished as a team," O'Neil said. "That year was unique. We weren't projected to do well. We didn't start out very good. We were very proud of the turnaround. That takes a special group of people to become Pac-10 champions. Guys I previously did not have a close relationship with, that year I did. We weren't going to accept going out on a bad note again. To have that turnaround…The best memory is the faces of the guys I went to battle with."

"That might have been the greatest feeling I've ever had in coaching," Oregon assistant coach Nick Aliotti said. "Up to that point in my career, it definitely was."

It was Oregon's first outright championship after sharing league titles in 1919, '33, '48 and '57 and the school's first nine-win season since 1948.

"It would have been a hollow feeling had we lost the game and still been able to go to the Rose Bowl," Brooks said afterward. "We did it on our terms. We didn't have to back in. I don't have to listen to any of that. This team deserves to go to the Rose Bowl. We're 7-1 in the league, and no one else did that.

"I've thought about this since the first day I took the job. I've always wanted to take Oregon to the Rose Bowl. I always thought it was possible—while a lot of people didn't. It obviously was possible. That's good news for everybody in the league who doesn't live in Los Angeles or Seattle."

OSU senior Kane Rogers doesn't like the memory of the post-game scene even today, 20 years later. The Tacoma, Washington native remembered during the Beavers' 14–3 upset victory at Autzen Stadium in Eugene in 1993, "the obvious disrespect the Ducks had for Oregon State was unbelievable. You want to be respected. You could see how the older guys felt about it, and it rubbed off on us younger guys pretty quick. After we lost [in 1994], I remember seeing those damn roses bust out at our stadium. That was salt in our wound. You don't want to lose to the Ducks, but to see them clinch a Rose Bowl berth on our field was a gut shot."

If there had been disrespect in '93, there was none of it from the Oregon side after the '94 game. "Those guys were busting to give us everything possible," Griffin said.

"Oregon State played a very determined game," Sherman said. "I walked out of the stadium with a lot of respect for [the Beavers]. They really brought it. Next to Arizona and Washington, it was the most physical game we played. They really wanted that game."

"Probably the most intense game [in which] I ever played," linebacker Rich Ruhl said. "They didn't want us to go to the Rose Bowl."

"We're a phenomenal team, and the Beavers are [supposed to be] garbage," Bidwell said. "Yet they played us as tough as any team that whole year."

Despite Danny O'Neil throwing for a record 456 yards, Oregon lost to unbeaten and No. 2–ranked Penn State 38–20 in the Rose Bowl. That was to be Brooks's final game with the Ducks. He left to become head coach of the St. Louis Rams.

"As I look back now, the highlight of my career was achieving something at a time at a school nobody would have expected to do that in a million years," Dino Philyaw said. "We set the program up for huge success in the coming years.

"We had a lot of hard-nosed, blue-collar guys. We didn't have the Nike contract and all the nice extra stuff they have now. It seemed like the fans were really fans. They watched us go from almost getting our coach fired to getting a job in the NFL. We had a true sense of perseverance. We never gave up."

Shanklin, now 42 and an insurance broker living in Gresham, hates his role in Oregon State football lore. "It sucks that is how I am remembered—as the guy who blew a chance to win the Civil War and knock the Ducks out of the Rose Bowl," he said. "But I've always had a philosophy. You can only do what you can do. As a player, you give your all in every game. Stuff happens.

"I was upset about it, but it couldn't be undone. I had a really good time at Oregon State. I can't say I would have changed it for anything else. Even though we didn't win like I was used to coming out of high school, that experience prepared me for today's business world. You're not going to win all the time. You have to react to defeat. That's what defines you as a person."

There's a certain irony to the key figures in the '94 Civil War game.

"Don Shanklin is my best friend," said Philyaw, 43, who runs a catering company in Eugene. "That's the crazy thing. It's amazing how something so big for me can be something so down for him. We joke about it now because we can. It's so odd how life works. We were tied to two of the biggest plays in one of the biggest games in Oregon history."

GREATEST (CIVIL WAR) GAME EVER PLAYED

After the 1994 season, things began to change at both Oregon and Oregon State. Mike Bellotti, offensive coordinator the previous five seasons under Rich Brooks, took over as head coach of the Ducks. Brooks had gotten it started, but Bellotti had been head coach for five years at Chico State before joining Brooks's UO staff in 1989 and was to take the program to much greater heights.

A peek at the '90 Oregon press guide shows Bellotti among the group of assistants along with Nick Aliotti, Steve Greatwood, Gary Campbell and strength/conditioning coach Jim Radcliffe. All but Bellotti and Aliotti remain at Oregon as members of Mark Helfrich's staff. Campbell is in his 32nd season, Radcliffe his 30th, Greatwood his 28th, Don Pellum his 22nd, Tom Osborne his 14th, John Neal his 12th. That kind of continuity is unusual, if not unprecedented, in big-time college football.

By 1996, Jerry Pettibone's time was over at Oregon State. In his place, a favorite son was hired. Mike Riley, whose father, Bud, had been a member of the OSU coaching staffs of Dee Andros and Craig Fertig, had grown up in Corvallis and quarterbacked the Spartans to the state championship as a high school senior in 1970.

Mike Riley had won two Grey Cups as head coach of the Canadian Football League Winnipeg Blue Bombers, served as head coach of the World League San Antonio Riders and had spent the previous four years as offensive coordinator under John Robinson at Southern Cal.

The first head-to-head matchup between Bellotti and Riley teams came in the 1997 Civil War at Corvallis. For Oregon, which entered

the game 5-5, a bowl appearance was on the line. Riley's first Oregon State team had started superbly, winning all of its non-league games—at home against North Texas, San Jose State and Utah State—while losing heartbreakers in its first two Pac-10 games to top-25 opponents Stanford (27–24) and Arizona State (13–10). The Beavers then dropped five in a row to Pac-10 opponents and entered the Civil War 3-7 overall and 0-7 in Pac-10 play.

The Ducks were headed to the Las Vegas Bowl, and the Beavers finished winless in conference action after Oregon's 48–30 win at Autzen Stadium. Bellotti recalls an incident that happened before the game. "One of my assistants had played against Mike in the Canadian League," Bellotti said. "He told me, 'Mike's teams come out feisty. They'll probably do something before the game.' We were stretching. The Oregon State players came out before the game, ran through our stretching lines, and it escalated into a fight. It fired our guys up. We won that game fairly easily."

Riley recalls the incident, too. "We had some guys go rogue on us," the OSU coach said. "Luckily, nothing too serious turned out on the deal, but our guys were in the wrong and provoked a confrontation at midfield. Mike [Bellotti] and I were chatting before the game and heard some commotion. We turned around at a time when everybody was jawing at midfield. We both went to separate our players. We're out there at midfield, 50 guys jawing at each other like there's going to be a big fight. A fight never broke out, but we proceeded to get killed in the game.

"It wasn't a very fun way to start my Civil War career as coach at Oregon State. That was a pretty good way to describe who we were in those days— not understanding what was the right thing to do or important to do. I was thinking we were making progress with that group, so I was surprised and disappointed in that behavior."

The Ducks won the game easily, in no small part thanks to Patrick Johnson, who enjoyed one of the greatest individual games in Civil War history, scoring four touchdowns on 337 all-purpose yards, one yard shy of Bobby Moore's school record (since broken by LaMichael James with 363 yards against Arizona in 2011).

The senior receiver caught six passes for 199 yards, including a 90-yarder from Jason Maas—second-longest in school history—to give Oregon a 48–16 lead early in the fourth quarter. Johnson caught three touchdown passes of 36 yards or longer, returned a punt 74 yards for another score and ran back the opening kickoff 59 yards.

It was a coming-out party of sorts for the world-class sprinter, the national prep leader at 100 and 200 meters as a senior out of high school in Redlands, California, and a member of the U.S. four-by-100 relay team that earned silver in the World Junior Championships at Portugal. As a freshman at Oregon, Johnson was the Pac-10 400-meter champion and made the 100-meter finals field at the NCAA Championships but quit track after his sophomore season in 1996 to focus on football.

Johnson—who played only one year of high school football—had played as a freshman under Brooks and played all four football seasons under Bellotti, the last three after Bellotti had taken over as head coach. "Brooks was kind of rough around the edges, but he preached toughness and was great to play for," said Johnson, 38, who would go on to a seven-year NFL career. "Bellotti was a laid-back, relaxed guy who didn't whoop and holler a lot. When he was going off, you knew it was something serious. He was self-assured and very detail-oriented. I was fortunate to play for both of them. It set up a great foundation for me and gave me the fundamentals I needed to go to the next level."

Football didn't go all that smoothly for Johnson at Oregon, though, at least at receiver. With competition from players such as Cristin McLemore, Dameron Ricketts, Tony Hartley, Donald Haynes and Damon Griffin, Johnson was resigned mostly to returning punts and kicks through much of his final three seasons. "I wasn't as tough as I needed to be," Johnson admitted, "and that's how we got into a game, by showing our willingness to go in and block."

It all came together for Johnson, though, in his final regular-season game. "Going into the Oregon State game, I felt the best physically I'd ever felt," he said. "I had an excellent week of practice, the best I ever had in my entire career at Oregon. I didn't drop a single pass, didn't miss a single assignment that week. And usually, you play how you practice.

"The coaches—Bellotti, [Dirk] Koetter, [Chris] Petersen—I'll say they rewarded me for that. That was going to be my last home game. They gave me some plays. It was the best game I ever played. I touched the ball nine or 10 times. To amass that kind of yardage when I touched the ball nine or 10 times…Never ever had a day like that before or since."

Oregon entered the 1998 Civil War contest 8-2, ranked 15th nationally and looking at the possibility of the first 10-win season in school history. The Ducks were coming off a 51–19 rout of Arizona State in which quarterback Akili Smith had thrown for 397 yards and four touchdowns. The 6-3,

220-pound senior came into the game ranked second in the nation in pass efficiency, with 2,877 yards, an already-school-record 26 touchdowns and only seven interceptions. Smith went into the game having thrown 72 consecutive passes without a pick.

"Akili has been playing as well as any quarterback in the nation the past couple of weeks," Bellotti told the media that week.

Today, Bellotti expounds: "Akili probably put together the greatest season of any quarterback to play at Oregon. He took that team on his back and didn't have the same supporting cast as we'd had the year before. He was an amazing athlete."

Bellotti made his remarks prior to Marcus Mariota's serious run at the Heisman Trophy in 2013, but there's no doubt Smith's 1998 season was one for the ages. He had come to Oregon from Grossmont (California) JC, the Ducks having won a recruiting battle with Oklahoma, California and San Diego State. Smith wound up enamored of Oregon's offensive coaches, including his coordinators, Dirk Koetter and Jeff Tedford, and wide receivers coach Chris Petersen.

"Bellotti was personable, easy to talk to, ran a good program," Smith said. "I flat-out loved that guy, loved everything he talked about—being disciplined, the organization of the program. It speaks volumes about a coach who has hired coaches who went on to be successful."

Smith split quarterback duties with Jason Maas throughout the 1997 season, and the same was true in the Civil War game that year, Smith completing just nine of 16 passes for 137 yards for two touchdowns with two interceptions.

"Jason was really the guy who spearheaded that victory along with Pat Johnson," Smith said. "I told myself if I ever get an opportunity to be the guy at quarterback, I'm going to make sure I get us a win in the Civil War."

Smith, though, had gone through brushes with the law the previous winter. He had been cleared of misdemeanor assault charges in a bar fight and went through a diversion program after being arrested for drunk driving.

"I'd gotten myself in a little bit of trouble, and I was real nervous about it," Smith said. "I had a final talk with Coach Bellotti. He had told me, 'If you don't straighten up, you're out of town.' I focused all my time and energy that summer preparing for [the 1998] season. Coach Tedford [who had just been hired to replace Koetter] helped me through it."

During the 1997 season, Smith's roommates were Johnson and running back Saladin McCullough, both seniors that season.

"I was actually their guardian," Johnson jokes now. "They said, 'Pat, we're going to have you live with us to make sure nothing bad happens.' Being around them is how I got better as a player. Those two guys' competitive nature rubbed off on me in a very positive way. I switched over from a track man mentality to being a football guy.

"Akili and I are like brothers to this day. One of the things that stuck out the most, he was so athletic for his size. Physically very gifted, and he had a cannon for an arm. I hosted him on his recruiting trip, and Coach Pete [Chris Petersen] said he'd be a top-five draft pick in two years."

Indeed, Smith would be the third player taken in the 1999 draft, by Cincinnati. He went on to an undistinguished six-year NFL career. Smith had the Beavers' respect, though, going into the '98 Civil War game.

"I had never seen anybody who could throw a ball like that," OSU guard Jared Cornell said. "He could throw a laser. He threw that ball on a rope. The guy was unbelievable."

"Hands down, one of the best quarterbacks in the country," said Beaver running back Ken Simonton, who became a close friend of Smith. "Strong arm, good feet, power, heads-up decisions."

"The best quarterback I played against in college," OSU safety Armon Hatcher said. "I played against a lot of good ones, but Akili was the best combination as far as moving in the pocket, arm strength, accuracy. He could scramble. He was hard to get down. He had it all."

Oregon had replaced McCullough at running back with Reuben Droughns, and he had three 200-yard games in helping the Ducks start the season 5-0. But he broke his ankle in a 41–38 overtime loss to UCLA and was lost to the season. His backup, freshman Herman Ho-Ching, was hobbled by a knee injury heading into the Civil War.

Oregon State had unveiled a pair of freshmen who would play a big role in the program's resurgence in 1998: quarterback Jonathan Smith and tailback Ken Simonton.

"Those guys started the season on the scout team and kind of came out of nowhere," Hatcher said. "In practice, we could see Kenny was good, real good. You saw Jonathan's throws in practice. He was real good, too. But I didn't know if Jonathan would get an opportunity that year."

As a 5-10, 165-pound senior out of Glendora, California, Smith thought he was headed for either Cal Davis or Humboldt State. Oregon State, recruiting prep teammate Dustin Janz, noticed Smith on the team's game film and invited him to walk on.

"I was anxious to get away from home and I wanted to be a coach," said Smith, now offensive coordinator at Washington. "I figured if I went to the highest level I could, it would only benefit me down the road. If it didn't work out, I could always transfer."

Mike Riley was the perfect coach for Smith, a redshirt freshman in 1998. "People talk about how he treats people and his demeanor, but I got a ton from him because he knew both sides of the ball," Smith said. "He had been a defensive coordinator and he had called plays on offense. He was thorough and could explain football on both sides. You always knew what to expect from him. You'd continually get positively coached."

Terrance Bryant had opened the season as the starting quarterback, and Smith saw spot duty against Nevada and Arizona. He came of age in one of the more remarkable performances in Oregon State history on October 24 at Washington. Playing little more than half the game in reserve of Bryant, Smith threw for a school-record 469 yards and three touchdowns in a 35–34 loss.

Simonton arrived at Oregon State as a 5-7, 180-pound freshman out of Pittsburg, California, choosing the Beavers over Boise State and Colorado. Simonton's plan was to play both football and baseball. He wound up with one at-bat during his college career, playing only his sophomore season.

The decision to come to OSU came down mostly to Riley. "He was recruiting me when he was at USC, which was my dream, playing for Tailback U," Simonton said. "Then he called when he got the Oregon State job. Mike truly cares about people. That's the thing I've always appreciated about him. He cared about the things you did as a young man. I learned so much just watching him coach. He's not a rah-rah guy, but he's a fierce competitor."

Hatcher, who had begun his OSU career under Jerry Pettibone, appreciated Riley, too. "I think I heard him yell once," Hatcher said. "He's genuinely nice but also a very good coach. Certainly an upgrade to the program. With Coach Riley, we seemed more Division-I-ish, more Pac-10-ish. We were finally on a level playing field. Now we can get this stuff going."

Linebacker Bryan Jones played his final two years under Riley. "He brought a change of attitude, a change of work ethic," Jones said. "Everybody was looking for a change. We needed something completely different. He brought that. He's a great coach. He fits Oregon State well. He's a players' coach. People knock on him for not yelling and screaming, but behind closed doors, there are some times when he's a little tougher than what people might think."

"Coach Riley was awesome. Still is," Cornell said. "It's tough to balance the football as well as the development side for kids that age. I wasn't a mess but was an 18-, 19-year-old goofball. He has 100 of them every year, and he deals with it better than anybody in the country, if you take into account every aspect—academically, personal growth and football development."

Oregon State entered the Civil War on a four-game losing streak, its last three setbacks by a combined nine points. The Beavers had lost 35–34 on the game's final play against Washington, fumbled away a potential winning field goal against California and watched UCLA score the winning touchdown with 21 seconds left in a 41–38 defeat to the third-ranked Bruins. Even so, the Beavers went into the Oregon game with a chance for the school's first five-win season since 1971.

"Oregon State is the best 4-6 team in the country," Oregon rover Michael Fletcher said during the week. "You throw the records out the window for this game."

"We'd played some really good football that year," said Marty Maurer, a sophomore tight end for the Beavers that season. "We'd lost three or four games by one play here or one kick there. And since we had a bye the week before the Oregon game, we had two weeks to prepare. We put some plays in for them.

"Coach Riley and his staff always do a great job with their film prep. Their plays to start the game are some of the best you'll see. They always put us in good situation to make plays, some good schemes to counter what they are facing. The other thing about Coach Riley, he changed the culture within the Oregon State program. I liked everything he brought to the table. And he was an Oregon kid who understood the Civil War. He gave extra time to study Oregon. He made sure that game was special. He understood the why and did a great job of getting that across to us."

"I'm disappointed for the seniors we couldn't achieve a winning season, but they've had a great year," Riley told reporters that week. "I told them if they can beat Oregon, they'll look back on this season with a lot of good memories."

Simonton, who had been a redshirt the previous year, had watched the Beavers lose at Autzen Stadium. "Going into last year, I had no idea what this little rivalry was about," he told the media before the game. "It was just, 'Oh, we're playing the Ducks.' But then you get there and you see the attitude of their fans, and you want to beat them a little more."

Simonton went into the game looking to become the fourth Oregon State player—joining Pete Pifer, Bill Enyart and Dave Schilling—to gain 1,000 yards in a season.

"He's like Barry Sanders," Bellotti said. "He's not very tall and he's hard to see behind the line. You can't find him, and then boom, he's gone."

Oregon entered the game as a 10-point favorite. Wrote the *Oregonian*'s Dwight Jaynes, who picked the Ducks to win 52–23: "If [the Beavers] can find a way to win this game, it will be one of the great achievements in the long history of the Civil War."

As was often the case, the weather for the 1998 game was nasty. It was a night game, and rain fell and winds blew through the night. It didn't take away from what may be the greatest Civil War game of all time, a 44–41 Oregon State win in double overtime.

It was a shootout, Oregon State's balanced attack against Oregon's passing game. Simonton carried 28 times for 157 yards and tied the school record with four touchdowns, and Jonathan Smith threw for 303 yards and two TDs. Akili Smith was sacked six times and hurried often, but he was 35 for 53 passing for 430 yards and four TDs and ran for a fifth score. Receivers Damon Griffin (10 catches for 133 yards and a TD), Jed Weaver (10 for 92 and a TD) and Tony Hartley (5 for 92 and two TDs) had big games for the Ducks.

Oregon State's defense stuffed the run. At halftime, Oregon had minus-16 yards rushing. The Ducks finished with 31 net rushing yards. Herman Ho-Ching, not at full strength, carried four times for 12 yards. Jerry Brown toted 13 times for 29 yards.

The Beavers trailed 24–17 and had one timeout left when they punted with less than seven minutes to go. Fletcher muffed the punt and the Beavers recovered on Oregon's 33, setting up a game-tying score.

"Fletch tried to jump over the ball and it hit his foot," Akili Smith said. "Fletch was a smart player. He'll look back on that as, 'I shouldn't have even gotten near that ball.' But it shouldn't have come to that."

"I know for a lot of people it's the play of mine they remember most," Fletcher said years later. "I wish I could get that changed. It was a line-drive punt on a windy, rainy night, and I thought I could catch it. Then it just died right in front of me, so I tried to jump over it, and it hit my leg."

"The Lord taketh and giveth," Bellotti said. "Had Michael not fumbled there, we would have been able to run out the clock. Instead, it went to overtime."

Whether Oregon would have been able to run out six-plus minutes is debatable. After Oregon State's game-tying touchdown, though, the Ducks responded, scoring on a 28-yard pass from Akili Smith to Hartley with 2:34 left to go ahead 31–24. The Beavers drove 71 yards, and Tim Alexander scored on a 30-yard hitch pass from Jonathan Smith, breaking four tackles en route to the end zone with 1:07 left.

It was on to overtime. Oregon State took the ball first and scored a touchdown to go ahead 38–31. Oregon took the ball and moved seven yards in three plays. On fourth-and-13 from the OSU 28, Akili Smith threw a pass over the middle intended for Donald Haynes, and OSU safety Terrance Carroll knocked the ball away. As it fell incomplete, thousands of OSU students poured onto the field to celebrate what they thought was victory.

"It was pandemonium, just chaos," Akili Smith said.

But wait a minute. There was a flag on the field. OSU safety Andrae Holland was called for pass interference on the play.

"I remember thinking it was over," Holland said. "Haynes ran a 15-yard 'in' route. I jumped inside of him. I thought I got the ball first, but the ref saw it from a different point of view. He said I hit him in the back first. After I saw the film, I thought it could have gone either way."

Oregon tight end Jed Weaver had been running a shallow cross pattern on the play. "Haynes was running a deep cross," Weaver recalled. "He was near the end zone and would have had a touchdown. I'm running my route and see the flag come out immediately, and I know the game's not over.

"And people are running by and yelling at you. It takes all your willpower not to give a clothesline to some of the fans running by, taunting you. It's like, 'How are they going to clear all these idiots off the field?' Then they all go back on the sidelines. It's like a high school game. They're all standing next to us, which means it's just that much more intense."

"There wasn't a lot of security on the field," Bellotti said. "There was virtually no crowd control. We had hundreds, if not thousands, of Oregon State fans standing on our sidelines, standing among us as we called plays and tried to tolerate them. There was no excuse for that. We had difficulties trying to get players in and out of the game."

As what security there was available tried to clear the field, players on both sides were going through a variety of emotions. Some of them didn't see the flag.

"When the pass went incomplete, I didn't go crazy," Jonathan Smith said. "I wasn't sure what the call was. Then when the play was called back and we had to do it again, it was totally deflating."

"I put my hands up and was ready to do a celebration," OSU linebacker Bryan Jones said. "Then Andrae snatched me up and said, 'Flag, dang it.'"

"I thought the game was over," OSU linebacker Darnell Robinson said. "The fans stormed the field, and it was, 'Let's get out of here.' You're looking around, and you begin to think, 'Uh oh. Let's get our heads out and get ready to go.'"

"I thought it was over," Oregon's Rashad Bauman said. "I was in the back of the end zone, trying to get to the locker room. And then they called us back. We all thought, 'We're going to pull it out.'"

"I didn't see the flag come in," OSU tight end Marty Maurer said. "Everybody rushed the field and everybody was going nuts, but you could see the Oregon players weren't moving. We knew something was up. Then you heard the whistles blow, and they started getting people back to the sidelines."

"At first I was ecstatic that we won the game," Holland said. "Then I saw the flag. It was, 'OK, try to get mentally prepared to go back at it.' We'd been put in that position all year. We were used to playing a lot of downs. I'm sure there were some thoughts of, 'Here we go again,' but it was more, 'Get your mind together and go play ball.'"

"I didn't see the flag right away," OSU's Jared Cornell said. "I started running toward the boundary and realized they'd thrown the flag. I was like, 'Oh Christ, they're going to hose us. They're going to get a whole new set of downs, and we're going to get hosed.' How many shots are they going to give them at the end zone? You give Oregon extra shots at the end zone, they're going to score. It was bound to happen."

"I saw Terrance bat down the ball, looked around, no flags," OSU's Armon Hatcher said. "My helmet came off, I started running around and I saw the flag come out. Seemed like it was super late. And they couldn't get everybody back into the stands. They had to get some glass off the field.

"At that point, I wasn't feeling like we were going to lose. I felt like we had a good grasp on the game. Our offense was in a zone. [The Ducks] weren't really getting stops. We had to hold them to a field goal. If we could do that, we had a good chance."

"I saw the flag and it was like, 'Whoa, that's on us,'" OSU's Jake Cookus said. "I kept my helmet on. I didn't want to get run over by the kids rushing the field. But we just had that feeling that we were going to win no matter what."

Riley wasn't so sure. "I was really nervous after we thought the game was over," the OSU coach said. "We had to go back and find a way to win it again—to try to win it again. That was a little scary."

"I realized it [was a penalty] right away," Simonton said. "And I didn't mind it. It was the first time all season our team had played four full quarters. There was no letdown. I didn't care if it went another overtime. I just knew the way we were playing we were going to win the game. I didn't get swept up in it...but it was neat seeing the fans react that way."

The Ducks felt quite the opposite. "It made us mad," Oregon's Damon Griffin said. "A lot of the fans were pushing and shoving us. We came to the huddle and said, 'OK, we have another chance.'"

"I saw the flag," Akili Smith said. "I saw the refs walk over and talk about it. I thought, 'Thank God we have another opportunity.'"

After order was semi-restored and the penalty was assessed, Smith hit Weaver for 12 yards and a first down at the OSU one-yard line. After two Jerry Brown plunges were stopped cold, Smith hit a wide-open Weaver off of play-action for a walk-in touchdown. It was 38–38 and on to a second overtime.

"I thought, 'This is perfect. We're going to win the game,'" Smith said.

"The real chaos came after they scored to force the second overtime," Maurer said. "The fans stayed at the sidelines. Seemed like there were 15,000 of them, with everybody ready to rush the field again. It was hard to move around."

"During that second overtime, half the defensive calls we ended up making on the field," Bryan Jones said. "I couldn't see [defensive coordinator Greg] Newhouse because the fans were on the sidelines right next to him. We'd shout out the call, hoping everybody could hear it."

"My brother, Josh, tells this story," Jonathan Smith said. "He rushed the field the first time. Then he winds up standing literally within 10 feet of me when Oregon was on offense during the second overtime. He says, 'I was standing right behind you, man.'"

Oregon got the ball first but had to settle for a 26-yard Nathan Villegas field goal to make it 41–38. Oregon State had to kick a field goal to force a third extra session or score a touchdown to win.

Jonathan Smith found Maurer on a flat route for nine yards on first down. "Surprised me that the first call was a pass," Smith said. "I thought, 'OK, Riley is playing to win.'"

On second-and-one at the 16, Simonton took a pitch from Smith and broke toward the right sideline, blowing past Oregon defenders to the end zone. "It was our 'Fire Steeler' play," Smith recalled. "I gave it to Kenny and watched him turn the sideline. I wasn't sure he was going to get to the edge. Once he got around the edge, I thought he was going to go."

"That wasn't supposed to be a touchdown play," Maurer said. "That was the play that was going to set up the touchdown. It was a single-back zone-read play, a staple of Riley's offense, to the short side of the field. I was the H-back. I motioned across and kicked out [a defender]. Ken came off my butt and went right down the sideline."

"The thing you love about Riley, he's going to go for the win," Simonton said. "When he gets the opportunity, he's going to put it in his playmaker's hands. We'd run the play several times, and we had been having problems with the linebacker shooting and blowing it up. But I'd spun off him and gotten a pretty big run in the third quarter, and that slowed him down a little bit.

"On [the game-winning] play, he hesitated, didn't shoot the gap and ended up getting washed up between the tackle and tight end. There was no more pursuit. Once I hit that sideline, I kind of relaxed my stride and thought, 'We got this.' I was pumping my fist, knowing we had it."

"Simonton got stronger as that game went on," Rashad Bauman said. "On the last play, he beat us to the perimeter, and being a speedster, he was able to turn the corner on us pretty good."

Maurer's first instinct was to look for a flag. There was none. The game was over. He was part of the mob atop Simonton in the end zone, along with fans who were helping them celebrate. Soon, fans had covered the field.

"We all ran to the middle of the field," Jared Cornell said. "It was crazy. I weighed 330, and there were times when I was being moved around and my feet weren't touching the ground. It was like a mosh pit. I ended up locking arms with Jason White and a couple of other guys. We tried to plow as fast as we could toward the locker room and get out of there. It was insane."

"It was like nothing I'd ever seen, the passion of the fans that night," Jonathan Smith recalled. "Shortly after the game, I worked my way off the field and went up into the weight room at the Valley Center. I looked out on the field and watched it all. It took awhile for the place to clear out."

Akili Smith, who had one of the great individual games in Civil War history, got caught in the opponent's on-field celebration. "I had a lot of fans come up to me and say, 'Ah, you lost, but you played good," Smith recalled. "They gave me a little bit of respect. That might have been the highlight of my career individually, but it's not about individual performance. The bottom line is, we lost the Civil War, and we didn't finish the season off as strong as I wanted to. I surely did think we were going to win, but we couldn't stop Simonton. It was a heck of a game. Those are the type of games you dream about, but you want to be on the winning side."

It was the final game at Parker Stadium. With donor Al Reser as its namesake and major renovations on the way, it was to be Reser Stadium for the 1999 season, with a natural grass field. Fans ripped out patches of the artificial turf as keepsakes. Only the crossbar remained on one of the goalposts.

There was exhaustion, mentally and physically, as both sides met with the media afterward.

"We didn't quite have a running game today," Mike Bellotti said. "I'm not sure it was the running backs, though I will give credit to Oregon State's defensive line. [The Beavers] ran the ball very well, and we did not have an answer for that."

"We got outcoached as much as we got outplayed," UO defensive coordinator Bob Foster said. "You cannot take that win away from them. It was not because we were tired. They played hard and got the job done."

Michael Fletcher: "They went stride for stride with us all day. Offensive, defensively."

Jonathan Smith: "Our offensive line won the game. We threw that one pass in the second overtime and I'm not even sure why. I felt really good about the way we were running the ball. We've rekindled the rivalry. It's so great to look in the eyes of our seniors and see them get to end their careers this way."

Riley: "We talked about needing an over-the-hump game. Was this it? We'll see. I hope so. It was a great win for us. We haven't necessarily arrived yet."

The Beavers were to arrive without Riley, who left a month later to accept the head coaching job with the San Diego Chargers. In his place came Dennis Erickson, who took them to a 7-5 record—their first winning season in 28 years—and the Oahu Bowl.

The Ducks would finish the season 8-4 after a wild 51–43 loss to Colorado in the Aloha Bowl. The Civil War loss still leaves a bitter taste to many of them.

"The worst thing to have to say is the only game you lost to the Beavers was your senior year," said Jed Weaver, who would go on to a six-year NFL career. "The whole game, I didn't think they could stop us at all. Our defense kept coming over to the offense and saying, 'We're going to stop 'em.' We were like, 'Just do it. Just one person make one play.' They couldn't do it. Kenny Simonton ran all over the place. Afterward, I felt rage. But that settled over time.

"I read one of John Wooden's books. He never focused on the end result. It was always being able to look at yourself in the mirror and knowing you

put everything out there. Sometimes in a team game, it doesn't go your way. I knew I gave my all. I could appreciate the epicness of that game and what happened. The Beavers had good players. I'd have rather played in that game than the zero-zero tie. But it was still very disappointing.

"I rode back to Eugene with my parents in a car full of people after the game. We're trying to get out of Corvallis. There were idiots who had been partying all day. They're yelling, 'Honk for the Beavers,' and they're stomping on the front of the car. My mom said, 'Honk just once.' I wanted to get out of the car and pummel somebody."

The Beavers, of course, look back on the game with pride. "Greatest game I ever played in," said Inoke Breckterfield, who would win the Morris Trophy as the Pac-10's top defensive lineman. "For our senior class to end the streak against Oregon, it was a fitting way to go out. I tell everybody we were the best 5-6 team in the country that year. I was glad to be able to get that 'W' for Coach Riley and all of us seniors."

"That game was the turning point of Oregon State football," Jake Cookus said.

"We'd finally done something big," Darnell Robinson said. "Finally started to change the history at Oregon State."

"We were part of the building blocks of the success Oregon State has had since then," Andrae Holland said. "We set the stage. That's something to feel proud of."

"Such a great way to go out," Armon Hatcher said. "It was like our bowl game, and a launching out of the past, and full speed ahead to the future."

"That was the most fun I ever had playing the game of football," said Simonton, who never played a down in the NFL but had a big season with the Scottish Claymores of NFL Europe, winning the league's offensive player of the year award. "I never experienced anything like that before or since. All the dynamics of that game, all the emotions, and being a big part of getting the program going in the right direction."

"The younger guys took that game and catapulted it the following year," Bryan Jones said. "Our class left knowing that year should have been more wins than it was. But guys in our class, we talk all the time. It's a pride thing to see where the program was when we first got there and to see where it's at now.

"That game was the crowning moment of my college career. There was no better way to end than the way it ended in one of the most memorable Civil Wars ever. I couldn't have written anything better than that. It was like a movie."

FIESTA FOR BEAVERS AND DUCKS

The ante was being raised at both Oregon and Oregon State as the twentieth century came to a close.

At Oregon, Mike Bellotti had taken the baton from Rich Brooks and run with it. Going into the 1999 season, Bellotti had put together four straight winning seasons, something that hadn't happened in Eugene since the Prink Callison era from 1932 to 1935.

At Oregon State, Dennis Erickson was in his first year after succeeding Mike Riley, the Beavers trading a future NFL coach for a past one. Erickson had coached the Seattle Seahawks for four years after a long, successful tenure in the college ranks, including national championships at Miami in 1989 and '91.

After starting the season 3-3, Oregon took a five-game win streak into the 1999 Civil War game at Autzen Stadium. The Ducks, with senior Reuben Droughns at running back and sophomore Joey Harrington splitting time at quarterback with junior A.J. Feeley, would wind up the season ranked 19th nationally with a 9-3 overall record. They were 6-2 in Pac-10 play, tied with Washington for second place behind Stanford, a team that didn't play that year.

Building on the momentum of 1998, Oregon State started Erickson's first campaign 3-0; lost to Southern Cal, Washington and Stanford in succession; and then reeled off four straight, the last one a 28–20 win over Arizona to clinch the school's first winning season since 1970.

Oregon State sophomore Ken Simonton would finish with a school-record 1,486 rushing yards and a Pac-10-leading 19 touchdowns while Droughns

rushed for 1,234 yards that season. They were 2-3 in the conference behind Arizona's Trung Canidate at 1,602. OSU sophomore Jonathan Smith led the league with a school-record 3,057 yards and 15 touchdowns passing with seven interceptions while Harrington and Feeley combined for 3,131 yards and 24 TDs through the air with nine picks.

Oregon's defense and Droughns were the difference in a 25–14 Civil War payback triumph at Autzen Stadium. Droughns, who would go on to a nine-year NFL career, carried 38 times for 197 yards and a touchdown.

"Reuben was amazing," center Deke Moen said afterward. "He's so durable. He kept pounding and pounding. We kept trying to make holes for him, but you know Reuben. He might not have anything and he'd find something."

Droughns, who had missed Oregon's 44–41 Civil War loss the previous year due to injury, read a poem to his teammates prior to the game. "It was [about] how we have to protect our house," Droughns explained. "It started like this: 'A few minutes until we enter our battle zone; a few minutes until we play our last game at home.'"

Harrington completed 13 of 24 passes for 146 yards and ran for a five-yard score. Tony Hartley had eight catches for 100 yards for the Ducks.

Smith was 21 for 38 for 248 yards passing but was sacked six times, three by Saul Patu. "Jonathan was throwing off his back leg a lot," Oregon linebacker Michael Fletcher said.

Simonton scored both Oregon State touchdowns and a two-point conversion but finished with only 63 yards on 24 carries. He had a net eight yards on 12 totes in the first half; the Beavers were at minus-27 yards on the ground through intermission. They finished with a season-low plus-27.

"Our best defensive effort of the year," Oregon D-coordinator Nick Aliotti said.

Erickson would have trouble with on-field deportment from players throughout his college coaching career. It was very much in evidence during the '99 Civil War game, when the Beavers sustained 15 penalties for 146 yards—including a whopping eight personal fouls. "We lost our composure," Erickson said after the game. "We did some really dumb things I'm not too happy about."

Punter Mike Fessler dropped a snap late in the first quarter to set up an Oregon field goal and give the Ducks a 6–0 lead. "It was just a bad day," Smith said. "We played like crud."

Oregon led 22–0 in the third quarter before Oregon State mounted a charge. With the Ducks ahead 22–14 and fourth down-and-inches at their

45 and 7:30 left, Bellotti went for it. "If you can't make two inches in the Civil War, I don't think you should show up," Bellotti said. "I talked to both our coordinators before I made that call, and they thought the same thing. Sure, let's do it."

Harrington got the first down on a quarterback sneak, leading to a 20-yard Nathan Villegas field goal—his fourth three-pointer of the game—that wrapped up victory for the Ducks.

In 104 Civil War games, the stakes had never been higher than in 2000, when fifth-ranked Oregon visited Corvallis to take on eighth-ranked Oregon State in a nationally televised game.

Both teams were 10-1 overall, the first 10-win season ever in both schools' history. The Rose Bowl and Pac-10 championship was on the line for Oregon, 7-0 in conference play, with its only loss 27–23 to Wisconsin in the second game of the season. A potential BCS bowl and a share of the league title was at stake for Oregon State, which also had an outside shot at the Rose Bowl.

The Beavers needed to beat the Ducks and have Washington State upset Washington. OSU was 6-1 in Pac-10 play, with its only setback 33–30 at Washington when Ryan Cesca missed a game-tying 33-yard field-goal attempt with 14 seconds left. The Beavers had beaten Southern Cal for the first time since 1967.

"The season will not be complete unless we win this game," proclaimed Harrington, a Portland native and Central Catholic High grad. "If we win this game, I will never forget it; if we lose this game, I will never forget it. This is something I will either cherish for the rest of my life, or else it will haunt me."

Anticipation for the Civil War throughout the state built through the week. In Corvallis, OSU students were scarfing up orange T-shirts that read "Attack the Quack." Another featured a cartoon duck with its bill taped shut. In Eugene, the T-shirt of choice was one of a duck chasing a beaver. A sign in a downtown Eugene shop read "Obliterate semiaquatic uncouth rodents."

In Portland, the T-shirt selling most read "Classic Blood and Guts Rivalry...Bragging Rights for One Season Only." Bragging rights, of course, were only the half of it.

Reporters were not allowed at the Duck Club luncheon, where Mike Bellotti was speaking. During his talk to Oregon boosters, Bellotti addressed what happened at the end of the 1998 game in Corvallis, where students and fans spilled onto the field at the end of the first overtime, only to have to clear it for a second extra session in a game Oregon State won 44–41.

What happened that night was "detrimental to the game," Bellotti told the UO supporters. "It really did not allow us to operate. And a lot of our players, coaches, coaches' wives, coaches' children were harassed and abused. I know that happens everywhere. It's just very difficult. It had nothing to do with the [result]. The game was won or lost on the field. But a lot of people are talking about not going there [for the 2000 game]. My youngest son is concerned to go there. That's a shame."

Word got back to the OSU camp of Bellotti's declaration.

"I think he's trying to get [his players] riled up," tight end Marty Maurer said. "You can start telling about all the things [the Ducks] said last year. I mean, it happens in any stadium you go to."

Maurer's father, Andy, had played at Oregon and gone on to a 10-year NFL career. Marty had not been recruited by the Ducks. "I don't hold that against him," he said in the days before the Civil War. "The Ducks are the Ducks, and I don't like them. My favorite team is the one playing the Ducks. I want to apologize to all the die-hard Beaver fans that I grew up rooting for Oregon. But things change. This is a different time, a new era. This is a Beaver State. That's what the [state] flag says."

Oregon State was installed as a four-and-a-half-point favorite, which didn't sit well with the Ducks as they prepared for a return visit to Corvallis two years after the '98 encounter.

"I don't understand how we are the No. 5 team in the nation, we are undefeated in the Pac-10...Granted, we are playing on the road against a very good opponent...but something doesn't seem right there," Harrington said. "It will be a good motivating factor for us. It just seems as if everyone is excited about the Beavers, everybody is talking about what a great season the Beavers have had. I don't want to take anything away from them, but we've had a pretty good season, too."

Defensive end Jason Nikolao was even more indignant. "We're the underdogs and that shows a lack of respect by a lot of people," Nikolao said. "A lot of people are going to feel stupid after this game. Everything about that place irritates me. Last time I was up there, I was treated like some punk on the street. I was spit on. I was punched on. Little kids, women, old people...All I saw was orange and black.

"Now I can do something about it on Saturday. I can do something to their players. Wherever there is orange and black, it's getting hit...I'm going to use all the anger from that night...I'm so mad...I hurt so bad when I walked off that field [in 1998], and there's no way I'm walking off the field that way again."

Nikolao said he'd had a dream about Oregon State quarterback Jonathan Smith. "He is singing…and I'm hearing every word he is saying," Nikolao said. "He's in Corvallis right now teasing me, teasing my teammates, sitting there laughing about everything. They are all dancing right now. Dancing and laughing."

Nikolao had watched game tapes of Beavers such as Ken Simonton, Chad Johnson and T.J. Houshmandzadeh doing a "pat-down" routine after big plays. "They pat each other when they are celebrating, like they are frisking each other," Nikolao said. "Well, I'm going to be doing some frisking myself. I'm looking for something. I'm looking for my pride, and I'm going to get it back."

There was extra trash talk on the field during Civil War games, too, Oregon receiver Marshaun Tucker said. "People will talk about your mother, your father," Tucker said. "It gets pretty bad out there."

Much ado about very little, the Beavers were saying. "Their players have been doing a lot of talking," OSU freshman linebacker Richard Seigler said late in the week. "They've been talking about our fans. They're talking about our program. We're not sweating that. We're going to let our pads do our talking on Saturday…They need to stop whining. What do you expect when they come to a Civil War game? Fans talk. You just have to let it roll off you."

Even so, when Oregon State athletic director Mitch Barnhart drove to Eugene for a Beaver Club meeting on Monday, he stopped by to meet with Oregon athletic director Bill Moos. The game-day security force at Reser Stadium, Barnhart told Moos, had been increased from the usual 220 to 350 to prevent recurrence of the '98 late-game problems.

"He talked to me about the measures they have taken to beef up security for this particular game, and I compliment them," Moos said. "They have a great plan. There is only so much they can do, but I am comforted that they have done all they could do in that regard."

As further precaution, Oregon State had installed two new goalposts costing $30,000 that were made of steel and were almost impossible to bring down.

For motivation, Bellotti had worn his 1994 Pac-10 Conference championship ring—featuring diamonds in the shape of a "1"—to practice. Defensive coordinator Nick Aliotti displayed his 1995 Rose Bowl ring. "Nick passed his around [to the players]," Bellotti said. "I've passed mine around. I told the kids I know where they can get one."

Of course, Dennis Erickson had done much the same thing in 1999 during his first meeting with the Oregon State players after being named to succeed

Mike Riley as head coach. Erickson had worn two national-championship rings from his years at Miami.

"These big, glittering things," guard Jared Cornell said the week before the Civil War game. "Here's this little guy with two rings on his fingers and gray hair, and I was just like, 'Oh my God!'"

More than 15 years later, Cornell hasn't forgotten the memory. "They had a meeting set up for 6:00 a.m.," he said. "We walked in to the media room and there's Coach Erickson, the guy we'd seen only on TV. The one thing I remember him saying was, he didn't come to Oregon State to win games or a Pac-10 championship but to win a national championship. Everybody looked sideways, like, 'Does he know where he's at?'

"His staff taught us how to win. The previous year we'd gone 5-6, but we didn't know how to close games out. There had been a culture of losing forever. After Coach Erickson came in, when we hit bumps in the road, you'd look at the sidelines and he didn't blink. It's a culture and attitude, and that's what Oregon State needed at that time. I loved playing for Coach E. He was a ton of fun. That staff was great. They were cocky and confident but not to a point where they were arrogant."

Most of the Beavers of those years enjoyed playing for both Riley and Erickson. "I loved Coach Riley, but Coach Erickson let me become 'D-Nasty,' the guy who was able to go out on the field and be a beast,'" said Darnell Robinson, a senior linebacker on the 2000 team. "When he came in, he got the players excited. Here was a guy coming in from the NFL. He'd won it all in college. Suddenly, we were winners versus us trying to prove ourselves. The bar was raised much higher."

"Riley is a great coach and a great person, somebody who relates well to players, who gets a lot of buy-in that way," center Chris Gibson said. "He doesn't have to be the fiery screamer and yeller. Kids want to play for him and do their best. Erickson and his staff had more of that fire and swagger and had proven success at the college level. Coach Erickson and Coach Riley are different as far as the way they motivate and the way they drive people, but they're both fantastic in their own styles."

"Erickson was the consummate professional," Ken Simonton said. "You were going to learn how to be a pro. We got some of the best day-to-day instruction. He set a learning environment. He brought that attitude that we needed, that 10-foot-tall swagger. Riley is humble, and you have to play for him to know how competitive he is, but you knew Erickson wanted to win, period. I learned so much about the game of football from both. They give you everything in terms of Xs and Os and preparation. Their styles were

different, but they both expected you to be men and act like professionals. Guys responded to that."

"Coach Erickson was a quite different personality than Coach Riley," safety Jake Cookus said. "The word that comes to mind with Erickson is players' coach. Coach Riley was a players' coach, too, but more laid-back. Dennis was really fiery. He wasn't afraid to call somebody out if they did something wrong, to get in somebody's face here and there. Coach Riley has a different way of approaching guys, but they're both effective ways."

"Dennis was my kind of coach," said defensive end Bill Swancutt, who began his OSU career under Erickson and finished it under Riley. "If you're not getting the job done, he'd tell you. The staff would be harsh on you but just to make you better. Riley had a different coaching philosophy. His style is more nurturing. I don't think one is better than the other. When Erickson was there, we'd have fights every day in practice. We had a swagger to us. We weren't going to get messed with."

Swancutt said the attitude carried over after Erickson left for the San Francisco 49ers and Riley returned after the 2002 season. "That first year, Erickson recruits were still there, and they had the Erickson influence, a nastier mentality," Swancutt said. "The idea was to be intimidating. With Erickson, we'd do an inside run drill and there'd be four or five fights in a 10-play set. It would get broken up, and we'd go on to the next play. When Riley came in, he didn't like that stuff at all. If a fight broke out, you'd get kicked out of practice, or we'd do a bunch of running."

Erickson likes to say when he first met with diminutive quarterback Jonathan Smith, he thought he was a manager. The two became close quickly. "Big-time quarterbacks are usually bigger kids," said Smith. "You have to love his sarcasm. Dennis was great in the way he exuded confidence. He prepared us well for big games. He'd drink three cups of coffee at halftime of a game. I've never seen a coach get away with yelling at the ref like he did. He was quick-witted and funny, a storyteller. He sat in every quarterbacks' meeting. He would let you know immediately if he wanted something different from you.

"I think I was the coach's pet a little bit. He always made me feel like I was the best player. At practice, if I threw a bad pass, he'd yell at the receiver. Playing for Erickson and Riley is huge for where I'm at now and how I'm going to be able to develop as a coach. It worked out perfectly for me."

Erickson, said Marty Maurer, quickly got into the spirit of the Civil War. "Dennis hated Oregon," Maurer said. "I don't know how much Dennis understood the rivalry when he came in, but he learned quickly

the first time Bellotti pulled some of his state supremacy quotes. He never credited us for winning. They lost games; the opponent never won. As coaches and players, you catch onto that really quick. There's added motivation to it.

"Coach Erickson went to one of the Civil War banquets after losing [in 1999], heard what was said and told us, 'I'm never going to another one.' He got right after Bellotti when he heard that stuff. He understood why everybody hated them. Dennis did a great job using Dee Andros [for motivational talks], telling stories and bringing in the history, too. He told the in-state players, 'Your job all year is to make sure your teammates are ready and understand your anger and hatred toward them. It's your job to get your teammates up.' Myself and the other state-of-Oregon kids, we made sure they knew the importance of it. That year, it wasn't just No. 5 versus No. 8. It was about us against the People's Republic of Eugene and how much we hated them and wanted to stick it to them."

Relayed that story today, Erickson—now an assistant coach at Utah—laughs. "All of the above is probably true," he said, "but I deny it."

Oregon's players of that era had strong feelings for Mike Bellotti.

"Coach B is a perfect coach," cornerback Rashad Bauman said. "He was very mild-tempered, had the ability to handle different personalities. That helped a lot. He was a father figure. We had a lot of guys coming from fatherless backgrounds. He played a key role in our lives."

"Playing for Coach Bellotti was a positive experience for me," tight end George Wrighster said. "He was a very good coach. He propelled us to a new level, then Chip Kelly took it further than that. It was great to be a part of building something, and not only building something, but we were really good at the same time. There are legacy starters, there are legacy builders and there are legacy sustainers. Coach Bellotti would fall into the legacy builder category. Coach Kelly falls into the legacy builder but also the legacy sustainer category at the same time."

"There's no better motivator in the business of football than Mike Bellotti, except for Coach [Mike] Singletary," said safety Keith Lewis, who played for Singletary with the San Francisco 49ers. "Coach Bellotti is very calm. He'll put you in your place when it's needed. He's a true coach. We bumped heads a couple of times, but it was for the better.

"On Senior Day [in 2003], they had us coming out of the tunnel, and I started to run right by him. He grabbed me and he gave me a hug. That's the kind of relationship we had. It was tough love, a love-hate relationship.

We had our confrontations, but I have nothing but the utmost respect for Coach Bellotti."

"The thing Coach Bellotti did extremely well was let his coaches coach," quarterback Joey Harrington said. "He didn't meddle. He hired great people. He set up a great system, then he let the players and coaches do their job. I've gotten to know Coach Bellotti a lot better in the last few years. As a 19-, 20-year-old kid, you don't always get to see the personality of your coach outside the office. I've found he's a wonderful guy. I'm happy to have played for him."

Over and over, Oregon players talk about the quality of coaches during the Bellotti era that has sustained to Mark Helfrich's staff today. "Those coaches have built the culture of Oregon," receiver Marshaun Tucker said. "Nick Aliotti, Gary Campbell, Don Pellum, Steve Greatwood, [strength/conditioning coach] Jim Radcliffe—that guy is going to be 150 years old and still working guys out. A lot of times head coaches or star players get all the credit. But what about all the assistants who have been there that long and continue to build over what they have done over the years? That's incredible."

The Ducks also had great respect for their on-field leader, Harrington, who as a junior had emerged as one of the premier signal-callers in the Pac-10. The 6-4, 220-pound graduate of Portland's Central Catholic High had been born and bred a Duck. His father, John, was a quarterback at Oregon during the Jerry Frei era from 1967 to 1969.

Joey would finish his career 25-3 as a starter, and that didn't include a pair of victories he engineered in relief of A.J. Feeley as a sophomore in 1999. "The General" went into the 2000 Civil War game 13-1 as a starter. Six times he had led comeback wins, three in a row prior to the Oregon State game. That included an unforgettable 56–55 double-overtime win at Arizona State on October 28—Harrington threw for a school-record six touchdowns— and a 27–24 overtime triumph at Washington State the following Saturday.

During the ASU game, fullback Josh Line related that week, "He was yelling to us, coming up and down the sideline. We were all listening. He rallied us together…Joey gets us back to believing we can win. It's in the fourth quarter [when you're behind] that doubt starts to enter in. And that's the attitude of a loser. Joey is not a loser. That doesn't enter his mind, and he makes sure it stays out of all of our heads."

"The guy finds a way to win," linebacker Matt Smith said. "It gives us confidence because we know that if it's a close game in the fourth, all we need to do is get a stop and he will lead the offense in for the points we need."

"There are quite a few on this team who lead, but Joey, he's the one," cornerback Rashad Bauman said. "We respect him."

"There are guys who lead by example, guys who lead through adversity and guys who lead by talking," tight end Justin Peelle said. "Joey does all of those things. There are a lot of people on this team who feed off him."

"This is a position I've been in my entire life," Harrington said that week. "I'm used to it. I'm comfortable with it. I don't like sitting back and leaving it to other people. I like knowing what's going on. I like being the guy the team rallies around."

Oregon State's Jonathan Smith had put together an impressive resume over his three seasons, too. But the 5-10, 175-pound junior wasn't about to compare himself favorably with Harrington, just as he'd made clear as a freshman when he went head-to-head with Oregon's Akili Smith. "I'm not doing anything on my own," Jonathan Smith said. "I'm not a Michael Vick. I'm not a Joey Harrington, who can do a lot of things on his own. I just don't do it. I realize I need help to be in the spot where I'm at. I have better people around me. I have a better running back [in Ken Simonton]. I have better wide receivers. I have a better offensive line. But he's a better quarterback. I just have better tools than he has. He's a proven winner, but I have more help beside me."

Ken Simonton today calls Smith "the consummate overachiever."

"I'm sure he accomplished more than he set out to as a player," Simonton said. "He was a quiet leader. He'd get sacked and I'd get on him to chew out his linemen, but that wasn't his style. He led by example. A great guy, a great teammate, a guy you wanted to hang out with and learn the game from."

"Jonny was cool, calm and collected, and kind of cocky," Jared Cornell said. "He and Coach Erickson had some lively conversations on the sidelines and in meeting rooms. Jonny likened himself to a coach on the field. He was extremely bright and fun to play with. Once he settled in and became 'Niner' [No. 9] the quarterback, I always felt like we had the guy. We didn't have to worry. Jonny would make the play, get the ball to somebody and we'd come out all right."

"Jonathan knew what was going on before it happened and countered everything with one of the smartest football minds I've been around, period," Marty Maurer said. "He had all the intangibles. He knew where to go with the ball and when, and he had a good pulse on the huddle. When we needed to be distracted, calmed down, amped up."

"Jonathan may not have had all the tools, the size and arm strength, but his football knowledge was fantastic," Chris Gibson said. "That was one of

the things that helped push him above and beyond—his ability to be that leader on the field and understand and see the game in a different way."

"I was always pretty confident in myself, but I wouldn't verbalize that," Smith says today. "I tried to deflect the attention at times, but I always felt fine with my skill set. I knew what my weaknesses were. Akili Smith and Joey Harrington were bigger, stronger guys who were going on to the NFL. I was going to be a coach, at least I hoped."

Oregon's biggest concern going into the game was its rushing attack. The Ducks had rushed for a total of 185 yards in their last three wins. "But that's OK," Harrington said then. "We didn't throw the ball well at the beginning of the season. We'll still find a way to win."

Asked if he would root for the Beavers against other opponents, Harrington shook his head. "Absolutely not," he said. "I'm a Ducks fan, flat out. My dad went there, my whole family. There aren't many people in this state who are neutral. You are either a Duck or a Beaver. There isn't much crossing of lines."

"The only thing that concerns me is Reser Stadium," Peelle said. "It's not easy winning on the road in the Pac-10, especially in a rivalry game, especially when it's No. 5 against No. 8. That's going to be the X-factor in this game, whether we can handle the hostility of the environment. Because I see the two teams as really even."

Senior linebacker Garrett Sabol said he didn't want to think about the possibility of a loss. "It would be awful," he said. "This season has been so amazing. Man, if we lost, it would kill me. It would be one of the biggest upsets of my life."

"Our kids have tremendous poise and confidence that if the game is close, we will win," Bellotti said. "We have done that time after time again."

It was not to be for Oregon in the 2000 Civil War game. The Beavers jumped out to a 14–0 first-quarter lead and held on for a 23–13 victory before a sellout crowd of 36,044 that left three teams—Oregon, Oregon State and Washington—sharing the Pac-10 championship at 7-1.

The emotionally charged battle was the most-penalized Civil War contest in history. Oregon had 12 penalties for 132 yards. Oregon State was penalized 13 times for 137 yards.

Jonathan Smith completed 14 of 27 passes for 246 yards and two touchdowns, and Ken Simonton rushed 24 times for 113 yards and a score. Oregon's Maurice Morris—who would finish with 1,313 yards rushing that season—went for 97 yards and a TD on 19 carries. Harrington was 24 for

46 passing for 333 yards, but his six turnovers (five interceptions, one fumble) were the difference.

"We killed Joey," Oregon State's Darnell Robinson said. "The week of that game, I met one of his friends who had gone to high school with him at a local bar. He said, 'When you sack him, tell him his nickname.' During the game, I got to him one time and called him his secret nickname. He looked at me flustered, like, 'How do you know that?' I wish I could remember that nickname. We talked a good game, but we backed it up."

"After our loss at Washington, we got into a rhythm, and everything was working for us," Chris Gibson said. "It was almost like the preparation for the Civil War came easy for us. We'd been at that high level for so long. We knew what we needed to do, and with everything riding on that game, we got it done. To walk out of there with a share of the Pac-10 title, from where we had come, it was almost a surreal feeling of accomplishment."

"I'm surprised we didn't beat [the Ducks] by more," Ken Simonton said. "They were a good team, but we had the home-field advantage, and we were a better team than they were. I remember going into that game relaxed. It was in our house, and we were going to break their necks. It was a physical game. We knew there was no quit in them. They fought back. Joey had a rough day. He left some balls up there that we took advantage of. They gave us a lot of opportunities. Once we got a lead, we knew we weren't going to give it up."

"For the first time, the Civil War didn't have as much importance as getting to a BCS bowl," Marty Maurer said. "It was nice to have the national attention for once on the game. We blitzed them offensively real quick. The Ducks came out soft and slow. It seemed like they weren't ready to play. We had receivers wide open. We were pushing them around pretty good on the offensive line. We did just about everything we wanted to, and our defense put their offense where they couldn't even function."

That's an overstatement. The Ducks amassed 27 first downs and 497 yards total offense that day. All the mistakes, though, were killers.

"Hands down, the worst moment of my college career," Harrington says today. "Not just because losing cost us an outright Pac-10 title and the Rose Bowl but because I felt so helpless. [On the interceptions] three batted balls, one ball I threw behind a guy and a hold that didn't get called. The fumble came as we were going in on the 10-yard line and I got blindsided by somebody. It wasn't anything that anybody did; the ball just bounced the wrong way. I still don't think I'm completely over that game."

"Tell him to look at the film," said Jake Cookus, who had three of the interceptions. "Not sure all those balls were tipped. My first one was, I know that. But I was lucky that day. Just in the right place at the right time."

Cookus had been a star quarterback and safety who had led Roseburg to back-to-back state championships his junior and senior years. The 5-11, 185-pound Cookus signed with Air Force because he wanted to play quarterback and the Falcons ran the option. He played for the Air Force prep team as a freshman, losing no college eligibility, before transferring to Oregon State.

"Three guys I played with at Roseburg were at Oregon State, including [center] Chris Gibson," Cookus said. "They encouraged me to come. So did Coach Riley. I figured I'd give it a shot."

Cookus had stepped in at safety when Calvin Carlyle was injured and had started five games as a junior in 2000.

Oregon State's defense was loaded, with nine players who would go on to NFL careers—ends DeLawrence Grant and LaDairis Jackson; tackle Dwan Edwards; linebackers James Allen, Nick Barnett and Richard Seigler; cornerbacks Dennis Weathersby and Terrell Roberts; and safety Terrence Carroll. On that day, OSU defenders would bat down five of Harrington's passes at the line of scrimmage.

"We had a great line and great linebackers," Cookus said. "I was very fortunate to be on the field with those guys. If you got that stuff in front of you, [opposing quarterbacks] throw some stuff up sometimes. I felt really prepared going into the game. I had a good idea what the Ducks were doing offensively. [Receiver] Keenan Howry was their go-to guy. Our coaches prepared us well. I had a good idea where Joey was going with his throws. We saw some things on film that he liked to do things in certain situations. I was trying to direct traffic a little bit. It turned out to be a great day for me."

If there was a weak link to the OSU defense, it may have been Cookus, who lacked great speed and experience. "I knew going into the game they were going to try to pick on me a little," he said. "Most teams were going to look at our secondary and say, 'Let's attack this guy.' I was glad Coach Erickson and Coach [Craig] Bray [the defensive coordinator] had enough confidence in me. I was ready to roll. I'm a competitor. I won't back down to anybody. You can't play with fear out there. You have to rise to the challenge and accept the opportunity."

On Oregon's first possession, Harrington overthrew Howry, who tipped the ball into the hands of Cookus. He returned the ball 31 yards to the Oregon 17. Three plays later, after a penalty, Smith found Robert Prescott

over the middle for 31 yards, a touchdown and a 7–0 lead. Prescott's second TD reception, for 49 yards, made it 14–0.

"We worked on [defending] that play all week, and they hit us with it twice for scores," Oregon cornerback Rashad Bauman said. "I can't say it was a surprise. We had prepared to stop that play. Being prepared for it didn't help us."

"We got up so fast on them," Jared Cornell said. "I was looking at the guys on the bench, saying, 'Is it going to be this easy?'"

Ryan Cesca's 32-yard field goal hiked OSU's lead to 17–0. Harrington, after throwing a 33-yard pass to Marshaun Tucker, scored on a six-yard run to close the gap to 17–7. On its next possession, Oregon had the ball fourth-and-two at the OSU 34. Bellotti called for a fake punt, but the punt unit appeared confused and Bellotti called timeout. The coach kept the fake punt play on, and the snap went to protector Gary Barker, who tried to pitch to punter Kurtis Doerr. The play was stopped for no gain, and the Ducks went into halftime trailing 17–7, having already been penalized nine times for 97 yards.

The Ducks were within 23–13 and still alive, driving at the Oregon State 10-yard line with six minutes to play, when Harrington—already with five picks—was blindsided by Sefa O'Reilly while back to pass. The ball squirted backward, and Grant recovered at the OSU 24. That was the Ducks' last gasp.

"We didn't play as well as we are capable of, and that's the hardest thing for a coach," Bellotti said afterward. "If we play well and they beat us, I can handle that. When we don't play well and contribute to our loss, that bothers me. The difference was turnovers and penalties, and we spotted them too many points. [The Beavers] are a good team, and you can't do that in a championship game on the opponent's field."

Missing out on the Rose Bowl, Bellotti offered, "is tough on the kids. It doesn't bother me that much. I don't want to say bowl games come and go, but we have been in a lot. It would be nice to be in the Rose Bowl, but the problem is, you want your team to play well. At times we did on both sides of the ball, but not consistently enough."

Oregon State did much of its offensive damage through the air. Prescott caught six passes for 109 yards. Chad Johnson had a 44-yard diving reception on OSU's first play from scrimmage, his only catch of the day.

"Funny story about that play," Maurer said. "When we broke the huddle, Chad had told Jonathan, 'You can't overthrow me. Anything you put up, I can run down.' Jon, instead of his normal five-step drop, took a three-step drop and threw it as far as he could. Chad had to lay out and catch it. I think Jon was doing a little gamesmanship there."

Johnson, who would go on to a successful and flamboyant NFL career, was a senior transfer playing his only season of college football. "Chad was the same then that he is now, without all the money," Maurer said. "That's a lot to take in. But he left his mark."

"Chad was harmless in a way," Smith said. "I remember the first time I met him. He shows up late July and goes, 'Hey, I'm going to get you a Lexus. I'm going to get you to the NFL.' I said, 'All right.' You could see the talent oozing out of the guy. He had no idea what he was doing in running routes when he started, but he had good hands, speed and vision."

"Chad let it go to his head the last few years in the NFL, but I've never seen a man show up in the kind of shape he was in and prepare on a daily basis that season," Simonton said. "He was running extra routes every day in camp. He had a focus that was unparalleled. He knew what he had to do and he did it. He walked that line."

Johnson didn't hurt the Ducks too much that day. Prescott and Simonton were the bigger weapons.

"I remember watching on film and thinking, 'We can handle them, no problem,'" Rashad Bauman said. "They had maybe five plays offensively. Our coaches told us, 'Stop two of these plays and we'll win.' We didn't stop them."

Simonton, held to 10 yards rushing the first half, got 103 yards on the ground after intermission.

"Kenny was the kind of runner who made a lineman's job easy," Chris Gibson said. "He was so compact and explosive, he could hide in there behind you. You just had to give him a little crease and he'd get through it and do good things with the ball. He was always appreciative of the linemen and everything they did. Just a great guy to be around and play with."

"The only reason Kenny didn't have a 10-year NFL career is because he didn't have sprinter's speed," Jared Cornell said. "He had vision and side-to-side agility like Barry Sanders. He could pinball around, shrink around in the hole. You'd think you had him pinned down and he'd gain five to seven yards. What made Kenny really good was he knew how to read our blocks. He was like a miniature offensive lineman. He knew our schemes and communicated really well."

"Ken was unique," Smith said. "He had such great vision. He would make you miss. He wouldn't flinch in the hole. He could catch it. He was smart. He was so competitive and tough, a poised running back. He allowed the O-line to go through their scheme and let plays develop. And he was a vocal leader. He'd be on guys more than I would."

"Simonton might be the best running back to ever come through the Pac-10," Darnell Robinson said, "and Ken didn't even like football. His first love was baseball. We knew it was on him to lead our team and get it done. His number should have been retired a long time ago at Oregon State for what he did for the program. I told [athletic director] Bob De Carolis that. He put the program on his back."

Robinson had been recruited by Jerry Pettibone as an option quarterback out of Sacramento. Robinson had finally passed his SAT on the fourth attempt and enrolled as a greyshirt in 1996. "I'm grateful for [then–defensive coordinator] Bronco Mendenhall," he said. "He stuck by me 110 percent. I didn't have a father figure growing up. Single mom, deadbeat dad, poor kid, three sisters. When Oregon State made me an offer, it was one of the best days of my life. I was lost when Coach Riley came in. Most new coaches want to clean house. He called me into his office and said, 'We're going to pull your scholarship.' I told him, 'I can't go back to the crib. There's nothing there for me.' He said, 'You have the spring to prove yourself.'"

The 6-foot, 225-pound Robinson would prove himself as a special-teams stalwart under Riley and then was a two-year starter for Erickson, playing a starring role in the rout of Notre Dame in the Fiesta Bowl.

"I'm grateful to all my coaches and especially to Coach Riley," Robinson said. "He was good for me and everybody else at Oregon State. Mike is a great community guy. He was able to rally the fans around and get everybody excited about the direction of the program. He set the road for what we were going to do later on."

The 2000 Civil War loss was a difficult time for the Oregon players.

"We played really badly the whole game, even though our defense kind of held us in there," Keenan Howry said. "We had so much riding on that game. We kind of played uptight…especially Joey tensed up a little bit. I think we all did."

Today, Howry wants it understood he doesn't blame Harrington for the loss. "Joey went out there every week and laid it on the line," he said. "He was a great leader and a great athlete. Not a lot of people realize how athletic he was. Looking back, we make all those mistakes and lose by 10 points. I remember thinking, 'I just don't want to be here now.' That's how the game felt that day. It felt like something was wrong.

"Ever since Joey took over the starting role, he was crowned the prodigal child of Oregon. With all the pressure that came with that, everybody placed the blame on Joey, but we all played uptight."

"I hate recalling that game," Marshaun Tucker said. "We had a great team. If we'd won the Wisconsin game, we wouldn't have been in that situation. Coach [Jeff] Tedford had a phenomenal game plan for us. He and Chris [Petersen] recognized Oregon State's defense at the time. [The cornerbacks] always pressed, and the coaches would get us in motion off the line and try to create some things. But I have to give it to [the Beavers]. They made more plays than we did, and unfortunately we didn't get it done."

The extra measures toward security didn't change things completely, remembers Oregon safety Keith Lewis. "As we were walking off the field, one of our players got hit on the head with a bottle," he said. "We couldn't get off the field fast enough. It was a rough crowd. You could compare it to the Oakland Raiders."

Afterward, Smith presented the game ball to athletic director Mitch Barnhart. "That was my favorite Civil War game," Smith said. "I took the final snap, the place goes crazy. So much fun. I remember after we said the Lord's Prayer in the locker room after the game, looking at the ground and thinking, 'You're a Pac-10 champion.' It was surreal, how far we had come."

"I remember walking off the field thinking, 'This is what we expected,'" Jared Cornell said. "In our minds, we were the best team in the country. I remember hoping somehow, some way, that Washington State would beat Washington so we could go to the Rose Bowl."

With Washington's 51–3 rout of Washington State, the Huskies were headed to the Rose Bowl. The Beavers were bound for the Fiesta Bowl, where they would thrash Notre Dame 41–9. Erickson became the second coach to be selected Pac-10 Coach of the Year at two schools, having shared the honor with USC's Larry Smith when he coached Washington State to a 9-3 mark in 1998.

"We dominated the Oregon game, we really did, from the start," Erickson said. "Under the circumstances, that probably was as good a win against Oregon as has ever been. It makes me cry we didn't go to the Rose Bowl, now that I look back at it. We were one field goal away from going undefeated. But God, it was a great year."

Oregon wound up beating Texas 35–30 in the Holiday Bowl but at a huge financial loss. A Rose Bowl berth would have meant a $12.5 million payday. The Holiday Bowl payout was $1.9 million.

"We still got the co-Pac-10 championship, but to lose out on the solo and the Rose Bowl, it left us with such a sour taste," center Dan Weaver said. "But it probably drove the off-season workouts that following season."

The Beavers and Ducks were both supposed to be on the top of the college world in 2001. The Ducks were the ones to meet the challenge.

Sports Illustrated picked Oregon State as its preseason national champion and put Ken Simonton and Joey Harrington together on the cover of its regional issues, each with a sword in his hand along with bounty (duck or beaver).

The Beavers were loaded with veteran talent, led by seniors Simonton and Jonathan Smith along with receiver James Newson; tight end Tim Euhus; and defensive stars such as tackle Dwan Edwards; linebackers Nick Barnett, James Allen and Richard Seigler; and cornerbacks Dennis Weathersby and Terrell Roberts.

Oregon came in with plenty of talent, too, including Harrington, tailbacks Maurice Morris and Onterrio Smith, tight end Justin Peelle, receiver/return specialist Keenan Howry and defenders such as Rashad Bauman and Steve Smith at cornerback and Kevin Mitchell, David Moretti and Wesly Mallard at linebacker.

Oregon State blew a gasket in its opener, a 44–24 ambush at Fresno State that was billed as the biggest game in Bulldog history. A three-week layoff between the second and third games due to the 9/11 disaster didn't help in a 38–7 home blowout loss to UCLA. After encouraging wins over Arizona and California, the Beavers lost a 16–13 overtime game at Southern Cal that one writer called "one of the most gut-wrenching losses in Oregon State history." OSU won the total offense battle 384–204 and held the Trojans to 33 yards rushing, but Ryan Cesca missed a pair of chip-shot field goals in the final six minutes of regulation.

The Beavers entered the Civil War 5-5 and with a bowl bid on the line. The Ducks, meanwhile, had bigger things cooking.

With Smith and Morris sharing ground duties and Harrington expertly guiding the offense, Oregon had navigated the schedule perfectly with only one hiccup, a 49–42 loss to Stanford in the seventh game in which two blocked punts, two interceptions and an onside kick spelled doom. The Ducks headed into the Civil War 9-1 and in line for the school's first BCS bowl game appearance.

The Beavers went into the Civil War confident of upsetting Oregon. "We feel we can win the game," Weathersby said. "We are a different team than we were earlier in the year. I think all the guys feel that way. [The Ducks] have a lot on the line. We were there last year. We don't want them to get what they want. The game means a lot to us because it would make us bowl-eligible. That's what we are shooting for."

The Ducks—especially Harrington—wanted revenge from the previous season. "Joey has had this one circled more than anyone," Peelle said.

Oregon had one more bit of incentive. Simonton needed 113 yards to become the first Pac-10 back with four 1,000-yard seasons. "We all said, 'It's not going to happen against us,'" Bauman says today. "He'd had a pretty good game against us the year before. The defense was really stoked. The hatred had been building for a few years. We were ready to rock-and-roll."

On a day when inclement doesn't begin to describe the weather conditions, Oregon prevailed 17–14 at Autzen Stadium to clinch the Pac-10 championship.

"It was a grind-it-out, ugly, cold, typical first-week-in-December game," Harrington remembers.

As Oregon had done in a losing effort the previous season, Oregon State dominated statistically, winning the battle in first downs (19–10) and total offense (359–209). Oregon didn't score from scrimmage until Morris—who gained 102 yards on 15 carries—got loose for a five-yard touchdown run in the fourth quarter.

The Ducks won by committing only one turnover (a Harrington fumble), by keeping Oregon State out of the end zone until late in the game and by making by far the biggest play of the game—a 70-yard punt return for a touchdown by Howry.

With winds gusting and rain pouring at times, no touchdowns were scored until the final period. Oregon State led 6–3 at the half on a pair of field goals by Kirk Yliniemi, who had begun his college career as a walk-on at Oregon.

It could have been worse. OSU's Barnett had an interception in his hands and a wide-open path to the end zone in the second quarter but dropped the ball. "I felt lucky, or happy, or relieved," said Bellotti of being down only 6–3 at the break.

The teams battled back and forth until Howry came up with one of the biggest plays in Civil War history on the first play of the fourth quarter.

A Los Angeles native, Howry had narrowed his college choices to Oregon State and Washington State before choosing Oregon. "It was really close with all three," Howry recalled. "Right before I was about to take my trips, Mike Riley left Oregon State for the San Diego Chargers, so I threw Oregon State out. The appealing part of the Cougars was they ran a similar offense to what we'd run at Los Alamitos High, with four wideouts. Mike Bellotti was the deal-maker for me. Being an ex–offensive coordinator, you could tell the attention to detail he always had and expected from everybody. He gave

me a sense of appreciation for what we were trying to do and how we did it. He made it a lot of fun to go out there every single Saturday for four years."

Howry was an outstanding receiver—he ranks third on the UO list in career receiving yardage (2,698) and fourth in receptions (173)—but maybe even better as a punt return specialist. He returned four touchdowns during his career, the biggest after Oregon State's Carl Tobey launched a line-drive punt into the wind straight at him on the Oregon 30-yard line.

"I remember how boring the game had been to that point," Howry recalled. "It was windy and rainy. We sat on the ball a lot, didn't throw it that often. I caught only two passes the whole day, in fact.

"We're down and it's into the fourth quarter. At some point in time in every close game, there is a point where somebody has to make a play to put your team in position to win. The previous punt [Tobey] kicked to me was similar—a line drive. I had a chance to make a pretty good return on that one, too, but got tackled. The next time, he kicked the ball right to me, an even worse punt. No hang time."

The only Oregon State player with a shot at Howry as he received the punt was Noah Happe, a sophomore defensive end who had released from inside on the punt.

"I remember that play vividly," Happe said. "Of all the plays in my career, I remember that one the most. The two gunners went straight for the returner but were held up by blockers. I had the same responsibility, though I was supposed to block first. Nobody came with a rush, so I released early. I didn't get touched running down the field. I was running straight at Howry. It was a decent return ball. [Tobey] had pretty good distance on the punt, but Howry had the ball for quite some time before the coverage arrived. I was the first one there."

"Once I got the punt," Howry said, "I looked up, and there was nobody within 10 to 15 yards. I had a blocker, Ty Tomlin, on the right. I'm thinking, 'I have room. If I go right now, [Happe] will try to cut me off.' I hesitated, Ty caught up to me and I broke to the side."

What happened next is what makes for great debate in Civil War lore. What isn't in dispute is that Tomlin took care of Happe. "It was a clip, big-time," Erickson would say afterward.

"I started to chop my feet and gear down," Happe said. "As Howry cut to his right, I cut to my left and got hit right in the back by a Duck. And suddenly, [Howry] had a clean shot right up the middle. The refs didn't call block in the back, but it was pretty apparent to most people who watched the game that it was a missed call.

"It was just one play in a lot of plays in a game but one of the more pivotal ones, unfortunately. If I hadn't gotten touched, I had 100 percent faith in my ability to make a tackle on him in the open field."

Howry, who has watched the game film many times, begs to differ. "The biggest frustration [for the Beavers] came because of how [Happe] fell," Howry said. "He flails to the outside when he is blocked. But look real close. Ty does a good job of getting his head across the front, makes a good block and pushes him out of the way."

After Happe was disposed of, "there was this huge crevice, and I just ran through it," Howry said. "When I broke through, I could hear the crowd, and I looked at the [Jumbotron] screen to make sure no one would catch me."

Howry returned the punt to the house untouched as the denizens of Autzen went crazy. Suddenly, Oregon led 10–6.

"In my history at Oregon, I'd had some big returns that got called back because of penalty," Howry said. "I could kind of sense there were no flags. I turned around to make sure. There was no flag. Yeah! It was still so early in the fourth quarter, there probably wasn't too much to get excited about, but I was pumped up. Oregon State was controlling the game, but we were all thinking just one big play could turn it around. I'm thinking, 'This could be the thing that puts us over the top.'"

Harrington remembers something else about the play. "I swear to you, at the moment the Oregon State defense divided, the rain just dumped," he said. "It was one of those surreal moments. As Keenan was sprinting down the field to put us ahead in the Civil War, the sky just opened up. The student section was going crazy, and you could feel something special was going to happen."

In the press box, Oregon radio analyst Mike Jorgensen remembers the scene, too. "It was like the wrath of God coming down on Autzen Stadium, right at that moment," he said.

There would be further drama. On the next possession, the Ducks put together a 12-play, 80-yard scoring drive that chewed up 7:45 of clock and began on a 28-yard pass from Harrington to Howry on third-and-10 from the UO 20. Morris's eight-yard run gave them a 17–6 advantage with 4:36 remaining. On a weather day like that, the lead seemed safe.

It wasn't. The Beavers marched 69 yards in 11 plays, Smith hitting Josh Hawkins for 24 yards and a touchdown. After a two-point conversion, the Ducks' lead was 17–14 with 2:13 left.

After a failed onside kick, Oregon needed one first down to wrap up the win. But OSU's Kyle Rosselle hit Harrington, whose fumble was recovered by Jake Cookus for a 23-yard loss at the Oregon 33 with 1:49 to play. Suddenly, the Beavers weren't far from field-goal range for Yliniemi, or worse from the Ducks' perspective.

"We're trying to kill the clock," Harrington said. "Coach Bellotti calls '24 load,' a strong-side run, reverse pivot and hand to the back. But he told me to just keep it. It was a really good call by coach. The back-side end is going to come crashing down. More often than not, it gives you a great opportunity to sneak around the edge, slide and get a first down. As I faked the handoff, [Rosselle] is sitting right there. He bats the ball out of my hands, and I fumble. It was one of those moments where my heart just sank. Not again."

Oregon's defense stiffened. On third-and-11 from the 34, Smith's sideline pass for James Newson, who had slipped and fallen, was intercepted by Rashad Bauman, who returned it 23 yards to the OSU 39. Game over.

"I had just dropped an interception the play before and was in a redemption mindset," Bauman said. "Newson lined up a little tight for the formation, so I thought 'out' route. As he started to run his route, I got a glance back at [Smith] and saw him sneak a look at Newson. They were going to him on an out. I sat on it, and as soon as he slipped, I undercut, picked it off and that was that."

"I'll be forever grateful to Rashad," Harrington says today. "He and I could not be more different people in every aspect of our life, but he is the kind of guy that you love to have in your corner. He was one of the most loyal, genuine, hardworking teammates you could ever ask for. He went out and made an interception on the sideline and became a legend in my book."

As they were walking off the field, Bauman remembers, Harrington beckoned a manager to get the game ball. He gave it to Bauman. In a way, it was a seminal moment in Oregon football history.

"He thanked me," Bauman said. "That's the kind of guy he is. That's the kind of team we had. We grew up together. That's what made our bond so close. No egos. We had a group that loved each other. That helped us pull out that game."

Harrington completed 11 of 22 passes for 104 yards. Smith had better numbers—20 of 36 for 252 yards. Harrington looks back and wonders if he pressed to bolster his chances for the Heisman Trophy.

"Nobody had made a statement for the Heisman yet," Harrington said. "That game presented another chance. I probably put too much pressure

on myself to go out and play a spectacular game—both to make up for the year before and to try to make a statement for the Heisman voters. I didn't play well. You can blame it on the weather, but Smith played pretty well that game. I don't know what it was with me and the Beavers, but I never played well against them."

Harrington—who had his own billboard in Times Square to promote his candidacy that fall—finished fourth in the Heisman balloting behind Nebraska's Eric Crouch, Florida's Rex Grossman and Miami's Ken Dorsey. Didn't matter a lick to his teammates, who had just watched Harrington in the 10th fourth-quarter comeback of his career and the fourth of his senior year.

"Joey is one of the best, if not the best, player ever at Oregon," Bellotti said afterward. "He's never worried about stats. The only stat that matters is winning."

"We loved having Joey at quarterback," Bauman says today. "We always had a chance to win. That year, he was the offensive leader; I was the defensive leader. That's pretty much how we ran it. Joey was so prepared for any situation. He was the ultimate quarterback. That was his profession. He started taking that on as a child, started prepping to be a stud.

"After we left Oregon, I once asked him who his favorite player was. I thought he'd say Joe Montana or Dan Marino or somebody. And he said Peyton Manning. Peyton Manning? He was still at Tennessee! But like Peyton, Joey was a student of the game. That's what he brought to the table."

Ken Simonton had a sub-par game—26 carries for 84 yards—and finished with 971 yards, failing to become the first player in Pac-10 history with four 1,000-yard seasons. He would finish his career with 5,044 rushing yards, which today stands third on the Pac-12 list behind Southern Cal's Charles White and Oregon's LaMichael James.

"I think I guaranteed he wouldn't get his 113 yards," Bauman said afterward. "It was all in fun. But we knew he wasn't going to get his 113. That's just the confidence we have in our defense. It's no disrespect to Ken Simonton. I'm just glad I didn't put my foot in my mouth. He didn't get his 113 and we got the victory."

Added safety Keith Lewis: "It feels good to know we ruined someone's history in the making."

Simonton was gracious in defeat. "We outplayed [the Ducks]. We just didn't put enough points on the board," he said. "But they are always one of the better teams because they never quit. They never are the best team

physically or athletically, ever. But you have to take your hat off to Coach Bellotti and his staff. They came out a little sluggish, were dropping some balls, but they won't quit, especially at home. That's the characteristic of great team leadership. If you have that, you're going to be competitive."

Bellotti said he was unconcerned about the Beavers' statistical advantage. "Everyone wants to talk about yards," he said. "I want to talk about the points given up, because that's what you lose with. Yards don't beat you; points beat you."

"We were loose this week—almost squirrelly," defensive coordinator Nick Aliotti said. "There was an air of confidence. The guys knew what was at stake, and they were enjoying the moment."

More than a decade later, Simonton said the loss still hurts. "It's tough to talk about even now," he said. "The Ducks stopped me short of 1,000, but that wasn't the big thing. We knew we could have—should have—won that game against a team that had played more consistently than we had that season. It came down to a few plays and Keenan Howry. It was one we let slip away. I never lost at Reser to the Ducks, but I never won at Autzen, either. It would have been nice to have that notch in your belt."

The Ducks, ranked second in the Associated Press poll, expected to play Miami in the Rose Bowl for the national championship that season. They were bypassed, however, because of a No. 5 ranking in the BCS standings. The nod went to Nebraska, which had been blown out by Colorado 62–36 in its regular-season finale. The bowl results made the decision look stupid: Oregon buried Colorado 38–16 in the Fiesta Bowl while Miami bombed the Cornhuskers—ranked No. 4 in the AP poll but No. 2 in the BCS standings—37–14 in the Rose Bowl.

THRILLER IN CORVALLIS, OVERTIME CLASSIC IN EUGENE

By 2006, the landscape had changed again at Oregon State.

Mike Bellotti was still running the show at Oregon, going through some ups and downs. The Ducks lost their last four games in 2002 to finish 7-6, went 8-5 in 2003, plunged to 5-6 in 2004 and rebounded with an outstanding 2005 season, going 10-2 including a 17–14 Holiday Bowl loss to Oklahoma.

Dennis Erickson had bolted Oregon State for the San Francisco 49ers after the 2002 campaign, hoping to take care of some unfinished business in the NFL. Mike Riley, after a season as assistant head coach with the New Orleans Saints, was all too happy to return to his old stomping grounds to succeed the man who had succeeded him.

The Beavers went 8-5 in 2003 and 7-5 in 2004 and then dipped to 5-6 in 2005.

A look at the four Civil Wars between 2002 and '05, all won on home turf:

2002—Oregon State 45, Oregon 24. It was the most points scored by the Beavers in the 109-year rivalry. Derek Anderson completed 21 of 370 passes for four touchdowns, James Newson snared 11 passes for 168 yards and a TD and sophomore tailback Steven Jackson motored 153 yards on 36 carries and caught a TD pass.

Oregon went without feature back Onterrio Smith, who was lost after knee surgery. Keenan Howry completed one of the most-storied careers in Civil War history, catching an 84-yard touchdown pass from Jason Fife and returning a punt 63 yards for a TD. Fife scored on an 11-yard run but

finished only 14 for 33 passing for 182 yards and was intercepted three times in the second half, twice by Mitch Meeuwsen. The Ducks had 11 penalties for 105 yards.

Oregon State, which finished 8-5, would get stomped 38–13 by Pittsburgh in the Insight Bowl. Oregon, which lost six of its last seven games after starting 6-0, suffered a 38–17 defeat to Wake Forest in the Seattle Bowl.

2003—Oregon 34, Oregon State 20. Oregon rushed for 218 yards against the Pac-10's top-rated defense, Terrence Whitehead leading the way with 77 yards on 24 carries. Kellen Clemens was only 11 of 26 passing for 125 yards, but three of the completions went for touchdowns, and he rushed for 64 yards and a score.

Oregon's defense, led by end Igor Olshansky, linebacker Kevin Mitchell and safety Keith Lewis, was the difference, holding Jackson to 66 yards and a TD on 18 carries. Anderson completed 21 of 45 passes for 271 yards and a TD but had two fourth-quarter interceptions and was sacked six times. The Beavers finished with 24 yards rushing.

2004—Oregon State 50, Oregon 21. Anderson, booed by home fans in October during a 49-7 loss to California, became one of six Pac-10 passers to throw for 10,000 career yards, completing 24 of 41 passes for 351 yards and four touchdowns. The senior quarterback also ran 12 times for 49 yards as Oregon State again posted its highest point total ever in the series. Mike Hass caught nine passes for 154 yards and two TDs, and Alexis Serna kicked five field goals as Oregon State dominated the total offense figures 455–235. Bill Swancutt had six tackles, three sacks, a forced fumble, an intercepted shovel pass and a 17-yard catch from Colt Charles on a fake field-goal play.

Whitehead rushed 18 times for 110 yards. Clemens completed only 13 of 29 passes for 126 yards, though for three touchdowns, was intercepted three times and was sacked six times for Oregon, which was denied a bowl bid for the first time since 1996. It was the last time the Ducks would not make a postseason appearance.

2005—Oregon 56, Oregon State 14. On a foggy day, the 10th-ranked Ducks gained revenge for the previous year by scoring their highest Civil War point total ever and the largest margin of victory in the series since 1987, even with Clemens on crutches after knee surgery. Dennis Dixon completed 12 of 17 passes for 204 yards and three touchdowns, and Whitehead carried 12 times for 81 yards as the Ducks outgained the Beavers 402 yards to 297. Freshman Jonathan Stewart took the second-half kickoff 97 yards for a TD.

Oregon State was also without its starting quarterback, Matt Moore, who injured a knee the week before against Stanford. Senior Ryan Gunderson,

making his first career start, was 22 for 43 passing for 175 yards and a TD but served up four interceptions. Aaron Gipson had two of them, including one he returned 60 yards for the first score 2:37 into the game.

"I remember how loud it was at Autzen that game," OSU guard Andy Levitre said. "The first touchdown Oregon scored, it was like my ears were ringing afterward. It sounded like a gunshot went off."

Hass caught 10 passes for 107 yards on his way to winning the Biletnikoff Award for the nation's outstanding receiver. Oregon State's Yvenson Bernard carried 33 times for 128 yards, but he paid for it.

"It was pretty much eight in the box the whole game," Bernard recalled. "It was so grueling. Oh my gosh, we were beaten. It was one of those games where you just wanted to get it over with. By halftime, we knew we weren't going to win that game."

OSU safety Sabby Piscitelli felt the same way. "The Ducks had the momentum from the first interception and never gave it back," he said. "I've never said this in my life, but I remember sitting on the sidelines actually trying to make the clock tick down faster. We weren't there mentally or physically. It was a crappy ending to a subpar year. I was excited when the game was over because I was looking forward to building for the next year."

As they entered the 2006 Civil War game in Corvallis, Oregon and Oregon State were on different paths.

Oregon had gotten out of the gates fast, winning its first four games and seven of its first nine. The Ducks, though, had been beaten badly by Southern Cal (35–10) and Arizona (37–10) and were considering a change at quarterback for the Oregon State game—Brady Leaf for Dennis Dixon.

Oregon State, meanwhile, had started slowly, as was becoming customary in the Riley era, losing two of its first five. The Beavers, behind senior quarterback Matt Moore and junior tailback Yvenson Bernard, then gathered steam with a run that would take them to victory in eight of their final nine contests.

Moore, a Valencia, California native who had transferred after starting his career at UCLA, had missed the 2005 Civil War game with a knee injury. "I was bummed I didn't get to play in that game," recalled Moore, who never played a game at Autzen but watched that one on crutches from the sidelines. "It was a great college football atmosphere. It's what you dream about as a kid. They're the Ducks, and you don't like them. I'm sure when they came into Corvallis they felt the same way about the Beavers."

After an inconsistent junior season—and enduring the wrath of disgruntled OSU followers at times—Moore had mastered Riley's offense and enjoyed a superlative senior campaign, going the final six games without an interception.

"Matt was fun," center Kyle Devan recalled. "He was a gunslinger. He grew so much from his junior to senior year, when he was one of the best quarterbacks in the conference."

"He was a great presence in the huddle," Bernard said. "With our offense, he made you feel like you could do anything. You can score if have 20 seconds and a long field to negotiate. It was so hard to see him get booed. The second half of the [2006] season, he absolutely destroyed it."

"Matt reminded me of Coach Riley," linebacker Joey LaRocque said. "He was never fazed by the things said about him. He put in the past a tough junior year, shined it and did the things he needed to do. It translated into an NFL career for him.

"Similar situation with Coach Riley. That first year I was there, we were coming off a tough season, lost a couple of games right off the bat and some of the fans had Riley's head on a stake. I remember vividly a guy carrying a 'Can Riley' poster. I almost went into the stands and pulled a Jermaine O'Neal on him. That's the kind of respect I have for Coach Riley. I don't allow people to talk poorly about him or coach [defensive coordinator Mark] Banker."

The 5-9, 205-pound Bernard had earned the respect of his teammates, too. "Ev ran with his heart and soul out there every game," said defensive end Slade Norris, who spent parts of five seasons on NFL rosters. "His body got so dang beat up because he gave everything. He carried our team."

"We came in as freshmen together," said Devan, who played five years in the NFL, making it to the 2009 Super Bowl with the Indianapolis Colts. "Since the day we got there, I knew he was going to be a great one. He was the hardest-running back I ever played with. He'd do anything to get a win. Every time he had the ball, I felt like we could break one."

"Everybody thought he was too small, too slow," Moore said. "He was the guy who showed everybody. Great attitude, showed up every day ready to work and he was tough as nails. The guy was injured all the time and played as much as he could. The thing I appreciated most was the way he pass-blocked. He wasn't afraid to stick his nose in there and get a block in pass protection."

"I'll take Ev over any back I've been with, even in the pros, and that counts Steven Jackson," said Roy Schuening, an offensive lineman who had

a four-year NFL career. "A great running back, a great person and he went to battle for you. He took care of his O-linemen. If there was somebody doing something cheap on us, Ev was the first guy to jump in and get after that guy. I got a couple of personal fouls defending Ev. That's just how it was. The guy was my brother. His vision was unreal. He saw stuff before it developed and had a knack for making tacklers miss. I thought he was good enough for the NFL."

Heading into the 2006 Civil War, Bernard felt momentum was on the Beavers' side. "I think we're going to win," he said. "We're sky-high right now. I don't think anybody can take us down."

Moore entered the game with a nation-leading streak of 122 passes without an interception. "I've been at Oregon State for two years, but I feel like I've been here my whole career," he said before the game. "I want to play with just as much emotion as the other guys. I know the Ducks and the Beavers are a pretty big thing in this state. You want to play it just like any other game, but it's Oregon State vs. Oregon, you know? It doesn't get any better than that."

Bellotti said the lopsided losses to USC and Arizona provided extra incentive for the Ducks. "Because of our last couple of games, it gives us an opportunity to reclaim some respect," he said.

A Reser Stadium record crowd of 44,015 watched Oregon State beat Oregon 30–28 on a 40-yard Alexis Serna field goal with 1:12 to play. It was the first Civil War game played on a Friday since 1927, moved up a day to maximize TV exposure on FSN.

The Beavers were looking for revenge after their 56–14 pounding at Autzen the previous year.

"The year before, we felt demoralized that they kicked the living crap out of us," said safety Sabby Piscitelli, who played six years in the NFL. "I hated that feeling. When that clock hit zero, work started toward the next Civil War.

"I went into the game with a lot of emotions. I wanted to prove a point. This one was the most physical Civil War I played in. I had a couple of big hits on Jonathan Stewart, and we were mouthing off at each other. As the leader of the defense, I wanted to make sure we came out firing. We needed to redeem ourselves, and we did."

"That was the first time I really felt an intense college atmosphere," said OSU defensive end Dorian Smith, a junior transfer that season who would go on to play four CFL seasons. "The others were just football games. I felt the meaning of why they call it the Civil War.

"Fans were screaming. The Ducks were talking a lot more than any other team. There was so much trash talk as they walked down the hill to get to that field. They were really high on themselves. They walked by where our D-line was doing individuals before the game, wearing their cool new white uniforms. They were talking bad stuff to us. I was the first one to say something back. I remember Coach Joe [Seumalo] reeled me in and said, 'Don't worry about that stuff. We'll take care of them on the field.'"

Crowd noise at both Reser Stadium and Autzen Stadium is deafening. It reaches a fevered pitch during Civil War games.

"I remember not being able to hear any audibles," said defensive end Victor Butler, now in his sixth NFL season. "It was the loudest I can remember at Reser, even more than when we beat USC—the loudest I've ever heard at any college stadium. The Superdome is pretty loud, but that day, it sounded like the 12th Man in Seattle.

"I played against teams from the SEC and Big Ten, but Oregon State fans are some of the most dedicated and loyal fans in college football. You can feel it as a player, and it makes you play better. My four years there, we never had a top-20 recruiting class. But we were able to get 10-win seasons and beat teams we shouldn't beat because we had a great coaching staff, we worked hard and the fans were fantastic."

Bellotti had chosen to give Brady Leaf his first career start at quarterback. "I felt we needed to make a change for a spark," the UO coach explained afterward. And the 6-5, 205-pound junior—younger brother of Ryan Leaf—had a good day, completing 25 of 42 passes for 274 yards and a touchdown. He also ran for a two-point conversion to give Oregon a 28–27 lead late in the game. But Leaf also threw a pass that Oregon State linebacker Derrick Doggett returned 34 yards for a second-quarter touchdown.

"He was throwing an out route to the slot receiver," Doggett recalled. "I read it, grabbed it and started running. I knew once I caught it I was going to score. The crowd was going crazy. It was a game-changer."

"That pick-six really hurt the team," Leaf said afterward. "The defense was doing a great job stopping them, and I gave up six points just like that."

This one was going down to the wire, though.

Stewart scored early in the third quarter on a 22-yard run to make it 20–14, but Bernard—operating on a gimpy ankle—answered with a six-yard TD run to make it 27–14 with 7:52 left in the third.

Oregon trailed 27–14 midway through the fourth quarter, but the Ducks mounted a pair of scoring drives, Stewart capping the first on a two-yard

run. OSU defensive tackle Ben Siegert blocked the PAT, though, his first big play of the day, keeping the score at 27–20.

Then Jordan Kent made the biggest play of his career, catching a 26-yard TD pass from Leaf with 3:07 remaining to get Oregon within 27–26.

Kent, son of then–Oregon basketball coach Ernie Kent, is the Ducks' greatest three-sport athlete in modern history. The 6-4, 210-pound Kent was a starter on the basketball team, but his best sport might have been track and field. During his time at Oregon, he ran the 100 in 10.41, the 200 in 20.56 and the 400 in 46.9 and was a four-time All-American on the 400 and 1,600 relay units. Kent, who didn't play football at Churchill High, played football only his final two seasons at Oregon.

"I realized my junior year I wasn't going to the NBA, and the Olympics were a long shot," Kent says now. "Football was something I'd always wanted to try. I knew it would be very difficult, but I was willing to put in the hard work. It was one of the best decisions I ever made."

Kent caught only three passes as a junior in 2005 as he acclimated himself to football but had thoroughly enjoyed the Ducks' Civil War rout. "The seniors wanted payback for missing out on a bowl game the previous season," he said. "That was the game we busted out the new uniforms with what I call the 'Atari' numbers. It was great to put a thumping on the Beavers."

Kent's best college game was his last regular-season contest in the 2006 Civil War. He caught four passes for 102 yards and the touchdown that could have been the game-winner. "In the third quarter, a lot of [Oregon State] fans were on me," Kent said. "I wanted to prove myself that season, not only to myself but to others who questioned my football ability. I wanted to show I belonged, that I wasn't playing on a favor from the coaches. I wanted to be a legitimate player."

After Kent scored, he posed in the end zone, drawing some more hoots and boos from the Beaver faithful. "I have the picture in my living room, the arm out and the ball in one hand," said Kent, 29, who spent three NFL seasons with Seattle and St. Louis and is now a broadcaster in Portland. "Oregon State stormed back, but it was easily my best football game, and I had it against a decent Oregon State secondary. It validated my decision."

When Brady Leaf walked into the end zone for the two-point conversion, Oregon had its first lead of the game at 28–27, with time waning.

"The defense came off the field, and I told myself, 'We aren't done,'" Sabby Piscitelli said. "I knew our offense was going to drive and score."

"We knew we had to score," Matt Moore said. "I went into the huddle and said, 'If we just execute and block, throw and catch—just the basics—we'll be all right.' It was sweet. There were wide eyes, and they were all kind of looking at me. That's what you want."

"It was one of those times when Matty Ice showed his leadership," OSU receiver Sammie Stroughter said. "He looked everybody in the eyes and said, 'Guys, this is what we practice for. When we were little kids, this is the moment we dreamed of.' Matt was nonchalant, smiling in the huddle. The first play, it was, 'Let's go.'"

"It was getting to 'Matt Time,' and Sammie was such an explosive player," Kyle Devan said. "He could break the top off any coverage. We knew if we gave Matt time to throw, we could make something happen."

"I remember thinking, 'We got this,'" Roy Schuening said. "I knew we had to get into field-goal range. Serna was pretty much automatic. I knew we'd move it down the field and take advantage of the situation. But we left a lot of time on the clock."

"Such a roller coaster of emotions down the stretch of that game," recalled Moore, now in his eighth NFL season. "I don't know if I was thinking this was going to be a how-you-are-going-to-be-remembered moment, but it kind of was. I'd learned a lot my junior year. I displayed a calm all year. I suppose in a crucial moment like that, it came out. It was like, 'Regardless of what happens, everything is going to be OK.' I tried not to get too high or too low. It was a pretty big situation."

It took only two plays for the Beavers to get into field-goal range. In driving rain, Moore hit Stroughter first for 16 yards and then again for 37 yards on a post pattern to the Oregon 27. After three carries gained five yards, Serna came onto the field, having already kicked field goals of 49 and 50 yards.

Serna was one of the great stories in college football. A 5-7, 160-pound native of Fontana, California, he walked on and won the kicking job as a redshirt freshman. In his first college game, he missed three extra points in a 22–21 overtime loss at third-ranked Louisiana State, costing Oregon State what would have been the greatest regular-season upset in school history. He won the job back and proved to be the best in school history on his way to winning the 2005 Lou Groza Award as the nation's top kicker as a sophomore. Serna never missed another extra point, making a Pac-10 record 144 straight.

As he walked onto the field for the most important field-goal attempt of his career, Serna felt confident despite the weather conditions. "I was just on that game," recalled Serna, who kicked for three years in the CFL. "It's hard

to kick from that distance in those conditions, but I knew Riley was setting up to kick the field goal. It was a boost of confidence to know he had the faith in me to make that kick. Everything was on the line for us.

"After we lined up, [the Ducks] called a timeout to ice me. I always liked it when opponents did that. When you first go out there, you have only a few seconds to kick the ball. You're nervous; you're rushed. When they called the timeout, it gave me an opportunity to calm down, get my mental game right. I remember standing there and feeling more relaxed. I was extremely confident that day. I remember looking up at my family in the stands, thinking, 'They don't know if I'm going to make this kick. They have to be freaking out.'"

Serna lined up the placement wrong. It was eight yards deep instead of seven. That made it more difficult for the snapper, Joel Cohen. "It should have been a 39-yard field goal, but being in the middle of the field, it's hard to tell where the hash marks were at," Serna said. "Joel's rotation was off, and Strow [holder Jon Strowbridge] didn't have time to spin the ball back. I kicked it with the laces facing up."

Serna's kick made it through, just a foot or two inside the left upright. It was 30–28 Oregon State with 1:12 to play.

"I try not to think about the conditions," Serna said afterward. "It was a sunny day to me in my mind."

The Ducks weren't done. Sophomore Jonathan Stewart had already had a big day, finishing with 17 carries for 94 yards and three touchdowns and also getting loose for a 68-yard kickoff return. He busted another one for 48 yards to the Oregon State 43-yard line with 57 seconds left.

Oregon moved to the Oregon State 27. Bellotti had lost confidence in Paul Martinez, who had missed two earlier field goal attempts and had an extra point blocked in the game. The UO coach went to sophomore Matt Evensen, who had made only one field goal all season, from 22 yards six weeks earlier against UCLA. Evensen's low kick was blocked by OSU defensive tackle Ben Siegert—his second blocked kick in the fourth quarter—on the game's final play.

"It felt like a good kick off my foot," Evensen said, "and then I heard that awful sound." It was Siegert's hand.

"That play is one we referenced over and over the next two years, reminding guys of what it takes to win a Civil War," said OSU guard Andy Levitre, a sophomore that season who is in his sixth season in the NFL. "Unless you're in a BCS bowl or a national championship game, it's a better feeling to win a Civil War than going to a bowl game."

Strouhter caught eight passes for 114 yards. Moore, who completed 16 of 22 passes for 255 yards and a touchdown and ran his no-interceptions streak to 144 passes, got carried off the field by celebrating Oregon State students.

"There was no stopping it," Moore recalled. "I was caught in the madness at Reser. After Siegert blocked the kick, I was standing next to Coach Riley. I hugged him and picked him up. I was going crazy. He smiled and said, 'OK, Matt, put me down.'

"The next thing I know, everybody was lifting me up and I got a ride off the field. That was the highlight of my football career. I'll remember it forever. I have an unbelievable picture of that in my house. It's a great reminder of the times in Corvallis, especially of that night."

Joey LaRocque, a junior linebacker who had transferred to Oregon State, loved the entire scene. "You play college football for times like that," said LaRocque, who played two NFL seasons. "You play your rival, it comes down to the wire, you win, everyone storms the field—it's a dream come true for a player."

After the game—the 10th straight time the home team had won in the series—Riley told reporters he ranked the win up there with the 44–41 double-overtime victory over Oregon in 1998. "There were so many big plays in that game, and a lot of changes in momentum," he said. "It kept everybody in suspense. Nobody knew until the blocked kick at the end how it was going to wind up. That's great for fans. It's hard on coaches."

Bellotti noted that the kicking game had "let us down" but emphasized he felt good about his players' effort. He went so far as to suggest it was a moral victory for the Ducks.

"I've never been more proud of a team in my life, victory or defeat," he said. "That's a difficult one to swallow, because we came back and gave ourselves a chance to win. It's hard when you give that kind of effort and look up at the scoreboard and not win. I think our kids won today. They showed what they can do, and I'm very proud of them."

Typical of the Ducks' desire was sophomore defensive lineman Cole Linehan, who had broken his foot against Arizona State on September 30. "I came back way too early, but you don't miss the Civil War," Linehan said. "I played probably 20 snaps, ended up breaking the foot and went back in for surgery."

Oregon State would go on to beat Missouri in a 39–38 thriller at the Sun Bowl to finish the season with eight wins in its last nine games. Oregon would lose 38–8 to Brigham Young at the Las Vegas Bowl to finish on a four-game skid.

Third place in the Pac-10 was on the line in the 2007 Civil War.

Oregon, with senior Dennis Dixon at the controls, got off to a great start that season. The Ducks, in fact, were one of the best teams in the country through nine games, going 8-1 and ascending to No. 2 in the BCS rankings.

Dixon, a Heisman Trophy candidate at that point, had hurt a knee in a 35–23 win over Arizona State but was cleared to play 12 days later at Arizona. His knee buckled early in the game, and he left as the Ducks went on to lose 34–24. Afterward, it was revealed that Dixon had torn the ACL in his left knee against Arizona State and aggravated it against the Wildcats.

"If Dennis didn't get hurt," Oregon D-lineman Cole Linehan said, "we'd have been in New Orleans, playing for the national championship."

Oregon State had gotten off to its typical slow start, losing three of the first five games. Then the Beavers got on a roll that would see them end the season winning seven of eight.

The Beavers were hoping to break through at Autzen to snap the 10-year string of the home team winning in the series. "I think we have a chance to break that home-field stranglehold, but it won't be easy," Roy Schuening said that week.

"A lot always rides on this game," Slade Norris offered. "You talk to the fans, this game is really for them. We don't hate the Ducks. We just love to beat them."

"The preparation leading up that week was tremendous," Victor Butler recalled. "We prepared like going to play the Super Bowl. Guys were dialed in. Guys were fierce. When we got to that game, we were so ready for what could happen, it was like playing Pop Warner."

Both teams went into the Civil War crippled by injuries. Oregon, which entered the game ranked 18th and as a one-point favorite, was without Dixon and his backup, Brady Leaf, who had two sprained ankles. The Ducks were also missing tailback Jeremiah Johnson, linebacker Spencer Paysinger and receiver Cameron Colvin to injuries. And junior tailback Jonathan Stewart would play with a bad case of turf toe.

"People are down," said Oregon's first-year offensive coordinator, Chip Kelly, the week prior to the game. "No one feels bad for you."

Oregon State had its own problems. Sammie Stroughter had suffered a kidney injury on a punt return against Arizona State and missed most of the season. Starting quarterback Sean Canfield was lost with a shoulder injury. And Yvenson Bernard had undergone arthroscopic knee surgery the previous week after getting hurt in a 52–17 win over Washington State.

"It wasn't like one team had more injuries than the other," Schuening said. "Both teams had star players down. It evened the playing field. There wasn't a big advantage. It was which team was going to out-physical the other one."

The Beavers had the advantage of a bye week prior to the Civil War. Oregon had lost 16–0 at UCLA.

"We've had a [bye] week to work on what they can do," Riley said before the game. The Ducks "have a good offensive line. They have one of the best running backs in the country [in Stewart]. They have gifted receivers. They have an outstanding defense. We can't be thinking they aren't going to be the same without Dixon."

Oregon State was going with sophomore quarterback Lyle Moevao, who was 2-0 as a starter. "He's not out there for his stats, he's not out there to score touchdowns," Kyle Devan said. "He's out there to win games."

The Beavers went into game day hoping Bernard, who had rushed for 1,037 yards and 12 touchdowns already that season, could play. He warmed up but could not go.

That meant senior backup Matt Sieverson would be called into duty.

After setting a state record with more than 2,700 yards rushing and 28 touchdowns as a senior at Bend High, Sieverson had come to Oregon State as a walk-on, with the promise of a scholarship after two years. He played special teams and as a reserve safety and receiver his first three seasons. Before the 2007 season, he was moved to tailback, where he shared backup duties with Clinton Polk behind Bernard.

Sieverson had seen spot duty through the season, gaining 68 yards on 16 carries with Bernard nursing an injury against Stanford and getting his first career start against Southern Cal, carrying 10 times for 33 yards. Coaches had alerted him before the Oregon game that he might be pressed into starting duty.

"I knew Ev was going to try to give it a go," Sieverson recalled. "The coaches told me he was going to do everything he could to get ready, but it was about 80 percent I'd be starting."

Sieverson wound up being one of the game's stars, carrying 27 times for 142 yards and a touchdown in Oregon State's 38–31 double-overtime victory before an Autzen Stadium record crowd of 59,050. The 6-2, 220-pound Sieverson scored on a 38-yard run on the second play of scrimmage, giving OSU a 7–0 lead 24 seconds into the game.

"Everybody [on the Oregon defense] followed James Rodgers on a fake around the end," Sieverson said. "The hole was five or six feet wide. I had

a lot better runs later in the game. It didn't take much ability to get it done on that play. I took the handoff, ran about as hard as I could and there was nobody there. It hit me about the 10-yard line I was going to score. I don't know if I've ever been that excited in my life."

"We called him the 'Great White Hope,'" Joey LaRocque said. "Matt came out of nowhere."

"I remember hearing about Matt breaking records in high school," said Bernard, who watched the game from the sidelines. "He was so quiet, so humble. When I was hurt, Sieverson out-practiced Clinton to get the starting nod.

"Matt just lit it up that day. That's how you finish your senior year, rushing for 100-some yards to help your team win at Autzen, the first time the road team won in the series in 14 years? It's crazy. It was really neat to see."

"Matt goes down as a Civil War legend," Kyle Devan said. "It's one of those plays ingrained in my head still today, one of the highlight plays of my college career. We ran a zone read on the weak side. He cut behind me and [guard] Jeremy Perry. We had good push on the D-line. I felt it was going to be tough getting those yards without Yvenson, but when Matt broke that one, I knew we had a chance."

"I always liked Matt," Schuening said. "He was a tough guy who ran hard. Not having Ev was disappointing, but when Matt broke that first one, that really changed things.

"We had a good O-line that year, with Devan, Perry, Adam Speer and Andy Levitre. We felt good about our ability to move bodies. Oregon had a pretty good D-line, but we felt like we had an advantage on them. Kyle and I were seniors. We vowed there was no way we were going out losing that game."

Without Dixon or Leaf, Oregon started third-string quarterback Cody Kempt, who sustained a concussion and departed early in the game. That left it up to fourth-stringer Justin Roper, a 6-6, 205-pound redshirt freshman. "The last man standing," Bellotti would say later.

Roper, who finished the game 13 for 25 passing for 144 yards and two touchdowns, connected with freshman Jeff Maehl for 31 yards and a score to tie the game at 7–7 with 4:02 left in the first quarter.

Oregon State regained the lead at 14–7 on Polk's one-yard TD run with 50 seconds to go in the quarter, and then Derrick Doggett went to the house with a 28-yard interception return—his second pick-six in two Civil Wars—to make it 21–7 early in the second period.

"The ball was tipped, and I caught it and was running down the sideline," said Doggett, a receiver and running back in high school. "I liked having the

ball in my hands, but I didn't want to get hit hard, so I tried to run away from [tacklers]. I got to the five-yard line with a whole bunch of Ducks running toward me. I'm thinking, 'Am I going to go out of bounds?' Then I thought, 'No, I have to score.' I went head-first into a couple of them, and with Alan Darlin pushing from behind, I got into the end zone."

The Beavers thought they tacked on more later in the period when tight end John Reese made an apparent touchdown catch in the end zone, but officials ruled it a dropped pass. Oregon responded with a pair of touchdowns, Roper first hitting Garren Strong for a three-yard TD. After Jairus Byrd's 33-yard return of a fumble recovery, it was 21–21 at intermission.

Roper ran seven yards on a bootleg for a touchdown to give Oregon its first lead at 28–21 midway through the third quarter. Moevao capped an eight-play, 71-yard drive with a one-yard sneak to even the score at 28–28 with 14:43 left. That set up one of the wildest finishes in Civil War history.

After a series of punts in the fourth quarter, Oregon drove for a potential game-winning field goal, moving to the Oregon State 36. Bellotti called upon Matt Evensen, the same kicker who had the potential game-winner blocked in the previous year's Civil War. Evensen's attempt was wide right, but Oregon State's Gerard Lawson was penalized for what an official described as "jumping and landing on an opponent" in an attempt to block the kick.

That advanced the ball to the OSU 21-yard line with 26 seconds to go. Bellotti, out of timeouts, chose to run one more play to position the ball in the middle of the field for a game-winning field goal. Roper lost three yards on the play. With the clock ticking down, Roper hurried into position to take a snap, intending to spike the ball to stop the clock. But a miscommunication on the Oregon sideline had sent the field-goal unit out. Roper, looking for center Max Unger, noticed that snapper Eric Steimer was in the game.

"I was about to take the snap from Eric and said, 'This isn't right—where's Max?'" Roper said.

Evensen tapped Roper on the shoulder and said, "Field goal."

With the clock ticking toward zero, Roper took the snap, and Evensen hurriedly got off the 41-yard field goal attempt, but it missed badly. And it was on to overtime.

After the game, Bellotti took responsibility for the mishap, but offensive line coach Steve Greatwood points the finger at himself. "I take responsibility for screwing that up," Greatwood says today. "I had taken my headsets off briefly to talk to a player and caught Mike saying something about field goal,

and I yelled for the field-goal team to take the field. Mike evidently had said we weren't [going for a field goal]. I missed it. The kick was hurried…It was a complete disaster. That has lingered with me throughout my career and will to the grave. That one hurts the most of all the Civil War losses."

Oregon got the ball in the first overtime, and Evensen converted a 25-yard field goal to give the Ducks a 31–28 lead. The Beavers managed only one yard on three plays, but Alexis Serna connected on a clutch 41-yard field goal to tie it at 31–31 and force a second overtime. The normally reliable Serna had already missed field-goal attempts of 33, 50 and 35 yards—the last one blocked.

Serna had been pressed into double duty when the team's punter, Kyle Loomis, quit the squad the day before training camp started. Serna, one of the nation's top kickers, was also one of the nation's worst punters that season but took one for the team since there was nobody else to handle the chores.

Swirling winds that day made it an adventure for both punters and kickers. "In warm-ups, the ball was flying every which way," Serna said. "The wind would switch directions, and I never got the hang of it.

"But when it got to the kick in overtime, I wasn't that nervous for some reason. You have the butterflies, but you get used to that nervousness. You use adrenaline to make the kick. I never thought about anything negative. I was visualizing the points on the board. I got this surge of relief and excitement when I saw it going through. That was probably the biggest kick in my career."

Oregon State got the ball first in the second extra session. The Beavers went right to the fly sweep play that had been so effective with true freshman James Rodgers all season. The 5-7, 185-pound wideout from Richmond, Texas, had been outstanding as a receiver, ball carrier and special-teams stalwart.

"James was a puny little freshman," Kyle Devan recalled. "He was always trying to run the fastest 40s in practice. You thought he might get tired and wear out, but he was in great shape. I didn't think he was big enough. I'd never seen a guy so small be any good. Yvenson was even bigger than him.

"Then he starts doing things, and Coach Riley and Danny [Langsdorf] began trying to get the ball in his hands. That's when the fly sweep was born. When we called the play [in the second overtime], I knew something was going to happen. It wasn't something we'd used for that long, so [opponents] weren't defending it as well."

When the fly sweep was called on first-and-10 from the 25-yard line, "I was thinking, 'OK,'" Rodgers said. "We'd been getting 10, 12 yards a pop with the play during the game. I was nervous. I didn't know if we could score, but it was like, maybe, if everything worked right.

"Then it just kind of unfolded. There was great blocking, and I turned the corner and saw a few of the Oregon guys getting tangled up, and it was off to the races. I just ran the ball into the end zone. It was a great moment—individually, the greatest moment of my career."

"As soon as he turned that corner, nobody was going to catch James," Slade Norris said. "It had been that way all year long. It was like the Ken Simonton play that beat the Ducks in overtime in 1998—it's eerie the similarity."

"Every time I think of that game, I think of James making it around his edge, using his speed and jumping over the corner pylon for that touchdown," Andy Levitre said. "One of the best memories I have of college football."

Alexis Serna ran onto the field for the conversion kick with a smile on his face. "It was amazing to see James come around that corner and score," Serna said. "Nobody on our team worked harder. During training camp, a lot of guys would be napping during the break. He was constantly studying his playbook. It was always fun with James. He thought he was taller than me—still thinks he is. We used to measure back to back. Guys would say, 'Alexis is just a little bit taller than you.' We're 5-6½, the both of us."

The Ducks got the ball with a chance to tie and force a third overtime, but they had to score a touchdown. They moved nine yards in three plays. It was fourth-and-one at the OSU 16. The ball was likely going to Jonathan Stewart, who was to enjoy another monster day against the Beavers with 39 carries for 163 yards.

"Stewart was just a man," OSU linebacker Alan Darlin said. "He carried the load for the Ducks that day. He was a well-rounded back, big, strong, fast, elusive. It speaks to his toughness, playing with the foot injury he had. I remember him cringing on the bottom of those piles sometimes, if we could get him down. We all got in the huddle, and I said, 'All right, guys. This is it. Make one play and we got this win.'"

OSU defensive end Dorian Smith had sprained a knee a month earlier against USC, and it was his first game back. "We're driving on the bus to Eugene, and our trainer, Barney Graff, is telling me a story about a player who 10 years earlier had a knee problem and they'd forgotten his brace," Smith said. "We're laughing about it, and about that time, I realized I'd left my brace in my locker in Corvallis. I called the other trainers. Nobody was

still there. So right before the game, Barney made a knee brace for me. It worked fine."

On the third-down play, Smith had missed a sack opportunity, but Derrick Doggett knocked down the pass. On fourth down, "I'm going, 'Please God, let me make up for it,'" Smith said. "We were 'surfing,' where the tackle goes along the line of scrimmage to take away the cutback lane. Jonathan cut back, and I saw the O-lineman go. I tried my best to make sure [Stewart] didn't gain an inch."

Stewart didn't gain an inch. Game over.

"Best feeling ever," Smith recalled. "My last Pac-12 game. What a feeling, to beat [the Ducks] in their house and to see their fans go so quiet."

"Greatest feeling I've ever had in sports, other than the AFC championship win with the Colts," Devan said. "We all ran over and celebrated with our fans in the southwest section of the end zone. There aren't many words to describe that victory other than sheer joy."

"It was like we'd won a national championship," OSU receiver Shane Morales recalled. "We ran to where our fans were. Ryan Gunderson was trying to climb over the edge to get into the stands, and a security guard yanked him down."

"To be able to go out that way and say I was 3-1 against the Ducks, I can't tell you what that means to me," Roy Schuening said. "I would love to have been 4-0, but 3-1 isn't bad. It's something I hold onto to this day and am not afraid to bring up to any Duck fans I run across."

Bellotti expressed pride in his troops afterward. "There were very few people in the world who believed they could win this game," he said, "but they believed they could. And they almost made it happen. Our kids did a tremendous job, and they deserved to win today…To me, this isn't about the loss of Dixon. This is about the loss, prior to Dixon, of Johnson, Paysinger and Colvin. That put us on the razor's edge. There was no depth."

There was a portent to the future when Oregon freshman Jeff Maehl caught his first-quarter touchdown pass. He had four catches for 86 yards that day, including one over the middle in which he was nearly cut in half by OSU safety Al Afalava.

"To this day, I'm amazed I hung onto the ball and didn't have to get carted off the field," Maehl said. "It was a vicious hit."

"He got right back up and pointed for a first down, even though he probably didn't know where he was at," OSU's James Dockery said.

Maehl caught the flavor of the rivalry that day. He would catch three touchdown passes in his four Civil War games—and he would never lose

another one. "It was an awesome game, going back and forth," Maehl said. "And it left a little chip on our shoulder for the years to come. We didn't lose too many games at Autzen."

Junior running back Jeremiah Johnson, who watched the game from the sidelines on crutches after knee surgery, felt terrible. "I thought, 'I let my guys down by not being out there,'" Johnson recalled. "I almost went into depression. I remember thinking, 'We can't lose to these guys again under any circumstances.'"

NO ROSES FOR BEAVERS,
BUT FOR DUCKS

There was a new sheriff in town. Chip Kelly was still a deputy in 2008, Mike Bellotti's final season as Oregon's head coach. But the offensive coordinator out of New Hampshire in the FCS ranks was already making his presence felt with a spread offense that was beginning to take the nation by storm.

Kelly had come on in 2007 as Mike Bellotti's O-coordinator and right-hand man with a trend-setting no-huddle offense that showed immediate results. In his first season, Oregon led the Pac-10 in scoring (38.1 points per game) and total offense (467.5 yards per game), setting school records in both categories, with mobile quarterback Dennis Dixon earning the conference's Offensive Player of the Year award.

By this time, Phil Knight was all in with financial support of his alma mater. The Nike co-founder and chairman had run track for Bill Bowerman in the late 1950s. He had Duck green and yellow running through his blood from childhood. His father, William, had gone to Oregon.

"He took me to my first football game, Oregon vs. Washington, when I was seven or eight," Phil Knight said. "I asked, 'Dad, which is the good team?' He set me straight. When I got into track in high school, Bowerman was the guy. It was pretty automatic I was going to Oregon."

Knight attended all the Civil War football games while in school. He worked summers part time in the *Oregonian* sports department and was a stringer during the 1957 game, won by the Beavers 10–7 at Corvallis.

"I drove down from Portland with a photographer," Knight recalled. "I was on the sidelines for the game. He'd take pictures and I'd make notes on

each of them. It was a wet day, and my notes were so soggy, I don't think he could read a single one of them.

"That was one of the great games in the rivalry. Oregon was driving at the end of the game and had the ball, fourth-and-goal at the two-yard line. Jim Shanley got the ball but carried it in his right arm when it should have been in his left. The ball got knocked out of his hand at the goal line, and Oregon State recovered the fumble. I thought he made it, and then he fumbled. Oops."

Knight flew down to Pasadena with some fraternity brothers for the 1958 Rose Bowl—Oregon vs. Ohio State, a game won by the Buckeyes 10–7. "My first trip to California," he said. "The only other state I had been to was Washington. On the night before the game, we went to a party. Ohio State's kicker [Don Sutherin] was there. He was having a beer. He said, 'I snuck out after curfew.' I told him, 'I hope you get caught.' In the third quarter of the game the next day, [Jack Morris] missed a field goal. Five minutes later, [Sutherin] comes in and kicks the game-winning field goal."

By then, Knight was into the Civil War rivalry. "Sure, I hated [the Beavers], totally," he said. "It was compounded my first time wearing the Oregon uniform, during a cross-country meet at Linn–Benton Park in the fall my freshman year. School hadn't even started. It was a five-way meet hosted by Oregon State. I'm sitting in the locker room, all excited to have an Oregon jersey on. There were seven runners—Bill Dellinger, Jim Bailey and five freshmen—and I'm the last guy.

"Bowerman comes in, looking very serious. He says—and this is almost the voice of God, mind you—'I want you freshmen to understand one thing. There is something very different about competing against Oregon State.' That stuck with me a long way."

After graduation, Knight plunged into his business career and was not much more than a casual fan of Oregon football. "I never had season tickets until sometimes in the '90s," he said. "I'd go to games a lot and paid attention to it, but I did a lot of traveling in those years."

The Civil War was always important to Knight. During the Dee Andros era in the late 1960s and early '70s, "I have memories of a lot of pain," Knight said. "Oregon State won eight straight, and a lot of them were really close. They were all painful. Especially in 1967, when we were ahead in the fourth quarter and the Beavers had a drive to win it with Steve Preece at quarterback."

In 1991, Knight bought a suite at Autzen Stadium. When the Ducks reached the 1995 Rose Bowl, "that was a really cool experience," he said. "I thought, 'Gosh, I hope we can come back again in my lifetime.'"

The next year, Oregon lost 38–6 to Colorado in the Cotton Bowl. "We got our ass kicked, but had another good year," he said. "The next day, I was sitting down to an adult beverage with Mike Bellotti and [offensive coordinator] Al Borges and asked, 'What would it take to get to the next level?' Mike said, 'Well, if we had an indoor facility that we could use to practice in the fall, we could raise ourselves considerably.' I said, 'I might be able to do that.' And that was the start of it."

Knight provided the bulk of the $14.6 million necessary to build the Moshofsky Sports Center, which opened in 1998 as the first indoor practice and training facility in the Pac-10. Today, Phil and wife Penny have contributed more than $230 million to Oregon to help fund the Matthew Knight basketball arena, baseball's PK Park, expansion of Autzen Stadium, renovation of Hayward Field and creation of the Oregon Athletics Legacy Fund.

The Knights also paid an additional $68 million for expansion of the Casanova Center, which was completed during the summer of 2013. The six-floor, 130,000-square-foot Cas Center is the Ducks' football operations base, with three outdoor synthetic turf practice fields, coaching offices and players' locker room, a full-service dining facility, video theaters, a players' lounge and underground parking, among other amenities.

The Knights have contributed to other entities at Phil's alma mater, including the William Knight Building for the school of law, endowed chairs and professorships and renovation of the Jaqua Law Library.

Asked how much his contributions have helped Oregon athletics, Knight said, "They've definitely helped. [The Ducks] have had some success. A lot of people have contributed to that, from Mike Bellotti to Pat Kilkenny. I've been a help."

Ironically, Penny Knight attended Oregon State for a year before finishing at Portland State. "She likes Oregon State," Phil said. "Truth of the matter is, I like Oregon State except for one game a year."

When baseball coach Pat Casey was being courted by Notre Dame after Oregon State won the second of back-to-back national championships in 2007, the Knights contributed money to help keep Casey at OSU. "Pat Casey is an institution the whole state should be proud of," Knight explained. "I would have hated to lose him."

Knight said he takes pride that the Rose Bowl was on the line during Civil War contests of 2008 and '09. "We have two of the best programs on the West Coast," he said. "That's a great thing for our state."

Knight has changed his feelings about the Civil War, though. "In the old days, it was the biggest game every year," he said. "I don't see it quite the same way now. With the advent of the information age and national

television and the way college football is now, you have rivalries with such schools as USC and Washington. It's no longer for the right to live in the state as it was during the Dee Andros era. I think it's still our biggest regular-season game, but Chip Kelly saw it an entirely different way."

Entering the 2008 season, Oregon's offense was loaded with talent, beginning with quarterback Jeremiah Masoli, a transfer from City College of San Francisco; tailbacks Jeremiah Johnson and LeGarrette Blount; receivers Terence Scott, Jaison Williams and Jeff Maehl; and tight end Ed Dickson. Johnson and Blount would both rush for more than 1,000 yards and the shifty Masoli another 718 that season.

Nick Aliotti's defense was loaded with future NFL players such as linemen Nick Reed, Will Tukuafu and Simi Toeaina; linebackers Spencer Paysinger, Casey Matthews and Patrick Chung; and backs Walter Thurmond, T.J. Ward and Jairus Byrd.

Two opponents—Southern Cal and California—slowed down Oregon's offense enough to post victories, and a third, Boise State, beat the Ducks in a 37–32 shootout at Autzen Stadium. The 19th-ranked Ducks entered the Civil War 8-3 and a four-point underdog to the 17th-ranked Beavers.

Oregon State was stocked with talent, too, including a pocket-sized addition to the offense, freshman tailback Jacquizz Rodgers. Rodgers, younger brother of sophomore receiver/special teams standout James Rodgers, burst onto the scene as the Pac-10's Freshman of the Year. There was plenty of talent around the Rodgers brothers on the offensive side, including quarterbacks Sean Canfield and Lyle Moevao and receivers Sammie Stroughter and Shane Morales.

OSU's defense was one of the best in the nation, led by ends Victor Butler and Slade Norris, tackle Stephen Paea, linebacker Keaton Kristick and backs Keenan Lewis, Brandon Hughes and Al Afalava. All of those defenders would move on to the NFL.

The Beavers lost three of their first five games and then rolled through six straight Pac-10 opponents to go into the Civil War game needing to beat the Ducks to secure the school's first Rose Bowl berth since 1965. Problem was, Jacquizz Rodgers hurt a shoulder in the previous game and was out of the Oregon game. Older brother James was to suffer a broken clavicle in the second half against the Ducks.

Oregon was looking to win its first game at Reser Stadium since 1996 and to avenge its 38–31 double-overtime loss at Autzen Stadium in 2007. And, of course, there was the opportunity to spoil a Rose Bowl party at Reser.

In the most explosive offensive show in the Civil War's 120-year history, Oregon cranked it up and never let off the gas pedal in a 65–38 rout before a Reser Stadium record crowd of 46,319. The Ducks rolled up a school-record 694 yards total offense, including a remarkable 452 yards in the first half—252 of them on the ground.

"Our offense could not be stopped," said Bellotti after the final regular-season game of his 14-year career as Oregon's head coach. "That was probably the most satisfying win of my career, and certainly the most satisfying Civil War."

"Terribly disappointing," was Riley's reaction in defeat. "We've had a good run for a long time, but tonight our bubble burst."

The Ducks had the advantage of a bye week to prepare for the game, "but if we'd had one week, it would have been the same outcome," said defensive tackle Cole Linehan, a senior from Banks High. "I talked to the defense before the game and the night before about what an important game it is for guys from Oregon, what it means to us.

"I got a chance to let those guys know how I felt about it, let them understand what it means growing up in Oregon and how significant that game is for both teams. People in our state take this game pretty seriously. If you get a chance to play in it, that makes it that much more special."

Offense was not the problem for the Beavers, who amassed 25 first downs, 374 yards passing and 463 yards total offense. Moevao tied a school record with five touchdown passes. Normally, 38 points is enough to win. Not even close in this one. It was the most points ever scored against an Oregon State team.

The big play was Oregon's calling card. The Ducks had eight plays from scrimmage of 35 yards or more, including runs of 83 and 79 yards by Jeremiah Johnson, who torched the OSU defense for 203 yards in the first half alone. That doesn't include interception returns of 40 and 70 yards for touchdowns.

"They made a lot of huge plays," Riley noted. "That was the biggest factor in the game."

The Beavers hurt their cause by coming away with only three points in two early trips inside the Oregon red zone, settling for a 24-yard Justin Kahut field goal. He missed a 21-yard attempt.

Johnson had been unable to play due to a knee injury in the 2007 loss to Oregon State at Autzen. The 5-10, 200-pound senior from Los Angeles wanted his final regular-season game to be special. "I remember that game

like yesterday," recalled Johnson, who finished with a Civil War–record 219 yards rushing. "On the drive to Corvallis, I wasn't talking to anyone. I had one thing on my mind—beating the Beavers. We had to get them. At our meeting the night before, I spoke to the group. I said, 'I was hurt last year. I'm going to go out there tomorrow and destroy. We have to kill them. Not just win the game but do it in high fashion.'

"When we went out for warm-ups that night, all of our guys were so tuned in, so focused. We wanted to not only beat those guys but to ruin everything they built that season. A lot of people weren't talking about the Oregon Ducks that year. It was, 'All they can get is the Holiday Bowl.' I told my guys, 'We're not going to the Rose Bowl, but we can crush some dreams here. [The Beavers] had a couple of lucky wins, they beat USC, but we can crush everything they're made of right now.' I looked in LeGarrette Blount's eyes. He was ready. I looked in all five of my linemen's eyes, and it was like, 'We don't want to let J.J. Down.'"

Oregon led 37–10 in the second quarter. The Beavers battled back to within 37–24, 44–31 and 51–38, but each time the Ducks answered with a touchdown.

"Our players just made plays," said Chip Kelly after his final regular-season game as Oregon's offensive coordinator. "It wasn't a scheme deal. It wasn't like we exposed anything. It had nothing to do with coaching. Our players made plays. That's what it came down to."

The Ducks rushed 51 times for 385 yards on their way to setting the UO single-season record of 3,334 yards. Masoli completed 11 of 17 for 274 yards and three scores. Oregon State had four turnovers, Oregon none.

"It was like a perfect storm," UO offensive line coach Steve Greatwood said. "We caught 'em at just the right time. It wasn't like we just lined up and dominated. We made some plays and were very opportunistic at times."

Oregon had five touchdown plays of at least 40 yards. Masoli hit Scott for a 76-yard TD pass. Three other Oregon receivers had a reception of at least 35 yards. Masoli ran for another 53 yards. Blount had a 46-yard run in his total of 112 yards. On one play, freshman quarterback Darron Thomas lined up at receiver, took a handoff and passed to Maehl for 35 yards.

Oregon's defense did enough damage to help the Ducks win handily as OSU managed only 89 yards rushing. The Ducks sacked Moevao five times, three by Reed, who set a school career record with 29½.

With Oregon ahead 10–7 late in the first quarter, Johnson had gotten loose for an electrifying 79-yard run on a stretch play to the Oregon State nine-yard line. On the next play, Blount scored to make it 17–7.

"It was an '18 stitch' call to the right," Johnson recalled. "I can either take it down the middle, off tackle or around the side. The guys were blocking their butts off. I cut right off a block by Jaison Williams and took off.

"After 30 yards, I was so tired, and I looked over to the right and saw Coach [Gary] Campbell running with me. That gave me more inspiration. I turned it on and got it to another level. I got knocked out of bounds and was pushed into one of the guys in our band. The momentum of that run sucked every ounce of 'rah rah' cheering out of Reser Stadium. I just knew that run would have their coaches yelling and having players second-guessing their assignments."

The Ducks led 24–10 late in the first half when they put together 17 points in a span of 90 seconds. Morgan Flint's 25-yard field goal started it. After an OSU punt, with Oregon facing third-and-19 on its 17-yard line, Johnson broke a run 83 yards for a touchdown.

"That was the most amazing play of the game," Bellotti recalled. "We were just trying to run the clock out before halftime. Jeremiah gets outside and starts to tiptoe down the sidelines. He breaks some tackles, and somebody punches the ball out of his hands. It comes loose for a second, he reins it in, they try to trip him, he finishes the play. It was indicative of the luck we had and the way our players were so determined to finish plays."

"Before the play, we called a timeout, and Coach Bellotti brought us over to the sidelines," Johnson remembered. "He told me, 'Just stay in bounds, let the clock run and we'll punt, so we can go to halftime with a nice little lead.'

"The Oregon State safety had rotated down to the middle. That was the only player who was unblocked. We were going right there. Jeremiah [Masoli] gave me a look before the handoff. It was wide open for me. I got the ball, and all I saw was the two safeties in front of me. I got rid of the first safety, and I'm trying to make the sideline, thinking, 'I can make something happen.' I cut inside, and one of their guys knocked the ball out. It was floating in front of me. I got it back and stiff-armed [a tackler] and put on two yards of straight power steps to get an inch in front of him. Then I was in the clear and dove and put that ball in the end zone.

"When I got up, I was so exhausted. Once I got the touchdown signal, I was elated. All the guys were trying to jump on me. You score like that on your home field, everybody goes crazy. You score at the rival school, everybody's sitting down. Their fans had to be thinking, 'What's next?' It was a killer."

The real killer came when Thurmond jumped in front of a pass intended for Morales and returned it 40 yards for a touchdown to push Oregon's lead to 37–10 with 43 seconds left before halftime. Oregon State came back on an 11-yard TD strike from Moevao to Morales, but the Ducks went into intermission with a comfortable 37–17 advantage.

Every time Oregon State rallied, Oregon had an answer. With the Ducks up 44–31 and facing third-and-six from their own 24 early in the fourth quarter, Scott won a jump ball with defender Tim Clark and went 76 yards for Oregon's longest touchdown pass of the season. Paysinger put an exclamation point on a banner Duck day with a 70-yard pick-six for the final score with 2:49 remaining.

"I feel bad for [the Beavers], because they're a good team," Aliotti told the media afterward. "They're well-coached. They were on the threshold of doing something real special, and that's got to be very tough. I know how it is to be on the other end of the thing. As happy as I am for us, I feel bad for them. That was a great win for us, a great team win for the University of Oregon."

"We knew what was on the line," OSU safety Greg Laybourn said. "To come so close to a goal like that and then play the way we did is disappointing. We didn't tackle the way we need to, and we didn't play the way we needed to. We couldn't contain Masoli the way we wanted to. He can make things happen in space, and he keeps the defense on its toes.

"We knew they get people in space and make you miss. We knew that was going to be the key, not giving them extra yards after the catch or after the first guy hits [the ball carrier]. We didn't execute. They really have a lot of athletes. I give credit to them; they played well. The running backs ran hard and the receivers made all the plays that came their way."

"We wanted this championship real bad," Slade Norris said. "I feel awful we couldn't bring that in for the fans. We knew Oregon was a good team, so it can't be disbelief. We knew we had to play a great game. We just didn't play the game we wanted to play. We gave up some big plays, but they also made those plays. That offense is hard [to defend]. They have so many options, and they can do so many things."

"We weren't trying to knock anybody out of the Rose Bowl, but there's no way in hell we were going to come up here and try to give it to somebody," Oregon center Max Unger said. "It's a hell of a win. It's a tough place to play, one of the hardest to play in the Pac-10. I didn't hear the snap count pretty much the whole game, so we had to work around that, which was fun. It was loud. It was real loud. This is the best win I've ever felt in my life. It doesn't get any better than that."

"They thought they had our number," Dickson said. "We wanted to come up here and prove we could beat them in their house."

Knocking the Beavers out of the Rose Bowl, said Paysinger, "was a little cherry on the top of the icing."

"That's what rivalry games are all about," Toeaina said. "Taking away everything they had for the whole season…It gives you a good feeling."

Many of Oregon State's fans held roses with which to litter the field after a Rose Bowl–clinching Civil War victory. It was not to be.

Oregon State's Rose Bowl chances now hinged on an UCLA upset of Southern Cal the following Saturday. "I'm not going to lose any sleep over that one," Riley said. The Trojans beat the Bruins 28–7 to earn the Rose Bowl nod.

Five years later, the Ducks look back on the 2008 Civil War game with fond memories, the Beavers with disdain.

"Our kids were relaxed," Oregon defensive coordinator Don Pellum said. "Coach Bellotti did a great job getting them ready for that game, keeping everyone's heads level. As we drove into Corvallis, the fans held roses. They were busting them out. Once we got going, the kids just played. Oregon State's defense is always good, but our offense figured out something."

"That was a pretty good day for us, man," said Maehl, now in his fourth year in an NFL uniform. "Especially coming off the year before, losing in Eugene, we wanted to go up there and make a statement. To put it all together and take that Rose Bowl from them made it that much sweeter."

"That might have been my favorite college game," said Unger, in his sixth NFL season. "Rolling into Corvallis, it was a crazy scene, with all the Beaver fans carrying roses. After the game, the bus ride home was fun. The Beaver fans were not happy at all."

"Playing the spoiler for Oregon State was one of my fondest football memories," said Dickson, in his fifth NFL season. "All I heard for a week was 'the Beavs.' We didn't want it to happen. We hung 65 points on them in their house. We wanted to rub it in. We had extra motivation.

"There was always something about that game. It didn't matter what the records were. There was extra intensity in practice the whole week. That's how serious the rivalry was. You got to get a little hate in your blood for that game. We had a little more hate in our blood that week. I remember walking off the field, seeing all those roses on the ground."

"The Beaver fans were so revved up for that game," Linehan said. "To beat them like we did was the highlight of my career. Except for us going

to the Rose Bowl, you can't get any better. That week, we were surrounded by Beaver fans everywhere we went. It was surreal seeing all those roses that went for naught. The fans, they thought they were going to the Rose Bowl. It's so much fun to go into a hostile environment like that—the Beaver fans were giving it to us, they were so passionate about it."

"That was my favorite moment playing for the Ducks," Reed said. "Hell yes, it was a great motivator, to knock them out. Afterward, they have a funny little visitors' locker room in the basketball arena. I remember looking around at all the seniors as we were singing our fight song…You have moments in your life that stand out. That's one of them for me."

On a night full of Duck heroes, Johnson was the biggest. "As we left the stadium, we had Beaver fans yelling, 'You still suck,'" Johnson said. "I'm thinking, 'You can talk all you want to, but you're not going to the Rose Bowl.' I remember the scene after the game. It was my last game as a Duck. I stood there in the middle of the field for a few minutes. I was happy for the team. I was happy for myself, coming back from ACL injury. Not many players come back from that. I was grateful and felt blessed that I was able to be in the game and play injury-free.

"I was doing an interview and my wife, Shanel, ran up out of nowhere, grabbed me and gives me the most gracious kiss. It melted my heart. And it was the Civil War, which made it even more special."

For the Beavers, it was quite the opposite.

"I have to give it to the Ducks," OSU linebacker Bryant Cornell said. "I hated playing against their offense more than any other opponent. Chip Kelly knew exactly how to exploit a defense. He knew how to poke and prod and do what works in a game. He knew we went fast and quick to the outside. He leveraged our quickness against us. He put a couple of sweep tosses in there, and his O-line would crack back on the inside linebacker, leaving our safeties exposed. It was really tough."

"It was a rude awakening," said Kristick, who played one year with the San Francisco 49ers. "That year, the Ducks took a step up. They had more to offer offensively. We had to prepare a little differently than from the years before. It's hard to practice for something that's as new as what that was, the speed of the offense. They had some really good players on their team. They threw everything in the book at us in that game. For us to lose that game was a big blow. Not just to our Rose Bowl dreams but for a lasting taste of the Civil War."

"I still get upset thinking about that game," Norris said. "I thought we had a great game plan. I thought we had the athleticism defensively to slow them

down. They had a bye week, so they made some changes with their offense we weren't planning on. Motioning the backs back and forth—we hadn't seen that at all. Our line stunts were dictated on where the backs were. It messed us up, and we couldn't get out of an early hole. Makes me sick. I felt so bad, with our fans holding roses out there, waiting for us to win. I felt guilty as a player."

"I remember playing my ass off, trying to do what I could," said cornerback Brandon Hardin. "By the time they had 40 points, I started to realize, 'We're getting pummeled here.' To finish the [regular] season off like that, seeing the rose petals our fans threw on the ground...Walking past that in my locker room, it left a nasty taste in the mouth. Losing, letting the fans down, and at home no less. It wasn't too pleasant."

"They put a beating on us and ruined our Rose Bowl dreams," said Stroughter, who played four NFL seasons. "To this day, I still have that bitter taste in my mouth. They had a great game plan. They played a flawless game. Even when things went wrong, they adjusted. They'd turn a bad play into a good play. No matter how hard we tried, the faster we fell. They came into Corvallis and took our best punch and put 65 points on us. It felt like 100."

"I have no answer for what happened," Butler said. "They were the better team that day. I was so ready to play. I would have played in front of 100 members of my family at the Rose Bowl. I can't say lack of effort. The Ducks just worked us, point blank. With the stakes that high, we folded under pressure and didn't get the rematch with Penn State we all wanted.

"Maybe we overlooked the fact we had to play a good Oregon team. Everybody was walking around, lining up tickets to the Rose Bowl, and we hadn't played the game yet. We were looking past [the Ducks], and I'm not over that yet."

Nate Costa looks upon the 2008 Civil War game as a defining moment in the series. "When I came to Oregon, everyone talking about the rivalry said it didn't matter how good you were during the regular season, the teams played each other tough," said the former UO quarterback, now a grad assistant at the school. "For the first two years, that was true. The teams were pretty even, with similar players and style of football. But that year we went there and blew them out of the water. We just dismantled them. That was the year when we separated ourselves from them from a mental standpoint. The games are still tough, but we felt we were always the better team from then on."

Oregon State wound up in the Sun Bowl, beating Pittsburgh 3–0. Oregon finished the season with a 34–21 win over Oklahoma State in the Holiday Bowl. Kelly, meanwhile, was awaiting an interview for head coach at Syracuse. In March 2009, heading off suitors at the pass, Oregon announced that Bellotti would be moved upstairs to the athletic director job, succeeding interim AD Pat Kilkenny. Kelly was the Ducks' new head coach.

Kilkenny, chairman and CEO of a San Diego–based insurance company, stepped in as athletic director at his alma mater in 2007. During his two years on the job, Kilkenny reinstated the Oregon baseball program, led the effort to get the $200 million Matt Knight Arena built and oversaw the hiring of Kelly as head coach. A native of tiny Heppner in eastern Oregon, Kilkenny was always a UO fan.

"It was basically an Oregon State community, but there were a handful of us who liked the Ducks when I was a kid," he said. "I was always one who went down a path less traveled. It seems like the Ducks were a better fit for my personality."

Kilkenny attended Oregon from 1970 to 1974, a Kappa Sigma fraternity brother of golfer Peter Jacobsen. It was the era of Dan Fouts and Ahmad Rashad, of Dick Harter and Ronnie Lee, of baseball's Dave Roberts and track and field's Steve Prefontaine. "College athletics at Oregon were exciting at that time," Kilkenny said.

When Kilkenny was 14, he attended a Len Casanova football camp in Eugene with his brother. Jerry Frei, then a Casanova assistant and later Oregon's head coach, coached at the camp. During the camp, Pat developed appendicitis.

"I was in the hospital for a week and lost 20 to 30 pounds," he remembered. "I was physically ill. At some point, there was concern I wasn't going to make it. Jerry Frei came over and saw me every day in the hospital, and Coach Casanova even came over a couple of times. I was one of a couple hundred kids at the camp. Why would Jerry do that for a kid? When he got fired [after the 1971 season], I was really upset with Oregon football over that. I still went to the games when Dick Enright was the coach, but it wasn't the same."

Kilkenny eventually got over it and became an avid fan and booster while living in San Diego. He became acquainted with Bellotti over the years and holds him in high regard. "Mike is the consummate professional," Kilkenny said. "He was characterized as being an offensive-minded coach, but he was mostly a winner. He knew how to win games. He did it with fundamentals of football—ball control, field position—and his teams never beat themselves. He was really good around the [athletic] department as far

as being supportive of the other coaches. Had we had more time to use him, he could have been a fabulous fundraiser. Very charismatic, a great public speaker and just a fine man."

Kilkenny said he has respect for the other side, too. "Mike Riley is one of the best coaches in the business and probably a finer gentleman," he said. "I really admire him and [athletic director] Bob De Carolis a lot. They do amazing things. We all have precious few resources, but they're more challenged than most. I respect them, and they always do it the right way."

Kelly was hired as offensive coordinator a week before Kilkenny came on board as AD. "When I came to talk to [former UO president] Dave Frohnmayer about coming to work, Chip was in the private aviation terminal [at the Eugene Airport]," Kilkenny said. "It was his first two to three days on the job. We got acquainted then."

Kilkenny became a Kelly admirer as the months and years wore on. "He is a very special man," Kilkenny said. "A man of few words— the anti-Bellotti, in a positive sense, in terms of personality, though he can be incredibly charismatic. He's brilliant, thoughtful, probably as independent-minded a person as I've met in my life. He is uncomfortable going down paths less traveled but all about doing things the right way. He has tremendous character.

"His organizational skills are in the top three to five of people I've met in my lifetime. He is focused beyond description in terms of keeping his head down to the task. His priorities were very clear. He wasn't necessarily interested in doing things that didn't help his program, but he was very clear about that up front."

Kilkenny spoke twice with Kelly about taking the head coaching job during his two years as an offensive coordinator. "The first time was when Mike was going to go to UCLA in 2007," Kilkenny said. "In my opinion, Mike was gone. It was his birthday, December 21, when it happened. Had it not been leaked by some people in Westwood to the media, he'd have gone. Mike is one of those guys who thinks everything through. When he could not be diligent, he had to stay. He just didn't have all the answers to his questions."

The second time Kilkenny and Kelly spoke about the head job was after the 2008 season. Kilkenny was concerned about losing Kelly.

"Chip was going to Syracuse," Kelly said. "Ironically, [Syracuse athletic director] Daryl Gross and I have become very good friends, but he created a problem. Had he stayed out of it, we could have managed it. But Chip was anxious. He was ready to be a head coach."

Bellotti had already arranged for Kelly to be his successor. "We had set the line of succession in place, which was my idea," Bellotti said. "I talked to Dave [Frohnmayer, the school president] and Pat and said, 'Let's make Chip the coach-in-waiting, or we'll lose him.' The plan was that I'd coach for two years more at most or maybe shorter than that. I told Chip I wouldn't keep him waiting forever. And then I had Syracuse and Mississippi State calling about him."

In March 2009, Bellotti was elevated to athletic director and Kelly became the head coach. "That was my idea, too," Bellotti said. "I coordinated it. I thought it was the right time. I'd been offered the athletic director job two years earlier, but I suggested we hire Pat. Pat did not want to stay in that position. It became apparent to me we were going to have a new president. I could do the best job protecting the football program by going into the athletic director's chair."

Bellotti would probably have preferred to coach one more year, if the Kelly situation hadn't come up. "Those things are always difficult," Kilkenny said. "There were a lot of matters involved. I'm a big proponent of win, win, win. It was hard to get everybody feeling they were winning. Maybe Mike's timing was different than what Chip wanted. Maybe Mike wanted to transition different than Chip wanted it to happen. Those variables made it difficult to get all the parties smiling.

"That was the hardest part of dealing with that change. In principle, the parties were all fine, but the devil is in the details. You have to put yourself second in those. I had such a fabulous boss in Dave Frohnmayer. He said, 'Just go manage it and handle it the best way it will work for the university.'"

Kilkenny believed the hiring of Kelly as head coach would be a positive move for the Oregon program. "By no means did I think he was going to take us to four straight BCS games," Kilkenny said. "That did not seem realistic in our evolution."

Nine months after taking over as AD, Bellotti resigned to become an ESPN college football analyst, landing a $2.3 million golden parachute from the UO athletic department on his way out the door. "It was a combination of reasons," Bellotti said. "One, the new president [Richard Lariviere] felt I was no longer the right fit for that role. Two, very few people get the opportunity to go to ESPN, and you only have it for a limited time. And three, I like college football. I could handle the [AD] job, but I liked the idea of the sportscasting role allowing me to be involved with football without the day-to-day pressures you had as a coach.

"It was not that difficult a decision, a mutual decision between myself and President Lariviere. I called three people that night—Pat Kilkenny, Dave Frohnmayer and Phil Knight—and said, 'This is what I want to do.' Phil asked, 'Are you sure?' And I said yes. It's interesting to be able to handle your own fate. That was something I felt very fortunate to be able to do."

As a head coach, Chip Kelly had a 4-0 record in Civil War games—the only Oregon coach to coach more than two games against Oregon State with a perfect record.

"There was no secret to it," Kelly said in May 2013, four months after leaving Oregon to become head coach of the Philadelphia Eagles. "I never thought of it as a mastery. I remember all those games. Every game had a unique feel to it, but we never went into a Civil War game thinking it was going to be easy, and it never was."

Unlike most coaches in the rivalry, Kelly didn't place more emphasis on the Oregon State game than any other. All 12 regular-season games were treated the same. "Win the Day" was his motto.

"I had a different perspective," Kelly said. "I was told by everybody about the hatred in the game. The problem was, I was always going against Mike Riley, a guy I couldn't hate. I wanted to compete and beat him like the next guy, but I didn't have the hatred like maybe you should have in an in-state rivalry game.

"I have a tremendous amount for respect for Mike and a lot of the guys who played under him—players like the Rodgers brothers and Jordan Poyer. I had respect for what they did and how they played. We knew it was going to be a battle every time we played them. It was interesting to me when you heard the fans talk with venom about the Oregon–Oregon State game. Not my style.

"It always meant something more than just the Civil War. In my four years, the game always hinged on something. You won for the right to go to the Rose Bowl or the national championship game or the Fiesta Bowl. Our games were of the utmost importance because of the BCS ramifications. I got blasted for it, but to me, every game was a rivalry game. We never diminished anybody. Our total focus each week was on who we were playing. We knew every game against Oregon State was going to be tough because of Mike Riley and his coaching staff. It was going to take everything we had to win."

At banquets and in interviews with media, Kelly went out of his way to let people know his feelings about Riley. "I just think the world of him," Kelly

said. "Mike's the classiest guy in college football. He is what college football is all about. His teams are tough, physical and fundamentally well-coached. When you're around him, you can't help but be impressed by him.

"Every coach [in the Pac-12] is unique. I look at guys who coach in other leagues, there's animosity. In our league, I never saw that. We had our coaches meeting in May and then flew cross-country for media things in New York and Bristol [Connecticut], and I had a chance to spend time talking with guys like Mike and Sark [Southern Cal coach Steve Sarkisian]. If you're the head coach at Oregon, you're not supposed to talk to the coach at Oregon State or [USC], but they're such good guys. We share the same issues you face as a coach. In our league, we all got along really well. Mike has always gone about his business as a pro."

Kelly said he never worked up dislike for Oregon State:

> I've never been that way. I've always been about healthy competition. I'll compete like a son of a gun against my brother, but I still respect him. It wasn't like I let my guard down against [the Beavers], but we wanted to beat the dickens out of anybody we played. That's the way it's supposed to be.
>
> One of the great rivalries in sports is Army-Navy. Watch after the game how their players shake hands and how they pay their respect to each other. Those games were always tough, hard-nosed and physical. That's what I always felt about our games vs. Oregon State. We were fortunate to come out on top, but both teams were prepared and got after it and laid it out on the field.
>
> I'd always talk to guys on Mike's staff. [Mark] Banker is one hell of a coach. [Mike] Cavanaugh and [Steve] Greatwood are good friends. Chris Brasfield was a grad assistant for us, and we know what he's about. If you ask members of both coaching staffs, they have a healthy respect for us, we have a healthy respect for them. We loved to compete against them, because you know you're going to get their best shot. That's what a rivalry should be. I grew up in a city where all four high schools played each other. We had friends from the other schools who you hung out with after the game, but when you were playing them, you wanted to kill them.

Riley said he always felt the same way about Kelly and his assistant coaches:

> You go into a rivalry series with all the stuff that surrounds the game. Then through the course of time, you get to know your opponent, both on and off

the field. I found that one of the best coaches I've seen through my years of coaching was working on the other sideline during the Civil War.

Chip did a tremendous job at Oregon and really impacted college football. A lot of people right now are trying to copycat what the Ducks have done. He made a personal impact on that program. I have great respect for the work he did. It's always tough to play against his teams, but I enjoyed the competition and relationship I had with him. That does not diminish in any way how badly you want to win when you play Oregon.

We've had unique results in this state the last 15 years. Now we're playing when there are big stakes nationally and even the Rose Bowl, with both teams ranked in the top 25—and in Oregon's case, the top four or five. I can speak for us in saying we have a great deal of respect for the work that's been done down there. We know it takes a lot of hard work to beat them.

One year during the Pac-12 coaches' media tour, the last stop was in Los Angeles. "Somebody asked me when I was going home, and I said the next morning," Riley said. "Chip overheard the conversation and said, 'Our plane is coming in tonight to take me home. Why don't you just fly back with me?' That was a bonus, to be able to get home a night early. I went to the airport with Chip and flew home on the Oregon plane. We were the only passengers. We had a good visit. And when we got to Eugene, it was funny, some of the guys there to unload the plane did a double-take when they saw me get off the plane with Chip."

Former Oregon quarterback Mike Jorgensen, in his 26th year as the Ducks' radio analyst, said it took a little time for Kelly's unique approach to the Civil War to sink in.

"Chip did a tremendous job of not making the Civil War bigger or smaller than any other game," Jorgensen said. "They treated every game the same. Once the mentality of Chip and his coaching staff became part of the norm for the team—it takes a year or two to buy into the fact—it's one of those habits. It took them 20, 21, 22 games to get in a habitual way to look at every single game and the way they approached it."

"A lot of the hoopla surrounding the game faded with Chip," said Steve Greatwood, in his 28th year as a member of Oregon's coaching staff. "It was Chip's personality. It's not like he didn't get a team any more ready to play the Civil War. Every coach, every player knew the importance of that game and what it meant to the program and to the fans in this state. He made sure

that everybody understood the game was a game everybody cared about in this state. But it was 'Win the Day'…Every game was a Super Bowl mentality.

"I've been very fortunate to work with some great head coaches at Oregon. Mike was very much the same way as Chip but with a different personality. Mike was more gregarious to outside influences and boosters. He was probably a better public persona than Chip was and a very good coach as well, very sharp and a great game manager. Chip was a brilliant coach in every way. His public persona was much different than his private persona. He was a jokester, someone who liked to have a good time, to laugh, to have fun with his guys. He was extremely loyal to the circle of people he worked with. I enjoyed working with Chip. He let you do your job and gave you a great deal of autonomy."

John Neal, in his 12th year on the Oregon staff, coached six years with Kelly. "Chip puts everything together that you could as a college football coach," said Neal, a veteran of 36 years of coaching. "I'd never had that before. He had such fabulous vision of what he wanted in a program. How he came up with it, I don't know. The guy at New Hampshire [Sean McDonnell] is a great coach. That rubbed off on Chip, and he got some things from Mike. He kept thinking about what he wanted to do as a head coach, bigger and better than anyone I've ever been around.

"People use the word 'genius.' Edison and Einstein and Barnard are geniuses. We're football coaches. But the genius of Chip was managing people, having a vision that is bigger than the normal guy. More than anyone I've ever been around, I was in awe of the guy and admired him as a coach.

"When the doors were closed, he was a fantastic guy. He's not crazy. We weren't at work all the time. We didn't meet to meet. We only met if there wasn't something to meet about. That's totally non-traditional. He had thoughts on how we sleep, how we practice, how we train. He got everybody involved. He brought tons of people to come in and talk to the team. A lot of the things he does will blow people's minds in Philadelphia. I hope the guys in Philly will listen to him and learn to trust. We trusted Chip Kelly as much as you can. It's not what you believe in as the leader, it's if the people who work for you believe it. That's what we have here. We're doing it now with Mark [Helfrich, Kelly's successor]. We believe in the guy. Chip is the one who designed that model, and it's being carried out. That's powerful."

Don Pellum played for and began his coaching career under Rich Brooks at Oregon. He served under both Bellotti and Kelly. "I hit the jackpot on head coaches," said Pellum, who now serves as defensive coordinator on the UO staff under Helfrich. "Mike didn't get fired up a lot, so when he did, the

kids would lose their mind. He'd have everyone jacked. Mike was the perfect personality here after Brooks. Brooks had taken the thing and molded it and made us tough and got the program headed in the right way.

"Mike came in with a different approach in the way he spoke to you. And Chip took it to the next level. He'd get the kids focused on not Oregon State but the next opponent, no matter who it was. He refused to buy into the rivalry, the 'throw-records-out-the-window' stuff. He did not want that in the kids' heads at all. That's what the current program was built on, and that's the way to do it. We're not trying to make one game more important, trying to add that pressure. We keep an even-keeled approach, do what we do every day and stay the course."

Kelly's players loved their time playing for him at Oregon. "A fantastic coach," Jeff Maehl said. "He brought so much energy, day in and day out, to the locker room and on the field. His football IQ is so high. He has such a passion for the game. He made you want to work hard every day and put everything on the line for him. You knew he was doing the exact same thing."

"Playing for Coach Kelly was wonderful," receiver Drew "D.J." Davis said. "He's a players' coach. He doesn't ask anything of you that you can't do. He's a great offensive coach but much more than that. He wanted you to go to class and be responsible as well as give 100 percent on the football field. I have total respect for the man. There are a couple of things he gave me that I carry with me that helped shape me to be the young man I've grown to be."

While former players respect Kelly and appreciate what he did to elevate Oregon football, there are those who resented him and the distance he kept with those ex-players, said Cristin McLemore, a star receiver from 1992 to 1995. "He's an incredible Xs and Os coach, but there's more to life than just winning on a football field," McLemore said in April 2013:

The human factor means far more than what you achieve in football. Everybody was so damn afraid of him, but nobody would say nothing. He treated people like children. There's the fear factor. I'm a grown man. I put my pants on one leg at a time, just like he does. Sometimes he forgets that and wants you to bow down to him. Don't act like you're the messiah of the world. That bothered me, the way he wanted people to perceive him.

There was a huge division between the players who played for coaches Brooks and Bellotti after Chip took over. There were guys like Dennis Dixon and Akili Smith on the sidelines for a game, and he sent Akili to the stands. A lot of people don't want to say it, because he did such a great job with wins and losses. I'm not taking anything away from Chip and what he did

on the field. Kudos to you, Chip. But there was a part of his program that he turned his back on. A lot of ex-players were shut out and not able to be a part of the program. A lot of them just said, "Screw it, I'm not going to support them anymore." I'm glad he's gone. I'm ready to get back to Oregon football, even if it means less "Ws."

McLemore said he has known Helfrich since college, when McLemore was at Oregon and Helfrich at Southern Oregon. "I'm so happy to have Mark in place," McLemore said. "He's an excellent coach. He's a disciple of Chip, and he'll use a lot of Chip in terms of football. He'll give us enough of Chip, and he'll bring some of his own flavor to the Oregon culture."

In November 2013, McLemore asked to be allowed to qualify his statements about the former Oregon coach. "I've had some interaction with Chip since I made those comments, and I sense a change in him," McLemore said.

He's so damn good as a coach, we forget he is a human being. It was wrong for me to come down on him so hard without knowing him as well as I should to make those statements.

It's not that I'm glad he's gone. I'd like to say a change back to the old guard would be welcome, and I'd be the first person in line for that, but I respect what Coach Kelly did for the program. Without him, we most likely wouldn't be where we're at today. But Coach Bellotti had that team on a path. Coach Kelly won those first three years with Bellotti recruits. I think Coach Kelly learned a lot from Coach Bellotti. It's been a great marriage of the two.

Chip's an East Coast guy, and with that comes an East Coast mentality. Mark's an Oregon guy—laid-back, salt of the earth. He knows how goddamn good he is, but he's not going to tell you that. He's going to deflect credit to others around him as the reason he's successful. That's the mark of a leader. Mark is a regular guy; Oregon likes and appreciates a regular guy.

Oregon State's players through the mid-2000s have a special feeling for Mike Riley.

"When he was named as Oregon State's head coach, a high school mentor who had played for him at Southern Cal called and had great things to say about him as a person and a coach," Kyle Devan said. "It all proved true. The thing that separates Coach Riley, he cares about you on and off the field. He wants to see you go somewhere after college. He instills growth both

athletically and academically in your personal life. He knows my parents' names. His coaching and knowledge of the game is every bit as good as any coach, but the way he treats the families and players separates him."

"Coach Riley is hands down the best coach I've ever been around," Yvenson Bernard said. "I've never heard players talk so reverently about a coach. He is a father figure. I can always go to him if I have a question about life. Kind of like my dad, he is a guy who doesn't need to yell at you, but you know what not to do. You don't want to upset him because he is so nice and gives you so much freedom. I can't imagine Oregon State not having Coach Riley. He makes the Oregon State Beavers what they are."

"I have not one bad word to say about Mike Riley," guard Roy Schuening said. "When he got to Oregon State, he weeded out the guys who were a cancer to the team. You saw an immediate effect. The biggest thing I talk about is the family atmosphere. I'm sure every school says that, but it's not true everywhere. He really drives that home. Guys play for each other. He gets so much more out of guys who weren't recruited by other big-time schools. The level of respect I have for him is out of this world. He's a man of his word and of integrity and ideals."

"A lot of coaches think yelling and screaming is the best option to get their point across," cornerback James Dockery said. "I learned from Coach Riley, you don't have to raise your voice to get your players to respect you and follow the principles of your program. Not all actions need a reaction. Coach Riley is a great leader of young men."

"Coach Riley sets such a high standard, if I were going to become a coach, I don't know if I could live up to it," kicker Alexis Serna said. "When he asked how you were doing, he genuinely cared. Never a last name; always a first name. We all felt like we didn't ever want to let Coach Riley down. We loved him and he loved us, and he earned our respect by treating us as individuals."

"I can't give Coach Riley too much praise," receiver Sammie Stroughter said. "Whatever I say, I'm still selling him short on what kind of person he is. You're in awe of the guy as a human being. He's going to teach you how to be a man on and off the field. He's very big on character. That's something I can't stress enough that I learned through my five years being there, me going through all the things I went through. He cared for me like a son."

"I couldn't have played for a better, more genuine guy," linebacker Alan Darlin said. "If he says something, he means it, and he's going to do it. He's fair and strict at the same time. He is great at developing kids into young men. He believes in discipline. He'll raise his voice and get angry when he

has to. If you do things right, you don't have to see that side of Coach Riley. You know you've done something wrong when Coach Riley raises his voice at you and scolds you."

"One of the best teachers I've ever been around," quarterback Matt Moore said. "Zero ego, which made me comfortable asking questions. One of the most overlooked traits in coaching is being approachable. That's Coach Riley. He genuinely cares about each and every player. I've played for guys I don't believe that to be true. I love the man. He's an unbelievable coach."

"The most fun time I ever had in football was playing for Coach Riley," receiver Shane Morales said. "He's like everybody's dad. One of the things I liked the most, you wouldn't see too many head coaches with his dog running around the office like his dog, Rudy, did. He is one of the best offensive minds in college football. Nothing but respect for the man."

The Rose Bowl was on the line again when Oregon and Oregon State squared off in the 2009 Civil War at Autzen Stadium. The difference from 2008, though, was that the winner would be the Pac-10 representative.

Oregon entered the Thursday night game ranked seventh nationally, with a 9-2 overall record, 7-1 in Pac-10. Oregon State was ranked 13th, with an 8-3 mark, 6-2 in conference play.

The Ducks had stumbled in their opener, losing at Boise State 19–8 and then turned it around with seven straight victories. They lost 51–42 in a shootout at Stanford but beat Arizona State and Arizona to set up the showdown with Oregon State.

The Beavers had their usual slow start, going 2-2 in their first four games. They won six of their next seven, coming into their own as they headed into the Civil War duel.

Oregon led the Pac-10 in scoring and rush offense. OSU led in pass offense and rush defense. It was a matchup of Oregon's rushing offense (231.4 yards per game, eighth nationally) and Oregon State's run defense (98.4 yards, 13th nationally). The Ducks entered the game having scored no fewer than 40 points in their previous seven Pac-10 games with junior quarterback Jeremiah Masoli at the controls.

Oregon State would have seven players named first-team All-Pac-10— quarterback Sean Canfield, tailback Jacquizz Rodgers, receiver James Rodgers, guard Gregg Peat, defensive tackle Stephen Paea (also the Morris Trophy winner as the loop's outstanding D-lineman), linebacker Keaton Kristick and special teams player Suasei Tuimaunei.

Oregon would have only one such selection, tight end Ed Dickson. But the Ducks had the Offensive Freshman of the Year, tailback LaMichael James, and the Coach of the Year, Chip Kelly.

Oregon entered the Civil War with a nine-game win streak at Autzen and a 6-0 record at home in 2009. "Our home field is a huge advantage," Kelly said prior to the game. "Our fans are the best in college football. We think we have a distinct home-field advantage."

"Either place is a tough place to play," Riley said. "Everybody knows you have to deal with the noise at Autzen, and you have to play with a lot of poise. We'll work hard at being able to function in that situation."

Kelly acknowledged it would be more difficult defending Oregon State with the Rodgers brothers healthy. "It's different with both those guys in there because Quizz and James are so good," the first-year UO coach said. "You can't gang up on the fly sweep because they'll hand it to Quizz, and you can't gang up on Quizz because they'll hand it to James."

The Ducks went into the game with a confidence about them. "I'm really excited for this game and looking forward to seeing our guys put a smacking on the Beavers," cornerback Walter Thurmond said. "We're about to win the Pac-10 championship and go to the Rose Bowl."

"We feel like it's our game to lose," linebacker Spencer Paysinger said. "We have an advantage in defense and overall offensive schemes."

Canfield, a 6-4, 215-pound senior, was playing in his first Civil War. "I've never been more excited for a game," he said. "I'm really looking forward to it. It's a great stage for us. In these situations, our team rises to the occasion."

OSU cornerback Tim Clark said the Beavers would draw incentive from the 65–38 Civil War defeat a year earlier as well as the win at Autzen in 2007. "You never forget a loss like that," Clark said. "It was an embarrassment, a horrible way to send out our seniors, one of the best senior classes in our school's history. To have a Pac-10 title and Rose Bowl [berth] snatched from you like that…none of us have forgotten that feeling. [The Ducks] are a really good team with a good track record. Autzen Stadium is a tough place to play, but we have some guys who know what it feels like to win there. We have to prove we can do it on that Thursday, and that's pretty much what we plan on doing."

Masoli's excitement level going into the game: "On a scale of one to 10, 10."

Kelly was asked if tailback LeGarrette Blount—suspended and out of game action but practicing since an incident after the Boise State loss in the season opener—would be available. "He's done a nice job," Kelly said. "He's a backup. Situation hasn't changed."

The game proved a thriller, with the Ducks coming from behind to win 37–33, write their ticket to the Rose Bowl and deny Oregon State a postseason trip to Pasadena for the second straight year.

"We fought hard," OSU linebacker Keith Pankey said afterward. "They just played better."

It was an offensive showcase for both teams, with LaMichael James leading Oregon with 166 rushing yards and three touchdowns and Masoli throwing for 201 yards and rushing for 40 more. Canfield completed 24 of 36 passes for 306 yards and two touchdowns with no interceptions, James Rodgers was the recipient of 10 passes for 139 yards and a TD while setting a school record with 303 all-purpose yards. Quizz carried only 16 times for 64 yards but caught seven passes for 73 yards.

The teams traded the lead four times in the first half. Canfield's 28-yard touchdown strike to James Rodgers gave Oregon State a 23–21 lead. The Beavers upped the margin on a nine-yard TD pass from Canfield to Casey Kjos midway through the third quarter, but Blount's surprising insertion at that point gave the Ducks a boost. The senior tailback carried for 51 yards in the second half, including a 12-yard touchdown to bring Oregon to 30–28 with 5:45 left in the third period.

With the Ducks trailing 33–28 after Justin Kahut's fourth field goal of the game early in the fourth quarter, James broke loose for a 52-yard touchdown to put them ahead for good. Morgan Flint's 34-yard field goal with 10:13 left increased the lead to 37–33.

Oregon State drove to the Oregon 27 with six minutes left, but Riley eschewed a field-goal attempt to go for it on fourth-and-15. Canfield's pass for James Rodgers sailed just past his reach.

"I thought we needed a touchdown," was Riley's explanation.

Oregon ran out the clock from there, twice gaining first down on fourth-down plays. On the first, Masoli ran for six yards, bowling over OSU safety Lance Mitchell for a first down.

"Masoli had scrambled to my side of the field," OSU cornerback Brandon Hardin recalled. "I was checking Jeff Maehl on the sideline, wondering if I should stick with him or push up to help make the tackle on Masoli. I decided to stick with Maehl. Masoli lowered his shoulder as Lance hit him. He had some good size. He might have outweighed Lance. When I saw Masoli break Lance's tackle and push forward, my hopes for the game were shot."

The second time, on fourth-and-two, Masoli pitched to freshman Kenjon Barner, who ran four yards to maintain possession. "The longest four yards

I've ever experienced," Barner said. "It took me an hour to cover those four yards. Everything was moving in slow motion. It sealed the game for us. What a great feeling to help my team reach the Rose Bowl."

Blount's contributions were a key to the victory. "We made him do a lot [to return to the coaches' good graces], and he did," Kelly said afterward. "Nothing was handed to him. He was fifth string when we started this thing."

Quipped offensive coordinator Mark Helfrich: "Coach Kelly went to the bullpen for the right-hander."

"This is unbelievable, to be able to contribute to the team's win," Blount said. "I've been waiting for a long time to get back in there, and I've been doing everything Coach Kelly wanted me to do. Everything that I've worked for finally paid off. I can't describe this feeling right now. I'm at a loss for words."

The opposition didn't feel quite the same about Blount's role in the win. "We're beating the Ducks in the third quarter," OSU linebacker Dwight Roberson says today. "They think they are about to lose, so they take Blount's suspension away and play him. Coach Kelly had said he was suspended for the entire season because he'd punched somebody in the face and had no composure. Then it's, 'Oh, we're about to lose, let's bring him back.' Super disrespectful."

The Ducks' balanced attack produced 489 yards, 288 on the ground and 201 through the air.

"We played our hearts out," Paea said. "Give credit to their offense—best offense in the nation."

After the game, Oregon fans stormed the field. The post-game celebration, Barner recalled, "was so much fun. It was the first time I experienced fans rushing the field. They went ballistic."

Masoli said he took some of the best shots he'd taken all day after the game. "It was too crazy," he said. "I couldn't see about half the time. Guys were hitting me on the helmet. Some fans punched me in the stomach. They were just too excited or something."

For the Ducks, it was the culmination of a dream. "I never thought going into college I'd be playing in the Rose Bowl or the BCS championship game," said receiver D.J. Davis, who would do both. "It made all the hard work worth it."

Dickson came away with an appreciation of the Civil War. "That one was intense," the UO tight end, a member of the 2012 Super Bowl champion Baltimore Ravens, says today. "Those are the games you remember the most. It's those games that lay the foundation of your college career. The

Civil War was a heated rivalry. I think it compares to the Ravens-Steelers rivalry. The NFL is the next level, but the Civil War was the hardest-hitting game we played at Oregon."

Oregon would lose to Ohio State 26–17 in the Rose Bowl. Oregon State would finish the season on a down note, too, falling to Brigham Young 44–20 at the Las Vegas Bowl.

In 2010, the Ducks won 37–20 in Corvallis to cap an unbeaten regular season and write their ticket to the BCS championship game, where they lost to Auburn 22–19. Oregon rushed for 346 yards against the Beavers, with Kenjon Barner (15 for 133 yards, two touchdowns) and LaMichael James (28 for 134) dividing the duty. Markus Wheaton had 10 receptions for 137 yards and a TD for Oregon State, while Jacquizz Rodgers carried 22 times for 87 yards in his final college game.

In 2011, Oregon won 49–21 in overwhelming fashion at Autzen, running up 38 first downs, 365 yards rushing and 670 yards total offense. Darron Thomas completed 27 for 40 passes for 305 yards and four TDs, James rushed for 142 yards and tight end David Paulson had a career-high eight catches for 105 yards and a TD. OSU freshman quarterback Sean Mannion threw for 299 yards and three scores but had three interceptions and was sacked six times.

Oregon was nearly as impressive in the 2012 game at Reser, winning 48–24. The Ducks piled up 570 yards total offense, including 430 on the ground. Barner (28 carries, 198 yards, two touchdowns) and De'Anthony Thomas (17 for 122, three TDs) ran wild while freshman quarterback Marcus Mariota carried eight times for 85 yards, including a 42-yard TD run 1:46 into the game. OSU's Mannion threw for 311 yards and a touchdown but was intercepted four times.

It was a fitting way for Barner to close out the regular season of his senior season. "In the pre-game, their defensive end, Scott Crichton, came up to me and said, 'I'm going to shut you down today,'" Barner says today. "I told him, 'You'll have to catch me first.' Trash-talking has never been my thing. I go out and get the job done. A lot of guys call me a silent killer. I'll get very intense. Once a Civil War game starts, there is definitely trash talk. Over my four years, we were able to shut that talk off pretty easily."

THE LETDOWN BOWL

For lack of a better term, the 2013 Civil War could be called the "Letdown Bowl."

After four straight BCS bowl appearances, Oregon entered the season ranked No. 3 in both the Associated Press and USA Today preseason polls. Fans looked at the Ducks to be a serious contender for the January 6, 2014 BCS National Championship Game in the Rose Bowl in Pasadena, California, and the Ducks played the part through the first two months, going 8-0 and ranking second in both polls.

Oregon State, which started No. 25 in both polls after a 9-4 season in 2012, lost its opener to FCS power Eastern Washington and then clawed its way back to No. 25 after winning its next six to improve to 6-1. That gave Beaver Nation hopes for perhaps another nine-win season and a major bowl game.

Oregon stumbled, falling victim to powerful running attacks by Stanford and Arizona in dropping two of three games in the regular season. Oregon State, meanwhile, ran into a rugged stretch of schedule, losing to Stanford, Southern Cal, Arizona State and Washington.

Rather than contend for a spot in the BCS title game, the Ducks entered Civil War week out of the race for the Pac-12 championship and the Rose Bowl. The Beavers' primary goal was to end a four-game losing streak and not to finish the regular season "half-and-half," as All-America receiver Brandin Cooks termed it.

Mark Helfrich was nearing the end of his first year as Oregon's head coach after serving as Chip Kelly's offensive coordinator the previous four seasons. Unlike Kelly when he arrived on the scene from New Hampshire in 2007, Helfrich knew all about the Civil War.

Helfrich had been raised a Duck in nearby Coos Bay, the son of former UO lineman Mike Helfrich. "There was that back and forth amongst the community," he said the Monday before the 2013 Civil War game. "Everyone was either a Duck or a Beaver. I wanted to be on the right side of that, for sure."

As a youngster, Helfrich had made the two-hour trip with his family to Eugene for many Duck games, including a few Civil War contests. The Helfriches even made it to Corvallis for at least one of the interstate battles. "I remember one year sitting in the bleachers at Parker Stadium, and it was pouring down rain," Helfrich said.

A fine quarterback at Marshfield High but not a Division I prospect, Helfrich was a four-year starter at NAIA Southern Oregon, turning down a walk-on invitation from Oregon. "That was one of my plans for awhile," Helfrich said of the walk-on opportunity. "I think it came down to thinking where I would be able to play sooner. Who knows what my solid 18-year-old logic was at that point. I also had an opportunity to walk on at Oregon State as a free safety.

"To play [for the Ducks] was always a dream of mine, but they were smart in not picking me. That didn't work out, but it's great to be in the current angle [as head coach]."

Asked if the Civil War was any more meaningful to him than other games, Helfrich began, "It's the next one, so it's very meaningful."

Then the first-year head coach added, "I certainly understand the makeup of that [rivalry], growing up in the state. I grew up in a community that was very divided in allegiance. I know what that means, there's no question about that. But it's more important this week for us to play better, for us to execute, to compete, to play our way."

During the Kelly era, the Ducks were trained to focus on every opponent the same—no more, no less. That philosophy carried through to the start of the Helfrich regime, at least to a point.

Oregon's most important player, quarterback Marcus Mariota, was asked if the Civil War game meant more than any other game on the schedule. "I know you're going to hate this answer, but we have to take it one game at a time," the 6-4, 210-pound sophomore from Honolulu began with a smile. "It's a faceless opponent."

Even though Mariota was a native of Honolulu, he'd been around the Civil War enough to know what it means to those who live in the state. "In all honesty, talking around the community, this game does mean a lot," he said. "It means a lot to the state. It's an honor to be able to play in it. To be able to represent this community the best we can is what we're going to try to do."

Few Ducks understood the Civil War better than receiver Keanon Lowe, a Jesuit High of Portland grad who grew up feeling the passion of those with ties to one school or the other. "In this state, you're either a Duck or a Beaver," the UO junior said. "Everyone I've grown up with or been around picks a side."

Lowe had grown up liking both schools. "I never had any hatred toward Oregon State as a kid growing up in the state," he said. "Always respected that program. Always respected [Coach] Mike Riley, especially. I root for Oregon State when they're not playing us."

Lowe was offered scholarships by Oregon, Oregon State and Washington. He verballed to the Huskies and then switched gears and signed with the Ducks. The Beavers, he said, were in it, too. "It's a great program," Lowe said. "They have great people there. When you have a coach like Mike Riley…he's a good person first and foremost. It was a tough call, but Oregon was where I was meant to be."

Lowe never attended a Civil War game growing up but watched "about every one" on TV. His biggest memory was "the one where Jeremiah Johnson got loose," Oregon's 65–38 victory in Corvallis in 2008 when the Ducks erased the Beavers' Rose Bowl hopes.

As a native, Lowe said the Civil War "means a whole lot. To all of us guys from Oregon, it means a lot."

So do the Oregon kids have to teach their out-of-state teammates the meaning of the rivalry? "When guys come on campus and start to learn about our program while they're getting recruited, it's obvious this is our biggest game," Lowe said. "The Civil War is a big deal. A lot of guys around the country don't know exactly what it means until they've experienced it."

Some of those guys said they, too, had caught the spirit. "I love the rivalry," said running back De'Anthony Thomas out of Los Angeles. "The Beavers play hard every game. It's a great feeling to go out there and represent for the state of Oregon."

Linebacker Boseko Lokombo, out of Abbotsford, British Columbia, was one of the Oregon players playing his final game at Autzen on Senior Day. "It's an opportunity for me and all the other seniors to finish strong,"

Lokombo said. "It's going to be very emotional. It's exciting. Both teams look forward to it. It's going to be a fun game."

Any hatred between players on the two sides? "Not at all," Thomas said. "I know a couple of their players from high school. It's always great to play against. It's fun. Every game with them is a hard game, and this is going to be another tough game to play. They're going to give us their best shot."

Lokombo begged to differ about the hate part. "I would say so, yeah," he said. "We do have bad feelings toward them. We'll talk a little trash before the game. We've beaten them a couple of times, and they're probably hungry to try to beat us, too."

Senior receiver Josh Huff said he considered the Civil War very important. "Oregon State is Oregon State," Huff said. "They have their deals going on; we have our deals going on. Two great teams are going to meet each other, and hopefully I'm on top of the final outcome. I can't end our [regular] season in a loss against Oregon State. I'm going to come out and give everything I have."

The Beavers had looked lost in a demoralizing 69–27 home loss to Washington the previous Saturday.

"We did, too," Huff said, the reference to Arizona's 42–16 dismantling of the Ducks in Tucson on the same day. "It's a lose-lose for the both of us. We have to go back to the drawing boards and get ready to go to war with those guys."

Huff said there's something special about facing Oregon State. "It's like one of those feelings you get when you're a kid in a candy store," he said. "You want to get what you want. If you don't get what you want, you're going to be mad. Hopefully, I'll be a kid who gets what I want."

Within the Oregon program, there were reminders that the rivals up the road were coming to town. Garbage cans adjacent to the Football Performance Center were lined during the week with the Beaver mascot. The Ducks' X-rated version of the OSU fight song—made popular during Civil War week in the Rich Brooks era—was to resurface.

"Yeah, that song is still around," Lowe said prior to the game. "I don't know every word. Maybe that's a good thing. Some of the older guys are going to teach it to some of the younger guys, but I won't be one of those guys teaching it."

From 1975 to 1997, the Civil War was as one-sided as an interstate rivalry can be, Oregon going 19-3-1, most of the domination accomplished during the Rich Brooks era. Mike Bellotti came on in 1995 and won his first three against Oregon State.

But OSU's 44–41 win in 1998's double-overtime thriller at Parker Stadium turned the annual game back into a rivalry again. For nine straight years, the home team won. In 2007, Oregon State turned the tables at Autzen, knocking off the Ducks 38–31 in double overtime.

It was to be OSU's last victory over its rivals. Beginning with a 65–38 thrashing of the Beavers in 2008, the Ducks won five in a row heading into the 2013 contest. That put an even higher premium on victory for the Beavers, heading into the game as a 22-point underdog but thirsting for an upset.

Some of the OSU players, including juniors Sean Mannion and Brandin Cooks, told the media during Civil War week they considered it no bigger than any other game.

"It's a big rivalry game, largely due to the fans and the passion surrounding the game," said Mannion, a transplanted Oregonian with family now in Silverton. "But I try to treat it like any other game. I don't want to think more about one game than any other."

"Just another game to me," said Cooks, a Stockton, California native. "I know [the Ducks] are a great team and it's a rivalry. They're another team you want to beat. We just need a win. I don't care if it's the Ducks or not. I don't look at it like that. I just want to get the win."

Seniors Josh Andrews and Rashaad Reynolds saw it a bit differently. "It's huge—the biggest game of the year," said Andrews, a guard from Fontana, California. "It's what we look forward to every year. I'm aware of the history behind the Civil War. It's one of the best rivalries in the nation. Glad to be a part of it."

"It's our No. 1 rivalry," said Reynolds, a cornerback from Pacoima, California. "When you go to Oregon State, you talk about that team down the road. You don't really ever say their name. They probably do the same to us. Two teams 45 minutes away from each other, that type of rivalry is going to create some of that…not hatred…The word ain't coming to mind, but you know what I'm saying."

Oregon State's four-game skid had left Cooks hungry to beat anyone. "We're on a losing streak," he said. "It don't matter if it's the Ducks or SC. It's important to not keep tallying these losses. I know we'll be ready to fight."

"They've beaten us five years in a row," Reynolds said. "Right now, we're not having the greatest season. They're having a pretty good season. They look at us like 'little brother.' I don't worry about that. I'm not afraid to play nobody.

"We're going to be ready for this game. When your backs are to the wall, you have to come out swinging."

No player in Oregon State's program had beaten Oregon. "That's one of the biggest things I want to say I did when I leave Oregon State, that I beat the Ducks," Reynolds said. "Going into this week, I feel good about it. I'm ready to go to war one last time."

Would it mean more to beat the Ducks at Autzen? "It'd be good to beat them anywhere," Reynolds said, smiling. "We could play them in the Truax Center."

"It would be special for our seniors," Cooks said. "And not just for them, but for the program. It's about everyone. We're doing this for everyone on the team and the coaching staff. I'm excited about the opportunity to go down there and take care of some business."

A reporter told Reynolds about the orange Beaver mascots adorning trash cans adjacent to the UO Football Center and the singing of the Ducks' X-rated version of Oregon State's fight song at some point after practice.

"I heard about the trash cans," Reynolds said, nodding. "Didn't know about the fight song. That's their prerogative. They can do whatever they want. It's funny to me. We don't do all the extra stuff. We're just going to prepare for our last [regular-season] game. What better way to go out than to beat the Ducks?"

Despite the coaching change, Oregon didn't seem to skip a beat in the early going of the 2013 season. In their first five games, the Ducks' spread offense was unstoppable, averaging 59.2 points while outscoring Nichols State, Virginia, Tennessee, California and Colorado by an aggregate 296–59.

Oregon then beat 16th-ranked Washington 45–24 at Seattle as sophomore quarterback Marcus Mariota—by now firmly entrenched as a bonafide candidate for the Heisman Trophy—threw for 366 yards and three touchdowns and ran for 88 yards and another TD. The Huskies hung close, drawing within a touchdown twice before the Ducks broke away for their 10th straight win over their Northwest rival. Sophomore Bralen Addison had two touchdown receptions, and senior Josh Huff, carted off the field in the first half after a right leg injury, came back to catch a 65-yard TD pass on the first possession of the third quarter.

After taking care of Washington State 62–38, the Ducks wore down 12th-ranked UCLA 42–14 after the game was tied 14–14 at the half. Byron Marshall got loose for 133 yards and three TDs to lead the rout.

But then Stanford attacked Oregon's Achilles' heel—rushing defense—running 66 times for 274 yards while holding the ball for 42½ minutes. The Cardinal were ahead 26–0 early in the fourth quarter before the Ducks stormed back, only to fall short, losing 26–20 in what ended their hopes to

play in the national championship game January 6 at Pasadena. The Rose Bowl was still a possibility, but Stanford would have to be upset by somebody in its final three regular-season games.

Oregon rebounded to beat Utah 44–21, but there was media fall-out with the Ducks' situation as they prepared for a visit to Arizona. Huff and back De'Anthony Thomas both revealed their feelings about having to "settle" for a potential berth in the Rose Bowl.

"I don't want to play in a Rose Bowl unless I'm playing for a national championship," Huff told reporters. "Deep down, I don't want to be a prep game for the national championship game. If we would have handled our business [in defeating Stanford] like we were supposed to, we wouldn't have had to rely on USC [beating Stanford the following Saturday] to get back in the Pac-12 Championship Game. We wouldn't have to be in the situation we are in now."

Thomas said the Rose Bowl "is not a big deal at all. We already won a Rose Bowl [45–38 over Wisconsin in 2012]. So it feels like, 'Whatever.'"

Southern Cal did its part, beating the Cardinals 20–17 at the Los Angeles Coliseum. Tucson, however, was a disaster for Oregon. Ka'Deem Carey rushed for 206 yards and four TDs as Arizona gained 304 yards on the ground in a 42–16 romp past the fifth-ranked Ducks.

Those comments were on the mind of reporters more than a week later as they interviewed Thomas and Huff prior to the Civil War. Asked if he regretted his statement about the Rose Bowl, Thomas shook his head and smiled. "Not at all. They're just trying to find ways to mess with our minds," he said, not specifying who "they" might be. "We have to block it out and keep playing like the Men of Oregon."

Huff had a different take. "The Rose Bowl *is* a big deal," he allowed. "We had high expectations. Any time you don't reach that, anything that falls short of that becomes a consolation prize. The Rose Bowl is a great deal. I wasn't dissing it or anything; I was just saying I wanted more. Unfortunately, we weren't able to finish last week. Now we're reaping that."

The Ducks were saying the right things about the Beavers, despite their four-game losing streak coming in. "They're good up front" defensively, Mariota said. "They're going to bring some pressure. They've been pretty good taking the ball away. We're going to have to focus on that. We were kind of lackadaisical with the ball last week."

"They're a physical team," Thomas said. "Everyone runs to the ball. They have great players on defense," he said, then bringing out his favorite phrase: "we have to handle our business and play like the Men of Oregon."

Several of the players mentioned one of Helfrich's favorite creeds—playing for one another, for the "guy to the left and the guy to the right of us."

"Any time you have a rivalry, Oregon State or Washington, it's going to be different," Huff said. "This is a big one, for ourselves and for the fans. It's been a tough season for us, but we have to keep pushing and get this one for the fans.

"I'm going to be very sad running through the tunnel the last time and seeing the true fans, the emotions they bring to Autzen. I just hope to go out with a bang."

Mariota—a redshirt sophomore eligible for the 2014 NFL draft—was being projected as a top-five pick. Several mock drafts had him going with the No. 2 selection. Had he thought about this being the last time playing at Autzen? "Not at all, and I'm being truthfully honest," he said. "I'm not sure. After the bowl season, I'll go home and talk through this with my family and see what's the best fit."

(Mariota wouldn't take that long to decide. The week after the Civil War, Mariota and junior center Hroniss Grasu both announced they would return to Oregon for the 2014 campaign.)

The Ducks understood they were going into the Civil War as healthy favorites. "But football's a crazy game," Keanon Lowe said. "Any team on any given week can fall to any other team. Unfortunately, that was us last week."

Helfrich said he had great respect for Mannion.

"Physically, he has the tools of a great quarterback," Helfrich said. "He's a big, physical guy with a big arm and quick release. He's a good decision-maker. He's a smart kid with a great feel for what they want to do, for their system."

Helfrich and Riley both being Oregon natives—Helfrich from Coos Bay, Riley from Corvallis—provided an interesting side angle for the media.

"I don't know of any other rivalry situation where guys are from the same state and they're coaching like this," Helfrich acknowledged. "I don't know Mike that well, but we're friendly when we see each other. I have a ton of respect for him, and I know some other guys on that staff pretty well."

Helfrich didn't want to have anything to do with the theory that Oregon State's season was shot after the dismal performance against Washington.

"I'm much more concerned with us flipping the page," he said. "I don't know globally anything about their program in that regard. I'm worried about our own problems."

Helfrich said there would be no overlooking the Beavers, at least from his perspective. Games are won on the field and not based on previous results, he implied.

"We have to show up every single game," he said. "Just because there's an 'O' on our helmets doesn't mean they give you 60 points on the scoreboard. You have to show up and grind that out every single practice, every single meeting, every single day.

"Our execution has to be better. Last week, we had a bunch of [problems] there. We need to catch the ball, block cleanly and play with a sense of urgency. Play how we play and take care of the rock."

For the first 10 weeks of the 2013 season, Oregon State was never perfect but always competitive. The Beavers opened the season with a painful 49–46 loss to FCS opponent Eastern Washington at Reser Stadium. The Eagles, ranked No. 3 in the NCAA's lower division, got an all-world performance from quarterback Vernon Adams, but it was still a shocking way for the Men in Orange to start the season.

They rebounded nicely, winning their next six games to go 6-1 and become bowl-eligible. Then came the meat of the schedule—Stanford, Southern Cal, Arizona State, Washington and Oregon. OSU lost the four games entering Civil War week, but the first three were hard-fought battles with ranked teams.

Then came the debacle against the Huskies, a 69–27 defeat. No emotion, no execution, no results. As Coach Mike Riley puts it, "That's as out of character as I've seen us play—ever."

Even with two losses in their previous three games, Oregon would be a formidable opponent, the Beaver players stressed. "Knowing that team, they're going to bounce back," Cooks said. "They're not laying down. They have a great defense. [Cornerback Ifo] Epke-Olomu is a first-rounder, Terrance Mitchell is another great corner, and their safeties are good. They have a team full of hungry people."

Still, the Ducks' two losses made it feel as if their invincibility quotient had dropped considerably. "They're a good team, but I feel like they're beatable," Josh Andrews said. "We've seen that they're beatable. We're going to work as hard as we can to go down there and beat them."

The poor performance against Washington was being placed in the rearview mirror, the Beavers said. "Trying to learn from it and forget about it at this point," Mannion said.

"We have to put it behind us, to be honest," Cooks said. "I'm not thinking about it no more. It was ugly. We all know it was ugly. That's all I can say about it."

Mannion and Cooks spoke on the sidelines toward the end of the Washington game. "We said we felt we have a good thing going here,"

Mannion said. "If we can right the ship and play our best football, we can still make it a season to be proud of. We're on the home stretch. Two games left—the Civil War and the bowl game. Everyone sees it as two more chances to play our best football."

Oregon's losses to Stanford and Arizona weren't providing more hope or inspiration in Mannion's view. "We go into every game expecting if we play our best football, we can beat anyone," he said. "That's no different for Oregon. Having seen other teams be successful against them gives us some idea what we can try to do schematically. But from a mental aspect, we have to go into every game expecting to win, regardless of whether [the opponent has] nine wins or one. If we need to see other teams beat them to feel good about our chances, we're in bad shape."

A native of Pleasanton, California, whose father, John, is now head coach at Silverton (Oregon) High, Mannion said he had grown to appreciate the Civil War rivalry. "It's a cool thing," he said. "Everyone in the state aligns with one team or the other. Playing a game that features that is a pretty cool experience."

But Mannion said Riley wasn't emphasizing the Civil War more than any of the other games on the regular-season schedule. "We have a team meeting every day," Mannion said. "Coach Riley always talks on a few things we need to be thinking about. I haven't seen anything extra. He makes it a point to treat every game as an equal. Every game is a big game. He hasn't been playing this one up more than any of the others."

Brandin Cooks had much the same perspective. "It's an amazing atmosphere to be able to be a part of, one of the biggest rivalries in the country," he said. "I recognize [the Ducks] are a rival, but I don't do anything different to prepare for them."

Rashaad Reynolds was asked if the Beavers had lost confidence after their uninspired performance against the Huskies.

"It was just a bad game by us," he said. "Ain't nothing else to say. We didn't play well and they had a good game. We know that wasn't us.

"We'll be ready for [the Ducks]. They always have weapons. They have speed at every position. We know it's going to be a challenge. That's what I play this game for. I love challenges like this. We have some unfinished business. What better way to go out your last regular-season game than with a win over the Ducks."

The weather was cold, crisp and winter-like as the 117th renewal of the Civil War kicked off at 4:00 p.m. at Autzen Stadium—47 degrees at kickoff,

under 40 when the game concluded. It was late-fall football weather in the Northwest, and the sellout crowd of 58,330 settled in for what turned out to be an epic battle between the long-running state rivals.

More than three and a half hours later, after 13th-ranked Oregon had escaped with a 36–35 victory, UO defensive coordinator Nick Aliotti said it best. "You talk about a good football game," Aliotti told the assembled press. "That was a fantastic football game if you're a fan. This one will be remembered for a long time."

If you were a Duck, you certainly felt that way. It hadn't been as easy as the odds-makers had predicted, but it was a win nonetheless, Oregon's sixth in a row in the series dating to 1894.

Play was far from perfect on either side. There were eight fumbles, six turnovers, some missed opportunities and untimely penalties both ways. But there was enough emotion to fill a Pentecostal church service on Sunday morning.

If you were a Beaver, the result brought mixed emotions. A valiant effort on the rival's home turf had fallen just short.

"It sucks," OSU quarterback Sean Mannion said. "There's nothing else to say about it. But there's a lot to feel good about, too. There was no quit in us. We came up short, but if every guy looks himself in the mirror, nobody can say he didn't give it his all."

In the end, there was too much Marcus Mariota, too much Josh Huff for the Beavers. Mariota was terrific, throwing for 285 yards and three touchdowns and running seven times for 53 yards. Huff was sensational, coming up with one of the greatest performances of his career, catching nine passes for 186 yards and three scores.

With Oregon State leading 35–30 and a minute and a half to play, Mariota led Oregon on a nine-play, 83-yard drive, hooking up with Huff for a 12-yard game-winning TD strike with 29 seconds to play.

"A weird game," Oregon coach Mark Helfrich said afterward. "We knew [the Beavers] were going to bring it. They played better than we did for a lot of the game, but our guys persevered."

Oregon State coach Mike Riley, bitterly disappointed with his players' effort in their hide-your-eyes loss to Washington the previous Saturday, gathered them on Monday with a stern message. "Don't tell me about the score this week," Riley told them. "I want to see us play football, and then we'll look at the scoreboard."

"I was totally devastated by [the Washington game]," he said. "Disappointed in myself, our staff, our team. It was absolutely essential that

we come out and play good football, play hard. I told the guys, 'Don't even look at the scoreboard until the end, because we have to play better and play with enthusiasm and passion. We're going to be in a stadium that is all pro-Oregon. We have to bring our own energy.' And they did. I was proud of them for that."

Going in, Riley didn't know what to expect from his players. "I wasn't sure," he admitted. The Washington game "put some doubt in everybody's mind about, 'Who are we?'"

Riley set the tone after the Beavers won the pre-game coin toss. Normally, he chose to defer, giving his team the ball to start the third quarter. This time, he chose to take the ball. "I just kind of finalized it in my mind that morning," Riley said. "I thought, 'What the heck, we've got to go for this. Let's take the ball and see what we do with it right away.'"

The Beavers marched from their own 26 to the Oregon 27, where on fourth-and-one, Mannion's pass for Brandin Cooks into double coverage was intercepted by Ifo Ekpre-Olomu in the end zone. Even so, it wasn't a three-and-out, and "it built some confidence that we were going to be able to move the ball OK," Riley said.

The Ducks moved quickly upfield, marching 80 yards in just seven plays. True freshman Thomas Tyner, the five-star recruit out of Beaverton's Aloha High, busted 40 yards on the first play from scrimmage. When De'Anthony Thomas danced five yards into the end zone, Oregon led 7–0.

Mannion found tight end Caleb Smith for 31 yards on OSU's next possession, but the Beavers wound up punting, and the Ducks were back in business. This time they moved 85 yards in nine plays, Tyner scoring from 13 yards out for a 14–0 lead late in the first quarter.

A rout, it appeared, could be on. "Everybody else thought the game was over," OSU cornerback Rashaad Reynolds said, "but we kept pushing."

Then the momentum swung. Oregon State was forced to punt, but Oregon's Bralon Addison muffed it and OSU's Ryan Murphy recovered at the UO 23—the first of three Duck turnovers in their half of the field.

On fourth-and-six from the Oregon 19, OSU's Trevor Romaine missed a 36-yard field goal attempt. The Ducks were penalized for running into the kicker, however, giving the Beavers fourth-and-one at the 14. The Beavers went for it, and Mannion's four-yard pass to Cooks made it first down at the UO 10. Storm Woods carried three straight times, the third for two yards and a touchdown to close the gap to 14–7 with 9:35 left in the second quarter.

Oregon went on the move again, Mariota connecting with Huff on a 44-yard deep ball to the OSU 10. Thomas gained only two yards on third-and-

goal from the two, though, and the Ducks settled for a 20-yard Matt Wogan field goal and a 17–7 advantage with 6:39 left in the half.

The Beavers were beginning to find some rhythm with their offense. Oregon's Achilles' heel in its losses to Stanford and Arizona was its run defense. The Ducks entered the game ranked fifth in the Pac-12 at 158.3 yards per game, and Oregon State came in 120th of 123 FBS teams in rushing offense at 72.8 yards per contest.

"We had some things we thought could work with our run game against their defense, and we worked it into the game plan," Riley would say later.

Terron Ward got things started with an 11-yard run for a first down and then got loose for 31 yards to take the ball to first-and-goal at the Oregon 6. A false start moved the ball back to the 11, and passes to Ward for three yards and Cooks for seven gave the Beavers the ball fourth down at the one. Riley chose to play conservatively, allowing Romaine to boot an 18-yard field goal to close the margin to 17–10 with 2:33 left before intermission.

"That brought us within one score," Riley said. "But I also thought we were probably going to kick some more through the course of the game. Trevor needed to find a rhythm."

After the kickoff, Oregon took possession at its 19. On first down, Mariota's pass was intercepted by Steven Nelson at the Oregon 32 with 2:19 still on the clock before halftime. Then came a play that proved costly to Oregon State's upset bid.

On second down, Mannion found Cooks deep down the right sidelines for 31 yards. The ball was ruled down at the Oregon one, and it appeared the Beavers had a first down there. After a long review, though, Cooks was ruled to have fumbled into the end zone for a touchback.

It was the worst thing that could have happened to the Beavers. An incomplete ruling would have given them the ball back at the 32 with time to still move for a score. Had the ball squirted sideways out of bounds, they'd have had the ball first-and-goal at the one. Instead, Oregon took over at its 20.

On third-and-17 from the Oregon 25, Mariota served up another interception, this time to Reynolds, who returned the pick 25 yards to the UO 28. It took Oregon State five plays to find the end zone, an all-alone Ward catching a swing pass from Mannion for the score. The teams went into the half tied at 17–17 but with decidedly different mindsets—the Beavers encouraged by their comeback, the Ducks frustrated they'd let their rivals back into the game.

Oregon took the third-quarter kickoff and got one first down. On fourth-and-one from their 45, Helfrich chose to go for it. Tyner was hit behind the line of scrimmage and fumbled. The ball bounced to Mariota, but he was tackled by Reynolds a yard short, and Oregon State took over at the Oregon 44.

The Beavers moved only to the UO 30, but Romaine's 47-yard field-goal attempt was on target, and they had their first lead at 20–17 with 10:43 left in the third quarter.

Oregon kicked into gear on its next drive, marching 75 yards on eight plays for a go-ahead touchdown. Mariota made two big third-down-and-seven plays, first hitting Addison for 11 yards on third-and-seven and then scrambling for 21 yards to the OSU 37. On second-and-one from the Beavers' 28, Mariota rifled a 28-yard pass to Huff, and Oregon was back on top 24–20 with 7:46 to play in the quarter.

Oregon State responded with a long drive beginning at its 23, the big play a 33-yard pass to reserve tight end Kellen Clute, pressed into duty when starter Connor Hamlett left the game for good on OSU's first possession with a knee injury. On fourth-and-one from the Oregon four, Riley chose to go for it, but Ward slipped as he started to turn the corner around the left side, falling at the five to give the ball to the Ducks.

After an Oregon punt, Oregon State moved to the UO 16 courtesy of a defensive holding penalty on the Ducks. But Oregon's defense stiffened, and OSU settled for a 37-yard Romaine field goal to draw to within 24–23 with 14:45 left in the game.

Thomas returned the ensuing kickoff 34 yards to the Oregon 42 and then had another pair of big plays, rushing first for 20 yards and then 14 more to take the ball to the OSU 24. The Ducks lost two yards in three plays, though, and Wogan's 43-yard field-goal try was wide left.

The Beavers took over at their 26 and immediately went to work. Ward busted 26 yards to the Oregon 48, and on third-and-10, Mannion found Smith for 23 yards to the UO 25. Another long Ward gainer, this one for 16 yards, took the ball to the Oregon four. On the next play, Mannion's swing pass to fullback Tyler Anderson gave the Beavers the lead. Storm Woods's running attempt at a two-point conversion failed, but Oregon State was back in front at 29–24 with 11:05 remaining.

Oregon's next possession was a doozy, an 11-play, 84-yard drive in which the Ducks converted two third-and-longs and a fourth-and-long situation. On third-and-eight from the Oregon 30, Mariota completed a 38-yard pass to Huff to the OSU 32. On third-and-13 from the Beavers' 35, Tyner

busted up the middle for 24 yards to the OSU 11. On fourth-and-11 from the Beavers' 12, Mariota finessed a TD strike on a post route to Huff. The Ducks failed on the two-point conversion but still led 30–29 with 7:56 to play.

True freshman Victor Bolden gave Oregon State good field position with a 36-yard kickoff return to the 38, but the Beavers went three-and-out. The Ducks did the same, though, and Oregon State took over at its 26 with 5:13 to go.

Mannion hit Smith for 23 yards to the 49, and the Beavers moved inside Oregon territory to the 25. On first-and-10, Bolden went right on the fly sweep, got a block at the line of scrimmage, cut upfield and went untouched into the end zone with 1:38 remaining. It was a play eerily reminiscent of OSU's last win in the series, when James Rodgers's 25-yard fly sweep in the second overtime produced a 38–31 win at Autzen in 2007. The Beavers went for two and failed again but led 35–30 as a packed house of Oregon partisans looked on with apprehension.

Later, Nick Aliotti was to reflect, "Giving our offense 1:40 is like giving most teams a whole quarter to score." As the game was dissected in the days following, there was criticism that Bolden should have downed the ball on his way to the end zone. That Riley should have milked the clock to the final seconds, allowing Trevor Romaine to kick a field goal, thereby leaving Oregon little time on the clock.

Riley, in fact, had entertained such thoughts as Oregon State embarked on the drive. "I had just told Sean, 'Don't say anything to anybody else, but use every bit of clock the rest of the drive,'" he said. "I was pointing toward an opportunity to kick a field goal with no time left."

When Bolden broke loose for the go-ahead score, though, that notion went out the window. "You're not going to turn down a touchdown at that point," Riley said.

The Ducks had all three timeouts left. Had they been able to keep the Beavers from getting a first down from that point, they'd probably have had more than a minute left, even if the Beavers converted a field goal. Romaine was officially three for three on field-goal attempts at that point, though he missed a 36-yard try early that was erased by an Oregon penalty. It would have been the ultimate gamble to, in Riley's words, turn down a touchdown.

So after Thomas was able to get the ensuing kickoff back only to the Oregon 17, the Ducks had 1:32 left to negotiate 83 yards, needing a touchdown to gain the lead. They required only 63 seconds.

As they huddled before going onto the field, Oregon's offensive players shared some words. "We practice that situation every day in practice," center

Hroniss Grasu said. "We call it 'Clutch.' We looked in each other's eyes and said, 'This is why we play football. This is where we become brothers. We're going to tell our grandkids about this drive.'"

Mariota's first pass went for 23 yards to Daryle Hawkins, the senior's second catch of the day. Mariota's next strike, for 19 yards, went to Bralon Addison, and suddenly the Ducks were at the OSU 41. After an incompletion, true freshman Johnny Mundt snared a Mariota aerial for 17 more yards to the Beavers' 24, with 58 seconds still on the clock.

On third-and-five from the OSU 19, Tyner picked up seven yards for a first down at the 12. Two plays later, Huff floated across the middle toward the back of the end zone on a drag route, beating OSU safety Tyrequek Zimmerman for a leaping catch on a ball thrown high and behind him with 29 seconds left.

"Quite frankly," Mariota would say afterward, "it was a bad throw. Huff made a great catch. I said, 'Thank you, man.'"

"Best throw he has made all year," Huff said with a smile.

Oregon's two-point conversion was no good, but a 36–35 lead was in the bank.

Oregon State had a last gasp, but it was for naught. Cooks had a great chance for a reception at the Oregon 31 that would have afforded Romaine a field-goal attempt of inside 50 yards, but the junior receiver couldn't hang on.

Soon it was over, and UO students were rushing the field, celebrating with the Duck players who were breathing a sigh of relief as well as exulting in victory.

The 5-11, 200-pound Huff entered the season in his third year as a starter, the presumed go-to guy for Mariota after catching 32 passes for 493 yards and seven touchdowns as a junior. It had been a big-play senior season for the Houston native, who came into the Civil War with 48 receptions for 850 yards and eight TDs. But the emergence of Addison, another Texan (Missouri City) who had 53 catches for 798 yards and seven scores coming into the game, had overshadowed Huff's value to the Oregon passing attack.

Then there were his comments about the Rose Bowl prior to the Arizona game. It left Huff in a bit of an uncomfortable position heading into the Civil War. Huff erased any negative thoughts with the game of his career in his farewell to Autzen Stadium.

"He is a guy who has had a much-maligned season," Coach Mark Helfrich told reporters afterward. "It's really great to see him go out in that style."

"Surreal," Huff said. "It's everything I dreamed of as a little kid growing up in the backyard playing with my dad and my cousins. All week I've been talking to Marcus [Mariota] about any time we're down and we need a big play, just look at me and I'm going to do what I can to get open. To leave on a note like this is amazing."

"The guy is a warrior," Mariota said. "He's been making plays his whole career. I have all the confidence and all the trust in the world in that guy. He made big play after big play tonight."

Huff wasn't of a mind to apologize for his Rose Bowl remarks. He saw his Civil War performance as redemption. "I don't regret anything I said," he said. "That's just me as a competitor. I know a lot of fans turned their back on me...but I came here to play for my teammates...and hopefully I got everybody back on my side. I do feel I gained everyone back on my side."

Tyner, gaining the start with Byron Marshall out of action with a foot injury, enjoyed his first 100-yard rushing game of the season, picking up 140 yards and a touchdown on 22 carries. "I grew up watching this game, so it was exciting for me," Tyner said.

Mariota looked more like himself than he had since donning a protective knee brace in the second half of the October 26 UCLA game, throwing well and running effectively. "His injury was more severe than anybody wanted to let on, including him," offensive coordinator Scott Frost said. "He was still limited, but you saw flashes of what he can do when he's healthy."

Mariota said the final scoring drive was one he'll always remember. "I've had several drives, but that probably sticks out the most," he said. "I just thought about not letting the moment get the best of me. I've always been taught to be calm, cool and collected. To me, it was another drive, but at the same time, you can't overlook what it really meant."

Aliotti, bristling at the idea that Oregon's season was a disappointment, suggested otherwise. "I know it's not exactly where we want to be," he said, "but 10-2 is a good season. If a 10-win season becomes not good enough, we're in a sad state of affairs, because it's hard to win 10 games. Maybe one of these days we'll get to 13 or 14. We all want that. Right now, we could only have been 10-2, and we're walking out of here 10-2."

"Our guys' standard is very different than anyone else," Helfrich said. "If we lose to somebody, it's 'We need to blow up our program.'"

As the game wore on, Helfrich became cognizant of its place in history. "We were talking in the middle of the fourth quarter, that this would be one they talk about forever," the first-year UO coach said. "And it turned into a great finish."

Or a heart-breaking one in the eyes of the Beavers.

"It hurts a lot," Rashaad Reynolds said. "Words can't describe how much it hurts. But I'm proud of my guys. We worked. We fought."

The team that had averaged 72.8 yards rushing per game went for 231 on the ground against the Ducks, Ward leading the way with a season-high 145 yards on only 17 carries. Oregon State had 545 yards total offense, Mannion completing 29 of 47 passes for 314 yards. The Beavers had given themselves a chance to win with an effort that lessened the sting of their listless performance six days earlier against Washington.

"From where we came last Saturday to Friday night was a long way, which is a good thing," Riley said. Oregon State's players "can be very proud. They competed like crazy and played some very good football against a good team and made a lot of plays on both sides of the ball, as did Oregon. We just left [the Ducks] a little too much time to make plays at the end."

When the fly-sweep comparison was made between Victor Bolden's run in 2013 and James Rodgers's in 2007, Riley smiled. "We just need that fourth-down stop by Dorian Smith again," the coach said, the reference to a tackle Smith made on Oregon's Jonathan Stewart on the final play of the '07 game.

When Oregon State's defense went onto the field for the Ducks' final series, "we had to go out and make some plays, and I thought we were going to do it," Rashaad Reynolds said. "But they made more plays than us on that last drive."

The Beavers were playing to win but also to redeem themselves after laying the egg against the Huskies. "We're a resilient bunch," Reynolds said. The Ducks "are one of the top teams in the nation, and we played them good for 60 minutes. Against a high-octane offense like that, we competed. It was competition down to the wire."

Riley didn't want to hear about the Ducks' lousy run defense. "They are not a poor run defense team," he said. "Stats mean something this time of year, and they've been good. Our kids just executed. Our interior five had an outstanding game and the tight ends did a good job, too, which is something we'd been missing. As the game went along, we had more and more success with it, and we built from that."

Riley was left to muse, "It makes you think of what might have been had we been able to be that balanced over the course of the year."

Oregon finished with 568 yards total offense and 283 yards rushing, but those were numbers the OSU defense could live with on a day when the offense came to the party, too. Beaver defenders had nine tackles for

losses, "which was big," Riley said. "The Ducks are so good offensively, but we made a lot of good plays behind the line of scrimmage to put them in tougher positions. It was good to see."

It was a loss but one that told Riley his players hadn't quit on him, as had been suggested by some followers of the program after the Washington game. And there would be a bowl game to look forward to.

Oregon State took care of business, clinching the eighth winning season in the 11 years of the "Riley II" era with a 38–23 victory over Boise State in the Hawaii Bowl. The Beavers, who finished 7-6, raced to a 38–6 third-quarter lead, taking advantage of a balanced offense and a pair of fumble recovery returns for touchdowns by cornerback Rashaad Reynolds.

Sean Mannion and Brandin Cooks wrapped up record-setting seasons.

Mannion set the Pac-12 single-season record with 4,662 passing yards and threw for 37 touchdowns, the latter tied for third on the Pac-12 list while ranking second nationally in each category. The junior quarterback ended the year with 10,436 career passing yards, second in OSU history and 10th on the Pac-12 list.

Cooks, who won the Biletnikoff Award as the nation's top receiver, led the nation in receiving yardage (1,730) and was second in receptions (128) and TD receptions (16), all school records and conference marks in the first two departments. Cooks exited the season ranked ninth on the Pac-12 career receptions list (226) and seventh in receiving yardage (3,272).

Oregon polished off Texas in the Alamo Bowl in much the same fashion as the Beavers whipped Boise State. UO used a pair of defensive touchdowns—interception returns by Avery Patterson and Derrick Malone—to full advantage in a 30–7 romp over the Longhorns, finishing the season with an 11-2 record.

The Ducks showed their prototypical balance offensively, passing for 253 yards and rushing for 216 yards behind one of the top performances of sophomore quarterback Marcus Mariota's career.

Mariota completed 18 of 26 passes for 253 yards and a touchdown with no interceptions but was just as effective with his legs. The Honolulu native carried 15 times for 133 yards—76 in the first quarter alone—while often leaving the Longhorn defenders grasping air.

Oregon's defense more than earned a share of the victory in coordinator Nick Aliotti's final game in a 24-year run as a UO assistant coach. The Ducks held the Longhorns to 13 first downs and 236 yards total offense. Texas quarterbacks Casey McCoy and Tyrone Swoopes combined to connect on only nine of 23 passes for 56 yards.

WHAT THE RIVALRY MEANT

R eflections on the Civil War, in the words of the men and players who participated through the years.

RON SIEGRIST, OSU, 1952–53 and '55, assistant coach from 1956–64: "I never hated the Ducks except one day a year. Playing USC and UCLA was a challenge, but Oregon was the biggest game every year."

JIM SHANLEY, UO, 1955–57: "We never thought too much about the Beavers until we got ready to play them. Then there was a lot of emotion. [Assistant coach] John McKay was a great guy for that. Having played at Oregon, he had some strong feelings. I can remember his pre-game talk about playing the Beavers and how important it was to beat them. It fired everybody up."

JOHN ROBINSON, UO, 1955–57, assistant coach from 1959–71: "The Civil War is in the hearts of everybody in the state of Oregon, and it doesn't need to be on ESPN. It's almost a private feud between the Ducks and the Beavers. I'm talking about the guy who grows up in the state of Oregon, goes to one of the two schools, knows the good times and the bad times. To the longtime Oregonian, it's most significant. As a player, you hated them. They were worse than the Russians or Red China. But time passes, and with Mike Riley coaching there now, I root for Oregon State, too."

BOB "TIGER" ZELINKA, assistant coach, OSU, 1955–64: "The Civil War game was the season, it really was. When I came up with Tommy Prothro [from UCLA], we thought the game we should be concerned with was Washington. After that first year, we realized the Ducks were the most

important opponent. I had one of the best relationships with the Oregon coaches of anybody on our staff. I was in charge of scouting. On several occasions, I'd go out to their alumni meetings and I'd stand up and sing the Ducks' fight song right along with their coaches. We had an outstanding relationship, but I wanted to beat them badly."

FRANK NEGRI, OSU, 1955–57: "I came over from Hawaii. It took awhile for me to get into the rivalry. I didn't get ingrained in it until after I graduated. I really started to hate them then. Maybe I was brainwashed into it. Maybe my thoughts about the rivalry matured. In any case, I got rabid about those Ducks. It just took awhile."

EARNEL DURDEN, OSU, 1956–58: "Oregon was our biggest game every year, no question about that. The guys prepared themselves. We were the best team in the state at that time. We wanted to leave that stamp on it. We were the best on the coast, and we wanted them to know that. "

TED SEARLE, OSU, 1956–58: "There was a strong rivalry between us and Oregon, and it reached over to the student body. They had bonfires, and students would steal something from the other school. Hell no, we didn't hate each other. I got to know the players from Oregon pretty damn good. We became good friends."

TED BATES, OSU, 1956–58: "After the first year at Oregon State, I began to understand what Civil War meant, mostly because of all the whooping and hollering everybody else made. I always wanted to win. They were our neighbors, and everybody at the school made a big deal out of it, and of course that got my adrenaline going. But being from Los Angeles, playing against USC and UCLA were bigger games for me."

JOE FRANCIS, OSU, 1956–58: "There was no bitter rivalry. I got to be good friends with a lot of Oregon players. My wife was from Medford. A lot of Medford kids went to Oregon. I had a good relationship with [Ducks] Jim Shanley and Norm Chapman. I'd say Washington was the team we couldn't stomach. [The Huskies] would try little things to shake you up. They'd come up to you before a game and say, 'Hey, watch out, brother, we're coming.' Or you'd kick a ball into their area and they'd say stuff to intimidate you."

DENNY BRUNDAGE, OSU, 1957–59: "We always pointed to the Oregon game. We tried not to, but even if it was in your subconscious, that was the No. 1 game regardless of where we were in the standings. To this day, I still have the same feeling when we play Oregon. It's just being a Beaver. Nothing against the Ducks, but there's that competitiveness. When I was playing, both teams had a lot of players from the state of Oregon. Some

of them were friends, guys like Jim Shanley and Joe Schaffeld. You wanted to do well. Now, we go to the beach with the Schaffelds every summer."

JACK CRABTREE, UO, 1957–59: "When I was playing, Oregon State wore on you after awhile. You didn't like the Beavers. That hasn't totally changed. I have a lot of Beaver friends. I belong to the Eugene Country Club, and a lot of those guys are Beavers. I give them hell about it. John McKay used to say, 'You can win all your games and lose to the Beavers, and you'll never be remembered. Or you can lose all your games and beat the Beavers, and you'll never be forgotten.' I used that one time when Rich Brooks had me speak to the team."

BOOKER WASHINGTON, OSU, 1962–64: "I understood even in my first year that if we didn't win a game all season, we had to win the Civil War game. You knew the history and felt you had to live up to that. I remember the coaches saying, 'There are players you will meet one day who played at Oregon State. You want to be able to hold your head up by saying you won this game. It's your last game of the year. You better make sure you do everything you can and play like hell, because it will be remembered.' I had a respect for the Ducks. There was no room for hating 'em. Hating 'em wasn't going to win us a game."

RAY PALM, UO, 1963–65: "I had friends at Oregon State. Paul Brothers was my quarterback in high school. It was like playing against your brothers. Washington was a bigger game. [Athletic director] Leo Harris and [Coach] Len Casanova, they just hated the Huskies. They conveyed that to us. They were dirty players—a lot of hits after the whistle, hitting guys away from the ball, stuff like that."

DICK WINN, UO, 1964–65: "We hated the Beavs. Hated those guys. Then my fifth year at Oregon, I was a grad assistant on the freshman team, and I played on a semipro team called the Eugene Bombers. There were some guys from Oregon State on the team, and you know what we found out? They weren't near as big pricks as we thought. Actually, we hated the Huskies more than the Beavs. Today, I pull for the Beavs in every game except when they're playing us. They have a great program over there. They're the enemy, but they put their pants on one leg at a time, just like us."

MIKE BRUNDAGE, UO, 1964–66: "When I played, recruiting was a lot different. It was very important to win the Civil War because we had so many Oregon kids on both teams. I didn't work up a real dislike for the Beavers. My brother had played at Oregon State, and I knew everybody over there. Who could dislike Paul Valenti? Bill Harper had been my high school baseball and basketball coach. Jim Jarvis and I played basketball and

baseball together. Good people all. The Washington game was more bitter than Oregon State, at least for me."

PAUL BROTHERS, OSU, 1964–66: "My sons played for Oregon. But become a Duck football fan? I did not. I wanted my kids to do well, but I was never able to pull myself together to cheer for the Ducks. I'm proud of the Ducks, don't get me wrong. They have a great program now. It's amazing what money will buy. During my time, it was the biggest game of the year for me. It's great to have been 3-0. Friends of mine who are Ducks will start talking and I'll say, 'But we never lost to you guys.'"

THURMAN BELL, OSU, 1964–66: "You were playing for your reputation in the state of Oregon. At the time, I didn't realize what a big deal it was going to be. In my five years, we never lost to the Ducks. I'm really proud of that, and it becomes more rewarding and more important the older you get. Dee Andros emphasized it, saying we were the farm boys and the Ducks were the city boys. They were the haves and we were the have-nots. But Tommy Prothro felt the same way. Those were the kind of games you lived for as a player."

JOHN DIDION, OSU, 1966–68: "Growing up in the Bay Area, Cal-Stanford was the biggest thing in the world, but it's nothing compared to the Beavers and Ducks. The night before the Civil War, we would have a roast duck meal, and the coaches had the ducks dyed green. They didn't miss a trick. Nowadays at get-togethers, they ask, 'Would everyone who never lost to the Ducks stand up?' We take such pride in that. It's almost impossible to describe how intense the rivalry was. We pointed to every game but especially that one. I have a hard time imagining anything more intense than the Civil War. I played in the Redskins-Cowboys and Saints-Falcons games, but nothing comes close to Oregon–Oregon State. I played professionally with a couple of Ducks, Bob Newland and Andy Maurer. Great guys. But I still don't root for the Ducks, and I never will."

DENNY SCHULER, UO, 1966–68, coached at Oregon from 1986–92, coached at OSU in 1996: "When I played, we were reminded often that we were the second-class citizens of football in the state, that Oregon State was clearly the best team. That hurt. Our goal was to get to their level. Our coaches were always prodding us to try to match up with them. I think over the years, the Civil War has been a huge game for the team that has been losing. I've found it to be a great rivalry, very intense, unlike Stanford-Cal, where fans are going to have a glass of wine and observe the game."

JESS LEWIS, OSU, 1966–67 and '69: "It was always a real battle. We never lost to the Ducks. That felt good. They were always cocky, strutting

around. It seems like they always thought they were a little better down there, and I don't know why. I have a sign in the driveway on the side of my house—'No Ducks or Huskies allowed.' Only Beavers. The Huskies were kind of fancy-pants, too. We didn't dislike them as much as the Quackers, though."

GEORGE DAMES, UO, 1966–68: "It still bothers me I never beat the Beavers. It bothers me more than losing to any other teams. I guess 'dislike' is the right word for how I felt about them when I was playing. There was just a bad feeling about the Beavers in several different ways—the way they acted, the way they put their clothes on, the way they played their game. Maybe it's just that I liked yellow and green better than orange and black. My junior year, the game had stopped because of a penalty. At the top of his lungs, [OSU quarterback] Steve Preece yelled, 'Dames, you're bush!' He was frustrated. He disliked us, too."

JON SANDSTROM, OSU, 1966–68: "I hated the Ducks, and I still do. The Civil War was the game. Even if we had a great year, the thing we wanted to do more than anything was beat the Ducks. If somebody from Oregon starts giving me too much trouble today, I can quickly remind them we never lost to them."

CLAXTON WELCH, UO, 1966–68: "I wanted to beat the Beavers more than anybody, but I admired and respected them. I never beat them in a varsity game, but we always played them tough. We played well against them, but we never won."

BILL ENYART, OSU, 1966–68: "To this day, I feel Oregon State is by far a greater institution than the U of O—the curriculum, the tradition, the campus. On my recruiting visit to Oregon, those guys were party-hearty types. I stayed in a dorm, and at the end of the night, guys were breaking lights out of the dorm. I came from a blue-collar, working-class family with conservative values. We'd have fun but didn't believe in damaging property. Believe me, I did my share of partying at Oregon State, but the school fit my personality.

"I rooted for E.J. Singler when he played [basketball] at Oregon, because he's a Medford kid, but I don't root for the Ducks. In the state of Oregon, we have to share the road, share the office with Ducks. It's more personal pride, and it's a metaphor for competition. We never lost to the Ducks. That was the most important game by far to all of us. The thought of losing the Civil War made us sick to our stomach. It's been a great disappointment to me and to Beavers everywhere that we've lost several years in a row now. They have a sugar daddy, they have a lot of

money, they're the Yankees of college football, and to have not been able to beat them has been disappointing."

ANDY MAURER, UO, 1967–69: "I don't know if I understood the rivalry until later. I remember being in Atlanta with Bob Berry and talking about Civil War week. Everybody in the [Falcons'] locker room was like, 'What, is USC playing Notre Dame? Texas vs. Oklahoma?' We said, 'No, the Ducks and the Beavers.' They said, 'Who?'

"At that time, it was important to the state of Oregon only. I enjoyed it more when my son [Marty] played. I'm sitting there with a full house at Autzen Stadium and it's the biggest game in the state of Oregon, and you get to be part of it. When you play nine years in the NFL, you have bigger games than the Civil War. Today, when I get with Ducks and Beavers, it has value. When I'm not, I never think about it. When I was at Oregon, we got really good at almost winning them. We just never did."

BILLY MAIN, OSU, 1967–69: "Including freshman ball, I went 5-0 against the Ducks. What we accomplished during the Giant Killers year was amazing, but never losing to the Ducks is right up there. The nature of what happened on the field against the Ducks was different than all other opponents. The only team that comes close to that was the Huskies because they were kind of like us—really tough, hard-hitting, disciplined. There was always borderline bad blood on the field against the Ducks. I remember thinking, 'This is more than a rivalry. These are guys who don't like each other.' Whether that was real or imagined, I don't know, but against the Ducks, each play felt like a game because of the pressure. You always had a packed house, there was tremendous emotion and the ramp-up to the game under Dee Andros was always incredible.

"During the Oregon games, there was nothing illegal, but there was a lot of wrestling around. As a pile would unfold after a play, there were little comments. We were taught to keep our mouths shut; don't interact with the other team. The Ducks always had a mouth on 'em. I remember that distinction. It had something to do with the character of the team. That was the nature of the Oregon–Oregon State rivalry in those years. Oregon was a renegade team—clearly not as good as we were, and they had a different culture, the way they played. We were more like the ex-marine, Dee Andros, a junkyard dog, get-the-job-done culture. That cultural difference still exists today."

BRYCE HUDDLESTON, OSU, 1968–69: "I remember the rivalry a lot from basketball games. Somebody put a live duck up on the catwalk at Gill Coliseum one game. They had to stop the game to go up and get the

duck down. I was there the night [Oregon coach] Dick Harter tripped our cheerleader, Rick Coutin, who was carrying the Chancellor's Trophy. My seats were four rows behind the visiting team's bench. When it happened, there I was, 5-2, and I got in Harter's face. I grabbed his shirt and was nose to nose with him for a second before cooler heads prevailed. Now, I have respect for the Ducks, but I'm a Duck-hater, too. It's nice to be able to say I never lost to them. But it's not the apex of your life."

KEN WOODY, UO, 1968–70: "When I was a freshman, our coach was Norm Chapman. He just hated the Beavers. We were behind at halftime, and Norm was walking around, smoking a cigarette, saying, 'Tom Blanchard, you're an All-American? Horseshit! Andy Maurer, you're an All-American? Horseshit!' Then he takes a drag off his cigarette and screams, 'I hate those people!' I was so fired up. We had to punt right after that, and the Oregon State guy called a fair catch, and I went in and just leveled him, and there were like four penalty flags. I came off the field and Norm said, 'Great hit, great hit.' Getting late hits against Oregon State was OK in his book. The last Civil War game Norm coached, the Ducks lost at Autzen in 1971. Some Oregon State fan gave him a bunch of crap at the end of the game, and Norm decked him. Charges were filed. They got dropped, but there was a little bit of a hullabaloo." [Said Chapman, who played at Oregon from 1955 to 1957 and coached there from 1966 to 1971: "You have to understand, Ken can embellish stories. I'll leave it at that."]

More Woody: "I redshirted in 1967. The Ducks led that game 10–0 in the fourth quarter before losing 14–10. In the locker room, Jeff MacRae threw his helmet against the cement, and it exploded. I went, 'Holy shit, this is serious.' Afterward, my parents were taking me to dinner. We get to the restaurant parking lot and there are two couples in their 70s, and everybody is drunk. One guy is wearing an orange and black beanie hat, the other guy a green and yellow scarf, and they're trying to fight. They're old, they're drunk and not very good athletes. That was my introduction to the Civil War.

"For a long time, I hated the Beavers, just despised them. I understand this is irrational, but it's all part of the rival deal. There was a cultural difference. They were the unsophisticated guys who would roll up their sleeves and get after it. Even now, they have a lot more guys on their team from the state of Oregon than the Ducks do. It seemed like that game meant more to them than it did to us. When I started working for Fox Sports and had an opportunity to know and work with Steve Preece, he's one of the best guys ever. So is Bob Grim. I root for the Beavs now every game but two—the Ducks and the Cougs. They're on their own in that one."

MIKE NEHL, OSU, 1968–70: "I was a big Oregon fan growing up. I had a Mel Renfro jersey. The Ducks didn't offer me a scholarship. Then I went to Oregon State and met Jess Lewis and some other players and was enthralled with how nice and normal they were. I bought into the whole rivalry thing. It was black-and-white. The Ducks were our adversary. Dee Andros would always say, 'Don't forget who you are, who you represent.' It became a very big deal to me. I remember thinking I wanted the distinction of never having lost to the Ducks. It feels good to be able to say that now."

BOB NEWLAND, UO, 1968–70: "When I was growing up, the Civil War was a huge deal. I never played on a varsity team that beat the Beavers. If you don't win the game, you have nothing to say. Losing to the Beavers is a bitter pill. I worked in the summer at Georgia Pacific plant for two summers while in college with [OSU player] Dan Zellick. We got to be friends.

"I have a very fond memory of Steve Preece. He called me after I got drafted by New Orleans. He'd just been traded to Philadelphia. He said, 'If you want to come up to Portland and work out with me in preparation for training camp, I could share a few things that might help you with the Saints.' I did that. We worked out together at the MAC club. Here's a guy I've never met before, one of the great OSU players, and he calls up a Duck out of left field and does a very nice favor for him. He also made a call on my behalf to some of his buddies in New Orleans. The rivalry may be bitter, but friendships can be formed that go on beyond that. I pull for the Beavers when they're not playing the Ducks. But it would have been nice to at least have beaten the Beavers once."

CRAIG HANNEMAN, OSU, 1968–70: "I always felt bad that Jerry Frei got canned by Oregon because he could never beat the Beavers. He was a good man, a good coach and had great assistant coaches. But I never felt bad about us beating the Ducks. That's what Dee Andros bred into us. Yeah, we really did hate the Ducks—and still do. Most of my teammates still do feel that. It never goes away. The intensity is still there. The opulence of their facilities, the sense of entitlement their fan base has…When you try and find ways to like the Ducks and admire the success they're having, everything about them today represents more what's wrong with college athletics than what's right. In the greater scheme of things, it's not that big. But when you're around your old teammates, it's with a great sense of pride we can say we never lost to those bastards."

GREG MARSHALL, UO, 1968–70: "I hated the Beavers. Didn't like them at all. Still don't like them. Tolerate them. Wish them the best of luck most of the time but generally don't like 'em. Something about the colors

and the school and that kind of stuff. I really don't want them to win. I never beat the Beavers. I don't know what that feels like. It still bothers me. We should have beaten them, but we never did."

MARK DIPPEL, OSU, 1968–70: "There was such intensity in those games. I remember being [in the hospital] during the birth of my children. Playing the Civil War was almost that same intensity, that same meaning in your life. I respected the Ducks in those years, guys like Tom Blanchard and Greg Brosterhous. They were friends and terrific athletes. The hatred came later, during the period when they took pleasure in beating you every year and Washington became a bigger rival for them. They piled on top of it. I couldn't stand them. Craig Hanneman, Scott Freeburn, Bob Jossis and I have sat together at games for 30 years. When Ken Simonton scored the touchdown to win the 1998 Civil War, there were four guys in their 50s, crying like teenagers. You could hold your head up again and not worry about moral victories."

SCOTT FREEBURN, OSU, 1968–70: "I never lost to Oregon. I've been happy about it my whole life. Nothing diminishes that. Dee Andros fostered that success in all he did with regard to that game. There are a whole lot of Ducks during that period who never won one. That still gives me a warm feeling. I didn't have much use for the Ducks. I always badly wanted to beat them. We felt that even if we went out with a little lesser talent, we'd still beat them. We were way more competitive. As an Oregon kid, I felt like I was in the right place. I've always been glad I went to Oregon State rather than Oregon. Going out my senior year with a Civil War victory was a crowning glory to my football career. I came out of that experience with three really close friends. We took our experience together in the Civil War and welded it into something that has been lasting."

CHRIS VEIT, OSU, 1969–71: "We knew they had good players and it was a big rivalry, and we were going to win. We didn't care how many All-Americans they had on their team. It was a duel between two philosophies. Oregon State was hard-nosed, grind-it-out, the agricultural college. The Ducks were a liberal school with a pro-style passing attack. We respected them but felt we could win the game. To this day, when sometimes the fans have all this hatred, I think, why? Players from both teams are out there giving it their all for their school."

JEFF KOLBERG, OSU, 1969–71: "Oregon recruited me. I remember going to dinner at the Kontiki [Restaurant] in east Portland with my parents and the Oregon coaches. They tried, but that was never going to happen. My parents, my brother and sister were all Beavers. There was no doubt where

I was going. If you weren't going to win the Pac-8 title—and we weren't—you wanted to beat Oregon. I ended up good friends with several of the Oregon players. It was always fun. When it was all over and you realized what you had done, it was a phenomenal feeling to know you beat Oregon. For another year, no matter what else happened, you still beat Oregon.

"Today, I hate 'em. I've thought they were the effing Ducks all my life—I didn't know they were the Oregon Ducks. When they played other teams, we wanted them to lose. When they played us, we wanted to beat them bad, and I'm sure they felt the same way about us. It's been a great rivalry over the years. The whole state gets involved, the students get involved. The neat thing about it over the last 15 years or so, the games have meant something on a national scope. When I played, it meant a lot to the players but to nobody outside the state."

JIM SHERBERT, OSU, 1969–71: "I don't dislike the Ducks. I hate the Ducks. To this day, I own nothing green. Not a pair of socks, not a T-shirt, nothing. Dee Andros created the environment. The Ducks were the guys down the road that you just don't lose to. I never did, except as a freshman, when we played Oregon twice and lost one of them. That still haunts me."

AHMAD RASHAD (BOBBY MOORE), UO, 1969–71: "When you live in Oregon, you learn that the Civil War is as big as any state game in the country. There may be as big, but there is no bigger. It's so important to the people there. That's where it counts. It's the biggest sports event the whole year in the state. There's so much pride. It's a bitter rivalry. That was the biggest disappointment of my college career, not beating them. We didn't get it done.

"As much as we hated them and really wanted to beat them when I played, now I'm so proud of the Beavers. Oregon has two good programs. We have both represented the state well. If Oregon State wins, I'm happy. If Oregon wins, I'm even happier. And when it comes down to those two playing each other, you just never know. No matter what, Oregon State is going to give you a heck of a game. The Beavers could be 1-9 and they're still a tough opponent. You look at the history, there have probably been more upsets than you can imagine. My stomach is always in knots when the Oregon State game comes up. You can't look at that game and say, 'OK, here's a win.' The Beavers will play as hard as they've ever played."

STEVE BIELENBERG, OSU, 1969–71: "There are a lot of rivalries in college football but probably none with more visceral hate than the Beavers and Ducks. To this day, I couldn't go to a Duck football game. I could go, but would I enjoy it? I'd rather go have my teeth pulled."

TOM GRAHAM, UO, 1969–71: "My son played at Colorado. The big rival was Nebraska. It was a fierce, nasty thing. I tell him that game paled in comparison to the hatred we had for the Beavers and I'm sure they had for us. Once at a basketball game in Corvallis, they cut a duck's head off and threw it on the court. At least that's how the legend goes. And yet you couldn't do that to the beaver, because it was the state animal.

"We just hated those guys. A good friend and former teammate of mine with the Broncos, Marv Montgomery, is always kidding me about the rings and blankets he won while at USC. I say, 'Yeah, but in three years, you never beat the Ducks.' I'm 2-0 against USC. Yet I can't say that about Oregon State, which was nowhere near the team USC was. We never beat a team we felt we were better than, but they proved on that day they were the better team. You have to give the devil its due, I guess. But I still don't like them. I live in Colorado. If I see an Oregon license plate, I pull up and ask, 'Duck or Beaver?' If they tell me Beaver, I don't even say anything. I roll up my window."

STEVE ENDICOTT, OSU, 1969–71: "I probably would have gone to Oregon, but [the Duck coaches] backed out on me during the recruiting process. During my years, the Civil War was hugely important for all of us in the Oregon State program, but it wasn't that big of a deal to me personally. We were just playing. My perspective has changed so much over the years. When Rich Brooks was coaching there, I rooted for them. I don't now. I don't care about the Ducks. I root for the Beavers."

FRED MANUEL, UO, 1970–72: "From day one, you hated the Beavers automatically. I didn't want to go to Corvallis for no socializing. I wouldn't buy nothing orange. Even after I got done playing, I hated Oregon State. There was some bitterness in me.

"I've grown up a little bit and realize they were just like we were. Maybe because we beat them my senior year, I'm not in awe of them anymore. I had respect for Dee Andros, the Great Pumpkin. He got his kids motivated to play. Even though they were out-talented by us, they came to play. They were hard-nosed. Man to man, they were going to take you on. Three yards and a cloud of dust, they'd keep pounding."

GREG SPECHT, UO, 1970–72: "I didn't have any animosity toward Oregon State. When I was in high school, I was in the stands at Parker Stadium for the USC game in 1967. I liked Dee Andros. He came to Salem all the time and would chat up the parents. The thing that bothered me when I got to Oregon was we got the crap beat out of us eight years in a row. We didn't like Washington at all, either, but the Civil War was the biggest deal.

"I always wanted to beat the Beavers bad, but I don't hate them. My uncle went to Oregon State. My daughter went to Oregon State and married an Oregon State kid. Their oldest child loves Oregon State and hates the Ducks. To the credit of the Oregon boosters, Oregon supports Oregon State in most everything. I don't feel that same level of support from Oregon State boosters toward Oregon. We have a benefactor they don't have. Our athletic programs have evolved in different ways than theirs have. But I can't tell you how much I was rooting for [the Beavers] when they won the national baseball title. I'll root for them unless they're playing them."

TIM STOKES, UO, 1971–72: "The importance of the game was all out of whack when I was there. Part of it was Oregon State had beaten us eight years in a row by the time I was a senior. That irked a lot of us. So many close games could have gone either way. There was never a bowl game on the line, so the game seemed to grow in importance.

"It always amazed me the depth of passion the community had for the game. I grew up in the Bay Area, but the Stanford-Cal game doesn't come anywhere near the Oregon–Oregon State game. I played in the Redskins-Cowboys and Packers-Bears games, and those were pretty intense, but nowhere near Oregon–Oregon State. I come from a broken family. My wife and son-in-law went to Oregon State. He worked as a manager for the football team under Mike Riley. My daughter played basketball at Oregon State. I have only one child who was a good Duck—my son, thank God. I don't like the Beavers."

DON REYNOLDS, UO, 1972–74: "I grew up in Corvallis listening to Dee Andros talk about the Civil War being for the right to live in the state. I knew some of our guys at Oregon did not get that concept because of where they were from. I understood that it was a big deal. Some of the guys began to figure out a little too late that it was more than just a regular football game. The emotions people have in Oregon about the game is real. I like to see Oregon State be successful in things, but when it comes time for the Civil War, there's no question I'm a Duck. I made a choice when I was in high school, and that hasn't changed. I love my Beaver friends, I care about the Beavers, but I wear green and yellow proudly."

BRUCE JENSEN, UO, 1975–77: "I was from Albany, and it was a tough decision between Oregon and Oregon State. I always had a good feeling about Oregon State. [OSU center] Greg Krpalek and I were real good friends. Neither team was very good, but we won every Civil War. For us to win that last game was a big deal in each of those years. I probably felt sorry

for the Beavers. They weren't any better than we were, and they lost the last game of the season. We went out on top and usually played pretty well."

KYLE GROSSART, OSU, 1975–77: "Being from Sacramento, I didn't quite have the Oregon vs. Oregon State mentality. But you got the message real quickly from the older players. The environment in the Civil War game was electric. I'd never experienced anything with that kind of emotion and passion. It was a real big deal. You could win that game and feel good about a lot of things. I didn't have that internal hatred for the Ducks as a player.

"As I've grown older, I've come to hate them. I've been in places where Ducks and Beavers are watching the games together, and there's a different attitude. It's emotional to me. There's an arrogance to the whole Duck thing that I despise. I work with a long-standing Beaver who grew up in Corvallis. He hates—with a capital H—the Ducks. With Chip Kelly out of there, maybe I'll ease up a little on them. I had a lot of respect for Rich Brooks. That took the edge off of me for a long time. The last 10 years, I've loved to see the Beavers beat Oregon in anything. I've never been close to an altercation with anyone in a sports bar, except with an Oregon Duck fan, and that's when my mom was there with me."

STEVE COURY, OSU, 1976–79: "I don't have any good Civil War memories. They were all competitive games, but when you lose them, you try to forget them. The last one, I remember the seniors saying, 'We can't leave this place having never beaten those guys.' I wanted to walk out of there one time with a victory, but we were not able to do that. The thing that is memorable is the week leading up, what a big game it is, how many people care about it. In the state, you're either a Duck or a Beaver. You can really feel that."

STEVE GREATWOOD, UO, 1977–79, assistant coach at Oregon from 1982–94 and 2000–current: "I'd have been a Beaver, but when Dee Andros got fired and they hired Craig Fertig, I never heard from them again. I never lost to Oregon State. I still take a great deal of pride in it. Including coaching, I didn't lose until my 10th Civil War, a pretty good string. Back in those days, it was like two starving dogs scrapping over a bone. Some of those years, it was to avoid finishing dead last in the conference. I've never had any kind of hatred for Oregon State. But it's a goal of myself and everyone else in our program to win the last [regular-season] game. That's usually against the Beavers."

RUDY GUICE, OSU, 1978–81: "My freshman year, I really didn't know much about the Civil War or the Ducks. I remember the buildup to that game, the speech from Dee Andros, from former Beavers and our seniors.

Still didn't register. The next year at Autzen Stadium, after pre-game warm-ups, we went to the locker room and mothers and kids spitting on us, cursing at us. I remember thinking, 'I don't like those people who really hate us.' It hit me then what the Civil War was really about.

"It was by far the biggest game on our schedule. We never won one, but I remember giving that extra. All of us did. You could feel the energy of the crowd. If I had to do it over again, I'd muster up and play even harder. There was a healthy respect among the players from both teams. I do remember one of our tackles, Craig Spiegelberg, getting into a fight during one of the games. He was the most mellow guy. For him to mix it up with somebody, it was like, 'Whoa, this must be important.'"

ED HAGERTY, UO, 1978–81: "I will cheer for all Pac-12 teams out of conference. In conference, I'll always cheer against the Beavers. I always want Oregon to be the team, to get the best kids in the state. Mike Riley has done a wonderful job at Oregon State. Everything you hear about him tells you he is a quality guy. I wish him the best of luck—just not against Oregon or against the other Pac-12 schools."

NICK ALIOTTI, UO, grad assistant 1978, assistant coach from 1988–94 and 1999–2013, assistant coach at OSU from 1980–83: "I knew right from the get-go how important a game the Civil War was under Rich Brooks at Oregon. There was no doubt there was something different about that game. Today, after coaching for Chip Kelly, I have mixed feelings. Here's why. I hate to put one game above the other. They all should be of equal value. You should always want to play your best. But at the same time, it feels a lot better if you have a year where you don't have to hear about how the Beavers beat you. I'm talking out of both sides of the mouth, aren't I? I've been a Duck for five different decades. It still means something to me. It even means more. You don't coach any harder or better, but more than any other game, you don't want to lose that one."

ERIC PETTIGREW, OSU, 1978–81: "I hated to accept the Ducks were better than we were. It has taken 'til now to admit that maybe they were a little better program than we were. We had respect for them, but we absolutely hated them. It was what we had been trained to do. They were the Ducks. Once you put that orange on, it just comes with the territory. We hated Autzen Stadium. A beautiful stadium but a most disgusting place to play. I still hate the Ducks. I have to admit it. Once you get inside their den and start meeting everyone, they seem like decent people. I have a guy who can suck me into any Civil War bet. I'll do a $20 bet. There's no way in the world I will turn down that bet. There will be a day again when I win."

NEIL ELSHIRE, UO, 1978–79: "I knew a lot of the guys on the other side, but to me, it wasn't that much more important than any other game. We didn't lose my two years. The goal was to not let them score, and we beat them 24–3 both times. But I wanted them to win the other 10 games. I've always rooted for the Beavers any time we didn't play them."

ED SINGLER, OSU, 1979–82: "When I played, I absolutely hated them. That was the biggest game of the year for us, no doubt. That was a tough four-year stretch, not being able to contribute to turning the program around. Today there's a stigma with me. Thirty years later, I can have fun and laugh with everybody, but it hurts knowing I never beat the Ducks."

GREG MOSER, UO, 1979–82: "Oregon State had made intentions they were going to offer me a scholarship. My sister was going to Oregon State, and my dad was a veterinarian who had done some speaking at the school. [Coach] Craig Fertig pulled the offer at the last moment, left me high and dry, but still wanted me to walk on. I went to Oregon a little bit out of spite but more because Coach [Rich] Brooks and his staff were honest. Had I gone to Oregon State, I'd have won three games in four years. I think it turned out a little better. The Civil War game was huge for me, and there was a little bit of a chip on my shoulder.

"It's very gratifying to have never lost to those guys. It was pretty intense. Every year, it was always going to be their year. They had been disappointed with their performance throughout the season. This was the game that could give them a good taste through the off-season. We ended up getting the best of them every time."

MIKE WALTER, UO, 1979–82: "Growing up in Eugene, my dad and I went to all the Oregon games. When the Ducks were away, we'd hop in the car and see a Beaver game. We were all Duck fans, but we cheered for the Beavers. I had a younger brother and sister who went to Oregon State, but they were always Duck fans. I love what Chip Kelly did at Oregon, but I missed that he didn't believe in rivalries. In a way, it's a little bit sad. That's not to say all games aren't important. But there's something about a natural rivalry."

JIM WILSON, OSU, 1980–81: "My grandfather was the dean of health and physical education at Oregon. There's a building named after him on campus. When we were growing up, my stepdad was a big fan. We'd go to all the Duck games. My three brothers all went to Oregon. I was interested in Oregon, but growing up in Corvallis, I was always really a Beaver. I wasn't a Duck-hater. I knew guys there and liked them. But in competition, you want to beat your friends bad. Even today, in my role as a broadcaster, I don't like

the name-calling and all the fan stuff. But I feel all of the tension and the stuff that surrounds the game more than I ever did as a player. When it's a Civil War game, it changes everything."

RYAN ZINKE, UO, 1980–83: "I always wanted Oregon State to win except in the Civil War. I didn't hate the Beavers. When I played, neither team was premier. The big dog in the house was either Washington or USC. What you didn't want to do was go into the next season after getting beat by Oregon State. It was always a spirited game. I felt fans on both sides were great fans. Now, it's clearly one of the best rivalry games in the U.S. The fans are enthusiastic, the stands are packed. When a team walks off unsuccessful, there's not a hatred. It's more like, 'OK, we're going to work hard and get you next time.'"

GARY ZIMMERMAN, UO, 1980–83: "We weren't very good in my years. The one ray of light was we never lost to the Beavers. It took me one season to get into the spirit of the rivalry. It was made very clear what that game meant to us and the program and the state. But I didn't really hate the Beavers. I hated Washington. The Huskies were just so cocky. They had purple towels in the visitors' locker room. They'd taunt you when you came through the tunnel, and the fans were jerks. They're easy to dislike. They've been getting payback, thank goodness. A lot of Duck whippings.

"I remember driving into Parker Stadium for the first time on our team bus. It looked like a high school stadium. I was shocked. The Beavers' program has come a long way. I give Mike Riley a lot of credit for that. It's amazing how they've done it with the disparity of financial support, how far they've come on hard work and developing their players. My daughter, Kelsey, plays volleyball at Oregon State. I thought it was good for her to go somewhere different and make her own name."

MIKE JORGENSEN, UO, 1981–84: "I liked Oregon State coming out of Ontario High. It was 50-50 between the Beavers and the Ducks. My mom's favorite was [OSU assistant coach] Dave Campo. When he left midway through the recruiting process, they brought in Bobby Roper. I was not a fan of his. I was always impressed with [UO assistant coach] Joe Schaffeld, who was from Vale, near Ontario. It swung Oregon's way.

"The Civil War meant everything. During those years, we weren't very good. That was our bowl game. There were a lot of in-state players on both teams. Once a year you got to try to beat up on each other pretty good and have one thing you could brag about at the end of the season. With Rich Brooks as the head coach, there was a real hatred for the Beavers. I hated

them. It mellows with age, but it was real. I participated. Washington was a big one, too. They were the big brothers. But there was nothing like the Civil War. I knew I'd live in this state the rest of my life. By God, I could never lose to those guys. I didn't want those guys bragging about beating me when I was 50."

RON HELLER, OSU, 1981, 1983–85: "Oregon didn't recruit me. I was mad. That's where I wanted to go. Rich Brooks went to high school with my mom. I wrote him a letter saying I wanted to go to his school. He never wrote back. That was the start of my hatefest for Oregon. Civil War week was crazy intense. It was so much fun, with all the on-campus stuff, the students rallying around you, the coaches doing special stuff, bringing former players back to talk or the Great Pumpkin giving you his classic speech. I hated Oregon. Still do. I live in Southern California, and everywhere I go I see the yellow 'O.' It makes me sick that everyone's jumped on the bandwagon. Money will buy you a lot of fans."

DAN WILKEN, UO, 1981, 1983–85: "Joe Avezzano didn't recruit me, and it just felt like there was something that was wrong with him as a coach. He felt phony. I was a Duck fan growing up in Eugene. I wasn't an Oregon State fan. It would have been really hard to go there. It was two different schools, two different philosophies. Eugene was a bunch of Birkenstock-wearing, tree-hugging liberals. Corvallis was much more conservative. It was an ag school vs. a liberal arts school; engineering vs. architecture. I never understood why anyone would want to go to Oregon State. So I wanted to win the game and show we were better.

"My freshman year, one of their guys took a cheap shot at me on a kickoff while I was standing out of bounds after the ball had been blown dead. He earholed me, almost knocked me out. I saw him running off the field high-fiving his teammates. I always felt they were cheap. You always wanted to drum them. The rivalry between us and Washington was bigger, but you still had to strap it on and have your head on a swivel against the Beavers, always watching, because you never knew."

DON PELLUM, UO, 1982–84, assistant coach from 1993–current: "When I played, it was bigger than any other game. The games were always hard. Neither team had a great record. If you won the Civil War, you could puff your chest out. Rich Brooks did a tremendous job coaching that game. He would lose his fricking mind. It oozed out of him. He'd have you ready to kill somebody. Mike Bellotti would have you sky high, but he wouldn't be sky high. He'd appeal to that man inside of you. It's really neat for fans from the 1970s and '80s to see what the significance of the Civil War is now, both in

teams are the Ducks and whoever plays the Beavers.' When it comes to the Civil War, it's a good thing to be a Duck."

ANTHONY NEWMAN, UO, 1984–87: "I went to the Craig Fertig summer camp in the seventh grade in Corvallis. I wanted to play running back at the camp. I wasn't getting a lot of run at running back. It was the longest week of my life. I didn't get an opportunity to do anything. A coach came to me and said, 'You look like you didn't have a good time. You might think about playing another sport. Football isn't for everybody.' I'll never forget driving back with my parents, crying, thinking I'm going to come back here and beat these guys some day. From that point on, I couldn't stand the Beavers.

"They recruited me out of Beaverton High, but we stopped it early. My dad told them, 'He doesn't want to go to Oregon State.' After I got to Oregon and played in the Civil War, every time I hit somebody, it was for back in the seventh grade. There are only so many guys who can say, 'I never lost to the Beavers.' I use that all the time. I respect Oregon State and all the players who were there when I played. It wasn't about the players. It's about that incident in seventh grade and the Oregon State fans who talk about their Beavers. That always gets on my nerves. They think they're the best, and they're not. They always say, 'We're going to beat you this year.' Well, no you're not."

ROBB THOMAS, OSU, 1985–88: "There was a special intensity to the game and how much our seniors cared. Every time you walked off the field after a Civil War game, you'd look into the helmet of a senior and see him crying. For most of the guys, it was the last time they were going to play football. It was really important to go out with a win. I feel fortunate to have done that. I still can't stand the Ducks, I really can't. I can respect what they've done with their program, but I feel the same way about our program. It's neat to see both be top-25 teams consistently."

MATT BROCK, UO, 1985–88: "The Civil War was always fun and intense. It was our focus, though as time went on, Washington became the main rival because we kept dominating the Beavers. The Huskies were like the stepbrother, and their fans were so bad, we had a chip on our shoulders about them. But I absolutely hated the Beavers. I remember thinking they shouldn't be on the same field as us. Rich Brooks and all the old Ducks would talk about how much they hated the stinking Beavers, and you'd go with it. You'd feel bulletproof and psychotic and want to go out and kill somebody.

"My high school daughter asked me, 'What happens if I go to Oregon State?' I said, 'I'll cheer for you if you play athletics, but I'm not wearing

any of that Beaver crap.' But I've learned to love the rivalry through the years. I respect the Beavers more now, what they do with Mike Riley and the consistency in their program. They don't have the same pockets to make it as Oregon. We have Phil Knight. We wouldn't be who we are without him."

DEREK LOVILLE, UO, 1986–89: "As a freshman, I remember hearing from the older players, 'If we don't win any game this year, we have to win this last one, the Civil War.' Records don't matter much. That first year was eye-opening in Corvallis. I couldn't believe how much hatred was in that game, from students, alumni and fans. In those games, everyone played hard. There was a lot of rhetoric going back and forth on the field, but it was healthy."

BILL MUSGRAVE, UO, 1987–90: "The rivalry is fierce because of the proximity of the schools, the limited population in the state and so many close bonds between both schools' alumni and students. I really disliked the Beavers, not only from a football aspect but from watching the basketball games those years. Bill Sherwood hit a heartbreaking shot from the corner to beat us one year. I was sitting right next to where it happened. I had to watch Gary Payton play those years for Ralph Miller. That heightened the rivalry for me, I guess. It's only been escalated with the success of both programs. Coach Riley is an amazing coach, and it's well documented the success the Ducks have. It's taken the rivalry to a higher level."

TODD SAHLFELD, OSU, 1988–91: "I wasn't a big Duck fan to begin with, but my cousin Brian Jackson wrestled there and didn't like it that much. That made my choice easier. And the Ducks never offered me a scholarship, which burned me a little bit more. I went on a visit, and Rich Brooks pulled me into his office and said, 'If you get other offers, you should probably take one.' I remember thinking, 'What an arrogant ass.' Maybe he was trying to be honest with me, but it was like he felt like his program was above me. It was always in the back of my mind when we played Oregon. I not only wanted to beat them, I wanted to prove to him that I can play football. It was nice to beat him twice while I was at Oregon State.

"I still feel the same way. When the Ducks were in the [2011] BCS championship game, I told a friend, 'I'm going to go out and buy an Auburn shirt.' He said, 'That's sad. They're state of Oregon.' I said, 'You don't understand the state. You're either an Oregon fan or an Oregon State fan.' That's the way it was and the way it is. As time goes on, you develop a hate for the other team. As much as I hate the U of O, I found myself watching a couple of their games last season. I've vowed not to go to Autzen ever again.

But they do have an entertaining style of football. Money makes college football go around."

BOB BROTHERS, UO, 1988, 1990–91: "It was by far the biggest game for us. We owned that rivalry when I came in. I lost two of three to the Beavers. That was bad, but some guys took it more personally than I did. I'm a little more along the lines that every game is important. We're truly blessed with Phil Knight and some of the other supporters. It's easy for an Oregon State fan to hate Oregon because of that. We have resources no other college athletic program in the U.S. has. It's a game-changer. When [Knight] started putting money into the program, look what happened. It's changed the trajectory of all our athletic programs. When I was playing, nobody could have guessed we'd be in the top 10 nationally in so many men's and women's programs."

MAURICE WILSON, OSU, 1989–92: "It was a terrific rivalry and a lot of fun to play in those games. I still feel a lot of animosity toward the Ducks. All of the games my four years were close. We only won one, but we played hard for the people of the state of Oregon. I'll always remember that."

MIKE BELLOTTI, UO, assistant coach 1989–94, head coach 1995–2008: "Cal Davis–Sacramento State didn't quite compare to the Civil War. The first year I went to Corvallis, I began to grasp the intensity and animosity involved in the rivalry. Rich Brooks didn't lose often. It was Rich's competitiveness and belief that was the most important game of the season every year. Even when the teams were relatively equal, he seemed to find a way to help his team be successful.

"Over the years, you try to put the losses out of your memory. My favorite game was my last Civil War in 2008. We hit on all cylinders. It was a fitting way to end my coaching career at Oregon. Oregon State was always the biggest game for me, no question. A lot of fans would want us to say Washington or USC, but you lived in the state of Oregon with the results of that game. Mike Riley and Dennis Erickson elevated the level and profile of that program. It was always a battle. Those two guys made Oregon State very relevant. I say this humbly: That was a tough team to prepare your guys mentally for, the intensity with which to approach that game. That's the difficulty of being the favorite. It's easier to coach the underdog when you have a chip on your shoulder."

TONY O'BILLOVICH, OSU, 1990–93: "I know you're always preparing for the next game, but I always wanted to spend a little more time hating my enemy. I couldn't ask for a better rival. I loved playing against the Ducks. I couldn't wait to play them. I always thought about them. It always ticked me

off when they had success. People say, 'It's good if both teams do well.' Good for whom? I don't ever want to see them be good."

DWAYNE OWENS, OSU, 1990 and '92: "A lot of my friends were Ducks back then. I didn't have the mentality where everything was about beating the Ducks. I still don't have that vibe. I'm a California kid. I didn't grow up on the Civil War. But I played to win. I had friends on the other side, but when you line up against me, ain't no friendships there. You're on the opposite of the ball, you're not my friend. But I never felt if you won that game, it made your season."

JERRY PETTIBONE, OSU, head coach 1991–96: "I knew what the Civil War meant to the program, to recruiting, to support, fundraising, improvement of facilities—everything. I had been part of huge rivalry games at Texas A&M, Oklahoma and Nebraska, but as far as the importance of a victory over Oregon, that's what grabbed me more than anything else. Every year, Dee Andros would stand in front of our kids. He'd say the same thing, but it fired them up, because it was the Great Pumpkin, and it was so sincere, and those kids knew it. I respected the Ducks and their coaches, Rich Brooks and Mike Bellotti. They ran a class program. I wanted to win that game, I guarantee you. I did everything in my power to make that happen.

"After I left Oregon State and went back to Oklahoma for a year as an assistant athletic director, my daughter, Shanda, went to Oklahoma for two years. Then she transferred to Oregon and worked as a student assistant in the football office for two years. All the Oregon coaches were wonderful to my daughter. That meant the world to my wife and me. We bought season tickets for the Ducks for those two years."

IAN SHIELDS, OSU, 1991–93: "It feels great I went 2-1 in the Civil War. That game is really a season unto itself. It's similar to the Army-Navy game. Army-Navy is about mutual respect, a healthier type of rivalry. Oregon–Oregon State, there was a little more animosity, and for some it boiled into the hatred part. I knew some of the guys who played at Oregon. Our campuses aren't that far apart. I liked a lot of them, but you still wanted to line up and beat them. They were well coached by Rich Brooks. It was a fair fight, and it was going to come down to some critical situations in those games. During those years, we had a fake duck named 'Sparky' that we'd hang on a rope from the goalpost, and we'd slap it as we went out to practice every day. Sparky usually didn't make it through the whole week."

DANNY O'NEIL, UO, 1991–94: "When I was playing, the Beavers weren't very good, but they'd play against us like a Pac-10 all-star team. They played so hard, you had to really be on your game to beat them. Your rivalry

is dictated by the feelings of the community. You care because everybody else cares. Oregon State and Washington were the two big rivalries. The Civil War means a lot to football fans in the state. I root for the Beavers every week except our week. When I was playing, I wanted them to do well. I always thought the Beavers' lack of success tarred the state of Oregon. If Oregon was 6-5 and Oregon State 1-9, we got lumped in together. I always thought it was best that both programs be successful."

JEFF SHERMAN, UO, 1991–94: "I probably hated Washington more than Oregon State. We were the Huskies' little stepbrother. We were the better team in the Civil War every year, even when we lost. We were the dominant program. Oregon State always played hard. When we beat them at Parker Stadium in 1994, our fans ripped the goalpost down. A month later, right before the Rose Bowl, a friend gave me a wrapped gift. It was a piece of the goalpost, 18 inches long, with the score of the victory painted on it. It's on a desk in the office at my house. It's the coolest piece of memorabilia I have.

"When I was 22 or 23, I wanted the Beavers to lose every game by 100 points. As you get older, you hate the Beavers less. I have a lot of friends who bleed orange and black. It's a lot easier for me to root for the Beavers and see my friends be happy, too. As long as Oregon is on top of the rivalry, I actually find myself rooting for the Beavers as well. But I still hate the Beavers when it comes to the Civil War."

CHAD COTA, UO, 1991–94: "When I played, I developed a pretty good dislike for the Beavers. We didn't dominate them by any means. They had a little bit of attitude. It built up the dislike for them, for sure. I love what the Civil War has grown into, especially the last few years with the national recognition, to see so much riding on it in both ends. I'll probably root for Oregon State most of the time. I will never root for the Huskies. Maybe it's a little bit of what Oregon State has going on with us now. We wanted to be where the Huskies were at. It's a role reversal now, but I still hate them."

BRYAN LUDWICK, OSU, 1992, 1994–96: "Being an Oregon-grown kid, the Civil War meant a lot, especially with our struggling seasons. It was kind of our bowl game. We put a lot of focus and energy into it. The Ducks were on their way up. They had a class program. I had a lot of friends who played for the Ducks. I knew a lot about them. At Oregon State, you're bred to beat up those guys as much as you can. We were the grinders, the blue-collar type. They were Nike's baby boys, with the flash and the hype. You learn to hate them. But when you're losing, you can't really say much.

"Today, Civil War is one of the most fun weekends. I have a couple of my buddies who are bigger Duck fans than I'd think is possible. I get invited to Duck games with them and make sure I have my orange and black on. I tell the joke: What do Oregon and Oregon State fans have in common? Neither of them went to Oregon. There are a lot of bandwagon jumpers over there. But the Oregon State program has done a great job. I can hold my head up high anywhere I go."

REGGIE TONGUE, OSU, 1992–95: "The Civil War was a game that no matter how good the teams were, it was going to be a close game. We were the black sheep of the state. The Ducks got all the nice equipment, all the publicity and they didn't respect us. So it was more of a game of earning respect than anything. They were always pretty good teams. I didn't like them very much at all. They were very disrespectful in a sport that has a gladiator-type mentality. There was respect on our end.

"In 1995, I hit Cristin McLemore on a middle screen and knocked his head off pretty good. The previous year, he had said in an interview that he didn't respect us at all, that we didn't deserve to be in the Pac-10. That gave me some fuel. I gave him a shot and sent him out of the game. Made me feel really good. I only beat the Ducks once, but we always played them tough. I was glad to represent Oregon State in those games."

CAMERON REYNOLDS, OSU, 1992–95: "Growing up in Oregon, you're bred on the Civil War rivalry. I didn't know which side I was on until college. We were thinking about the Ducks even in the off-season. If we could beat the Ducks, that legitimized the program. There were some guys who took it to the next level, where they would drive around Eugene, not taking I-5 south. I was never one of those guys.

"As fate had it, my father-in-law was a linebacker at Oregon [Terry Ranstad], and my mother-in-law [went there], too. I can't bag too much on the U of O. I always tell Terry, at least he was smart enough to send all three of his kids to Oregon State. His son, Hal Ranstad, was a southpaw pitcher for Pat Casey. Now it's fun. When Terry comes over to babysit his grandchildren, he brings a pack of Duck stickers and puts them around the house. I'll pay my kids a quarter for every Duck sticker they find in the house so we can toss them. He went a couple of months with a Beaver sticker on his car. Didn't know it was there. It might be blasphemy, but I'm pro-Duck as long as they're not playing the Beavers."

CRISTIN MCLEMORE, UO, 1992–95: "When I played, the Civil War had a lot more meaning than it does today. It was a game that had so much value, so much pressure placed on it. It taught people a lot about what a

rivalry means. I had a lot of good friends who played for the Beavers, some of the most humble, real guys. I still have some friendships from back then as close as my Duck friendships. But when it came to Civil War week, we got down to business.

"I don't hate the Beavers. For them to bring some success to the Northwest when they're not playing the Ducks, great. I want the state of Oregon to be represented well. But during the Chip Kelly years, it wasn't a Civil War. There's no war to it when those guys lay down out there. That's kudos to Chip and his crew. They put up big numbers and make opponents quit wanting to play. But Chip didn't do a good job translating what the Civil War meant. Coach Brooks and Coach Bellotti, they knew what it meant to everybody in the state."

KANE ROGERS, OSU, 1992–95: "The name 'Civil War' was appropriate. We had a distinct hatred for the Ducks. I couldn't stand them. That was driven into my mind my redshirt year when we beat them. A senior, James Jones, said, 'We own the state.' At that point, I realized how much it meant to beat the Ducks, to finish a season with a good taste in your mouth because you won the game. Today, I root for the Ducks to lose almost as much as I root for the Beavers to win. Initially, it was just that they were the rival down the road. But there is such a sense of entitlement in the fan base at Oregon. That's what took it to another level for me."

ALEX MOLDEN, UO, 1992–95: "We were taught to hate the Beavers. I found out quickly that every time we played them it would be a knock-down, drag-out fight. They were going to play with some fire. We had to match or exceed that. Every Civil War, I changed my face mask to an old-school, one-bar-down-the-middle, one-bar-across model. It was the only game I did that for. It was going to be a smash-mouth type of game. That was my little tradition. I didn't cheer for them during the year, but I didn't hate them. When that week came, something did come out inside of me with a disdain for them.

"But now, I just have respect. I played for Coach Riley with the San Diego Chargers. Mark Banker was my coordinator and Rod Perry my secondary coach. Great coaches and great people. So I cheer for them—kind of. I want them to do well, for them to rank high, too. So when the Civil War comes, we can knock them down."

BUSTER ELAHEE, OSU, 1993–94, 1996–97: "I live in Seattle and still deal with the Civil War. There are quite a few Ducks up here, and they have some Civil War wins in a row to put in my face. Whenever they can, they smash the Beavers. They know I bleed Beaver orange. I remember before

the 2001 Fiesta Bowl, one of the OSU linebackers, Darnell Robinson, called and said, 'It was because of what you guys did before us that made us get here.' That gives me chills right now saying that. It's good to see where the program has gone and think I was part of building that. I've never had a dislike for the Ducks. I respect them and I respect the Beavers. It's a great, old-fashioned rivalry."

REGGIE JORDAN, UO, 1993–96: "After Oregon State beat us my freshman year, Jerry Pettibone started a campaign building a Beaver dam between Eugene and Corvallis. He declared, 'We own the state.' That was terrible. They'd won, what, one game in 200 years? To this day, that burns me. They had some Beaver statue they rubbed before every game. That was a poorly conceived idea they had—one of many.

"The Civil War is something that stays with you. I live in Oklahoma, but I still get that anxious feeling at Civil War time. I affectionately refer to Beavers as the 'rodents.' I have some friends who are on that side. I have quite a few lunches and adult beverages owed to me. One of my good friends, Kevin Roberts, is assistant wrestling coach at OSU. He wrestled at Oregon when I was there. I root for him. I just hate the colors he puts on his back every day. I'm proud to be one of the guys on the good side."

DINO PHILYAW, UO, 1993–94: "I didn't think much of the Beavers. There was nothing to 'em. They were always a dollar short, that's what I always felt like. I have a lot of friends today who are Beaver fans. Great people, but they're still a dollar short. I root for Oregon State when we're not playing them. I want that game to be one of the most-watched games in the country. I don't want to hear about Ohio State–Michigan. I want to hear about Oregon–Oregon State."

CORY HUOT, OSU, 1994–96: "The Civil War was the most intense experience I've had in my life—so much electricity on the field. I played at Nebraska in front of a crowd of 70,000, but there's nothing like a rivalry game. I hated the Ducks. I envied them because they got to go to the Rose Bowl, but they were better than us. They deserved it. I couldn't stand their uniforms. I still can't."

PATRICK JOHNSON, UO, 1994–97: "I loved everything about the Civil War. The time of year. The color of the leaves. The smell in the air. The rituals during the week. We had painted flags of every team in the Pac-10 at Autzen. We'd go spit on the Oregon State flag before practice that week. It was always a tough game. During the [Jerry] Pettibone era, when you got the ball, you'd better do something with it. If the Beavers got it, they were going to sit on it. And they played really good defense.

"I had a lot of buddies who went to Oregon State, guys like Armon Hatcher and Reggie Tongue. Never met a bad guy from Oregon State. It's inherently bred into you to hate them as a team, though. From day one, the enemy is identified. In our case, we had two—Oregon State and Washington."

DAMON GRIFFIN, UO, 1994–96: "I was really close to signing with Oregon State. I loved everything about it. Jerry Pettibone was the coach, [running back] J.J. Young was from my area of South Pasadena. The thing that killed it was they wanted me as a receiver. I didn't want to go to a school to block. And after I went to Oregon on a recruiting trip, [the Ducks] blew everybody else away. I live in Keizer now, in Beaver country. Every one of my neighbors is a Beaver. I drive around wearing Duck gear and see people looking at me. Most of the time, it's pretty cool. During Civil War week, it's not safe to go around my neighborhood."

ERIC WINN, UO, 1994–97: "I grew up with a strong dislike for the Beavers. The Civil War was always a huge deal. In some fans' minds, Washington became almost a bigger rivalry, but the Civil War was always huge. When I played, I absolutely hated the Beavers. I don't know if that has softened over time, but I don't wish them ill will the same way I do Washington or USC. I want us to beat them by a lot, but it's great for the state of Oregon when both teams are good. I like it when they're good and we kick their ass. With the Huskies, I'd just as soon they go 0-12 forever. Today, the Oregon fan base has a level of arrogance to them that is different than the Beavers'. If I were an Oregon State person, I'd hold more ill will to the Ducks, given our success and the media attention we get."

BRYAN JONES, OSU, 1995–98: "As the years progressed, I acquired a learned hate. We didn't like the Ducks at all. You talk to guys who played in my era, they still do not like the Ducks. We don't wear anything green or yellow. They had an arrogance, and we were the Pac-10 doormats, so they felt we weren't worthy of playing against them. We would look at the uniforms and all the things they had from Phil Knight. We didn't even have a Nike contract at the time. That added on to the extra hatred we had in being the second-class team in the state. To this day, I don't like their fans. In the state of Oregon, there's an overwhelmingly more Duck push than Beaver push. Pretty much everywhere you go, you have Oregon something or other. There are times it irritates me."

INOKE BRECKTERFIELD, OSU, 1995–98: "I gained an appreciation for the Civil War the week going into the game my freshman year. I could feel it. By my junior year, it was deep inside me. Still is, all these years later. To this day, I can't stand the colors green and yellow."

JOSH BIDWELL, UO, 1995–98: "Growing up in southern Oregon, there were more Oregon State fans than Oregon fans at the time. But I was always a Duck fan as a kid. Maybe it was the colors or something. When I got to Oregon, Civil War week was about all sorts of traditions and songs and chants and body paint and jerseys and helmets that come out for practice. The coaches encouraged you to take it as far as you want, with taste."

ANDRAE HOLLAND, OSU, 1995–98: "When I played, there was a level of—how can I articulate this?—a level of distaste for the Ducks. It was a love-hate relationship. They're the Ducks, but you respected their success. We had some great games against them. Those Civil War memories stick with you for a lifetime. You never truly understand it until years later."

JED WEAVER, UO, 1996–98: "There's a special place for hatred for the Beavers in every Duck's heart. The Beaver fans hate the Ducks and the Duck fans hate the Beavers. Because there's no NFL team in Oregon, the rivalry is as big-time as it gets in the state. People choose one or the other. Even with people who didn't go to either school, it seems pretty divided. It's a whole different level of competition and intensity, no matter what the records are or what the game means.

"It was always fun playing at Parker Stadium. We dressed in Gill Coliseum and walked across the street to the stadium. There were fans all around yelling at you. They had a bronze beaver that the Oregon State players would rub on the way by, so we all got to spit on it. I'm a devoted Duck. I have my Duck license plates in south Florida. Being a fan of the game and understanding the history, it's nice to see the Civil War have more meaning than ever these days."

AKILI SMITH, UO, 1997–98: "I loved the Civil War. It was one of the greatest rivalries in college football. There was nothing like it. I liked the Beavers. Sometimes we would visit each other's turf socially. There were a couple of guys I was friends with. We'd go to Corvallis, or sometimes they'd come down to Eugene and hang out. And then it was, 'We'll settle it on the football field.'"

DARNELL ROBINSON, OSU, 1997–2000: "We were Oregon's stepchild. We were the Cinderella team, the guys trying to make a name for ourselves. That's never going to change. That's a private school. They have Phil Knight. He makes sure they're well taken care of. What he did for that program to separate those guys is phenomenal. Now Oregon State is a nationally recognized program, too. When I was there, we were getting the used Nike stuff. Now the Beavers are getting brand-new everything. They have a great stadium. We played on concrete. Now they have a nice

[artificial] grass turf. To see the 180-degree turn with that program, give Coach Erickson and Coach Riley a lot of credit. I feel good every year when I see announcers talk about the Civil War. I was able to beat the Ducks when it meant the Pac-10 championship. I don't think it can get any better."

RASHAD BAUMAN, UO, 1997–98, 2000–01: "My first year, it was like big brother beating up on little brother. The next year, they beat us in Corvallis. That was my first opportunity to understand the rivalry. We had the whole year to hear everybody talking about how the Beavers won, to have the Beaver fans happier than the Duck fans. It was hell to hear that all year long. I started to develop my hatred for the Beavers right then. But it was more than just the Beavers for us. We were trying to get on the national stage. The Beavers were just in our way. Before the 2000 Civil War, Chad Johnson knew someone I knew in Eugene and got a letter to me, saying, 'I've seen you on TV interviews. I have no ill feelings to you. May the best man win.' Later we played together in Cincinnati, and we laughed about it."

KEN SIMONTON, OSU, 1998–2001: "Coming in as a freshman, I knew so little about the Civil War it was laughable. I was shocked by how serious people took it. I thought, 'Come on, man. The teary-eyed speeches? Where was all this emotion last week?' My first Civil War experience was at Autzen as a redshirt my first year. The fans sat on your neck. A little old lady was sitting behind me screaming, 'Blank the Beavers!' It told me right then and there how serious it was. They routed us that game. That next year, I wanted nothing more than to ruin their season. The Civil War is a part of my life now. We come up for the game every other year—I refuse to go to Autzen. I will root for the Ducks in national championship games, keeping it in the Pac-12. But outside of that, no love."

JOEY HARRINGTON, 1998–2001: "The Civil War is not as cutthroat as Auburn-Alabama and not as big as Michigan–Ohio State, but it's special. For 28 years in a row, Oregon State did not have a winning record, and for two decades, Oregon wasn't too far ahead. But for 120 years, this game has been played and the fans show up. They have pride in their universities. And whether you're playing in the Toilet Bowl with umpteen fumbles, or you're playing at Parker Stadium when Oregon beat Oregon State to clinch the Rose Bowl, or at Reser Stadium when Oregon State beat us to clinch the Fiesta Bowl, it's passionate and it's real. For a good week, and an occasional basketball game or two, there's a hatred that comes out from the other side. But for the other 350-some days a year, people are proud to be Oregonians. You'd never see an Auburn fan rooting for Alabama basketball, but I guarantee you, there were a good

number of Duck fans rooting for the Beavers when they won back-to-back national baseball championships.

"I said after the 2000 Civil War game in Corvallis I'd never go back to that godforsaken city. I've driven through Corvallis, and of course at some point, I'll go back. I just haven't had a reason to. Part of me wants to just hate the Beavers with every bone in my body, but part of me is proud to be an Oregonian and proud to have a team represented by a guy like Mike Riley. We are so lucky right now between Riley and Mark Helfrich—the two nicest head coaches in all of college football. Mark is the Eugene version of Mike Riley. Mark is a wonderful person, and it's hard for me to root against a guy like Riley. I want to, but the reality is, unless they're playing against the green and yellow, I'm secretly hoping Oregon State does OK."

JAKE COOKUS, OSU, 1998–2001: "The Civil War was always the biggest game. The No. 1 goal every year was to beat the Ducks. I always respected them. Now, if we're not playing them, I like to see them win, so something's on the line and to bring more attention to the state of Oregon when we play them. I'm biased, but I think it's the biggest rival game in the country."

CHRIS GIBSON, OSU, 1998–2001: "The Ducks didn't offer me out of high school. If they'd offered, I'd have thought pretty seriously about going there because of the level the program was at the time. It was a motivating factor for me any time we were playing them—not that I needed any more motivation. It's one of those games that not a whole lot needs to be said. Being a true Beaver, there's not a lot of love lost for Oregon with me. I don't root for them. I enjoyed watching Chip Kelly coach. He was entertaining when he was there. But I could never be a Duck fan."

JONATHAN SMITH, OSU, 1998–2001: "I redshirted my first year. That was my first experience with the Civil War at Autzen Stadium. We were getting beat pretty bad, and behind us, there was a guy holding a beaver with a rope around its neck. He was turning it over and pounding it on the ground for every point they scored. That opened my eye to what the rivalry is all about. During those years, you felt like you were the younger brother. There was a little bit of arrogance on their part. I always checked their scores, hoping they would lose."

MARSHAUN TUCKER, UO, 1999–2000: "Coach Bellotti would put extra emphasis during Civil War week. He'd dress somebody in Oregon State gear and have him run through our practice. He'd post bulletin-board material. He was going to let you know how imperative it was to win the game. In those years, we couldn't stand each other. Fast-forward 13 years: I

don't dislike Oregon State. I root for my school, but I don't dislike the Beavers. I always tell my 13-year-old son, 'If you get a scholarship to Oregon State, I'm the biggest Beaver fan.' I'll hide my Oregon gear under the orange."

DAN WEAVER, UO, 2000–03: "There was a different energy going into the Civil War than any other game. As a kid who grew up in Oregon, I didn't have to be taught any of that. I didn't hate the Beavers as a whole, but there were certain players. I hated Richard Seigler. I would have tried to hurt him if I had the opportunity, too. He'd stand there and yap and talk and jabber the whole game. My senior year, he was standing over the ball, yelling that Tim Day was cool because he's from Las Vegas, but the rest of us were garbage. In 2001, they had a pretty good D-tackle, Eric Manning. We were jabbering throughout the game. We won, and I was able to tell him at the end to check out the scoreboard. My junior year at Reser, we walked out for pre-game, and there were people talking and tailgating. This dad and his young son came running up by the restraining rope. The dad—who had been tailgating quite a bit—was mother-F-ing us, and he double flips us off. And his son was double flipping us, too. The picturesque sign of sportsmanship."

TIM EUHUS, OSU, 2000–03: "Oregon never offered me a scholarship out of Churchill High in Eugene. I begged, borrowed and tried to steal one, but they were to that point where they could recruit anybody they wanted. They were looking for 6-4, 250-pound guys. Fortunately for me, the Beavers didn't have that luxury yet. They recruited a tall, skinny kid, 6-5 and 200. My dad was a lifelong Beaver fan from the Terry Baker days, and my uncle Keith played freshman ball at OSU. I always had a connection to Oregon State, but they were so bad in the early '90s. We went to Civil Wars and cheered for the Beavers, but we had season tickets at Autzen. It was a better quality of football to watch.

"Some people say, 'I cheer for the other team unless they're playing us.' I don't think you'll find many people who played football at Oregon State who would ever cheer for the Ducks in any sport. They're your rivals. You don't want to see them be successful. What the Ducks have done the last few years has been great for the Pac-12, but as a Beaver, it leaves a negative taste in the mouth. I'll respect their coaches and what they do, but I'm never going to cheer for the Ducks against anybody. When Oregon and Oregon State play, it's a game I want to win, and I don't care what sport. If there is Civil War competition, I'm going to tune in and cheer for the Beavers. It's one of the best football rivalries around. I travel all over the country. I tell people I'm from Oregon State,

and they say, 'Oh, the Ducks?' I say, 'Not the Ducks, the Beavers.' They say, 'Oh yeah, you guys are bitter rivals.' You got that right."

GEORGE WRIGHSTER, UO, 2000–02: "I didn't really care about the Beavers. I cared much more about Washington, actually. The rivalry with Oregon State is more passionate for the older guys when both teams weren't very good. Now it's the haves and the have-nots. I dated a girl who went to Oregon State. I have been to Corvallis many times. I used to work out with Chad Johnson and T.J. Houshmandzadeh. They hate us, but we don't hate them that much. They want to be us. They say they don't want to be us, but they do. They want the uniforms, the stadium, the branding, the national spotlight, but they can't have it. They're jealous. They think they're harder workers and we're spoiled and not as tough as them. In reality, the proof is in the pudding. They haven't beat us in, what, six or seven years?

"When they beat us in Corvallis in 2000, that was when I started hating the Beavers. I saw T.J. at the Red Robin in Eugene a few days before the game. He sent over a note on a napkin: 'We're going to get y'all.' I talked to him years later, and he thought we were going to jump him in the parking lot. After the game, the fans stormed the field and were in our faces. It was like a LeGarrette Blount moment for me. I pushed one of them down just to get out of my way. It was the most obnoxious thing I've seen in my life. That made me never want to lose to them ever again. They are not good fans, not good people. I don't want them to have any bragging rights. I don't even want them to feel they will ever be able to be anything like us. We're the big brother, and they'll always be the little brother, and they need to stay like that. I want it to be the type of rivalry where people say, 'Is this even a rivalry?' I want it to feel like when they do win, they are so few and far between that they can keep their coach for the next five years because they won the one game."

KEENAN HOWRY, UO, 1999–2002: "I was recruited by Mike Riley at Oregon State. I really liked him—a great coach and personable. But it came down to the Ducks going faster in the right direction. I could tell they had some things working that were going to propel them into the national spotlight over the next four years. Luckily, I made the right choice. But you could tell Oregon State was turning the program around, too. You learn real quick once you get there that there is a healthy but natural dislike for one another. If you're a Duck, you learn to hate the Beavers fairly quickly. It is the most underrated college football rivalry in the country. I always tell people, it has to rank up there with some of the best. I'd put it up there with any of them."

rivalry anymore. If we win a championship, we might have to go through Oregon State. That's pretty cool."

SABBY PISCITELLI, OSU, 2003–06: "The fans built up the rivalry more than the players, but you could feel the different aggressiveness in those Civil War games. I didn't have a huge dislike for the Ducks at first. They really wanted to beat us; we really wanted to beat them. You try to keep it sportsmanlike, but it's more physical, more talkative. You want to win for the school and for your fans. I didn't have a great liking for some of the Oregon players, the way they liked to talk. I'm kind of quiet until you cross me, then I'll develop a dislike. That's the way it was for Oregon. But I have no animosity. I'm a supporter of the Pac-12. I'm Oregon State all the way—that's my school, I do anything to support them—but when a Pac-12 team plays in bowl games, I want to see them win. I don't cheer for Oregon, but unless they're playing Oregon State, I'm kind of neutral."

SAMMIE STROUGHTER, OSU, 2004–06, 2008: "It's a bitter rivalry. You win the Civil War, you have 365 days of bragging rights. You can go 0-10, but if you win that Civil War, you're daddy of the state. I knew a lot of the Oregon players from high school ball in California. But once they cross over to the green uniforms, it's, 'Oh no, you're a Duck. I can respect you, but I really dislike you.' I am thankful to have played in the Civil War. It's something I wish other people could experience. The state is split in half. It's crazy. I can't stand being at Autzen Stadium when they score and that cannon goes off. Oh my goodness. That's the most annoying sound."

YVENSON BERNARD, OSU, 2004–07: "Throughout my career, my passion to dislike Oregon grew every year. I'm not going to use the word hate—that's a strong word. But I tend not to go south toward the Eugene area. Every time I see green and yellow, I frown. My first Civil War game as a redshirt in 2003, we played at Autzen. The first kickoff, Harvey Whiten just got lit up. The crowd was so excited. They didn't care that Harvey was hurt. It killed me. I thought, 'Oh my God, I do not like the Ducks.' I know a bunch of their players. They're great, but I always wanted to beat those guys. I was 3-1 in the Civil War. I always let the Ducks know that if they want to start talking trash."

ALEXIS SERNA, OSU, 2004–07: "My first Civil War experience was my redshirt year at Autzen in 2003. The Ducks were talking trash the whole game. There was just a cockiness that was bothersome the whole way. From that point on, it was a rivalry I wanted to win every year just so we could shut them up. It grew to a hate feeling from that moment.

"Of all the teams I played against, that was the only team that I never shook hands with any of the kickers after the game. I don't root for the Ducks, ever. I was fortunate to be 3-1 against them. Coming from Southern California, the big rivalry is USC-UCLA, but the passion is not the same. We have the biggest rivalry on the West Coast by far. I make sure when I go watch the game at Autzen, I wear my letterman jacket. They can't say too much with the kind of career I had against the U of O. Kids who grow up in Oregon dream of playing for either school and being the difference in the game. To have that opportunity was amazing."

RYAN DEPALO, UO, 2004–07: "Being an Oregon kid, I had a lot more energy going into the Civil War games. There was a lot of excitement around it. It's a whole 'nother mindset. There was a lot of trash talking. Hits were a little bit harder. There was a little more pride in winning that game."

ROY SCHUENING, OSU, 2004–07: "I grew up a Beaver fan, so I knew what the Civil War was about. There wasn't a whole lot that needed to be said about that game. It didn't take a whole lot to get pumped up for it. Everybody goes a little harder. The intensity that rivalry brings, it takes everybody to a whole new level. I have a few buddies who are Ducks, but I hardly ever went to Eugene in college. I didn't like going down there. I still don't. The rivalry does something to you. It's great for sports. I only lost once to them. To lose was a sick feeling, and then you got to hear about it for a year from your hometown people, in the media. I was glad to come back my senior and finish up in Eugene with a win."

GARREN STRONG, UO, 2004–07: "What was crazy was how the Civil War compared to the Oregon-Washington rivalry. The Civil War brought out the whole state of Oregon. You also got to see the house divided— maybe the mother being an Oregon State alum, the dad being an Oregon alum. People in the community have been going to that game for a lot of years. It always interested me to hear about the history and how important the game was, no matter what the records were at the end of the season. You hear about the tradition and see how people are so invested in it. You always want to come out victorious, so we can say, 'We beat you guys last year, and we plan to do it again this year.'

"I didn't like the Beavers just from the talking that goes on during the games. Things got pretty intense. I don't catch Corvallis at all. I don't like the city. I keep my distance from there. But I'll go to the Civil War in Eugene. It's so much fun. After those three or four hours, the best team comes out on top, no matter what the record is."

KYLE DEVAN, OSU, 2004–07: "When I came to Oregon State, we had a lot of Oregon kids in our class who grew up as Beavers. They taught the rest of the class what the Civil War was about. I don't like going to Eugene. I don't own green stuff. I lived the Civil War. I don't hate those guys, but I have a lot of pride in my school. You know the crowd is going to be that much louder, the hits are going to be that much harder. It's the biggest game of the year for you, no matter what bowl game you're going to. You're trying to knock each others' heads off."

KEITH ELLISON, OSU, 2004–05: "I still don't like the Ducks. I do not root for them. I hope they do not win. I was only at Oregon State for two years, but once you become part of the Beaver family, you develop a strong dislike for that school and that city. I always looked at Oregon State as the school that nobody gives enough respect. We all got overlooked by somebody else. Nobody's going to think of Oregon State as a glamorous program. We had to go prove ourselves against the Ducks. It's not just about uniforms and facilities, though. It's work and what you do on the field. That's why Oregon State's players don't like the Ducks. They think they are better."

MAX UNGER, UO, 2005–08: "I came into the Civil War as a total outsider from Hawaii. It meant a lot more to the guys from Oregon like Cole Linehan, whose brother played for the Beavers. We also had a lot of coaches who played at Oregon. You could always tell it was rivalry week. I have to defend the rivalry in the [Seattle Seahawks] locker room every day. The passion of the fans in the state of Oregon rivals any other rivalry in the country."

VICTOR BUTLER, OSU, 2005–08: "I knew about the Ducks growing up. A kid in the neighborhood, Sultan McCullough, his brother Saladin played for Oregon. When I got to Oregon State, I found out that the Civil War rivalry was like the Red River Shootout between Oklahoma and Texas. If you're a Beaver fan, you come from anywhere from Beaverton to Roseburg for this game, and you look forward to it all season.

"I didn't hate the Ducks more than anybody. I hated every team we played. You had to treat every game like a big game. I hate to lose more than I love winning. Any team we played, I wanted to beat the snot out of. I can't say I was ever envious of the Oregon uniforms. I never thought they were attractive. Oregon State's uniforms might not be the coolest ever, but we never looked like the Ducks. They have a couple of thousand combinations. You'd think they could come up with one good one."

JEREMIAH JOHNSON, UO, 2005–08: "[Former Duck] Terrence Whitehead was one of the main influences of being a Beaver hater. He

pretty much was like, 'We don't deal with no Beavers. We got to kill them every year.' And you get that vibe from the fans and the people in Eugene. We don't take no losses to Beavers. Coach [Gary] Campbell went through a lot of Civil Wars where Oregon State came out victorious. He told me, 'We can't lose to these guys.' I had a good friend who played for Oregon State, Daniel Drayton. When they beat us [in 2006 and '07], he rubbed it in my face. That put a chip in my shoulder. I was so mad I thought, 'I can't lose to these guys no more.' I told him if he weren't a Beaver, we'd be talking all the time. We speak a different language.

"I don't want to seem like a traitor, because I'm going to be a Duck for life. I took it as my job to instill it into the young guys behind us, like LaMichael [James]. Two years ago, we had a Beaver with the [Denver] Broncos. An offensive tackle; don't remember the name. I don't associate with Beavers. I didn't introduce myself for six days. After the sixth day, I said, 'Hey, Beavhead' in disrespect. He said, 'Ah, you went to Oregon.' I said, 'You're damn right I did.' You're set in a way, and you know that's the right way."

NICK REED, UO, 2005–08: "I never hated the Beavers as much as any Duck should. One of my good friends is [ex-OSU player] Gregg Peat, so I spent a lot of time hanging out in Corvallis. When I got to Eugene, I didn't understand what the Civil War was about, but as I lived there longer I understood it's a huge rivalry in the state. The two years we lost, it was kind of embarrassing every time I had to drive through Corvallis. Not so much seeing the players—nobody said anything about the game too often—but it's just the feeling that you really do feel you owned the state those two years that you won the Civil War, and the two years we didn't, I had to keep my head down driving through Corvallis. It made the Civil War so much more special to me because I knew so many [Beavers] so well. It was a hallowed game. I wanted to beat them every year, but I didn't hate them any more than any opponent."

JORDAN KENT, UO, 2005–06: "With my father as basketball coach at Oregon, I learned about the rivalry as a kid. It's a unique situation where the campuses are so close. As the rivalry went on, you saw a difference in cultures. Once Oregon got to about 1999 and the Nike stuff kicked in and the football success picked up, the Ducks developed the cool vibe. They were a trendy brand, where Oregon State retained a bootstrapping mentality. Before that, it was bootstrapping for both schools. Once Oregon made that push and committed more dollars to athletics, things changed. The Oregon State side thought, 'Who do you think you are, better than everybody?' Oregon was like, 'Hop on board; this is where it's at.'

"I never really had a hate for the Beavers. I played with more of a chip on my shoulder against them than any other opponent. But if you had to pick a team [for which] you had disdain, it's Washington. Against Oregon State, there's more pride on the line because you are with these people year-round. My first year with the Seattle Seahawks, [former Beaver] Joe Newton was a teammate. We'd known each other through high school. When Oregon State beat Oregon in 2007, he rubbed it in my face. In 2008, we knocked them out of the Rose Bowl, and I rubbed it in his face."

MATT MOORE, OSU, 2005–06: "I learned pretty quickly once I got to Corvallis about the rivalry and how much it meant to a lot of the people in the state. UCLA-USC is not even close. The Civil War is one of the best games there is. Playing in the Rose Bowl isn't the same as playing in a smaller stadium with a crazier atmosphere. After playing in both games, I'd take the Civil War. And I completely bought into not only what Coach Riley was teaching me but the view of Oregon State and Beaver Nation. I still live my life along those terms. I don't like the Ducks. I've learned to deal with them, but I don't root for the Ducks. If you're a Beaver, you can't stand them."

COLE LINEHAN, UO, 2005–08: "Chip Kelly has a totally different mindset about the Civil War. He is set in his ways. He's not from Oregon, was never an Oregon guy. But he had a good philosophy as long as people buy in, and we bought into everything Chip said. He believes every game is a bowl game, and he never wavered from it. Guys who played in the Civil War, though, they know. Whether they're from Oregon or not, they know the significance of it. Coach talk was always, 'The next game is the biggest game,' but you had that game circled on the calendar. Every game is big. I understand that. But rivalries are real. I don't buy that all games are the same. That game has more significance than the other ones."

JOEY LAROCQUE, OSU, 2006–07: "If I hear people talking about how wonderful the Ducks are, I say, 'Yeah, I never lost to them, so I don't give a damn.' I had really good friends who played for Oregon. I call them hoodlums. They'd come onto the field, spitting on the Beaver signs before the game, talking trash. Those classless bums. At the same time, I'm friends with some of them, guys like Casey Matthews, Nick Reed and Terence Scott. But for that one day, friendships are cast aside. It's like you never even knew the guy.

"As we were busing to Autzen my senior year, I called a Eugene radio station and started talking mad stuff, something about how we're going to slaughter the Ducks. All the guys were listening to it on the bus radio. They got pumped up, and we started shaking the bus and almost put it on its

side. I didn't get in trouble with the coaches. Maybe it was outlandish, but I was always a prankster. The coaches knew we had this swagger to us. We went into every game thinking we were going to win. We could do stuff like that, and we could back it up. That day at Autzen, the fans were nuts. I was having little girls flip me off. At the end of the game, you could hear a pin drop. It's exciting to go into a place like that and stun them into silence."

DORIAN SMITH, OSU, 2006–07: "It's one of the best rivalries in the country. It's great for the state of Oregon. It's cool to travel around the state and see people so proud wearing the orange and black or green and yellow. I didn't dislike the Ducks coming in. When we beat them in 2006, we were excited and we got to taste victory [chicken] wings for the first time. That was a big deal. Then we look in the paper and see this big article that even though they lost, they're getting a brand-new players' lounge, PlayStations, state-of-the-art lockers and everything. That added fuel to the fire to come back and beat them next year. We knew we'd never get the recognition Oregon got, but it made us work harder."

SLADE NORRIS, OSU, 2006–08: "I didn't have the hatred ingrained for the Ducks when I came to OSU, but it's amazing how much things can change. It wasn't the players. It was just the fans who were so dang cocky. There's something about those Oregon fans that got to me. The Ducks were very well coached, a great program. It was always fun to play against them. You know you were in for a dogfight. After I got into the NFL, I met a ton of guys who played at Oregon. No matter how much I tried to hate them, I couldn't. They were all nice guys."

ED DICKSON, UO, 2006–09: "If you lost all your other games but beat the Beavers, you were going to be all right. You always circled that game. You don't know what the Civil War really is until you play in the game. A lot of people underestimate it. It's not just a rivalry. It didn't matter what your record was; it was Civil War week. Both teams respected each other.

"I wanted to beat them bad and embarrass them. There was a strong dislike. I went to parties in Corvallis, and if they didn't like me, I didn't really care. The Rodgers brothers, Markus Wheaton, Sammie Stroughter—those guys are really cool. Other than that, I couldn't care less about them. The Beavers were not allowed in Eugene—only certain guys. If they introduced themselves and didn't act like a jerk or a punk, we'd let them in. Otherwise, kick them out of Eugene."

SHANE MORALES, OSU, 2006–08: "I only played once at Autzen Stadium, in 2007. It was like nothing I've ever experienced. Very hostile. They're very loyal fans. They hate everybody, and they're pretty mean.

Little kids flipping us off and telling us to 'F' ourselves while sitting on their parents' shoulders, because their parents were doing it, too. My dad was president of the OSU player-parent association and wrote to the Oregon school president about it. Jeff Krusskamp, our defensive end, yelled at the kids, 'Santa isn't real.' As far as the players, there's going to be dislike, but there's also respect. They're a good program. You won't find another rivalry like the Civil War. I'm getting chills right now talking about it, that's how cool it is."

KEATON KRISTICK, OSU, 2006–09: "I dislike Oregon more than I did when I first came to Oregon State. We beat them my freshman year, then we broke the curse at Autzen the next year and I figured we had their number. They won the last two, though. I didn't like Autzen. The crowd was a little bit on top of you. They do that with the intention of trying to get in your head. They were rude. It was an inhospitable crowd. I hope the Oregon State fans don't go below the belts to what Oregon fans would say. But I'm going to say it's the best rivalry on the West Coast."

DREW "D.J." DAVIS, UO, 2007–10: "My two years under Coach [Chip] Kelly, we treated the Civil War just like any game. The only difference was bowl implications. We never talked about the Beavers. It was pretty much just taking care of business. You can't put any game any bigger than any other. Once you do that, you put pressure on yourself to perform. But we knew it was the team down the street, and we had a little bit of edge not wanting to lose to the Beavers.

"Mike Riley is a very good coach. He doesn't always get the best players but grooms them and makes them into a real good team, even though they might not have had what we're capable of. We knew they couldn't keep up with the way we ran our offense. They have a little chip on their shoulder, as well they should. We had to buckle down and make sure we didn't overlook that game."

JAMES RODGERS, OSU, 2007–09, 2011: "When we lost in 2009, it made me realize, I can't like those guys at all. But I didn't have a problem with the Ducks. I had friends who played for their team. We're not going to be friends on the field. Afterward, we can be friends. To me, it's just football. They put on the pads like every other team. The fans and media, they make it a little more than what it is. I didn't have any issues with any of their fans. I respected them, and hopefully they respected me."

JEFF MAEHL, UO, 2007–10: "I had heard a lot of stories about the rivalry, that you didn't know how intense college football was until you played in the game. It was one of the most fun games every year because of the fans

and the atmosphere. It was always the last game and a pretty big game for bowl setups. Two of the games determined [the Pac-10 representative to] the Rose Bowl. It was on your mind at the beginning of the year it was going to be a big game. Both sides don't like each other, but we had a lot of respect of them, their coaching staff and players. There was always a lot of talking going on, but there weren't any cheap shots. It never crossed the line."

JAMES DOCKERY, OSU, 2007, 2009–10: "The Ducks were a little flashy—rightfully so, when you have that kind of backing from Nike. Oregon is the premier university in the country when it comes to that. But Oregon State was a more family-oriented program. I liked playing the Ducks, have a lot of respect for what they were able to do in the Chip Kelly era. I liked his aggressiveness and self-confidence, and his players reflected that. In-state pride is what magnifies that game the most. You want to give the Oregon State fans the right to brag in their households, at work places that often are civilly divided. I always wanted to give Beaver Nation a year to celebrate. It seemed the Ducks were always the trendy pick. You take pride in trying to change that. There were certain Ducks I wasn't too fond of, but I had a stronger dislike for the Huskies and the Trojans.

"I'm not going to be jealous of the Ducks. They worked hard to get where they're at. But there will never be a time when I pick Oregon as my team. I'll always root for their opponent unless they're playing out of conference. Their fans are very boastful. It's like the rich kid who has everything and likes to throw it in your face. The Oregon State fan is more humble. We're taking steps toward being a national school. When we reach that level, I hope we maintain our humble beginnings."

BRANDIN HARDIN, OSU, 2008–10: "If there was one game I wanted to win every year, it was the Civil War. I remember there was a table of freshmen sitting in training table and [senior] Inoke Breckterfield trying to explain it to us. He said, 'Come Civil War week, you'll see the state split in half. You'll see all the flags coming out and things getting rowdy.' But being on the field and watching as a redshirt freshman, that's when it hit me how important it was to the fans and also the university.

"When I was in the NFL, I met a bunch of Ducks and was shocked how nice they are. A lot of my dislike was aimed at the Ducks' brand and not necessarily the players. I never had any issues with them on the field. Their fans were the ones always saying bad things and harassing us. I never beat them when I played. I always felt like we were the little train that could. The Ducks were Nike University. We thought they were spoiled. We wanted to be the team that beat them."

NATE COSTA, UO, 2006–10: "When I got to Oregon, everyone talked about the rivalry, how it didn't matter how good you were during the regular season, the teams played each other tough. For the first two years I was there [2006–07], that was true. Oregon and Oregon State were pretty even. We had similar players and style of football. But in 2008, we went to Reser Stadium and blew them out of the water. That was the first year when we separated ourselves from a mental standpoint. We felt we were the better team from then on. The game was always a big deal but wasn't as big as it used to be under Mike Bellotti.

"Oregon State does a lot of great things, but we're a little ahead of them. Since my playing days, I've found I like Oregon State fans. Most are very good people. There's no hatred or ill will toward them on my end. Now if you want to talk about the Huskies, that rivalry is a little more mean-spirited and will continue to be. The current state of that rivalry has Husky fans on high alert. Duck and Husky fans are very similar. That's what stirs up that hatred."

KENJON BARNER, UO, 2009–12: "When it came time for the Civil War, everything gets cranked up. The coaches' attitudes changed, the veterans' attitudes changed. Our coaches have been together a long time, and they've been to a lot of those games. You knew what the rivalry meant to them. If anything, that feeling intensified once Coach [Chip] Kelly became head coach. I redshirted my first year. The Civil War was in Corvallis. I had to walk through the fans and experience how much of a rivalry it was. It was one of the most hostile crowds I've ever been around. I was cool with different guys on their team—I know Lyle Moevao and I talk to the Rodgers brothers all the time. That hindered me from being able to dislike them as much as I should have. But once game time came, there were no friends on that other side. I went 4-0 against them. I'll be talking about that the rest of my life. It was a pleasure to be part of one of the greatest rivalries there is."

JORDAN POYER, OSU, 2009–12: "Growing up in the state, you watch the game every year. Civil War week is a major topic at school. Kids dress up in their orange and black or their green and yellow. To be able to play in a game like that is pretty crazy. I went four years without a win. That was hard. But they're a great program. Can't take anything away from them. I guess now that's over, I can admit that it's personal. I never said that while I was still playing.

"Growing up, I wanted to go to either Oregon or Oregon State. [The Ducks] were sending me letters, and then I went to their camp and they stopped looking at me. So it was like, 'OK, you don't want to recruit me? I'll

go to Oregon State and beat you.' I wanted to be able to say I beat Oregon, but it didn't happen. The Ducks think they're better than us. You see them out in Portland or Corvallis or Eugene. That's just how they act. That's OK. We feel good about our program. We're all brothers. That's the most important thing."

CODY VAZ, OSU, 2010–13: "I grew up in California watching Civil War games on TV. I remember watching the 2007 game, when we beat the Ducks in Autzen in overtime. So I was familiar with the rivalry, but you only realize the magnitude of it once you're a part of it. It has to be one of the best rivalries in the country. The Ducks have had some great teams. During Civil War week, everybody in the whole state is really excited about the game. You take things week by week, but in the off-season and during the season, a lot of fans have it in the back of their mind and can't wait until the Oregon week. If you're at Oregon State, you don't like them. I'm sure they feel the same way about us. You just want to beat them. It's the biggest game for us."

COLT LYERLA, UO, 2011–13: "I went to a Civil War game when I was 12 or 13 years old. I found the in-state battle interesting. It's taken really seriously. You find that more [in rivalries] in the southern states. It's cool we have that in Oregon, too. I'm trying to find the right word… Well, it's exciting, for sure, but probably more exciting for the fans than the players. The Oregon State players have been really cool with us; we've been cool with them. It's a fun game to play in, for sure, and the rivalry is heated, but more so for the fans. There's no bad blood on the field that I know of. For Chip Kelly, every game was the Super Bowl. The most important game was the next game. Whether that be Tennessee Tech or Oregon State, it was treated exactly the same. Because it's such a big deal to win the Civil War in Oregon, the feeling after the game from the fans is more of a relief to beat Oregon State than anyone else. For me personally, it had to do with whoever the best team is. I wanted to beat the best."

BRANDIN COOKS, OSU, 2011–13: "My first Civil War was at Autzen Stadium. It was pretty wild. They have one of the top-five loudest stadiums in the country. It was even more crazy than Wisconsin. Our crowd was wild for the Civil War, too. It was fun. You hear all the history of the Civil War, all the big-time players and great games they've had. It's the most important regular-season game for us because of all the things that come with it. You want to win all 12 games, but going into a game like that, you're going to get that special feeling you don't get against other opponents."

DYLAN WYNN, OSU, 2011–current: "I grew up in California and had never been to Oregon before my first visit to Corvallis. But I found out quickly the Civil War is huge. The Ducks are good. They have a lot of talent. Very disciplined. Great coaching. I hate them, but they're good. Everyone seems to love the Ducks in California. The people in Corvallis are my type of people. Corvallis has a homey kind of feel. Everybody knows everybody. I know all my neighbors. When I went to Eugene and onto the UO campus, it was a little too spread out for me. For me, the Civil War is the biggest game of the year. You don't look ahead too much, but if you don't have it in the back of your head all times of the year, you're not a Beaver. Coach Riley does a good job of stressing every game the same, but we've lost the Civil War a few years now. Every Beaver has a vendetta."

CHAPTER 26

FLIP FLOPS AND FAMILY ACTS

For 120 years, families have aligned and divided in support of their school of choice in the Civil War. Not just alumni and fans. It's been true with players, coaches, team officials and others who have had their impact on sport in the state of Oregon, too.

Thomas J. Autzen, who established a philanthropic foundation to support construction of what is known as Autzen Stadium, graduated from Oregon Agricultural College in 1909. (His son, Thomas E. Autzen, graduated from Oregon.) Rich Brooks, the longtime Oregon coach for whom Rich Brooks Field at Autzen Stadium is named, is an Oregon State graduate who served six years at his alma mater as an assistant coach. Longtime OSU head coach Lon Stiner's son, Lon Stiner Jr., was captain of the 1955 Oregon team.

There have been noted switcheroos in employment and allegiance over the years, such as Oregon State broadcaster Mike Parker, an Oregon graduate and Duck diehard for many years; Oregon public-address announcer Don Essig, an OSU graduate and former member of the school's alumni association board of directors; and Hal Cowan, who served as sports information director at both schools.

After Brooks took over at Oregon, he made a practice of recruiting sons and nephews of former teammates at Oregon State, including Rich Ruhl (Dick), Ricky Whittle (Leroy), Bobby DeBisschop (Dick), Kyle Crowston (Marv) and Bob Brothers (Paul). Some football families are split personalities, such as the Maurers, with Andy playing at Oregon and brothers Dick and Ken and son Marty playing at OSU.

Some skip a generation—Herm Meister was a placekicker at Oregon in the mid-'60s; now grandson Kyle Kempt is a quarterback at OSU. Some families are staunch one way, such as the Wilcoxes (father Dave, brother John and sons Josh and Justin) and the Winns (Dick and son Eric, brother Harvey and son Mark) at Oregon. Others split the difference, such as brothers Darrel (UO) and Ron (OSU) Aschbacher, John (UO) and Mike (OSU) Nehl, Mike (UO) and Denny (OSU) Brundage, Don (UO) and Forrest (OSU) Pellum, Cole (UO) and Josh (OSU) Linehan and T.J. (UO) and Terron (OSU) Ward. There are also cousins Kenny (UO) and Markus (OSU) Wheaton and Jed (UO) and Brandon (OSU) Boice, and father Bob (UO) and sons Dan and Rob (OSU) Sanders.

Let's visit a few of the stories…

Mike Babb grew up in Eugene as one of the bad guys.

"I was a diehard Beaver growing up," said Babb, son of Oregon State alum and booster and Eugene businessman Bert Babb. Both of Bert's parents and two sisters went to Oregon State. Bert's father, Bert Sr., had played baseball at OSU from 1920 to 1922 with Ralph Coleman, who would serve as the school's coach for 35 years. The Beaver roots were deep.

"I always got harassed by my friends at school, and I'd give it back to them," said Mike, 55, who now lives in Kennedale, Texas. "They were Oregon fans, and I was an Oregon State fan. There was no love lost there."

During Mike's childhood, the Babbs had season tickets at Parker Stadium, 13 rows up on the 50-yard line. "One game when I was 6, my parents couldn't find me," Mike remembered. "I was sitting on the UCLA bench, talking to the players."

Bert Babb, 82, went to Oregon State from 1950 to 1952. After he got out of the service in 1953, he entered the grocery business in Eugene and had a long, successful career. He has attended 61 straight Civil War football games and has OSU season tickets to many sports, including basketball, baseball, gymnastics and wrestling. He became close friends with former Beaver coaches Dee Andros and Ralph Miller. Bert was instrumental in helping Jerry Pettibone renovate the Valley Football Center in 1996.

Mike Babb graduated from high school in 1977, Rich Brooks's first year at Oregon. "Rich did a home visit with me, but there was really no thought about going to Oregon," Babb said. "My school was already paid for. My dad had saved money for it. I'd been raised a Beaver."

Babb walked on at Oregon State and, as a true freshman, beat out senior scholarship punter Wendell Smith after the first game. "I was the punter

until I got into an argument with the head coach a few games into the season," Babb said.

The head coach was Craig Fertig, in his second season as the OSU mentor. The special-teams coach was Ed Sowash.

"The only coaching I got the whole year was this [advice]: 'Keep your head down and follow through,'" Babb said. "I was struggling with my consistency. One day, Craig told me he had been a punter in college and would be out the next day, a half hour before practice, to work with me. He didn't show up on time. I said, 'Coach, I was here waiting for you.' He said, 'I got hung up in meetings and couldn't make it.'

"We made an appointment for the next day. Same thing. I called him on it. That day at practice, I went against an 11-man rush for about a half hour. I got a punt blocked toward the end of it, and [offensive coordinator] Tony Kopay swore me up, one side and the other, calling me every dirty name he could think of. The next punt, I sent one out about 60 yards. Then I told them what they could do with the ball. I got benched after that. The biggest mistake Oregon State ever made was hiring Craig Fertig. I don't have a problem saying that."

Babb wound up punting 43 times for a 34.3-yard average that season, ranking 10th among Pac-8 punters. Smith, who punted 29 times for a 36.6-yard average, was sixth. By the time the Civil War came around on November 19, Babb had enrolled for winter term at Oregon with the intention to play both football and baseball, unbeknownst to his father.

"I came home from work one day and my wife, Shirley, said, 'Sit down. I want to talk to you,'" Bert Babb recalled. "She never said that. I asked, 'What the hell is going on?' She said, 'Mike didn't go back to school. He is transferring to Oregon.' I said, 'I don't think so.'"

"My dad wouldn't talk to me for two weeks after that," Mike said.

After they got back to speaking terms, the Babbs met with Andros, then Oregon State's athletic director. Mike enrolled in community service and public affairs at Oregon, which Oregon State didn't offer. That made it possible for him to not lose a year of eligibility as long as OSU didn't object. Oregon petitioned the Pac-8 and, with Andros's blessing, was granted three more years of eligibility for Babb beginning the following fall.

An outfielder, Babb played only one season of baseball at Oregon but was the Ducks' regular punter for three years. As a sophomore in 1978, he ranked fifth in the Pac-10 with a 40.6-yard average. As a junior in 1979, he ranked eighth with a 36.4-yard average. As a senior in 1980, he was seventh with a 39.2-yard average.

In two of those three seasons, Babb ranked higher than Oregon State's punter. He out-punted his adversary in the two games he played against Oregon State, averaging 42.9 yards on nine punts in 1978 and 37.9 yards on seven punts in 1980, both Oregon victories. "I remember the game in Corvallis my sophomore year, walking down the ramp at Parker Stadium," Babb said. "I was singled out by a lot of the students and called a bunch of names."

Babb missed the 1979 Civil War after breaking his neck while tackling UCLA's Kenny Easley on a punt return. "I had an angle at him at the sidelines, dove at him and fractured my sixth vertebrae," Babb said.

Brooks served as the Oregon kicking/punting coach at the time. "Best coach I ever had," Babb said. "Not only did he teach me how to punt, he taught me the physics and philosophy behind punting the football. He taught me how to punt into the wind, why the ball does what it does. I've taught several high school kids how to punt because of him."

Mike's status presented a dilemma for his father. "I rooted for the Ducks when Mike played at Oregon, but I'm always a Beaver," Bert said. "Shirley went with the Ducks on the road while Mike was playing, but I'd stay at home and watch the Beavers. Who'd I root for in the Civil War? The Beavers, hoping Mike had a good game. [Former UO athletic director] Bill Byrne was a good friend of mine, and I had a skybox the first 10 to 12 years at Autzen Stadium. Then I gave it to Mike before he moved to Texas. I have a skybox at Reser. I don't go to any Duck games."

Mike does occasionally but admits to mixed emotions. "I'm a Duck," he said. "But I'm still a Beaver fan, too. I root for them all the time—except when they play the Ducks."

When Mike Parker was 14, his family moved from Los Angeles to Cottage Grove. One of the first things his new friends asked him was who he was pulling for in the Civil War football game.

"I didn't know what they were talking about," Parker said, "I didn't make a decision on that for awhile, but I quickly realized that was an important question from the outset of my life as an Oregonian."

Before too long, Parker was a Duck. After moving north in March 1973, he attended his first Civil War game that fall at Autzen Stadium. He hasn't missed one since.

"I've seen 41 in a row," said Parker, 55, Oregon State's radio play-by-play voice for football, basketball and baseball since 1999. "The streak was jeopardized when I was driving a cab in 1998."

Before we get there, understand that Parker graduated from Oregon in 1982 a full-fledged Duck fan. He caught the fever as an undergrad and carried it through his early years as a broadcaster in Portland. His first job was hosting *Duck Talk* with KFXX radio in 1990. He was the Ducks' sideline reporter in 1991 and '92. Through the '90s, he would sometimes report for his talk show on Monday afternoon with a voice hoarse from yelling at referees and cheering for his Ducks.

"I was pretty passionate about Oregon, no denying that," Parker said.

In September 1998, Parker was laid off from his sportscasting job with KEX radio. He had a wife and two young daughters to support. "I strongly considered getting out of the business," he said, "but I also wanted to leave the door open. Radio was what I always wanted to do. Instead of jumping careers, I decided to just make ends meet for awhile."

From November 1998 to May 1999, Parker drove taxis in Portland at night. The 1998 Civil War game kicked off at 3:30 p.m. on November 21 at Parker Stadium.

"I was supposed to work from 5:00 p.m. to 2:00 a.m.," Parker said. "That was going to be the end of the streak. We needed the money. At the last minute, I called in and said I'm only going to work a half shift. I wanted to see the Civil War. I drove to Corvallis with no game ticket, parked, bought a ticket and sat in the OSU student section." He sat mesmerized as Oregon State won 44–41 in double overtime.

"My life took a turn in an odd way that night," Parker said. "Essentially by myself among Oregon State students, I watched the greatest game in Civil War history, watched an absolute classic unfold."

As Ken Simonton scored the game-winning touchdown, Parker was sprinting (to this day, the man can really hustle) to his car to beat the traffic out of Corvallis and back to Portland. "I was still in theory a Duck," Parker recalled, "but I remember having an odd feeling of gladness. I liked [OSU coach] Mike Riley, liked what I just saw, was happy for Oregon State and was strangely content with the result. It was a preparatory moment for what was about to happen in my life. Looking back, the beginnings of my conversion had begun."

Parker worked the late shift driving cab that night. "Many of my fares were Beaver revelers partying after the big win," Parker said. Former player "Tony O'Billovich was one of my customers. He was rolling down the windows yelling 'Go Beavers' and less-than-kind things about the Ducks. Even though I skipped four hours of work, Beaver Nation made it up to me with good tips that night."

In March 1999, Parker was asked to fill in for Darrell Aune, the longtime voice of the Beavers, calling a baseball series at Cal State–Northridge. Aune was undergoing eye surgery. Parker had been the radio voice of the Pacific Coast League Portland Beavers in 1987 when OSU coach Pat Casey played for them. Parker worked the series and impressed OSU athletic director Mitch Barnhart, who was looking to replace Aune and called Parker in for an interview.

Parker's reputation as a hard-core Duck preceded him. "I have a pretty tainted past as far as your constituency is concerned," Parker told Barnhart. "Listeners know I love the Ducks. If you hire me, you'll do it over a lot of objections on that basis alone, and I wouldn't be upset if you felt that way. But I want you to know, I want this job more than anything I've wanted in my life. If you hire me, I will work diligently to become a fully committed Beaver right away."

Barnhart, who had worked as an administrator at Oregon before taking the OSU job, just smiled. "If you're the right guy and it's the right fit, that won't be an issue," Barnhart said.

Parker was hired in May 1999 and called 17 baseball games that spring. One of the first events he worked was the "Beaver Golf Caravan," in which coaches and administrators traveled the state to meet with alums and fans and drum up interest in OSU teams.

"Dennis Erickson was on that caravan," Parker said. "My first week on the job and I'm in a motor home, traveling the state with Dennis. He was funny and great to be around. I immediately took to what was going on with the athletic department. Paul Valenti and Dee Andros and Jimmy Anderson, they'd call me into their office and say, 'We're going to take care of you and help you become a Beaver.' I loved those people immediately. I'm the voice of the Beavers? It was all surreal."

If there was any question about Parker's allegiances, they were erased during the first Civil War football game he called, a 25–14 Oregon win at Autzen Stadium. At one point, Parker thought OSU receiver Roddy Tompkins had been interfered with.

"I'm yelling, 'They're mauling Tompkins, with no flag!'" Parker said, laughing. "I thought, 'OK, that didn't take long.'"

Parker's first football season at OSU was Erickson's first and the Beavers' first winning season in 28 years. "The night it was fully cemented was when we beat California. I barely had a voice," Parker said. "The joy of seeing the Beavers clinch a winning season was magical. Timing is everything. It wasn't that easy to replace Darrell, a legend, one of the best broadcasters I've ever

heard. He'll always be the voice of the Beavers for a lot of people, no matter how long I last, and I respect that. But to be swept along with Dennis and what was happening with OSU football, it couldn't have worked out any better."

There are some from the Oregon side who regard Parker as a Benedict Arnold. More, he said, are happy that he landed with a job. Former UO defensive coordinator Nick Aliotti told him, "I'm going to miss you, but I'm happy for you."

"Those type of things mean a lot of to me," Parker said. "During one Civil War at Reser—it must have been 2008 or 2010—Phil Knight was sitting by himself in the press box. I walked by to say hello. 'Mike, you're one of the rare people who has been a friend to both programs,' he told me. That Phil would say that meant a lot to me. I don't feel that anymore—I'm not a friend to Oregon anymore—but a large part of my life was spent that way. Now I get to finish my life as a friend of Oregon State. But it touched me that Phil would recognize that and say something about it."

Parker notes that these days, "my life is reversed. Some of the things I once thought were great, I hate, and vice versa. I'm thoroughly converted to love the Beavers. But life is all about the relationships. While I'm not close in any way to the Oregon people anymore, there are still people there I respect and am grateful to. They're happy for me, that I'm at Oregon State, getting to do what I've always wanted to do."

Of all the games he has called, the 2000 Civil War game at Reser Stadium sticks out. Oregon and Oregon State both went into the game ranked among the nation's top 10. The Beavers won 23–13, sending them to the Fiesta Bowl and a 41–9 rout of Notre Dame.

"It was a 12:30 p.m. kickoff," Parker recalled. "A bright, sunny, cold, clear day. I went out for an early run through the parking lot. I'm weaving through all the tailgaters, members of Beaver Nation looking forward to a great day of football. The run, and the game itself, were invigorating. It was one of the special days I've had as a professional and, quite frankly, as a fan. It meant that in two short years, the Beavers had gone from 28 years of losing to a share of the Pac-10 championship. I was in awe."

Don Essig's voice is synonymous with Oregon football and basketball. This is his 48th year at the microphone as the Ducks' public-address announcer for both sports. "It would be fun to get to 50," said Essig, 75.

It wasn't always that way. Essig graduated from Oregon State in 1960. Not only that, he was a yell king for the Beavers. Not only that, for a time he was a member of the OSU Alumni Association Board of Directors.

Essig takes some credit for Oregon State's upset 15–7 victory over Oregon at Hayward Field in 1959. The Ducks went into the game 8-1 and ranked 15th nationally. The Beavers were 2-7. The week before the game, Essig was part of a group of students that ran off 5,000 pamphlets to spread around the Corvallis campus, denigrating the Beavers. The group also dumped a load of manure outside the OSU football locker room at Gill Coliseum with a sign, "The Ducks Will Crap on the Beavers." The OSU school newspaper, the *Barometer*, speculated the next day it was the work of Oregon students. The idea was to fire up the Beaver players.

"It worked," Essig said. "We won the game. But if we'd have been caught pulling that prank, we'd have been kicked out of school."

After the game, Oregon students collected on the field and threw mudballs at OSU fans in the end zone. "They peppered the hell out of our cheerleaders," Essig said. "I still have a scar from where I got hit in the back of the head."

Upon graduation, Essig was hired for a teaching position from 1960 to 1963 at Oregon City High, where he got experience as a PA announcer at football and basketball games. He moved to Eugene in 1963 and worked games at Sheldon High until 1967, when the Oregon job opened. Athletic director Norv Ritchey hired him.

"I put all my orange and black clothes in the back of the closet and went out and bought some green and yellow," he said.

Essig has become an essential part of the athletic experience at Oregon. His catch phrase, "It never rains in Autzen Stadium," is the title of his biography. Through the 2013–14 basketball season, he had called more than 1,000 games, including 734 men's basketball games and 306 football games.

There have been funny Civil War moments but none more memorable than Essig's faux pas during the 1995 game at Autzen. "Reggie was set for a punt return," Essig recalled, "and I announced, 'Tongue is going deep for the Beavers.' Dan Fouts will not let me forget it. Every time I see him, he reminds me."

Essig has been a devout Duck for many years. "I take a lot of crap from my Beaver buddies over it," he said. "But I still give money to the Oregon State music department. I sang in the school choir and the Choralaires for four years. My wife and I are Beaver fans except when they're playing the Ducks. The day both Oregon and Oregon State come into the Civil War undefeated will be my last game. It wouldn't get any better than that."

In 2009, Essig was made an honorary member of the "Order of the O," the Ducks' Lettermen's Club. "That might be the thing I'm most proud of," he said.

Nobody has a worse Civil War record than Hal Cowan did during the time he was sports information director (SID) at Oregon and Oregon State.

The North Salem High and Linfield grad—his roommate in college was Fred von Appen, whose 35-year coaching career included nine years in the NFL and five years at Oregon—was the SID at Oregon from 1967 to 1974, when the Beavers' Dee Andros was dominating the rivalry. Cowan's Civil War record with the Ducks was 1-6. He moved to Oregon State in 1976, the year before Rich Brooks became Oregon's head coach and took control of the series. Cowan's Civil War mark with the Beavers was 7-21-1. Overall Civil War slate: 8-27-1.

"I wondered for a long time if I was the reason we were losing," Cowan said, only half-kiddingly. "It was tough on me."

Cowan was one of the first people former UO football coach Len Casanova hired when he resigned to become the school's athletic director. When Andros followed suit at Oregon State in 1976, Cowan was one of his first hirings. He retains warm feelings for both.

"I'm all the way a Beaver," said Cowan, retired and living in Bend. "I really dislike Oregon now. It always comes down to the people you work with. When I worked at Oregon, we had great people there. It was a lot of fun. I don't like the Nike influence down there now. I still like some of the people there, but I don't like the direction they're going. It's like they want to buy the world. I'm a dyed-in-the-wool Beaver these days. I don't root for the Ducks, not in anything."

A small fraternity of coaches has worked at both Oregon and Oregon State. Denny Schuler is among them. A split end and halfback during his playing days at Oregon from 1966 to 1968, Schuler served as a grad assistant at his alma mater in 1970 and then coached there as an assistant under Rich Brooks from 1986 to 1992. He was offensive coordinator during Jerry Pettibone's final season at Oregon State in 1996 and worked at the school in an administrative role in 1997.

"I've been a Duck and a Beaver—not too many people can say that," Schuler said. "It's common during training camp for a team's coordinators to exchange playbooks. The year I was coaching at Oregon State, [defensive coordinator] Bronco Mendenhall wouldn't give me one. 'You have too much Duck blood in you,' he told me. I had to go to Jerry and demand. The players looked at me suspiciously—kiddingly, I think, but there were some people who doubted my allegiance because I had been at Oregon for so many years."

During his years at Oregon, ex-Beaver Brooks would have his seniors sing an X-rated version of the Oregon State fight song during Civil War week. Schuler had grown familiar with the words. When he was called up onto the "Rookie Stage" during 1996 training camp in Corvallis, the players demanded he sing the fight song.

"I only knew the Duck version," he said. "If I'd sung that, they'd have hung me. They gave me two more days to learn it. I had notes written on a sheet in my hand. I finally got it out. To this day, I don't know the real Beaver fight song."

Schuler's wife, Cindy, has the distinction of being the only person to wear the mascot costume for both schools. A former Oregon cheerleader, Cindy would often serve as the Duck mascot during functions in Eugene.

"When we were at Oregon State, she was asked to be the Beaver mascot for a Civil War luncheon in Salem," Denny said. "So we go up there and my good buddy, [former UO kicker] Ken Woody, knew about it. I told him to keep quiet. He told Mike Bellotti. Mike had a good time with that."

All Kirk Yliniemi needed coming out of Monmouth's Central High was a chance.

A soccer player only until his junior year at Central, Yliniemi taught himself how to placekick by watching Bend native Ryan Longwell kick in the NFL. Yliniemi worked out an arrangement with the football coach to practice a half hour with the football team on Thursdays during the season. "That was it," he said.

Yliniemi kicked no field goals as a junior, just extra points. "My coach didn't believe in kickers too much that year," said Yliniemi, who figured he'd play soccer in college. But he made 12 of 16 three-point attempts as a senior, including a state playoff–record 52-yarder against Hidden Valley in the state quarterfinals at Autzen Stadium.

"I fell in love with Autzen," he said. "It was a real cool stadium. Oregon State had just signed a freshman kicker, Ryan Cesca, so I decided to go out at Oregon."

Special-teams coach Tom Osborne contacted Yliniemi. "It evolved from, 'We have a spot for you as a walk-on,' to 'We can't get you into training camp, but we'll have a tryout when school starts,'" said Yliniemi, 33, now an engineer for a large contractor in San Jose. He said he was 13 for 16 during the tryout, including one from 55 yards, "but that wasn't good enough to get me a spot. They said, 'Come back winter term and we'll try to get you in the off-season workout program.'

When I gave them a call, they said they'd bring me in spring term and give me a tryout."

By that time, Yliniemi had decided to transfer to Oregon State and challenge Cesca for the kicking job. After watching Cesca miss three field goals in a 23–17 Oahu Bowl loss to Hawaii in 1999, "I told myself, 'I can beat this guy out. I'm a better kicker than him,'" Yliniemi said.

Yliniemi met with head coach Dennis Erickson and special teams coach Jim Michalczik. "Dennis said he'd give me a chance to try out," Yliniemi said. "I said, 'I got that story from Oregon. I don't want my time wasted.' He said he would get me into spring ball and give me every opportunity to prove myself."

Yliniemi began spring practice as the No. 6 kicker. By the end of the spring, he had moved up to third on the depth chart behind Cesca and Mike White. Yliniemi redshirted during the Fiesta Bowl season of 2000 while Cesca was earning first-team All-Pac-10 honors. As a sophomore in 2001, Yliniemi was called upon in a couple of games in place of the struggling Cesca and kicked field goals of 43 and 28 yards—while also missing from 32 yards—in a 17–14 loss at Oregon.

"That was pretty cool," Yliniemi said. "I still think I made the field goal that was called no good. They had 20-foot uprights instead of the standard 35- to 40-foot uprights, so it's harder to tell. I felt so motivated by not getting a chance at Oregon. It made me a better kicker. I focused so much harder. I wanted to prove Mike Bellotti and Tom Osborne wrong. They gave me the runaround and wasted a year of my eligibility."

Over two-plus seasons at OSU, Yliniemi was one of the most accurate kickers in NCAA history, making 37 of 43 attempts, including five of six from beyond 50 yards. Two of the misses were blocked. As a junior, he made his only attempt, from 41 yards for the game's first points, in a 45–24 rout of Oregon. As a senior, he was two for two, making from 29 and 28 yards in a 34–20 loss to the Ducks.

"A lot of the people who loved that I went to Oregon didn't like it when I switched to Oregon State," Yliniemi said. "It was fun to be in the middle of that. I like rivalry games. My brother and sister are both diehard Beaver fans who married diehard Duck fans. Makes it interesting."

Denny and Mike Brundage share a bloodline and a birthday—August 5—but not a school. Denny, 69, was a guard and linebacker for Oregon State from 1957 to 1959. Mike, 63, was a quarterback at Oregon from 1964 to 1966. They grew up in Roseburg.

"Mike was a lot better athlete than I was," Denny said. "Star quarterback, all-state in basketball and state tennis champion his junior and senior years."

Denny played for Tommy Prothro. During those years, his younger brother often watched the Beavers' spring and fall practice sessions. "My folks were closer with the Prothros than with [UO coach Len] Casanova," Mike recalled. "Recruiting was very personal in those years. I'd come home for dinner after practice, and Tommy or Cas would be there eating with my family."

Mike fielded offers from the four Northwest schools and Notre Dame, finally deciding on Oregon after the Shrine Game in August. "I knew Tommy very well, but they were running the single wing, and I ran the 100 in about 18.2," Mike said. "Cas ran the T formation, which gave me a chance to be a drop-back passer. I'd been around Oregon State all my life, but I just liked the atmosphere in Eugene better."

The Brundage boys were very close growing up. "Denny very much looked out for me, and I looked out for him," Mike said.

One time when Denny was 16 and Mike 10, they went duck hunting at Summer Lake. "I had a 410 single-shot shotgun," Mike said. "Denny put me 20 yards in front of him and showed me how to put the safety on. I tripped, the gun went off back toward him and I filled him and his buddy with buckshot. I thought they were dead, but they weren't. My one and only hunting experience."

The brothers have a friendly rivalry over their Civil War loyalties. "I always tell Mike he's entitled to one mistake in his lifetime," Denny said. "After I retired, I went hunting all over the world. In my trophy room I have a 55-pound mounted beaver. I have a duck hanging in its mouth."

When your father is Dave Wilcox, you're likely to be both a football player and a Duck fan. It was a way of life for brothers Josh and Justin Wilcox, who followed in their Hall-of-Fame father's footsteps to play football at Oregon.

"I always wanted to be a Duck," said Josh, a tight end at Oregon from 1993 to 1996 and now a loquacious radio sports talk show host in Portland. "My dad and uncle [John] had played there. I was a ballboy during Chris Miller's senior year with Brady Brooks [son of coach Rich Brooks] and Greg Byrne [son of athletic director Bill Byrne]. I also ballboyed when Bill Musgrave played. I wanted to be the next Jeff Thomason. We'd play pranks on one of our neighbors, county commissioner Cleve Dumdi, by putting KUGN Duck stickers on his orange and black mailbox."

After two years at Oregon in 1963 and '64, Dave Wilcox embarked on an 11-year career with the San Francisco 49ers that led him to election to the Pro Football Hall of Fame in 2000. He settled in Junction City, where Josh and Justin were raised.

"Junction City was a straight Oregon State town during that time in the '80s," Josh said. "I'd go up to Corvallis and watch the Orange Express teams and A.C. Green play basketball and Erik Wilhelm and Robb Thomas play football."

The Wilcoxes were tuned in more closely to the Oregon athletic programs, of course. Josh, whose only scholarship offers were from Oregon and Oregon State, listened when OSU head coach Jerry Pettibone and assistant Brady Hoke—now Michigan's head coach—paid a recruiting visit to the Wilcox household in 1992.

"There was a point in time when I looked at Oregon State seriously," Josh said. The Beavers "wanted me as a linebacker. I have to admit, I entertained the notion, 'Why not go against the grain?' But going to Oregon and wanting to be a tight end won out."

Had Josh chosen OSU, his father "would have been just fine with it," he said. "Oregon State had been his second choice, too. My mom would have cared. She'd have had to change her wardrobe."

Oregon State beat Oregon during Wilcox's freshman season, 1993, and took the Ducks to the wire in losses in '94 and '95. "I had a lot of respect for [the Beavers]," Josh said. "They were blue-collar—kind of like me. They were good defensively with Rocky Long. The rivalry was really there for us, that and the Huskies. The Huskies in terms of hatred. The Civil War in terms of fighting with your neighbor. The Huskies were like the people in a different neighborhood who thought they were better than you."

After his Oregon career, Wilcox played two years with the New Orleans Saints. He also had stints with NFL Europe ("I was Kurt Warner's roommate in Amsterdam, which was good for me—I didn't get into as much trouble"), Arena Ball and the XFL. All the while, he was trying his hand at pro wrestling, advancing all the way to a short stint with WWE in Louisville.

"I was mostly a heel, but we were always trying to figure that out," said Wilcox, 40. "I got beat up by Dusty Rhodes in a match in 2000. At one point I trained hard-core with Dory Funk Jr. I worked out with guys like Brock Lesnar and John Cena. I did a show for Rowdy Roddy Piper at Mac Court and wrestled Mr. Perfect in a battle royal. Eventually, I decided no way would my body physically hold up. My back, shoulder and neck were killing me."

No matter where Wilcox was, he always made it back for Oregon–Oregon State football. As a youngster, he watched the Toilet Bowl in 1983 and hasn't missed a Civil War game since. "I understand why Coach [Chip] Kelly said every game is big," Wilcox said. "I completely get that. But being a native Oregonian, I have a different feeling about it. The Civil War means something. It always has.

"I remember meeting Dee Andros at a golf tournament with my dad. I thought, 'Wow, that's the guy Dad talks about in the same breath as Coach Casanova.' It doesn't get much better in terms of college football rivalries. I think the players get it. I think Coach [Mark] Helfrich gets it. It's part of the reason I went to Oregon, to get to play in games like that."

Bob Sanders was a pretty big deal at Oregon in the late '40s, a fullback and linebacker who played with Norm Van Brocklin and helped the Ducks to the 1948 Cotton Bowl game. When his sons, Dan and Rob, chose the bad guys up the road, Bob didn't blink an eye.

"I loved it when the kids chose Oregon State," Bob Sanders said. "I'm a Duck and proud of it, but I thought they made a good choice. We're all pretty polite about things during Civil War week."

Both Sanders boys—Dan a safety, Rob a linebacker—were recruited by OSU, Oregon and California out of Manchester, California. Dan was a three-year starter for Dee Andros in the early 1970s. Rob played his freshman year at Cal and then transferred and wound up being a part-time starter for the Beavers. Their sister, Susie, was a cheerleader at OSU, too.

"Dad never put any pressure on us to go to Oregon," Dan said. "I don't think he was that happy with how things were being run at Oregon at the time. I don't remember it being a big thing when I told him I was leaning toward Oregon State. He was supportive. He said, 'I really can't blame you,' which was helpful to me. It would have been difficult if he'd wanted me to go to Oregon.

"The decision for me was easy. I didn't have any loyalties. And once we got into playing the Ducks, I didn't like 'em at all. There was a lot of strong dislike between the programs when I was there. During the games, there was a ton of talking going on. We relished beating them most every year. It was sheer hatred, no question about that."

Rob Sanders transferred to OSU after Cal made a coaching change following his freshman year. It was a turbulent period of social unrest at Berkeley in the early '70s. "It was a war zone," Sanders said. "The house I lived in got tear-gassed. Both Oregon and Oregon State re-recruited me,

but Corvallis was a better spot for me. Dad was good about it. He supported Dan and me, came to our games, supported the program. He'd preferred we'd have gone to Oregon, but he never made it a problem. Hasn't changed anything for them, though. Mom and Dad are still Oregon fans."

Like his brother, Rob felt strongly about Oregon State's archrivals during his playing days. "I don't know how they looked at us, but we just hated the Ducks, hated everything about them," he said. "We felt they looked down on us. New guys would come in and didn't quite get it at first, but they'd get it eventually. I've evolved. I really respect the Ducks' program and I root for them now, but for years, I'd root for whoever they played."

Dan has come around like his brother, to a point. "It's neat for the state of Oregon to have a program do what they have done on a national level the last few years," he said. "I'm happy for my dad, happy for the Ducks. The Beavers have hung in there quite well, too. Mike Riley has done a great job with a lot less to work with than Oregon. I'd just like to see us beat them again before too many more years."

Aaron and Robb Thomas are members of a select club—father-and-son receivers who played in the NFL. Each played for a full decade. Aaron caught 262 passes for 37 touchdowns with San Francisco and the New York Giants. Robb had 174 receptions and 11 TDs during his time with Kansas City, Seattle and Tampa Bay.

Both played at Oregon State, Aaron from 1958 to 1960 under Tommy Prothro and Robb from 1985 to 1988 for Dave Kragthorpe. Robb nearly wound up elsewhere, though, due to disinterest despite some remarkable athletic ability that made the 5-11 Thomas a multi-sport phenom at Corvallis High. As a senior, he high-jumped 6-9 and placed second in the state meet to Gus Envela in the 100 (10.7) and second in the long jump to Latin Berry (23-0).

"I spent some years in Klamath Falls growing up, and [Olympic decathlon champion] Dan O'Brien was a year ahead of me in school," Robb said. "I remember doing some track stuff with him. He was a squirmy kid. I'd have probably been a decathlete had I not played football."

Initially, Wyoming was the only school to offer Robb a scholarship. He decided he didn't want to play that far from home. "About a week before the signing date in February, Robb said, 'Dad, can you help me find a place to play closer to home?'" Aaron remembered. "I called up Don Read at Portland State and asked if he would have interest in Robb. He said yes but had just assumed he was going to Oregon State. Robb had not heard from Oregon State.

"I made arrangements for Robb to visit with Read in Portland. The next day, I got a call from Kragthorpe, who said he wanted to talk to Robb. When they met, he offered a scholarship—probably because somebody else they were recruiting turned them down. It was the easiest recruit Kragthorpe had that year."

Kragthorpe didn't recruit Thomas's younger brother, Lance, either. He wound up at Oregon, where he played linebacker and deep snapper for two years before transferring to Fresno State. "I was fine with Lance going to Oregon," Robb said. "Oregon went hard after him and we didn't. He got his school paid for and a chance to stake his own path."

Robb remembers a play his senior season in the Civil War game. "We had a quick kick, I went down trying to make a tackle and got blindsided by a Duck," Robb said. "I look up and there's this kid, Marcus Woods, who played with Lance at Corvallis High. 'That's for your brother,' he said as he stood over me. I wanted to kill that kid."

This may be letting the cat out of the bag, but John Nehl works for Oregon State.

Nehl, who punted at Oregon from 1973 to 1975, is employed by the Oregon State University Cascades master's program in his native Bend.

"When John went to work for Oregon State, I said, 'A Duck finally sees the light,'" said older brother Mike, a kicker and punter at OSU from 1968 to 1970.

When John didn't follow Mike to Corvallis out of Bend High in 1972, "I was a little disappointed in a way," Mike said. "I'd preferred he have gone to Oregon State, but he had a wonderful experience at Oregon. It was fine with me."

John was five years Mike's junior. "He'd beat the hell out of me when he got bored, but really, we were pretty close," John said. "It was a difficult decision not to go to Oregon State. I grew up thinking Jess Lewis and Bill Enyart and Craig Hanneman walked on water. But I made the right decision."

There is more mixed blood in the Nehl family. Mike's son, Gabe, got his undergraduate degree at Oregon and then a master's at Oregon. Mike's daughter, Missy, played soccer and basketball at Oregon State. "Gabe's a Duck, but Missy's a Beaver through and through," Mike said. "Makes for interesting times during Civil War week."

Few families have had greater impact on college football in the state of Oregon than the Maurers. Not bad for a bunch of boys who played eight-

man football in high school at Prospect, a town of about 200 people in southern Oregon, 45 miles east of Medford.

The father, Ray, was a logger. There were five boys and a girl. Four of them wound up as Beavers. The two oldest—Andy and Mike—were Ducks. Andy, the oldest, chose Oregon over Oregon State because both schools offered room and board but the Ducks also covered compulsory fees.

"To this day, I don't know what compulsory fees are," said Andy, 65, a Christian financial marriage counselor. "Hey, I'm from Prospect. But I live in Medford. I'm a city guy now."

Andy was a starting tight end who went on to a nine-year NFL career as a tackle and guard, playing in two Super Bowls.

The next sibling, Mike, followed Andy to Oregon and played frosh ball before entering the service for the Vietnam War. Dick, Ken, Ron and Lori chose a different path, all enrolling at Oregon State. Dick and Ken were starters and Ron a walk-on for the Beavers during the Dee Andros era.

"It's pretty amazing for a bunch of eight-man football players to play in the Civil War, isn't it?" Andy said.

Dick, a fullback, was recruited by both Oregon and Oregon State. "The Beavers were a fullback offense in those years, which sounded good," he said. "One thing that turned me from Oregon was when I went in for my visit, they introduced me as 'Andy's brother Dick.' It wasn't, 'Dick Maurer, Andy's brother.' I knew right then I had to carve my own path."

Ken, an offensive tackle, followed Dick to OSU. "Dick was there, I liked Dee Andros and Oregon State was the place to go back then," Ken said. "It was not really talked about much, though. Wherever we went was fine. Andy didn't care. We were from a small town. We all wanted to make it in Pac-8 football, no matter where we went."

In the next generation, along came Marty, Andy's son and a quarterback, safety, punter and kicker for 2A Cascade Christian in Jacksonville in southern Oregon. "I grew up a Duck fan, based off my dad," said Marty, 35, owner of Medford Heating and Air Conditioning. "They didn't offer me a scholarship. But Oregon State did. It was time to switch gears."

Andy was unhappy but not with his son. "He didn't like it that [Oregon] didn't think I was good enough," Marty said. "For awhile, he made it a personal vendetta. 'My son's not good enough to play for you?' He took offense. We all took it personal. It is personal. I thought it every game I played the Ducks. It was motivation, to show they made the wrong choice."

Marty was a three-year starting tight end at OSU, a key piece of the offense for Mike Riley as a sophomore and Dennis Erickson as a junior and senior. Two of his favorite games were Civil War victories in 1998 and 2000.

"I'm very happy we won the ones that meant more, with more on the line," Maurer said. "Every time I caught the ball near the sidelines, I was hoping I'd be tackled near Mike Bellotti so I could run him over. The hatred was so much. That still resonates today."

Prior to the Civil War game his senior season, Maurer told the media, "I don't like the Ducks. I want to apologize to all the die-hard Beaver fans that I grew up rooting for Oregon. But things change. This is a different time, a new era. This is a Beaver state. That's what the flag says."

During those years, Andy made a temporary conversion. "Blood's thicker than water," Marty said. "It's family, and we root for family. Dad was on our side. He was rooting for me. Oregon State was his family for awhile. He probably forgave [the Ducks], but he didn't forget."

"For four years, I was a Beaver, absolutely," Andy said. "They got total loyalty for four years. But they got dumped really fast after Marty left. I wore black real good but not orange so well. In the Civil War, I'm a Duck, even though the rest of the time I can be a little bit of a Beaver."

Marty's wife, the former Brandi Bonnarens, played volleyball at Oregon State. "Andy gets both barrels aimed at him when they come visit," Dick said. "When Marty was at Oregon State, Andy was all Beaver, but the Ducks have had some pretty good success lately. I guess he claims them again."

Today, the Maurer brothers are "civil" as they watch the Civil War together. Each roots for his team but accepts the other. Marty is not quite that way. "I hate the Ducks with a passion," he said. "I hate that they use black now. Show me a black 'O' on a car and I want to spray-paint it orange. My favorite teams are Oregon State and whoever plays the Ducks. If you have that stupid zero on your car window and you get in front of me, I should be able to get in your bumper, get you loose and put you into the wall. NASCAR fans will get that."

Forrest Pellum has had significant health problems in recent years, including a major neck surgery two years ago. At 55, he is totally disabled with a caregiver, living in Portland. "I'm happy to be alive," Pellum said.

Pellum is an Oregon football fan now but, more than that, a fan of younger brother Don, an assistant coach for the Ducks for 22 years.

"My brother is blood," Forrest said. "I'm a Duck fan, but really, I'm pro-state of Oregon, whether Oregon State, Oregon or Portland State. As long

as it doesn't hurt Don's success, I don't mind Oregon State winning. If I'd gone there for four years, maybe it'd be a little different."

The Pellums were out of Banning, California, Forrest a cornerback, Don a linebacker. Forrest, two years older, wound up playing two years at Mount San Antonio JC in Walnut, California.

"I was a C student in high school," Forrest said. "Don was a straight-A student. I wasn't the kind of person who was a bookworm. I always told Don, 'Do the opposite of what I do.' He threw a newspaper every morning for four years in high school. He'd put the bag on his back and jog the route every morning, and he wore a weight vest, too. He was a very disciplined person. I wish I could say that about myself."

The Pellums wound up taking a recruiting trip together to Oregon State—Forrest out of junior college, Don out of high school. Forrest wound up choosing the Beavers, Don the Ducks.

"I would love to have played with my brother," Don said. "I had a good time on my [OSU] visit, but I felt more comfortable at Oregon."

"Signing day was a very sad day in my life," Forrest said. "It was like losing my brother. I went one way, he went the other."

During the next three years, "The biggest competition we had was who could send our little sister the most stuff," Don said. "We were always cordial. We both redshirted [in 1981]. I went up for the game in Corvallis two weeks before they were going to play us, and they had a countdown to the Civil War in the locker room after the game. It was like, 'Wow, we didn't have one of those.'"

Forrest was a starter in 1980 and '82, redshirting in 1981 due to an elbow injury. Don was a reserve in '82 and a starter the next two seasons. They met up on the college gridiron only once, during Oregon's 7–6 Civil War victory at Parker Stadium. They were on the field together for a few plays that day—Forrest returning punts, Don covering them as a gunner.

Before one of them, "Forrest went over to a teammate, pointed to me and said, 'You gotta get him,'" Don recalled. "We can't say the words he actually said. I came out smoking off the line of scrimmage and ran right through [the blocker] but didn't make the tackle. Wish I could have gotten to my brother. You'd have seen a true Civil War moment."

"The guy blocking on the outside was Craig Sowash," Forrest said. "I just told him, 'Get him, Sowash.' Don was thinking, 'OK, I'm going to kick his ass.'"

Forrest, who says he did some teaching and coaching football, admires the career his brother has forged. "When he was playing at Oregon, I always

respected the Ducks," he said. "I never beat them in two tries. I was happy my brother was on a team that had a little success.

"We both went to college to get a degree. Football was secondary. Every day I beat myself up for not getting that degree. My brother, sister and I are a very tightknit family. I don't mention Oregon State in front of him, period. Oregon State's in my heart, but my brother's in my blood. He runs through my veins."

Dick DeBisschop was a standout center/linebacker at Oregon State, a teammate and fraternity brother of the great Terry Baker. Even so, when son Bobby was being recruited out of Ontario High, there was no pressure applied.

"He wasn't a dad who made me wear Beaver colors," Bobby said. "Dad told me stories about playing for Tommy Prothro, and I got to meet him a couple of times. I always rooted for the Beavers as a kid. They weren't very good. Oregon was better, and Rich Brooks was the coach."

Brooks had played with Dick DeBisschop at Oregon State. They were good friends. Oregon State had gone 0-11 and 1-10 the first two years under Coach Joe Avezzano, "and that's a tough one," Bobby said. "It came down to Oregon and Oregon State, and it felt like Oregon was ready to take that next step up. A lot of guys going on recruiting trips the same time as me were more interested in the Ducks and other schools. That swayed me a little bit."

Bobby chose Oregon with his father's approval. "The Beavers blew it, really," Dick said. "Bobby liked the school at Oregon State and liked the assistant coaches but didn't feel comfortable with Avezzano. When he said he was going to play for Rich, I felt fine about it. It was the right decision."

Bobby was a linebacker as a freshman and then switched to tight end as a sophomore and was a starter through much of his final three seasons. Dick rooted for the Ducks in every game during Bobby's years and also during Brooks's 18-year tenure as the Oregon head coach.

"I would never root against Rich, but I couldn't go to a Civil War game, except when my son was playing," Dick said. "I couldn't root against the Beavers and I couldn't root against Rich. What do you do?"

Neither DeBisschop ever lost to the other school. Dick was 2-0-1 against Oregon, Bobby 3-0-1 against OSU.

Bobby has respect for Oregon State's program. "Because I grew up as a kid who enjoyed the Beavers, I have a little different perspective," he said. "I've been to Beaver reunions with my dad, which have been fun. The Civil War probably doesn't mean quite as much to the players now because both

teams usually go to bowl games. But there are a group of fans who don't ever want to go through a winter with a loss to the other side.

"I can't have us lose to the Beavers. If you're a Duck, you just can't do it. There's that pride about winning the state. It still means a lot to some of the old players and fans who understand the history."

Rich Ruhl was another son of a Beaver—the late Dick Ruhl, a linebacker at OSU from 1962 to 1964—who wound up playing for Rich Brooks at Oregon. He earned Pac-10 Defensive Player of the Week in the final regular-season game of his career in 1995, making 15 tackles in a 12–10 victory over the Beavers.

"That was right up there with the best game of my career, and it was special doing it against the school my dad played for," said Rich, a linebacker at Oregon from 1992 to 1995. "I always wanted to show him we were the better school."

When his father was alive, Rich would make a pair of wagers on the Civil War game each year. "We'd bet $100," Rich said. "And there was a flagpole at the family ranch in Lexington [in eastern Oregon]. Whoever won the Civil War got to fly their flag at the house that year."

Ruhl's feelings about the Beavers have tempered over the years. "I don't dislike them now," he said. "I want them to win every game until they play the Ducks. I don't get that same sense of feeling from my friends who are Beavers, though. They want us to lose every game. It's a lot of bitterness, I guess, because we have Phil Knight on our side. I hate the Huskies. I could have them lose every game. Maybe it's the same thing the Beavers have against us. There's an arrogance. You want to beat them so bad all the time."

It seemed as if Josh and Cole Linehan—sons of longtime state-of-Oregon prep football coach Ron Linehan—were destined to be Beavers. Their grandfather and uncle were hardcore Oregon State fans, and their mother attended school there. Sure enough, Josh signed out of Banks High with Oregon State and wound up as a starting tackle for the Beavers under Mike Riley in the mid-2000s. Cole, two years younger, had other ideas.

"Josh and I grew up Beaver fans," Cole said. "I went through the recruiting process, visited Washington and narrowed it to Oregon and Oregon State. I liked the Oregon coaching staff and the fact they'd been there so long. Josh had just gone through a coaching change with Dennis Erickson, who had bailed for the NFL. There was more stability at Oregon and a chance to win more games. I had a better feel for the Ducks."

"I told Cole he had to do his own thing, make his own decision," Josh said. "I wasn't going to try to sway him. I could see from the start of it he wanted to take a different path than I did, which was fine. My grandpa was disappointed, but I figured it was his decision. I did tell him, 'When you decide you want to be a Beaver, let me know. Maybe you could transfer.'"

"When I first committed to Oregon, I told my grandmother, and she started crying that I was not going to be a Beaver," Cole said. "That's always a good start."

Cole became a starting defensive tackle at Oregon but was never on the field at the same time as his brother. Josh had a high ankle sprain his junior year in 2005 and blew his knee out midway through his senior year.

"That disappointed the hell out of me," Josh said. "I wanted to beat his ass in those games, to go up against him. That was the one thing I was looking forward to when he went to school down there. It's one of the only ways for two fat-kid linemen to get any publicity—one on each side of the Civil War."

In the '05 game, Cole had an interception, a forced fumble and a sack for a 24-yard loss by OSU quarterback Ryan Gunderson in a 56–14 romp over the Beavers at Autzen Stadium. "I wish Josh had been on the field when all that was happening," Cole said. "That was my only career interception, and I returned it 14 yards. Gunderson's a good buddy of mine. We always rib each other. He tackled me on the play, clipped my ankle to bring me down. There's a great picture of me running the ball with Josh's backup, Andy Levitre, in the background."

"I'm standing there, watching on the sidelines, thinking, 'This could only happen with me not playing,'" Josh said. "One of those once-in-a-lifetime deals."

During the '05 game, Linehan family members wore multicolored platypus shirts, representing both Oregon and Oregon State, and took some heat. "The fans could not take the idea they were going to root for both teams," Cole said. "They were angry at them. My sister-in-law said she got yelled at by some Oregon guys: 'You're either a Beaver or a Duck.'"

Beaver and Duck linemen of that era became pals. Josh and Cole were in the thick of it. So were players such as Nick Reed and Max Unger from Oregon and Kyle Devan and Roy Schuening of Oregon State.

"We'd do river floats or have barbecues or just hang out, usually in Banks or in Corvallis," Cole said. "We all knew each other really well. It made Civil War games fun. I'd have conversations with Devan, giving

shots back and forth. We wanted to beat each other real bad, but it was cool to still have friendships."

"Five or six [Ducks] went to my wedding," Josh said. "Good guys, all of them."

Does Josh root for the Ducks when they're not playing the Beavers? "Hell no," he said. "There's no way I could root for the Ducks in any way, shape or form. People always say you can root for both. No, that doesn't work for me. I don't have a hate for the players. It's the arrogance of the fans. No way you can root for those type of people. You want to shut those yuppie hippies up. I tell Cole, Oregon and Washington, you are the same freaking schools in different states."

Cole isn't as venomous. "I wanted to beat the Beavs more than anybody, but other than that, I want to see them have some success," he said. "My wife [Melissa] is a Beaver. My buddies make fun of me. She takes it serious. She's very knowledgeable about sports. We learned a lesson quickly. The first Civil War we went to, we sat next to each other. We have not done that since."

Tony O'Billovich had what he calls "the game of my life" in the 1992 Civil War game, making 12 tackles in Oregon's 7–0 win at Corvallis. He was part of Jerry Pettibone's 1991 and '93 Oregon State teams that went into Autzen Stadium and won.

"I was built to play in that game," said O'Billovich, son of OSU linebacker Jack "Mad Dog" O'Billovich, a star on the Beavers' last Rose Bowl team in 1965. "I wanted nothing more than to follow in the footsteps of my dad, a Beaver legend. I went to every Beaver function you can think of as a kid. Everybody would come up and say, 'Hey, Mad Dog!' There was never a question where I was going to school."

O'Billovich didn't have to be taught the significance of the Civil War. "Was there another game?" he said. "Dad never jammed hatred for the Ducks down my throat, but that was our rival. It was, 'You gotta win the Civil War.' He gave me the game ball from winning the Civil War his senior year. I have one from my senior year, too. I keep both balls in my office. We are the only father-son captain duo in the school's history."

Ironically, Tony didn't start in the '92 Civil War game after providing locker room material for the Ducks in a newspaper interview that week. "Something to the effect we were going to send them home with their feathers between their legs," O'Billovich said. "Somebody called my dad and read him the story, and he reamed my ass. When he got hot, you got

it good. It was, 'You'd better back it up now.' My mom called, crying, and said, 'I didn't raise that kind of son.' The next day, I'm walking in the hall at Gill Coliseum and I pass Dee Andros. 'Hey, O'Billovich, screw 'em. I love what you said.'"

Don Shanklin has been a staunch Beaver since quarterbacking Jerry Pettibone's offense during the mid-1990s. Now Shanklin has shifted allegiances, with son Tyson Coleman playing linebacker at Oregon.

"I'm kind of split right now," Shanklin said. "In today's world, I wear green and yellow. I'll give them four or five years. I still cheer for Oregon State when we're not playing the Ducks, but I have to cheer for my son's team. At the [2012] Civil War game, I have a couple of pictures of myself wearing green and yellow. It felt funny. A couple of times I found myself cheering when the Beavers were making a good play. I'd think, 'Dang, I'm not supposed to do that.'"

Duck fans will always revere Kenny Wheaton for his unforgettable 97-yard interception return against Washington in 1994. They would have loved to have had cousin Markus Wheaton follow in his footsteps. But Wheaton signed on with Oregon State, becoming one of the greatest receivers in OSU history.

Markus, 16 years Kenny's junior, was a schoolboy living in Dallas when Wheaton was a member of the Cowboys for three seasons. "He and his brother were a year apart," Kenny said. "They'd come out to games, and I got a chance to know them."

When Markus was being recruited by both Oregon and Oregon State, "I got a couple of phone calls from the Ducks asking to put a word in," Kenny said. "But my best advice to Markus was go where you feel comfortable. I'm a Duck, always will be, but you have to go where you're comfortable. I told him I respected Coach [Mike] Riley and thought Oregon State was a good program. Still feel the same about it. With my son, if he gets to that point, I'll tell him the same thing. Oregon suited me, but that doesn't mean it has to suit you."

When he married Lauren McJunkin in March 2013, Armon Hatcher married into a Duck family. Lauren's father, Tim, played defensive end at Oregon from 1974 to 1975. Does that mean Hatcher, a four-year starter at safety for Oregon State from 1995 to 1998, became a fan of both schools?

"Actually, I'm going to start hating the Ducks a lot more," said Hatcher, 37, who lives in Portland. "Lauren's a diehard Duck fan. Since I met her, it

has deepened the hatred. I didn't really hate them, but I do now. I've told [Lauren and Tim] our two-year-old son can't wear any Duck gear, but they still buy it. It has to go. He can only wear Oregon State stuff from now on."

Hatcher said during his playing days, he grew friendly with many of the Oregon players. "Mostly, it's the fans, the attitude," he said. "They think very highly of themselves, even though they don't have a long tradition as a national power. You grow not to like them. I'm not hanging out in Eugene. I have respect for their program, but you don't ever want to lose to them."

During his playing days at Oregon State from 1979 to 1982, Ed Singler was a star quarterback. His wife, Kris, was a receptionist in the OSU athletic department. And when son E.J. chose Oregon to play basketball coming out of South Medford High, he got his father's approval.

"I thought it was great," Ed said. "It wasn't about me. It wasn't about Kris. It was about E.J.

"Frankly, Oregon did a better job recruiting E.J. than Oregon State did. He started going to Oregon football games and felt the vibe and saw Oregon basketball having more success than Oregon State. He felt more of a connection. Kris and I were never going to tell them what to do. I remember [OSU coach] Craig Robinson was in Medford for a golf tournament. He had recently gotten hired. I said, 'Coach, it's too late in the game. He's going to Oregon.'"

Jim Sherbert was an All-Pac-8 defensive end at Oregon State for Dee Andros in the early 1970s. Had things worked out at Oregon for his father, Jim Sr., it might have been different.

"I ruled out Oregon because of my father's experience there," Sherbert said. "He had grown up in Gresham and attended Lewis & Clark College for a year before serving in World War II. When he got out, he enrolled at Oregon and went out for quarterback at 25 or 26 years old [in 1946]. He came home from practice one day and told my mother, 'There's a quarterback who can punt the ball more accurately than I can pass it. His name is Van Cocklin.'"

The quarterback was Norm Van Brocklin, destined for the Football Hall of Fame.

A former placekicker at Oregon, Herm Meister was pleased when grandson Cody Kempt went to his alma mater to play football. The quarterback didn't last at Oregon, however, transferring to Montana State for his final two

years. Now Cody's younger brother, Kyle, is a redshirt freshman at Oregon State, and grandpa Herm couldn't be more pleased.

"Kyle is built to play for Coach [Mike] Riley in that offense," Meister said. "I have all the respect in the world for Mike and his staff, and Kyle is majoring in engineering. It's a perfect fit. My friends are calling me a platypus now. I have to put away all my green stuff for the next four years. I'll be wearing orange and black."

Among the more curious oddities in Oregon football in the mid-1950s: The Ducks had two quarterbacks named Crabtree—Jack and Tom—who were no relation. Tom, from Coos Bay, lettered in 1955 and '56. Jack, from Norwalk, California, lettered from 1955 to 1957.

"We always say he's the related one and I'm not," Jack said. "The strangest part was that we played the same position. My sophomore year I had a great game against Arizona in Tucson and was named national player of the week, but the [Associated Press] story gave him credit for it."

TIDBITS THROUGH THE YEARS

From the *Corvallis Gazette* game story after Oregon Agricultural College's 26–8 victory over Oregon in the 1897 Civil War:

> *All the OAC lads played like steam engines and their teamwork was excellent. Pap Hayseed* [Harvey McAllister] *was in every play. He was always out in interference and for a center, made some surprising tackles. His whole heart and head were in the work, and both organs are above the ordinary.* [Dan] *Bodine, though suffering from an accidental knife wound on his left hand, seemed to be in perfect form and was unmovable except when he wished to be moved.*

When news of the outcome reached Corvallis, wrote the *Gazette*, "a roar went up from hundreds of happy people and the college students had an impromptu parade."

From the *Oregonian*'s game story of Oregon's 38–0 Thanksgiving Day 1899 victory over the Aggies:

> *It was a very pretty exhibition of individual playing by the home team. Heavy plays were directed against the tackles and around the ends. Heavy line-charging was done by the "Farmers," which was their chief tactics. The university did not do much battering and by keeping the ball away from their opponents did not allow them to make use of their full*

strength...The college was almost always on the defensive and had the ball only a few times...OAC weighed 1,735 pounds in the aggregate, University of Oregon 100 pounds less...During the game there were many manifestations of enthusiasm on both sides. The Eugene rooters were the loudest. Toward the end of the game the ladies unfolded a yellow banner inscribed "Champions of Oregon."

On the same day, university officials delivered to Coach Frank Simpson "a testimonial letter signed by every member of the faculty commending the conduct and management of the football team. The clean and gentlemanly playing of the team is largely due to his coaching as well as the skill that has been developed as exhibited in the games with the Multnomahs [Multnomah Athletic Club] and the Berkeleys [California]." Simpson resigned after two seasons to resume his studies at a medical college in San Francisco.

Headlines from the *Oregonian*, two days after a scoreless Civil War tie in 1902: PLAY THE GAME OVER. Oregon and Corvallis Elevens Want Another Try. BOTH SIDES ARE DISSATISFIED. Oregon Men Attribute Failure to Score to Costly Fumbles—Corvallis to Inability to Break Stubborn Defense.

"The big intercollegiate football game is being played over and over again in the minds of gridiron enthusiasts, and partisans of both the University of Oregon and Oregon Agricultural College are trying to figure out just why their favorites failed to win," read the story. "Friends of the Eugene team attribute their failure to score to critical fumbles and there is some reason in this, for Oregon fumbled repeatedly and never regained the leather. Corvallisites are bewailing their team's failure to take the pigskin over the line when it was within two yards of Oregon's goal, and they admit that Oregon's superior defense prevents the Farmer lads from winning the honor of combat."

By 1902, football was king on the Eugene campus, but the "Physical Culture" department at UO was growing. According to the '02 *Webfoot*, the school's first yearbook:

The year's working physical training consists of classwork for the men three times a week, the ladies twice a week, the gymnasium being open from 8:30 a.m. until 5:30 p.m. The classwork consists of light gymnastics such as marching, dumbbell drill, wand drill and setting up exercises, and heavy gymnastics, consisting of apparatus work on long horse, side horse, parallel

bars and flying rings. The Swedish system is taught, embracing exercises on rope and pole climbing, stall bars and Swedish ladder. The classes have basket ball teams which are equally enjoyed by both sexes, an indoor baseball team and a hand-ball court in connection with the gymnasium. The aim of the work is twofold. First, to maintain and restore the health of the student. Second, to train the body so that all parts get an equal amount of benefit, so that the qualities of grace, courage, endurance and self-possession are developed.

Sports offered that year were football, track and field, golf, indoor and outdoor baseball and basketball for the men and basketball, handball and tennis for the women.

Trickery was the byword of Oregon's 7–3 victory over OAC in 1924 on a wet sawdust Bell Field before a crowd of 17,000, the largest crowd ever to watch a sporting event in the state.

It was Joe Maddock's lone season as UO coach, and for the week before the game, the Webfoots rehearsed a "man hiding out" play "until his players could go through it confident with their eyes shut," a report said. Also known as the "dead man" play, a player would stand along the sidelines and then take a step in bounds just before the snap and have a pass thrown to him before the defense could recover.

In the '24 Civil War game, Oregon's "lanky" end, Bob Mautz, hid out near the sidelines. "There was a quick lineup," the report said, "and before OAC could spot him and break it up, he had grabbed a 15-yard pass and run untackled across the line."

Later in the same game, the Aggies turned the tables. OAC end Fritz Tebb, who was also a pitcher on the baseball team, ran a hidden ball bootleg with the entire Oregon team in pursuit of a bogus ball carrier on the other flank. He ran for 38 yards, but the field was so muddy he couldn't tell where the goal line was and dived over what was really the 10-yard line. On the play, Oregon claimed the ball had not been legally snapped but that the Aggies had merely faked a snap. Referees ruled in OAC's favor, and the ball was placed on the UO six-yard line. Three running plays netted three yards, and on fourth-and-goal from the three, Wes Schulmerich's pass was incomplete, giving Oregon the victory.

Hall of Fame coach Knute Rockne taught a "Knute Rockne Method" football course at Corvallis's Bell Field each summer from 1925 to 1928.

Rockne was in the latter stages of his Notre Dame career (105 wins and six national championships in 13 seasons) where he coached the legendary Four Horsemen. Rockne made visits to Corvallis because of a friendship with three men—Aggie coach Paul Schissler, ex-OAC player and coach Sam Dolan and Michael "Dad" Butler, the school's head track coach.

Dolan had starred in football at Notre Dame in the early 1900s. Butler knew Rockne as a boy, and he had served as the young man's coach at the Chicago Athletic Club, where Butler was a manager. Schissler's Lombard College (Galesburg, Illinois) team had lost only 14–0 to Notre Dame in 1923. Rockne had written a letter of recommendation to help get Schissler the OAC job. When the Aggies went cross-country to beat New York University 25–13 to end the 1928 season, Rockne made the 180-mile round trip from South Bend to Chicago to visit with Schissler during the Beavers' workout there en route.

Maybe Rockne's presence helped the Aggies in the Civil War. They won 24–13 in 1925, 16–0 in 1926 and 21–7 in 1927 before losing 12–0 in 1928.

There was little political correctness in newspaper reporting in the 1920s. Evidence was in a column written by the *Oregonian*'s L.H. Gregory about Oregon State quarterback Howard Maple (OAC officially became OSC in 1927, but Gregory evidently didn't get the word) written prior to the 1928 Civil War:

"Howard Maple, the slippery fat boy who plays quarterback for OAC, is a football contradiction. Not that he is not a great player—ho ho! That he certainly is. This year, particularly. But he doesn't look like a great player, nor especially does he look like a great quarterback. Maple isn't fast. But try to stop him! He is roly-poly, chunky, short-legged, not even long-armed. He has none of the sylph-like grace of Gibby Welch or George Guttormsen. He is not over 5 feet 7 inches tall. To look at him, you'd think, here's the typical running guard, for he is of that blocky type like [William] Walterskirchen of Gonzaga, though the latter isn't quite so fat. Yes, fat! Maple weighs at least 175 pounds, more likely would scale 185. Not lack-of-condition fat, for no athlete trains more faithfully; just a natural fat boy.

"Maple is not one of those brittle boys. Southern California gave him a rough afternoon, from which he emerged minus one tooth, and with three others so badly pushed out of position they had to be pulled later. Four teeth for his country in one session is quite a sacrifice…Why Howard Maple, the roly-poly fat boy quarterback, should be so weirdly hard to stop is one of those mysteries. I doubt he could run the hundred in track costume at much

better than 11 flat. He is just one of those rare players who don't seem to need the speed—though in one respect he is lightning fast, and that perhaps is the answer; he can turn and pivot while at full speed on the imprint of a buffalo nickel."

Gregory wrote he was anticipating a great matchup between Maple and Oregon's Johnny "Flying Dutchman" Kitzmiller, who "is at least one step in every 10 faster than Maple, maybe two." Kitzmiller rushed for 44 yards and a touchdown and threw for Oregon's other score in a 12–0 victory. Maple gained 24 yards rushing and completed eight of 21 passes for 65 yards.

Eighteen years later, L.H. Gregory was on the scene at Corvallis's Bell Field for Oregon State's 13–0 Civil War triumph over Oregon. Oh, what the teams would have given for artificial turf.

Wrote Gregory: "You wouldn't have turned a cow out to grass or a dog out to die on the kind of day this was, or the muddy morass of a football field on which Oregon State and Oregon played their 50th annual football game. After one slide in the gooey gumbo, the players' numbers were smeared out, their uniforms became a mass of sticky mud and they resembled giant jumbo bullfrogs leaping in a bog. Under the circumstances, it was surprising how well they played."

One of the spectators at the '46 Civil War game in Corvallis was Portland native Johnny Pesky, second baseman for the Boston Red Sox, who had just lost in seven games to St. Louis in the World Series. Pesky had taken the relay throw when the Cardinals' Enos Slaughter raced from first base to home on a single for the winning run in the eighth inning of Game 7. Pesky, who died in 2012 at age 92, handled the relay long enough to be branded forever as the man who "held the ball."

With both teams fumbling on a slippery Bell Field, a wise guy in the stands yelled, "Give the ball to Pesky! He'll hold onto it."

It was a funny line. But to be fair to Pesky, Slaughter had been stealing on the pitch to Harry Walker, who stroked a hit to left-center. Reserve Leon Culberson was in center field because Boston's regular there, Dom DiMaggio, had injured his knee. Culberson's relay throw came to Pesky, but Slaughter kept running.

"I didn't hear anything," the late Pesky told the *Portland Tribune* in 2003. "Everybody was screaming. When I looked up, Enos was 20 feet from home. I threw the ball. Maybe if I'd had a better arm, I'd have gotten him."

Longest punt return in Civil War history: Oregon's Woodley Lewis, 91 yards for a fourth-quarter touchdown in a 20–10 loss in 1949. Lewis caught the punt on one bounce, eluded three OSC defenders, bumped into blocker Bob Roberts, nearly fell but regained his stride and raced to pay dirt. It was Lewis's fourth TD return of 70 yards or more that season. Lewis went on to an 11-year NFL career, making the Pro Bowl as a rookie with the Los Angeles Rams in 1950.

Another sign of different times from the *Oregonian*'s 1949 Civil War game story: "There was a solemn note. Over in one corner, sophomore end John Thomas was stretched inertly on a bench, mumbling incoherently. Dr. Waldo Ball, the Beaver team physician, revealed Thomas had suffered a slight concussion when smacked trying to tackle Earl Stelle late in the fray. 'He's coming out of it now,' Dr. Ball said. 'I'm sure he'll be OK.'"

Nine players who participated in the 1950 Civil War game had played together on the state team in the first Oregon High School Shrine All-Star Game two years earlier—Dan Zarosinski, Sam Baker, Bob Redkey, Cub Houck, Gene Morrow, Bill Sheffold and Wes Hoglund of Oregon State and Tommy Edwards and Jim Calderwood of Oregon.

Zarosinski, a guard who began his OSC career under Lon Stiner and finished it under Kip Taylor, said the Civil War was a focus of both coaching staffs.

"My freshman coach was Al Cox," Zarosinski said. "The first day of practice, he started talking about beating Oregon. It was even more so when Kip took over. First team meeting, it was, 'Got to beat Oregon,' and it carried down from there."

Zarosinski considered Taylor "a good coach. He moved me up to first team—I have to believe he was a smart coach. He was a real talker. He had his pep talks. Some of the older guys took it with a grain of salt. The younger guys bought into it."

When Oregon State upset eighth-ranked Michigan State 25–20 at Portland's Multnomah Stadium in 1949, Zarosinski was a sophomore. The Spartans "had a couple of All-America guards," he said. "First series, the guy across from me—Don Mason—looked over to me and said, 'You better get out of here, you little shit, before you get hurt.' We had no facemasks in those days. Next play, I hit him right in the mouth. He went crying to the referees, and I didn't have any problem with him the rest of the game."

When Oregon freshman George Shaw intercepted a Gene Morrow pass in the 1951 Civil War, it was his 12th pick of the season—an NCAA record. Shaw, who also played quarterback and returned punts, became a first-team All-American in both football and baseball. He was the No. 1 pick in the 1955 NFL draft and played eight seasons in the NFL and AFL.

During the 1952 Civil War, won by Oregon State 22–19, Oregon State sophomore safety/linebacker Ron Siegrist played the "spy" role against Shaw.

"Wherever George was—quarterback, halfback—I lined up on him," Siegrist said. "I'd just drop back and cover, unless he ran. Last play of the game, they put him at split end. He ran a streak. He was faster than I was because he could run. I was chasing him and never saw the ball, but I saw his eyes go up as it was getting to him. I jumped as high as I could. My hand somehow hit the ball, and we won the game."

In his six seasons as Oregon State's head coach from 1949 to 1954, Kip Taylor's record was 20-36. Good thing the Beavers had Oregon on the schedule. Taylor's first five teams won the Civil War before a 33–14 loss in 1954, his final game. Taylor's non–Civil War mark was 15-35. "OSC's Kip Quashes Resignation Rumor" was the headline after Oregon State's win over Oregon in 1952. He was to last two more seasons.

Bud Gibbs played at OSU under Lon Stiner and Kip Taylor and then coached three years for Tommy Prothro from 1958 to 1960. Then Gibbs moved over to administration, eventually serving as the school's registrar.

"Tommy had planned on me running his offense when he changed from single wing to T formation," Gibbs said. "But I was married with three young kids, and the coaching salaries were bad. When I had a chance to go into administration for a lot more money, from the standpoint of looking out for family, I had to do it. Otherwise I'd have been with him for a long time."

John Robinson played under Len Casanova at Oregon and coached under him for eight seasons there until his retirement in 1966. Robinson was head coach at Southern Cal when current Oregon State coach Mike Riley served as his offensive coordinator from 1993 to 1996.

"Mike and Len are the same people," said Robinson, who coached the Los Angeles Rams from 1983 to 1991. "Two of the great human beings ever. Great coaches, too, who have the same ability to influence people."

Robinson continued coaching at Oregon during the Jerry Frei era from 1967 to 1971. "I had one of my most embarrassing moments coaching against Oregon State," Robinson said. "It was Jerry's last year at Oregon. We wore yellow helmets. I said, 'Coach, we need to do something different. Let's paint our helmets green.'

"He didn't think it was a great idea, but he let me do it. We all sat down on Friday after practice and spray-painted every helmet green. They were the most beautiful green you've ever seen. Then it rained, and about halfway through the game, the paint started to strip off. Our helmets were dripping green paint, and Jerry was looking at me with an 'if-looks-could-kill' stare."

Robinson considered the Civil War the biggest game on Oregon's schedule each year, but Washington was 1A.

"Robbie hated the Huskies, and he passed on that feeling to his players," said quarterback Bob Berry, who played on the UO Frosh under Robinson in 1961. "He called them 'big-school guys' and 'cheaters.' We were just the little Ducks. We played up at Seattle that year and had to play our game on their practice field. That got him going. We were ahead 21–0 at halftime. Then he gave an impassioned halftime speech, and we went out and had some live tackling on the sidelines just for show before the second half started. He was psyching [the Husky Pups] out. Mel Renfro ran the third-quarter kickoff back for a touchdown, and we beat them 51–0."

For 27 years, 11 players off the 1960 Oregon Frosh team—Bob Berry, Rich Schwab, Dick Imwalle, Bill Youngmayr, Ron Jones, Buck Corey, Monte Fitchet, Dennis Maloney, Lowell Dean, Doug Post and Ron Stratten—have gotten together annually for a vacation. In recent years, the reunion has taken place in Goodyear, Arizona, the first week of April. Several other ex-Ducks from that era, including Dave Wilcox, Tim Temple, Arlon Elms, Jack Clark and Dick Winn, have joined the group. "I guess we like each other," Winn quipped.

Bryce Huddleston was in a quandary when Oregon State's Black Student Union staged a walkout in 1968.

Huddleston was the BSU president as well as a junior wingback on Dee Andros's football team. A disciplinary measure against linebacker Fred Milton for a Van Dyke beard worn in the off-season triggered the revolt. Huddleston was a major part until his mother caught wind of it.

"It was during those times when Tommy Smith and John Carlos raised the black gloves at Mexico City, when Muhammad Ali was stripped of his

title," said Huddleston, who has lived in Corvallis and run a janitorial service since the late '60s. "There was this feeling that the white man was screwing the black guy. It was a black and white deal in Corvallis, and I was right in the middle of it. I was wrapped up in the Black Power thing.

"So Mrs. Andros calls my mother and tells her I'm acting like an idiot. My parents were raised in an Oklahoma Baptist church. It was, 'Yes, sir; no sir,' with my father. So my mother calls me about boycotting and raising hell. She says, 'I'll tell you what you're going to do. Shave your mustache, resign from the Black Student Union, go apologize to Dee Andros, [athletic director] Jim Barratt and the coaches and players. Have that done by 9:00 a.m. tomorrow or I'll fly in and do that for you.' I did it. A lot of the black kids were calling me Uncle Tom, but you have to respect your parents. I didn't want my dad to hear about that stuff. He'd have come and shot me."

Huddleston said when he returned to the team, he was fifth-string halfback. "Dee told me, 'Bryce, you'll be the smallest pulling guard in the Pac-8,'" he said.

An outstanding amateur golfer and one of the true characters in the Corvallis community, Huddleston did a double-take when his daughter, Kearston, attended Oregon. "But I'm trying to tell people, don't take this rivalry thing too seriously, because the interbreeding and incest between the schools is rampant," he said. "We should be supporting both schools. I love what Oregon State has done for me. You couldn't drag me out of here with a team of horses. I always hope the Beavers beat the Ducks, but we don't have the money they have. Maybe they are the big brother, but we are to be respected, too."

Huddleston tells a story about an airport meeting with Oregon linebacker Tom Graham during Huddleston's senior year at OSU. For a sociology project, Huddleston flew from Eugene to San Francisco dressed "preppy"—yellow Izod shirt, tennis shorts, sneakers. "Everybody was saying, 'Ah, you go to Oregon State?'" he said.

On the way home, Huddleston was dressed in soul brother black—beret, turtleneck, leather jacket. "I had my best Huey Newton outfit on," he said. "Nobody would look you in the face. On the way home, though, Graham was on the plane. He was a real reserved, quiet, respectful guy. I'm a talker. Tom did most of his talking with his hits on the football field."

A few months later, they met on the field at Autzen Stadium. Graham was credited with 37 tackles in a 10–7 loss to the Beavers. "He got me pretty good several times in that game," Huddleston said. "He'd knock me on my butt, pick me up and say, 'Hurry back.' Boy, could he bring it."

Graham and Rich Akerman drove to school together from Los Angeles in March 1968, both winter high school graduates getting an early start at college. Akerman's father had bought him a new El Camino.

"We're heading off to see the world," Graham recalled. "Then I notice he had a three-speed on the column. I'd never driven a stick shift. I'm like, 'Good grief, I hope he can drive the whole way.' Sure enough, after a couple of hours, Rich said, 'I'm tired. Your turn to drive.'"

Graham had to fess up. "That's OK, I'll teach you," Akerman said. After a few bumpy miles, Graham gradually got the hang of it. "We've been buddies ever since," Graham said. "We call ourselves blood brothers."

When Lake Oswego High won the state 6A championship in 2012, Graham had a pair of connections. Akerman served as line coach for head coach Steve Coury. A volunteer coach was Dick Coury, Steve's dad and an assistant coach with the Broncos when Graham played in Denver. Graham flew out to Portland for a few days, conducted a pre-game chapel service for the Laker players and watched the game.

When Mike Nehl was punting for Oregon State from 1968 to 1970, he had some retrieving help from neighbors.

"The Reynolds boys used to shag punts for me," said Nehl, in reference to the five boys in the family that lived across the street from Parker Stadium. They included Donny, who became a star halfback at Oregon and played major-league baseball for the San Diego Padres; Larry, who played both baseball and football at Stanford and wound up as a player agent; and Harold, a former All-Star second baseman now a broadcaster for Fox Sports and the MLB Network.

"There would be a kicking game at the start of practice, and then I'd go off to the netherlands to punt," Nehl recalled. "Sometimes managers would shag them, and sometimes the Reynolds gang would pitch in and do it. They were great kids."

Jeff Kolberg recalls Donny Reynolds and close friend and high school teammate Mike Riley carrying the Beavers' helmets while playing at Oregon State in the late '60s. Kolberg grew close to Riley's parents, Bud and Mary. Bud was OSU's secondary coach during those years.

"I blew out my knee playing in Canada after my senior year, and it got infected," Kolberg said. "The infection went through my body. I was in the hospital for 19 days and almost died. I had no place to go. Mike was [a

freshman] at Alabama, and Bud and Mary took me in. I stayed with them in Mike's room for a couple of weeks while I rehabilitated. They'd call my parents and check in with them. Finest people in the world. Can't thank them enough."

While at Oregon State, Kolberg became renowned for his special talent of eating glass. "I started doing it my senior year in college, about the time I started focusing on my studies," he said.

While attending the New England Patriots' training camp the next summer, the legend grew. "We were out drinking one night, and I saw one of my teammates bleeding in the mouth from eating glass," he said. "I said, 'Hey, if you're going to do it, do it right.' I showed him how to do it. The next week, the *Boston Globe* did an article on me. The next thing you know, somebody sends my mother the front page of the *Globe* with a picture of her son with a piece of glass in his mouth."

Kolberg's father, Elmer, had been a star at Oregon State from 1935 to 1937, earning the game ball after the Beavers' 14–0 Civil War victory as a senior. He later played in the NFL with Don Looney, father of the notorious Joe Don Looney, a certifiably oddball halfback. "My mom gets a call from Joe Don's mother, Mary Looney," Jeff said. "She said, 'Now you know how I feel.'"

What was Kolberg's trick while eating glass? "I did it every once in a while when I had too much to drink," Kolberg said. "Nobody does it sober. The trick is you don't eat the glass, you break it. When you bite into it, you hook the glass around your eye teeth. And as you break the glass, break away from you so you don't get cut. Then you start chopping it up in little pieces with your teeth, and you swallow it. When it comes back out, you hope it doesn't rip your ass. My brother, Doug, showed me how to do it. Sad thing is, I see my kids do it, too. Passing down through the generations, unfortunately."

Kolberg and a few teammates may have been the last players to double up in rugby at OSU. Kolberg played all four years he was at the school (1968–71). "Coach Andros was great about it—eventually," Kolberg said. "The first year I played, he didn't like it. But Dee came around and allowed the rugby team use of the practice field for our games. A lot of guys—Jim Lilly, Ken McGrew, Gerald McEldowney, Butch Wicks—wound up playing rugby. [Football's] Bill Robertson was our trainer. It was a club sport, but we had a good program and a very good time."

Only two players have had as many as three 100-yard rushing games in the Civil War: Oregon State's Dave Schilling (1969–71) and Oregon's Derek Loville

(1986–89). Loville is the only player to have four. "At least I have one record," Loville said with a laugh. Loville, third on Oregon's career list with 3,296 yards rushing, played seven NFL seasons and earned three rings with Super Bowl champion teams—San Francisco (1995) and Denver (1998 and '99).

On an expedition from May 15 to June 2, 2013, former OSU defensive tackle Craig Hanneman (1968–70) scaled Mount Foraker in the Alaska Range in the vicinity of Mount McKinley. It was the third try for Hanneman, who would turn 64 a month later. Fewer than 200 people have reached the 17,400-foot summit of Mount Foraker. Hanneman is believed to be the oldest. "All six in our crew made it," Hanneman said. 'We hit the perfect weather window. The previous two times, we had strong climbers, but we didn't have the weather."

Hanneman, who played four years in the NFL, had previously climbed Mount Everest, among other conquests. "The pride I feel for having made it to the top ranks with any of them," he said. "We had to climb two mountains to climb this one. There is a lot of up and down just to get to the Sultana Ridge. It took us 10 days just to get to the start of the main mountain at 6,000 feet. It was a mountaineer's dream to be on that mountain—totally isolated from everything. To have those scenic views…we were psyched the whole time. I was obsessed with climbing the mountain for nine years and finally got it done. It was right up there with Everest in terms of achievement."

Hanneman and three of his fellow defensive linemen at OSU from the late 1960s—Scott Freeburn, Mark Dippel and Bob Jossis—have had OSU football season tickets together for years. They have also made several climbs together. And in the summer of 2012, they joined ex-teammate Jim Sherbert to participate in the Running of the Bulls at Pamplona, Spain.

"Amazing experience," Sherbert said. "We drew from the team concept we had during our time together at Oregon State. I was an inner-city kid. Craig was a farm boy from Turner. Ideologically, so different. Yet today, we're as close as can be."

Andy Maurer didn't catch a lot of touchdown passes as a tight end at Oregon. He caught one for 16 yards from Tom Blanchard on a curl pattern, though, for the Ducks' only TD in a 10–7 Civil War loss to Oregon State as a senior in 1969.

"I talked to [ex-OSU coach] Dee Andros about it years later," Maurer said, "and he said, 'We knew they never threw to you, so we never covered you.'"

Maurer—then 6-4 and 225—had played fullback as a sophomore. "Jim Evenson was the starter," Maurer said. "Every time we got behind, he didn't want to play, so he'd fake an injury and I'd go in. I got to play all the time."

There has been a Greg Marshall play at both schools—a fullback who played at Oregon from 1968 to 1970 and a defensive tackle who played at Oregon State from 1975 to 1977. "I used to sign my bar tab," said the Ducks' Greg Marshall, "and it would show up on the other Greg Marshall's bill."

Oregon's Marshall said he chose his school "because Oregon was rated pretty high by *Sports Illustrated* on its list of party schools." He said he avoided Washington because "I met another fullback, Bo Cornell, on a recruiting trip to Seattle and didn't want to have to compete with him."

Steve Endicott second-guesses his decision to play quarterback in Dee Andros's Power-T offense attack from 1969 to 1971.

"In hindsight, I should have gone to Stanford to play baseball," Endicott said. "I was accepted into school there. The Power T didn't fit my talents. I wasn't an option quarterback. Steve Preece was the perfect guy. 'Fox' was a great runner, though he couldn't pass worth a spit. I went to Oregon State for friends and family, and it was fun. It was such a great family atmosphere. Jeff Kolberg, Billy Main, all those guys…The best thing about Oregon State was the guys."

Endicott played only one season of baseball, at third base during his sophomore year in 1970.

During Ahmad Rashad's senior year in 1971, Oregon lost to Nebraska 34–7 and Texas 35–7 but upset Southern Cal 28–23.

"Those teams outweighed us 30 pounds a man," Rashad said. "Seemed like we had 35 guys to 100 on their side."

But Rashad, then known as Bobby Moore, cherishes his experience playing for the Ducks from 1969 to 1971. "Those were three of the most wonderful years of my athletic career," said Rashad, a member of the College Football Hall of Fame. "There's nothing quite like college football. Once you get to a pro team, it's pretty good, but it's a job. That's where you go to work. In college, you choose to go there. You know everybody on campus. You're part of the student body. You have pride in your school. It's an experience that's like none other. I remember my college games better than the NFL games. I still bleed the Oregon colors. I wear 'Ducks' on my forehead."

Darrell Aune was the Beavers' radio play-by-play voice from 1970 to 1998. He remembers his first Civil War game in 1970, won by Oregon State 24–9 to finish the season 6-5. At that point, the Beavers hadn't had a losing season since 1959.

"There was some grumbling by fans who didn't think the record was as good as it should have been," said Aune, 71 and living in Monmouth. "Well, flash forward 28 years and tell me if 6-5 was a bad record."

From the mid-'70s to the late '80s, the best thing about Beaver athletics was Ralph Miller's basketball team. In 1979, Craig Fertig's last football team opened the season with a 35–16 loss at New Mexico. "The Lobos hadn't won an opener in some time," Aune said. "The first time they got the ball, they scored. We go to commercial break, and one of our sponsors was Miller Beer. The first thing we hear is, 'It's Miller Time!' And everyone who has a headset on in the booth breaks out laughing. We were ready for basketball season already."

Through the 28 years without a winning football team—from 1971 to 1998—basketball "not only helped me, it helped all the fans," Aune said. "If I heard it once, I heard it 150 times a year come November as the Civil War neared: 'Football is almost over. Hang in there. We're going to kick [Oregon's] ass in basketball.'"

During the 1972 Civil War game, KEX radio—Oregon State's flagship station—scheduled too many commercials. "They were trying to run four 60-second commercials during each quarter," Aune recalled. "That's OK in the fourth quarter, but it could be difficult in the first quarter because teams aren't calling timeouts. I had to make some judgments of when are we going to go to commercial. The only option early in a game was change of possession."

Oregon State went three-and-out on its first possession and punted. Aune went to commercial. Play resumed before the commercial finished. On first down, Oregon handed to Donny Reynolds, who went 60 yards for a touchdown.

"When we get back from break, Donny is 20 yards upfield," Aune said. "The crowd is roaring and he hasn't scored yet, but he's close. I had Donny run the fastest 60 yards in history."

Donny Reynolds went into the 1973 Civil War game at Autzen Stadium with a sore ankle.

"I'd hurt it at Washington State three weeks earlier," said Reynolds, then a junior running back at Oregon. "In the third quarter, I got tackled on a

carry near the sideline. One of their tackles, Jim Mott, grabbed my ankle and started twisting it. I tried to roll but couldn't keep up as fast as he was twisting it. He said, 'I got him, I got him.'

"That hurt—and I don't mean physically. I never condoned trying to go out and hurt somebody, but that's exactly what he did to me. I was crying leaving the field—not because of the pain but because somebody would do that in a game."

Reynolds had passed the 1,000-yard mark for the season earlier in the game but would not return in a 17–14 defeat.

Mott, now a retired teacher living in Troutdale, said Reynolds's version of the incident is "total BS."

"The only reason I know what play he was talking about is, a couple of weeks after the game, a friend of mine asked if I tried to hurt [Reynolds]," Mott, 61, said. "I said, 'What are you talking about?' I guess that was the word around town.

"I was the backside defensive end on the play. [The Ducks] ran a sweep around right end. I was trailing the play, coming as fast as I can. As [Reynolds] cut back inside, I dived to tackle him. The turf was wet, and I kind of slid. As I wrapped up on him, we rolled. That was it.

"I never tried to hurt anybody—except maybe a quarterback in the pocket. I didn't say a word to anybody. Nobody in those days trash-talked. The entire four years I played, I never said a word to anybody. I never said anything just because I was so damn tired. I didn't know that was Donny Reynolds. It was just their tailback on that play. I didn't know it was him and I didn't know his ankle was hurting."

There was an irony to it, though. The *Eugene Register-Guard* had interviewed Mott the week of the game. Mott had noticed something while watching game film of the Ducks playing earlier in the season, and he mentioned it to the reporter. "One of the Duck receivers had taunted a defender, holding the ball out to him for about the last 10 yards on his way to the end zone for a touchdown," Mott said. "I told the [reporter], 'That's total bush—typical Oregon.' Maybe they were pissed at me for that. I do remember Dee [Andros] telling me, 'Jimmy, button your hat on good this week.'"

Mott clearly wasn't a fan of the archrivals. "I went duck-hunting the Sunday before the game and shot a mallard," he said. "Then I hung it from a light fixture in our locker room. Everybody had to walk by it to practice. I figured somebody would take it down, but it stayed up there all week. It was karma. We blew them away—17–14."

Fred Von Appen worked as an assistant coach under both Dick Enright and Don Read at Oregon (1972–76). Von Appen, who later coached several years in the NFL and as a head coach at Hawaii, had an interesting take on what happened with the Ducks under Enright, who lasted only two seasons, and Read, who coached for three after serving as offensive coordinator under Enright the previous two.

"Dick was a good guy and an excellent offensive line coach," Von Appen said. "Jerry Frei and John Robinson were gone, and most of our players had been recruited by them. We had some locker-room issues but decent personnel, and we were a transitioning team at that time. Dick had been a highly successful head coach in high school, but that doesn't necessarily translate to the next level. The job is so all-encompassing.

"When he was let go [after two years], he was very embittered about what happened. Those of us who stayed at Oregon, he felt it was a stab in the back. That was not the intent. Don was the last guy to stab somebody in the back."

When Read was fired after a 4-7 season in 1976, "we knew the alumni were getting a little restless," said Von Appen, who served as Read's defensive coordinator. "It had been a slow rebuilding job. Don had recruited some good kids, and we had some good players coming.

"The Civil War that year was played in Corvallis. I was upset with our defense at halftime, and we met in the bowels of Gill Coliseum. I pitched a fit, which I didn't normally do, and threw a chair partially for effect and partially because I was pissed. The chair went through a blackboard. We later received a bill from Oregon State for the blackboard. We came back and won that game [23–14] and thought we'd saved Don's job. Had he been left in place, we were about ready to turn that corner and have a pretty good team that next year. But the alums thought he wasn't charismatic enough. Driving to work the next Monday, I heard a sports bulletin on the radio that Don had been fired. One of the great guys I was associated with in my 38 years of coaching."

The quarterback during Don Read's first year as head coach at Oregon was Norv Turner.

"The fans called him 'Norval Turnover,'" said then UO defensive coordinator Fred Von Appen.

Turner succeeded Dan Fouts as Oregon's quarterback in 1973 and '74, the Ducks going 4-18 over those two years. "It was a tough road for Norv," Read said. "He had a terrific mind and was analytical, but he didn't have the skills or the polish Dan did. I knew he was going to be a great coach."

510

Turner has coached in the NFL since 1985 and was head coach at Washington, Oakland and San Diego. He is currently offensive coordinator at Minnesota.

Read has lived in Corvallis since 2004 to be close to his son, Bruce, who is special teams coach at Oregon State. Don Read has also volunteered his time coaching with Mike Riley, with whom he is close. But he maintains pride in the level of success achieved at Oregon, dividing his plaudits between Rich Brooks, Mike Bellotti and Chip Kelly.

"I wouldn't give it to any one but to all three of them," Read said. "They built on things and did it the right way. They took a team that was struggling in the bottom part of the conference to the top. Nike got on board, and now they have facilities as good as any. I see them as one of the great programs in the country. I root for the Ducks in every game except when Oregon State plays them."

When Eric Pettigrew was a freshman at Oregon State in 1978, Coach Craig Fertig brought back Tommy Prothro's "Black Bandits of Benton County" uniforms for the Civil War game. Not the idea—the uniforms themselves, having been stored in an equipment room for nearly 15 years.

"We were squeezing into them," said Pettigrew. At least he was. At 6-6 and 280, he was several sizes bigger than most who ever suited up for Prothro at OSU.

"You had to attach it at the crotch before you tucked the shirt in, but not all the guys could do that," Pettigrew said. "There were flaps hanging outside the pants. It wasn't a good look."

Oregon won that game 24–3 at Parker Stadium, a game in which OSU quarterback Steve Smith was bloodied by a hit from UO linebacker Willie Blasher in the second quarter. "Blasher blindsided Steve—unfortunately, because I missed a block—out of bounds along the asphalt warning track," Pettigrew said. "It started a mini-riot. Players from both sides were grabbing each other. Everybody was going nuts. Steve's bloody lip was the grossest thing I've seen in my life. He was bleeding from the right side of the bridge of his nose to the other side of his lip. A piece of his lip was hanging down. Blood was pouring out."

The cut was stitched up, and Smith returned for the second half "and played pretty well, considering," Pettigrew said. "I have an incredible amount of respect for him to be able to return after that."

Todd Welch and Ladd McKittrick were close high school friends who wound up at rival colleges, Welch a linebacker at Oregon, McKittrick a quarterback

at Oregon State. Welch had always looked up to McKittrick's father, Bobb, a storied offensive line coach for the San Francisco 49ers.

Fate would put the two together for their final college game in 1984. Welch sacked McKittrick three times in Oregon's 31–6 victory at Parker Stadium, the final game for OSU coach Joe Avezzano.

McKittrick had been the starting QB as a junior but became the backup behind JC transfer Steve Steenwyk. But Steenwyk and five teammates were caught breaking curfew the night before a game at UCLA the week before the Civil War.

"Joe knew about it, broke it up but let the guys play" in a 26–17 loss to the Bruins, McKittrick remembered.

When the staff found out about it after the game, several of the assistants threatened to boycott the Civil War game if the players weren't disciplined, McKittrick said. "Jack White and Nick and Joe Aliotti were the coaches I knew about" who would have quit, he said.

Avezzano benched the players, including Steenwyk, for the Oregon game. That meant McKittrick would be the starter. "On Monday I was told I would start," McKittrick said. "I hadn't gotten a lot of reps at practice all year, but I thought, 'OK, let's go figure this out.'"

Welch had 16 tackles, including the three sacks. "Todd had the game of his career," McKittrick said. "We were mouthing off to each other a couple of times but not seriously. The head referee, Gordon Reese, told us to break it up one time, and I said, 'It's OK, we're friends.'"

"It was the only game Ladd's father saw him play in college because of his duties with the 49ers," Welch said. "Bobb came into our locker room after the game. I had a bunch of media around me. He said, 'Todd, you had one hell of a game. I just wish they'd have blocked you a little bit better.' I remember going over to [the Beavers'] locker room and telling Ladd, 'Wish we had one more game against each other so you could have a chance for some revenge.'"

Welch said the biggest highlight of that '84 game was seeing teammate David "Curley" Culp, a senior backup defensive tackle, receive the game ball. "Curley worked so hard in practice," Welch said. "He was a quiet gentleman, never famous, but he made a couple of big tackles in that game. Seeing him end his career that way was beautiful in my eyes."

When he was a junior at Oregon in 1985, tight end Bobby DeBisschop scored a touchdown on a 22-yard pass play in the second quarter of a 34–13 Civil War win. Then he flipped the ball to the covering safety in the end zone.

"The guy comes trotting up, and I pitched the ball to him," DeBisschop said. "He caught it, looked at it, spiked it and jogged off, kind of upset. Tony Cherry saw me do it and did the same thing on the next touchdown."

The game story in the *Corvallis Gazette-Times* called it an "un-Civil act."

"The next practice, [assistant coach] Steve Greatwood threw the paper down and said, 'We don't need this kind of publicity. We're going to run,'" DeBisschop said. "I didn't know he was pretending. Then he said, 'Ah, I'll let you get away with this, since it was the Beavers.'"

There were many around Oregon State's program in the late 1980s who thought Dave Kragthorpe was very close to turning things around. Kragthorpe finished 17-48-2 in his six years, so there's not much argument using his record. He didn't have much luck in the Civil War, either, going 1-5, with only a 21–10 win in 1988 on the plus side.

When Kragthorpe arrived at Corvallis in 1985, he had been athletic director at Utah State for two years after a three-year term as head coach at Idaho State. Prior to that, he had been offensive coordinator at Brigham Young for seven years and installed a horizontal passing game when he took over at OSU.

As for the Civil War, "I didn't know how intense it was before I got there," said Kragthorpe, 81. "The term 'Civil War' and all of that type of thing was a little beyond what I expected. It's a great rivalry, comparable to the biggest ones in the country. There are five or six I would put in that category. During the time I was there, the reality was Oregon's program was a lot stronger than ours. It was always an uphill battle for us, though you'd like to do better than we did in terms of percentage."

Kragthorpe said he had a "distinct" feeling of dislike for the Ducks. "They were good people, but they had an aura of superiority," he said. "They'd been winning for years in the series when I got there. That was their attitude—they expected to win. It motivated us, but there's nothing magic you can come up with. Statistics would bear that out."

Jerry Allen became a Duck fan growing up in Grants Pass as a schoolmate of Tom Blanchard, later a standout quarterback and punter at Oregon.

As a student at Southern Oregon College, "I remember seeing O.J. Simpson and Jim Plunkett play at Autzen Stadium," said Allen, in his 28th year as the radio voice of Oregon football. "In those years, you went to Oregon games to watch who was coming to play them more than the Ducks."

When Allen became a part of the Oregon broadcasting team in 1987, football coach Rich Brooks had still not lost a game in the Civil War dating back to his sophomore year as a player at Oregon State in 1960.

"Rich was driven to succeed in that game," Allen said. "He had [the Beavers'] number. He just did. He believed, and his kids believed, that he was always going to win against Oregon State. I realized if a Beaver like Rich could be that rabid in the Civil War, I'd better be green in my blood, too. I got a sense and a feeling for how important it was. It was not just a game. It was almost a matter of life and death. Losing to Oregon State was not an option."

As emotionally attached as Allen has grown to the Ducks over the years, he hasn't put the Beavers on his black list. "I hate to lose to them, but I don't hate them," he said. "I have some good friends and relatives who are Oregon Staters. You get around kids and coaches, they're really all the same. It's the color of the uniform that's different. But to me, the Beavers are the biggest game every year. It's in-state. It's the pride thing. You're around it all year long. You see the Oregon State colors and you're around that all the time. All the games are big, as Chip Kelly would say, but it's never going to be anybody else other than Oregon State for me."

Allen considers Oregon coach Mark Helfrich a combination of predecessors Mike Bellotti and Chip Kelly. "Mike was such a gentleman," Allen said. "He was just as competitive as Rich Brooks but had a personality about him that made you feel part of the program. Chip was brilliant, but his entire life was football. If you couldn't help him in some way win, he had more important things to focus on.

"Mark's a brilliant football mind, more a part of the offense during his last few years as coordinator than people realize. Reminds me of [OSU coach] Mike Riley. It's difficult to dislike a team when the man at the top is as nice a person as Mike is. He is so respectful of fans and the media and the way he deals with the public, it's tough to dislike his team."

Oregon coach Mark Helfrich and ex-OSU halfback Cameron Reynolds (1992–95) have a relationship that goes back to when Helfrich was quarterback at Marshfield High and Reynolds was Lakeridge's star ball carrier in 1991.

The Pirates "upset us in the first round of the playoffs at our place," Reynolds said. "Then we played against each other in the Shrine [All-Star] Game. He was one of the quarterbacks for the South and we won, so I was able to redeem myself."

The two played together for "a sort of semipro" team in Vienna, Switzerland. "He was running our offense, doing a lot of coordinating while he was playing, and I was a running back," Reynolds said. "We got to know each other really well. He's a great guy. He had that kind of a calm confidence under pressure. He was the kind of guy who was always thinking a play or two ahead. He had the ability to get what's out in his brain in a coherent way to the people around him. I knew if he wanted to go into coaching, he was going to be a success."

Cory Huot was a country boy from Anaconda, Montana, when he was recruited by Oregon, Oregon State and Washington State. He wound up at OSU (1991–94) as a three-year starting linebacker. He recalls his first recruiting trip to Eugene in January of his senior high school season.

"I flew in on an eight-seat plane from Butte to Kalispell to Spokane to Seattle to Eugene," Huot said. "Left at 8:00 a.m., got in at 4:00 p.m. This white 1989 Corvette pulled up to get me, a big black man. It was [assistant coach] Gary Campbell. I was shaking in my boots. He said, 'You must be Huot. Throw your bags in the back. Let's roll.' Not a lot of Gary Campbells running around Anaconda."

After small talk with Campbell on the drive to campus, Huot was wide-eyed as he saw the UO coeds "all wearing Birkenstocks. I thought I was on Mars."

Huot's host for the weekend was linebacker Joe Farwell, "a suburban California surfer dude with long hair. I liked to hunt and fish, wore a crew-cut. The only thing we had in common was we were white guys. But I liked him. We had a great time."

At the end of the visit, Oregon coach Rich Brooks brought Huot into his office. "He said, 'We want to offer a scholarship, but I know Oregon State is recruiting you to play fullback,'" Huot recounted. "Dave Kragthorpe had just been voted Pac-10 Coach of the Year that year. Coach Brooks said, 'I want you to know they just signed the best fullback in the state of Oregon. I want you to come here as an athlete. I don't want to pigeonhole you into a position. We may use you at running back, tight end, linebacker.' He was using strategy to leverage me. He didn't threaten me but was saying if I went to Oregon State I might not play. I put that in the back of my mind as a little extra motivation."

Two weeks later, Huot visited Corvallis. Linebacker Todd McKinney, a Bend native, was his host. "Good fit," he said. "Met a lot of guys like Tony O'Billovich, Todd Sahlfeld, Chad de Sully, Pat Chaffey, Scott Sanders. We went fishing on the Alsea River and had a few Coors Lights. More my speed."

After the Beavers upset the Ducks 14–3 at Autzen Stadium in 1991, Oregon got payback with a 7–0 victory at Parker Stadium in 1992. Following the game, Farwell had what surely was the first reference to the "big brother/little brother" theme made popular nearly 20 years later by Oregon's Cliff Harris.

"It was just time to let them know what's up," Farwell told the media. "We are the best team in the state. Last year, Oregon State came up to us like our little brother. You know, you beat up your little brother all the time, and every now and then he gets mad and cracks you in the face. And then he runs off and you're sitting there going, 'Ouch,' with a sore chin. We beat up on them and we're going to keep on beating up on 'em for years to come."

(Before the 2010 Civil War, Harris, a talented cornerback/return man with a penchant for finding off-field trouble, dropped this on reporters who asked the significance of the Civil War: "I know it's a big-time rivalry for Oregon—not just in Eugene but the whole state of Oregon. This is basically like the big brother/little brother backyard brawl." When asked who the big brother is, Harris replied, "You know we're the big brother.")

Farwell was involved in a critical part of the 1992 Civil War after the Beavers had moved to first down at the Oregon 35-yard line late in the third quarter. Farwell drew a personal foul on OSU's Dwayne Owens, who was ejected from the game.

"He [blocked] me pretty good, had me going back, and then he grabbed my facemask," Farwell said. "I was trying to get off him. He just basically rolled me up and was sitting on my face. He started hitting me. So of course, I retaliated a little bit and grabbed his privates. I thought I'd get him off me faster that way. He gets up on me and just stomps on mine. I always wear a cup during a game, so it finally paid off. The joke's on him because he got thrown out. I was fine. I was just acting."

Says Owens today: "The referee said I stepped on someone, that's all I remember. I was trying to get up. He grabbed me. I didn't do anything other than block him and try to get up. Leaves a bad taste in my mouth even today."

The 1992 Civil War was rough for Oregon safety Chad Cota even before the opening kickoff.

Farwell was making the rounds with teammates, getting them fired up. "Joe came up and head-butted me," Cota said. "My front tooth cracked and busted."

The second or third quarter, Cota took a blindside block. "I'd never been hit that hard," he said. "My head bounced off the turf. One of the worst concussions I've had. I didn't know where I was. Had to leave the game. I was totally dysfunctional."

Todd Sahlfeld played linebacker at Oregon State (1988–91), his first three years under Dave Kragthorpe, his last season under Jerry Pettibone. Practice protocol was much different under the two coaches.

"Kragthorpe's practices were intense, with a lot of fights," Sahlfeld said. "Every day there was scrimmaging between first-team offense and defense, which created a little division. We weren't one unit. Then when Pettibone came in, he was completely against that stuff. The first day of spring ball, there were fights breaking out, and he got right into us about it. 'You don't fight your teammates,' that was his thing."

One of the unlikeliest heroes in Civil War history is Joshua Smith, whose four field goals provided all the points in Oregon's 12–10 victory at Autzen Stadium in 1995.

Smith, now 38 and a vice-president of marketing for a medical company in Denver, played quarterback on a Colorado Springs, Colorado high school team that was, well, lousy. "We were 0-27 in three years," Smith said. "I was also our punter and kicker—I led the state in punting average my junior year—but we didn't score many points and I wasn't recruited much. In one game, I had a 68-yard punt, and Derian Latimer—who wound up being a teammate at Oregon—returned it 80 yards."

Smith was invited to walk on at three schools—Alabama, Southern Cal and Oregon. "Visited all three on our own dime," he said. Smith and his parents spoke with UO coach Rich Brooks, who would soon leave for the St. Louis Rams. "We totally fell in love with the campus, and the program had a nice family atmosphere," Smith said.

After committing to the Ducks, Smith worked out daily through the summer and planned to turn out for the team when school started in mid-September. He was watching ESPN on a Sunday morning, working at a golf course, when he noticed on the crawl that Oregon kicker Matt Belden had been injured on a kickoff in the Ducks' opener at Utah. Belden would be out for the season.

When Smith got off work and returned home that afternoon, his parents told him Oregon assistant coach Neal Zoumboukas had called. "We'd like Josh to come out and compete for the job," Zoumboukas had told them.

"I packed a bag and flew to Eugene the next day," Smith said. "They got me enrolled in school, and I went straight to practice. The first day was not a good one. We were on wet grass, and I was slipping and falling. I was first in a punting line with Josh Bidwell, Matt Brewer and a couple of others. Then I went over to the field-goal line and was shanking pretty much everything."

Smith's placekicking got better, though. On Wednesday, first-year head coach Mike Bellotti stopped practice, gathered the players and said, "If Josh makes this kick [a 47-yard attempt], no conditioning today."

Smith made it and was immediately placed on the travel squad. He kicked a pair of field goals in Oregon's 34–31 win over Illinois that Saturday and became the Ducks' regular kicker. The highlight that season was making four of five field-goal attempts in the 12–10 Civil War triumph.

"The coaches emphasized we had to win to get into a quality bowl," Smith said. "It was played on a cold, rainy night. You could tell from the opening kickoff it was going to be a complete dogfight. Every player on both sides was totally hyped. I got into a groove early in the game, made two, then missed one in the middle of the game. A couple of Oregon State players were jawing at me pretty hard. I said some choice words back to them."

Bellotti was good in situations like that, Smith said. "He'd walk up and tell you a joke and take your mind off it," he said. "He said, 'Next time we're going to need you.'"

Smith made a 35-yard attempt with 9:21 remaining for the game-deciding points. "After the game ended, I literally could not get off the field," he said. "I missed the entire locker room [meeting] where they hand out the game ball. They had to come back and get me. I just got mobbed. The student section surrounded me. There were pictures, shaking people's hands...It was an amazing experience. I remember all the seniors coming up and giving me hugs and saying, 'You're part of the team now.' It was a really good feeling."

The next spring, Bellotti told Smith he had one transitional scholarship available for a walk-on, and it was going to special-teams standout Eric Winn. "I understood," Smith said. "Eric was a great guy. I was happy for him."

But Smith asked for a conditional release so he could seek a scholarship at other schools. "Oregon would have had the opportunity to match if I got one," he said. "I didn't want to leave Eugene, but my parents were schoolteachers, so a scholarship was a big deal."

Smith got his conditional release, Kansas State offered a scholarship and Oregon found scholarship money. Smith stayed and then suffered what he calls "a sophomore slump" during his junior year in 1997. He missed a potential game-winning 36-yard field goal in a 24–22 loss to Southern Cal.

Josh Frankel did much of the kicking the rest of the '97 season and JC transfer Nate Villegas did most of it in 1998, though Smith had one final Civil War moment. His fourth-quarter field goal sent the game into overtime. "That was my only kick all year," he said. Oregon State won 44–41 after the second extra session.

Today, Smith remains dedicated to his alma mater. "I have 5-year-old twin boys," he said, "and they are diehard Duck fans."

After the 1995 Civil War, Oregon was trounced 38–6 by Colorado in the Cotton Bowl. Star receiver Cristin McLemore said the Ducks' disappointment at not making a repeat Rose Bowl appearance was evident.

"I have never been more disappointed in my teammates in my life, except maybe the Cal game my sophomore year, when we were up by 32 points and lost 42–41," McLemore said. "This was the worst game I was ever associated with, except that one. I saw guys give up. They were packing it early in the third quarter. I don't know what it was. Maybe we didn't have enough guys who believed yet, but it was frustrating. Colorado had no business beating us.

"I got hurt and left in the fourth quarter, which was fine by me. Everybody else had taken their shoulder pads off by that point. A [Colorado] safety was trying to get me all game. I kept running the slot on him, and he kept getting shots on me. Graz [Quarterback Tony Graziani] got sloppy and led me out, and the safety's helmet hit me flush and blew me up. It felt like my whole thigh was bombarded by a car. I had cracked ribs—end of my career."

Which teammates quit? "I don't want to point fingers," he said. "That would be horrible to do. I just felt like some guys weren't giving it their all."

Armon Hatcher got terrible news prior to the 1995 Civil War game. The OSU freshman safety's best friend, Bilal Sadree, had died of cancer on the Wednesday before the game. The funeral was tentatively set for Friday. He immediately flew home to Los Angeles, intending to catch a late flight that night to be back for the Saturday Civil War. When he arrived, the funeral had been changed to Saturday.

"I had to make a decision," Hatcher said. "Pretty much everybody advised me to fly back and play in the game. After talking to my brother, that's what I decided to do."

After visiting with Sadree's family, Hatcher flew back and played in the Beavers' 12–10 loss at Autzen Stadium.

Today, Hatcher said, "I have a little bit of regret that I didn't go to the funeral. But I saw his family. They said, 'There's nothing you can do here.' And they were right."

Denny Schuler served as offensive coordinator during Jerry Pettibone's final season as head coach at Oregon State in 1996. Pettibone had been unsuccessful trying to establish a wishbone attack.

"Jerry knew he had to evolve to a different style of offense," Schuler said. "I spread things out. I wanted to run the option and throw the football, much like Chip Kelly is doing today. That premise is very sound, but I didn't have a quarterback who could throw it any better than I could.

"Tim Alexander was a great talent but couldn't throw the football nearly as well as I wanted. We moved to a pro set and an 'I' formation and had a pretty good running attack, but everybody was loading the box because we couldn't throw it. We only had two receivers on the squad.

"The defense was pretty sound. Rocky Long left the year I came in, and it was Bronco Mendenhall's first year as D-coordinator. He did a nice job with Rocky's scheme. There just weren't enough players in the program. The facilities were bad. The budget was horrible. It all got better, but Oregon State was trying to play catch-up to the Ducks in many ways. Those were tough years for the Beavers."

Jared Cornell is one of the few recent Oregon or Oregon State players to play for three head coaches. The offensive guard (1997–2000) was recruited by and redshirted his first year under Jerry Pettibone, played as a redshirt freshman and sophomore for Mike Riley and finished up with Dennis Erickson, a starter on the 2001 Fiesta Bowl team.

"I really liked Jerry," Cornell said. "He had a great heart and wanted the best for his players. It was tough timing with the wishbone and the way things were going with wide-open West-Coast offenses. It was also a tumultuous period for the Oregon State athletic department, which was circling the drain, terribly in debt, drawing 20,000 fans at [football] games. Then they brought in Mitch Barnhart and Bob De Carolis and Mike Riley, and that seemed to steady the boat."

During Pettibone's final season, 1996, Oregon State was 2-9, beginning with a 35–14 opening loss at home to Montana. The Beavers drew fewer than 30,000 for their first five home games, including 17,215 for Northern Illinois, before ending with a Civil War crowd of 35,822.

Oregon's Keith Lewis and Oregon State's Richard Seigler could fill a reporter's notebook as well as play football. In 2002, the two engaged in an entertaining war of words over which program should be able to claim supremacy. Seigler had invited Oregon fans to come over to the other side, surmising that "a lot of you guys just don't know you're Beaver fans yet."

"I don't feel like all the Duck fans are against us," Seigler told the media. "I think they really want to be Beaver fans and they're just too caught up in their ways to make the transition. We're expanding Reser, so seats will be available. For all those Duck fans who want to come on over, I'm saying we will welcome you with open arms."

Prior to the 2003 Civil War, Lewis was barred from interviews by Coach Mike Bellotti. Seigler, somehow slipping by Coach Mike Riley's censorship, made up for it. "Bulletin-board material won't really mean anything this week," he said. "Everyone is going to be so fired up, anyway. It won't bring anything extra to the table."

Lewis, Seigler maintained, "just says some crazy stuff. I don't go as far off the edge like him. He jumps off the cliff sometimes. I've never even looked over the edge...We back up what we say, especially on defense. I don't know what to say about him. He should be focused on Steven Jackson and James Newson and Mike Hass, that's what I think."

Lewis had the last laugh as the home team won the Civil War for the seventh straight time. He came to the post-game interview room wearing a bright orange Oregon State T-shirt. "Seigler said today was the last day for Duck fans to switch over to Beaver fans," Lewis said. "I figured since their apparel is so cheap, and I got it off the clearance rack, that I would be a Beaver for today."

Ironically, Seigler and Lewis became good friends as teammates with the San Francisco 49ers.

During his four years as Oregon State's coach (1999–2002), Dennis Erickson went 2-2 with Oregon, winning the home games and losing on the road.

"The Civil War was what college football is all about," he said. "It's the rivalry of rivalries. I've been through a lot of them in my career, but that one is special. You're either a Duck or a Beaver in that state. We always felt like we were the poor guys in the rivalry. There's hate there—probably more than there used to be. But at least they have respect for each other."

Erickson, now an assistant coach with Utah, still carries enmity for his old OSU rival. "Of course I dislike the Ducks," he said during the summer

of 2013. "If you're a Beaver, you don't like them. Even though I'm at Utah now, I'll always feel that way. Their fans still yell stuff at me when I go into [Autzen] stadium."

Cancer took the life of Tyler Strong, the younger brother of Oregon receiver Garren Strong, the week before the 2007 Civil War game. Tyler was 18. Garren was 22.

Tyler was diagnosed during his freshman year in high school at San Jose and Garren's freshman year in college. The plan had been for Tyler to come to Eugene to watch the '07 Civil War.

"He didn't make it," Garren said. "It was a pretty emotional week, burying my brother and then playing my final game at Autzen."

Strong missed three days of practice and then returned to Eugene in the week to resume practice. The support he got when he returned "was amazing," he said, "especially from my teammates. Guys like Dennis Dixon, Cameron Colvin, Jonathan Stewart, Jason Willis...I could go on and on. If there was anything I needed, or I just wanted to talk, they were there for me. We became closer, and it helped me through that rough time.

"It gave me resolve, that I was going out to finish my season and be strong enough to represent my family and my brother. We had a lot of injured seniors that year. It was one I really wanted to win to cap off my senior year and represent the seniors who couldn't play."

Strong caught a three-yard touchdown pass late in the second quarter. The Beavers, however, prevailed 38–31 in double overtime.

Trent Bray was a good enough middle linebacker at Oregon State to be named first-team All-Pac-10 as a senior in 2005. Bray said it wasn't always easy, though, being the son of defensive coordinator Craig Bray. Trent played only his redshirt freshman year for his father before head coach Dennis Erickson moved on to the San Francisco 49ers.

"It was a good experience to play for my dad, but when he left, it wasn't necessarily a bad thing," said Trent, who now coaches linebackers for Mike Riley at OSU. "Some of my teammates may have viewed me differently, like they couldn't say certain things around me. Maybe some of them felt I got preferential treatment. It was a little awkward in that regard."

In the 2004 Civil War game, a 50–21 win by Oregon State, senior defensive end Bill Swancutt had the game of his career, with three sacks, his only career interception and a pass reception for a first down off a fake field goal.

The Beavers had been practicing the fake punt play since training camp but had never run it. In the Oregon game, Colt Charles took the snap and threw to Swancutt for a 17-yard gain.

"We practiced it every practice," Swancutt said. "It was pretty cool to finally get to use it in my last [regular-season] game. I remember running the route and watching the ball, which seemed like it was in the air forever. The only [reception] of my career."

Swancutt's interception—also the only one of his career—came in the late third quarter off a shovel pass from Oregon's Kellen Clemens. "Coach [Mark] Banker had said, 'You have one more series and I'm pulling you,'" Swancutt said. "Over the years, teams would run shovel passes my way because I was going after the quarterback so hard. On that play, it instinctively hit me [that the Ducks were running a shovel pass]. I stopped and jumped right in front of it. It's too bad I couldn't have stayed on my feet. I'd have gone in and scored and probably gotten a 15-yard penalty for excessive celebration."

In 2004, a bowl bid was on the line as both Oregon and Oregon State entered the Civil War 5-5. Said OSU junior Mike Hass, after making nine catches for 154 yards and two touchdowns in the Beavers' 50–21 win: "Us going bowling and the Ducks not—that's all I could ask for."

"We couldn't be stopped in that game," said Hass, who won the Fred Biletnikoff Award as the nation's top receiver the next year. "I scored both touchdowns on the same play, a corner post. [Defensive coordinator] Craig Bray told me the Ducks had something like 10 different coverages to use against me. Most of the time, they were double-teaming me. On one of the touchdowns, I caught it over the top of the corner and snuck by the safety. The other time, I cut in front of the corner. It was a cool game, a nice feeling to send [the Ducks] home and a better feeling to send their fans home."

OSU linebacker Keith Ellison (2004–05) played five years in the NFL, but he said the teammates who made the biggest impression on him were Beavers—defensive end Bill Swancutt and middle linebacker Trent Bray.

"Swannie had an unbelievable motor," Ellison said. "He did not stop at all on the football field. When I first got there, he was the star of the defense. On one play during training camp, I had to do a blitz and had to tell him. He looked back at me and said, 'Don't worry about it, I got it.' I was going to let him do whatever he wanted to do. Trent was the smartest player I ever played with. He taught me so much about how to play linebacker. When I

converted from safety to linebacker, he helped me out. I studied the way he prepared and how he played the game."

Former OSU tight end Joe Newton played with ex–Southern Cal tackle Kyle Williams when they were both with the Seattle Seahawks. Newton said Williams told him the Trojans "used to make up stories about Swanny. They said that he was raised by wolves because he was such a tough guy to block. A savage raised by wolves—completely unblockable."

Joe Newton played at 6-7 and 250 at Oregon State. He remembers going up against Oregon defensive end Igor Olshansky—6-6 and 310—as a freshman in 2003.

"I vividly remember trying to block Igor," Newton said. "He was a big, very strong man. I remember thinking, 'Man, this guy is a beast.' I'm not small, but I'm no Ukrainian power-lifter."

Derek Anderson was so tight with Dennis Erickson, it created a dilemma when Erickson left for the San Francisco 49ers and Mike Riley replaced him after Anderson's sophomore season at Oregon State in 2002.

"I contemplated leaving," said Anderson, in his 10th NFL season. "Then I talked to [former OSU quarterback] Jonathan Smith, and he said, 'You're really going to like [Riley]. You need to stay and check it out.'

"Mike used a very complicated system. I struggled because Dennis's system was so simple. But by my senior year, I had it down. I learned a lot more from those two seasons than I did the first two to make me more NFL-prepared. My first training camp, a lot of things were identical to the way we called the plays under Mike. The year I went to the Pro Bowl [with Cleveland], we used essentially the same system as we had at Oregon State."

When Tim Euhus was choosing between Colorado State, Boise State and Oregon State out of Eugene's Churchill High, he took a recruiting trip to Fort Collins, Colorado.

"I did not find one guy I felt I could be a teammate with, a guy I could hang out with," Euhus said. "It was not a culture I wanted to be a part of. It was kind of scary. [Head coach] Sonny Lubick had me at a suite in the hotel and pressured me to commit. He said, 'If you leave now [without committing], no scholarship for you.' After I met Coach [Dennis] Erickson, it was in my heart I was going to Oregon State."

Euhus wound up playing tight end with two of the best quarterbacks in OSU history, Jonathan Smith and Derek Anderson. "Jon was a great leader,

one of the smartest quarterbacks I played with at any level," said Euhus, who played three NFL seasons. "He'd get in the huddle and just handle it. He knew the game extremely well, prepared extremely well, and he had a cannon—serious velocity throwing that football. Derek had every physical attribute you'd want in a quarterback. The guys loved him. They rallied around him. Derek was much more emotional than Jon. Jon is such a good coach, a lot like Coach Riley, because he keeps his emotions very tight to the vest. There's room for both types of players. But Derek's way can bring the guys together a little bit better. You played for and respected Jon. With Derek, everybody was his best friend."

Tight end George Wrighster said he considered UCLA, Arizona, Wisconsin and Florida State before choosing Oregon, where he played from 2000 to 2002. At the time, he said, it almost felt like a consolation prize.

"I remember being kind of mad when I told my parents," said Wrighster, who grew up in the San Fernando Valley in Southern California. I was like, 'Who goes to Oregon? Why is it that I want to go there?' I was supposed to be a big recruit.

"It's one of the best decisions I've ever made. If I had it to do over again, the only school that would be tough to turn down is Stanford. I was a real good student with a 1,410 SAT score. I took an executive grad-school course [at Stanford] that was amazing, and the networking gained from going there is hard to beat. But I'm a proud Duck. For an overall great college experience, I'd rather go to Oregon. I rep Oregon all day on Twitter. The people of Eugene are amazing, and playing at Autzen Stadium was the best."

Wrighster, 33, lives in Los Angeles and owns two bakeries in Pasadena, California. He is also an avid blogger and devoted one post in 2009 to Oregon's supremacy over Oregon State:

"Breaking news: It is being reported Oregon State coach Mike Riley will only be able to dress 20 players for the Oregon game. The rest of the players will have to get dressed by themselves! Eugene and Corvallis are separated by one highway, but the separation between the green/gold and black/Pumpkin orange is much greater. In Eugene, we have a saying: If you see a Beaver with a championship ring, call the police. He's a thief!"

Brothers Jed and Dan Weaver made their presence known at Oregon—Jed as a tight end from 1996 to 1998 and Dan as a center from 2000 to 2003. There are other Weaver relatives who have made names for themselves in sports. Pitchers Jeff and Jered Weaver are their first cousins.

"Our dads are brothers," said Dan, 34, a CPA for a lumber company in Portland. "We'll see if the baseball stuff catches on with any of our kids."

Dan Weaver said two of the best talents he ever played with, running back Onterrio Smith and quarterback Joey Harrington, were opposites in terms of accountability. "Onterrio was a cool guy, and what a talent—just a specimen of athletic ability," Weaver said. "But you couldn't really trust him when the going got tough. Joey was a quiet leader. He tried to be more vocal his senior year, but he was forced into that role. That wasn't his nature. He led by example. You didn't have to worry about when it came down to the end of a game. He'd do the right thing. You had no worries when it came to him."

Weaver walked on and earned a scholarship as a sophomore. "My senior year, they gave a talk to prospective walk-ons and told them, 'You're no different than our scholarship guys,' which was a load of you-know-what," he said. "But the difference between Oregon and a lot of places, they give you a fair shake to become one of those scholarship guys. You're not just a practice dummy. You have a chance to step outside that role and become a player."

One of the biggest challenges during Josh Linehan's time as an offensive lineman at Oregon State (2003–06) was blocking Oregon's man-mountain defensive tackle, Haloti Ngata.

"I only went up against him once, in 2004 when I was a redshirt freshman," Linehan said. "He came as advertised. I don't know if you can find a more powerful guy than Ngata. You couldn't move him. He never got a sack on me, but that guy was a freaking load. He literally lifted me off the ground one time, but he didn't get by. But he was on the other side a lot, though, going up against Roy Schuening."

"I learned a lot from Ngata," Schuening said. "I did OK when I was a sophomore [and Ngata a senior]. Being a young guy, I ran my mouth a little bit, just was being cocky. On one play, he ended up planting me in Derek Anderson's lap and I gave up a sack. I learned it's not about running your mouth but about doing your job and letting your play speak for itself. He was a classy player."

Linehan had much the same experience. "My first year, I did a little bit of talking," he said. "Every now and then I'd say something. After that, I learned that you don't need to open your mouth. Once you start getting the respect in the conference and put your time in, you don't need to talk. If I said something [to Ngata], he probably told me to shut up."

The 2009 Civil War game was a classic, won by Oregon 37–33 in a battle for the right to represent the Pac-10 at the Rose Bowl. In a suite watching the game at Autzen Stadium with former Oregon athletic director Pat Kilkenny was Chris Anderson, newly named publisher at the *Oregonian*. Both are Heppner natives. Anderson was once editor of the Oregon State school newspaper, the *Barometer*, and remains a devout Beaver fan.

"I hadn't seen Chris since the 1960s," Kilkenny said. "We reconnected via the Internet. He was a gentleman that day. He brought with him mock-ups of the newspaper with two different headlines—one with Oregon winning, the other with Oregon State winning. When the game was decided, he brought out the good ones, which was really cool. His allegiances were with the Beavers, but he was a class guy."

Coaching is about relationships—even on other staffs, sometimes. The current offensive line coaches at Oregon (Steve Greatwood) and Oregon State (Mike Cavanaugh) are pals.

"We've recently come out of the closet with our friendship," Greatwood said. "That doesn't mean I would ever tolerate the thought of losing to [the Beavers]. But I have a great deal of respect for Mike and their program."

"The secret's out, I guess," Cavanaugh said. "I first met Steve when I was at the University of Hawaii and he was recruiting the islands for Oregon. We have quite a bit in common even though we're Civil War rivals. We're O-line coaches, we enjoy good food and cold Bud Lights. Every summer we get together and barbecue and drink a lot of beer and solve life's problems. We never even talk football. Steve is a genuine, salt-of-the-earth kind of guy. The only time we don't talk is the week of the Civil War."

So Cavanaugh doesn't hate the Ducks? "Hate is a strong word," he said. "My mother always said that. I hate the Ducks but not the coaches."

SOURCES

Edmonston, George P., Jr. "Andros Shows Valor on Another Field." *Corvallis Gazette-Times*, March 7, 2002.

McCann, Michael. *Oregon Ducks Football: 100 Years of Glory, 1894–1995*. Eugene, OR: McCann Communications Corp., 1995.

Moseley, Rob. *What It Means to Be a Duck*. Chicago: Triumph Books, 2009.

Warren, Edward. "The Development of Football in the University of Oregon." Thesis, University of Oregon, 1937.

Welsch, Jeff. *OSU Football—Celebrating 100 Years*. Corvallis, OR: Corvallis Gazette-Times, 1993.

ABOUT THE AUTHOR

Kerry Eggers has been writing sports for Portland newspapers since 1975. A Corvallis High School and Oregon State University graduate, he began his professional career with the *Oregon Journal* and moved over to the *Oregonian* in 1982. He has been a sports columnist with the *Portland Tribune* since 2001.

Eggers is a five-time winner of the Oregon Sportswriter of the Year Award, most recently in 2011. He is past president of the Track & Field Writers of America and former winner of the Jesse Abramson Award as the nation's top track and field writer.

This is Eggers's sixth book. The others are *Blazers Profiles* (1991), *Against the World* (with Dwight Jaynes, 1993), *Wherever You May Be: The Bill Schonely Story* (1998), *Clyde "The Glide" Drexler* (2004) and *Football Vault: The History of the Beavers* (2009).